Fred O'Leary

Corkscrews

1000 Patented Ways to Open a Bottle

Schiffer Publishing Ltd

77 Lower Valley Road, Atglen, PA 19310

In memory of Bob Nugent

Library of Congress Cataloging-in-Publication Data

O'Leary, Fred, 1933-
 Corkscrews / Fred O'Leary.
 p. cm. -- (A Schiffer book for collectors)
 ISBN 0-7643-0018-0 (hard)
 1. Corkscrews--United States--History. I. Title. II. Series.
 NK8459.C67064 1996
683'.82--dc20 95-53671
 CIP

Printed in Hong Kong
ISBN: 0-7643-0018-0

Published by Schiffer Publishing Ltd.
77 Lower Valley Road
Atglen, PA 19310
Please write for a free catalog.
This book may be purchased from
the publisher.
Please include $2.95 for shipping.
Try your bookstore first.

CONTENTS

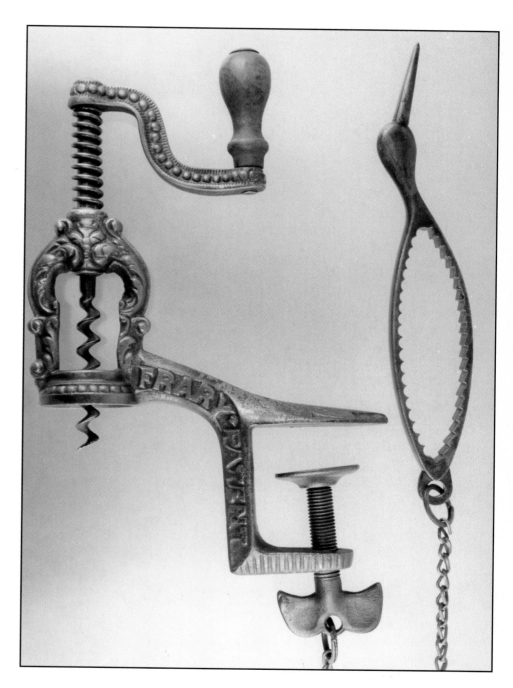

Fig. A1-1 FRARY PATENT APD FOR 5 AV-
ENUE The rare FRARY corkscrew with cork
gripper and wire cutter accessory. Is it a patent
or isn't it? (See Appendix One.) *Courtesy of Jack
D. Bandy.*

FOREWORD

Fred O'Leary's ambitious *Corkscrews... 1000 Patented Ways to Open a Bottle* is a researcher's labor of love in which we are given a look into the evolution of corkscrew design and construction as recorded in the files of the U. S. Patent Office. Three years of dedicated study enabled Fred to uncover and present a full one-thousand U.S. patents – many for the first time – giving proof of the creative drive, ingenuity, imagination, and inventive skill of free people driven by a strong competitive spirit.

Beyond assembling a valuable resource, Fred breathes life into the subject by relating colorful anecdotes about the inventors and their sometimes quirky claims of invention. Both utility an design patents are included. The coverage of American bar corkscrews os the most extensive I have seen.

As an enthusiastic collector since 1949, I have known about or been lucky to find hundreds of patented corkscrews from around the world. Until Fred's book, however, I had no idea so many U.S. patents existed, either specific to corkscrews or for devices that include a corkscrew among other functions. The scope is breathtaking: from kitchen gadgets to household tools, poison bottles, champagne taps, match boxes ...as a far-out example, I was amused by a pocket knife that brought together a corkscrew and monkey wrench, of all combinations! The book is rich in informational gems and witty observations about specific patents, much like William Johnson's "Kitchen Utensil", patented in 1930, which not only pulls corks but is useful in "sewing fowl." One can only marvel at such inventive diversity, which Fred has done a monumental job in capturing for us.

With nothing comparable on the market, this book will surely become the primary reference not only for corkscrew collectors but also wine enthusiasts, antique dealers, historians, engineers, and cross collectors whose primary interests may be knives, bottle openers, can openers, glass cutters, tools, etc. It will be a conversation starter and a stimulus for those who are curious about inventors and the workings of small and enduring mechanical contrivances as a corkscrew.

This book is serious research made fun and we should be grateful to Fred for giving us such an enjoyable insider's view of corkscrews and their inventors.

Brother Timothy Diener
Cellarmaster (Ret.)
The Christian Brothers Winery
Napa, California

ACKNOWLEDGMENTS

For the longest time, I thought all authors were experts. Now I know better. Authors may be goal-driven but, speaking for myself, I feel I am at the beginning of the learning curve. This book is more a compilation than a creation. My role has been, wittingly or unwittingly, that of a channel through which the knowledge and experience of others has been given expression. I have *depended* on the experts, without whom there would have been no book with *my* name on the cover.

What started in simplicity has reached some degree of complexity in fulfillment, thanks to a host of individuals, many of whom are meeting in print here for the first time. It is the least I can do, except to reassure each of you that your contributions were indispensable and that you deserve a reflective sense of personal pride well beyond my public disclosure.

First to the Patent Clearing House, Sunnyvale, California, now the Sunnyvale Center for Innovation, Invention and Ideas (SCI³), I give thanks for letting me camp out in the stacks for the past three years, asking questions that were not always mainstream and using resources generally reserved for inventors. Particularly I wish to single out Dottie Hamilton for her interest in things antique, Janet Berkeley for her capacity to juggle mega-doses of inquiries while making you feel you are the only one and Marjory Cameron whose soft graceful presence brings dignity to an otherwise frenetic scene. They were there for me before a book became evident, as they are for many a would-be inventor whose fame is only a distant promise.

Thanks to Steve Lawrence of Superior Color Labs, San Jose, California for guiding me from the ground while I piloted my camera to a successful landing time after time. No amateur photographer ever obtained better professional prints than did I. Surely, miracles took place in his laboratory while I slept.

Thanks also go ... to Rochelle Mendle for introducing me to Nancy Schiffer, whose company chose me for this project long before I knew I was up to it ... to Denis Alsford, lifetime collector of match holders and author of the fine recent publication by that name, also by Schiffer Publishing Ltd., for his support and encouragement. He has already been where I was treading for the first time, never failing to lift me up when the way got fuzzy. I have never met Denis, but there is much we have in common ... to Don Thornton for showing by example what good research and a lot of egg beaters can whip up, in his fine publication, "BEAT THIS, The Egg Beater Chronicles" ... to Wayne Smith, author of "Ice Cream Dippers," for his willingness to share historical information laboriously scooped out by his own personal efforts ... to Steve and Donna Howard for appearing out of nowhere to open their archives to me ... to Bob McLoraine of Le Creuset of America for his information on the fabulous Screwpull, supplemented by Don Minzenmayer who knew the late Herbert Allen personally ... to Phil Lewis of Red Coach Antiques, who volunteered information on The 1876 Centennial Exhibition to a complete stranger upon a single phone call ...

The list of contributors also includes Formica Corporation, the Edison National Historic Site, Susan Federighi, Linzy Norton, Peter Marzio, Peter Altman, Winston E. Cock Jr., James Rollband, Phil Lewis, and my brother, Brian O'Leary, who is way ahead of me in the art of writing and business of publishing, and likely to remain that way.

And then there are the collectors whose corkscrews grace the pages of this book. What a bunch! They opened their homes, their awesome collections, their precious time, their wisdom and knowledge to me. My files bulge from their letters, their literature and their own articles written from research conducted at American libraries, Recording Offices and former factory sites. They include Bob Nugent, Bert Giulian, Howard Luterman, Milt Becker, Don Bull, Nick D'Errico, Jane Wlochowski, Mike Wlochowski, Jeff Mattson, Joe Paradi, Ron MacLean, Fred MacAdam, Joe Young, Jack Bandy, Herb Danziger, Lehr Roe, Bob Sager, Dennis Bosa, Wayne Meadows, Brother Timothy Diener. The list extends to Dean Walters and Joel Goodman, dealers by profession, which we cannot hold against them, but who are indeed masters in the art of putting corkscrews in motion. Not many collections lack representation from the offerings of one or both of these professionals. Lest I forget, it was the wives who informed us when it was time to quit for dinner and laid out the towels. How they put up with us sometimes, I will never understand. They remain true, even upon discovering what we paid for the last corkscrew.

I particularly wish to single out for recognition Bob Nugent and Ron MacLean. Their collections are not only deep and comprehensive, especially in the subject matter covered by this book, but their knowledge is seemingly boundless, far surpassing that which has been collectively absorbed by the rest of us mere mortals. It was they who struggled through the first draft, before the spell checker kicked in, and who rendered comments that considerably sharpened the accuracy of my writing. Let the potential author beware of that which doesn't first pass muster under the scrutiny of these two. Ron, bless his heart, also volunteered for a *second* round, taking a lot of fun out of the experience of beholding the finished product for the first time. No one can claim better mentors.

I also wish to shine the spotlight deservedly on Brother Timothy, collector *emeritus,* who is one of those rare individuals whose last name is not needed for universal recognition. His long and respected stewardship at The Christian Brothers is familiar to almost anyone associated with wine. What is not known about Brother Timothy is that he was Chosen for this role after being primed for a career as a teacher. In graciously accepting my invitation to write a Foreword, for which he too had to read the manuscript, he found himself teaching once again — this time English, with me the student.

Finally, I want to thank my family for putting up with my total physical absence in the beginning and only my back later, as I settled in to the 12" separation between my nose and the computer screen. Meighan and Colin, bless you and good tracking as you look ahead to your careers. I hope I have set an example you can be proud of, even if we couldn't "hang out" together so much. To my wife and best friend, Suzie, who clothed me and fed me, dared to be human in the bear's den I once called home, whited out a million blotches, taught me how to spell "category," and demonstrated far more patience than I deserve. I say thank you for waiting for my return to normalcy and for being willing to truly stretch the meaning of "for better or worse."

The project had hardly taken form when our beloved Golden Retriever, Wowzer, was pulled from us by the Great Extractor. His spirit now lives in Juliette. These two loyal companions kept a constant vigil at my feet throughout the project. Were it not for them I would have enjoyed scant physical divergence. Even at that, how boring it must have been for them, how many balls did not get fetched ... I hope to make up for it now. This one's for you, Wowzer. We finished what you helped begin.

My heartfelt thanks goes out to you all. *You* are the true experts.

Fred O'Leary
September 21, 1995

PREFACE

As a restaurateur during the 1970s I became very involved in wine. It was nothing short of total commitment: extensive wine list, classes, newsletter, guest speakers and tastings, all staged in a decor punctuated with wine paraphernalia and artifacts. Although attentive to the service of wine, I considered the pulling of the cork to be a necessary evil — at best a nuisance, at worst a potential for disaster. It was something to be done before taking up the important business of evaluating and enjoying the wine.

That has all changed. In time I became an ex-restaurateur with an inherited love for wine and a closet full of wine artifacts. Later, when the artifacts came out of the closet, displaced by a growing wine "cellar," I underwent my personal transformation from a wine lover to a wine-loving corkscrew collector. And although the collecting bug has long since taken on a life of its own, the corkscrew is now accepted as an integral part of the sensual experience. Maybe it is my imagination but the wine just seems to taste better when I bring out one of my beloved antiques.

The screw part of the corkscrew, known as the "worm," has been around for the better part of three centuries, which, except for the most esoteric fine tuning, puts it beyond the claim of invention. The other part is a different story, having attracted, for better or worse, a full measure of the creative spirit. New, patentable ideas continue to come forth, with no end in sight, save for the inevitable day someone invents a stopper that works better than the cork. It seems like a lot of fuss for a handle, but that's what makes corkscrews so special. Is there a perfect corkscrew? The clue is not to look at the curly pin but amongst all those Angels dancing on its head.

For anyone who has been the victim of a crumbled cork, a floater, a chipped bottle, a strained back, a ripped pocket, an inappropriate ceremonial utterance..., here are 1,000 well-intentioned attempts to solve your problem. To the minds of these imaginative inventors, each works perfectly every time. In real life... well, you be the judge. To honor their name, whose collective genius I hope to have captured in this book, I respectfully raise my glass to each for being one patent closer...

"...to the perfect corkscrew!"

INTRODUCTION

That reminds me of our trip to Afghanistan. We lost our corkscrew and were forced to survive for several days on food and water.
Attributed to W. C. Fields

Every household has one. Every bar, restaurant, church and camper trailer has one. Every hospital, apothecary and hawker's wagon once had one. Just about any place you looked you could find one, except maybe the headquarters of the Women's Christian Temperance Union, which might not have withstood the scrutiny of a modern airport security detector. What is this thing that is more universal than TV and indoor plumbing?

The trusty corkscrew.

Even collectors with typically hundreds of corkscrews at their disposal are likely to have an old reliable stashed in the tangle called the kitchen drawer. It just sits there between the egg beater and potato peeler waiting to be called to duty... waiting to do its job and be taken for granted... again. But if lost or broken, like our ancestors found as far back as 400 years ago, nothing else works. It doesn't have to be pretty, but unless you have one when you need it, your picnic or dinner is going to be inconvenienced, at the very least. That absolute has not lost itself on the inventive mind.

In the free world, invention is synonymous with "patent." Whereas early corkscrews were commissioned almost as works of art, by the time the Industrial Revolution took hold, corkscrews became items of 'manufacture', with the pursuit of profit driving the economic engine. Because risk is a companion to profit, Governments dangle the carrot of a limited monopoly in return for disclosure, which fuels even further invention. Motive shifted from the needs of the benefactors to the needs of the producers. When art, a capability of the few, gave way to greed, a capability of the many, we got corkscrew patents.

Of course, in the very first place, the corkscrew owes its existence to the cork stopper, produced from the bark of the... well uh, cork tree, indigenous to southern Spain and more significantly to American wine makers, Portugal. Having the unique property of holding its shape without absorbing or transferring impurities, the cork had no equal for sealing bottles during most of the 19th century. That meant in addition to wine, medicine (including the remedies and cures inappropriately referred to as "patent" medicine), beer, champagne, whiskey, cider, sarsaparilla, ink, perfume, catsup, poison... you

name it, all came sealed in corked bottles. With the added impetus of the Industrial Revolution, corkscrew invention flourished during the last half of the 19th century and well into the 20th. Today, with more specialized stoppers used for bottling liquids, the corkscrew is associated almost exclusively with wine. So, while wine may have given the corkscrew its mystique, the other applications gave it its diversity, as we shall see.

Except for "Design" patents, which first appear in Chapter 2, art is not a consideration in the granting of a patent. While many attractive corkscrews came to be patented, claims of invention must be limited to that which is "new" and "useful." The litmus test for being "new" is that it not be obvious to a person "skilled in the art" of that subject. Let's say your brother-in-law comes to you with a better idea for a corkscrew. Assuming you know something about corkscrews, ask yourself this question: would it have occurred to you? Perhaps somewhat of an oversimplification, but if in your heart-of-hearts you know you would not have thought of it, it passes the test of invention. Not written into patent law but appearing in declarations of a majority of earlier patents is the supplication, "*can be produced at less cost.*" How this facilitates elevation to patenthood is unclear, but the fact remains, most of the patent activity took place at the low end (although you would never know by today's prices).

The term "useful" is almost impossible to pin down — the broad condition being that the invention have a "useful purpose" and that it be able to "perform the intended purpose." That allows inventors to drive to (through?) the Patent Office in a semitrailer. Although the patent may protect the inventor, it does not have to protect the user. There are no warranties or guarantees implicit in the existence of a patent. The invention must simply be demonstrated to do what is claimed, no matter whether it has any practical application or not. That is left to the marketplace to decide. Nor did it have to *prove* its economy, durability or even safety. Patent law notwithstanding, anyone familiar with gravity would know that a device for attaching feathers to human arms would be somewhat risky to use for flight; or that a chastity belt would be able to cure insanity; or that

an outdoor ceiling would make an airplane fly (Fig. I-1). Many corkscrews of yesteryear seem almost laughable by today's standards, yet were granted patents for being new and useful.

So if it didn't have to be beautiful, functional or safe, what did make an invention patentable? As an independent observer, unconnected with either the Patent Office or the legal profession, I hereby offer my unofficial 'citizen's' view, based on my experience with the patent system.

The key seems to center on the concept of "improvement." There are very few paradigm patents that change the direction of the human race. There aren't many Alexander Graham Bell, "Mr. Watson — come here — I want to see you" moments. Instead there are literally millions of incremental ideas, taking what is and making it different, if arguably better. A critical notch added in the right place, a simplified movement, all went into the evolution of an idea until made obsolete by the next paradigm invention. Thus, although the lantern was replaced by the light bulb and the horse and buggy by the automobile ('horseless' carriage), lanterns

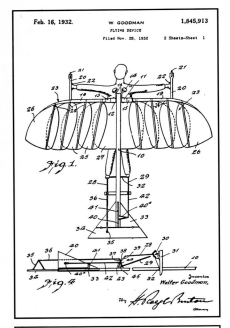

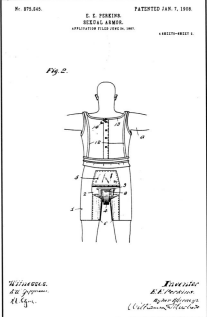

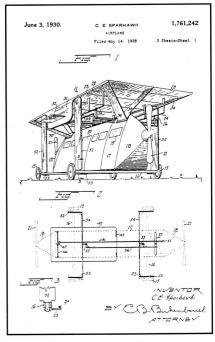

and buggies got to be very sophisticated in their time. Inspiration, fame and riches do not come to everyone, but like the lottery, the incentive is there for anyone to take his or her best shot.

If the patent system was responsible for producing more cheap, ugly, inelegant, sometimes unworkable and indistinguishable corkscrews than would otherwise have been the case, leading to such confusing codification and limited production, why all the fuss? The question provides its own answer. It is a mess dear to the hearts of collectors and ripe for the sorting by would-be authors.

The procedure for obtaining a patent is quite structured. It starts with an idea in the mind of the "applicant" who must first determine whether it has already been patented. This is accomplished by reviewing past patents (the "search"), generally with the aid of a patent attorney. Assuming no prior patent is found, an application is "filed" with the Commissioner of Patents and Trademarks, Washington D.C., located in Virginia (Fig. I-2). Taking the term literally, the Patent Office puts the application in a file for a couple of years, or so it seems, before an "Examiner" gets it out and goes through the same search

process as did the applicant, only taking longer. Perhaps it is unfair to imply that a patent review is a long drawn out affair, considering that there is a backlog of several hundred thousand applications at any one time. On the other hand it is curious how the lag between filing and decision can be so varied over the course of history, if applications are taken on a first-come first-served basis.

If the patent is eventually approved, the proud new possessor is home free to make a temporary (or hopefully permanent) living from the invention, either by selling the patented product without having to worry about someone else profiting from the idea, or selling the rights to use the patent, much like a royalty. Needless to say, things can get pretty sticky between two inventors whose ideas are similar and concurrent. As far as the Patent Office is concerned, the edge goes to the inventor who can prove to be the first with the idea, not necessarily the first to file. For the combatants themselves out in the real world, the issue must often be decided in court. Either way, the greater good is achieved from disclosure of the idea, which generates more ideas and perpetuates the system.

What inventors do to corks

(or claim that "ordinary" corkscrews do, that theirs don't). A sampling of 'action' words taken randomly from patent specifications:

pump, blow, agitate, spring, unplug, rip, split, burst, impale, spike, inject, probe, punch, drill, cut through, disconnect, unseal, induce, budge, worm, displace, shove, propel, eject, ease, discharge, reel, suck, yank, expel, wring, squeeze, siphon, uproot, extirpate, free, hoist, undo, coax, uncover, ream, crack open, pin, disintegrate, embed, interlock, lift, wrench, rotate, press, catch, wedge, compress, pull, expand, pressure, screw-home, embrace, chisel, pierce, force, insert, engage, tap, strip, hook, grab, penetrate, grasp, turn, stamp, depress, unseat, claw, puncture, destroy, sever, scrape, release, pry, rap, perforate, crimp, slit, manipulate, gouge, oscillate, thrust, secure, grip, lacerate, bore, guide, tear, loosen, remove, push, hold, swing, extract, fasten onto, clasp, clamp, tilt, extend, contract, enter, cover, extricate, reverse, abut, lock, bend, raise, twist, spear, flatten, plug, pass through, mount, drive-home, affix, draw, collapse, plunge, retrieve, unscrew, elevate, open, strike, ratchet, withdraw, break, carry, loop, project, clinch, encircle, cut, hammer, separate, cramp, dislodge, straddle, actuate, bind, mutilate, dispose, jerk, anchor, sink into, expel, prick, arrest, overcome, jack, expunge...

Fig. I-1 Patents that passed the new and "useful" test.

FAST TRACK OR
LOSE TRACK?

In order for an applicant and Examiner to function in a system that is over 200 years old and has produced nearly 6,000,000 patents, it became necessary for the Patent Office to establish a CLASSIFICATION SYSTEM, broken down into Classes and Subclasses, where the field of search can be more limited and manageable. It is both a blessing and a curse, for the Classes and Subclasses themselves are now more numerous than the number of patents issued when the classification of patents first began. With new and revised Classes and Subclasses continuing to be churned out, often having overlapping and esoteric interpretation, the search can be more daunting to an inventor than marketing the invention. Were it not for the computer, the task would be insurmountable instead of merely frustrating, for the inventive at heart and the clerical at heart are in many respects, anathema to each other.

The procedure applies equally to historians in general and corkscrew patent researchers in particular. My reason for visiting the local patent library,[1] was to learn a little more about my modest collection of corkscrews marked with a U. S. patent (Fig. I-3). There was no thought of a book, let alone contract, to spur me on — only the simple curiosity of an innocent collector. Being of sound mind and formal education, I looked up "Corkscrew" under "C" in the "INDEX TO THE U. S. PATENT CLASSIFICATION SYSTEM." There, unmistakably, are to be found the magic numbers, "81" (the Class designation for "TOOLS") and "3.45" (the Subclass designation for "RECEPTACLE CLOSURE REMOVER. Screw type"). I was then able to access all the patent numbers issued in that category on microfilm, which turned out to contain a total of 111 patents.

The system works!

[1]Sunnyvale Center for Innovation, Invention and Ideas (SCI³), Sunnyvale, California

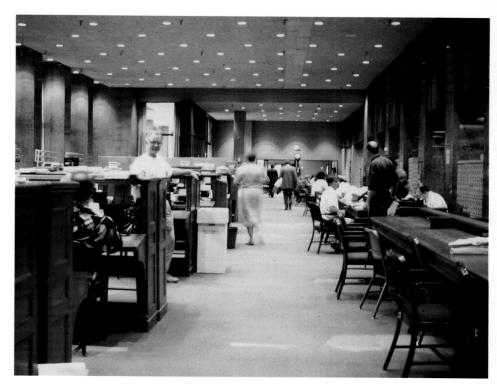

Fig. I-2 The search room at the "P. T. O." (Patent and Trademark Office), located in the "Crystal Plaza,"Arlington, Virginia.

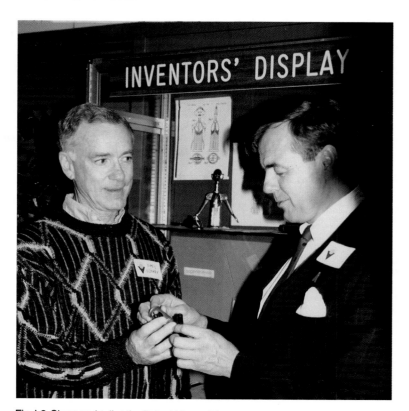

Fig. I-3 Show-and-tell at the Patent Library. The author grabs a moment in the spotlight with Bruce Lehman, Patent and Trademark Commissioner, on a visit to the local facility. The object of admiration is an 1862 Chinnock patent. In the background is an exhibit of U. S. patented corkscrews put on by arrangement with the library.

But wait. On further review, of the 111 patents, curiously only 100 were for corkscrews. Why would there be anything other than a corkscrew in the corkscrew Subclass? How could there be any ambiguity over what a corkscrew is? Either it is one or it isn't one. More ominously, why only 100 when everyone knows there are more? Of course, the answer is that there are *many* more, some even having patents with the title of "Corkscrew." Clearly, there was a mysterious hand being played across the table of time.

(Before proceeding further, let me respectfully suggest that no one ever attempt to do what I did next, least of all an inventor, whose mission it is to *rule out* the existence of a prior patent rather than find all the patents that are close to some arbitrary criteria — in this case, corkscrews. You may not even want to *read* further if you are the empathetic type or get anxious in Government offices. Going beyond this point is dangerous to the rational mind, it is haunted by ghosts of Bureaucrats Past, it tantalizes, titillates, torments and plays on expectations only to dash them with disappointment and disillusionment. It gobbles up hours of time and spits out crumbs of false leads. The labyrinth of Classes and Subclasses, the capricious indexing of weeks, months, quarters and years, the creative titles in a forgotten language, the legalese that attempts to draw pictures... all that and more awaits the corkscrew patent researcher who dares enter Patent Wonderland beyond Class 81, Subclass 3.45.)

In retrospect, the corkscrew patents harvested from the group in which they are indexed turns out to have only 10% of the total.

I rest my case.

ALL ABOARD THE PATENT LOCAL

Forewarned is forearmed. Allow me to continue. Later we shall rejoin the folks who have fast-forwarded to the pictures.

Meanwhile back with the "C's" in the INDEX TO THE U. S. PATENT CLASSIFICATION SYSTEM, I next looked up "CORK PULLERS" (81 3.7) and "CORK REMOVING IMPLEMENT" (D8 42). These two subclasses produced zero and 67 patents respectively. Now, you may wonder why there are *no* corkscrew patents listed in the Subclass for "CORK PULLER." The reason is that this is now the Subclass for 'LEAF-SPRING SPREADERS." Apparently the change had not yet caught up to the Index. I also found that "BOTTLE Openers. Hand manipulated types" referred me to 81 3.7, giving me *two* ways to get to Leaf-Spring Spreaders. Remember, this is Patent Wonderland.

cork.screw *n* a pointed spiral piece of metal with a handle used for drawing corks from bottles

With the Index having limited use for me, I decided to take on the formidable "MANUAL OF CLASSIFICATION" contained in six loose leaf binders, each one thick enough to require two hands and a lot of lifting. In it (them) can be found the word "Corkscrew," but unfortunately, not indexed. It seems there were some classifiers (obviously non-wine lovers) who felt that other features of the corkscrew were more important than the corkscrew part. Hence, we inherit Class 7 ("COMPOUND TOOLS"), Subclass 154 ("RECEP-

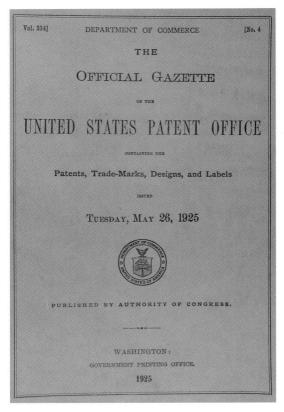

Fig. I-4 An OFFICIAL GAZETTE for May 26, 1925.

TACLE OPENER OR CLOSURE REMOVER ..with corkscrew") or Class 30 ("CUTLERY"), Subclass 408 ("CAN OPENER ..with other cutlery means"). Both classifications produced corkscrews, but they were in the minority. By the time I was into "COMPOUND TOOLS PLIER TYPE ..with tool pivoted to plier," the likelihood of finding a stray corkscrew was remote. Moreover, I also discovered that whenever a patent had other functions, it could be assigned to more than one classification. Thus my work became repetitious as I kept looking up the same rejections. The further I ventured into the 'fringe' subclasses, the fewer and fewer hits I got per category, which was very inefficient, time consuming and frustrating.

It was beginning to look like there was no room left for a logical mind to operate inside the collective consciousness of the patent system. If only they had followed Webster's in the first place.

One clue that I could be in over my head, was that I found myself peeking randomly at neighboring pages in the "OFFICIAL GAZETTE OF THE UNITED STATES PATENT AND TRADEMARK OFFICE," hoping to pick up stragglers by sheer chance. The fact that I actually found some in this manner was unsettling. So much for the scientific method!

The OFFICIAL GAZETTE is the official journal of the Patent Office, published weekly (Fig. I-4). It contains, among information of a more general nature, a compendium of each patent issued that week.[2] It has been in continuous publication since July 7, 1874, when it replaced the "REPORT OF THE COMMISSIONER OF PATENTS." The OFFICIAL GAZETTE is indispensable to inventors and researchers who have another life, for it would be impossible to look up every patent. Instead, patents which cannot be ruled in or out by their title alone can be skimmed for relevance by a fast check in the OFFICIAL GAZETTE. Although the format has changed throughout its existence, the OFFICIAL GAZETTE offers a representative drawing from the many contained in the actual patent, together with a summary of the specifications and/or one, a selection, or all the claims. As will be seen, the discretionary implications of what is chosen to represent the patent in the OFFICIAL GAZETTE can trip up corkscrew historians, but it is a small price to pay for sanity. In modern times the foregoing summary is referred to as the "Abstract," which constitutes the first page of the patent. The full patent, which can often consist of many pages of drawings and claims is kept at the Patent Office, where copies are made available to anyone on request for a fee.[3] Many libraries maintain a full compliment of patents either on microfilm, paper or both. Since the early 1970s patents have been stored on CD-ROMS, meaning all patents still active can now be searched on a computer.

Depending on verbosity and number of patents issued, the OFFICIAL GAZETTE has been historically bound into monthly, bi-monthly or occasionally overlapping monthly volumes. Currently even one week's worth of patents makes up a decent size book. It is an impressive sight to behold all those

[2]Patents are issued on Tuesday, regardless of holidays or the Patent Commissioner's birthday.
[3]Modern researchers are advised to ignore these instructions, which are printed on many patents issued in pre-inflationary times: "Copies of this patent may be obtained for five cents each, by addressing the 'Commissioner of Patents, Washington, D.C.' " (No. 1,297,797, is one such example). Currently the fee is $3.00, having risen through 50¢ as recently as the 1970s.

books lined up in a continuum of nearly 150 years... a national heritage at the fingertips. Most of the activity takes place around the 'current' shelf, but occasionally some would be known to stray into the vicinity of the old and venerable tomes where corkscrew research was in progress.

While the OFFICIAL GAZETTE is a Godsend for scanning patents, the problem still remains, which patents to look up in the first place? That requires finding the right Class/Subclass in the CLASSIFICATION SYSTEM. In my case, there were too many potential Classes and Subclasses to deal with either because of mystical bureaucratic procedures or because the corkscrew function was deemed to be too insignificant to cross reference any of the conventional corkscrew Subclasses. If only the classifiers had the bias of us collectors who have a worm's eye view of everything!

MINING FOR FISH

At this juncture, the inventor's search would probably be over. Either the inventor would 'successfully' not find a prior patent in the Class/Subclass appropriate for his or her idea or would unsuccessfully find one that spares him or her the trouble and cost of filing... only to be nailed in the examination. As for corkscrew research, the battle was just beginning.

My last fling with the CLASSIFICATION SYSTEM can be likened to mining. Shunning the manuals, I started looking up patents in Subclasses adjacent to a proven Subclass, much like digging a 'vein' until it runs dry. The obvious advantage to this approach is that it avoids entrapment by false expectation. It didn't matter *what* they called the Subclass or what the long forgotten rationale was for including corkscrews in it. It only mattered that there *were* corkscrews in it. Many patents were discovered by the mining method. Sometimes things work better when you don't have to think.

After abandoning the patent mine, I headed for the village of "Fishpatent," still hoping to catch patents with a net, or at least a hook. It was the last rational thing left for me to do short of using my bare hands.

Fishing for patents outside the CLASSIFICATION SYSTEM, brings into play yet another publication of the Patent Office, the "INDEX OF PATENTS" (not to be confused with the aforementioned INDEX TO THE U. S. PATENT CLASSIFICATION SYSTEM). In this handy volume, patentees and titles are indexed for the *entire year*. Thus, using a small net such as the title, "Bottle Opener," it is possible to look up individual patents in the OFFICIAL GAZETTE directly without having to identify the assigned Class/Subclass.

Titles beginning with "Bottle..." bore results, as in "Bottle Closure Remover," "Bottle Opener," "Bottle Opening Device," "Bottle Stopper Extractor." So did "Can Opener," "Combination (or "Compound) Tool," "Knife," "Pocket Knife," "Stopper Extractor" and others. More difficult to track were titles with literal alphabetical indexing, such as "Device For Pulling Stoppers From Bottles" or "Detaching Device For Bottle Closures" listed in the D's, or "Combined...(fill in the blank with anything from "axe" to "zipper")" listed in the C's. Generic titles such as "Implement" or "Tool" were a nuisance (and in my opinion, either a cop-out or a not very subtle attempt to broaden the perceived definition of the invention, and hence protection) but nevertheless had to be checked. The procedure is followed for each year, with an occasional quarterly indexed year thrown in requiring a quadruplicate effort. The Index approach yielded excellent results, but as the foregoing titles suggest, the work was tedious. At least it kept the MANUAL OF CLASSIFICATION on the shelf.

Finally, when the net started coming up empty, I was left with only one recourse — a hook. This involved following hunches, receiving leads from other collectors, looking up names of inventors known to be active in the field, checking patent references published in more recent patents and having a patent fall into my lap by the Luck-O'-The-Irish while on my way to looking up another. They come one-at-a-time this way, which I welcomed with open arms, now that they were free to hold on to something other than a MANUAL OF CLASSIFICATION.

By this time, one year later, it was apparent that finding patents had become more than a pastime; like collecting actual corkscrews, it had taken on a life of its own. Still without a book in mind, I nevertheless found myself at the point of no return. To validate the work I had accomplished required an all-or-nothing commitment to finish the job. To stop now would have 'wasted' much of what I had done. There is an enormous difference between finding a lot of patents — more than anyone knew existed — and finding *all* of them.

At a balanced fulcrum the slightest nudge can decide the issue. A fellow corkscrew collector announced that he was seeking information on corkscrew patents issued since 1920 for publication.[4] Considerable research had been done on pre-1920 patents,[5] but no one had picked up the ball beyond that point. A furious exchange of patent numbers ensued, benefiting us both. It also planted a seed in my own mind that I might be on the threshold of a publishing opportunity myself. No one had found, or at least published, as many patents as I already had in hand.

Nor had anyone undertaken to consolidate all years into a single volume, combined with photographs of extant examples. Moreover, I was certain there were more patents to be found. I knew I had something of value but the job was still incomplete. With no format in mind, I realized I had to continue on to keep my dream alive. I decided to publish.

PUMPING UP AT THE PATENT LIBRARY

Thus, in spite of (or because of) two centuries of good intentions and diligent effort by thousands of nameless clerks, they were no help to me now. If the CLASSIFICATION SYSTEM facilitated patent *search*, it complicated patent *research*. If these legions of nameless clerks were able to confound, confuse and distract my rational mind, they had no defense for the *irrational*. They could play with my mind but not with my muscles. They could not stop me from *turning pages*.

Starting first with the annual REPORT OF THE COMMISSIONER OF PATENTS, and continuing on with the OFFICIAL GAZETTES, I looked at every patent. Drawings for patents issued prior to 1874 were separated from the specifications so that it was necessary to have *two* volumes open simultaneously. Initially, drawings appeared in class rather than chronological order. Hence each page had wide gaps in numbers, making it difficult to find a drawing with just a number to go by (Fig. I-5). Note also that the drawings were not titled, making identification often a matter of guesswork. Fortunately a corkscrew is easy to spot, but that did not prevent me from taking a few side trips just out of curiosity. In 1859, the chronological order in effect today was mercifully established, but the layout on an individual page was random, starting generally with the lowest number in the upper left corner and then exploding into a willy-nilly complex of borders and unrelated scales (Fig. I-6). With the introduction of the permanent format of the OFFICIAL GAZETTE in 1874, drawings and specifications finally got together on the same page in numerical order, although the amount of abridgment varied considerably (Fig. I-7).

[4]AMERICAN CORKSCREW PATENTS 1921 - 1992, Nicholas F. D'Errico III
[5]GUIDE TO AMERICAN CORKSCREW PATENTS VOLUME ONE 1860-1895; VOLUME TWO 1896-1920, Bottlescrew Press, Philos Blake (pseud.)

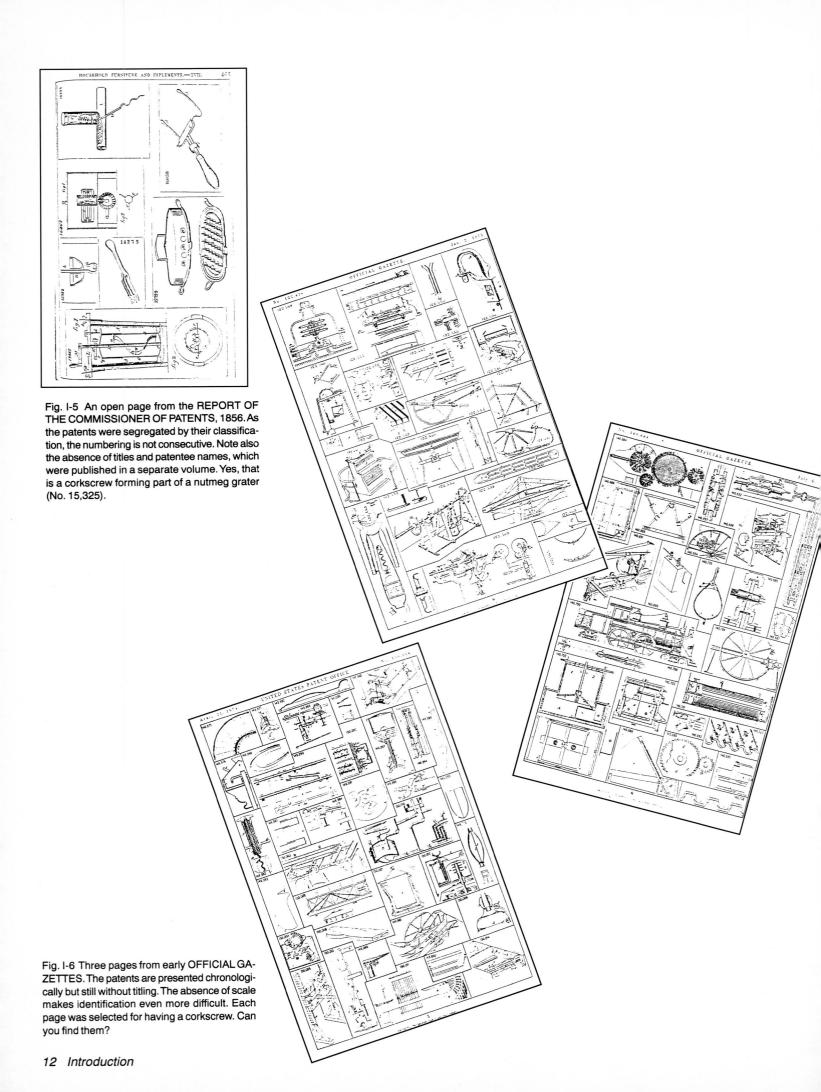

Fig. I-5 An open page from the REPORT OF THE COMMISSIONER OF PATENTS, 1856. As the patents were segregated by their classification, the numbering is not consecutive. Note also the absence of titles and patentee names, which were published in a separate volume. Yes, that is a corkscrew forming part of a nutmeg grater (No. 15,325).

Fig. I-6 Three pages from early OFFICIAL GAZETTES. The patents are presented chronologically but still without titling. The absence of scale makes identification even more difficult. Each page was selected for having a corkscrew. Can you find them?

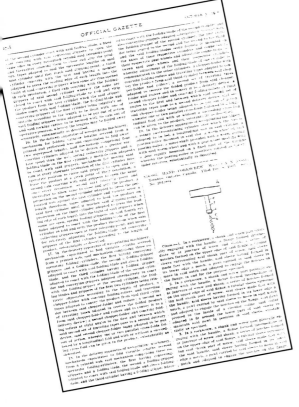

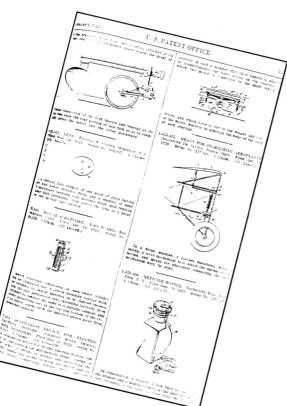

Fig. I-7 **a.** A wordy page from the OFFICIAL GAZETTE of October 30, 1906, typical of the period in which all claims from the patent itself were published. Because of volume considerations, a slimmed down format was later instituted, which limited the number of claims published or provided a summary. **b.** August 8, 1922 is an example. Note the appropriate name for the holder of patent No. 1,425,456.

Four, five, six... patents to a page, page after page for hours at a time, extending into weeks and then months, I became a witness to American history viewed through the prism of the patent system. I experienced the times through living documents rather than having them interpreted for me in a history book. I entered into and out of eras: from Civil War ordinance patents to artificial limb patents that followed, from horse-and-buggy hitches to spark plugs, from lanterns to the electric light bulb... it was a magnificent procession. I discovered a whole new vocabulary of words much like stock quotation symbols of today, such as gig, thill, clinker, hame, olla, dibble, trace, pritch, twitch, gyve. There were singletrees and doubletrees and whiffletrees. Sad irons must not have been very happy. Inventions of the era included a "Wiggler" (No. 1,109,625) and a "Slub Detector" (No. 752,732). For the slow afoot there was a "Slug Catcher" (No. 992,203) and instead of going to a pet psychiatrist, one could use a "Device To Prevent Dogs From Worrying Sheep" (No. 1,046,177). Whether the device worked for a "Can't Dog" is uncertain (No. 442,620).

A "Cream Separator Cup" (No. 1,222,206) illustrates the mind operating at a lower level, while greater minds were developing homogenization. If you had thought of tying a shoe to the end of a stick in 1881, you could have been there first with an "Animal Poke" (No. 263,563) or having a knack for bending wire in 1907 could have enshrined your name with a "Milk Pail Holder" (No. 868,692). There was once a day when skis were skees, bicycle seats were velocipede saddles and someone actually 'invented' a "Stadium" (No. 1,444,360) and a "Highway Crossing" (No. 1,689,161). Presumably anyone attempting to 'make' an overpass in 1928 would have to reckon first with Mr. Skultin.

There were things that worked well and things that worked... well, let the user beware. I can't imagine how much marketability there could be for an "Appliance For Producing Dimples" (No. 1,648,221), but basketball players might appreciate an "Apparatus For Stretching Fingers" (No. 835,968). Ouch (fortunately there is a "Finger Bandage" the same week). Podiatrists could extol a "Toe Straightening Device" (No. 1,055,810). If that didn't inflict enough pleasure, the masochists could always turn to a "Device For Applying Electricity To The Human Body" (No. 309,897).

If you didn't know *what* it did, you could always fall back on "Article Of Manufacture" (No. 1,709,168), "Combination Instrument" (No. 1,357,481) or "Utility Tool" (No. 2,157,481). "Fragile Article" (No. D-95,291) seemed to rule out a corkscrew, but "Controversial Device" (No. 644,066) got me curious enough to look (no such luck). Name a fruit or vegetable and there is a picker for it, or a separator, clipper, topper, puller, pitter, you name it. Don't get caught in a "Trip Trap" (No. 358,980). They must have smoked 'em young in those days; otherwise the flash of inspiration might never have come to the inventor of a "Combined Toy & Cigar Cutter" (No. 333,669). The Patent Office's tendency to personify titles with the *user* of the patent, rather than the use *for* the invention, gets them in historical trouble. No problem with "Smoker's Receptacle" (No. 1,937,084), "Watchmaker's Cabinet" (No. 1,754,905), "Lumberman's Log Grab" (No. 1,751,905), or "Swimmer's Device" (No. 1,754,704); but "Housemaid's Pail" (No. 160,500), "One-Armed Man's Assistant" (No. 103,023), "Scrub-Woman's Knee Pad" (No. 736,641), "Invalid Bed" (238,799) or "Cotton Picker's Sack" depicting a black field worker (No. 699,324), is politically sensitive in our time. I don't know in which camp to put "Cop Skewer" (No. 1,151,864). Despite the high bureauocratese, no one came up with "Closure Opener," as far as I know.

How come so many of the corset patents were taken out by men? What good is 14 years patent protection for a dress design? Did you know that Alexander Graham Bell took a fling at a "Flying Machine" (No. 1,011,106)? How many ways could there be to prop up a golf ball? There are over a hundred patents for a "Golf Tee," including one with a corkscrew (D-319,170). Closer to the subject matter is the turn-of-the-century phenomenon of the "Unrefillable Bottle." How many patents would you guess addressed the 'problem' of the dilution or reuse of a bottle... 100? 1,000? Based on a sampling taken for the typical year, 1906, there could be an astonishing 10,000 patents granted solely for the purpose of making liquids go on a one way journey. Here is what a typical 'inventor' had to say: "Be it known that I... have invented certain new and useful Improvements in Non-Refilling Bottles..." (note initial caps signifying an entire class of bottle). "My invention... has for its object to provide such a bottle which when once filled and afterward emptied cannot be refilled, thereby preventing the fraudulent sale of liquids of an inferior make under the original label." Step right up folks, and get yer' 100% pure snake oil!

1,245,736. POISON-BOTTLE INDICATOR. WILLIAM H. KETLER, Camden, N. J., assignor of one-third to Alexander Macallister, Camden, N. J. Filed Mar. 19, 1917. Serial No. 155,834. (Cl. 40—4.)

Fig. I-8 Where's the corkscrew? Only the actual patent knows.

Patent libraries today would be a lot smaller if patent attorneys didn't extend every sentence with, *"... substantially as set forth"* instead of using a plain period (.). Period. If all patents are supposed to be different, why do they all use the same legalese?

It was also fun to run into patents for familiar things like "Board Game Apparatus" (No. 2,026,082). Most people would recognize it by the trade name, "MONOPOLY." I even chanced upon the patent for my garage door slider. And, oh yes, I found corkscrew patents.

It is interesting that the patents I discovered turning pages would never have come to the surface under the conventional Class/Subclass search, or, in fact, any other systematic approach. By the same token, I would never have found them all by turning pages either. That is because cork extraction was not always the primary function. It is difficult for a die-hard corkscrew collector like me to understand, but many "combination tools," so prevalent in the early part of the century, had more important things to do than open a bottle, whether wine or otherwise. The eyes of the inventor and Examiner don't necessarily see a corkscrew with a tool on it like we collectors do. Although a corkscrew might be present in the patent, there could be various views drawn which did not show it. If one of those views happened to be selected for the OFFICIAL GAZETTE, only the most intuitive page turner would catch it (Fig. I-8).

Therefore everything turned out fine after all. What I did, although not planned from the start, was what had to be done. All my previous work, including the overlapping and dead-ends became instantly validated once I surrendered to turning pages. The goal could be questioned, but not the process.

BOOKED FOR IMPERSONATING AN AUTHOR

Wouldn't you know that once my goal became clear, opportunity knocked. Thanks to a mutual acquaintance, I was introduced to Schiffer Publishing, Ltd., one of the most respected publishers of books on antiques and collectibles in the world. Thus, with no prior experience in the business of writing and photography, but with 1,000 corkscrew patents and a new found zest for recluse living, I became an author one August afternoon. That they could see past me to some bottom line, known only to them, was indeed a leap of faith. If they were contracting for excitement, they got a bargain. The publishing business is still a mystery to me, but they got their book.

I must also resign myself to the likelihood that more corkscrew patents will be found in the future. It is inevitable — perhaps even a Law — that researchers be brought before the court of humility as soon as their work becomes published. There is no guarantee I have found every single patent involving a corkscrew, but it is unlikely any more will be found by formal search. Accidental discovery is always possible.

The flip side to confirming everything that *did* get patented is being able to rule out what *didn't* get patented. Despite the ubiquitous markings "PATENT APPLIED FOR" or "PATENT PENDING," many corkscrews never made it to the big leagues. This marking was permitted by the Patent Office upon filing the application, which did not extend patent protection retroactively, but could scare off impostors. "PATENT APPLIED FOR" was commonly used in earlier marking, while "PATENT PENDING" or "PAT PEND" is common today. Now, at long last, the collector, dealer or curious bystander can rest assured *if it is not in this book it didn't get patented!* That's not to belittle the collectibility or value of an unpatented corkscrew. All it reflects is a prudent inventor with an unpatentable idea. Considering the boldness of some markings there may also be an overzealous marketing department involved. If the existence of a patent or even an application for one implied more value, so much the better. It was milked for all it was worth.

Another area of confusion I hope to clear up is the difference between "utility" and "Design" patents. Utility patents are issued for what they do and are the foundation of the patent system. The term "patent" means utility patent, with or without the modifier. Design patents apply to appearance only and are designated as "*Design* patents" by the Patent Office. Both types have entirely different numbering systems. Far more utility patents have been issued than Design patents, making higher utility patent numbers older than lower

Design patent numbers. Don't be fooled by an unknowledgeable (or knowledgeable) dealer asking an 1876 price for a 1951 "patent." Even inventors were known to exploit the confusion by conveniently leaving out the "D" in the mark. Design patents are more fully covered in Chapter 2.

Very likely, and in fact I hope stimulated by patents brought to light for the very first time in this book, will be the discovery of more corkscrews that are not among the precious few that have been photographed. Surely the attics, if not kitchen drawers of America contain more overlooked and forgotten examples that were once the pride and joy of an aspiring inventor. Maybe they were cast aside as being too "ugly" for use at finer occasions or they didn't work as well as their more stylistic Continental cousins or they became relegated to other duties because of their disparate "Rube Goldberg" working parts (for more on Rube Goldberg see Chapter 3). Whatever the reason, with the number of corkscrews in the hands of collectors now known to represent less than half the patents, surely the field is ripe for discovery. Welcome to the hunt!

A CORKSCREW IS A CORKSCREW IS A CORKSCREW...

A few words about my own criteria for what constitutes a "corkscrew." Generally in keeping with a collector's point of view, as opposed to the U. S. Patent Classification System or Webster's, I use the term loosely to include anything with a worm or helix on it, whether singularly, in conjunction with other functions or as part of the stopper itself. Also included are tools that are designed to remove a cork from a bottle without the use of a worm or helix and tools dedicated to sparkling beverages such as taps, and in some cases nippers and grippers. Not included are patents for removing stoppers not made of cork, or for engaging an element added to the cork, with or without a separate tool (although some are given recognition in Appendix Two). Finally, patents not involving a corkscrew are included if an example is found to exist with a corkscrew. If these criteria tend to confuse the non-technically inclined, I suggest you not belabor them. Just have fun with the book and leave the unpublished patents to the uncorkscrew collectors.

Patent research is best done alone ' because it demands an almost trance-like focus and concentration. The mouth and ears are no help. Corkscrew collecting, on the other hand, is very social, involving a network of personal contacts — the wider the better. Some-times I found myself confusing the two roles. If I showed up at the Patent Library late or chatted with an aspiring inventor, there's no harm done. The patents will still be there. Show up after sunrise at the Flea Market and expect to hear from an excited sleep-deprived rival about the treasure discovered by flashlight. Mark your page in an OFFICIAL GAZETTE and take a bathroom break. No problem, it will still be there when you return. Spotting a curious corkscrew on a table and deciding to think about it practically assures it will be gone when you make up your mind an hour later (if you can even find the aisle). Finding a neat old patent costs nothing (except time). Procuring the actual piece often involves complex and extended negotiations, gut-wrenching decisions and may have serious implications for your bank account. The typical corkscrew collector is no different from any other collector in this respect. Will it be the vase or the new sofa? The etui or a trip to Hawaii? These are tough choices patent researchers don't have to face. The moral of the story is: it's OK to have two hats, but know which one you are wearing at all times.

CORKSCREWHOLICS ANONYMOUS

Since the Patent Office has all the patents, that is where one goes to find them. Finding live corkscrews to photograph is an entirely different matter. Even *I* have a better collection of U.S. patented corkscrews than the Smithsonian. The sources for real live corkscrews are the private collections. Fortunately, collectors are a friendly and cooperative lot. Everyone understands that the more information we share, the better off everyone is. The first realization of this truth came in the founding of the International Correspondence of Corkscrew Addicts (ICCA) in 1974. Limited to 50 members with extraordinary collections and having in common a penchant for travel and getting up early, there has always been a waiting list of eager and qualified applicants. Unable to contain the growing number of enthusiasts, the Canadian Corkscrew Collectors Club (CCCC) was organized in 1981, with unlimited membership but no less dedication. Members of both organizations (many individuals belong to both) are able to trade information and corkscrews, meet new friends and engage one another in friendly dialog on an international level. Without the cooperation of members of the ICCA and CCCC, the photography and much of the historical background for this book would have been quite limited. Despite the enormous number of 'new' patents published here for the first time, the photographs are what bring the patents to life.

So, into the living rooms of North America I went, like a one-man-band lugging my portable camera stand, filters, light diffusers and film. A Blake patent in Connecticut, a Korn in New Hampshire, a Garimaldi in Toronto, a Morgan in Freeport, a Russel in Los Angeles, a Pitt in Vancouver, etc., etc., etc. Superb collections; incredible finds; wonderful stories; unconditional cooperation; gracious hospitality. That much all collectors seem to have in common. But individual collections are very different, generally broad but invariably deep in some niche. I found beautiful and artistic 18th century pieces to be very distracting, indeed. There were handsome English T's, ingenious Continental mechanicals, whimsical figurals, pocket knives, bar mount corkscrews, miniatures, combination tools, advertising pieces... It was hard to keep my eye on the ball with a veritable world-class exhibition awaiting me at each stop. If I had one example of a type in my collection, someone was bound to have a dozen variations. No two collections are alike and certainly no one owns all the corkscrews. Were the photographs in this book to represent a single collection, it would rival any exhibit of historical artifacts in any museum in the world.

If corkscrew collectors have in common the insatiable urge to hunt, they are diverse as human beings in displaying their collections. Some literally live with their collections. Corkscrews are everywhere — in the living room, den, kitchen... yes, even the bathroom. Vacant space is precious in a house of a thousand corkscrews.[6] Others confine their collections to a form of trophy room, separate from everyday living, possibly a wine cellar or even a room built on or converted specifically to 'house' the collection. Corkscrews are displayed in showcases of all sorts — flat, wall mount, floor standing — the

[6]Were it not for *some* self-discipline, the number could be considerably higher. Given the choice of 10 mediocre corkscrews or one good one, most beginning collectors tend to opt for the former. Over time, selectivity and specialization tends to occur, with quality taking precedence over quantity. Despite that, collectors often find it necessary to absorb a number of common corkscrews in lot purchases, just to get their hands on one or two gems. Anyone who is serious about collecting ultimately comes to the realization that value appreciation and joy of ownership take place at the higher end, not lower. The price for gaining that knowledge is inevitably boxes and/or drawers full of "stuff."

cases themselves often antiques in their own right. Some corkscrews hang directly on walls, rafters, beams and moldings or stand upright on shelves in similar fashion to a retail store, inviting handling and use (and dusting). Type collections are often catalogued in shallow drawers, adapted from spool or map cabinets. Curiously, the method of display seems less related to the nature of the corkscrew than the nature of the collector. I have seen the ubiquitous 'waiter's friends' in display cases and rare 18th century harps on peg boards. Some collectors are instinctively attracted to attractive corkscrews involving precious metals and artisan creativity. Others can be turned on by an item of simple manufacture, having virtually no intrinsic value but rare in terms of a particular variant.

While most collectors are knowledgeable, some are true scholars. They not only know more, they have an inner desire to share their knowledge with others. Through articles, research papers and a willingness to spend time with others who are interested, they continue to expand our horizons, giving meaning to our collector selves and setting challenges for future research.

If some are natural-born teachers, others are natural-born traders. For most collectors a corkscrew is perceived as being in chaos until it comes 'home' to the collection like the prodigal son. There it remains in comfort and security, surrounded with order and love, happily ever after. The price paid becomes a distant memory. Not to be confused with a dealer who engages in the buying and selling of corkscrews for a living, the trader is turned on by the action itself. Collecting is a two-way street. Corkscrews come and go; collections are in a constant state of flux. The currency of payment is another corkscrew. Every corkscrew in the collection has a present 'value' which if met or exceeded will put it in motion. Length of possession is never certain. Every collector has a trader demon inside, even if it amounts to no more than buying a 'second' to trade or sell. Sometimes a trade may be the only way for two sought after pieces to exchange owners, as a rare corkscrew is often harder to come upon than the money to buy it.

OLD WIVES' TALES AND PUPPY DOG'S TAILS

Also commonly seen in collector's homes are wine and corkscrew related artifacts which provide added ambiance for the collections themselves. All that exposure to shops, shows and markets through the years creates an antiques' consciousness. Antique furnishings are attracted into the home as if by osmosis; even other collections. Some spouse collections are significant in their own right. You can often spot a couple 'working' a show by taking the left side/right side of an aisle in pursuit of treasures for both collections.

The conclusion is you cannot tell a corkscrew collector's house from the street, but once inside you know that you are in a very special place that could only be created by extraordinarily dedicated people.

Do collector's use their corkscrews? Yes, with practical limitations. To some, the corkscrew represents a time capsule, bringing pleasure from the pure act of owning it. Others liberate their collections by selecting and choosing unabashedly from among virtually irreplaceable corkscrews the one that feels just 'right' for an occasion. The joy of the moment is worth the occasional broken worm. The corkscrew is by its nature a rugged instrument, designed to withstand much more trauma in its usage than it is exposed to in the act of collecting it. Earthquakes, UV light, UPS and wagging dog's tails are nothing compared to the demands of a tight cork. But age fatigues corkscrews as well as people and most collectors apply discretion as to what is still considered working worthy and what is 'retired' to a life of fondling.

Many antique corkscrews don't work very well for reasons other than age and condition. A corkscrew designed for a 19th century cork may be overmatched on a 20th century cork. If the corkscrew is combined with other functions on a tool, often in a secondary position of leverage, as are typical of many U. S. patents, you can forget about a graceful opening ceremony. And, quite frankly, many of the whimsical and satirical pieces emanating from the Deco/Prohibition period were meant to make a statement rather than actually open a bottle. Worms and helixes could be bought in bulk for attaching to *anything*, which would then become the handle. And even though a collector might want to use every corkscrew in a collection, my experience is that the corkscrews come in faster than the wine can be consumed. Thus a discretionary default is already built in to the decision making process.

And of course not every bottle of wine ends up being served at a state banquet. As mentioned earlier, even corkscrew collectors have kitchen drawers. What type of corkscrew is in my kitchen drawer? Because of a former life as a restaurant owner, I am very comfortable with the so-called 'waiter's friend', first patented by Wienke in 1883 (No. 283,731) and continuing to attract 'inventors' today (No. 4,437,359). Although not kept in the drawer, I also reach often for a "Screwpull," the high-tech corkscrew developed by Herbert Allen in a series of patents obtained in the 1980s and early 1990s (see Chapter 6).

Collectors are often asked how they got started in corkscrews. In my case, I acquired my first corkscrew (and other wine related artifacts) in the early 1970s, to decorate the restaurant I owned. It was years later before the same corkscrew came to decorate my living room and the 'urge' to collect took hold. To the non collector, and perhaps to the fellow collector who has not put words to it, let me describe what that urge means to me:

I am but a speck on a continuum of time. The corkscrew gives me a sense of where I stand. Antiquities surround us but they exist in a state of randomness. I find order in corkscrews. Few mechanical concepts survive the generation of their birth, let alone 400 years without significant modification. Not many 1860 patents are in use today, but my Chinnock still is. Almost everything else is obsolete or even laughable, now relegated to the museums, history books and landfills. I can relate to the founding of our country when holding an 18th century Irish silver picnic corkscrew. The beginning of the Industrial Revolution is marked by an English iron wing-nut model; the mechanical one-upmanship of my Tucker and Sperry brings me out of the Civil War period into the current century with the mass-produced Walkers, Williamsons, et al. Art Nouveau, Prohibition, Art Deco, even plastics have their place on my time line. Maybe it's stretching the point that Abraham Lincoln comes immediately to mind when I spot a venerable old wood handle 'T' at a flea market, but there are no historical gaps in my imagination that can not be filled by a very tangible corkscrew.

If that represents the sentimental justification for my habit, the joy of the hunt is the emotional part. I simply love looking for corkscrews, never knowing which table, display case or inquiry is going to be *the one* (Fig. I-9). My eyes are like x-rays, my ESP like radar, able to spot a curly needle in any haystack of junk or gems. Anticipation is exhilarating; the moment of eye contact, spiritual. Possession may be comforting, but by definition, the moment of discovery can be experienced only once. So the hunt never ends. With increased knowledge there comes a quality to each 'hit', some being better than others (which is as far as the double-meaning can go in a clean book). When two collectors get together, it is the *story* that becomes the energizer. Sessions reliving the moments, admittedly with a little embellishment, can go on long into the night. I feel good when I can be a party to that precious part of someone's life.

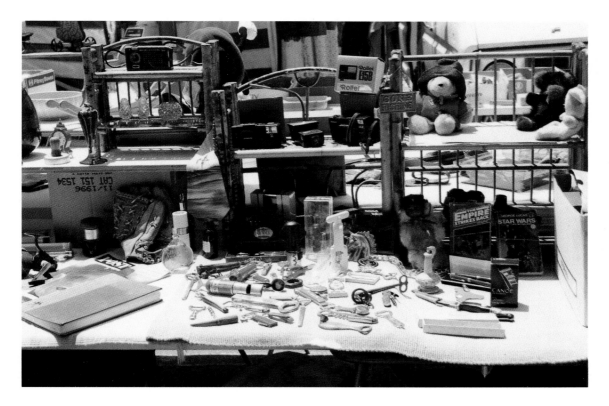

Fig. I-9 What all corkscrew collectors dream about: a flea market find. Can you spot the ringer?

Corkscrews give me meaning, a sense of purpose; they bring the past to life and life to the past.

With such longevity, corkscrews exist for dabbler and collector alike, to reach out and touch at any flea market, antique store or weekend garage sale. Like any commodity, supply and demand rules the market. Why some old piece of twisted steel can cost more than a used car is because there aren't many of them around (corkscrew lots can be found only at Christie's). On the other hand, one can acquire a simple wood handle 1885 Haff patent for the price of lunch. Some might scoff at a $1.00 can opener; another might be in Corkscrew Heaven if it is a variant of 3 or 4 others already in the collection. It's not always the price that determines the 'value' to the individual.

A different sort of accomplishment comes from finding a corkscrew at the beginning of its market cycle. Everyone has a corkscrew 'Rembrandt' story. This is not to gloss over reality. Rare corkscrews are expensive; common corkscrews are cheap. No matter whether they work, how pretty they are, how much melt-down value they have, the bottom line is always a price agreed upon by two people.

It is my fond hope that you will be touched in some way by the corkscrew story, represented in these pages by United States patents. This is not, nor is it intended to be, a history book. Dis-

covering the patents and taking pictures of everything extant are what I set out to accomplish, even though I didn't know it in the beginning. For practical reasons, full scale patent drawings were out of the question as were additional pages of drawings. I have generally used the first page as being the most representative of the full patent. Written pages, referred to as the "Specification of Letters Patent" until the early 1920s and now considered just the "specifications" without formal heading, are excluded entirely. The reader wishing to pursue any patent in depth is encouraged to seek out a local facility or library, which may turn out to be right 'under your nose', as was mine.

Formatting the pages became a compromise between scale and quantity. By reducing patents to a scale of nine per page, it permitted more opportunity for photography, captioning and page variety. It has the added benefit of neutralizing imperfections inherent in microfilm. Some poetic license has been taken in scaling the photography. Group shots provide exact relative sizing; a comparison between frames will require some imagination. The purist can always refer to the caption dimensions for absolutes. To keep from exacerbating the volume of numbers, captions referring to a patent are identified by the patent number. General illustrations are numbered by order of appearance (Fig. 1-1, Fig. 1-2, etc.).

As I know I will not pass this way again, I hope I got it right.
Good hunting!

ABOUT CHAPTER LEADS ...

At the beginning of each chapter is a photograph of a corkscrew atop its applicable patent. They all have a Williamson connection. For over a century, this prolific manufacturer turned out corkscrews of great diversity and practical utility, some under patent protection issued directly, some under Assignment, and some without patent protection whatsoever, in the form of complete corkscrews or parts supplied to other manufacturers. Their prowess is unprecedented in the history of corkscrew manufacturing in America, if not the world, with different examples continuing to turn up in antique circles today, much to the delight of collectors. For a closer look at the Williamson story, see Chapter 2, but obviously it spans all six ...

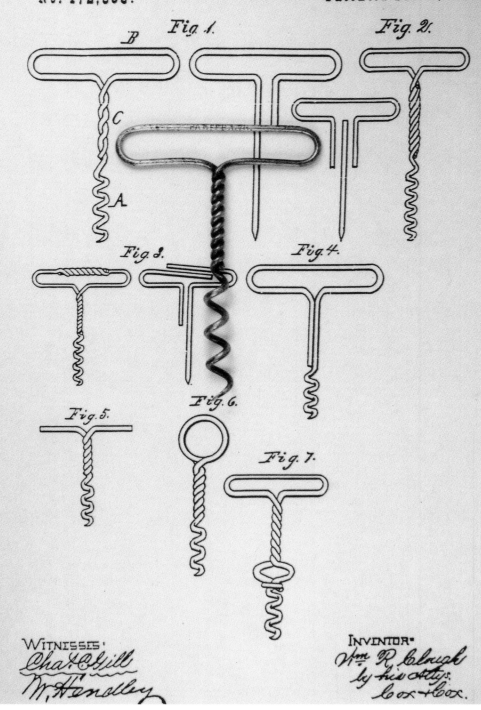

172,868
William R. Clough
February 1, 1876
PAT. FEB. 1. 76. A simple wire corkscrew produced by the C. T. Williamson Company, under agreement with the patentee; 3.7".

CHAPTER 1
PRIOR TO 1880

105 Corkscrew Patents

Although spanning a chronological period of 90 years, most of the patent activity prior to 1880 was compacted into the last 20 years, when 196,569 of the 223,211 numbered patents were issued and all but 4 of the corkscrew patents. Thus a direct statistical comparison can be made with the other ·twenty-year chapter segments.

The power to enact laws relating to patents is given to Congress under the Constitution of the United States. One of the early matters taken up by the First Congress was the establishment of a patent system, culminating in the passage of the Patent Act, which was signed into law by George Washington on April 10, 1790. Modeled after the Colonial system which had been operating prior to the Revolutionary War, the new law granted patent protection for "new and useful" inventions for a period of 14 years from date of issue, which could be renewed for another 7. In 1861 the term was changed to an unrenewable 17 years, where it remained until 1995 when the term was set at 20 years from the *date of application*.

HISTORIC PATENTS

March 14, 1794 COTTON GIN Eli Whitney
November 19, 1833 PLOW Cyrus McCormick
June 21, 1834 REAPER Cyrus McCormick
February 25, 1836 REVOLVING GUN Samuel Colt
September 10, 1846 SEWING MACHINE Elias Howe and Isaac Singer
April 13, 1869 STEAM POWER BREAK George Westinghouse
November 14, 1874 WIRE FENCE (barbed wire) Joseph Glidden
June 6, 1876 TELEPHONIC TELEGRAPH RECEIVER Alexander Graham Bell

The idea of handing out temporary monopolies is of Anglo Saxon descent, but not until the 17th century did the power become separated from the patronage of monarchies. Originally, patents were considered favors, to be handed out arbitrarily to those in a position of influence. The protected enterprise did not even have to involve invention. Today, the patent is established by law and has become the revered symbol of a free society. It is as much an honor to own a patent as it is an opportunity to better one's life. The operative word is *opportunity*. A patent does not give the inventor any more rights than already exist in a free country to make, use, sell or go broke from an idea. What the patent does do in theory is exclude *anyone else* from making use of the idea for the duration of the period covered by the patent.

Despite the dominant presence of Thomas Jefferson during the formative years, a prolific inventor in his own right, the patent system was distinguished neither for its organization nor the efficacy of the patents granted. The Founders were so preoccupied establishing a Country that from 1793 to 1836 there was little time to administer a patent system, let alone examine applications. Patents were granted *automatically* upon registration and payment of the fee. With the notable exception of the cotton gin, patented by Eli Whitney on March 14, 1794, the inventive juices did not begin to stir until mid-century, when some of the most important inventions of that era, or any era, were conceived. Also contributing to this extraordinary period was the discovery of the telegraph by Samuel F. B. Morse (1844), the Otis elevator (1850s), the process of making abundant and inexpensive steel by Henry Bessemer and William Kelly (1860s), and the phonograph of Thomas Edison (1877), who would later reach notoriety with his 1,000 unsuccessful light bulbs.

Capping off the period was the 1876 United States Centennial Exhibition held in Philadelphia, the site of the signing of the Declaration Of Independence 100 years earlier. The exposition spread through some 180 buildings on 450 acres showcasing the latest and most futuristic offerings of inventors and manufacturers. For the modest admission price of 50¢, the public was treated to demonstrations ranging from a steam-powered thresher-separator to 6,000 nature-powered silkworms from China spinning silk before their very eyes. In Machinery Hall was the Corliss 1500-horsepower steam engine, largest and most powerful in all the world, and a curiosity called the "typewriter." In the Main Building, housewives were introduced to a resilient waterproof floor covering anointed with the name "Linoleum." England offered up a "bicycle" (or more appropriately, a "velocipede") and from France arrived a large hollow torch sculpture which was the downpayment segment of a giant statue to be erected at the entrance to New York harbor, and for which a Design patent was issued in 1879 (No. D-11,023). France also demonstrated an electric arc light, a forerunner of the incandescent lamp, later finally perfected by Thomas Edison. There was also a curious voice carrying machine on display, for which a patent had just been issued, and even more noteworthy, a world-class corkscrew making machine presented by relative unknowns William Rockwell Clough and Cornelius T. Williamson. Perhaps no other singular event established America as the "Land of Progress" than did the Philadelphia Centennial Exhibition, with money and the making of it, its message to the World.

The period is noteworthy not only for its significant inventions, but also for the relative absence of 'ordinary' patents early on. Clearly, pioneering took precedence over inventing during the first half of the century. But then, as society became more structured, the citizenry began to realize the patent system offered an opportunity for *anyone* to get ahead, not just the so-called 'geniuses'. For example, whereas 6,980 patents had been issued in the 60 years prior to 1850 (none involving a corkscrew), it took less than 6 years to duplicate that number and in 1864 it was accomplished all in one year. Today there are more patents issued in one month than all of those first 60 years combined. The Generals finally got an army.

Meanwhile, much was happening across the Atlantic with the first ever patent for a corkscrew issued in 1795 to an English minister by the name of Samuel Henshall, whose idea consisted of adding a round disk or button

Fig. 1-1 The first patented corkscrew by Rev. Samuel Henshall of Birmingham, England in 1795, initiating a litany of 'self-pullers' on both sides of the Atlantic.

patent protection as the second half of the century unfolded, but inventive they were not. Very handsome, well-made specimens survive, often found marked by their makers' "H&B" (Humason & Beckley, New Britain, Connecticut), the Clark Brothers (also Connecticut); and from Will & Finck, M. Price and J. H. Schintz, all cutlery manufacturers in San Francisco, whose corkscrews were made with worms supplied by H & B (Fig. 1-2). Although some trade journals of the times did advertise "patented" corkscrews, this was generally a tip-off that the piece was imported.

Despite Europe's head start, it was not until 1860 that the patent offices on both sides of the Atlantic got into full stride. So overlapping and intercon-

nected were the countries experiencing their industrial revolutions, it was difficult to pin down the country of origin for early inspiration. Pre-1880 inventors Charles Chinnock (Nos. 35,362, 38,147 and 40,674), George Twigg (No. 73,677), and William H. Van Gieson (No. 61,485) seemed to have a foot in the patent systems of both countries. Chinnock somehow was able to claim residence in both places. Twigg clearly hailed from Birmingham and his U. S. patent drawings were lifted literally from the British patent of a year earlier. Although some mystery surrounds the Van Gieson corkscrew, it is thought to have been manufactured in England, although no evidence has yet been found of it being patented there.

between the worm and the nicely shaped shank (Fig. 1-1). Being slightly concave on the underside, when the disk met resistance against the rim of the bottle, a sudden burst of energy was transferred to the long embedded cork, causing it to loosen its grip. From then on it was easy lifting. For over a century England produced button corkscrews, which became collectively known as "Henshalls." Later in the century U. S. inventors expanded on the idea with a flood of so-called "self-puller" corkscrews. Self-pullers will be discussed in the next chapter.

There followed in England and the Continent an unprecedented advancement in corkscrew technology, often incorporating very aesthetic combinations of wood and bone handles with iron and brass mechanics. Whereas the 18th century produced artful corkscrews consistent with the demands of not-so-snug corks, the 19th century needed more engineering to their corkscrews to keep up with the advancement in bottle making and cork fitting. While the United States was preoccupied with starting up a country, the other side of the Atlantic got well ahead inventively and in the acquired taste for what went inside the bottle.[7]

Consequently for the first half of the 19th century *not any* corkscrews were known to have been produced in the United States, let alone patented. Perhaps home-made examples were in circulation, but none manufactured on any scale. On the other hand, significant numbers of wood and bone 'T'-handle corkscrews were manufactured without

Fig. 1-2 U. S. wood handle corkscrews manufactured outside the patent system from the mid to late 1800s. Top: H&B. MF'G CO; left center: J. H. SCHINTZ; right center: M. PRICE S F; bottom: WILL & FINCK SF CAL.

[7]Ironically, the modern English patent *system* is younger than the U. S. system, revamped by the Patent Law Amendment Act of 1852. Nevertheless, British *corkscrew* invention was more advanced when American inventors finally got in gear.

The first known corkscrew to be marked with a United States patent was a rubber case roundlet patented under Nelson Goodyear's invention for the "Manufacture of India Rubber," dated May 6, 1851 (No. 8,075). There was no mention of a corkscrew in the patent, which was granted for the *process* of hardening rubber, rather than its applications. Fortunately for collectors who like to drive in wheeled vehicles to flea markets looking for rare roundlets, Goodyear did not stick with corkscrews.

The first known patent to show a corkscrew in the drawing and mention one in the specifications was George Blanchard's "Nutmeg Grater," patented in 1856, which converted an otherwise common nutmeg grater into a handle for a corkscrew (No. 15,325). This patent followed another only a month earlier for a "Twine Cutter" which dealt with the tenuous corking of gaseous liquids (No. 15,098). At the time, corks could be harder to *keep in* rather than pull out, especially with effervescent liquids literally bursting to get out, like beer and champagne. Therefore, it was the practice of the day to tie them down with string and, later, wire. Once the string was removed, there was nothing to prevent the cork from becoming a mis-

guided missile. Until Blanchard, that is, who came up with a design for a cut-and-catch cup to snatch it right off the launching pad.

Another early patent involving a corkscrew was L. J. Wicks' "Boot Jack" patented February 8, 1859 (No. 22,923). There was also a scraper, a screw driver and a hammer on the same tool, making it the first combination tool to provide a corkscrew. Oh, what wrath Wicks would wrought, stirring up the invention gods in this manner. It would be more than a century before they would rest again.

The earliest patent date for an actual "Corkscrew" was March 27, 1860. That much is certain. What is not certain is who gets the honor of being first, for as chance would have it, *two* patents were issued that day, one to M. L. Byrn (No. 27,615) and the other to Philos Blake (No. 27,665). The usual arguments have been vented by collector/historian/advocates on both sides. *Byrn has the lower number and therefore should have the distinction...* the Patent Office does not recognize priority within a week's batch. *Blake applied earlier...* the Patent Office does not determine priority on the basis of application date but rather when the invention was first conceived, which could never be proved either way. *Blake's is mechanical, thereby being more "inventive" while Byrn's is a glorified screw...* good point, but conclusive only in that Blake had the first patent

for a mechanical corkscrew and Byrn for a non-mechanical corkscrew. It doesn't settle who was first overall. *Blake's corkscrew is known to have been produced and can be confirmed by patent marking while a marked example of Byrn's has yet to be found...* the question is not who was the first to *produce* but who was the first with a *patent* for a corkscrew in the United States. *Blake was from inventor stock, being the nephew of Eli Whitney, and had a legitimate manufacturing business that included a later corkscrew patent assigned to it by Edward Burgess (No. 32,396). Meanwhile Byrn was a one-time patenter[8] with questionable credentials as a doctor, minister and concocter of medicines...* and on and on. It is great stuff for research articles and kitchen table talk, which will likely never be resolved, nor probably should it. Certainly it will not in this forum, which will take the politically safe middle ground (some may call it cop-out) and proclaim the official results to be a dead heat.

[8]Byrn did obtain a provisional patent in England one month later than his U.S. patent, referring to his corkscrew as a "gimlet... adapted to draw corks or wooden bungs of all sizes." As near as can be determined, Blake did not seek an English patent for his corkscrew.

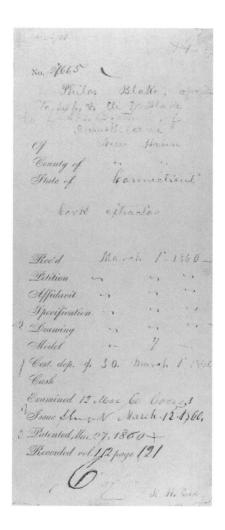

WHO WAS FIRST?

The actual patent documents of Byrn and Blake indicating that both applications were officially "Rec'd" March 1, 1860. Other documents indicate, however, that Blake signed his "Petition" February 9 and forwarded it with a letter dated February 24, while Byrn's "Petition" was dated February 27. Despite the even start, Byrn's application was processed faster (by a different Examiner), obtaining an "Examined" date of March 9 and "Issue" date of March 10, to Blake's March 12. Moreover Byrn's patent was recorded on page 17 of "vol. 112," while Blake's appears on page 121.

The first cork pulling device to *not* use a corkscrew was also patented in 1860. Nevertheless, it was still called a "Corkscrew" (No. 29,539). The year 1860 also saw the first patent for a bottle tap (No. 30,920). Due to the tenuous relationship between the bottle neck and the cork, many retrieving tools were patented during this period, some intended to force the cork into the bottle *on purpose,* thereby enabling the device to grasp the floundering cork in its Venus fly-trap mechanism. The first of the genre was L. J. Morrill's "Cork Drawer," patented May 17, 1864 (No. 42,784). For the distinction of being the first woman to receive a patent for a corkscrew the honor goes to Susan Currie of New York, New York. Her 1869 patent for a "Medicine Spoon" has the spoon serving as handle for the cork stopper and the cork serving as handle for the spoon... all thanks to the corkscrew (No. 92,278). Well, maybe the corkscrew wasn't the most prominent thing on her inventive mind. Incidentally, Ms. Currie shared the same Witnesses and Attorney on her patent documents as did the next in line, C. G. Wilson of Brooklyn, New York (No. 92,552). An explanation of this coincidence lies beyond the scope of this book, but hints at the connectivity of many inventors and their advisors.

Modern day patents bear little resemblance to these earlier times, where patents were processed with little or no examination. There were relatively few existing patents to research or infringe upon and fewer market forces compel-

ling litigation. These were relatively easy times for the Patent Office whose responsibilities were far more bureaucratic than legal or scientific and far more "Approved" stamps were worn out than "Rejected" stamps. Unlike today where Examiners are evaluated by the litigation their decisions *avoid,* the patents granted one hundred years ago almost *invited* litigation, which had the effect of building up precedents and structures for adjudicating later patents. A patent was desirable not only for warding *off* competition, but also perceived by some as giving an edge to products seeking market acceptance. The presumption was that, all things being equal, a consumer would be more likely to buy a patented product than an unpatented one. Hence the patent was used as a marketing tool and marking tended to be very prominent throughout the 19th century. Whether ego entered into it we'll never know, but it is not likely human nature has changed all that much in the last one hundred years.

Perhaps the most contentious of the early patents were for the so-called glass cutting tools. Although boasting of invention, these cheap, utilitarian and sometimes indistinguishable combination tools lead a merry chase through the patent system and courts for years. It all began in 1869, when Samuel C. Monce of Bristol, Connecticut obtained a patent for a "Tool For Cutting Glass" (No. 91,150), which was essentially a steel wheel attached to a "...handle like the handle ordinarily used for a dia-

mond-tool." In 1873 he obtained another patent for an "Improved Glazier Tool" (No. 140,426) adding a putty knife "... united in one common tool." The story repeated itself the following year with the patent of Heman Brooks of Waterbury, Connecticut for a "Knife-Sharpener" (No. 150,225). The next year, 1875, brought an "Improvement In Rotary Paper-Cutters" (No. 166,954) by Frank R. Woodward of Hill, New Hampshire. In the patent specifications and drawings, Woodward clearly spelled out the superiority of his asymmetrical conical shaped cutting wheel. The litany continued with the 1880 patent of Benjamin Adams of Springfield, Massachusetts (No. 229,228), with yet another refinement to the cutting wheel. The drawing was depicted in large scale and in cut-a-way format so that the handle did not even show.

What do glass cutters have to do with corkscrews? In today's world, nothing. In the 19th century world of Monce, Woodward, et al, the corkscrew was an optional extra. Tools with a corkscrew were produced under all five patents (Fig. 1-3). To complicate matters further, an example exists of Monce's first patent model marked "W. L. BARRETT PAT.D 1873." Barrett was a former foreman of Monce's who went off on his own to produce glass cutters in 1873, but research has not uncovered a patent in his own name for a tool involving a corkscrew. Moreover, "THE WOODWARD TOOL" also exists in a format marked "THE ANDRESS TOOL." All these tools have combinations of

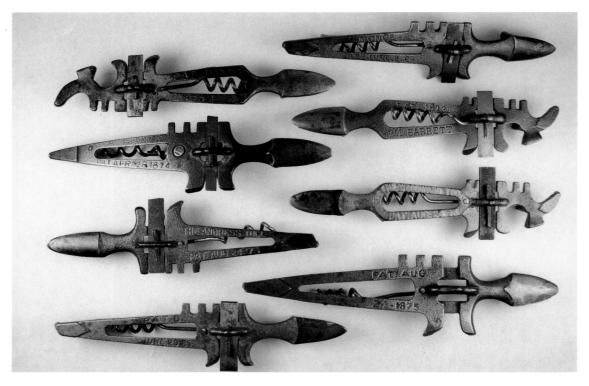

Fig. 1-3 Glass cutter tools of the 1870s. It is hard to tell the players even with a program. *Courtesy of Bob Nugent.*

functions that included knife sharpeners, hammers and even pliers, in subtly different configurations marked under the patent 'protection' of the tiniest element of all: the glass cutting wheel. Talk about the tail wagging the dog!

For years Woodward and Monce went at it in court until finally in 1879 Woodward succeeded in having Monce's 1869 patent invalidated by "... establishing the fact that similar tools had been made and used before the invention thereof by Monce." It was a hollow victory considering the number of Monce tools in existence today, probably the result of continued production well after 1879. Moreover, two modern-day giants in the manufacture of glass cutting tools — the aforementioned William L. Barrett Company and The Fletcher Terry Company — both were established by one-time Monce employees. So while Woodward might have prevailed in court, Monce is recognized as the real father of the steel glass cutter.

The only patent known to be issued for a glass cutting tool encompassing multifarious functions, including a corkscrew, was the 1881 patent of Othon G. Rombotis, Chicago, Illinois (No. 246,419). The closest known example is marked "KNOX'S C. TOOL PHILA. U.S.A." (not pictured), but cannot be confirmed as the Rombotis patent. Even though a previous patent did not exist for a tool combining all the elements, it is clear from the massive number of tools still extant, these things were literally flying out manufacturing plants for over 10 years prior to the Rombotis patent. Even England is known to have produced similar tools in the mid-1870s. Patents are theoretically not supposed to be granted for "aggregation," that is combining independent things which do not co-function or duplicating a number of existing things to create a supposedly "new" one. With all due respect to the energy of the principals and the market-neutral position of the Patent Office, this was one case where a glass cutter did not cut straight!

Aside from wire corkscrews, which were produced in prodigious quantities in the late 19th Century, perhaps the oldest and most commonly found U. S. patent today was taken out by George Havell of Newark, New Jersey, October 16, 1877 (No. 196,226). It is comforting to know that it is possible to swap modern tokens for something 100 years older, for it is the change pocket that Mr. Havell had in mind for his corkscrew. The "Folding Bow," as the class is referred to in collector parlance, had been around for more than a century before Havell presented his "improvement" to the Patent Office. But once again, like any good inventor, he found a way around that:

"The handles of this class of corkscrews are usually made of round wire, and shaped in such a manner that in drawing the cork the fingers are crushed together, which, besides being unpleasant, reduces the power of the hand. The wire for the screw is reduced in the screw part from a certain thickness needed at the upper part where it rests in the spring handle, which reduction causes considerable labor and cost. This thick part is also weakened by drilling a hole for the introduction of a pin to form the ears or pivots by which the screw is suspended in the handle. My improvements are designed to obviate these difficulties."

Hyperbole aside ("crushed"?), Havell's idea apparently had merit. Look for his 'clover' (3-finger) and 'bell' (2-finger) configurations, preferably marked.

Marking was the patentee's means of putting the competition on notice that a product was protected by patent. Until the mark appeared (and, of course, the patent was issued), there would be no legal grounds for proving that infringement occurred or establishing a dollar value to the damages. Up until the mid-1920s the mark generally consisted of the patent date; thereafter it has been the patent number.

Marking is important to today's collector too. The mark not only confirms a corkscrew's pedigree and age, but also possibly its rarity. Once the patent protection period had expired, everyone could get into the act, literally flooding the market with legal impostors, if the idea still sold. Even the original patent holder might extend production long after losing protection or voluntarily forsake protection along the way. Marking would be just another added cost and complication to the production schedule. Thus any piece with a patent mark may likely have been produced in lower quantities than one without it.

Despite the advantage to the inventor (why go through all the search, filing and expense otherwise?), *still*, many patented corkscrews never got marked. If it looks like a patent, it walks like the patent, it quacks like the patent... but is it a patent? For some corkscrews we'll never know. No one has yet found a marked Byrn, raising into question whether it was produced in the first place (No. 27,615). A marked Loffler still eludes all seekers, although like Byrn, there are many close examples extant (No. 59,241). Van Gieson's elegant direct pressure corkscrew, when it was marked, has not been known to disclose more than the tantalizingly terse "PATENT" (No. 61,485). The manufacturer can not be excused for lack of space. Even Greely found a way to mark his extractor, which

can put a good pair of bifocals to the ultimate test (No. 379,010).

One class of corkscrew not yet mentioned and rarely found marked is the champagne tap. Champagne taps or "bottle faucets" were plentiful during the late 19th century and early 20th century, represented by no less than 8 patents prior to 1880 alone. Appropriate for any effervescent liquid, it was champagne that gave it notoriety. Anyone who has sampled the remainder of a bottle of the bubbly on New Year's Day could add 'waste' to the woes of that day. The champagne tap made it possible to draw champagne by-the-glass over an extended period without loss of effervescence, creating the means for closet consumption between celebrations *and* the morning after. Today it has fallen out of favor except to a new breed of 'addict'.

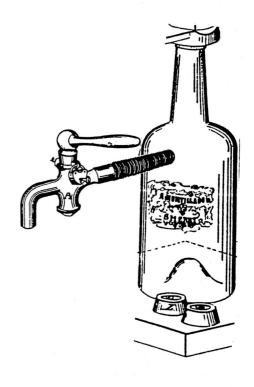

Materials used for pre-1880 corkscrew making in the United States were largely wood and metal in combination, the metal being cast and forged, rarely brass and never precious. It also has bequeathed to us the first patented applications of wire in its infinite variety, perhaps none so appropriate as for the corkscrew. The name synonymous with wire corkscrews is William Rockwell Clough (rhymes with "stuff"), a prolific inventor and producer of inexpensive wire things. What "Cloughs" lacked in beauty, was *over*compensated for by the quantity produced. More Clough-inspired wire corkscrews have been sent into the world than any other, making them the universal starter of a corkscrew collection.

The saga of W. R. Clough spans nearly 55 years of patent history that includes both the United States and England. The first of his known U. S. patents was a Reissue of the patent rights for a "Paper File" in 1865. In total it is possible to attribute at least 18 U. S. patents to Clough that are unrelated to his 12 confirmed corkscrew patents, covering the likes of hair pins, nursery pins, binders, buckles, hose supporters, easels and bill files (Fig. 1-4). Curiously, for all of Clough's fascination with wire, no patent was apparently sought for nor did he ever produce a cork retriever. These gadgets had many useful household purposes, among them the cleaning of lamp chimneys.

Clough's first patent for a corkscrew (No. 161,755), also patented in England the same year, was a simple wire device commonly used in vials and small bottles, where a cork was the universal method of bottle closure. The

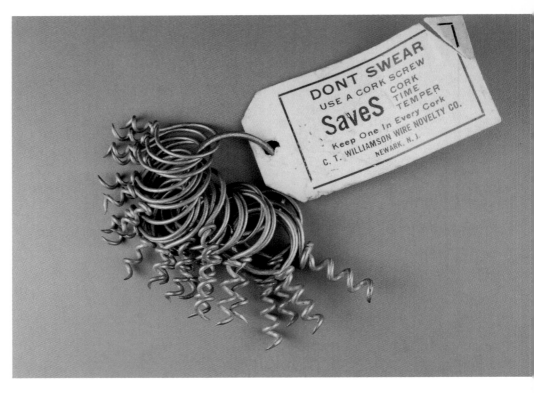

word "in" is appropriate, for the user would be expected to leave the corkscrew in the cork for recorking after each use (at least that's what the corkscrew manufacturers wanted). The low cost of production made it feasible to include a corkscrew with the bottle, or in the alternative, to offer corkscrews by the dozens to keep on hand (Fig. 1-5). Were one to open a typical medicine cabinet during the second half of the 19th century and early 20th century, one would find shelves full of bottles in varying states of attrition, all topped with a wire corkscrew awaiting the pull of an index finger (Fig. 1-6). Significantly,

Fig. 1-5 A ring of corkscrews produced by C. T. Williamson Wire Novelty Co. They would be part of the medicine cabinet arsenal.

Clough and Williamson's machine demonstrated at the 1876 International Exhibition (Centennial) in Philadelphia, was cited not for making "corkscrews" as such, but for making "cork handles of wire" (Fig. 1-7).

Clough's second corkscrew patent (No. 172,868), while applying the same rationale for simple and economical construction, expanded the concept into a corkscrew that is "formed of one or more pieces of wire" and may have

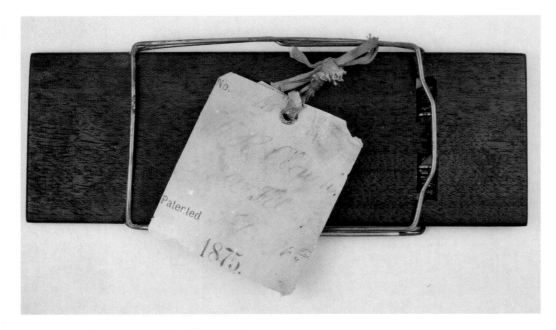

Fig. 1-4 W. R. Clough's patent for a "Bill-File" with the actual model. *Courtesy of Jack D. Bandy.*

Fig. 1-6 **a.** The personal desk of Thomas Edison, left undisturbed from the date of his death in 1931. What's the connection? **b.** Three "LISTERINE" bottles topped with corkscrew 'handles'. *Photo credit: U.S. Department of the Interior, National Park Service, Edison National Historic Site.*

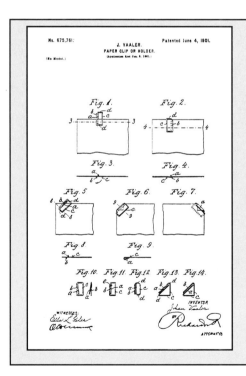

WHO INVENTED THE PAPER CLIP?

Because of his many patents for wire holding devices for home and office use, speculation has long circulated amongst corkscrew collectors that William Rockwell Clough was the inventor of the paper clip. While the idea is tantalizing, there is, unfortunately, no substantiation for the connection, at least in patent annals. The most likely candidate is a Norwegian, one Johan Vaaler, whose Patent No. 675,761, June 4, 1901 is full of twists, although none exactly like the ubiquitous drawer filler as we have come to know it. Evidence suggests many others had been tackling the problem well before the granting of this patent. Clough may very well have been one of them.

REPORTS ON AWARDS.

14. Clough & Williamson, Newark, N. J., U. S.

MACHINE FOR MAKING CORK HANDLES OF WIRE.

Report.—These handles are a new article of manufacture, and the machine which produces them at the rate of thirty-two per minute is distinguished for great originality and ingenuity, and is to be commended for these features, as also for the cheapness and perfection of its product.

Fig. 1-7 The official record of Clough and Williamson's award for their corkscrew making machine at the 1876 Philadelphia Centennial Exposition. *Courtesy of Phil Lewis.*

"wood or other material... inserted within the handles, or loops, or eyes, and employed as supplemental handles, when desired." This got one step closer to the heavy duty corkscrew consistent with the demands of beer and wine.

Sometime during or immediately following the granting of his first two corkscrew patents, Clough had become a business partner of Cornelius T. Williamson, also of Newark, New Jersey. The marriage was brief. A split occurred in the early 1880s resulting in Williamson obtaining full patent rights to both Clough patents. Thus, many of the early "Clough" corkscrews that come down to us by the thousands were actually produced by Williamson. Williamson was indeed a fierce competitor in the manufacture of wire and steel devices for the home, with many patents obtained either by his own invention or by rights acquired from other inventors. For example, an 1883 catalogue (Fig. 1-8) offers a Barnes patent (No. 179,090) and a Zeilin patent (No. 254,760).

Don't feel sorry for Mr. Clough, however. While he may have forsaken rights to a couple of clever twists of wire, Clough still had an ace in the hole. The idea of forming a corkscrew from wire could be implemented only with the use of appropriate mandrels or even better, a *machine*! Therein lay Clough's expertise — not so much corkscrew technology as corkscrew *making* technology. It was the *machine* demonstration that had so fascinated visitors to the Centennial Exhibition in Philadelphia and the Universal Exposition in Paris one year later. While Williamson claimed to

be "the sole owners and only manufacturers of all goods covered by said patents" (Nos. 161,755 and 172,868), the machine was the star, which was not at the time under patent protection. The London Times stated the following in its August 22, 1878 issue referring to the American exhibits:

"Close by... stands CLOUGH and WILLIAMSON'S 'Wire Cork Screw Machines,' (*C. T. Williamson, successor*) which catches a straight piece of steel wire and throws it out a cork screw of such temper that it may be driven through an inch deal plank and not yield a hair's breadth. The deftest waiter will take as long to pull a cork, as this machine to make a half a dozen Cork Screws of an *Exceptionally good Quality.*"

The quote was prominent in the layout of Williamson's 1883 catalogue with the italics presumed to be Williamson's, added to favor his side of the equation.

In 1890, now free of any business ties to Williamson, Clough would receive the first of two U. S. patents for a machine (No. 441,137).[9] Ten years later he patented another, which would frequently be referenced in the marking on actual corkscrews (No. 659,649). These patents were not surrendered to Williamson; rather, they became Clough's catapult to a career of independent corkscrew patenting and producing in his new home of Alton, New Hampshire, carrying well into the 20th century (Fig. 1-9). Clough and Williamson became corkscrew giants, but they were *separate* giants the rest of their lives.

Clough type corkscrews were made from wire twisted in various configurations, all climaxing into a helix. The helical form is not peculiar to corkscrews, it having experienced many varied applications through the centuries. No less a mind than Archimedes adapted the helix form to raise water

[9]Clough had previously been granted an English patent for a corkscrew making machine in 1878, suggesting that he was on a proprietary track well before his split with Williamson.

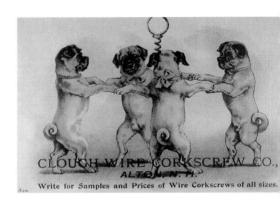

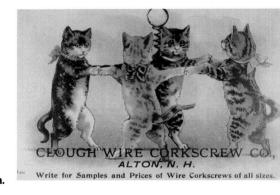

a.

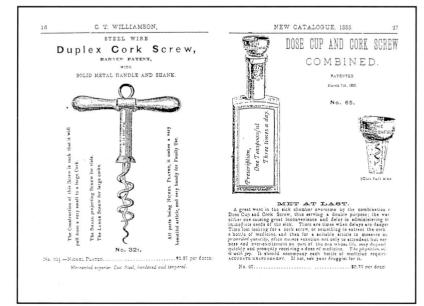

Fig. 1-8 Two pages from the 1883 catalogue of C. T. Williamson offering the Barnes and Zeilin patented corkscrews.

b.

Fig. 1-9 **a.** Two advertising art works of W. R. Clough, perhaps symbolizing his glee over splitting with Williamson and taking up residence in his new home of Alton, New Hampshire, c-early 1890s. **b.** Clough's letterhead, c-early 1900s. *Courtesy of Jack D. Bandy.* **c.** The Clough homestead. The factory is in the background. *Photo courtesy of Jack D. Bandy.*

c.

Archimedes' water-screw.

Fig. 1-10 Archimedes' water-screw making use of the helix form as far back as 200 B. C.

from one level to another (Fig. 1-10). A forward look to the "Universal Corkscrew" in Appendix Three will illustrate actual patented uses for the helical form. Countless other uses exist outside the patent system. By looking at the wire helix from the end, it will be found to have an open center (Fig. 1-11). That means the entire length of the wire travels through the cork in the same spiral tunnel forged by the point. Critics claim the helix is the most effective payload, since it provides grabbing power without breaking down the cork. On the other hand, many a wire helix has been stretched or bent on a stubborn cork, making it one of the most often found faults in grading its condition today. While generalizations are often misleading, a common characteristic of British corkscrews is the wire helix.

The other method of arming a corkscrew is the cut worm (not to be confused with caterpillars), twisted from a flattened strip of metal and filed to the desired cutting edge, or in a later technique, milled from a solid steel rod. Looked at from the end, the core is "solid."[10] Solid core worms are efficient at getting into tight places, but don't always transfer their grip to the rest of the cork. Soft moist corks are inclined to crumble and hard brittle corks to hollow under the stress of being drilled through their inner gut (perhaps the caterpillar analogy is not so far fetched?). Rather than twisting out of shape, the unforgiving metal is more susceptible to breaking off at the point (if the glass doesn't yield first), especially if the angle of entry is not straight and true. Appearing to be more "sub-

[10]Usually referred to in collector circles as a "web helix" or "center cut" worm. "Bladed" is another commonly used expression.

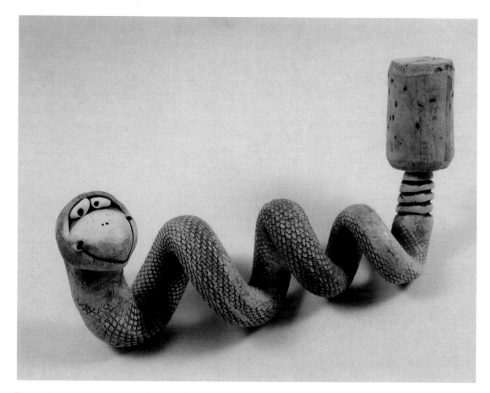

Fig. 1-11 A reptilian demonstration of the helical form.

stantive" than wire, the solid core worm was often used for cutting foil and wire, which also took its toll on points. In Byrn's patent (No. 27,615), specific mention was made of the advantage of using his screw for cutting wire. Continuing the generalization, Continental corkscrews can be said to favor solid core worms.

Variations exist on both sides of the aisle, including the "Archimedean" worm with its *external* thread spiraled

down a tapering rod, but all can be considered sub-headings of the two main categories. United States patents seem to have no regard for such esoteric matters. The type of worm used is more dependent on producer efficiency (read cost) than user advantage. Clough used wire because it was cheap and could easily be extended into a handle or handle attachment. Others used the solid core approach because the shank

was best suited to the patented mechanics. Again, its effectiveness on the cork was secondary to the means of manufacture. Where the patent begged the issue, the inventor/producer often produced both varieties, letting the decision lie with the consumer. Many patents refer to the worm only as "corkscrew," not intending to make or imply any differentiation between a helix or solid core configuration. Certainly no claim could be made for invention of either type, so until high-tech coatings and scientifically sharpened points entered the picture late in the 20th century, inventors put their minds to work on other parts of the mechanism. Complicating matters further, devices for extracting a cork without screw entry of any kind were called "Corkscrew" anyway (Nos. 29,539, 32,394, 38,155, 58,889, 58,969, 59,241, 82,355, 89,477, 104,453, 172,104).

A glance at the patents themselves reveals a gradual transition in format from hand calligraphy to lithography, with the free-hand disappearing entirely in 1871. The fact that drawings exist for early patents should not be taken for granted. While the requirement of examination and patent numbering was instituted in 1836, establishing the foundation for today's system, it was not until 1870 that the patent laws became codified and specifications and drawings became issued entirely in printed form. Prior to that time it was customary for an applicant to submit a model, which became part of the application and undoubtedly simplified documentation. Were it not for two devastating fires, the Patent Office would have been up to its roof in models. First, in 1836, an estimated 7,000 models and 9,000 drawings were destroyed, which were partially restored from the records of the inventors themselves who held the original patents. Then came the devastating fire of 1877 in which an estimated 87,000 models were destroyed. Much of the historical documentation available today, therefore, is based on restoration, which was an ongoing process encouraged or discouraged depending on the Administration then in office. Many of the earlier hand-lettered corkscrew drawings are possibly restorations of earlier lost documents. Models of corkscrews were certain to have existed, but only one is known to have made its way into a collection... so far (see No. 219,101). Many collectors have apparent prototypes in their collections that eventually went into production, but it is not the same as having the precious one-and-only Patent Office model tag attached.

Today the Patent Office owns only a token number of patent models, which are on display for historical interest. The rest have been sold off to private interests. The first corkscrew patent to ac-

tually specify the absence of a model was a "Revolving Glass Cutter" by B. F. Adams, No. 229,228 (could that be only a coincidence?), putting in limbo the whereabouts of some 100 potential corkscrew models. Fire and neglect probably did claim its share. But surely somewhere lies a trunk waiting to be opened...

Referring to the drawings, each page is titled with the name of the patentee rather than the Patent Office itself, using capital letters for the first initials and last name of the patentee and initial caps for the patent title. This type style would continue in use until a new font was adopted in 1898. Patent numbers were on the left, the patent date on the right. The juxtaposition would hold until mid-1922, when they changed places. Many of the drawings were crude, at best, with no particular attempt at standardization. Some kept to elevation view only, others introduced perspective. Cross section was denoted by parallel lines drawn at angles (known as "hatching"), which could designate wood, metal, glass or cork. Where parts interacted, the angle and/or spacing of the diagonals would be altered. Sometimes internal lining was more artistic, attempting to make an elevation appear to be "shaded" and hence three-dimensional. Props were often added, such as hands and, of course bottles, demonstrating use of the device. Props also helped establish scale. Because all patents were depicted in at least one overview, which was generally used for the OFFICIAL GAZETTE, a smoking pipe would appear to be the same size as a blast furnace or a Clough wire handle comparable to a cart wheel in the absence of a point of reference (Fig. 1-12). Dotted lines would be superimposed over hard line to illustrate hidden parts or other positions of the mechanism. The one consistent technique adhered to in all drawings was the labeling of separate "Figures" by numbers (Fig. 1, Fig. 2, etc.) but it was open season on parts, which employed capital and small letters and numbers in infinite variety (Fig. 1-13).

The written specifications make up the other part of the patent, which until the modern era, completed the document.[11] Thus, for tangible patents (i.e. those not involving a process, which could not be illustrated) the minimum collation was two pages. Where there were multiple pages, drawings and specifications were separately numbered. Aside from repeating the patent number, date and title in capitals under

[11] Today's patents also have a *lead* page, which contains, in addition to titles, references and search information, a summary of the patent ("ABSTRACT") and representative drawing taken from the drawing page(s).

242,602. CORKSCREW. W. ROCKWELL CLOUGH. Brooklyn, N. Y. Filed Mar. 25, 1881. (No model.)

Claim.—1. A corkscrew formed of a single piece of wire, the handle of which is constructed of a piece of wire and flattened at the part with which the hand is brought in contact in the operation of extracting the cork, substantially as specified.

2. A corkscrew in which that part of the handle with which the hand comes in contact in the operation of extracting the cork is constructed of flattened wire, substantially as set forth.

3. The corkscrew herein described, consisting of a single piece of wire twisted to form the screw, the stop, and the handle, that part of the handle against which pressure is applied in extracting the cork being flattened, substantially as set forth.

242,603. VEHICLE. WENDEL COLLIS. Pittsburg, Pa. Filed Feb. 28. 1881. (No model.)

Claim.—1. The tongue L, carrying the divided connecting-rod H, in combination with the hinged bolt D. hinged plate E, and the rod P, substantially as and for the purposes shown and described.

2. The tongue L, carrying the divided connecting-rod H, cross-bar M, wheels N N, and rods *n n*, in combination with the pivoted bolt D, hinged plate E, and the rod P, substantially as herein shown and described.

Fig. 1-12 A page from the June 7, 1881 OFFICIAL GAZETTE, again demonstrating the perils of scale. A miniature Clough wire corkscrew performs a "cartwheel" in comparison to the next-in-line patent.

Fig. 1-13 An example of labeling run amuck,
not a machine for making alphabet soup.

the large masthead "UNITED STATES PATENT OFFICE," the "Specification of Letters Patent," as it was formally called, presented the patentee's name *in full* (only first initials are used on the drawing pages), along with the city and state or country of residence (not provided at all on the drawing pages). Beginning with patents issued in 1873, the filing date was incorporated into the heading, which was critical because it was the first to invent that received the all important patent. The filing date was not the absolute criteria, but unless an earlier moment of conception could be proven, the filing date was often the only practical way of establishing priority. It also provides a historical peek into the Patent Office bureaucracy, for the lag between filing and issuing dates can be considerable. In general, the review period has tended to lengthen over time. Most patents during this early period were issued within six months of the date of filing. Today, it is rare for a patent to be issued less than 3 years from date of application.

Of particular interest in the comparison of file/issue dates are the patents for Sperry (No. 204,389) and Tucker (No. 207,631). Both gentlemen were from Connecticut (once again the hotbed of controversy), both invented uncannily similar single-lever type corkscrews. Aside from Sperry's being called a "Cork*screw*" and Tucker's a "Cork*extractor,*" the major distinction between the two appears to be Sperry's replaceable worm, which may have been a factor in favor of granting each a patent. There is no telling who had the idea first. While the earlier filing date does not automatically favor Tucker — exactly 35 days ahead of Mr. Sperry — it does suggest there existed a sense of urgency between the two. That is particularly evident in the fact that the Patent Office, in its mysterious way, which claims to advance applications in the order received, granted Sperry his patent *first*, on May 28, 1878, a positively warp-speed *15 days* after making application, while Tucker's took un-

til September 3, 1878, a more normal 5 months after submission. Could Sperry's familiarity with the patent system have been a factor? Certainly he knew his way around the Patent Office with 4 patents already under his belt. Meanwhile, Tucker was a first-timer. Complicating matters further, an almost exact triplicate of the idea had already been patented in France by Alphonse Delavigne nearly 5 years earlier (Fig. 1-14). Being as how the Atlantic Ocean was more of a pond than a moat, it is difficult to imagine that both these participants and the Patent Office were collectively oblivious to the existence of this previous patent. Make of it what you want, both the Sperry and the Tucker corkscrews were manufactured with some degree of success and in sufficient quantity to have become fixtures in collections today, with neither having an edge in workability or price (both excellent and both very expensive!).

Both Sperry and Tucker went on to successful careers in basic manufacturing, so it is not likely either lost sleep over the strange confluence at the Patent Office. Tucker would even out-patent Sperry when all was said and done, but never would he or any other corkscrew inventor beat the 15 day examination.

Articulating a patent was itself an art form, reciting first the object of the invention by referring to the sad state of affairs the "new and useful" invention was going to irrevocably correct. Even one's own prior patents were not off limits to fault-finding. Then occurs a monologue peculiar to the patent system of describing in words what is pictured in the drawing, with appropriate references to numbered and lettered elements. This presumably would enable anyone to know what it was they were prevented from copying, but of course, it also revealed what could be built upon for an even newer and more useful invention (which is just what the Patent Office wanted).

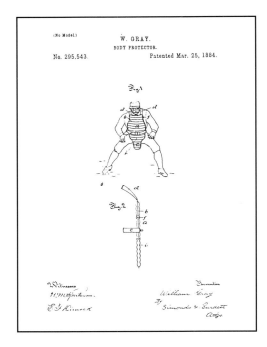

CORKSCREWS AND THE NATIONAL PASTIME

Corkscrew collectors can be thankful that were it not for another invention, Tucker may never have gotten to bat with his corkscrew patent. While attending a game in the early 1880s known as "baseball," Tucker and his friend William Gray were amazed at the absence of protective gear. While in the 'olden days' pitchers had pitched underhand to *let* the batter hit the ball, now they had gone to sidearm and even overhand to speed their delivery. Catchers were taking a beating. The inspiration came mutually that a protective pad might help keep more catchers from being struck in the chest and abdomen, frequently causing knock-outs and game delays. Early experiments with rubber and straps were less than encouraging, complicated enormously by the machismo attitude of the catchers in refusing to appear sissy-like, but eventually they persevered on both counts. Thus we have today the first patent for a catcher's "Body Protector," No. 295,543, March 25, 1884. Both individuals being bent on other interests, agreed to sell their patent to A. G. Spaulding & Brothers. Tucker, with his portion helped finance the W. W. & C. F. Tucker, Inc. Manufacturing Company, maker of oil cups, metal cutting shears, industrial machinery and his patented corkscrew.

Fig. 1-14 Alphonse Delavigne's French patent of July 26, 1873, remarkable for its similarity to the 1878 U. S. patents of Sperry and Tucker.

At the conclusion of the word-picture, the applicant stated the "claims" for which a patent protection was sought. This is important, because technically the claims became the basis of infringement litigation, not the patent. It also gave the patent attorney the opportunity to say, "substantially as specified and for the purposes set forth" for every claim. Although protection extended theoretically from the moment of "invention," damages could only be *calculated* from the date the patent was granted. Historical incidences of infringement are difficult to research, as records exist only of cases going to appeal. Lower court decisions, out-of-court settlements and voluntary withdrawal from the market leave no structured paper trail.

Speaking of lawyerly things, while it is theoretically possible for an eager inventor on a tight budget to navigate the treacherous patent application minefield alone, few do without the assistance of a patent attorney. In a simpler, less contentious time, some applicants apparently did do their own thing, or at least signed their patents without the benefit of an attorney. Over one-third of the patents issued prior to 1880 were unattested while only an occasional maverick shows up after that, the last being in 1937.

On the other hand the specifications written without the co-signature of an attorney have been found to be quite refreshing, if not downright colorful. Kiehl and Kohler had this to say about their "Improvement in Combined Bottle-Openers, Knives, Ice-picks, Graters, and Cork-Screws," a title which in itself sounds like it could only have come from the pen of an attorney (No. 169,175):

"The object of this invention is to supply a want greatly felt... (Ed. note: lawyers aren't supposed to deal with feelings) ...for removing the stout hinged wires used for holding the corks in bottles containing soda and mineral waters, sarsaparilla, or the like, used in nearly all bottling establishments; at the same time to combine with it a knife for cutting lemons, an ice-pick, a nutmeg-grater, and a cork-screw, all in one implement, as a new article of manufacture to the trade, its generally (sic) utility being readily understood." (Ed. note: lawyers don't make grammatical mistakes.)

"The utility of the... (repeat title) ...all combine in the same implement is so obvious, and these implements are in such constant use during summer, not only by keepers of saloons, restaurants, &c., but also in private families, as to require no further description."

Now, would a lawyer say there is nothing more to say, or just say nothing more? Moreover, would a good lawyer have advised his client to imply that the utility of his invention was limited to the good ol' summer time?

Early patents were also witnessed by two individuals, the signatures appearing at the bottom of each drawing page and once at the end of the specifications. The names were often different in the two sections. To the delight of historians of minutia, the "Witness" and "Attorney" signatures provide much fodder for the exposure of incestuous business relationships. For example, Charles Morgan and Michael Redlinger, two major patentees of bar mount corkscrews at the turn of the century, shared the same attorneys and witnesses on the drawing pages of Nos. 549,607 and 589,574. But guess who witnessed Redlinger's specifications? None other than Charles Morgan!

Similar affiliations existed between other patentees, indicating invention did not always occur on desert islands. Burgess (No. 32,396) has already been mentioned as an assignor to the Blake Brothers (No. 27,665). Clapp (No. 74,199) and Ridgway (No. 81,292) had the same witnesses and are a notch apart from being the same corkscrew. Davis (No. 455,826) was a business associate of Puddefoot (No. 522,672). But nowhere was the inbreeding more blatant than amongst the bar corkscrew bunch. The subject will be discussed more fully in the next chapter.

Another characteristic of the early patents was the plural title, such as "Corkscrews," "Cork Extractors," etc., betraying an archaic belief system that physical matter was finite. This was a carry-over of the 18th century Newtonian laws of gravity and motion. The Patent Office, indeed the scientific community itself, found order in a physical universe that could be observed and measured. What might go on outside the "box" still threatens conventional science and complicates a patent system reflexively tethered to a classification system today. But in the 19th century it was a shroud. All of invention was initially thought of as "belonging" in one of 22 categories (Fig 1-15). It lead to the speculation that someday everything would be invented, bringing into question the need for a patent system at all!

In defense of the Patent Office, were it not for some structure, well-meaning Examiners, whose own work areas often consisted literally of a cubicle, would be no match for free-wheeling inventors, whose motives were not always on the side of the angels. Hence we have an "improvement in corkscrews" or "improved apparatus for..." which was typical of the patent titles of the period. To some extent the Patent Office will always be playing catch-up, such is the nature of the relationship between Government and a free enterprise system.

Nor have patents been granted historically on fixed rigid criteria. The ease or difficulty of obtaining a patent has ebbed and flowed through the years, depending on very practical considerations such as volume, the Commissioner, and yes... even politics. Patenting could be encouraged or discouraged — 'toughened' if too many applications were coming in, 'loosened' if the flow was slow — thereby providing some counter stimulation to the business cycle.

The period draws to a close with the penultimate patent going to L. C. Mumford (No. 212,863). While no examples are known to exist, the patent is a forerunner of the type of extractor still in use today, often referred to as the "AH-SO," consisting of two prongs that straddle the cork rather than penetrate it. Waiters claim with some justification that removal is simple and swift, allowing the cork to remain unviolated and available for reuse. As with any tool, a long tight cork is a challenge, which this tool seems less capable of meeting than many. But for turn-of-the-century application, it could back up much of what was claimed.

Fig. 1-15 Contents page from the COMMISSIONER'S REPORT of 1858. The patent world was not quite flat, but it was divisible by 22. Demonstrating an early lack of conviction over just what classification corkscrews belonged in, the Patent Office couldn't decide between category XVII and XXII. So they used both.

To look back upon the United States patents of the pre-1880 period is to sense an imminent explosion of a different sort than occupied the hearts and minds of combatants in a Civil War. While most of the nation's industry was above the Mason-Dixon Line, not all tinkerers were apparently dressed in blue. For, less than 16 months after Appomattox and exactly twenty months after the Battle of Nashville, patent No. 57,256 was granted for a "Bottle Faucet" to W. W. Meglone of Nashville, Tennessee. Obviously the way had been cleared for the true nature of American ingenuity to assert itself. With citizens now able to direct their God-given talents and energy to competition in the market place rather than the battle field, a rapidly developing industrial base could now be converted to the manufacture of things to live by — or at least mend by — rather than kill or maim by. Not the least of influences was a receptive patent system that enabled anyone with an idea to reach for the brass ring. Like the Oklahoma Land Rush, the race for the almighty buck was on.

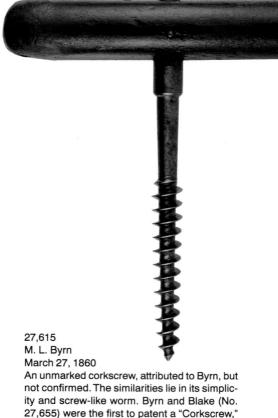

27,615
M. L. Byrn
March 27, 1860
An unmarked corkscrew, attributed to Byrn, but not confirmed. The similarities lie in its simplicity and screw-like worm. Byrn and Blake (No. 27,655) were the first to patent a "Corkscrew," both in the same week, leading to endless debate over who was 'first'; 4.5".

b.

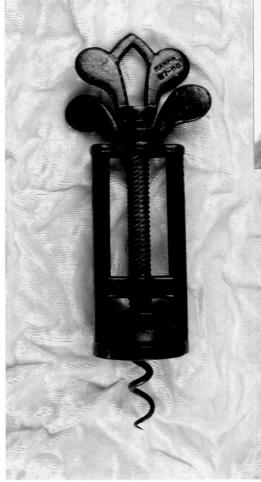

a.

27,665
Philos Blake
March 27, 1860
Two confirmed examples of the Blake patent, the other 'first' patent for a "Corkscrew," issued the same week as Byrn (No. 27,615). **a.** MARCH 27-60; 7.0". *Courtesy of Nicholas F. D'Errico III.* **b.** Close up of patent date mark. **c.** Unmarked example, nickel plated on cast brass. Thought to be a later production model following resumption of manufacturing after the end of the Civil War; 7.1".

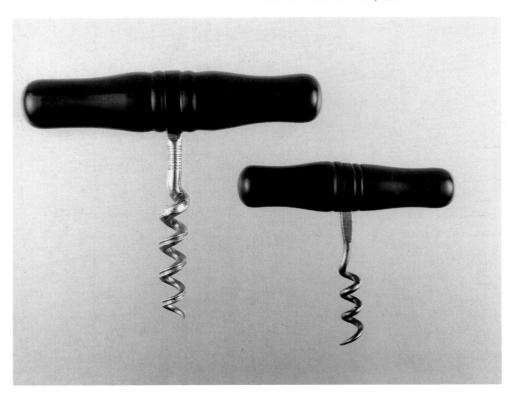

8,075
Nelson Goodyear
May 6, 1851
GOODYEAR'S PATENT MAY 6, 1851 **a.** The earliest known U. S. patent date marked on a corkscrew, in this case a roundlet. The patent applies to the process of hardening rubber. Fortunately for Goodyear (and collectors who like their corkscrews rare) he discovered other uses for his idea; left: 2.9", right: 2.1". **b.** Larger roundlet shown partially open/closed.

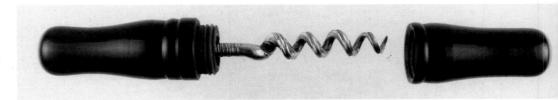

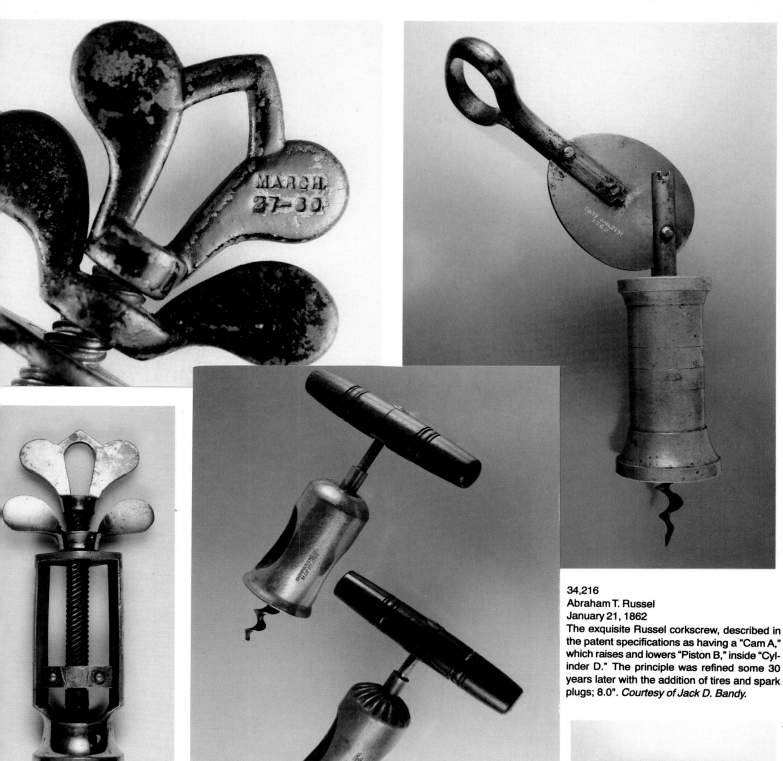

34,216
Abraham T. Russel
January 21, 1862
The exquisite Russel corkscrew, described in the patent specifications as having a "Cam A," which raises and lowers "Piston B," inside "Cylinder D." The principle was refined some 30 years later with the addition of tires and spark plugs; 8.0". *Courtesy of Jack D. Bandy.*

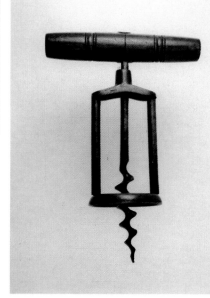

c.

35,362 (see also 38,147)
Charles Chinnock
May 27, 1862
The earliest of many 'self-puller' patents to follow, which extracts the cork by continuous turning rather than pulling. Commonly found with a wood handle shown in a later patent drawing (No. 38,147). No known examples exist of the 'coffee grinder' handle. **a.** Above and below: CHINNOCK'S PATENT MAY 27, 1862 Note smooth and crimped barrel tops and distinctive oval windows to grasp cork for removal after extraction; 4.7". *Above, courtesy of Jeffrey Mattson.* **b.** An open barrel example marked CHINNOCK MAY 27, 1862; 4.8". *Courtesy of Jack D. Bandy.*

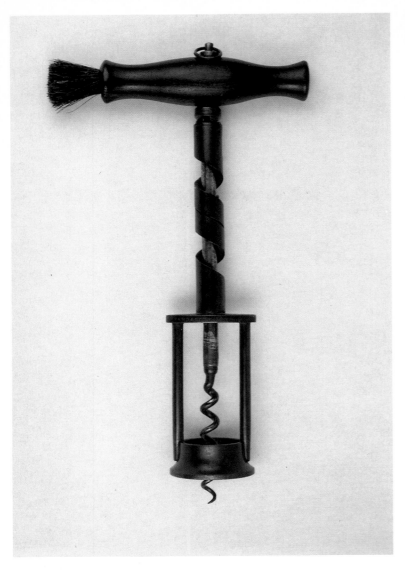

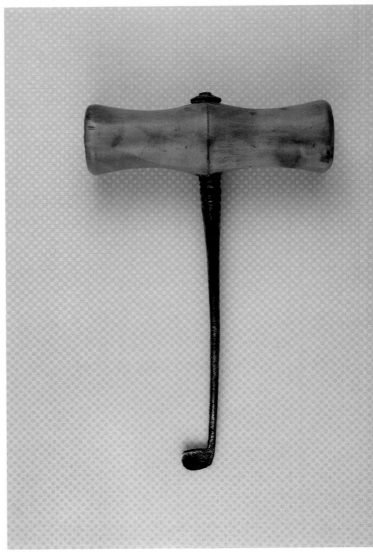

38,147 (see also 35,362)
Charles Chinnock
April 14, 1863
B. B. WELLS STRAND & CITY LONDON SELF-ADJUSTING PATENT A cam and ratchet mechanical corkscrew by Chinnock, called an "improvement" on his May 27, 1862 patent. Note the handle and distinctive oval window barrel shown in the patent drawing are very close to the production model of the earlier patent; 9.4" contracted, 10.3" fully extended. *Courtesy of Dennis Bosa.*

59,241
Karl Loffler
October 30 1866
An unmarked example of a non-screw pull, similar to the Loffler patent. Note it is called a "Corkscrew," despite having no worm; 4.4". *Courtesy of Howard Luterman.*

61,080
William C. McGill
January 8, 1867
PATENT A plain version of McGill's patent providing a wire cutter and can opener blade on the handle. The patent also features a "shearing bar" and frame with left-hand threaded shank; 5.0". *Courtesy of Bob Nugent.*

54,640
John Adt, Assignor To Elisha Turner
May 8, 1866
PAT'D MAY 8, 1866 Adt's spirally slotted case becomes a 'T'-handle by sliding the plug at the top of the corkscrew into the open end; 2.3" closed.

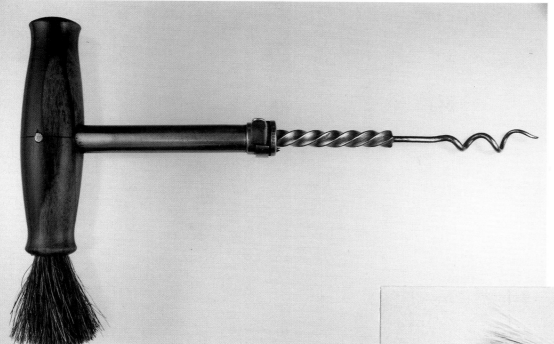

73,677
George Twigg
January 21, 1868
The first U. S. patent for a true corkscrew is-
sued to a foreign resident (the first non-resident
patent over-all was No. 47,161 for a cork re-
triever, nevertheless called a "Corkscrew"). The
drawings are identical to the English patent is-
sued the prior year. **a.** Left: G. TWIGG'S
PATENT ENGLAND OCTOBER 10th, 1867 U.
S. AMERICA JANY. 21st 1868 Made with a
wood handle and three-post barrel; 8.3". Right:
G. TWIGG'S PATENT ENGLAND OCTOBER
10, 1867 G. TWIGG'S PATENT U. S.AMERICA
JAN. 21. 1868 The same mechanism but with
a metal handle and two-post barrel; 7.7". **b.** Metal
handle example showing close up of U. S. patent
marking.

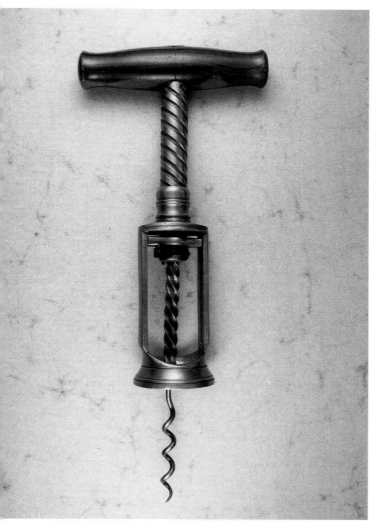

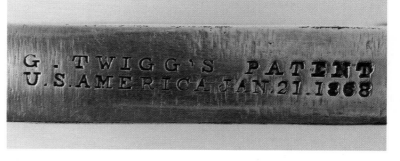

61,485
William H. Van Gieson
January 22, 1867
The Van Gieson corkscrew was patented in the
United States but thought to have been manu-
factured in England where no record of a patent
has been found. **a.** PATENT; 8.2". **b.** PATENT
Variation with open barrel; 7.0". *Courtesy of Bob
Nugent.*

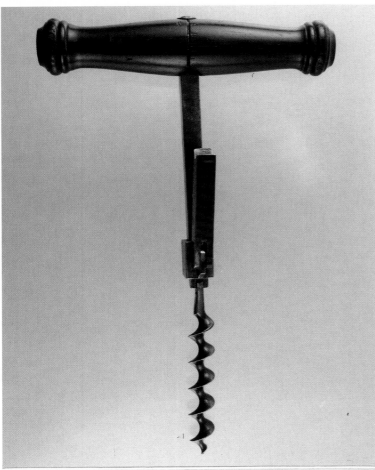

91,150
S. G. Monce
June 8, 1869
-MONCE- PAT JUNE.8.69. The earliest of many similar looking glass cutter tools made with and without a corkscrew. A corkscrew is not included in any of the patents; 5.9". *Courtesy of Bob Nugent.*

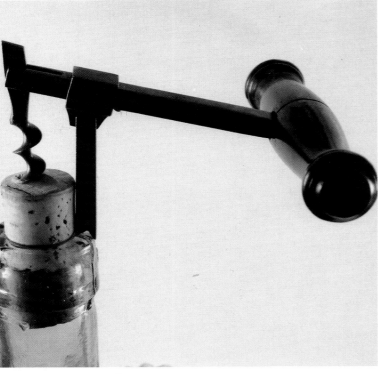

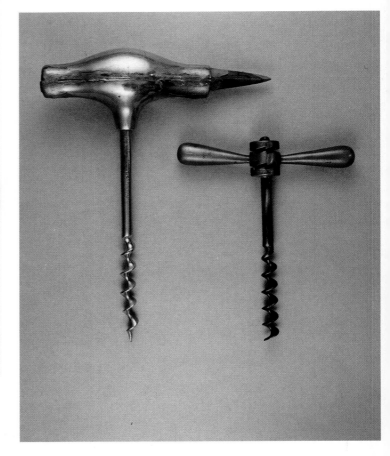

74,199
Seth E. Clapp, Assignor To Himself And Charles L. Ridgway
February 11, 1868
Clapp's clever lever corkscrew. The single lever acts as a sleeve to hold the shank straight and rigid during insertion (a.). When slipped away from the joint, the corkscrew is able to pivot, causing extraction with a downward push of the handle (b.). Assignee, Charles Ridgway, later 'improved' the lever by adding a notch (No. 81,292); 6.0". *Courtesy of Jack D. Bandy.*

106,036
Walter Dickson
August 2, 1870
Dickson's ratchet corkscrew. Left: PAT AUG 2, 1870 with spike. The ratchet mechanism is inside the handle; 5.5". Right: Unmarked example with ratchet pawls exposed; 4.0". *Courtesy of Bob Nugent.*

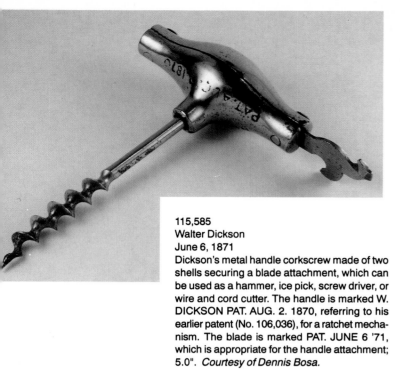

115,585
Walter Dickson
June 6, 1871
Dickson's metal handle corkscrew made of two shells securing a blade attachment, which can be used as a hammer, ice pick, screw driver, or wire and cord cutter. The handle is marked W. DICKSON PAT. AUG. 2. 1870, referring to his earlier patent (No. 106,036), for a ratchet mechanism. The blade is marked PAT. JUNE 6 '71, which is appropriate for the handle attachment; 5.0". *Courtesy of Dennis Bosa.*

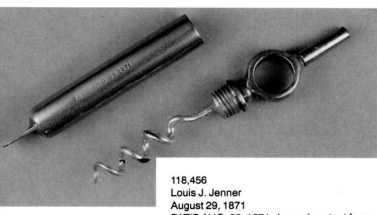

118,456
Louis J. Jenner
August 29, 1871
PAT'D AUG. 29, 1871 Jenner's patent for a replaceable watch key, seen at the top of the ring, and watch opener (small screw driver) at the base of the sheath. Note the patent's crudely hand-lettered title which uses his name in the possessive; 3.1" closed. *Courtesy of Howard Luterman.*

140,426
Samuel G. Monce
July 1, 1873
PAT'D 1873 W. L. BARRETT Another glass cutter patent making no reference to a corkscrew, but there it is; 5.6". *Courtesy of Bob Nugent.*

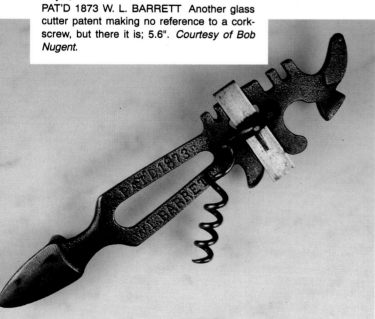

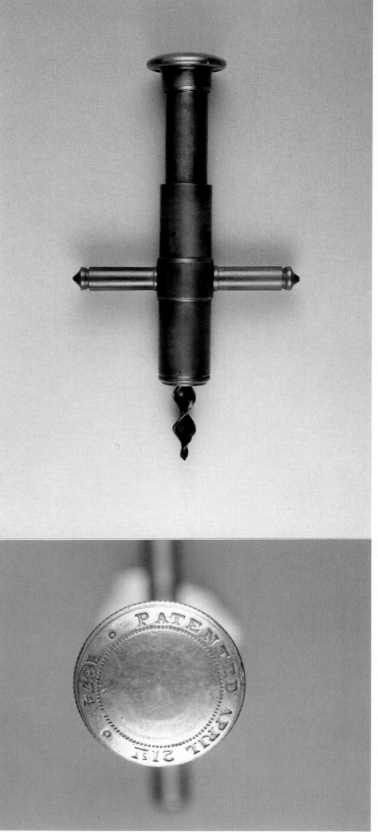

149,983
John A. Bragaw
April 21, 1874
a. PATENTED APRIL 21st 1874 Bragaw's patent, similar in principle to a surgical needle. The cork is penetrated by pushing the knob with the thumb while two fingers hold the cross bar. Note the plural title. Like most early patents, invention was considered to be a process in which "improvements" were made in an established category. Thus Bragaw's patent is officially an "Improvement in Cork-Screws;" 4.1". **b.** Close up of knob showing patent marking.

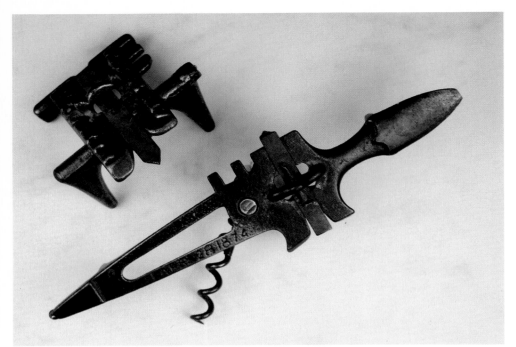

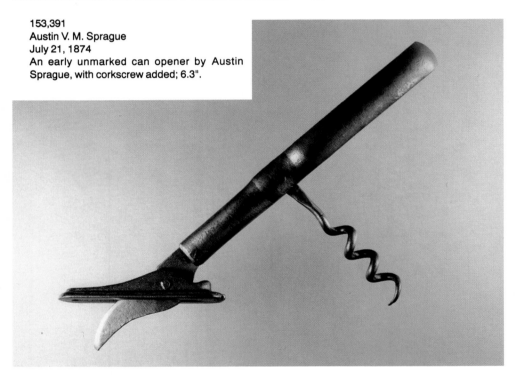

150,225
Heman P. Brooks
April 28, 1874
Two tools having in common a patent for a knife sharpener. In one case it has been extended into yet another glass cutter with corkscrew. Above: H. P. BROOKS PAT APR 28 1874. Below: PAT APR. 28 1874; 5.9". *Courtesy of Bob Nugent.*

153,391
Austin V. M. Sprague
July 21, 1874
An early unmarked can opener by Austin Sprague, with corkscrew added; 6.3".

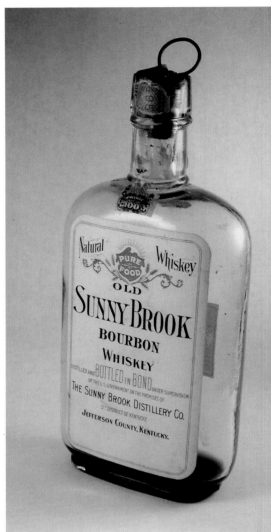

b.

161,755
William R. Clough
April 6, 1875
a. Clough's first wire corkscrew patent, more likely to have been produced by C. T. Williamson after acquiring the patent rights from Clough. Although the patent deals entirely with the bending of wire, the production method required that a ground point wire be used, as illustrated by the example on the left, rather than the more economical scarf cut, as illustrated on the right. The latter corkscrew is covered by patent No. 337,309, issued to William Crabb. *Courtesy of Ron MacLean.* **b.** A wire corkscrew is still embedded in an unfinished pint of "Sunny Brook Bourbon Whiskey," a pre-Prohibition product carrying a back label certifying to its "Bottling in Bond" in accordance with the Congressional Act of March 3, 1897; bottle, 8.3". **c.** This bottle was labeled as "Cough Syrup" but it may have been the alcohol that made you "feel good;" bottle, 6.6". **d.** A wire corkscrew comes furnished with a miniature unopened crock of BOLS gin; crock, 4.0".

a.

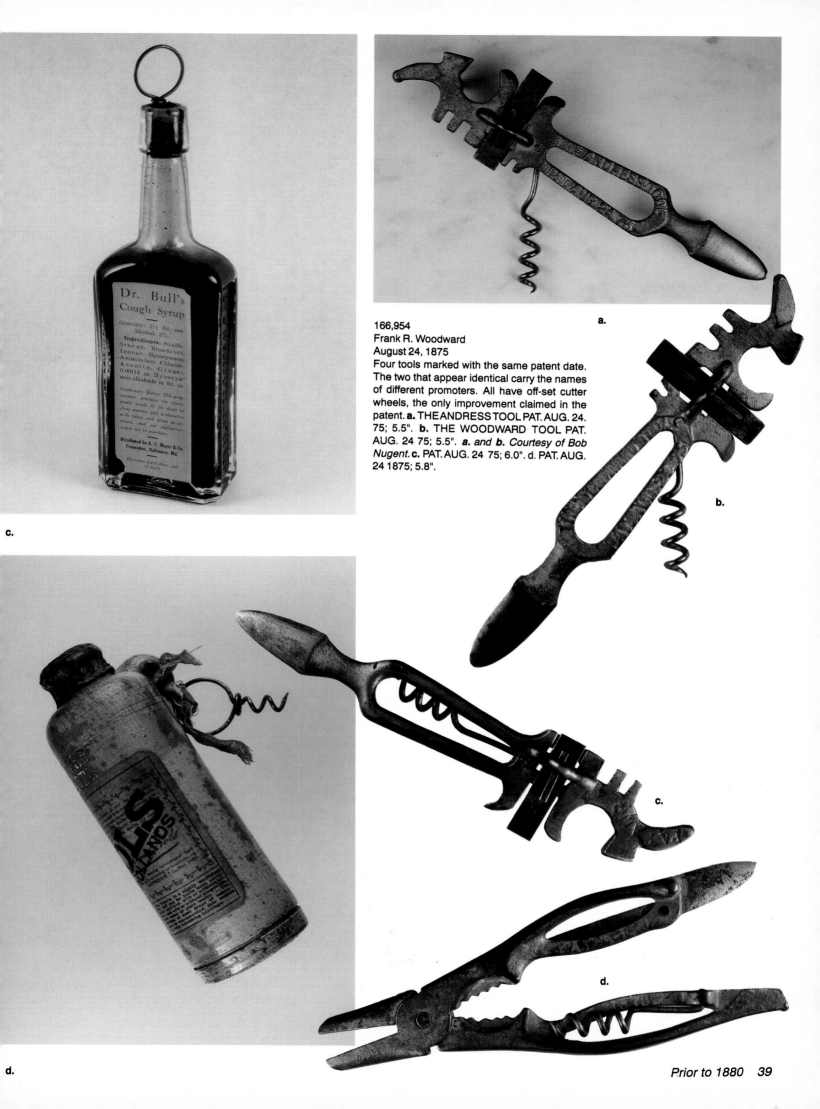

166,954
Frank R. Woodward
August 24, 1875
Four tools marked with the same patent date.
The two that appear identical carry the names
of different promoters. All have off-set cutter
wheels, the only improvement claimed in the
patent. **a.** THE ANDRESS TOOL PAT. AUG. 24.
75; 5.5". **b.** THE WOODWARD TOOL PAT.
AUG. 24 75; 5.5". *a. and b. Courtesy of Bob
Nugent.* **c.** PAT. AUG. 24 75; 6.0". d. PAT. AUG.
24 1875; 5.8".

c.

a.

b.

c.

d.

d.

169,175
George A. Kiehl And Ernst H. Kohler
October 26, 1875
Unmarked lethal tool by Kiehl and Kohler whose patent title serves as a mission statement. The socket-bracket (not pictured) prevents turning; 5.9" x 3.7".

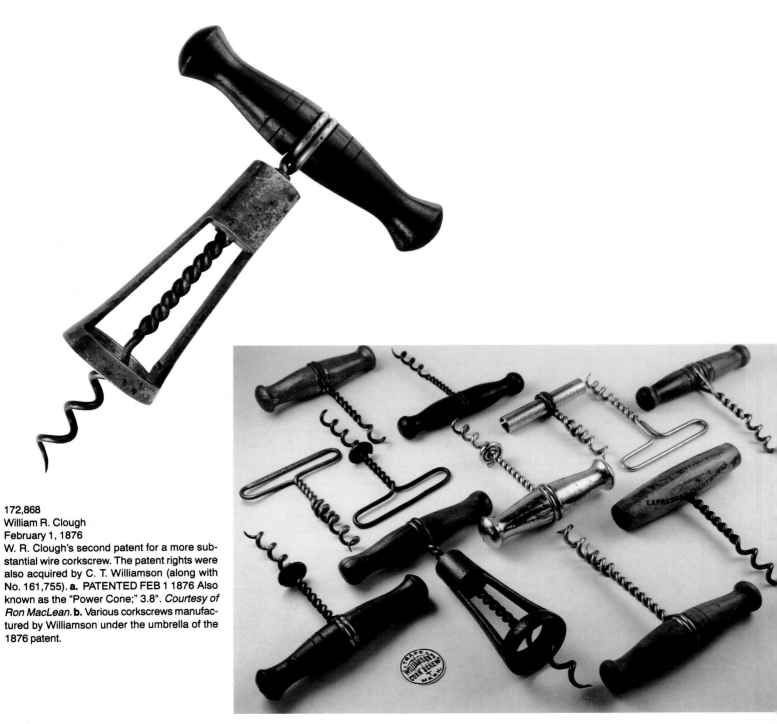

172,868
William R. Clough
February 1, 1876
W. R. Clough's second patent for a more substantial wire corkscrew. The patent rights were also acquired by C. T. Williamson (along with No. 161,755). **a.** PATENTED FEB 1 1876 Also known as the "Power Cone;" 3.8". *Courtesy of Ron MacLean.* **b.** Various corkscrews manufactured by Williamson under the umbrella of the 1876 patent.

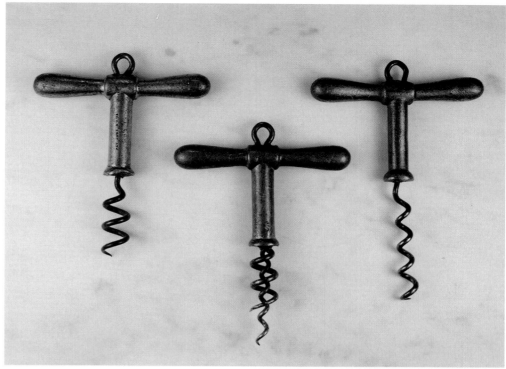

179,090
Joshua Barnes
June 27, 1876
Barnes' duplex helix "adapted to pull corks of all sizes, from those used in vials and small bottles up to those used in large bottles." **a.** Patented corkscrew with combined helixes flanked by examples of the "stouter" and "slender" spirals orphaned by breakage. Left: PAT JUNE 27 76; 3.0". Center: unmarked; 3.5". Right: unmarked; 3.8". *Courtesy of Bob Nugent.* **b.** PAT JUNE 27-76 All wire version; 3.5".

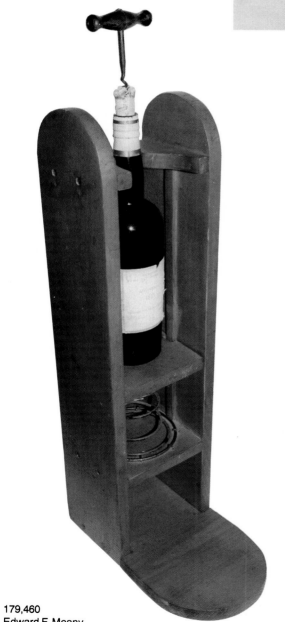

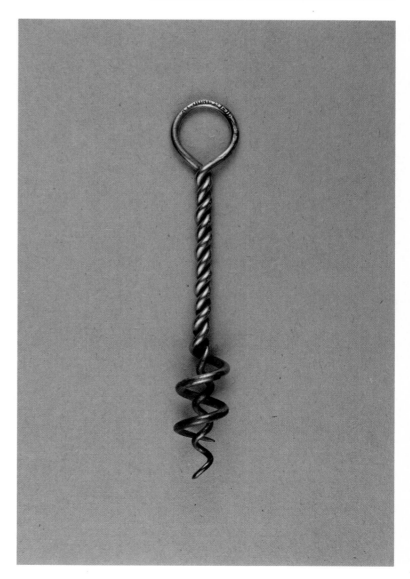

179,460
Edward F. Meany
July 4, 1876
A replica of Meany's centennial "Bottle Holder" constructed from the patent drawing. *Courtesy of Nicholas F. D'Errico III.*

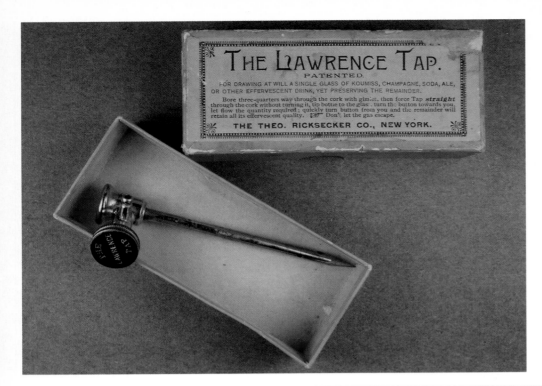

183,445
William Bentley And Richard Bentley
October 17, 1876
BENTLEY'S PAT. OCT. 17. 1876 on top of valve
housing, THE LAWRENCE TAP on spigot knob.
Shown in original box with operating instructions;
4.2".

196,226
George Havell
October 16, 1877
Havell's folding bow in various configurations
and sizes, all marked PAT. OCT. 16, '77 Above:
as shown in the patent drawing with convolu-
tions for separating the fingers. Below: open bow
models for two or three (four?) squeezed-to-
gether fingers. *Courtesy of Ron MacLean.*

204,389
Alfred W. Sperry
May 28, 1878
PATd MAY 28 1878 Sperry's record 15-day
patent for a single lever corkscrew with replace-
able worm. Very similar to Tucker, No. 207,631;
8.7" fully extended. *Courtesy of Bob Nugent.*

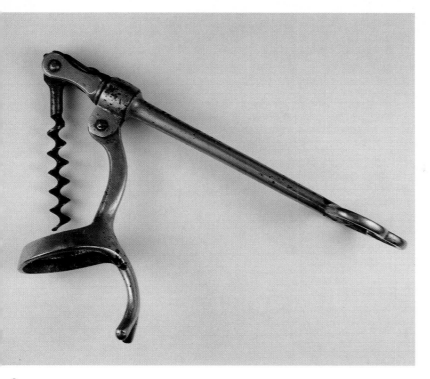

a.

207,631
William W. Tucker
September 3, 1878
Tucker's patent for a single lever corkscrew applied for a month before Sperry's similar patent (No. 204,389), but granted 3 months later than Sperry. **a.** and **b.** PAT. APLd FOR Original handle with three finger holes true to patent drawing. Because it was more difficult to make, not many were produced; 8.3" fully extended. **c.** PAT'D SEP 3, 1878 The relatively more common production model with 2-finger handle; 8.9" fully extended. *All courtesy of Bob Nugent.*

c.

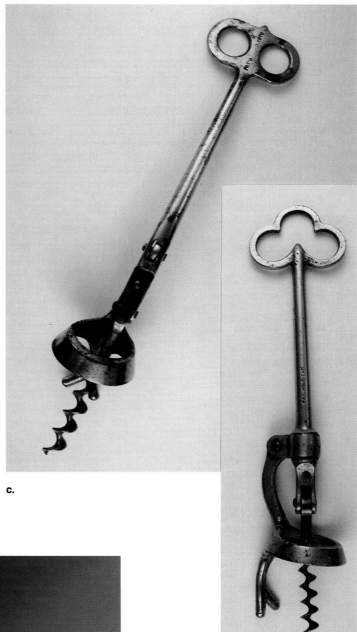

b.

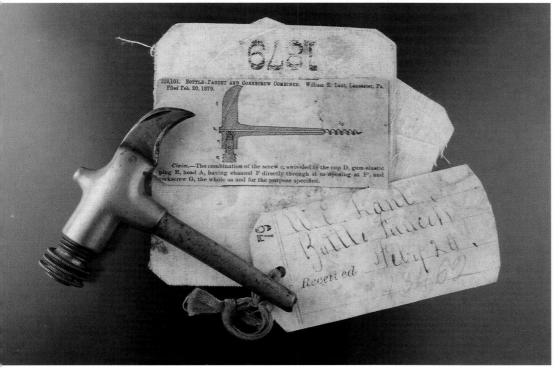

219,101
William E. Lant
September 2, 1879
The actual patent model for Lant's "Bottle-Faucet and Corkscrew Combined." The corkscrew portion is broken. The tag bears the hand-lettered name of the patentee and the patent title, together with the application date of "Feby 20" (1879) and serial number "13462." Underneath is the exact clip as it appears in the Official Gazette. *Courtesy of Jack D. Bandy.*

W. A. WILLIAMSON.
CORKSCREW.

No. 587,900.

Patented Aug. 10, 1897.

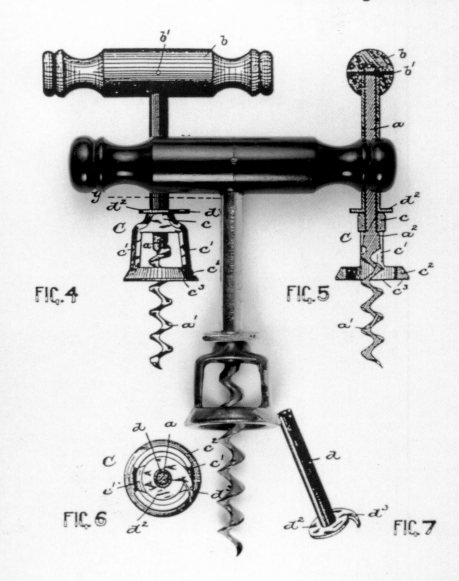

FIG. 4

FIG. 5

FIG. 6

FIG. 7

WITNESSES:

INVENTOR:
WILLIAM A. WILLIAMSON
BY
Fred'k C. Fraentzel,
ATTORNEY

April 22, 1889 The Oklahoma Land Rush

1892 World Columbian Exposition, Chicago

1892 Ellis Island opened, beginning 50 years of unprecedented immigration

587,900
William A. Williamson
August 10, 1897
WILLIAMSON CO. NEWARK, N.J. PAT. APL'D
FOR on handle; WILLIAMSON CO. MAN'F'RS
NEWARK, N.J. on shank. A 'self-puller' with a
flat fixed wire cutter above the bell; 5.6".

CHAPTER 2
1880 THROUGH 1899

265 Corkscrew Patents

Invention accelerated in the United States during the 1880s and 1890s, producing the corkscrews that today form the nucleus of many collections. Highlighting the period was the genius of Thomas Edison, who obtained over half his record 1,093 patents during this time. Corkscrews had their movers and shakers too, but it was the little guy that has made today's collecting so fascinating. Of the three names who dominated the field at the turn of the century, two have already been introduced: Clough and Williamson. The third to begin his run on patent history was Edwin Walker. Eventually he too would meet up with Williamson.

Reconstruction following the Civil War became the genesis of empires that are today 'Blue Chip' companies. The back alleys of industrial America also flourished. Even if they did not make it to the Avenues, dreamers turned their gazes upward to the penthouses and westward to the Pacific Ocean. Opportunity was everywhere, becoming a magnet to immigrants and residents alike, who wished to make something better of their lives. Invention was the ticket for many. The number of patents issued more than *tripled* the previous twenty years and new States such as Utah, Missouri and California started showing up with regularity on the patent roster. Corkscrew patents were a microcosm of the general trend. In the scramble, industrial tycoons used patents as stepping stones, while the individual inventor looked to some pot-of-gold at the end of a single patent. They may have been at different ends of the economic scale, but all were welcome at the Patent Office.

Since a diversity of inventors characterizes this period, what resulted was a diversity of inventions. Mechanical corkscrews, bar corkscrews, non-screw pulls, champagne taps, combination tools, can openers with corkscrews, stoppers using corkscrews, cork retrievers, 'waiter's friends', pocket knives with corkscrews, twisted wire corkscrews, sheathed corkscrews, even match holders with corkscrews made it into the patent records. The material of choice was very un-precious metal, much of it cast, with a diminishing use of wood. There was a perfunctory use of surface scrolling on some bar corkscrews (after all, they were used in public places) but that was perhaps the inventors' only deference to design. Bright nickel plating was often offered as a merchandising option, but not likely to have been indicated in the patent specifications. Clearly the corkscrew was not considered a glamour item (yet). Rather, it was a utilitarian and unceremonious device used to pull corks out of bottles in order to gain access to the liquid inside. It didn't matter that English and French counterparts were doing it with style and grace. That may be OK for them, but it was not the American way, because it increased cost of production.

That did not preclude the first activity in "Design" patents, which was a category established by the Patent Office in 1842 to cover appearance rather than function. But not appearance as in artistic. The invention is not judged by how well it interprets life but by whether it succeeds at looking like nothing previously designed. The criteria is applied whether for a can opener or a figural handle corkscrew (yes, even a can opener has "looks"). The Patent Office is not an art critic; its sole mandate is to establish invention. Of extraordinary precocity was Anton Trunk's shocking handle of a topless bather, also produced in full birthday attire (No. D-16,799). Coming on the heels of the Victorian era and oblivious to the early rumblings of the church-faring temperance movement, which ultimately gave us Prohibition, it is ironic that a 'fair lady' should become the United States first Design patent for a corkscrew. Not only was it first, but also the last to deal with the subject. Henceforth figurals brought before the Patent Office Examiners were generally dedicated to the animal kingdom and politicians.

In many cases, however, Design patents were sought for strategic purposes — to protect a pending utility patent during its longer waiting period or to protect an unpatentable part of the overall tool 'through the back door', so to speak. Puddefoot's application for a Design patent issued in October, 1892 (No. D-21,761) was made 2 days before his application for a utility patent on the same piece, which was subsequently issued in July, 1893. It is not likely Browne had looks in mind either, with his Design patents for a "Can Opener" (Nos. D-29,231 and D-32,875). A utility patent was issued for the latter, one month after the Design patent (No. 654,089). The indefatigable Walker and Williamson, who will reenter the story shortly, obtained Design patents on accessories that became key elements on corkscrews later given full patent protection. Even W. R. Clough, the Wire King himself, got bitten by the design bug with his signature wood handle (No. D-30,234). It was his only defection from the mundane world of machines, mandrels and twisted wire.

If corkscrew aesthetics did not call out for attention, often the patent marking did. The "John Hancock" of corkscrew marking had to be Wilber B. Woodman of Newark, New Jersey. His through-the-handle wire corkscrew is as much sought after for its prominent casted marking as its ingenious mechanics (No. 344,556). There is no mistaking the "WOODMANs PATENT" on one side or the "PATd JAN.Y 6.1886" on the other. The only trouble was, while he got his name spelled right, the patent date was off by a wide margin. Curiously, January 6, 1886 fell on a *Wednesday,* which is one day later than patents had been issued every week since early 1872! Thus he was wrong on both counts, possibly causing him some redness of face at the time, but

only adding to the charm of the cork-screw today.[12]

Individual patents jump off the pages of the OFFICIAL GAZETTE, challenging the collector to find them in real life. Pitt's powerful design takes one's breath away with its mechanical 'presence' and over-large scale (No. 262,613). It positively dwarfs Austin's small manicure set with its multiplicity of tools able to convolute practically into a square knot (No. 266,073). Perhaps no other American corkscrew, patented or unpatented, is as 'pretty' as Leroy Fairchild's roundlet (No. 388,125). A silversmith by trade, Fairchild brought artisanship to an otherwise unremarkable patent. His finely detailed silver and gold craftsmanship is gem-like in quality, which has not gone unnoticed in today's collector prices. Given light, the Fairchild literally shines upon the rest of the field. As a functioning corkscrew it is nothing out of the ordinary.

Reduced to its elements, the classic corkscrew consists of a helix, a shank and a handle. Like the wheel, there is not much opportunity for improvement. Inventors, therefore, cannot tread on that sacred ground, which they skirt by introducing mechanics and/or a method of construction. A good example of the latter were two patents issued three weeks apart in 1885 to Edward P. Haff of Brooklyn, New York (Nos. 315,773 and 317,123). Entitled "Corkscrew" in both instances, the patents clearly limited their scope to the point where the rubber hits the road, so to speak:

"The object of my invention is to provide a handle for corkscrews and tools or implements of a similar character which, while of cheap and simple construction, shall be strong and durable and securely attached to the metal shank of the tool..." (No. 315,773).

The second patent was even more succinct, adding only that it provided,

"...increased strength to the handle and to the junction between the handle and the shank" (No. 317,123).

Haff enjoyed a modest success with his patent protection, judging by the variety of corkscrews he manufactured and their relative availability in today's antique marketplace. A New Yorker through and through, he was the sole or co-owner through his business of at least 20 patents involving various sundries for the home. The common Haff corkscrew is clearly recognizable by its characteristic turned wood handle with a wide metal band, usually but not always marked with patent dates. However, production was clearly not limited to this style alone. Any relatively narrow shank, including twisted wire, that enters directly into the handle, whether metal or wood, has to be considered a

Haff 'suspect'. Two pins straddling the shank on the underside are a tip-off to authenticity; however, since glue was also known to be used, other clues sometimes have to be pursued. Most Haffs have wire helixes.

During this period, considerable energy was devoted to bypassing the screw altogether. While purists may question the efficacy of a 'screwless' corkscrew, anything that purports to pull out a cork (remember, it didn't have to change the course of history to get a patent) is fair game to the collector. Faced with the challenge, the would-be inventor had two points of entry: slipping down the side of the cork next to the glass or pushing through the guts of the cork with a means of grabbing it from beneath without pushing it in first. A 'third' choice was some combination of the two. With Mumford, we have already seen the first of the two-prong tools, which depended on grip friction being greater than bottle friction (No. 212,863). Two later patents improved substantially on the original by implementing a housing for the prongs and adding a handle (Nos. 474,480 and 655,725). Meanwhile, Mann came up with a 3-part 2-pronger which consisted of a tubular handle with a removable cap and prong (No. 245,301). When not in use the prongs stored conveniently in the tube, which in turn stored conveniently in any pocket. Dudly picked up on the idea over 25 years later, reducing the detachable parts to two instead of three (No. 847,744) and adding a cap lifter.

A twisted wire version of the 2-prong was claimed by Devries (No. 544,463) and a folding version by Piper (No. 556,554), but none became a commercial success until Maschil Converse of New York City emerged with his 1899 patent (No. 624,457). In the preamble to his claim of invention, Converse swept away the competition with this scornful sentence:

"In this type of cork-extractors heretofore various devices have been employed to adapt the prongs to operate on corks of different diameters, involving more or less complication, consequent costliness of manufacture, and liability to derangement or breakage, and in all the flat external plane surfaces of the blades or prongs have been arranged at right angles to the longitudinal axis or plane of the handle, so that it is inconvenient to adjust the prongs astride the cork."[13]

In other words Converse turned the flat side of the prongs parallel to the handle. Either he really was on to something or he was a good salesman, because very little evidence exists today of his competition. Meanwhile, the Converse is a regular feature of the flea

market circuit. The modern day version of the 2-prong, which can be found in flea markets *and* supermarkets (!?), has gone back to Mumford's way of orienting the prongs at right angle to the handle.

Meanwhile, the barb/hook school of screwless invention had no 800 lb. gorilla at its forefront, possibly due to the fact that it was difficult to beat one's chest over an idea that didn't work very well. Just the minimal extra thickness was often too much for the cork or the bottle. Mills (No. 434,192) and Phillips (No. 601,380) tried using thinner prongs hoping that multiple notching along their entire length, would compensate for the reduced friction. Simultaneously, White (No. 524,035) and Peterson (No. 632,742) tried concealing lifters in the shank during penetration, then having them pivot out once past the cork. Call added a touch of his own to the idea (No. 911,292). The closest thing to perfection may have been the brainstorm of Benjamin Greely (No. 379,010), rather blatantly copied by Leeser four years later (No. 467,232). Appearing to be a common button hook, Greely's specifications called for a teeny-weeny grove along the shank,

"... forming a passage for the escape of air and gas from the bottle, whereby the cork is not only more easily pulled, but the pent-up air or gas is given a chance to escape, thus obviating the annoyance now caused by the popping and spurting in opening champagne, cider and the like."

They just thought of everything, those inventors. In the packaging of Greely's "Cork Extractor" he used no less colorful language boasting that his idea works even better than a corkscrew! (Fig. 2-1)

Bravado was not Greely's style in the marking of his extractor, however. If Woodman (No. 344,556) was the extremist for his epic corkscrew marking, Greely had to be the minimalist. In fairness to Mr. Greely, the surface available for marking was somewhat limited, yet his "PAT MAR 6 88" may be the smallest marking in patent history. At least Greely salvaged some distinction for his efforts, if not the one intended.

[12] In Woodman's defense, it could be argued that he had adopted the "Patent Allowed" date, which was the date of notification to the applicant of a successful examination. The patent would then be granted after payment of the fee. Detrimental to this theory, "Notices of Patent Allowance" were issued on *Thursdays*, once again putting Woodman a day away from explanation.

[13] Converse was Lucian Mumford's attorney in the patenting of the latter's 1892 patent for a 2-prong extractor (No. 474,480). He *wasn't* the attorney for Mumford's later patent No. 655,725, August 14, 1900.

A more primitive form of barb was Tormey's 1890 patent (No. 441,604). Designed for jugs and demijohns "... made from or covered with a non-transparent material," the device had not one but two "claws... capable of removing one or more corks from the vessel at one operation," or in case the first one missed, turned or messed up the cork. The handle was specially turned on one end to push the cork in first, before drawing it out. Not very sophisticated, but hey, a bobbing cork would be about as easy to catch blind without a Tormey as a fish without a fishing pole.

Speaking of keeping the fingers out of work that can be done by a tool, aside from bar corkscrews, very little inventive energy has been expended on removing the cork from the worm *after* extraction. Until Hessel, that is. In his 1882 patent (No. 258,420), Hessel added a cone to the shank just above the worm. After pulling out the yucky cork with the brand new corkscrew just purchased at the local mercantile, the new owner is instructed to just leave it on! The next cork will do the dirty work, forcing the old one on to the cone and splitting it. The pieces could then be politely whisked away while its hoister becomes cocked for the next occasion, and so on. Not addressed in Hessel's patent was the age-old and important wine custom of smelling the cork for the presence of trouble before allowing liquid to enter the mouth. Noses are best used for protecting taste buds, not fencing with the lethal end of a corkscrew. While he could not be criticized for the fundamental logic of his patent, Hessel certainly could not be mistaken for a wine connoisseur! In his defense, Hessel may not have had wine in mind in the first place, but even the thought of opening whiskey after catsup after cough medicine borders on the crude.

At the opposite (pinnacle) end of the wine spectrum was the very user-friendly concept first patented by Carl Wienke in 1883 (No. 283,731). Servers of wine know it as the 'waiter's friend'. Perhaps the most functional of all corkscrews, the 'waiter's friend' is durable, employs leverage, can be equipped with a foil cutting blade (originally a wire cutting blade for 'olde tyme corques'), cap lifter folds up nicely and can be carried in the pocket. It is the universal choice of restaurants and many a home. While it must have been difficult to find fault with Wienke's idea sufficient enough to justify another patent, David Davis managed to put a different spin on his "invention" (No. 455,826):

"My invention relates to an improvement in *wire-cutters* (italics mine) and cork-pullers, the object of the same being to provide a lever-corkscrew of such construction that the device will be found to pos-

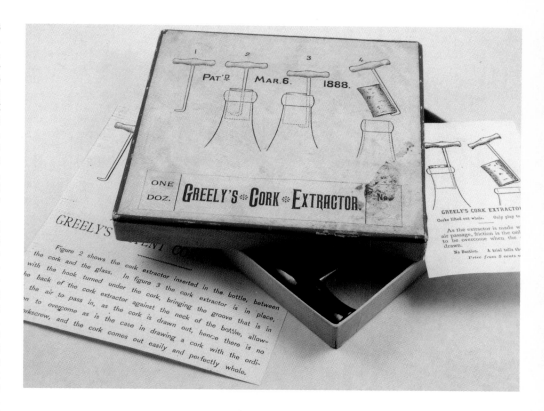

sess every detail in connection with an implement of this character to render the same serviceable in every respect, and especially to provide a corkscrew with means for cutting the wire on bottles in connection with means for conveniently removing the cork with but a very slight effort—a feature which is especially desirable and absolutely necessary to a perfectly-equipped implement of this character, as all malt liquors and many grades of wines are provided with wires to better secure the corks from involuntary ejections."

Whew! In other words Davis entered Corkscrew Patent Land through the wire cutter door. Note there is no Figure reference for the corkscrew in the drawing, despite the title.

That a wire cutter could be elevated to patent status seems odd by today's standards, where wire is used only with champagne and requires no special device to remove. However in the late 19th century the wire was often more of an obstacle than the cork itself, which did not have nearly the tight tolerances of today's bottles and corks. Moreover, with beer and effervescent beverages often stoppered with a cork, it was the wire that stood between containment and premature ejection. It might have made Davis' idea relevant for the times, but it seems quite marginal viewed in hindsight.

Fig. 2-1 Benjamin Greely's total package, designed to take over the known corkscrew world of 1888.

> "The object of this invention is to remove the irksomeness of removing or displacing the binder by the fingers, whereby the fingers are often cut, and oftener rendered very painful."
>
> Justus A. Traut
> Patent No. 107,125 (Appendix Two)

If a wire cutter was the door used by Davis, could there possibly be a door left for Charles Puddefoot to enter? Was there ever a doubt? Here is what he had to say:

"The invention consists in the peculiar construction of a corkscrew belonging to that class in which there is an arm pivoted to the frame and forming the fulcrum in drawing a cork. Further in the peculiar construction of the frame, the spring for holding the screw in its open and closed position and for holding the fulcrum arm in its open and closed position, and further in the construction of the fulcrum arm whereby it is provided with means for removing the wire from the cork. Further in the peculiar construction, arrangement and combination of the various parts." (No. 522,672).

Puddefoot used the "peculiar construction" door.

The 'waiter's friend' did not come soon enough for Alfred Parker, who perceived cork pulling as an irresistible force meeting an immovable object. Where no leverage was provided by the corkscrew, Parker found an alternative to the 'grab-it-by-the-knees' method. He reasoned that a strap held down by the foot would provide the necessary body leverage to restore dignity to the occasion. Hence the patent records are blessed with patent No. 441,804. No known example exists, but one cannot deny the straightforward logic of Mr. Parker's idea. It is one of those "why-didn't-I-think-of-that?" inventions.

Patents do not exist for the enlightenment of theorists. They exist in real time to make money for the inventor. By keeping copy-cats away for a given period, the patent allows the inventor to take his/her best shot at the marketplace. There is a sense of urgency that arrives that fateful Tuesday, not an annuity. There is no guarantee that the effort and expense will be rewarded. No longer is the inventor's focus on what the invention will do, but what it will do *for me*. The idea (patent) or the invention has to be *sold*. That means establishing sales' organizations, accounts receivable, advertising, attractive catalogues, witty slogans, catchy names, wining and dining clients... the whole package. Some take naturally to the conversion, some fail miserably at it and some hit the jackpot. Ironically, antique collectors often have to pay up dearly for a failure, while a couple of bucks buys someone's success. A good example of the latter is Edwin Walker, who in addition to being a genius as an inventor, could sell the pants off his competition.

Born 1847, in Sheshequin, a small town in north central Pennsylvania, Edwin Walker received his first patent for a "Combination Tool" in 1884 (No.

291,820), which was patent-speak for a detachable handle chisel. Four patents and four years later he received his first corkscrew patent for a bar mount (No. 377,790), which perhaps did not presage his later success in other areas, but put him in the game to stay. For in his relatively full life (and afterlife), Walker can be confirmed to have been named in at least 59 U. S. patents, his last patent being issued posthumously in 1921, four years after his death. He apparently went to corkscrew heaven bequeathing to the rest of us a practical joke. Careful observers of patent No. 1,385,976 will spot it.

Walker began his manufacturing career with the founding of E. Walker Tool Company, Erie, Pennsylvania, in 1883. Six years later he sold his interest to form The Erie Specialty Manufacturing Company, featuring household items including lemon squeezers, ice shavers, milk shake machines, cigar cutters and, of course, corkscrews. In 1892 he reorganized and renamed the company The Erie Specialty Company. Corkscrew buffs will note that the appearance of "...Manufacturing..." (or "ESM") in the marking indicates a corkscrew predating 1892. Following a second patent for a bar mount corkscrew in 1891, which also was less than a box office hit, the miracle finally occurred with patent No. 501,975, July 25, 1893. Known by the patent name of, simply, "Corkscrew," collectors the world over know it for a clever attachment called the "bell" (or "bell cap"), and for the name he bestowed on the genre itself, "self-puller."

The mechanical concept of self-pulling cork extraction was not new with Walker. Chinnock, more than 30 years earlier in his patent No. 35,362 claimed, "This invention is a simplification of all mechanical corkscrews, doing away with all combination screws, pinions, levers, or cams and using only the screw *which pierces the cork as the power for lifting it*' (italics mine).

He went on to describe how the screw is turned into the cork until the frame meets the top of the bottle, "...as the downward motion of the screw is then stopped, *the cork rises on the screw till it is drawn*." Walker in his specifications stated, "...when the yoke (bell) contacts with the top of the bottle *the continued turning of the screw operates to raise the cork up within the yoke*."

In other words, both extract the cork by turning rather than pulling. The only difference was that Chinnock's barrel was free to ride up the shank until arrested by the handle; Walker's bell rotated in place with the added feature that it's sharp edge cut the wire securing the cork in the same operation.

Judging by the availability of Chinnock's patent in the antique marketplace, his patent was a modest commercial success. Walker's, on the other hand, was a bonanza.

The Patent Office was anything but idle during the years that intervened between Chinnock and Walker, for others too sought to capitalize on the self-puller concept. Notable patents were issued in rapid succession to Bennit (No. 277,442) with a fixed "cup" into which "*...the cork may be raised from out of the bottle by continuing the rotation of the screw*," much in the tradition of the English "Henshall" (Fig. 1-1); Strait (No. 279,203) with a conical "cutter" threaded to the shank such that, "...after the cutter is down sufficient upon the neck of the bottle the handle is turned farther, and thus *the screw is forced down into the cork, and the cork will then move upward upon the shank*"; Curley (No. 297,232) also with a "cup" which is slotted for "quickly disengaging a cork from the corkscrew after it has been drawn from a bottle...," extraction having been accomplished "*...by turning the handle until the cork is drawn up into or against the cup with sufficient force to render the friction between the cork and cup greater than between the cork and neck of the bottle*"; and Griswold (No. 302,331) also with an inverted cup but having "...certain material advantages over previous corkscrews of the like class," (maybe because it was called a "shield"?) such that, "...the screw having been driven into a cork in a bottle in the usual manner, *as soon as the lower edge of the shield bears against the mouth of the*

PATENT SEMANTICS

What's in a name? Maybe a patent. Whereas all self-pullers have *arresting* hardware somewhere between the worm and handle, making them appear to be patentably different may depend as much on what they are called as how they accomplish their mission. Each inventor has coined a term of his own for the *sine qua non* of the self-puller.

Henshall:	cap, button or plate
Bennit:	cup
Strait:	conical cutter
Curley:	cup
Griswold:	shield
Walker:	collar of a yoke (1st patent)
	yoke of a head (2nd patent)
	collar (1st Design patent)
	head (2nd Design patent)
	collar of a head (3rd patent)
Williamson:	yoke

bottle the cork is started and raised for a short distance into the flaring mouth of the shield..." And so it went. Walker was destined to outsell them all, which was good for him, bad for the rest and expensive for us. If Strait, et al only knew what their corkscrews were going for now!

Walker meanwhile kept working away at the perfect bar corkscrew with four more patents, when in 1897 the bell rang again (No. 579,200). Admitting that his first bell was "old," he went on to describe the addition of a prong with which to cut wire in a separate maneuver (Fig. 2-2). It was another instant winner. Walker had obtained a Design patent for this pronged bell in the previous year (No. D-25,776). It was called a "Corkscrew *Collar*," a term which would stick in future sales and marketing literature.

Before reaching the climax of Walker's accomplishments, it is necessary to back-track to 1892, when an invention came to light that changed the world. With all due respect to Hiram Codd for his successful invention of an internal stopper for effervescent liquids (Fig. 2-3), which spawned a line of marble pushers often combined with corkscrew (No. 251,525), the most common form of bottle stoppering was the cork. William Painter, on the other hand, had the idea of sealing the bottle with a round piece of sheet metal lined with a thin layer of cork and crimped over the rim by a stamping machine.

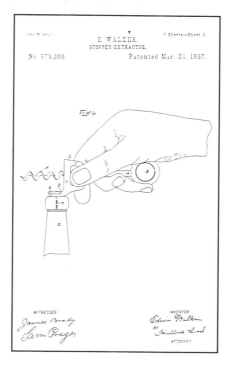

Fig. 2-2 Patent art, advertising art and post card art illustrating Walker's 1897 patent for a bell with wire cutter prong.

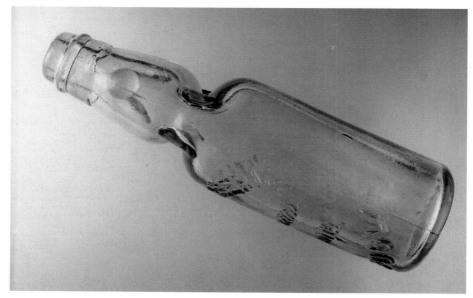

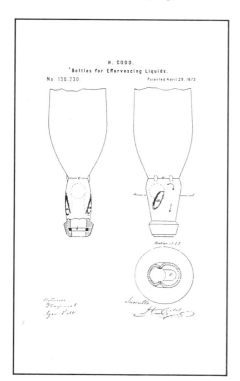

Fig. 2-3 Hiram Codd's 1873 patent calling upon a marble to hold back the tiny bubbles. With a 'marble pusher' one's thirst could be quenched, but only a broken bottle could satisfy a marble collector.

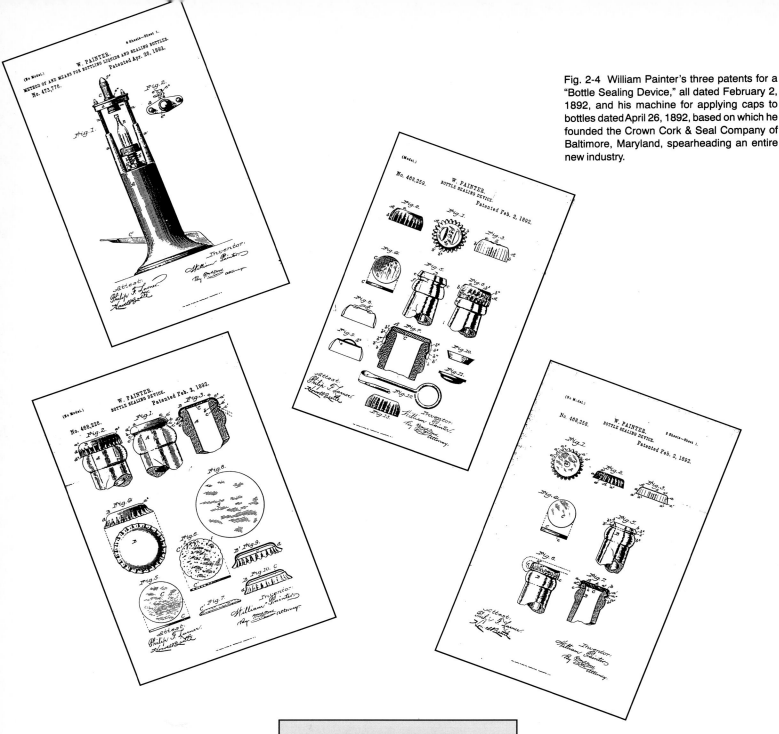

Fig. 2-4 William Painter's three patents for a "Bottle Sealing Device," all dated February 2, 1892, and his machine for applying caps to bottles dated April 26, 1892, based on which he founded the Crown Cork & Seal Company of Baltimore, Maryland, spearheading an entire new industry.

His three patents all dated February 2, 1892 and one dated April 26, 1892, gave us the crown cap (Fig. 2-4). Like the hardware/software interdependence of a computer, a bottle sealer can exist only in a world of unsealers, of which there were none in 1892. Painter introduced his own idea in a patent assigned to his now burgeoning company, the Crown Cork and Seal Company, February 6, 1894 (No. 514,200).

It was not long before the rest of the world caught on that the crown cap was a winner. By the turn of the century the infrastructure was in place, lasting until the advent of the modern 'twist-off' cap. Every bottle opener had a cap pry as its sole purpose or in combination with other functions. Inventors flocked to the patent counter with their 'better idea' for how to pry off caps.

THE FIRST CORK-SCREW COLLECTOR'S CLUB?

Curley, Bennit, Strait, Hicks, Reynolds — prominent names in U. S. self-puller history — hailed from Troy, New York, which was a bustling manufacturing center in the late 19th century. Even Griswold lived nearby in Pottersville, a scant 60 miles away. It is thought that some, if not all these gentlemen were members of a local cork-screw club, creating opportunity for cross-fertilization and supporting the theory that ideas were bandied about amongst them. It is not likely that Walker was invited to join the club!

It was becoming a giant industry, the potential of which did not elude Edwin Walker. Filed February 21, 1899 and granted April 17, 1900 was a patent for a "Corkscrew," with the familiar bell and prong, but this time,

> "... provided with a recess in the ring forming the lower portion of the head and a hook on the upper portion of the head above the recess adapted to engage and remove a bottle seal (cap)" (No. 647,775).

Once again Walker backed up his utility patent application with a Design patent for just the "Corkscrew Head," which was granted September 12, 1899 (No. D-31,505). Slurring history, perhaps helped along by Walker's own ambiguity, it is this device that carries the universal recognition of "Walker Collar."

Fig. 2-5 **a.** A page from a turn-of-the-century catalogue of corkscrews, showing some patents still going strong. On the left is a Bennit (top center) and probably a Hicks and Reynolds (top right). The page on the right shows a Barnes, at this point over 25 years on the market and well past its patent protection (top left). The same page also offers a curiously spelled "Schinnock's Patent" which would now be approaching 40 years of production (No. 35,362). Note "Walker Collar" models featured on both pages. **b.** This catalogue page, perhaps a little more recent, also offers a Barnes, but with no indicated patent marking. Also shown are a Davis waiter's corkscrew, patented July 14, 1891 (No. 455,826), and two versions of "The Detroit" by Puddefoot, patented July 10, 1894 (No. 522,672). Meanwhile note the "Williamsonized" wood handles, lower left. Earlier catalogues show a "Clough" marking, for the 1876 patent acquired by Williamson (No. 172,868).

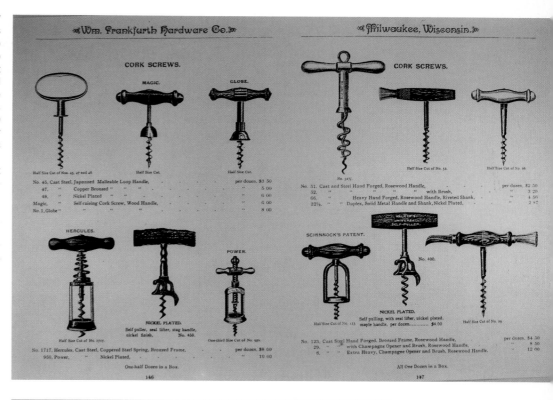

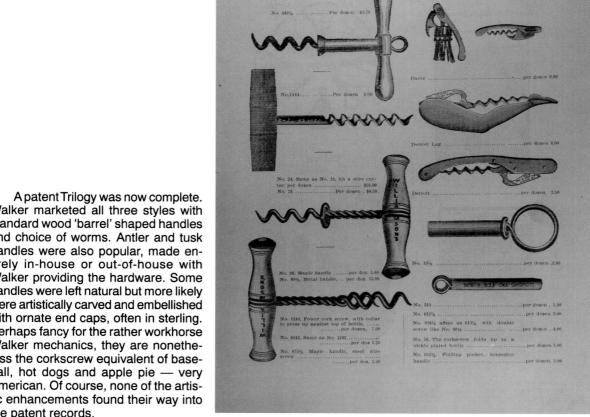

A patent Trilogy was now complete. Walker marketed all three styles with standard wood 'barrel' shaped handles and choice of worms. Antler and tusk handles were also popular, made entirely in-house or out-of-house with Walker providing the hardware. Some handles were left natural but more likely were artistically carved and embellished with ornate end caps, often in sterling. Perhaps fancy for the rather workhorse Walker mechanics, they are nonetheless the corkscrew equivalent of baseball, hot dogs and apple pie — very American. Of course, none of the artistic enhancements found their way into the patent records.

With other corkscrew patents to follow, including more bar corkscrews, Edwin Walker is the most patented of all corkscrew inventors in the United States with his 19 utility and 2 Design patents. That would normally be enough for any person's obituary. However, Walker had another distinction.

1 9 0 9

ERIE SPECIALTY COMPANY

ERIE, PA., - U.S.A.

MANUFACTURERS OF

FINE HARDWARE, KITCHEN, HOTEL, BAR, DRUGGIST SUNDRIES
AND SODA FOUNTAIN SPECIALTIES

ALSO

ADVERTISING NOVELTIES

CABLE ADDRESS "SPECIALTY" WESTERN UNION CABLE

Through his Erie Specialty company, he went on to produce the world's largest variety of ice cream dishers (scoops), under at least nine patents, as well as a diversity of other sundries, all marketed as THE QUICK & EASY LINE (Fig. 2-6). Thus there were "Quick and Easy" champagne taps, "Quick and Easy" self-pullers, "Quick and Easy" bar mount corkscrews, "Quick and Easy" ice cream dishers, "Quick and Easy"... etc., etc. It is also noteworthy that Walker produced at least 10 patents for cigar cutters in his lifetime and five for phonograph sound reproduction devices.

Fig. 2-6 From a 1909 catalogue of Edwin Walker, illustrating His Pullness himself and the marketing sloganism of the Erie Specialty Company.

LET US ALL PULL TOGETHER FOR 1909.

Yours truly
Edwin Walker

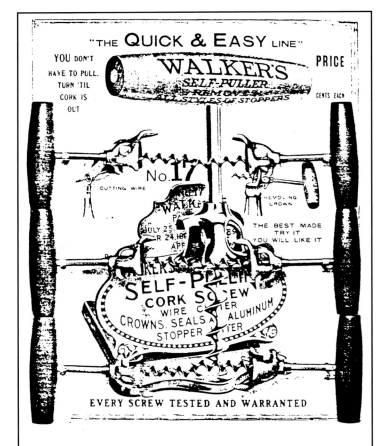

Meanwhile, things were also happening in Newark, New Jersey. Remember that Cornelius T. Williamson was actively producing wire corkscrews in the 1880s under patent rights obtained from W. R. Clough for patents issued in 1875 and 1876 to which he added two more patents issued in his own name: a "Combined Spoon And Corkscrew," September 12, 1882 (No. 264,391) and a folding bow type wire "Corkscrew," March 27, 1883 (No. 274,539). In 1888 Cornelius retired, turning over the reins of the business to his son, William A. Williamson. The company was incorporated in 1890 as the C. T. Williamson Wire Novelty Company, remaining in Newark, New Jersey (Fig. 2-7).

With the death of his father in 1896, William became company president. Thoroughly familiar with the operation and in fact already named in two non-corkscrew patents of his own, W. A. Williamson became an even stronger force than his father. A wire corkscrew that folded into a metal band was patented in 1889 (No. 405,385). Possibly because of a similar 1884 Clough patent (No. 302,321), under which Clough was actively producing corkscrews, Williamson's version never reached full fruition. Examples are rare. In 1897 Williamson also patented a 'roundlet', pictured in the patent in the shape of a bottle, but manufactured also in a plain case much like a lipstick dispenser and a 'bullet' (No. 583,561). The concept was "improved" three years later by a patent assigned to Williamson by Ralph W. Jorres of St. Louis, Missouri (No. 657,421). In between was a patent, also by Jorres, that has not yet been found (No. 644,043). The other two patents are very common and show up in all three configurations, often with advertising plaques attached. A tapered case was also manufactured under the later patent, but apparently not the earlier.

Like Walker's modest beginnings, all was a prelude to the real encounter. On August 10, 1897 W. A. Williamson was issued a patent for a "Corkscrew" that met Walker head on. Note the date falls between Walker's second and third bell patents. The drawings show a very familiar looking bell, referred to as a "yoke," giving it his proprietary ring. In the specifications Williamson stated, "This invention has reference to that class of corkscrews provided with a yoke which when it comes in contact with the annular edge of the mouth of a bottle as the screw is continued to be turned will cause the cork to be loosened from within the neck of the bottle and will turn it up into said yoke with but little difficulty." (No. 587,900)

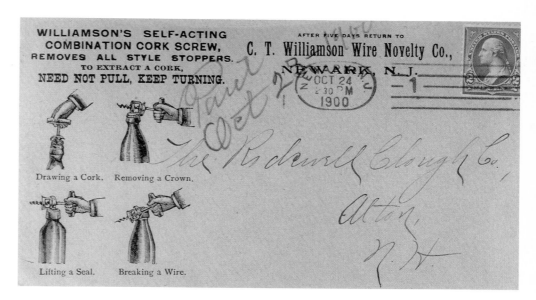

Fig. 2-7 An envelope under the masthead of "C. T. Williamson Wire Novelty Co." addressed to "The Rockwell Clough Co., Alton, N. H." It is canceled "Oct 24 1900" some 10 years after the two corkscrew titans had broken up. Note Williamson's advertising for his new bell corkscrew, the head portion of which was granted a Design patent December 13, 1898 (No. D-29,798).

Is this not *déjà vu* all over again? One has to concede enough difference in the details to justify patent protection for both Walker and Williamson, but there must have been much gnashing of teeth. Certainly there was no backing down. Williamson later added a Design patent for a "Cap Lift" on December 13, 1898, which would have been for its looks, but it was ever so functional working in concert with his bell (No. D-29,798).

Williamson and Walker bells are here with us to stay, their plain 'barrel' shaped handles often printed with advertising.[14] To the untrained eye, they look alike; collectors will know the difference by the method of attaching the handle to the shank. In the Walker version, a pin runs lengthwise through the handle with its head visible on one end. In a Williamson the pin goes *across* the handle, with the head showing on one side. Yet, unlike Haff 10 years earlier (Nos. 315,773 and 317,123), neither made the handle mount a claim of the patent, although Williamson did illustrate the method. The Walker bell is also identified by a sharp edge on the bottom, designed for wire cutting. A Williamson bell-bottom is flat.

The two combatants also had a different method of marking their products. Both were known to mark the round end of the wood handle, generally with the name of the company, city and patent date. Walker is also known to have marked the bottom of the handle in large letters with "WAL" on one side of the shank and "KER" on the other. Williamson was much more inclined to

[14]Aside from an early dowel-and-sphere handle (see Appendix One), Walker's standard handle was 'barrel' shaped, often printed with advertising. Williamson did likewise during this period, sometimes flattening one surface, or squaring the whole handle, to better feature the advertising. Perhaps most characteristic of Williamson, however, was his turned Rosewood handle, not used for advertising.

leave his mark on metal, often in vertical format on the shank and curiously in the possessive, as in "WILLIAMSON'S." In the next chapter we will find that Williamson eventually positioned himself to manufacture Walker corkscrews, but that is getting ahead of the chronology. It should also be noted that Williamson patented a bar corkscrew, but in this arena he was barely a blip in a very crowded field.

Bar mount corkscrews represent the best and worst of American ingenuity. The idea of bringing the bottle to the corkscrew rather than the other way around was not born in the United States, but it was certainly exploited here. The first bar corkscrew is thought to have been English, with a registered design issued to Joseph Haynes of Regent's Park in 1844. Perhaps not coincidentally a similar design turned up in the U. S. patent of J. P. Miers and J. Groendyke in 1864 (No. 41,385) followed 3 years later by J. Walker's version (No. 61,488), and another by C. G. Wilson 2 years after that (No. 92,552). The final prime of the pump was administered in 1877 by J. E. Baum (No. 197,201). From then on the engineers went on a 100 patent binge, compacting an astonishing 79 patents alone in the 20-year period 1884 to 1903.

Fig. 2-8 A bar corkscrew in every home? If Gilchrist's Marketing Department had anything to say about it.

Hand-held corkscrews do their thing, for better or worse, one occasion at a time. But what if bottles have to be opened by the case-load? Not even Parker's foot strap had an answer for that. The justification for an entire industry of rapid fire cork extraction obviously did not depend on the opening of liquor and wine, or on home use generally, although creative manufacturers could not be faulted for lack of effort in cultivating that market (Fig. 2-8). It was *beer* sold in taverns and restaurants across the land that gave bar mount corkscrews their one glorious comet-like existence; after Painter's crown cap had taken hold, the bar mount was doomed, relegated to the pursuit of historians and eccentric collectors. In its place came "wall mounts" providing a stationary lip which yanked off a cap as fast as one could say "bartender."

Harry J. Williams spoke for all bar corkscrew inventors in his mission statement:

"... to provide an improved cork-extracting implement simple in operation and construction and of great power, and which will by a continuous movement drive the screw into the cork and draw the latter out of the bottle-mouth; then by a reverse movement, discharge the cork and return the parts to first position, ready to extract another cork" (No. 531,670).

Patentable differences existed for the mechanics (did they ever!), but the end result is always the same: *Grip* bottle... *Insert* worm... *Pull* out cork... *Eject* cork from worm... *Return* to start. A *G-I-P-E-R* usually took only a couple of seconds to perform and very little strength. To the first-time user, it might actually have been quite fun to execute one, until the quantity of extractions took away the novelty. The action was facilitated by a "speed worm" having a steep pitched twist that got into the cork with fewer revolutions. Hand-held corkscrews with speed worms were not uncommon at the time, including English imports and unpatented examples manufactured by both Walker and Williamson. A patented speed worm is illustrated in Qvarnström's ratchet mechanism (No. 535,726).

The *grip* may be nothing more than a collar requiring some counter force to be furnished by the operator holding the bottle against the mechanism, or mechanical as, for example, Raymond Gilchrist's stand-alone patent for a "Bottle Holder" with a spring tension grip (No. 823,678). Many other examples exist which were a part of the main patent. A mechanical bottle grip had the additional advantage of aligning the bottle with the corkscrew, so that it would enter the cork straight and true. Otherwise, a highly leveraged bar corkscrew could inflict serious damage to a

glass bottle lined up even slightly askew to the direction of the action. In some instances, the bottle grip teamed up with the inner mechanics to perform other functions of the *G-I-P-E-R* as well.

Insertion requires the other (non-bottle or bottle grip holding) hand and could be in the form of a plain lever, with or without wood grip; a lever with a right angle grip or turning knob; or a horizontal crank. The earlier patents tended to feature a separate lever arm connected directly to the corkscrew. Later patents found ways to consolidate all the action into one lever, making them 'automatic'. This required an internally threaded lug or nut which remained stationary relative to the worm passing through it, causing it to turn.

The *pull* out generally required that the bottle remain steady while the mechanism reverses direction. Alternatively, the same H. J. Williams in an earlier patent pushed the bottle away from the cork that was held stationary by the mechanism (No. 450,957). Of course it is necessary that the worm stop revolving. Otherwise it would simply thread itself back out of the cork. This was accomplished by having the worm travel back up into the mechanism (i.e. out of the bottle) in unison with the nut.

(At this point in the operation there is generally a 'reload' step that returns the mechanism, nut and all, back to its lowest point with the cork still on the worm.)

Ejection of the cork is accomplished by reversing the turn of the worm as it withdraws back up through the stationary nut, thus spitting out the cork and *returning* everything back to the ready position. Some patents accomplished the foregoing in one round trip of the lever; others required two. Most bar corkscrews employing a side lever opted for right-hand drive, while the left hand remained 'passive' with the bottle. Left-handed aficionados were accommodated by Barrett (No. 385,834) and Jull (No. 422,348), but in most cases lefties had to be satisfied meeting righties half way, such as with the straddling lever of Edwin Walker (No. 377,790) or the symmetrical configuration of the "Phoenix" by Charles Morgan (No. 728,806).

Beyond the basic package, everything else became buyer's choice, such as the mounting method (bar or wall, clamp or bolt), optional bottle grip, wire breaker, price and aesthetics. To spark sales of specific models, many advertisers entered into the picture by adding their name cast on an attached plate which was designed to be clearly visible to bar patrons. Obviously this would have to be a 'front' bar model, as opposed to a back bar or wall mounted version. Once again advertising created opportunity for all parties — the bar

corkscrew manufacturer, the advertiser and the establishment. And if the customer enjoyed tippling the advertised product, there was immediate reinforcement for having made the right choice.

Beyond their common function, American bar corkscrews have their characteristic absence of aesthetics. Proprietors were concerned not so much with getting the job done in style as getting the job done with the greatest efficiency. That meant iron was the choice of materials, not brass as commonly used for contemporary English bar corkscrews (Fig. 2-9). Instead of 'wasting time' polishing brass, more beer could be opened. A token acknowledgment was made to looks by nickel plating and surface scrolling but the essential 'beauty' was in the inside, with lugs, gears, oscillatory cam-disks and gudgeons hidden from view and compelling only to the most avid engineer. Anyone could build one of these things from the patent drawings and specifications, but who would want to? Most have multiple pages of drawings and claims only a mother would volunteer to proof-read.

The most often found place of residence for bar corkscrew patent holders was the otherwise normal mid-west town of Freeport, Illinois, the designated home for no less than 27 patents, including Design patents. There is a reason: Freeport was the site of Arcade Manufacturing Company, a foundry established in 1885 by two entrepreneurial brothers, Edward and Charles Morgan, along with a successful business man and tavern owner named Albert Baumgarten, whose establishment was known as the "Arcade Sampling Room" (Fig. 2-10). Baumgarten's financial resources, along with his business naming acumen, caused him to be installed as President, but it was the two Morgans who provided the force behind the operation. Arcade *Manufacturing* Company initially produced a variety of castings for home and industrial use, but none became as successful and dearer to the hearts of collectors than its coffee mills and cast metal toys... and, of course, bar corkscrews, of which 8 patents were issued to Charles Morgan alone. Shortly after the turn of the century, Baumgarten left Arcade to form Freeport Novelty Company, which also produced bar mounts under patents issued in his own name.

But the story of Freeport is not that simple. Of all the patents issued to residents of Freeport, not one can claim total independence from the rest. Wahler, Devore, Linsley, Morgan, Redlinger, Schermack and Tscherning all used the same patent attorney. L. M. Devore was once a Witness for Morgan. The same individual signed as a Witness for Morgan 6 times,

Fig. 2-9 The elegant "Rotary Eclipse," one of many English bar mounts that required polishing, which was apparently not in the job description of the typical American bartender. It never made it across the Atlantic, except to grace the homes of corkscrew collectors.

Redlinger 2 times, Schermack 2 times, Tscherning 4 times and Wiles once. Wiles witnessed Tscherning on four patents issued on the same day, but was also the named patentee on one of them, thereby technically becoming a Witness to his own patent (probably a Patent Office mistake). Bitner was among the attorneys listed on patents for Morgan, Redlinger, Schermack, Tscherning and Wiles as well as his own. Morgan witnessed Redlinger's specifications (but not the drawing). Baumgarten shared patent attorneys and Witnesses with Coomber and Gilchrist. Etc., etc. One is almost afraid to dig deeper for fear of finding wives and girl friends treated with the same communal permissiveness. Of course it might make a more interesting book!

With all that incestuous patent behavior amongst the players, it is only natural that it is reflected in the pieces themselves. In the rush to patent, markings often applied to older models, which were dropped as fast as a new idea could reach production, often before the rightful patent was issued. It was not unusual for markings to be one or two patents behind, with some never

catching up. Arcade Manufacturing Company may not have been the only entity to liberally pass patents around, but they certainly elevated the practice to an art form.

But for 4 patents claiming a Chicago residence, yet nevertheless carrying names of the 'Freeport Gang', the total Freeport connection would actually be 31 patents, clearly making it America's bar corkscrew capital. The most patented *individual* however was (once again) Edwin Walker with 12 bar corkscrew patents, followed by Raymond Gilchrist with 9 and Charles Morgan's 8. The peripatetic Gilchrist received his patents first in Peoria, Illinois, then in Jersey City, New Jersey, then back in Chicago for two more, before settling down in Newark, New Jersey for a tenure at the Gilchrist Company, makers of metal novelties, among

Fig. 2-10 A typical sampling room of the late 1800s, forerunner of the modern "package store." From the lack of ambiance, it was obviously not a place for idling away the time with conversation and libation. The proprietor would purchase spirits in bulk, some by the cask, then bottle it for retail consumption. Concoctions could be mixed and blended to order, hence the name "sampling." In the foreground is a "Champion" bar corkscrew.

Fig. 2-11 The Arcade Manufacturing Company, Freeport, Illinois, as rebuilt in 1893 after a devastating fire.

THE ARCADE PLANT.

which were ice cream dippers and mixers. Although never claiming a Freeport residence, Gilchrist did make use of their Witness and attorney pool, which raises Freeport's sphere of influence to *at least* 40 patents. Gilchrist also obtained a batch of 8 patents for an electric mixer on the same date in 1923, well after the last of his bar corkscrew patents in 1914. Obviously he had seen the handwriting on the wall.

With the crown cap well established by 1920, bar corkscrew mania was over. No justification remained for a machine gun version of the corkscrew, except as a silent reminder of the 'good old days' or for a somewhat contrived wine opening ceremony conducted at the table on a tripod. 'Tripod mount', however, just never caught on. Besides, bar mounts have never divested themselves of their association with blue collar beverages. Not that they don't work for wine, but certainly it would be considered bad etiquette to open a bottle out of sight of the customer, just as it would be awkward to escort the customer from the table to the bar to perform the operation. There are some modern reproductions of bar corkscrews available today, but there will be no comeback for the one-time champion of corkscrew technology.

Bar corkscrews are reservedly collected by most collectors today, but only a few approach the genre with a passion. With collections numbering into the thousands, it is challenging enough to catalogue and display hand-held pieces. Bar corkscrews take imagination *and space* to display, to say nothing of the aesthetic displacement caused by the American types — taking up book shelf space that could be occupied by an attractive vase or, well, *books*. The dynamics of personal taste, the exposure to dust — the very institution of marriage itself — often comes into play in the deployment of a bar corkscrew collection.

A similar aversion to 'ugly' utilitarian implements applies to can openers. There are can opener collectors whose minds and motives can only be surmised. Corkscrew collectors collect can openers because they have corkscrews on them. Very few, however, display them next to their prized 19th century mechanicals. There must have been a similar mentality applied to the invention itself. The corkscrew helped make the tool more marketable, but could never have been mistaken for the host implement.

The first can openers did not include a corkscrew. It was all an inventor could do to overcome the resistance of the can, to also have to bother with appending a helix. Like the evolution of the crown cap, it took can technology to pave the way for can *opener* technology. Food preservation in bottles

was known to exist in the 18th century. A primitive type of canister was in use in the early 1800s which had the major inconvenience of generally being heavier than its contents, in addition to being virtually impenetrable. A tin of roast veal carried by William Edward Perry in his 1824 Arctic expedition is said to have borne these instructions: "Cut round on the top with a chisel and hammer." Even during the Civil War, hungry troops were known to attack canned rations with knives, bayonets and even rifle fire meant for the other 'enemy'.

As Painter's crown cap begot specialized cap lifters, thinner cans begot specialized can openers. Earlier patents picked up on this trend, evidenced by William McGill's wood handle corkscrew "...armed at one end with a lance-like blade (adapted) to pierce the thin sheet metal of which sardine or other cans are composed" (No. 61,080), thereby becoming the first corkscrew to be combined with a can opener (or was it the other way around). At least it was called a corkscrew. A smattering of other combination tools involving a corkscrew were also patented prior to 1880, but the race was really not joined until the next decade when inventors took their best shots at defining the ultimate configuration of the tool. None stuck until 1895 when William G. Browne of Meriden, Connecticut developed a structure in which a strip of sheet metal was looped into a handle and joined by rivet at the payload can opener blade, which was subsequently enhanced with a cap lifter. The corkscrew held in ready position snugged neatly between the sides out of harm's way (No. 541,034). For the next 50 years inventors would find fault with this or that element, but the essential launching platform for a corkscrew on a can opener can be traced back to Browne's invention, aptly named "KING."

Collectors of corkscrews with United States patents have to redefine their criteria when it comes to can openers, as so many were produced under patents that did not even mention a corkscrew. In fact many of the functions had separate and independent patents, such that on a single tool the can opener blade carried one patent, the cap lifter another, the can piercer still another, etc., all individually marked but never held under a blanket patent. Such is life. It probably ruffles the feathers of the can and bottle opener collectors too, much to the delight and profit of antique dealers.

Bottle collectors also share a page of history with corkscrew collectors. As we have seen, the late 1800s enjoyed a period of unparalleled growth. Buck chasing — the green paper kind — was a national preoccupation. Business

clearly got ahead of the regulators allowing promoters and fleece artists to operate with immunity and semi-respectability. No better example existed of the phenomenon than the nostrum — liquid remedy for life's ills, brought into home use after the wide spread medicine 'treatments' prescribed for dysentery, malaria and typhoid during the Civil War. No matter that the ailment was real or imagined, self appointed authorities rose with credentials in hand to offer a 'cure' for it. Got impure blood? Cleanse it with "Ayer's Sarsaparilla" (it also treated chronic fatigue). Suffering from indigestion and dyspepsia? Take "Parker's Ginger Tonic... the best health and strength restorer." A mostly rural and gullible America, with limited medical resources, bought the story... and bought... and bought. These so-called "patent medicines" not only purported to stamp out ailments like rheumatism, catarrh, neuralgia and sciatica as so many household pests, but even conjured up phony ills to treat like "weakness" of mind or body, a "broken-down" system, strains, excesses, injured powers and even bad habits. Asked if your liver was torpid in those days, one might have reached for the bottle before the dictionary. Of course, the reason was, most of these concoctions were fortified with alcohol and/or drugs. Today we know that even placebos produce results, so who's to say the stuff didn't work, especially if it made you feel 'tipsy'?

The other common features of the medicine cures were that they were all frauds and that, thanks to the cork, they all required a corkscrew to open... at least the ones that didn't come as a pill, plaster or contraption. Even the term "patent medicine" was phony, for the last thing a concocter wanted was to blow the operation's cover by disclosing the secret formula. It was a marketing ploy, exploited to give the product apparent respectability, but one will search the patent records in vain for an actual patent.

The elixir came generally dressed in a fancy bottle that was often embossed with the maker's name and applied with elaborate labels. Often it was peddled from a horse-drawn wagon, which allowed the fox to get out of town before the goose discovered it had been fleeced. It created a whole industry of hype, with a new art form in newspaper advertising, free-advice almanacs (read manufacturer propaganda) that were claimed to have the second highest circulation to the Bible and a fad in trade card collecting, especially among the younger set, who apparently were not unlike today's sports cards' enthusiasts (Fig. 2-12).

Snake oil was usually presented in a folksy rhetorical dialogue that pushed on emotional buttons. It charmed, en-

ticed and boasted all at the same time, offering up secret blends of nature's secretions discovered after exhaustive scientific research by the benevolent founder, who more often than not prefixed his or her name with "Dr." The pitch often included gushy testimonials from sympathetic spokespersons such as baseball players, nuns, vets, etc., as well as plain everyday folk of all ages who had fallen victim to croup, burns, long working hours, bruises and falls — in other words, life itself. One farmer even claims to have cured his horse of colic by feeding it a mega-dose of "Davis Pain Killer," which no doubt also cured the bank account of the salesman.

Even reputable firms like Sears, Roebuck & Co., on their way to becoming the largest merchandiser in the world by virtue of their famous catalogue of corkscrews and other sundries, lent their name to the craze. Not averse to offering the public what it wanted to spend its money for, Sears had a thriving drug section resplendent in colorfully labeled remedies all priced to sell. Many manufacturers even had their own corkscrews made up, which presaged the next generation of corkscrews — the advertising corkscrew. Not until 1906 did the Government finally come to the rescue with the passage of the Pure Food and Drugs Act establishing standards and requiring claims to be provable. Hucksters headed for their next con while the reputable companies softened their line into *external* potions like fragrances, atomizers and hair tonics. It brought an end not only to a colorful era, but also, alas, to the universality of the cork stopper.

The United States corkscrew had been commoditized by its association with nostrums, beer and booze, but it had not suffered the indignity that was about to take place. For rather than settling into a useful life in the main house, it was about to be cast to the tool shed, as if in punishment for its indiscretions. A few decades later, its penance completed, it would be let back in — to the kitchen — but it would take verily half a century before it would make its grand exclusive reentry into the wonderful world of wine.

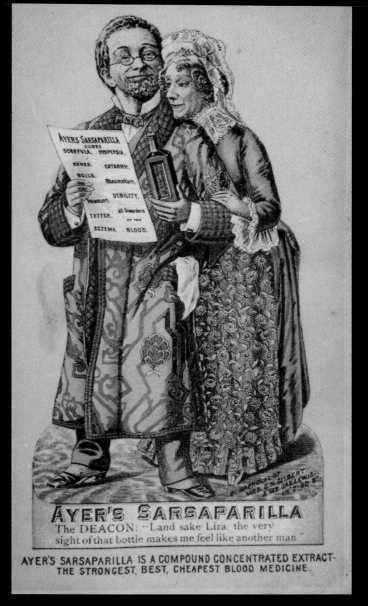

AYER'S SARSAPARILLA

The DEACON: "Land sake Liza, the very sight of that bottle makes me feel like another man."

AYER'S SARSAPARILLA IS A COMPOUND CONCENTRATED EXTRACT-
THE STRONGEST, BEST, CHEAPEST BLOOD MEDICINE.

Fig. 2-12 Trade cards. Generally made for products sold to the home, trade cards tended to depict bucolic scenes of fantasy, with children often used as the main subjects. This collage of bottled remedies has a theme which by now is probably obvious.

ABOUT STANDARD PATENT REMEDIES

We carry in stock at all times almost every known patent remedy, every remedy of merit, every remedy that is now being or has ever been advertised to any extent, and our price to you is the lowest wholesale prices on such remedies. We can usually save you from 25 to 50 per cent on any patent medicine of any kind. If there is a known remedy wanted and you do not find it in our catalogue, send your order to us. If it is a dollar article it will be perfectly safe for you to send 75 cents, if it is a 50 cent remedy, it will be perfectly safe for you to send 40 cents. Be sure and send enough. We will fill your order immediately and if you have overpaid us we will return the balance of the money with your order. It will pay you handsomely to order any patent remedies from us. You will be saving all the profit your druggist would make and more.

Sears, Roebuck and Co.
Catalogue
Fall 1900

Fig. 2-13 Corkscrews and remedies by mail order catalogue. Left: from the Sears, Roebuck & Co. 1902 Catalogue No. 111, offering bar corkscrews along with Walker's first bell. Center: an open page from their Fall, 1900 Catalogue No. 110. Lending their name to the dubious cure-all fad perhaps hastened the enactment of the Pure Food and Drugs Act of 1906, which required proof of all claims. Right: from the Montgomery Ward & Co Fall/Winter 1894-95 Catalogue No. 56, offering among others, a Greely and Davis corkscrew.

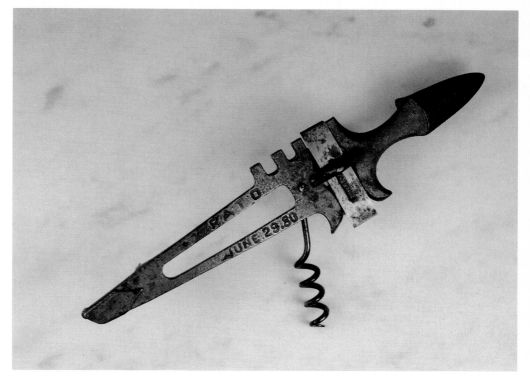

229,228
Benjamin F. Adams
June 29, 1880
PAT'D JUNE 29, 80 The continuing saga of glass cutter tools produced this patent by Benjamin Adams for an 'improvement' in the revolving cutter. The rest of the tool is outside the scope of the patent; 6.0". *Courtesy of Bob Nugent.*

242,602
W. Rockwell Clough
June 7, 1881
Clough's next generation in wire corkscrews after making the split from C.T. Williamson. The patent specifies a flattened top in the loop handle, supposedly making it easier on the finger and providing a surface for advertising. **a.** WAMPOLE shown close up; 1.6". **b.** Original bottle of Henry K. Wampole & Co. Inc., Philadelphia with matching corkscrew.

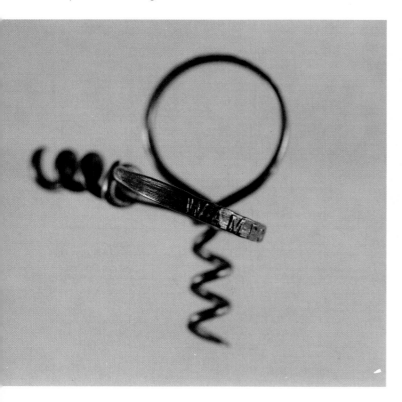

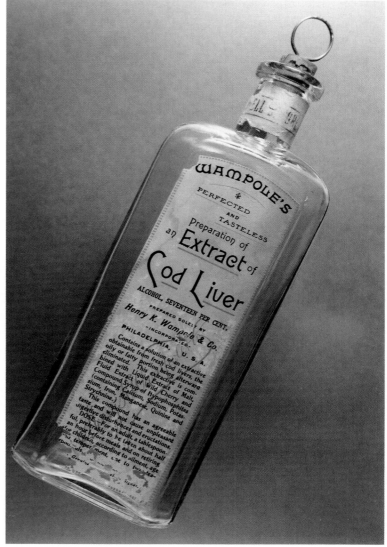

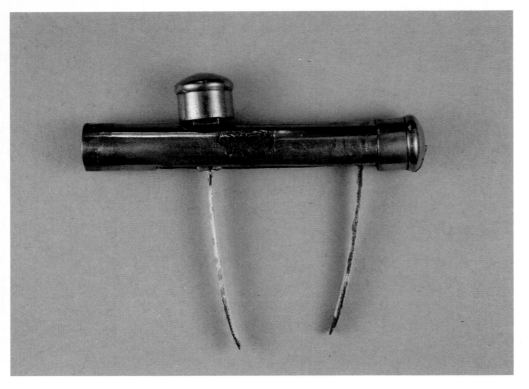

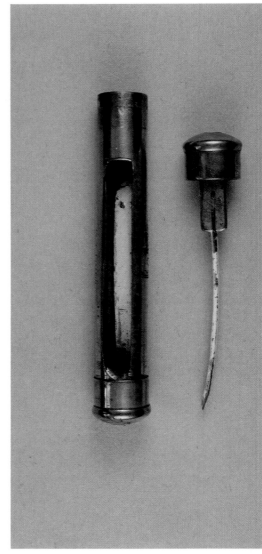

245,301
Fred. Mann
August 9, 1881
B. LEW'S KORKZIEHER An adjustable two-prong pocket extractor by Fred Mann. **a.** Shown in the working mode. **b.** Shown with independent prong removed, revealing pivoting prong folded inside sheath; 3.3" closed. *Courtesy of Bob Nugent.*

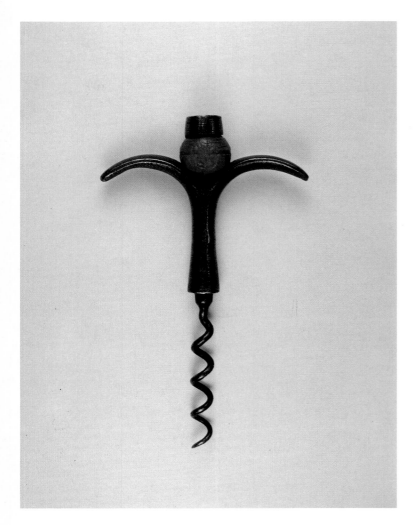

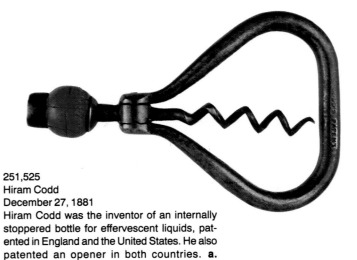

251,525
Hiram Codd
December 27, 1881
Hiram Codd was the inventor of an internally stoppered bottle for effervescent liquids, patented in England and the United States. He also patented an opener in both countries. **a.** CODD'S PATENT GF HIPKINS A combined corkscrew and marble pusher situated in the crotch of a common 2-finger 'eyebrow' handle; 5.0". *Courtesy of Bob Nugent.* **b.** CODD'S PATENT G. F. HIPKINS & SON A folding version; 4.2" closed, 5.2" open. *Courtesy of Dennis Bosa.*

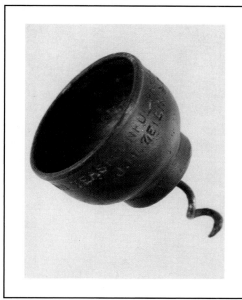

a.

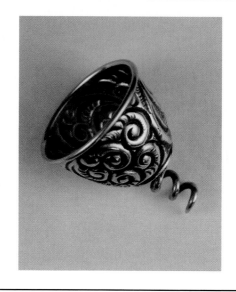

b.

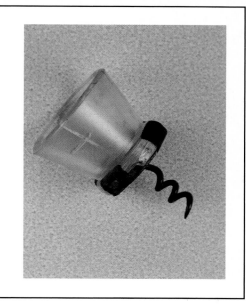

c.

254,760
J. Henry Zeilin
March 7, 1882
Variations on a dosage cup and corkscrew. The corkscrew would be kept in the cork stopper between 'medications'. **a.** ONE TEASPOONFULL PARRISHS HYPOPHOSPHITES J. H. ZEILIN & CO PHILA. PA.; 1.2". *Courtesy of Bob Leger.* **b.** STERLING; 1.5". **c.** Unmarked; 1.7". *Courtesy of Bob Nugent.*

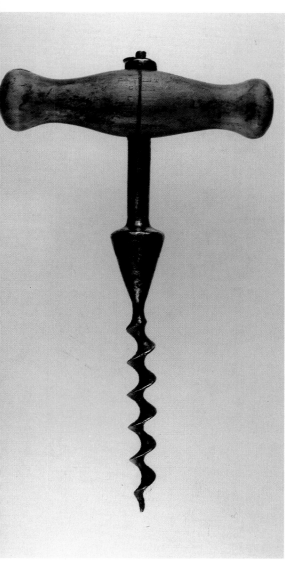

258,420
Richard Hessel
May 23, 1882
A conical cork splitter which causes the old cork to be thrown off by the rising new cork, ad infinitum. Because of obscure markings in which only the word PATENT... is discernible, it is not possible to make the Hessel connection without some reservation; 6.0".

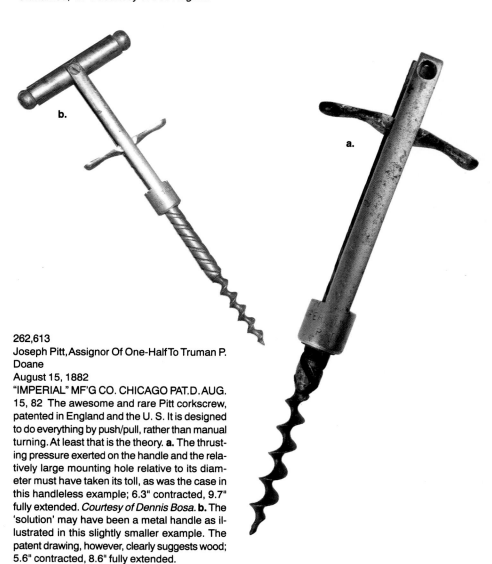

262,613
Joseph Pitt, Assignor Of One-Half To Truman P. Doane
August 15, 1882
"IMPERIAL" MF'G CO. CHICAGO PAT. D. AUG. 15, 82 The awesome and rare Pitt corkscrew, patented in England and the U. S. It is designed to do everything by push/pull, rather than manual turning. At least that is the theory. **a.** The thrusting pressure exerted on the handle and the relatively large mounting hole relative to its diameter must have taken its toll, as was the case in this handleless example; 6.3" contracted, 9.7" fully extended. *Courtesy of Dennis Bosa.* **b.** The 'solution' may have been a metal handle as illustrated in this slightly smaller example. The patent drawing, however, clearly suggests wood; 5.6" contracted, 8.6" fully extended.

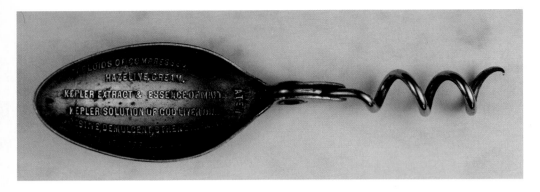

264,391
Cornelius T. Williamson
September 12, 1882
PATENT A combination medicine spoon and folding corkscrew, offered up as an example of the type, not specifically this patent. It is suspect because, (a) it does not conform to the patent, (b) there is no Williamson mark, which he had a habit of putting on everything, (c) it advertises an English product, (d) there is a British patent for it, taken out by Williamson in 1892, and (e) evidence points to Clough possibly being the inventor in the first place. Conclusion: it is probably English; 4.1" open.

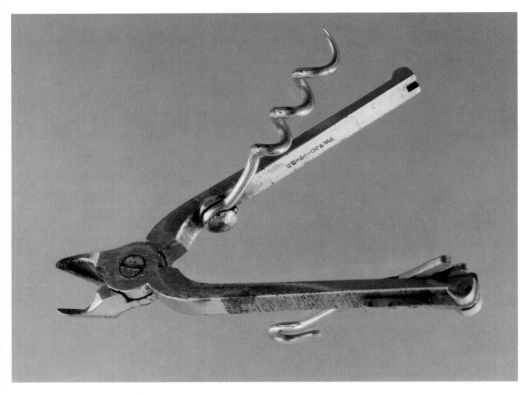

b.

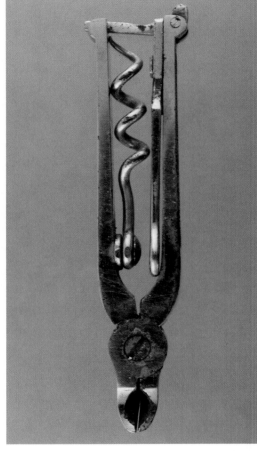

a.

266,073
Aaron M. Austin
October 17, 1882
PAT. 10-17-82 A nifty little manicure tool that folds, twists and pivots every which way except into a square knot. **a.** In the closed and 'locked' position; 3.4". **b.** Shown partially opened. *Courtesy of Bob Nugent.*

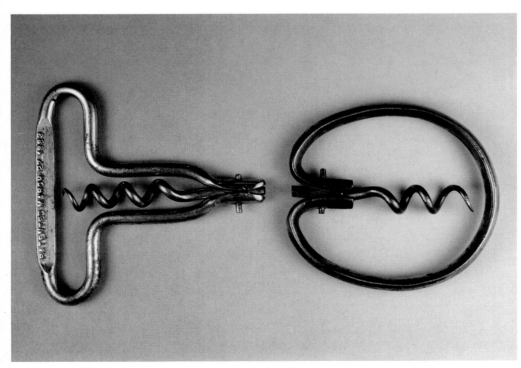

274,539
Cornelius T. Williamson
March 27, 1883
C. T. Williamson's folding bow. Above: PATENTED MARCH 27. 1883; 2.8" closed. Below: rarer version, unmarked; 2.5" closed. *Courtesy of Nicholas F. D'Errico III.*

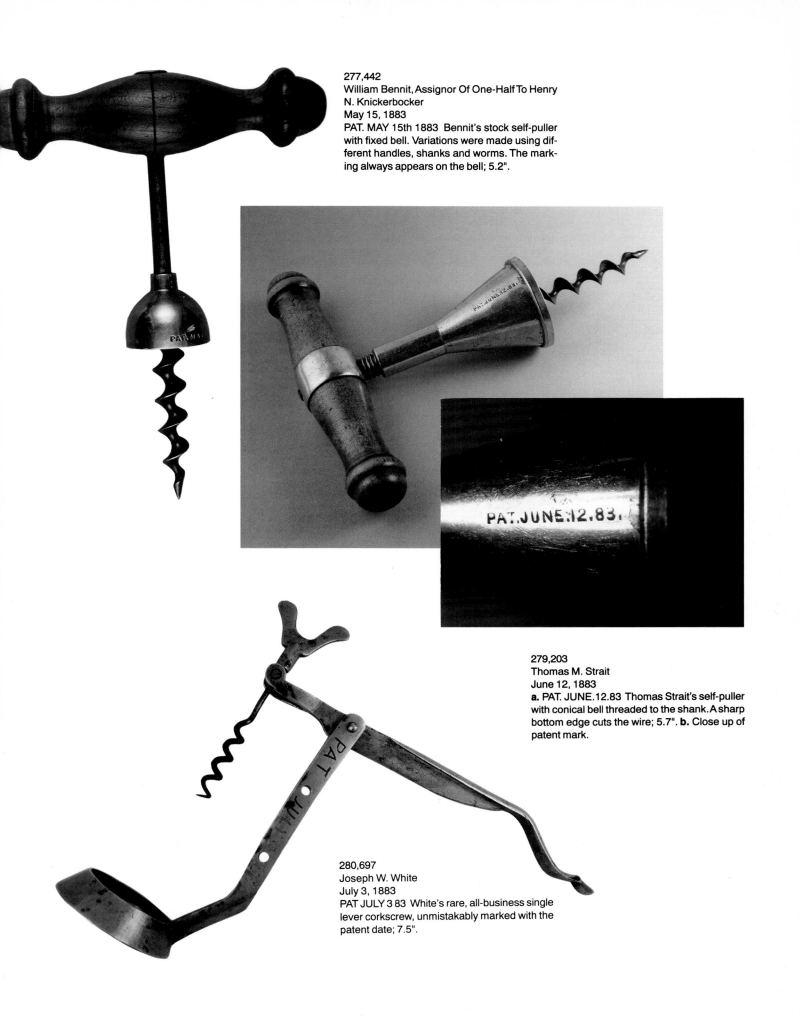

277,442
William Bennit, Assignor Of One-Half To Henry
N. Knickerbocker
May 15, 1883
PAT. MAY 15th 1883 Bennit's stock self-puller
with fixed bell. Variations were made using dif-
ferent handles, shanks and worms. The mark-
ing always appears on the bell; 5.2".

279,203
Thomas M. Strait
June 12, 1883
a. PAT. JUNE.12.83 Thomas Strait's self-puller
with conical bell threaded to the shank. A sharp
bottom edge cuts the wire; 5.7". **b.** Close up of
patent mark.

280,697
Joseph W. White
July 3, 1883
PAT JULY 3 83 White's rare, all-business single
lever corkscrew, unmistakably marked with the
patent date; 7.5".

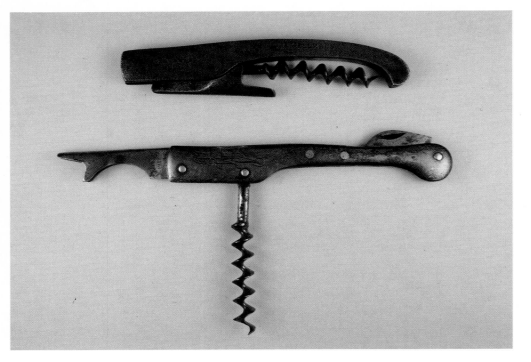

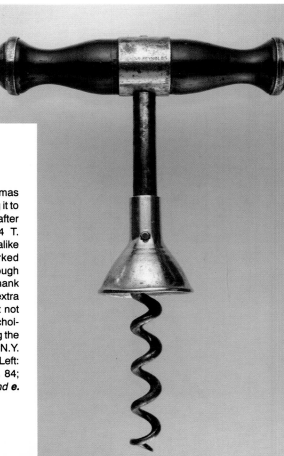

283,731
Carl Friedrich Albert Wienke, Assignor To Rudolph Dolberg
August 21, 1883
The 'waiter's friend' first patented by Carl Wienke and still going strong. Above: PATENT No 283,731 U.S.A. A. WELLMANN NEW ORLEANS; 4.3". Below: AUG 21st. 1883 PATd; 5.9".

296,661
Wilber B. Woodman
April 8, 1884
At first glance a simple wire corkscrew with loop handle and sheath. As indicated by the patent title, this loop is different, which accounts for the patent; 3.0". *Courtesy of Bob Nugent.*

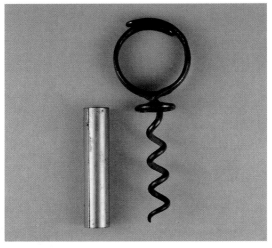

a. b.

283,900
George W. Korn
August 28, 1883
KORN'S PATENT A pocket knife with a retractable blade designed to turn the cork, which could then be easily worked out of the bottle; 6.0" open. *Courtesy of Bob Nugent.*

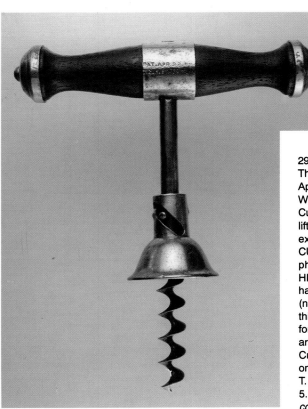

297,232
Thomas Curley
April 22, 1884
Which one is the Curley patent? **a.** Thomas Curley's self-puller with slotted bell allowing it to lift and turn away from cork for removal after extraction, marked PAT. APR. 22, 1884 T. CURLEY, TROY, N.Y.; 5.0". **b.** Curley look-alike photographed on the same scale, marked HICKS & REYNOLDS TROY, N. Y. Although having the same action, the slot is in the shank (not visible) rather than the bell, hence its extra thickness. No patent has been found, but not for lack of effort on the part of corkscrew scholars; 5.8". **c.** Close up of marking, confirming the Curley patent. **d.** THOS. CURLEY TROY, N.Y. on shank, showing a modified bell; 5.1". **e.** Left: T. CURLEY. TROY, N.Y. PAT'D MAR. 22. 84; 5.1". Right: T. CURLEY PAT'D; 5.1". **d.** and **e.** *courtesy of Bob Nugent.*

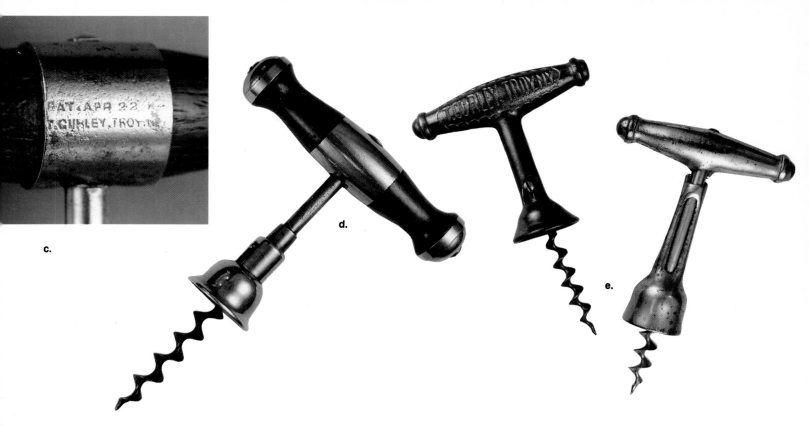

c.

d.

e.

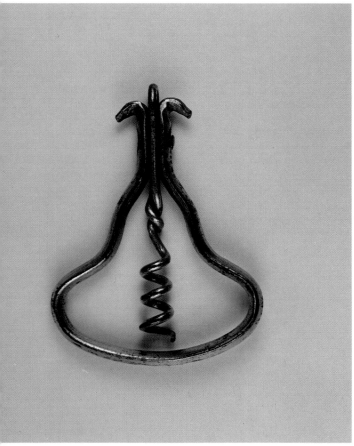

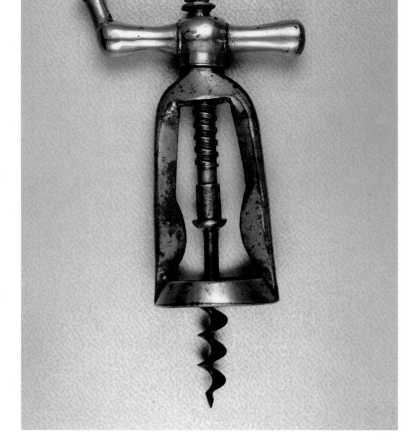

299,100
Joshua Barnes
May 27, 1884
PAT. MAY 27, 84 Barnes' folding bow with distinctive wire cutting 'ears'. The primary claim is for a flattened cutting edge extending from the point, which is difficult to discern from the photograph or patent drawings. Barnes is curiously silent about his former patent (No. 179,090), which is resurrected in Fig. 6 of the patent drawing; 4.8" open. *Courtesy of Bob Nugent.*

299,738
Charles Chinnock, Assignor To Jonathan L. Hyde
June 3, 1884
Chinnock's final patent, coming after a gap of nearly 20 years since the introduction of his successful self-puller (No. 35,362). The left-hand threaded shank causes the cork to rise by reversing the turn of the handle. Unmarked; 5.5".

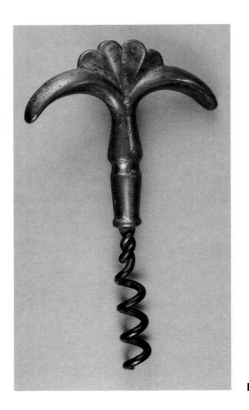

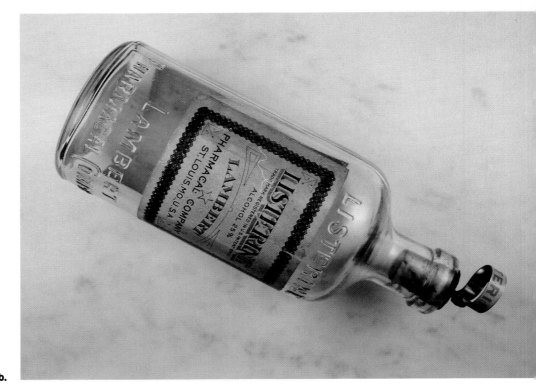

b.

299,864
Joseph A. Smith
June 3, 1884
A curious patent by J.A. Smith, curious because
it is of questionable invention, applying only to
how the shank is twisted upon itself for mount-
ing to a cast handle. Note only the "a" and "b"
patent drawing references. It would seem to be
a better candidate for a "Design" patent. Un-
marked; 3.9". *Courtesy of Bob Nugent.*

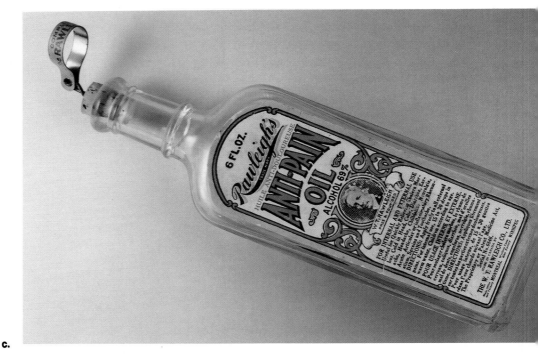

c.

a.

302,321 (see also No. 441,137)
William R. Clough
July 22, 1884
a. A cacophony of colorful bands advertising
potions of dubious medical efficacy. Clough re-
ceived an English patent for the same corkscrew
one day later, on July 23, 1884. Bands were also
marked under another patent for the *machine*
that made the corkscrew (No. 441,137). **b.** The
ubiquitous LISTERINE advertising, without
patent marking, in original bottle. *Courtesy of*
Nicholas F. D'Errico III. **c.** Also common
RAWLEIGH'S advertising, without patent mark-
ing, in original bottle. *Courtesy of Ron MacLean.*
d. Advertising WAKELEE'S CAMELLINE, no
patent marking, shown with amber and cobalt
bottles. **e.** THE CLOUGH CORKSCREW PAT'D
JULY 22-84 MADE IN U.S.A. J. M.
MACONNELL NEW YORK, advertising
SCOTT'S EMULSION, all on one tiny band,
shown with an original bottle, 1894 calendar and
trade cards. **f.** CLOUGH'S CORKSCREW PAT.
JULY 22, 84, advertising CARTER'S INK, in
original bottle. *Courtesy of Ron MacLean.* **g.**
CLOUGH'S CORKSCREW MADE IN U. S. A.
PAT. NOV. 25-90 (referring to the machine
patent), advertising ST. JACOB'S OIL, with trade
card.

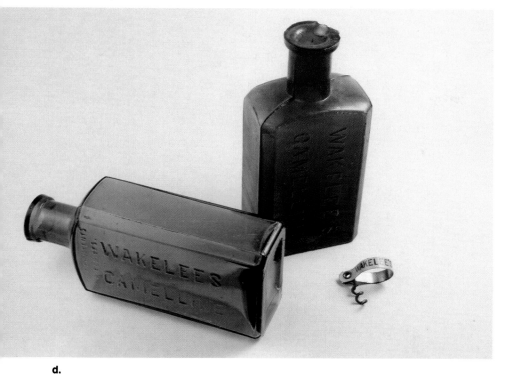

d.

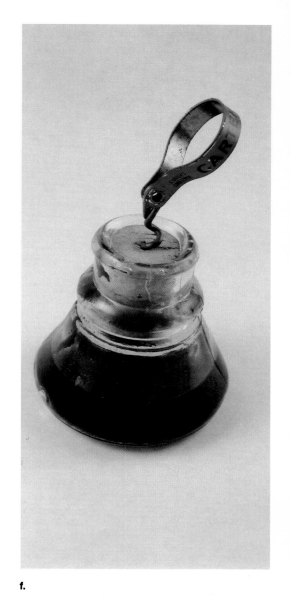

f.

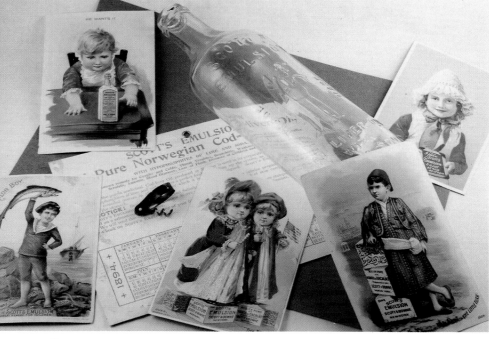

e.

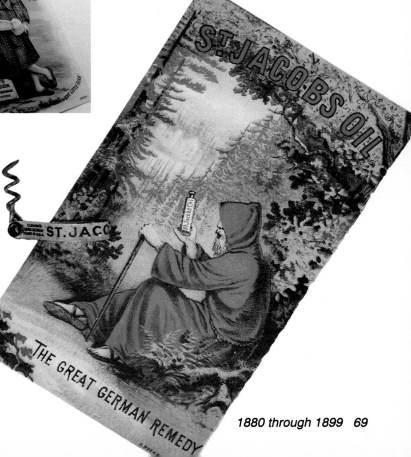

g.

303,400
William Redlich, Assignor Of One Half To He[...]
Redlich
August 12, 1884
William Redlich's one-and-only patent for a [...]
corkscrew. The early technology required th[...]
hands, meaning for the human species two fu[...]
tions had to be performed consecutively rat[...]
than simultaneously. One hand is taken up h[...]
ing the bottle, while the other hand first cra[...]
the turn handle to penetrate the cork, then tra[...]
fers over to the lever to pull it out. That acco[...]
plished, the bottle is put down, freeing up t[...]
hand to hold the cork while the lever hand g[...]
back to the crank for reversing out the wo[...]
Courtesy of Jack D. Bandy.

315,773 and 317,123
Edward P. Haff
April 14, 1885 and May 5, 1885
Technically not corkscrew patents but han[...]
mount patents by Haff, manufactured in a di[...]
sity of styles and sizes. Although sometin[...]
glued, the separate sections were more co[...]
monly fastened by two small pins located eit[...]
side of a wide nickel plated brass band. [...]
marking is on the band. **a.** Left: PATENTED A[...]
14th '85 MAY 5th '85; 4.5". Center: HAFF. M'F[...]
Co. NEW YORK PATd APL. 14, 85. MAY [...]
85; 3.9". Right: HAFF. M'F'G. Co. NEW YO[...]
PATd APL. 14, 85. MAY 5th 85; 4.3". **b.** Cen[...]
PATd APL. 14, 85; 5.0". Left and right: unmark[...]
Note twisted wire shanks; 5.0". *Courtesy of [...]
Nugent.* **c.** HAFF MF'G Co NEW YORK PA[...]
APL. 14. 85. MAY 5th 85. **d.** Unmarked, nic[...]
plated brass sheath covering a solid wood co[...]
4.7". **e.** HAFF. M'F'G. Co. NEW YORK PA[...]
APL. 14, 85. MAY 5th 85 Rare shaft spring a[...]
frame variation; 4.9". *Courtesy of Jeff[...]
Mattson.* **f.** PATENTED APL. 14th '85 MAY [...]
'85; 5.1".

302,331
Charles L. Griswold, Assignor Of One-Half To
James B. Clarke And William N. Clarke
July 22, 1884
Griswold's self-puller with extended free-mov-
ing bell and nicely turned handle. **a.** PAT JULY
22, 1884; 5.0". **b.** Another example showing
close up of patent marking. Griswold marked
the wood handle rather than the bell.

a.

b.

c.

d.

e.

f.

322,991
Frank L. Stowell
July 28 1885
a. An eraser and point sharpener marked PAT JULY 28. 85. The patent makes no mention of a corkscrew; 4.7". **b.** What is that peeking out the end? Could it be something with which to open a bottle of ink?

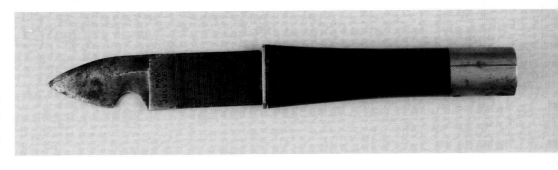

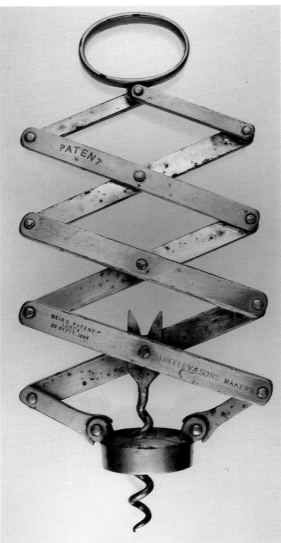

a.

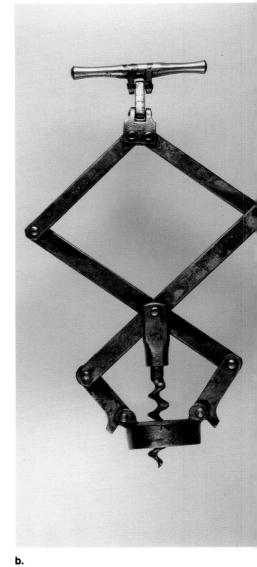

b.

c.

330,357
Marshall Arthur Wier
November 10, 1885
Variants of Wier's concertina, made in England (a.) and most likely France (b. and c.). **a.** PATENT WIER'S PATENT 12804 25 SEPT 1884 T. HEELEY & SONS MAKERS The date refers to the English patent; 13.0" open. **b.** PAT. NOV. 10. 1885 "THE RELIABLE;" 8.3" open. *Courtesy of Ron MacLean.* c. PAT. NOV. 10. 1885 PEERLESS; 10.5" open. *Courtesy of Nicholas F. D'Errico III.*

333,697
Edward A. Thiéry And Charles F. Croselmire
January 5, 1886
A patented silver process for ornamenting jewelry, heads for canes, umbrellas and, although not mentioned specifically, corkscrews. Silver is electroplated to the object, then artistically cut away. **a.** SOLID SILVER PAT. JAN. 5-86; 5.0". *Courtesy of Bob Nugent.* **b.** SOLID SILVER PAT. JAN. 5-86 on the handle of walking cane; 36.2". **c.** Corkscrew handle removed; 3.9". **d.** Detail showing exquisite carving of a cork-pulling 'gnome'. **e.** Detail of reverse side, showing patent marking. **f.** The patent drawing.

c.

a.

b.

(No Model.)
E. A. THIÉRY & C. F. CROSELMIRE.
ARTICLE OF JEWELRY AND METHOD OF ORNAMENTING THE SAME.
No. 333,697. Patented Jan. 5, 1886.

Fig 1. *Fig 2.*

Fig 3. *Fig 4.*

Fig 5.

Witnesses:

Inventor:

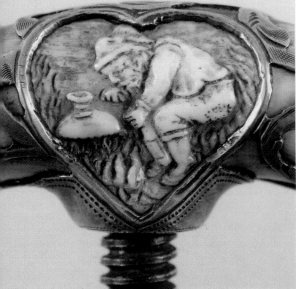

d.

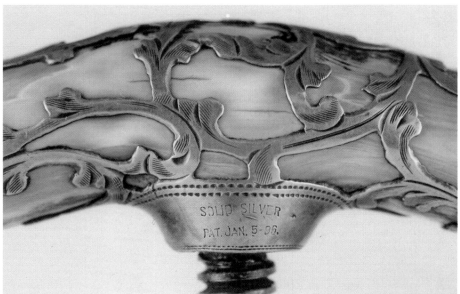

e.

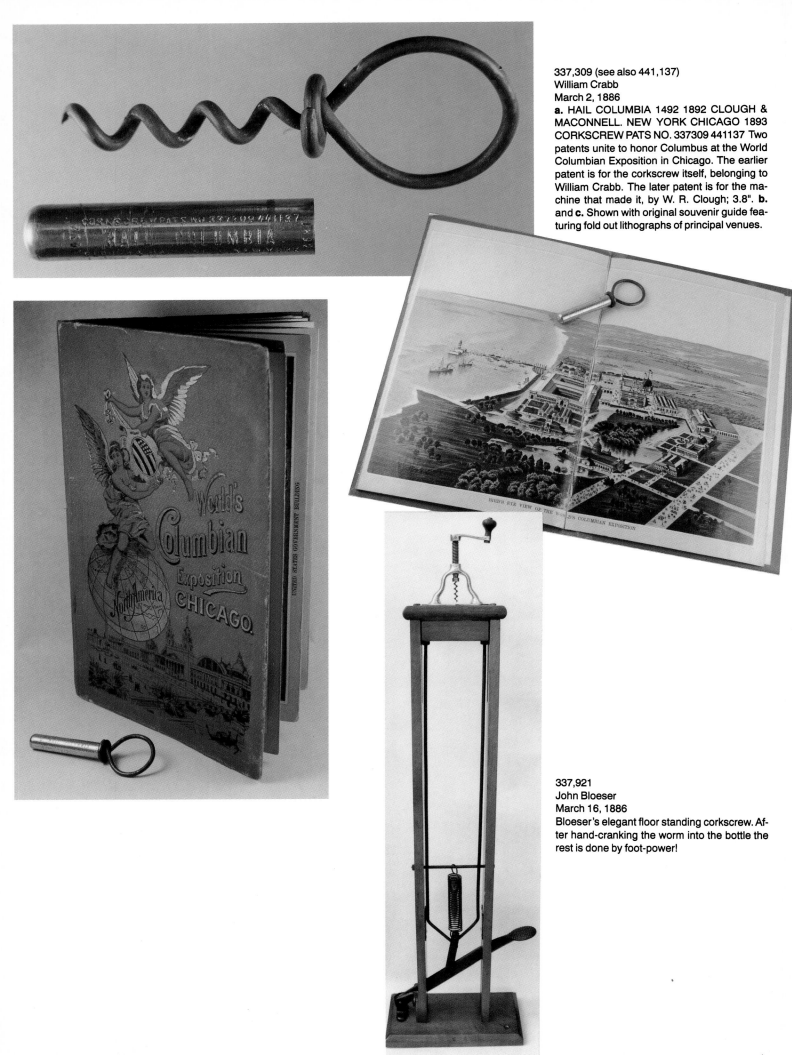

337,309 (see also 441,137)
William Crabb
March 2, 1886
a. HAIL COLUMBIA 1492 1892 CLOUGH & MACONNELL. NEW YORK CHICAGO 1893 CORKSCREW PATS NO. 337309 441137 Two patents unite to honor Columbus at the World Columbian Exposition in Chicago. The earlier patent is for the corkscrew itself, belonging to William Crabb. The later patent is for the machine that made it, by W. R. Clough; 3.8". **b.** and **c.** Shown with original souvenir guide featuring fold out lithographs of principal venues.

337,921
John Bloeser
March 16, 1886
Bloeser's elegant floor standing corkscrew. After hand-cranking the worm into the bottle the rest is done by foot-power!

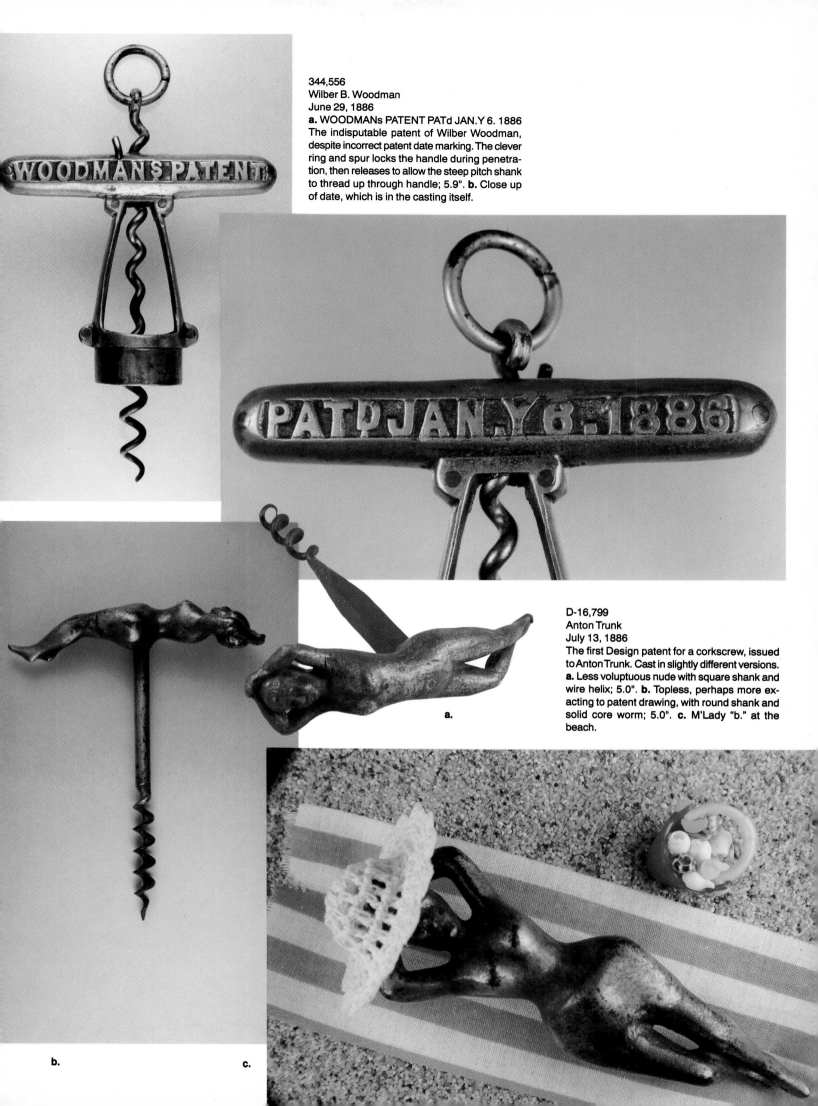

344,556
Wilber B. Woodman
June 29, 1886
a. WOODMANs PATENT PATd JAN.Y 6. 1886
The indisputable patent of Wilber Woodman, despite incorrect patent date marking. The clever ring and spur locks the handle during penetration, then releases to allow the steep pitch shank to thread up through handle; 5.9". **b.** Close up of date, which is in the casting itself.

D-16,799
Anton Trunk
July 13, 1886
The first Design patent for a corkscrew, issued to Anton Trunk. Cast in slightly different versions. **a.** Less voluptuous nude with square shank and wire helix; 5.0". **b.** Topless, perhaps more exacting to patent drawing, with round shank and solid core worm; 5.0". **c.** M'Lady "b." at the beach.

a.

b.　　　　**c.**

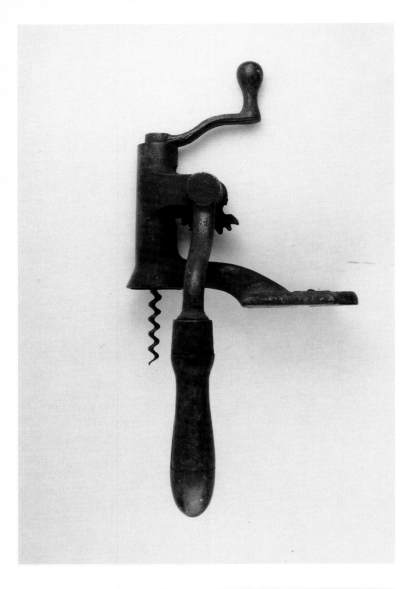

350,308
John A. Hurley, Assignor To The F. F. Adams Co.
October 5, 1886
THE F. F. ADAMS Co ERIE PA. U.S.A. PATd OCT. 5, 86 The third of four patents issued to John Hurley in a flurry of activity over a two year period. Earlier bar corkscrew technology, which this represents, had separate screw and lift handles requiring the operating hand to transfer from one to the other, thus taking two operations for extracting the cork from the bottle and two for extracting the cork from the worm. Note the patent drawing indicates left-hand drive. The machine itself is definitely for 'righties'. *Courtesy of Jeffrey Mattson.*

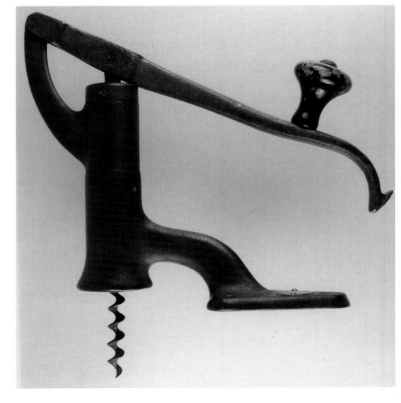

356,936
Le Roy B. Haff
February 1, 1887
STERLING A nicely appointed and rare roundlet, probably the Haff patent. The corkscrew slides into position on a slotted carrier inside the case. The free outer cap slips on to form a 'T'-handle; 3.0" closed.

372,266
Daniel J. Hurley
October 25, 1887
Hurley's final of four patents issued for a bar corkscrew in a two-year period. The single lever handle is first rotated, then lifted without having to remove the hand. Following extraction, the cork is gripped instead of the bottle and the handle operation reversed. **a.** T. J. HURLEY. ERIE, PA **b.** LOVELL MFG. CO LTD. ERIE, PA. PAT'D OCT. 25, '87 The same only adding a wire breaker notch to the handle. *Courtesy of Wayne Meadows.*

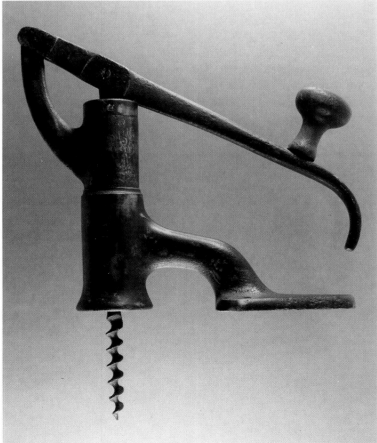

a.

b.

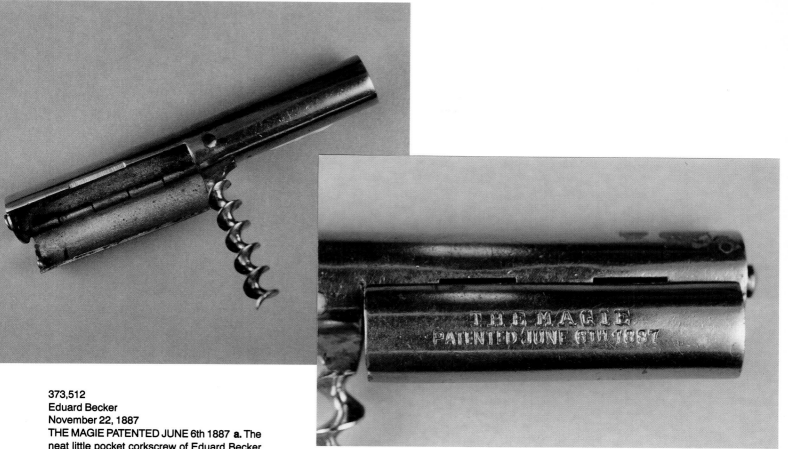

373,512
Eduard Becker
November 22, 1887
THE MAGIE PATENTED JUNE 6th 1887 **a.** The neat little pocket corkscrew of Eduard Becker with pivoting worm and hinged 'door'; 3.7" closed. **b.** Close up of patent marking.

377,790
Edwin Walker, Assignor To The E. Walker Tool Company
February 14, 1888
Edwin Walker's first patent for a bar corkscrew, which is little more than a large scale version of a hand-held single lever corkscrew.

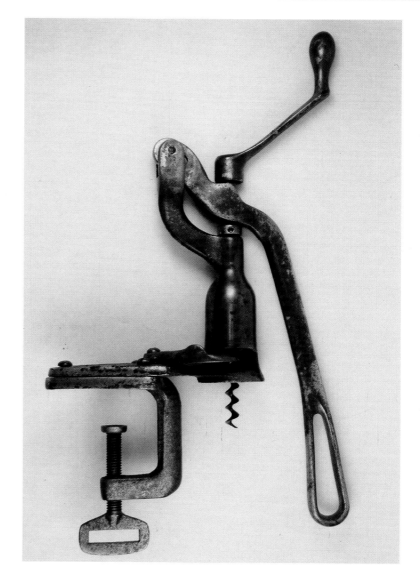

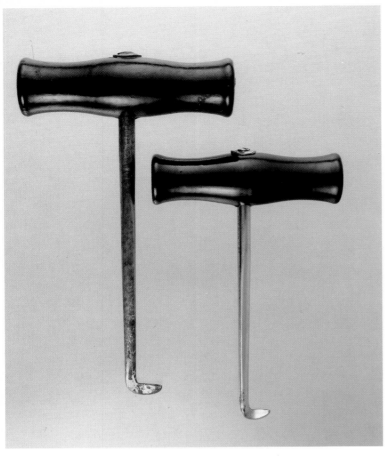

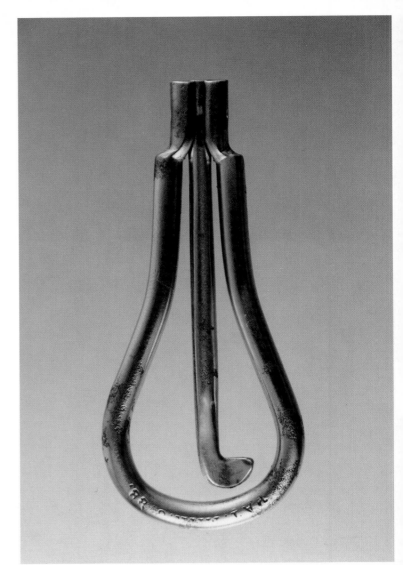

379,010
Benjamin J. Greely
March 6, 1888
PAT MAR 6 88 Greely's extractor picking up on an old idea but adding a groove assist to allow air back in to prevent having to fight a vacuum. The patent drawing could be mistaken for a button hook. **a.** Wood handle version in two sizes; left: 4.5", right: 3.7". *Courtesy of Ron MacLean.* **b.** Close up of marking and 'Greely's groove'. **c.** Rare folding handle version; 2.5".

388,125
Leroy W. Fairchild
August 21, 1888
The roundlet of Leroy Fairchild may be as close as a U. S. (utility) patent gets to corkscrew aesthetics. Digging deep into vocabulary, the specifications came up with the word "neat." The corkscrew in its many manifestations is of gem-like quality, truly unique in U. S. patent chronicles. **a.** PAT. AUG 21, 88 STERLING F; 2.0" open. *Courtesy of Bob Nugent.* **b.** Left: PAT. AUG. 21, 88 STERLING F. Right: PAT. APD. FOR STERLING F; both 2.3" closed. *Courtesy of Howard Luterman.* **c.** 14K-F What is this picture doing in a book on corkscrews? **d.** Because there is a corkscrew inside; 2.4" closed, 2.0" open. *Courtesy of Ron MacLean.*

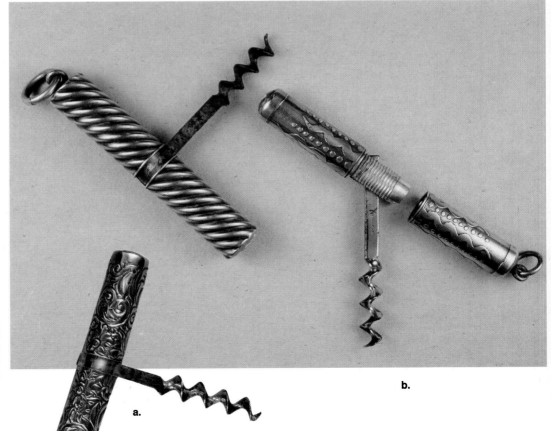

a.

b.

d.

c.

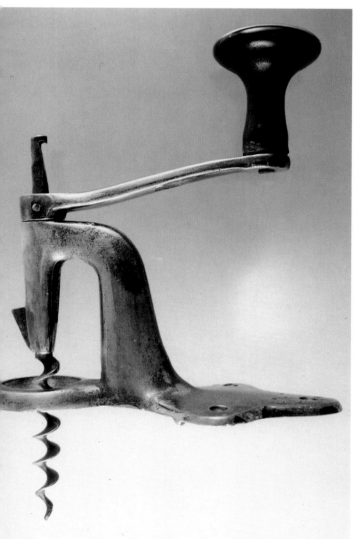

390,183
Charles Morgan And Edgar H. Morgan
September 25, 1888
PAT' APLD FOR The Morgan brothers' entry in a quartet of similar crank-handle bar corkscrew patents issued September, 1888, all originating in Freeport, Illinois (see Nos. 388,844, 388,888 and 390,159). The entire operation works on the 'self-puller' principle. The rotation of the corkscrew first penetrates the cork, then lifts it out of the bottle as the rim presses against the collar. The cork meets its fate on the fixed wedge splitter. Note L. M. Devore (No. 390,159) signed as a witness. Both Morgan and Devore filed applications on the same day —April 3, 1886.

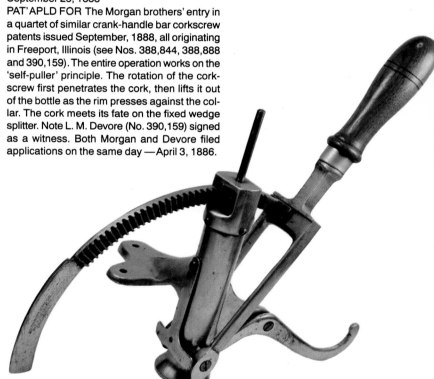

392,116 (see also 384,839, 478,545)
Raymond B. Gilchrist
October 30, 1888
Gilchrist's early concept for a bar mount, developed in a series of three patents, each improving on the prior. This rare unmarked example is closest to the middle patent, although features of all three patents are present. Pulling the handle down turns and inserts the worm. As the crescent shaped bar passes beyond the toothed area the worm stops turning, while the second lever is simultaneously engaged lifting the cork out of the bottle. The cork is ejected and the mechanics re-primed by returning the lever arm to the up position.

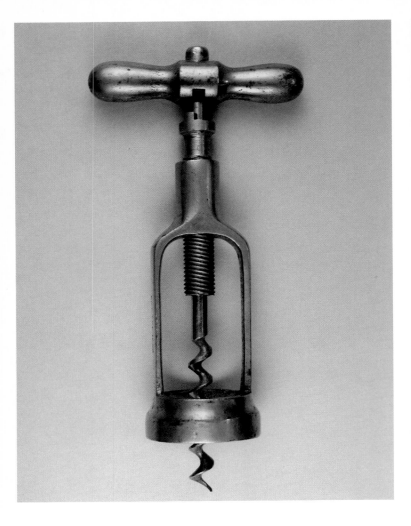

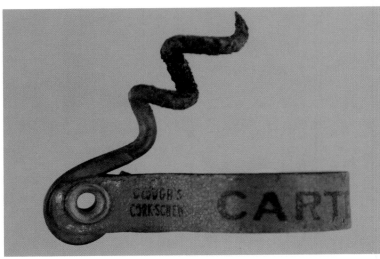

401,672
Seymour Landon Alvord And Edward E. Brown,
Said Brown Assignor To Said Alvord
April 16, 1889
PAT. APL. 16, 89 A continuous-turning extractor by Alvord and Brown. The corkscrew rides freely inside a hollow shaft threaded to the frame. At full penetration the clutch is engaged causing the left-hand threaded shaft to rise relative to the frame; 5.5". *Courtesy of Bob Nugent.*

405,385
William Alex. Williamson
June 18, 1889
a. CARTER'S INKS. WILLIAMSON CO. NEWARK, N. J. At first glance, an example of Clough's 1884 patent (see No. 302,321), used in advertising the same product. The difference is a patentable internal "post" created in the original stamping, but is concealed when joined in the final assembly. The Williamson mark tells the tale. It is a rarity, which should send collectors scurrying for a closer look at their own cache; 1.5" closed. *Courtesy of Jack D. Bandy.*
b. CARTER'S INKS CLOUGH'S CORKSCREW PAT. JULY 22, 84 Chances are, this is what they will find; 1.4" closed.

434,818
Elgin Edgar Wood, Assignor Of One-Half To Benjamin Westwood
August 19, 1890
PAT 90 EW providing four no-nonsense ways of cutting cans, with a corkscrew thrown in for good measure; 7.8". *Courtesy of Bob Nugent.*

441,137 (see 302,321 and 337,309)
William R. Clough
November 25, 1890
Fig. 13. on drawing Sheet 6 provides the only visual evidence that, indeed, a corkscrew comes out the other end of this machine. Curiously, the Witnesses are different from those named on the other pages. This patent is often found marked interchangeably with No. 302,321.

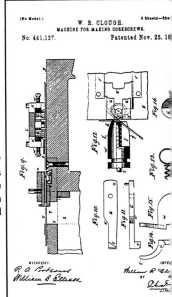

441,604
Bernard Tormey
November 25, 1890
PAT. NOV. 25, 1890 Tormey's push-it-in handle then pull-it-out barbed shank; 10.8". *Courtesy of Bob Nugent.*

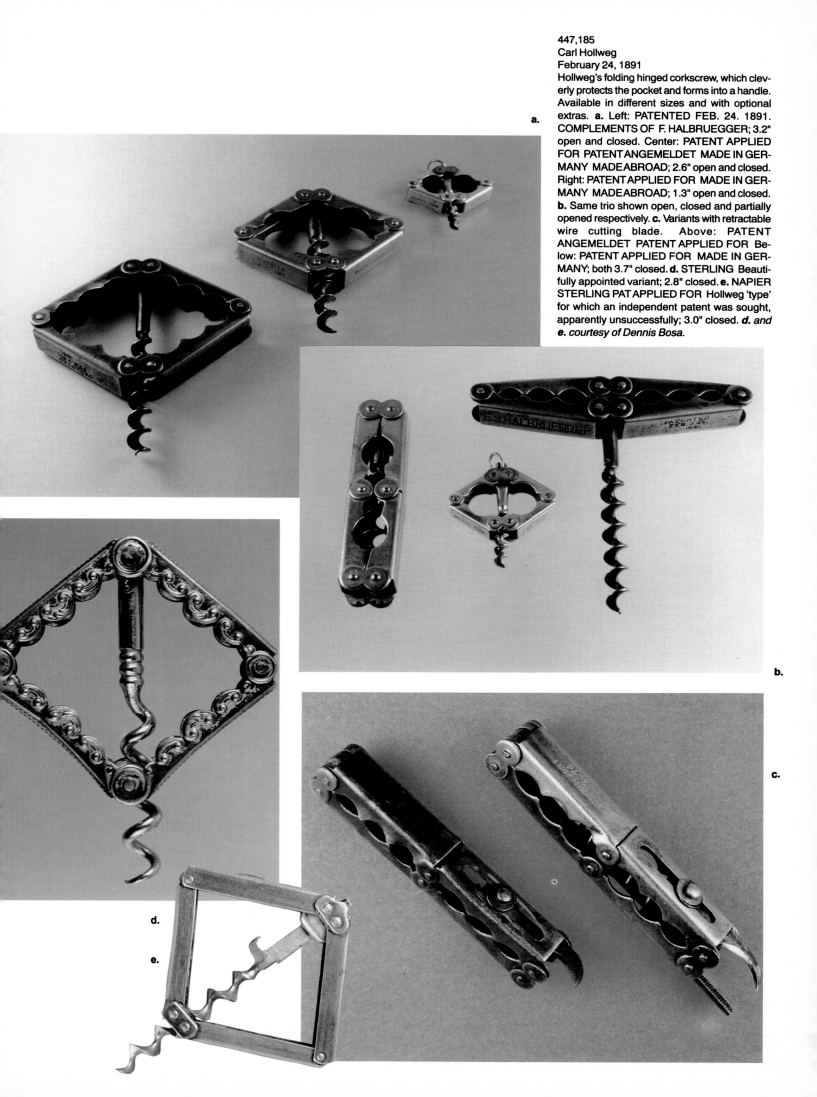

447,185
Carl Hollweg
February 24, 1891
Hollweg's folding hinged corkscrew, which cleverly protects the pocket and forms into a handle. Available in different sizes and with optional extras. **a.** Left: PATENTED FEB. 24. 1891. COMPLEMENTS OF F. HALBRUEGGER; 3.2" open and closed. Center: PATENT APPLIED FOR PATENT ANGEMELDET MADE IN GERMANY MADE ABROAD; 2.6" open and closed. Right: PATENT APPLIED FOR MADE IN GERMANY MADE ABROAD; 1.3" open and closed. **b.** Same trio shown open, closed and partially opened respectively. **c.** Variants with retractable wire cutting blade. Above: PATENT ANGEMELDET PATENT APPLIED FOR Below: PATENT APPLIED FOR MADE IN GERMANY; both 3.7" closed. **d.** STERLING Beautifully appointed variant; 2.8" closed. **e.** NAPIER STERLING PAT APPLIED FOR Hollweg 'type' for which an independent patent was sought, apparently unsuccessfully; 3.0" closed. *d. and e. courtesy of Dennis Bosa.*

a.

b.

c.

d.

e.

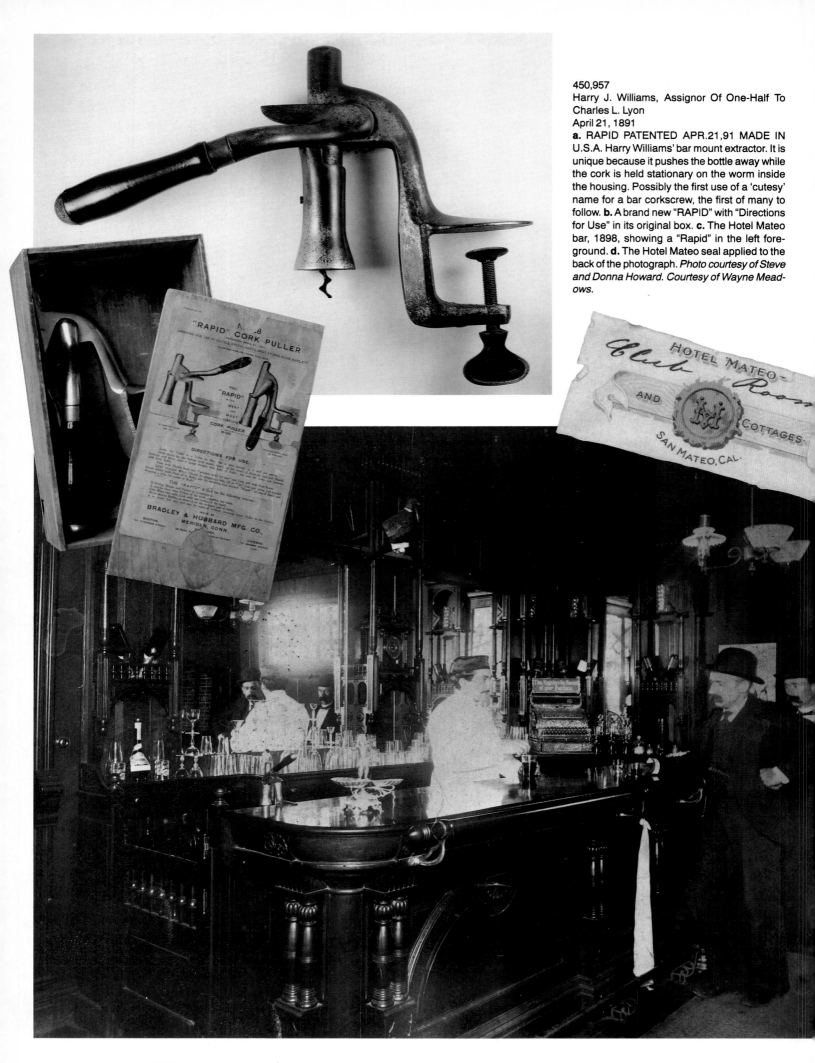

450,957
Harry J. Williams, Assignor Of One-Half To
Charles L. Lyon
April 21, 1891
a. RAPID PATENTED APR.21,91 MADE IN
U.S.A. Harry Williams' bar mount extractor. It is
unique because it pushes the bottle away while
the cork is held stationary on the worm inside
the housing. Possibly the first use of a 'cutesy'
name for a bar corkscrew, the first of many to
follow. **b.** A brand new "RAPID" with "Directions
for Use" in its original box. **c.** The Hotel Mateo
bar, 1898, showing a "Rapid" in the left fore-
ground. **d.** The Hotel Mateo seal applied to the
back of the photograph. *Photo courtesy of Steve
and Donna Howard. Courtesy of Wayne Mead-
ows.*

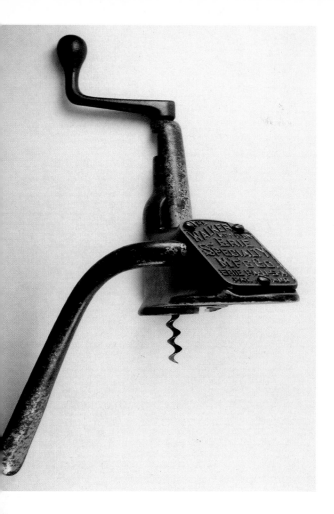

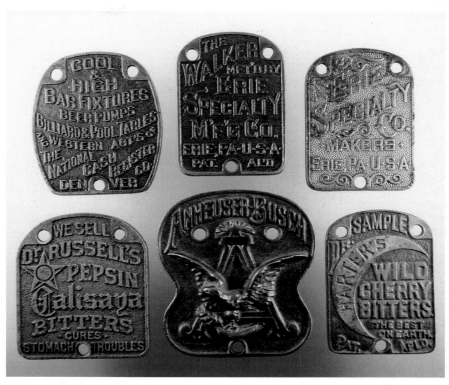

452,625
Edwin Walker
May 19, 1891

a. THE WALKER MFT'D BY ERIE SPECIALTY M'F'G CO. ERIE, PA. U. S. A. PAT. AL'D Walker's second bar corkscrew patent, sometimes known as the 'beaver tail' corkscrew for the shape of the lever arm. With the lever arm in the up position, one hand holds the bottle while the other turns the crank handle driving the corkscrew into the cork. The same hand is then transferred to the lever, now in the down position as shown in the photograph, and lifted, causing the cork to be extracted. Walker was concerned with infringing upon Hurley's September 7, 1886 patents (Nos. 348,743 and 348,911). Accordingly, he connected the lever arm directly to the top of the corkscrew stem outside the housing rather than to a long sleeve holding the corkscrew, which was Hurley's method. Of such fine distinctions are patents made. **b.** Not by accident, the base in the Walker patent was angled toward the bar patron, making possible the attachment of customized name plates. Appearing to be the first of the genre, others were quick to follow.

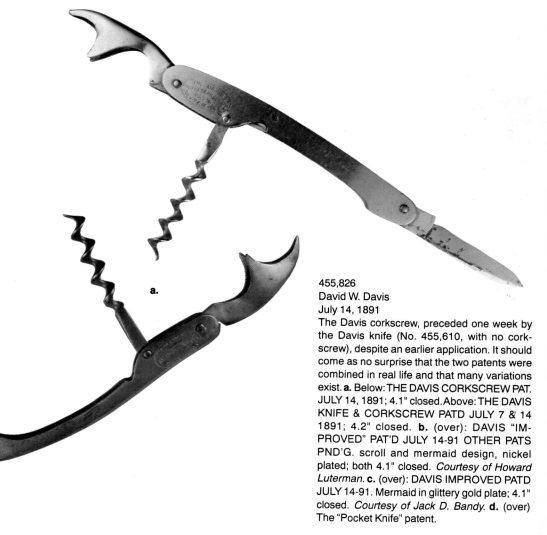

a.

455,826
David W. Davis
July 14, 1891

The Davis corkscrew, preceded one week by the Davis knife (No. 455,610, with no corkscrew), despite an earlier application. It should come as no surprise that the two patents were combined in real life and that many variations exist. **a.** Below: THE DAVIS CORKSCREW PAT. JULY 14, 1891; 4.1" closed. Above: THE DAVIS KNIFE & CORKSCREW PATD JULY 7 & 14 1891; 4.2" closed. **b.** (over): DAVIS "IMPROVED" PAT'D JULY 14-91 OTHER PATS PND'G. scroll and mermaid design, nickel plated; both 4.1" closed. *Courtesy of Howard Luterman.* **c.** (over): DAVIS IMPROVED PATD JULY 14-91. Mermaid in glittery gold plate; 4.1" closed. *Courtesy of Jack D. Bandy.* **d.** (over) The "Pocket Knife" patent.

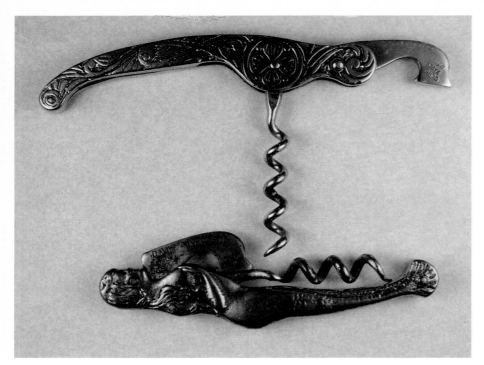

b.

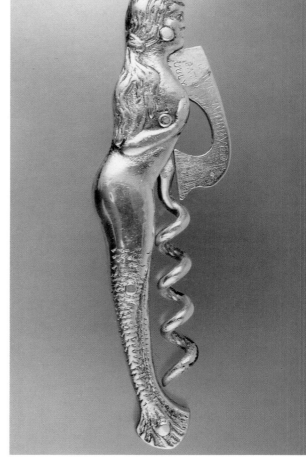

c.

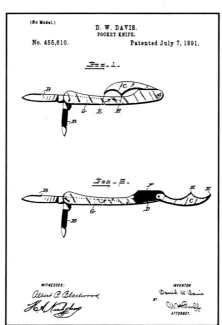

(No Model.)

D. W. DAVIS.
POCKET KNIFE.

No. 455,610. Patented July 7, 1891.

WITNESSES:
Albert B. Blackwood
H. A. _____

INVENTOR
David W. Davis
BY

ATTORNEY.

d.

474,480 (see also 212,863, 655,725)
Lucian C. Mumford
May 10, 1892
Left: MAGIC CORK EXTRACTOR PAT. MCH.
79. MAY 10.92 MADE IN U. S. A. Right: MAGIC
CORK EXTRACTOR PAT. MARCH 4-79 MAY
10-92 Self-proclaimed as the "Mumford type of
cork extractor" (from the preamble of patent No.
655,725), neither can be confirmed to contain
the inner mechanism cited in the patents, mark-
ing notwithstanding. The selection of this patent
for illustration is therefore arbitrary. Mumford was
mindful of the need for adjustable prongs to
clamp on to the cork, which in these examples
are spring loaded. No example of the earliest
patent is known to exist; both 5.2". *Courtesy of
Jack D. Bandy.*

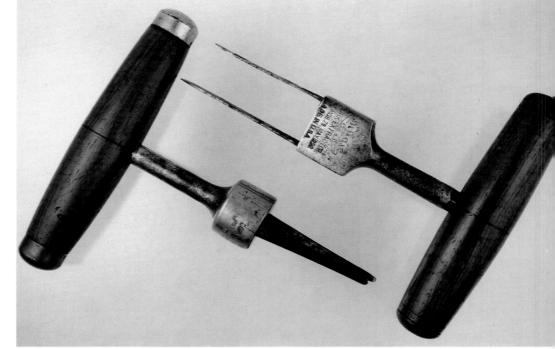

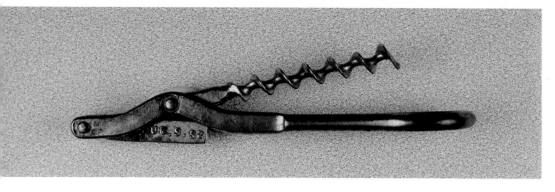

501,468 (see also D-21,761)
Charles Puddefoot, Assignor To The Detroit Cork Screw Company
July 11, 1893
THE PUDDEFOOT PAT'D AUG. 9. 92
Puddefoot's folding corkscrew with dual patents. Puddefoot applied for the utility patent 2 days after applying for the Design patent, which is the marked patent. It was also patented in England July 27, 1892; 4.0".

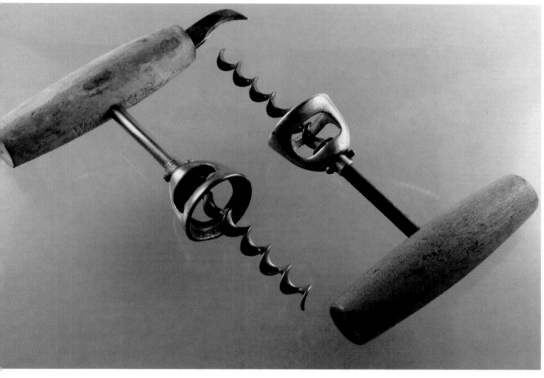

501,975
Edwin Walker
July 25, 1893
Walker's first in a series of three bell patents. Note characteristic Walker "edged" bell and lengthwise handle mounting pin. **a.** Left: WALKER stamped into the underside of handle armed with wire cutter blade; 5.8". Right: unmarked; 5.7". **b.** Unmarked tusk handle with carving of wart hog in bas relief and ornate end cap; 5.8". *Courtesy of Don Bull.* **c.** Unmarked barrel-shaped bone handle; 5.9". *Courtesy of Jeffrey Mattson.*

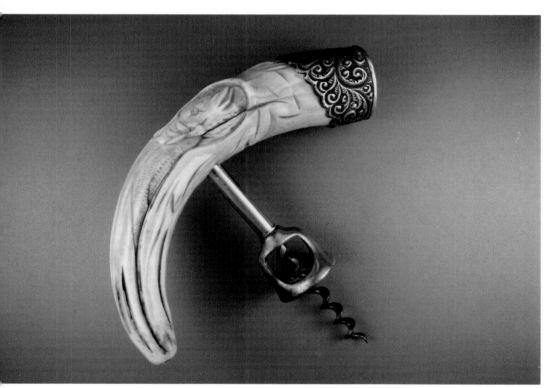

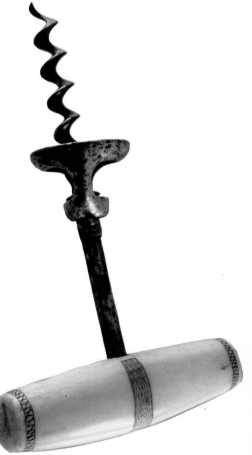

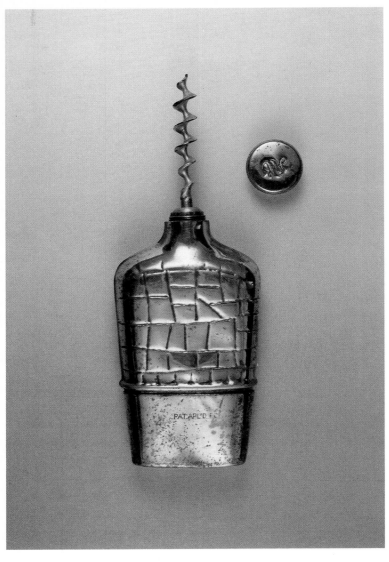

502,351
Proctor Dean, Assignor Of One-Half To George
H. Orr
August 1, 1893
PAT. APL'D FOR Dean's pocket match and cork-
screw holder, disguised as a flask. In later Pro-
hibition times it was the flask that became dis-
guised. There is also a compartment for stamps;
4.7" as pictured.

509,819
Charles Meerroth
November 28, 1893
MEERROTH A rare pocket screw that slides
out one end until reaching the mid-point, then
pivots into action and is locked by a sleeve. A
neat little hinged end plug keeps things con-
tained when not in use; 4.0" closed.

514,200
William Painter, Assignor To The Crown Cork
And Seal Company
February 6, 1894
PAT'D FEB 6 94 As inventor of the crown cap,
Painter had a self-interest in bottle openers. No
mention is made of a corkscrew in the patent,
but it was a natural marriage lasting well into
the 20th century, making it a common tool.
Rarely are they found marked with the original
patent though; 4.4" closed. *Courtesy of Ron
MacLean.*

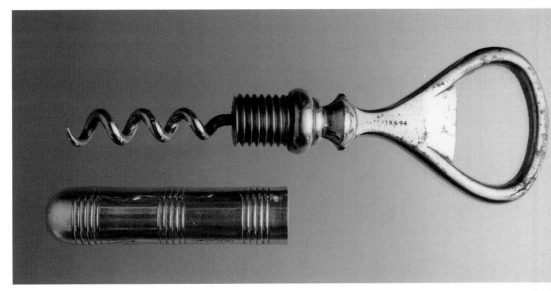

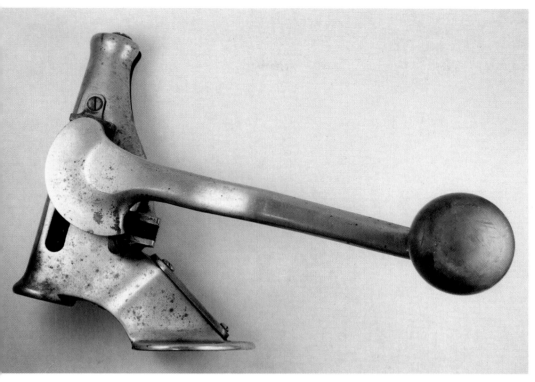

515,412 (see also 543,224, 557,734)
Edwin Walker
February 27, 1894
QUICK & EASY PAT. FEB. 27 '94 FRED
MESSMER MFG. CO. SALOON SUPPLIES
ST. LOUIS, MO. The first of three similar pat-
ents, forming the next generation of bar cork-
screws by Edwin Walker. Each patent improves
on the former by specific reference. The opera-
tion takes one pull towards the operator and re-
turn. Also marketed as the "Unique."

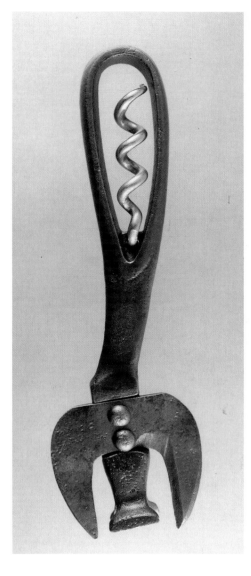

517,268
George L. Donovan, Assignor Of One-Half To
Darkes Fagan
March 27, 1894
Donovan's unmarked "Can-Opener." The two
blades align opposite to a 'V' and 'U'-grooved
fulcrum, for use on either round or square cor-
nered cans. Contrary to first impression, the
blades are not intended to prolong the working
life of the tool through redundancy or to give
equal opportunity to left-handed operators; 5.2".

518,018
Eduard Becker
April 10, 1894
Left: COLUMBUS FRUHER D.R.P. 70879; 6.0".
Right: COLUMBUS D R PATENT 70879; 3.9".
Shaft springs are distinctively German. The ring
holds the split barrel together by gravity during
insertion. After extraction, the sides can be
opened, providing finger access to the cork for
removal from the worm.

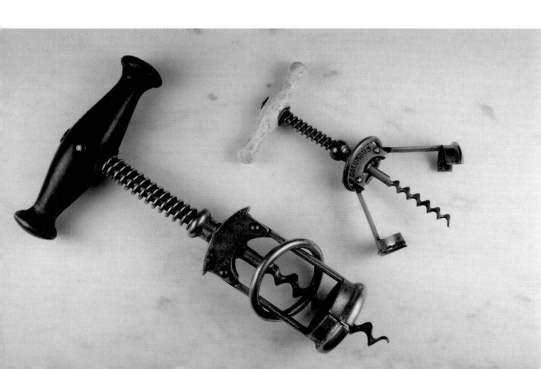

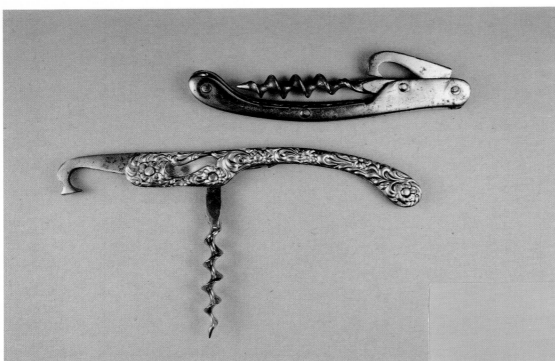

a.

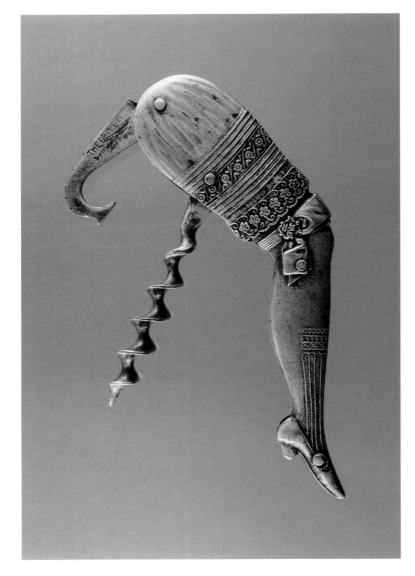

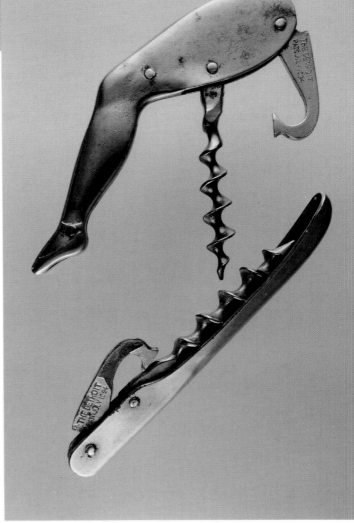

c.

b.

522,672
Charles Puddefoot
July 10, 1894
Puddefoot's version of a 'waiter's friend', all marked THE DETROIT PAT'D JULY 10 '94. Note similarity to Davis patents (Nos. 455,610 and 455,826). Both men were in business together. **a.** Conventional shape, plain and fancy; both 4.0" closed. *Courtesy of Bob Nugent.* **b.** Above: in the shape of a lady's leg. Below: with 'boat' handle; both 4.1" closed. **c.** 'Steppin' Out' version of b. (above); 4.3" closed.

531,670
Harry J. Williams
January 1, 1895

a. INFANTA-N28-PAT JAN 1st 95 Harry Williams' smaller scale crank handle bar corkscrew with right and left handed threads, "...just as in the old well-known arrangement of screws in devices of this kind which were adapted to be held in the hand." Williams was referring to the classic English 'Thomason' type corkscrew with its hermaphrodite shanks. The cork is extracted from the bottle by turning the handle one way, then removed from the worm by reversing direction. **b.** The 'Thomason' corkscrew, patented 1802. The brass barrel is decorated with 'Autumnal Fruits' in bas-relief; 8.0" closed.

a.

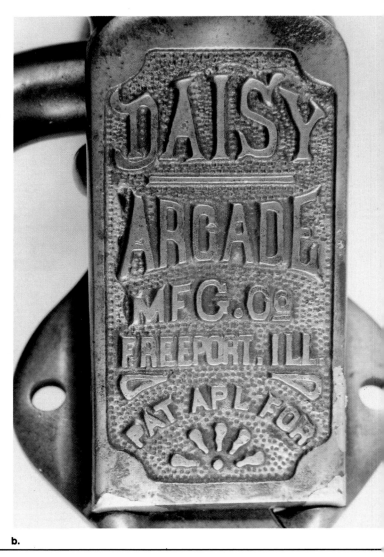

b.

532,575
Charles Morgan
January 15, 1895

a. DAISY ARCADE MFG. Co FREEPORT, ILL. PAT APL FOR Charles Morgan's "Daisy," pictured in the start/finish position. It is one of few bar corkscrew patents in which the bottle grip has a working role, besides just holding the bottle. The operation takes two round-trip tugs of the lever arm to complete. The first towards-and-away cycle is performed while the bottle grip is engaged, allowing the corkscrew turning nut to move freely inside the mechanism. At this point the cork will have been separated from the bottle but not the corkscrew. When the bottle grip lever is released, it springs back, freeing the bottle and forming a stop to the movement of the nut. The second pass of the lever arm then ejects the cork. A later patent (No. 549,607) made minor modifications to the mechanism and added a wall-mount bracket. **b.** Close up of the standard plate. **c.** Various advertising plates. **d.** Drawing from an early catalogue. **e.** THE DAISY MANFD. FOR J. CHACKSTAFF BAR AND BOTTLERS SUPPLIES DENVER, COLO. PAT. JAN. 15, 1895 A bright plated example. **e.** *courtesy of Wayne Meadows.*

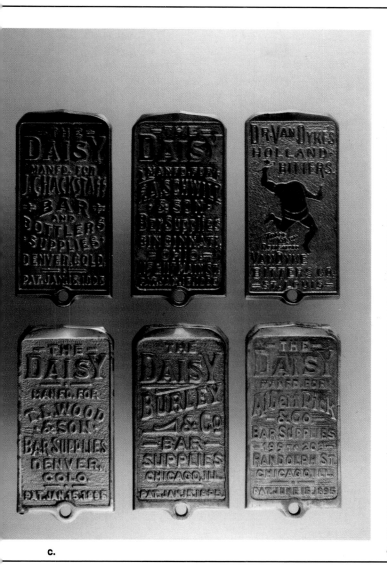

c.

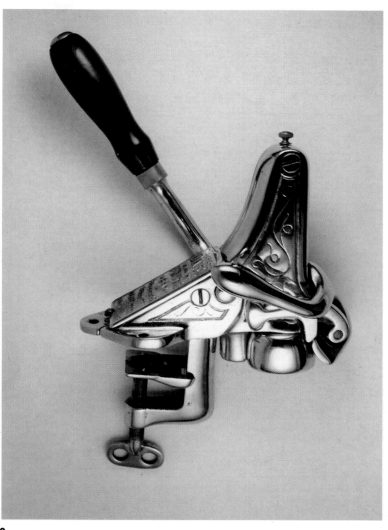

e.

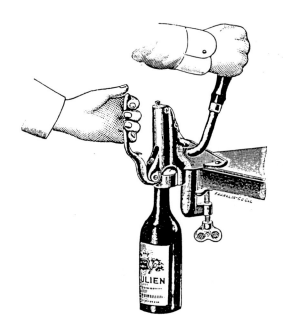

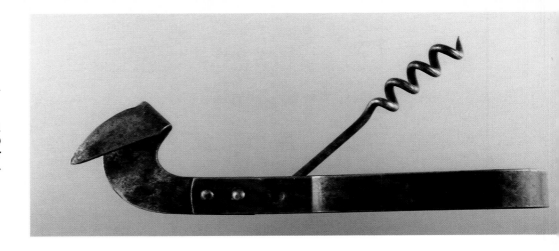

540,857
Robert Franken, Assignor Of One-Half To William L. Johnson
June 11, 1895
CUMMING CAN OPENER MADE BY THE P. H. CUMMING MFG. CO. LTD. TORONTO PATENT PENDING An example of a can opener patent donning a corkscrew in real life; 5.4".
Courtesy of Ron MacLean.

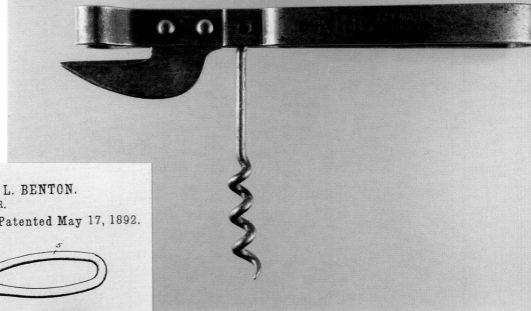

541,034 (see also 896,577)
William G. Browne, Assignor To The Browne & Dowd Manufacturing Company
June 11, 1895
a. KING PAT. MAY 17-92 & JUNE 11-95 This is the later of the two marked patent dates on W. G. Browne's "King" series of can openers. A subsequent patent (No. 896,577) added a cap lifter; 5.4". **b.** NEVER SLIP PAT. MAY 17-92 Browne's initial patent, which contained no corkscrew; 5.6".

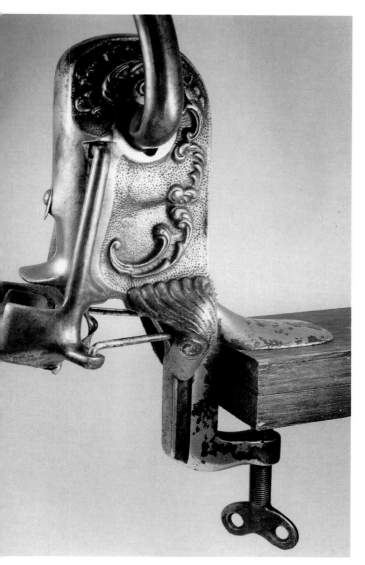

546,747
Michael Redlinger And Matthias Redlinger, Jr.
September 24, 1895
The Redlingers' patent, curiously unmarked. It is unique for lifting the bottle rather than lowering the corkscrew. The bottle neck is snap-jawed into the holder with the lever arm in the back horizontal position. Raising the lever arm causes the entire mechanism, including the bottle, to raise on the fixed mounting clamp post. The corkscrew never changes position except to rotate on the penetration and ejection cycles. Lowering the arm moves the bottle off the cork, whereupon the bottle can be pried away from the jaws. The lever arm is then raised and lowered sans bottle to spit out the cork. All of this is spelled out in 7 pages.

547,478
Edward E. Brown
October 8, 1895
Brown's go-it-alone patent for a corkscrew that can preset the cork penetration depth. He had previously teamed up with Alvord (No. 401,672). **a.** Illustrating setting for approximately half-way penetration, unmarked; 5.9". *Courtesy of Bob Nugent.* **b.** Illustrating two sizes, both marked PATENTED OCT. 8. 1895; left 5.9", right 4.3".

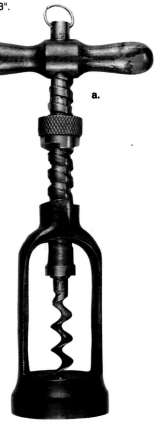

a.

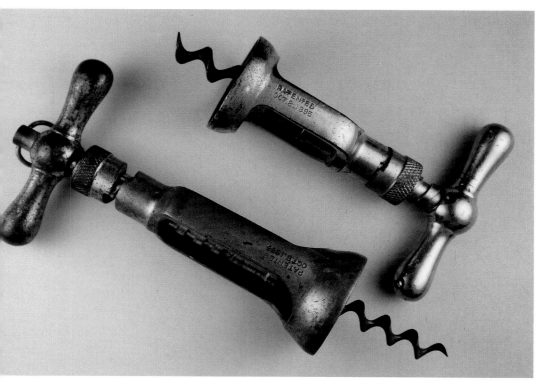

b.

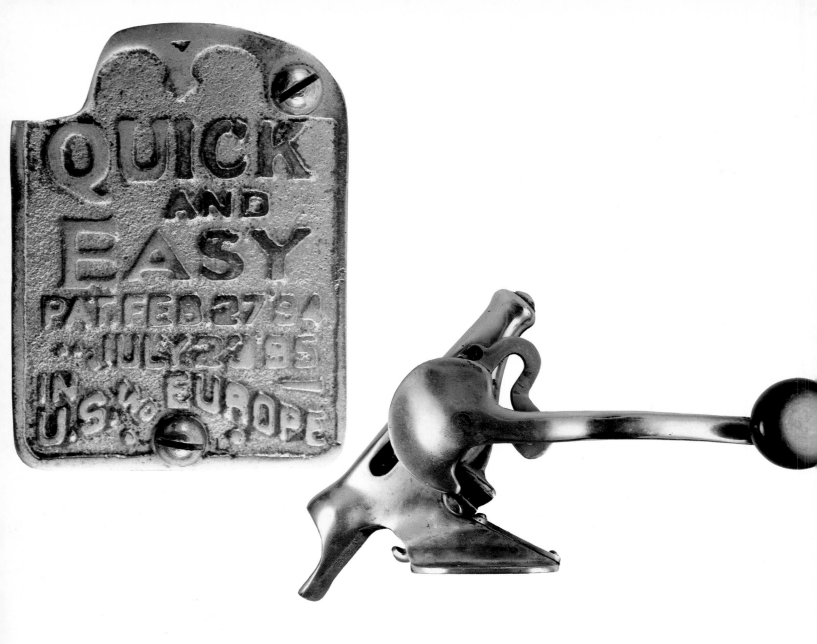

557,734 (see also 515,412, 543,224)
Edwin Walker
April 7, 1896

a. QUICK AND EASY PAT. FEB. 27 '94 JULY 23 '95 IN U.S. AND EUROPE Although marked for the earlier patents, this is an example of the later patent, taken out by Edwin Walker to make further improvements, all referencing his prior patent(s). The middle patent (not illustrated) reduced the travel of the operating lever while increasing its leverage. It also provided a bottle rest to better align the penetration of the worm to prevent breakage. This patent added a "yoke... (the curved armature astride the main lever arm) ...to insure the movement of the parts" and a bottle clamp lever (not included in this example). Note also the tip of a wire breaker barely visible behind the mounting base. The operation takes one round-trip of the handle, from a start/finish position as pictured, to roughly parallel the housing, then returning. *Courtesy of Ron MacLean.* **b.** Close up of applied plate. **c.** A photo, c-1904/5, taken of an 'establishment' from the London, Ontario (Canada) region. Next to the "Quick and Easy" bar corkscrew in the foreground is a patented "Quick and Easy" lemon squeezer. On the back wall can be observed examples of the raw materials often used in the making of fancy handles for Walker bells. *Photo courtesy of Ron MacLean.*

a.

b.

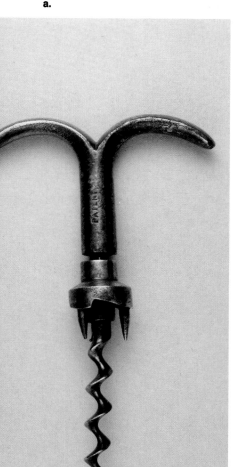

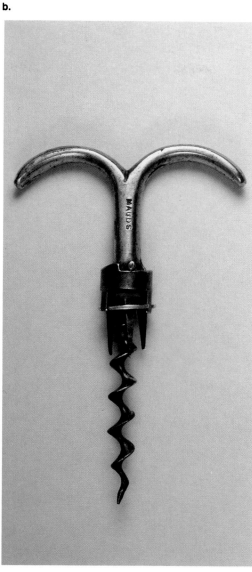

561,016
William Robert Maud
May 26, 1896
Englishman, William Maud, literally consolidated two prior English patents into one U. S. patent for four methods of engaging locking spikes to turn the cork once penetrated. The corkscrew was manufactured in England. **a.** PATENT Consistent with the 1894 English patent; 5.0". **b.** MAUD'S PATENT Consistent with the 1895 English patent; 4.5".

573,475
Carl Hugo Müller
December 22, 1896
DRP No 8917 Müller's "Corkscrew Knife." Note the working length of worm which retracts the entire length of the handle. Most pocket knives have worms fixed-pivoted somewhat near mid-point, limiting their length to half that of the handle. German inventors especially, developed ingenious ways to deploy a full length worm, many of which were patented in the United States, including the next one pictured; 3.6" closed, 5.6" open. *Courtesy of Bob Nugent.*

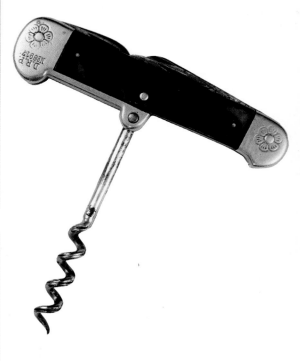

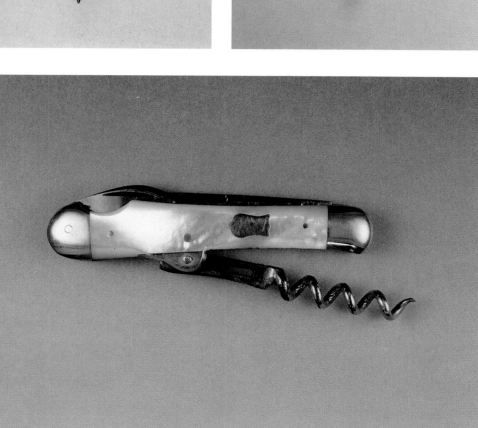

577,259
Adolph Kastor
February 16, 1897
Kastor's "Combined Corkscrew And Pocket Knife." A slotted shank allows a full length worm to retract into the knife. Unmarked; 3.3" closed, 6.5" open. *Courtesy of Bob Nugent.*

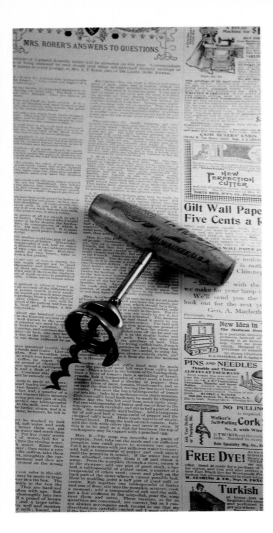

579,200 (see also D-25,776)
Edwin Walker
March 23, 1897
WALKER SELF PULLER PAT. JULY 25 '93
Walker's second of three patented bells which provides a wire cutting prong. Pictured upon the March, 1897 issue of "The Ladies Home Journal," containing an ad for the very same corkscrew, coincidentally published the same month and year as the patent. The marked date stamped into the end of handle refers to the first bell patent (No. 501,975) which indicates Walker had handles left over. Application for the utility patent was filed four months after the Design patent was issued; 5.5".

583,561 (see also 657,421)
William A. Williamson
June 1, 1897
WILLIAMSON CO. NEWARK N. J. PATENTED JUN 1 97 A 'bullet', 'bottle' and plain versions of the Williamson roundlet, distinguishable by having the helix pivoting on a sliding plug contained in the base. The bullet and bottle were often applied with an advertising plaque; bottle and plain roundlet 2.8" closed, bullet 3.0" closed. *Courtesy of Ron MacLean.*

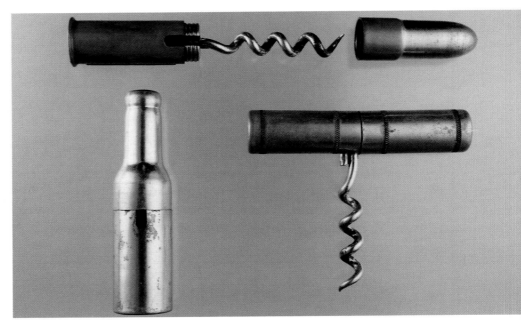

587,900
William A. Williamson
August 10, 1897
Williamson's self-pulling corkscrew specifies a plain washer above the bell (patent drawing Sheet 1), or, alternatively, a flat fixed wire cutter (Sheet 2). Characteristic of a Williamson corkscrew, the shank is mounted by a pin through the side of the handle and the bottom of the bell is flat. The shank is contained in an outer tube, which often was decorative. Both types were also made with barrel-shaped handles. **a.** WILLIAMSON CO. NEWARK, N. J. PATENTED AUG. 10 '97 on handle; WILLIAMSON'S on shank. The "washer" version. Note large size 'squared' bell and less common maple handle; 6.0". **b.** An advertisement for the patented corkscrew, which covers it all, including an appeal to the ladies. **c.** Williamson also made a slightly larger fixed wire cutter with a bent tab for cap lifting, which is probably more common than either patented version. An antler handle example is illustrated lying on a 1906 Christmas promo. Note more modernized 'rounded' bell; 6.2".

a.

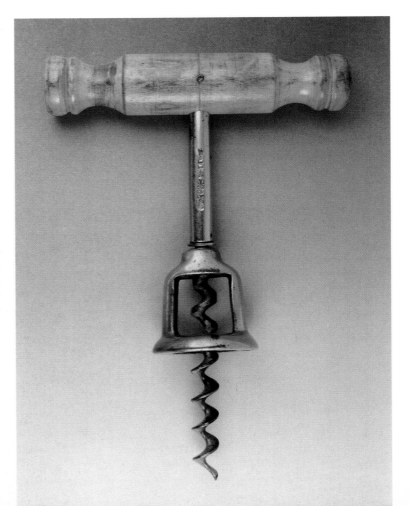

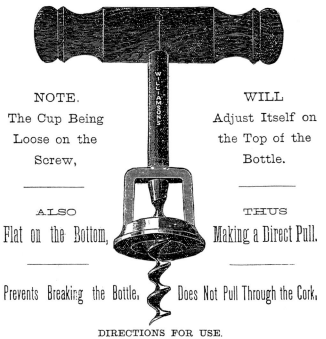

WILLIAMSON'S
POWER CORK SCREW.

NOTE.	WILL
The Cup Being	Adjust Itself on
Loose on the	the Top of the
Screw,	Bottle.

ALSO	THUS
Flat on the Bottom,	Making a Direct Pull.

Prevents Breaking the Bottle, Does Not Pull Through the Cork,

DIRECTIONS FOR USE.
KEEP ON TURNING, DO NOT PULL.

We recommend this Cork Screw for Household Use. With it
LADIES can draw tight corks EASILY.

FOR SALE BY

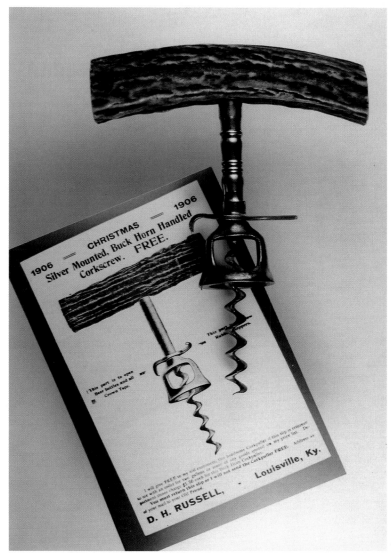

b. c.

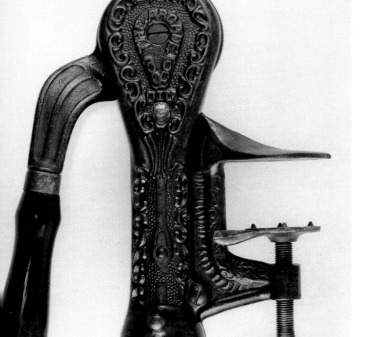

589,574, (see also D-25,607)
Michael Redlinger
September 7, 1897
THE ARCADE PAT. AP'D FOR Redlinger's
single stroke bar corkscrew. Starting with the
handle as shown in the patent drawing, the cork
is removed from the bottle by the time it reaches
the position in the photograph. Reversing direc-
tion removes the cork from the worm. "Arcade"
stands for "Arcade Manufacturing Company" of
Freeport, Illinois, headed by Charles Morgan
who witnessed the specifications. The Design
patent application was approved in 19 days. The
utility patent took nearly four years. This patent
is also inaccurately referenced in the marking
of other bar corkscrews manufactured by Ar-
cade (see Nos. 620,949 and 728,806).

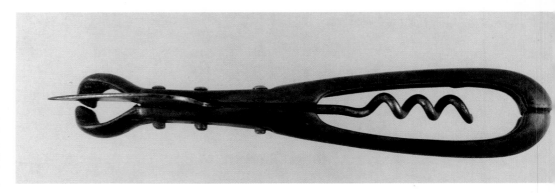

D-29,231 (see also 654,089)
William G. Browne
August 16, 1898
PAT. AUG 16 1898 (year obscure). Browne, spelled with an "e" (the other Brown was a prolific producer of wall mounts), stepped up to the patent desk five times in as many years for can opener patents, not counting an earlier patent bereft of a corkscrew. Never once did he refer to a prior patent; 5.2". *Courtesy of Dennis Bosa.*

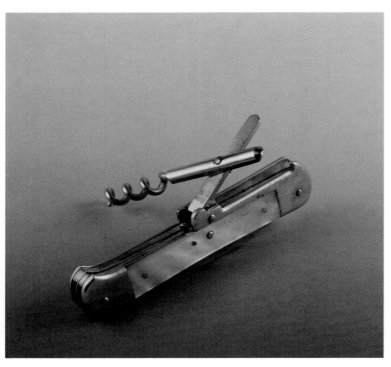

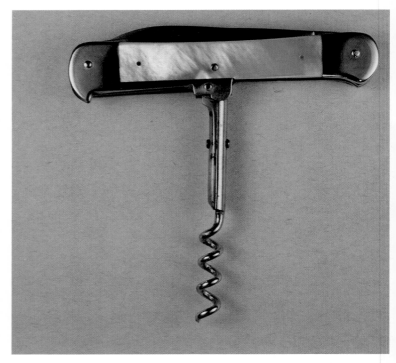

610,530
Ernst Hammesfahr
September 13, 1898
Hammesfahr's unmarked version of the corkscrew pocket knife, following the lead of Carl Muller (No. 573,475) and Adolph Kastor (No. 577,259). The corkscrew pivots from the center as with most pocket knives, but the split shank allows it to extend its length; 3.5" closed, 6.8" open. **a.** Partially opened. *Courtesy of Jack D. Bandy.* **b.** In full operating position. *Courtesy of Bob Nugent.*

611,046
Edwin Walker
September 20, 1898
Walker's peg-and-worm, drawing upon a 200-year-old technology. The peg is threaded to secure a hold in the flat disk at the head of the worm. When not in use the point is protected by a cup at the top of the peg. Left: S. S. PIERCE CO. BOSTON; 3.5" closed, 2.5" open. *Courtesy of Bob Nugent.* Right: 'LER'S MALT WHISKEY!'; 3.7" closed, 2.9" open.

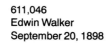

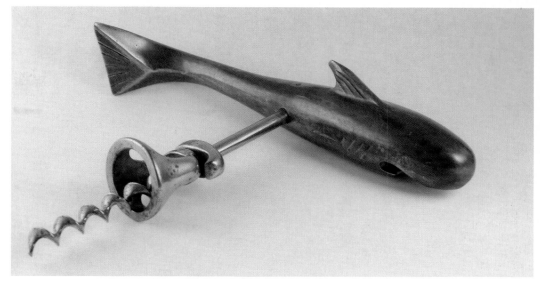

a.

c.

b.

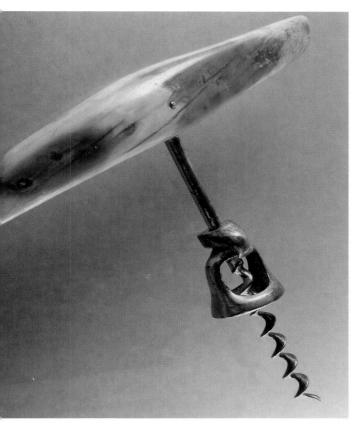

d.

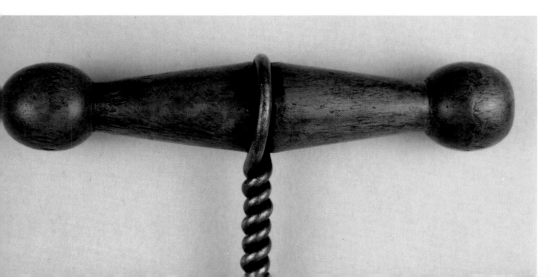

D-29,798
William A. Williamson
December 13, 1898
Williamson's "Cap Lift." **a.** Close up of cap lift shown mounted to shank just above the bell, unmarked. **b.** Shown with fossilized tusk handle; 6.5". *Courtesy of Jeffrey Mattson.* **c.** Shown with metal denizen-of-the-deep handle; 6.0" *Courtesy of Wayne Meadows.* **d.** WILLIAMSON'S marked on shank, WILLIAMSON CO. NEWARK, N. J. stamped into end of handle. Made without bell. Note Williamson style mounting with cross-pin in center of handle, 4.6".

D-30,234
William R. Clough
February 21, 1899
Clough's Design patent for a wood handle, 4.0".

620,949
Charles Morgan, Assignor To The Arcade Manufacturing Company
March 14, 1899

a. CHAMPION PAT. SEPT 7, 1897 DES. PAT. JUNE 9, 1896 Marked for Michael Redlinger's patents (Nos. 589,574 and D-25,607) but applicable to Morgan's 1899 patent which was promptly assigned to Arcade Manufacturing Company, of which both were principals. Such was the inbreeding of patents passing through Arcade. Possibly the most recognized American bar corkscrew of them all. The operation requires a round trip of the handle in a three-quarter arc starting in the position pictured. **b.** CHAMPION REG U S PAT OFF A chrome plated Art Deco model manufactured long after patent rights had expired. *Courtesy of Jack D. Bandy.* **c.** WILLIAMSONS NEW ERA PAT NOV 12 1895 SEP 7 1897 MAR 14 1899 One of two known "Williamsons New Era" variations, this one claiming kinship to the "Champion" patent. The other is closer to Morgan's "Phoenix" (No. 728,806). The marking of Williamson suggests that Arcade was not averse to putting someone else's name on their patents—for a price, of course. *Complements of Ron MacLean.* **d.** HANDY PAT MAR 14 1899 Another variation attributable this patent, but having little outward resemblance to the CHAMPION. Possibly of later manufacture.

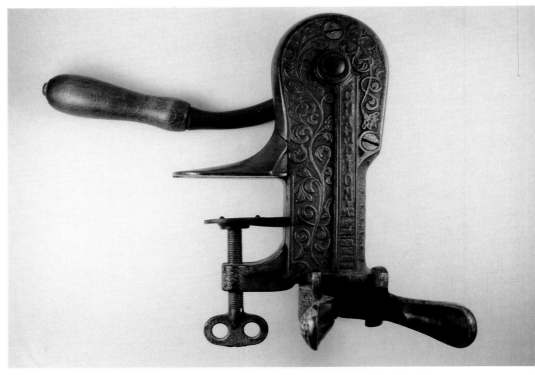

a.

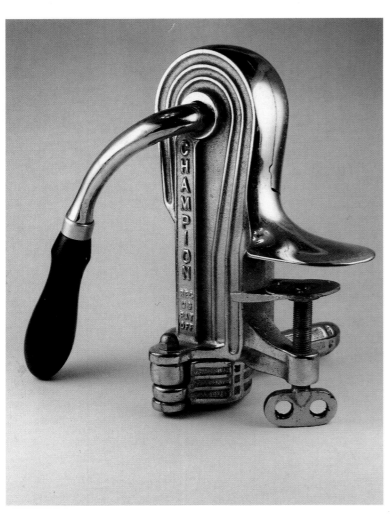

b.

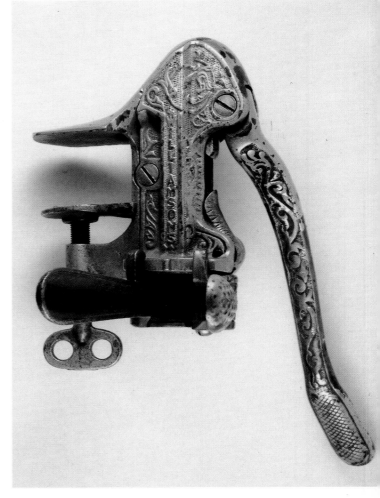

c.

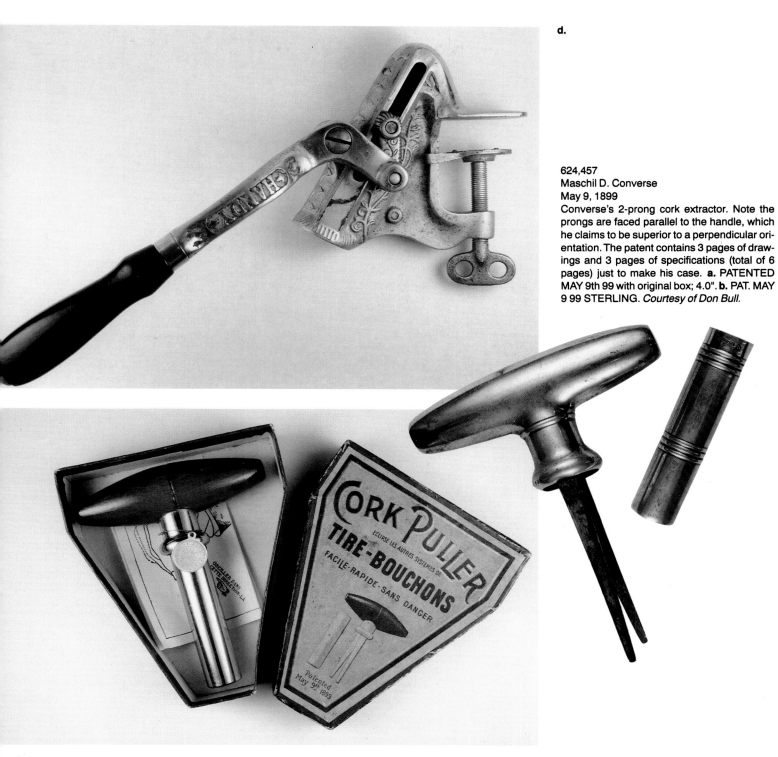

624,457
Maschil D. Converse
May 9, 1899
Converse's 2-prong cork extractor. Note the prongs are faced parallel to the handle, which he claims to be superior to a perpendicular orientation. The patent contains 3 pages of drawings and 3 pages of specifications (total of 6 pages) just to make his case. **a.** PATENTED MAY 9th 99 with original box; 4.0". **b.** PAT. MAY 9 99 STERLING. *Courtesy of Don Bull.*

636,531
George W. Jopson
November 7, 1899
PAT NOV. 7-99 Although the bow differs from the drawing, Jopson's patentable improvement applies to the locking sleeve; 5.0" open. *Courtesy of Nicholas F. D'Errico III.*

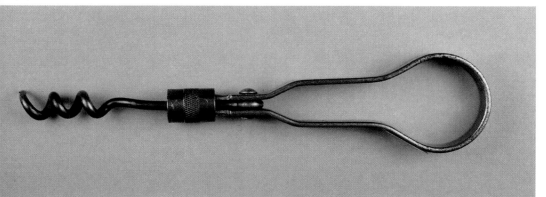

December 17, 1903 Wright Brothers flight

April 18, 1906 San Francisco earthquake

1914-1918 World War I

1919 Beginning of Prohibition

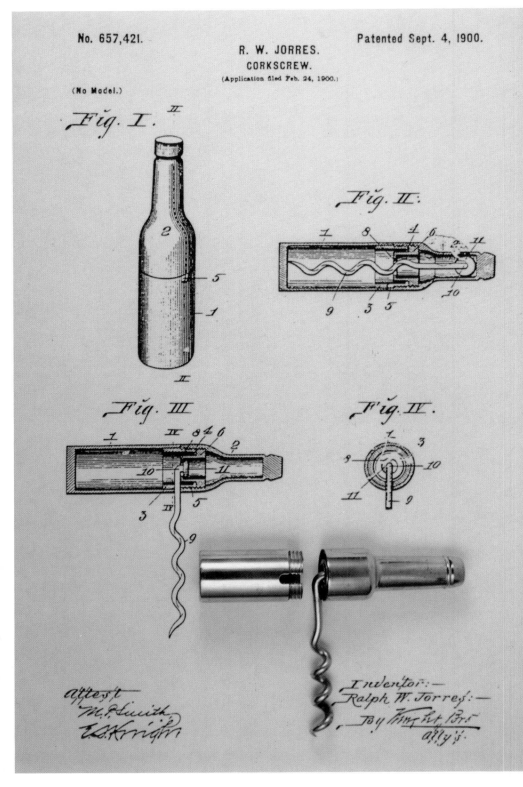

657,421
Ralph W. Jorres, Assignor To William A.
Williamson
September 4, 1900
WILLIAMSON CO. NEWARK N. J. PATENTED
JUNE 1. 97 Nickel plated brass roundlet in the
shape of a bottle, mismarked for the earlier
patent, but betrayed by having the helix affixed
to a plug contained in the top section, rather than
the base. Also produced in plain and bullet form;
3.0".

CHAPTER 3
1900 THROUGH 1919

317 Corkscrew Patents

For the first 100 years of the United States patent system, would-be inventors of a better bottle opener had to deal with primarily one kind of stopper — the cork. 'Improvement', therefore, consisted of making a 'better' corkscrew. With more than one-third of all corkscrew patents issued prior to 1900, it is safe to say the corkscrew had become a fairly sophisticated and efficient instrument. Everything changed with the proliferation of more content-specific containers and closures. Whereas today we have tools that go one-on-one for every task, the prevailing wisdom at the turn of the century was that tools had to be more versatile.

And complicated.

Inventors became transfixed by combinations, reasoning that anyone would rather have an axe, wire stripper, comb, can opener, knife sharpener, pliers, cap lifter, hammer, ruler, button hook, jar wrench, saw, knife/fork/spoon, screw driver, cigar cutter and nail file all neatly embodied *in one tool,* than individually scattered about the house, yard, barn and the most recent addition, the garage. It was more economical to produce and more convenient to use.

The following might represent the inner musings of an aspiring inventor hunched with growing anticipation over the figure coming to life on the drawing board: "Darn, I forgot the corkscrew. No problem. I'll tuck it in under the tack pryer."

Hear what Erik Nylin had to say in his effort to create the ultimate combination tool:

"The present invention... has for its object a structure in which is combined as many different tools as possible, conveniently and symmetrically arranged." (No. 914,601).

Even good taste became compromised with alcohol doctored in seemingly endless combinations to indulge the sweet tooth (Fig. 3-1). To the modern table wine drinker, Catawba, Ginger Brandy, Muscatel and Wild Cherry Bitters seem more like medicine than accompaniments to a fine dinner. And if the sought-after flavor was not offered in packaged form, pure grain alcohol was also available for customized blending. No wonder the corkscrew got no respect!

From the standpoint of the tool itself, as if wide *intended* uses were not enough, much *unintended* use was also a factor, with many a corkscrew handle commandeered for hammer duty and worms found convenient for prying. Much to the consternation of collectors, beautiful horn or bone handle corkscrews of the era, adorned with ornate sterling silver end caps and often monogrammed, are known to have been defaced on the head of a tack or whatever needed pounding, and not all worms were bent or broken inside a cork. It seems a shame to dishonor a corkscrew this way, yet inventors were clearly not promulgating respect for tools by their over zealous combining of incompatible elements.

Patent titles themselves got into the hyphen game with only 19 patents actually called by the simple moniker, "Corkscrew" (there were nearly four times that number in the previous 20 year period) and less than half used the word "Cork..." anywhere in the title, despite the presence of a cork removal function. OFFICIAL GAZETTES became so wordy and thick — pushing 4" between covers — that in 1906 it became necessary to split monthly volumes. The world was indeed getting complicated.

Perhaps the only counter-trend to complication was the dropping of witnesses from the patent documents, which has provided such juicy material for historians of bar corkscrews, for one example. Witness signatures started disappearing from the drawings in 1917. In a 1922 patent there appeared a "Witness" line with no signature (No. 1,425,456). After that Witness recognition was rare. The last to appear on a corkscrew patent was in 1942 (No. 2,304,997). The specification page stopped noting Witnesses in 1926.

Meanwhile, barely 3 in 5 patents bore an "Attorney" signature prior to 1880. After that, few escaped the meter.

Fig. 3-1 Look what corkscrews had to open! A pre-prohibition distiller's line card offers plenty of trouble for the constitution but not the pocket book. The 1¢ postage stamp on the mailing envelope is date stamped at the sender station, "TIPPECANOE CITY. OHIO OCT 24 10 AM 1906" and at the receiver station, "HEREFORD PA OCT 25 1906 P.M." The exact time of the afternoon date stamp is unknown.

With the corkscrew becoming lost or subordinated in the technological hodgepodge, it is a wonder some of these tools ever find their way into corkscrew collections. The patent drawings didn't always feature the sought after implement for removing a cork, showing either peek-a-boo glimpses (No. 737,483), dotted lines (Nos. 647,528 and 1,196,060), understated scale (Nos. 749,548 and 1,231,746) or a corkscrew buried amongst the parts and pieces (No. 1,059,883). Some provided a corkscrew so far down the food chain it may never have seen action, or if it did, it might have been as likely used to pry open a can of paint as pull a cork. F. Feyrer's 1915 patent for a "Combination Penknife" started with a folding ruler, required a "blade" to be pulled out from between the sides exposing a corkscrew that pivoted out at right angle to the blade — a compound joint that made a mockery of leverage (No. 1,127,609). Add in the non-screw types, many of which were classic "what-is-it?" tools, no wonder collectors are ambivalent. If a person were to own a collection of just the 1900-1919 patents, a casual observer would be hard pressed to come up with a theme. All by itself, E. Kaas' 1916 "Combination Tool" would qualify its owner for any number of collector clubs (No. 1,187,842).

Fig. 1.

Consider also the Labrèche patent (No. 1,109,073). Now, if ever there was a useless tool for non-smoking, bald-headed teetotalers, this is it! Yet patents of this ilk were churned out of the Patent Office like there was no tomorrow. Because they attempted so much, these gadgets delivered very little to the real world of consumers, despite their 'reasonable' price and the preponderance of well-groomed sinners.

It has given American corkscrews a 'bad rap' amongst purists. An essentially honest tool became corrupted by an outbreak of invention after having enjoyed a two-century reign of relative exclusivity. Yet there was something compelling about the 'machismo' of the American combination tool. Perhaps tradition was violated as new thinking probed the frontiers of the next technologies. But there is no denying the energy and excitement that squeezed through that bottle neck of time. We are left with history and the artifacts that define that history. It is the only history and artifacts we have. They are as representative of their period as any artifacts are of any other period. To scoff at them is to patronize history, and to possibly fail at grasping the meaning of it. The knife collectors and tool collectors are probably saying the same thing about their fields, which were so callously invaded by corkscrews during the turn of the century industrial treasure hunt.

For the very reason these tools did not work well and/or were cheaply constructed and/or were manufactured in limited quantities, they do not show up very often in antique circles today. Collectors will have a much easier time of it rounding up Walker and Williamson bells than some fanciful concoction of tools embodied in one implement, that may have passed muster at the Patent Office but never made it into the American home. Or if they did, as soon as one function shut down — a likely event — it cheapened the rest of the tool, resulting in disuse and eventual discarding. But one generation's disdain for a tangle of worthless metal is another's lust. A 20th century American combination tool with all its appendages intact can be as significant a find in terms of *rarity* as some 18th century types performing many of the same functions.

None of this seemed to bother the inventors or manufacturers. Rather than cowering sheepishly in anonymity behind the trinket pollution they had promulgated, they instead took pride in their creations. Provincial marking of name, city and state, gave way to nationalism, where goods were unabashedly proclaimed, "MADE IN U. S. A.." Perhaps producers were too busy producing to smell the roses of utility and good taste. What they smelled instead was an international marketplace in which they were becoming dominant players.

Patent marking accuracy often became dispensable in the rush to market, making it impossible to line up the patent to the piece. For multiple patent holders, old numbers were put on later models and "Patent Applied For" continued to appear long after the patent was granted (or rejected). No profit conscious manufacturer (was there any

other kind?) would think of throwing away a barrel full of handles just because they might be marked with the wrong patent. Patent authenticity was the least of the manufacturer's worries, if an order had to go out tomorrow. Stock on hand would get used up first; the legal niceties could be dealt with later. And because a new die was expensive, the 'old reliable' might remain in service long past its appointed time. The obsessive-compulsive collector of today is no match for an expedience-driven manufacturer of yesteryear. The same holds true for the reader, who is respectfully asked to accept the some-times rather shaky patent assignments adopted herein, despite an understandable yearning for a more perfect world.

Thus, rather than looking down the nose at history, a more appropriate response might be to see the humor in it. One of the most enlightened observers of the times was Rube Goldberg, a leading American cartoonist for over two decades, starting around 1910. His comical drawings satirized the conventional wisdom that machines provided the answer to all life's problems (for the prior generation it had been patent medicines), concocting fanciful and absurd means of accomplishing the desired result — which itself was questionable. He was so successful that his name itself now stands for a contraption or institution rendered useless by its complexity. A "Rube Goldberg" is what you get when misguided intention meets up with excess means. Yes, inventors did lose sight of the mark, wrapped up in the dazzle rather than the actual effectiveness of their ideas. The corkscrew did not escape Rube Goldberg's humorous scrutiny (Fig. 3-2).

Real live corkscrew patents can also be *written* with the chain-like linkage of elements typical of a Rube Goldberg device. Here is an excerpt from Harry Vaughan's 1916 patent for a "Bottle Opener":

"I have provided a cut away portion 8, pressed the corners 9 and 10 apart so as to receive the fixed end 11 of the spiral cork screw 12 which is held pivoted in the recess 13 formed by said spaced apart corners 9 and 10 by means of a pin or rivet 14. At the opposite end of the cut away portion 8 is an extension 15 having a recess 16 stamped thereon to receive the point 17 of said cork screw 12..." (No. 1,207,100).

Satire is often expressed in a political context (perhaps because politicians are such easy targets), but Rube Goldberg was not taking on the foibles of Government as much as the dehumanization of industry. This was the era of the tycoon. Until anti-trust action was taken under the Administration of

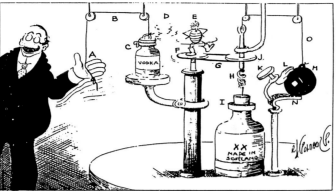

WHEN YOU SAY "HAVE A DRINK", NATURAL MOTION OF HAND (A) PULLS STRING(B) AND LIFTS LID (C), RELEASING VODKA FUMES (D) WHICH MAKE RUSSIAN DANCING-BUG (E) FEEL GIDDY- HE STARTS DANCING NATIONAL DANCE OF RUSSIA AND REVOLVES PLATFORM (F)- PULLEY (G) TURNS CORK-SCREW (H) AND IT SINKS INTO CORK (I) BRINGING DOWN DISC (J), WHICH HITS SURFACE (K) AND CAUSES WOODEN HAND TO PUSH IRON BALL (M) OFF SUPPORT(N), CAUSING CORD (O) TO PULL CORKSCREW WITH CORK FROM BOTTLE.

Fig. 3-2 "Our Own Self-Working Corkscrew." A "Rube Goldberg" corkscrew that didn't get patented (unless he discovered what *really* went on inside a bar corkscrew).

Theodore Roosevelt, people like Dale Carnegie, Cornelius Vanderbilt, Henry Ford,[15] John D. Rockefeller, and J. P. Morgan wielded more power than Government itself. Silversmiths, blacksmiths and gunsmiths were now factory workers, clerks and sales reps named Smith. Each contributed a part to a greater whole. The bigger the thinker/leader, the more parts could be assimilated into the whole. The compartmentalized corkscrew became a symbolic microcosm of the empires, monopolies and corporate structures to which individuals submitted their individuality. Not that it was forced on society. A Model-T Ford assembly worker in Detroit was higher on the economic scale than a share cropper in Oklahoma. But the relentless, serious minded pursuit of growth produced a different world than existed before the turn of the century... and ever more complicated corkscrews.

Bar corkscrews got so over-invented that by the close of the second decade all 101 patents had been issued.[16] The corkscrew was a bit player on a portable workshop called a pocket knife that could literally spring into action as fast as a gunslinger's draw. Inventors took themselves and their inventions seriously, perhaps making them more vulnerable to contemporary pundits and hindsight criticism. Much of the stuff is just plain goofy by today's standards, which did not bode well for their longevity. The need to be complicated outweighed even the growing need for better mechanics to handle tighter longer corks in (what else) machine-made bottles. Indeed, many inventors became more enamored of the

machinery than the end product. It is not likely that a corkscrew vision appeared to McConnell, but oh! how he must have loved creating his machine (No. 1,238,166). The patent is the longest of any involving a corkscrew, taking up 6 pages of drawings and 11 of specifications, easily beating out the 7 drawing and 5 specification pages by W. R. Clough for *his* machine (No. 659,649).[17] Even the modern patent for-format has not produced a more epic patent, although the gap has been closed by the ever increasing technical nature of the world we live in.

It is like a breath of fresh air to come upon a Murphy, another self-puller but straight forward in execution (No. 672,796). Perhaps because he was from the old school, having produced simple 'T'-handles in New England for some 50 years, that Murphy's patent stands out from his peers with such purity.[18] It performed no better or worse than Walker's third and final bell patented a year before, but Walker's clout beat up Murphy in the marketplace (No. 647,775). It was to be the last honest self-puller patented until the modern era.

Another corkscrew-and-nothing-but-a-corkscrew, one of only two of its genre patented in the United States (but never manufactured here), was Armstrong's concertina (No. 747,351). The other was by Wier, patented 18 years earlier (No. 330,357). Revealingly, both were Englishmen and both obtained patents in their own country first. The principle of the concertina is much like the physics of a pulley. Each arm takes on a share of the load. By the time the resistance reaches the handle, it has been reduced to a fraction of the unenhanced pull. Hence the common name of "lazy tongs." The most prolific producer of concertinas, before or since, is probably France.

Lacking elegance, but representing a good effort nonetheless, was Noyes' reversed waiter's screw where the corkscrew was placed at the *end* of the tool rather than the middle (No. 824,807, coming right on the heels of No. 793,318). The lever action was therefore *down* rather than the usual up. It never caught on except perhaps as an advertising exegete for "Green River...The Whiskey Without A Headache." Any example found with different advertising or no advertising whatsoever, is likely to be rarer. Rarer still is the first patent, which, due to the success of the improvement, may not have been produced.

That corkscrews are used for advertising is a given in today's world of nothing-is-sacred commercialization. Almost everything else is a media opportunity, so why not the corkscrew? The earliest known intended use of advertising was W. R. Clough's improved wire corkscrew, patented 1881 (No. 242,602).[19] In the specifications he stated that the former corkscrew,

"...while answering admirably the many purposes for which it was constructed, is objectionable in that the handle being made of light wire and generally only large enough to receive one finger, cuts or bruises the flesh, especially when the cork fits tightly in the mouth of the bottle."

Clough remedied this "objectionable" condition by flattening the wire at the top of the ring,

"...for the purpose of broadening the surface against which the finger presses, and to afford a space whereon, if desired, the name of the contents of the bottle or other matter could be stamped."

Thus arrived without fanfare the first advertising corkscrew.

Being the typical inventor, who was never satisfied with the way things were, Clough was back again at the Patent Office a mere two years later with another idea (No. 302,321).[20] The patent states that,

[15]Imagine if Henry Ford had gotten into the corkscrew business. He almost did! A young Henry Ford was assigned half the patent rights to an "Automatic Cork Extractor," No. 241,929, to which he later added four wheels. The rest, as they say, is history.

[16]Recent patent activity suggests the bar corkscrew may not be dead yet. See Nos. 4,766,780, 5,372,054, where the corkscrew has been 'applianced' by electricity. Could the computer chip be next?

[17]The longest patent for a corkscrew itself up to that time was a 12-page missive of William A. Williamson for a bar corkscrew, with 6 pages each of drawings and specifications (No. 615,938).

[18]Murphy also produced mechanical corkscrews, though not under patent.

[19]Characteristically, Clough found fault with the status quo and, by specific reference, even criticized his own prior patent (No. 161,755). Since the rights then belonged to Williamson, could it have been an easier target?

[20]Once again Clough claimed his latest idea was an improvement on Patent No. 161,755, then belonging to Williamson.

"...the handle cannot be sufficiently flattened to avoid hurting the finger, and hence it has often been necessary in the construction of the wire goods to employ heavy material for the sake of securing as much width as possible to the handle. As a consequence, the worm was much too bulky for small stoppers and the article rendered unseemly and expensive, besides the defect was only partially remedied."

The answer was a flat metallic band which could be looped and joined with the screw in an eyelet at the ends, allowing the screw to pivot in the manner of a miniature folding bow. Curiously, the patent made no reference to the band as a surface for "advertising" yet examples of this corkscrew are rarely found *without* advertising. Instead Clough was more concerned with the limitations of a single piece of wire in which,

"...it frequently occurs that the tempering of the screw precludes the possibility of working the handle into any ornamental configuration, and it has not been unusual, in order to preserve the handle in condition for further treatment, that the tempering of the screw has been slighted."

The last of Clough's self-flagellation took place in 1892 with yet another, but this time *decisive*, improvement to his way of thinking (No. 474,055).[21] Finding the usual "objection" with the strength of the handle and the tendency to cut into or bruise the finger, Clough determined he had found the answer once and for all:

"My invention remedies the foregoing objections entirely, since by it I produce a corkscrew having a handle which will neither collapse nor cut the finger of the user, and at the same time will afford a surface on which the name of the contents of the bottle or other matter may be placed."

The idea was to provide a vertical band, which reinforced the wire loop and created a surface for art. By invention standards Clough may have been right; by market standards, the idea was a flop, as no examples are known to exist. Meanwhile, the loop band is a staple of antique hunting.

C. T. Williamson for his part patented a medicine spoon with a corkscrew handle (No. 264,391) which was silent on the advertising implications, but a similar spoon, often attributed to Williamson, is known to have been produced in England with names of medicines stamped on the bowl. His 1883

patent for a wire corkscrew specifies a flattened section of the wire handle,

"...to render (it) more durable, and to present a surface upon which any name or other data may be stamped" (No. 274,539).

Usually it is found with *his* name on it. As previously mentioned, Williamson's son, William, who had taken dead aim at Clough's band corkscrew with his version in 1889, also made no mention of advertising (No. 405,385).

The side of the 'waiter's friend', first patented by Wienke (No. 283,731), is perhaps the most widely used advertising surface on a corkscrew manufactured today. However, Wienke never intended that his corkscrew be used for commercials, at least as far as the patent was concerned. The same could be said for the barrel-shape wood handles employed by Walker and Williamson in their "self-pullers." No mention was ever made in the patents for the use of the handle for other than functional purposes.

An early patent to bring up advertising for general use was Dean's "Combined Corkscrew, Match Holder, &c." (No. 502,351). The first can opener to do so was William Browne's 1895 patent, stating that his objective was,

"...to produce at a low cost for manufacture, a simple, strong, durable, convenient and effective article, composed of few pieces, attractive in appearance, and well adapted for advertising purposes" (No. 541,034).

Instead of being product-specific, like the earlier Clough medicine corkscrew, the "A" word had been unleashed. For better or worse, the corkscrew had been deputized for catching consumers.

Because of the natural relationship between opener and beverage, the first advertisers tended to be brewers and distillers. The opener was a handout, removing at least *that* obstacle to consuming their product. Later the skids were greased by the *purveyors* of beer and wine including liquor stores, bars, restaurants and hotels. By 1916, as the patent of M. L. Vaughan made possible, everyone got into the act (No. 1,207,100). It was a match made in heaven. Here was a necessary tool, often carried in the pocket, able to communicate its silent message over and over and it was cheap enough to give away. No wonder the corkscrew producers had economy on their inventive brains. They wanted to sell corkscrews and advertisers were a big market for them. Even the patent marks became secondary to the blurb (Wilber Woodman, may he rest in peace...).

Of course, what made the corkscrew an ideal surface upon which to tout a product was not the awkward and

inconvenient circular worm but the nice flat handle. Following a period when metal was mostly cast, the producers were now obtaining metal in sheets from the mills. Bigger and better machinery was able to press, stamp, bend, fold, punch and in general manipulate sheet metal much more economically than the casting process. The end result was the creation of flat surfaces which could become palettes for creative art and ad, often in combination. Later, plastics in living color would become the choice of discriminating advertisers.

Advertising as a function first appeared in a patent drawing with the 1903 patent of W. J. Lowenstein, which was actually a means of attaching the corkscrew to the bottle (No. 728,735). A corkscrew intended for general advertising was illustrated in the 1906 patent of J. D. Coughlin (No. 814,834) and the 1916 patent of D. H. Pettingell (No. 1,203,257), which couldn't have worked as no examples are known. Curiously, the two most frequently found advertising corkscrews today never promoted advertising in their patent specifications or drawings. They are the aforementioned Vaughan patent, known as the "Nifty" for the marking usually found when the surface was *not* used for advertising (No. 1,207,100) and Clough's ubiquitous wood sheathed corkscrew, which carried patent dates of 1900 for his "Machine For Making Corkscrews" (No. 659,649) and 1910 for an added cap lifter attachment (No. 950,509).

The patenting of pocket knife corkscrews flourished during the turn of the century, evidenced by over 20 patents issued between 1890 and 1920. Many of the patentees were German, hailing from Solingen, a major center for the manufacture of knives. The earlier patents tended to be more corkscrew-conscious than the later patents which diversified into other functions, including cap lifting and, of course, advertising. Moreover, a corkscrew attached near the center of the knife, using the body of the knife as a 'T'-grip handle, could only be half the length of the knife itself. Pulling a cork with a short worm is not easy, and never graceful, as users of a Swiss Army Knife can attest. Many patents starting with C. H. Müller's "Corkscrew Knife" in 1896 devised ways to retract the corkscrew along the *full length* of the knife, while still pivoting from the middle, thereby nearly doubling the corkscrew's length (No. 573,475). Two month's later Kastor patented his own version, calling it a "Combined Corkscrew And Pocket Knife" (No. 577,259) and slightly over a year later came Hammesfahr's "Pocket Corkscrew" (No. 610,530). The last of the type were Windhövel & Weÿer's 1911 "Pocket Corkscrew" (No. 989,680)

[21] For the third time Clough pointed to the inferiority of Patent No. 161,755.

and C. W. Tillmanns' 1929 "Handled Tool" (No. 1,701,467). Although the patents are, by necessity, different in mechanics, the inventors had a singular purpose in mind, which was to engineer a pocket knife on to a corkscrew. For everyone else, the corkscrew was put on to the knife. In time, so was the advertising.

Another interesting handle for a corkscrew was the match box. Six patents were issued for this device, two of them prior to 1900 and four between 1900 and 1919. Unlike a pocket knife in which the blade(s) and corkscrew pivoted from between reinforced scales, the match box was, by definition, hollow. The only strength occurred on the edge where the corkscrew was attached, but with hardly the means to stand up to a mighty cork. They were also awkward to use, by virtue of having to pivot from one end. Accordingly, their limited manufacture makes them a rare breed, rarer yet if found without corkscrew stress. In theory, however, the tool provided a single-tool answer to the 'gentleman' who might be tempted to smoke and drink at the same time, not a bad combination to sell into.

A one-of-a-kind device, smacking of pure invention, was Wilson Brady's 1917 patent for a "Stopper-Extractor" (No. 1,213,452). It didn't make the corkscrew obsolete as he might have wished, but it did work — better than many corkscrews of the day. And it saved on corks too, allowing them to be reused on a partially consumed bottle. The patent called for pins (the number unspecified, but three are to be found on the actual piece), which are pushed into the cork at an angle. Once lodged in the cork, the entire mechanism could be twisted, taking the cork with it. The device could also be used for flat stoppers, such as milk stoppers, making the tool arguably more versatile than a corkscrew.[22]

With the death of Edwin Walker in 1917, the C. T. Williamson Wire Novelty Company, then run by William A. Williamson (see Chapter 2), lost its greatest rival. Realizing the market visibility of the Walker name, Williamson moved quickly to take over production of the patented Walker bells — now out of patent protection — which continued to be offered along with his own bell in catalogues as late as 1946, even past Williamson's own death in 1932. This maneuver made Williamson the largest manufacturer of corkscrews in North America. With the *third* generation Williamson having no heirs, the C. T. Williamson Wire Novelty Co. was purchased by the Eastern Tool & Manufacturing Company (later ETAMCO) in 1946, still manufacturing and distributing corkscrews as well as various bar, fountain and restaurant specialties. Corkscrews continued to be manufactured through the 1970s, with even the emergence of a patent, by the then President of ETAMCO, George Frederick Peterson of Boonton Township, New Jersey, March 30, 1976 (No. D-239,362). Finally, in 1982 the C. T. Williamson Co. ceased operations as a Division of ETAMCO, following an unprecedented stewardship of *106 years* of corkscrew manufacturing, involving directly or indirectly scores of corkscrew patents. Even the casual collector cannot fail to be impressed with the incredible diversity and stamina of the corkscrews in circulation today, carrying the familiar "WILLIAMSON'S" mark.

World War I brought a marked deceleration in patent activity and hence the proliferation of combination tools. The thought process was not changed by the war as much as opportunity. Manufacturing turned to supporting The Cause — corkscrews straightened into swords, so to speak. The year 1919 recorded the lowest number of utility patents for corkscrews — six — since 1881. With Armistice Day, November 11, 1918 came a new threat to corkscrew making, this time coming from the home front. A relatively unnoticed wartime measure to help the boys had become, during the tumult of the times, the 18th Amendment to the Constitution, prohibiting the manufacture, sale or transportation of intoxicating liquors. Eulogized as the Noble Experiment, the country would live 'dry' until 1933, when it was mercifully repealed by the 21st Amendment. Like 'dry' white wine, Prohibition turned out to be pretty 'wet'.

Fig. 3-3 The Trade Mark registration for the term "U-NEEK," published in the OFFICIAL GAZETTE, September 30, 1947.

Ser. No. 505,614. EDGAR V. PHILLIPS, doing business as Phillips Specialty Mfg. Co., Conneautville, Pa. Filed July 13, 1946.

U NEEK

FOR COMBINATION JAR AND BOTTLE OPENER.
Claims use since Nov. 10, 1945.

[22]In 1947, thirteen years after Brady's patent rights had expired, Edgar Phillips of Conneautville, Pennsylvania received a Trade Mark for the term "U-NEEK," applying to a "Combination Jar And Bottle Opener" (Fig. 3-3). There is no evidence linking it to Brady's device.

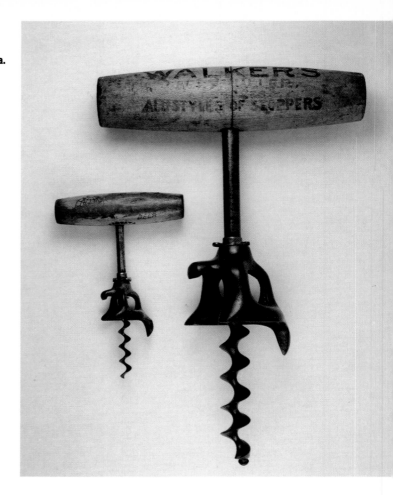

a.

647,775 (see also D-31,505)
Edwin Walker
April 17, 1900
Walker's third and final patent for a bell with prong and added cap lifter function. Universally known as the 'Walker Collar'. The Design patent was applied for and granted during the wait for the utility patent. **a.** Is the corkscrew on the left miniature or standard size? Left: no patent marking; 5.5". Right: WALKER'S SELF PULLER REMOVES ALL STYLES OF STOPPERS is marked on the giant model; 11.9". *Courtesy of Jack D. Bandy.* **b.** Left: no patent marking, with relatively less common wire helix; 5.4". Right: WALKER'S PATENT on end of handle, with solid core worm; 5.7". **c.** through **n.** The 'Walker Collar' was frequently used as the working hardware for fancy and artistically carved handles created out of ivory, bone, tusk, and antler, often embellished in precious metals. They represent, perhaps, America's definitive artisan corkscrew, produced after the turn of the century. *c. courtesy of Bob Nugent. f. courtesy of Jeffrey Mattson. l, m, n. courtesy of Don Bull.* **o.** A nugget of gold plugs the mounting hole of a tusk fossil; 6.5".

b.

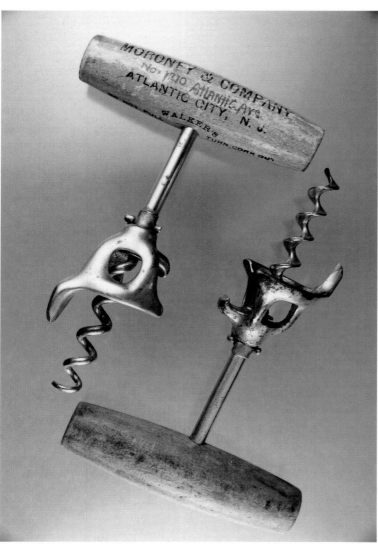

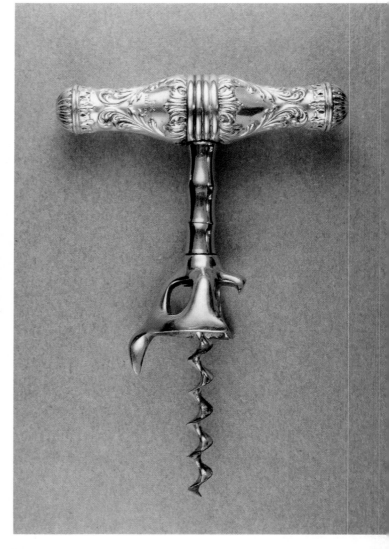

c.

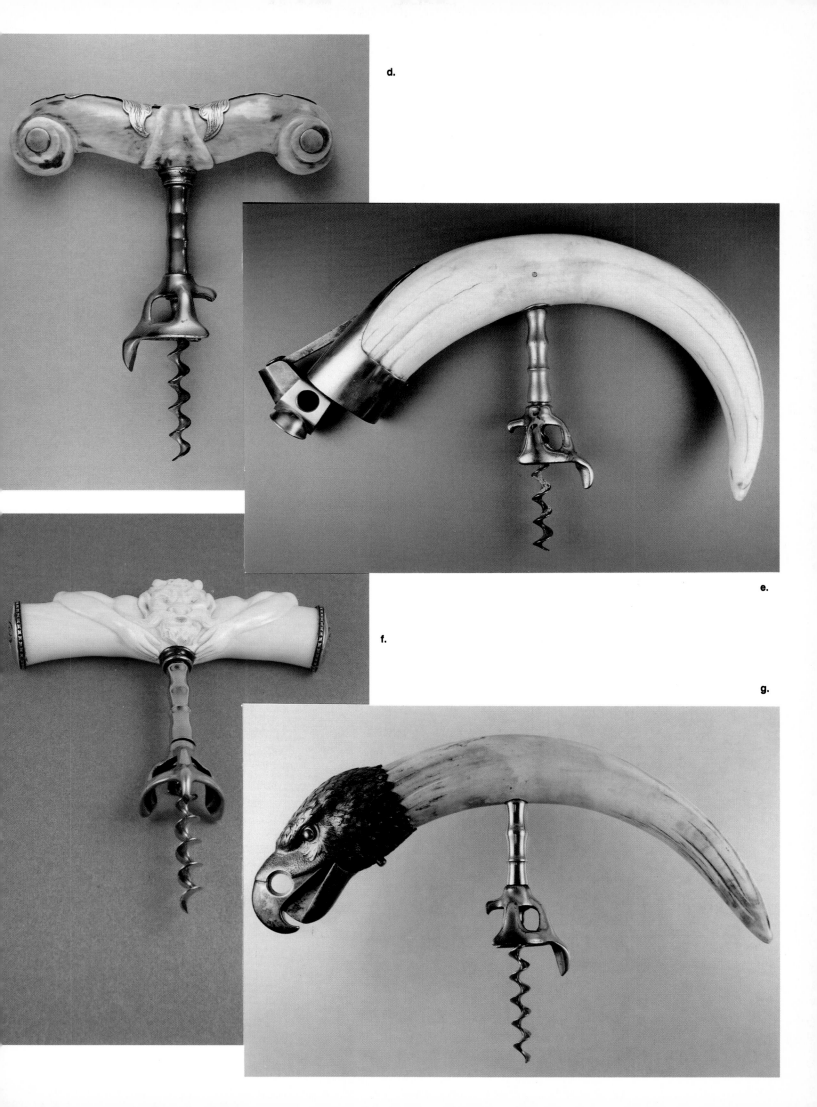

d.

e.

f.

g.

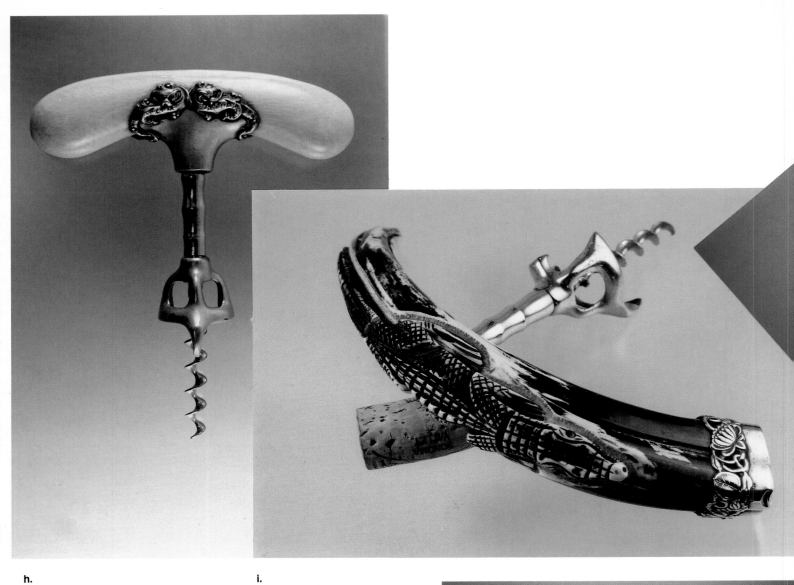

h.

i.

j.

k.

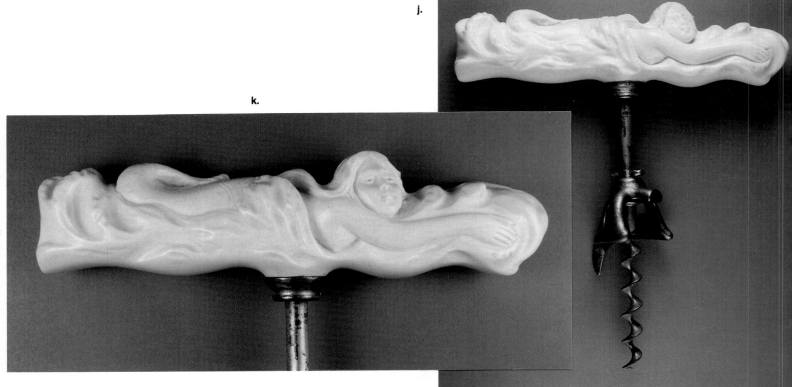

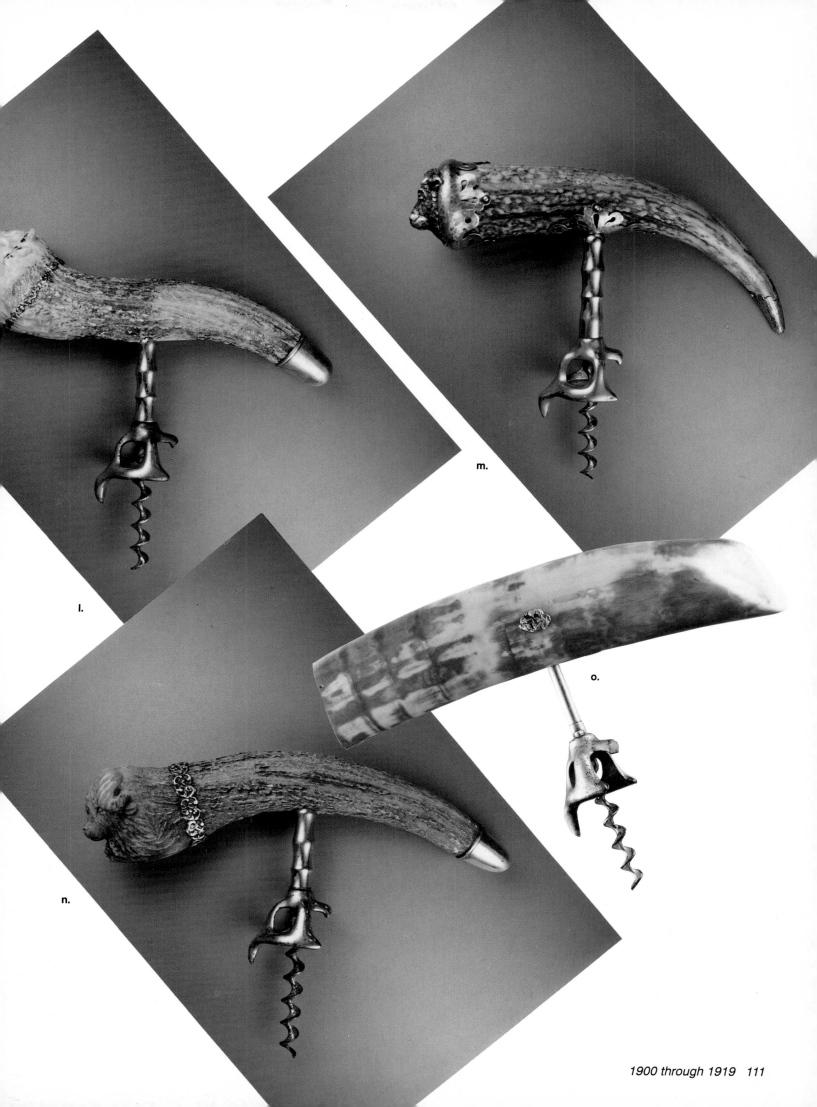

l.

m.

n.

o.

649,498
Edwin Walker
May 15, 1900
LITTLE QUICKER PATENTED JULY 23 1895
APR. 7 1896 PATS PENDING Another Walker
bar corkscrew of questionable marking apply-
ing to earlier patents. Curiously, a Canadian
patent exists for this exact machine. The 1900
U. S. patent is probably a closer match than the
marked patents, except for the jaw-like bottle
clamp, which is appropriate to the 1896 patent.
Courtesy of Ron MacLean.

654,089 (see also D-29,231, D-32,875)
William G. Browne
July 17, 1900
PAT 8-16-98 6-26 & 7-17-1900 Browne's
'cover-all-the-bases' marking on his final can
opener patent. None of the marked patents show
a corkscrew; 5.0". *Courtesy of Bob Nugent.*

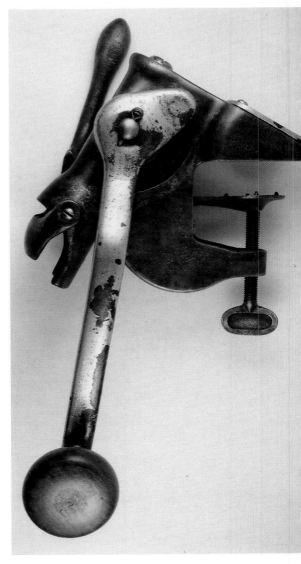

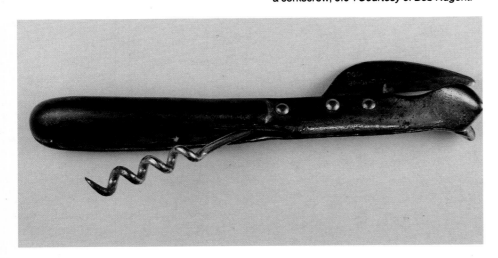

657,421 (see also 583,561)
Ralph W. Jorres, Assignor To William A.
Williamson
September 4, 1900
a. WILLIAMSON CO. NEWARK N. J. PAT-
ENTED SEP. 4, 1900 Jorres' improved round-
let, assigned to William A. Williamson. Manu-
factured in 'bottle', 'bullet' and plain case, just
as with former patent (No. 583,561). The differ-
ence is that the corkscrew is attached at a right
angle to a round disk that stores in the top rather
than the base; bottle and plain roundlet 2.8",
bullet 3.0". *Courtesy of Ron MacLean.* **b.** A ta-
pered case (same marking) was also manufac-
tured under this patent but not, apparently, the
earlier one; 2.8" closed.

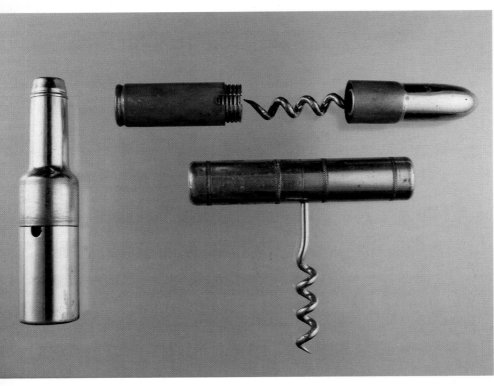

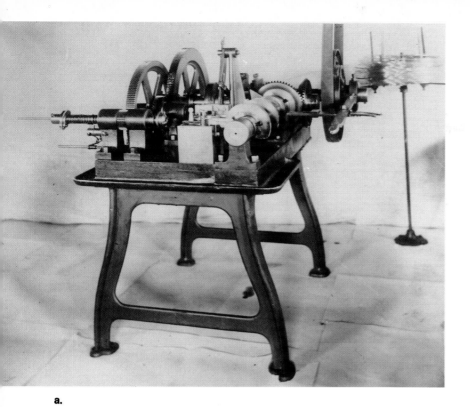

a.

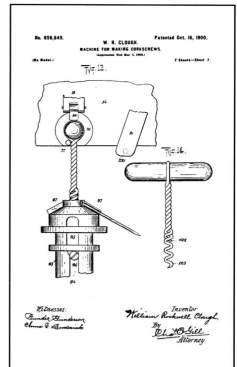

b.

659,649
William Rockwell Clough
October 16, 1900

a. Clough's machine for bending wire into a cork-screw. The wire is drawn from a spool seen in the right background. The finished product would emerge in the foreground, where the sharp eye will pick up the shape of Clough's Design patented handle (No. D-30,234). Clough often marked corkscrews with this patent date, even though it applies to the machine, not the corkscrew. *Photo courtesy of Jack D. Bandy.* **b.** The end product of the 12 page patent is illustrated in Sheet 7, Fig. 14. **c.** N. W. CO, CINCINNATI, O. PAT. OCT. 16, 1900 The ubiquitous wood sheath corkscrew, ideally suited for advertising; 3.7". **d.** At first glance the same as c. The difference is a left-hand worm. It is technically not appropriate to this patent, as the Clough machine could produce only right-hand worms. This corkscrew was hand made; 3.0". *Courtesy of Ron MacLean.* **e.** The "All-Ways Handy Combination," a tool combining two patents — a marked PAT. APR. 30, 1910 patent for the blade and Clough's wire corkscrew, advertising WITTER SPRINGS WATER. Shown engaging an original WITTER SPRINGS WATER bottle, with the sheath handle inserted into the corkscrew ring for pulling assist; 6" closed. **f.** In this example the wire corkscrew is back-loaded in an interesting milk opener, marked THE WIZARD PATENTED. *Courtesy of Bob Nugent.* **g.** FOUR-IN-ONE WARRANTED CAN & BOTTLE OPENER PAT. FEB. 10 '00, with advertising. The marked patent is not placed. Were it not for Clough, it might have been a Three-In-One tool. *Courtesy of Ron MacLean.* **h.** "BULL-DOG" This time the Clough is in the tail end of a can opener, which may or may not have a patent of its own; overall length 7.0". **i.** At one end of an otherwise conventional cleaver is a 'thing' that swivels from tack hammer to meat tenderizer. The functions in between can only be imagined. At the other end is an upstaged Clough corkscrew; overall length 14.7". **j.** CIGAR BOX & BOTTLE OPENER PAT. PEND., with related advertising; 9.0".

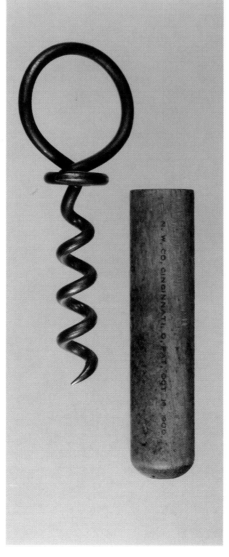

c.

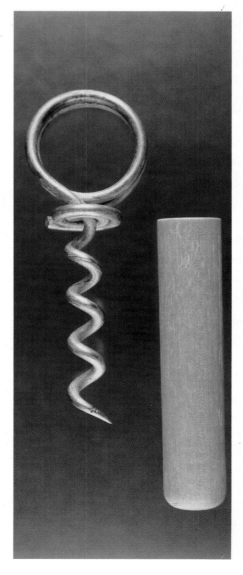

d.

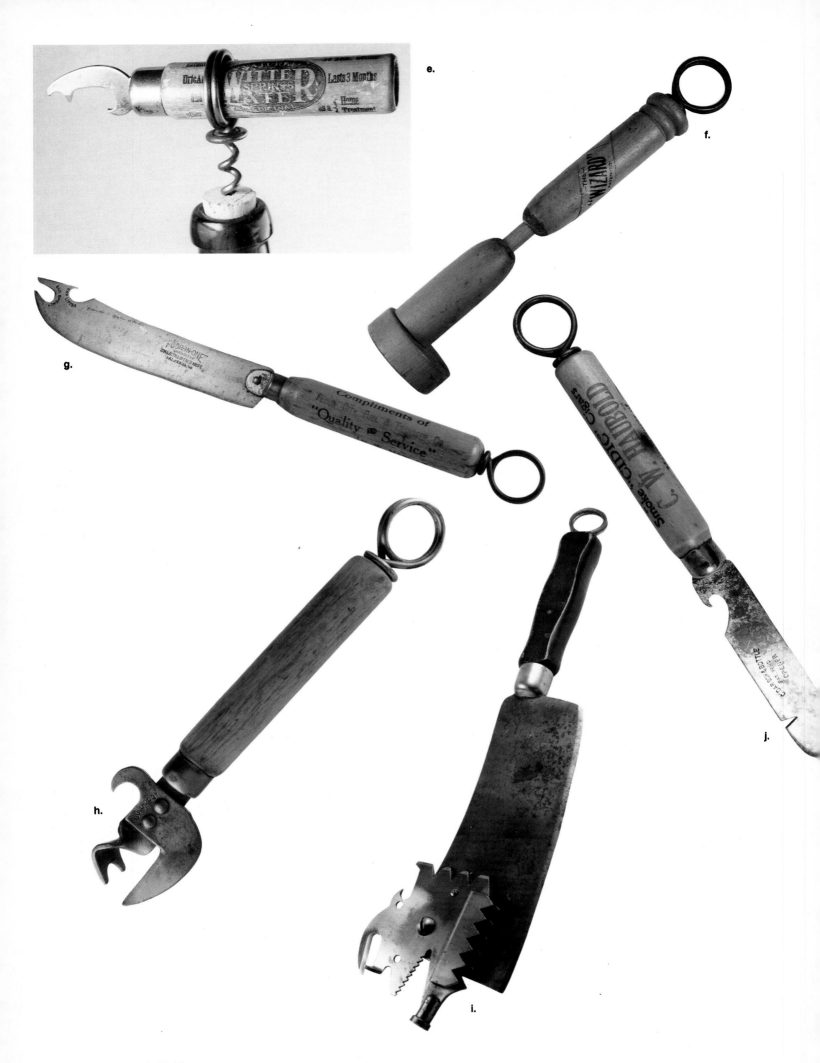

D-34,096
Augustus W. Stephens
February 19, 1901
A relatively common cap lifter with advertising, made rare by the addition of a corkscrew (a similar 'addition' was made to D-45,678), marked PAT'D FEB. 19 1901 CHICAGO SPEC. BOX CO.; 3.0". *Courtesy of Don Bull.*

672,796
John R. Murphy
April 23, 1901
A variation on the 'self-puller' bell. This one is by New Englander, John R. Murphy, son of Robert Murphy, maker of cutlery and corkscrews for over half a century. Murphy corkscrews are marked on the metal, not the handle. Left: PAT APR. 23 '01 R. MURPHY; 5.6". Right: R. MURPHY HARVARD, MASS PAT. APRIL 23, 1901 The antler handle is less common; 5.2". *Courtesy of Ron MacLean.*

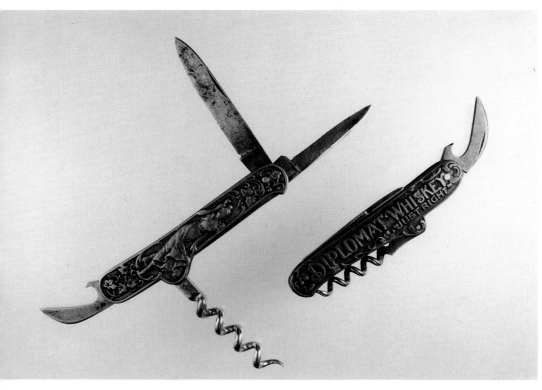

673,153
John D. Baseler, Assignor By Direct And Mesne Assignments, To Augustus W. Stephens
April 30,1901
Pocket knife attributed to Baseler's "Stopper Extractor" patent for its fold out cap lifter blade. Note most of the drawing labeling is concentrated on the cap lifter, which constitutes the patent. The sharpened point was specifically designed to puncture the stopper so that in the interest of health it could not be reused. The corkscrew and blades are not claimed. Left: WESPER BROS. GERMANY; 3.4" closed. *Courtesy of Jeffrey Mattson.* Right: GLASNER & BARZEN CO. GERMANY; 3.2" closed.

675,032
Albert Baumgarten
May 28, 1901
SHOMEE ALBERT PICK & CO. CHICAGO,
ILL PAT MAY 28 1901 Baumgarten's clamping
bar mount corkscrew is specifically designed to
partially pre-pull corks from "effervescing liquids"
(read beer), so they can be opened by hand
when ready to pour. The mechanism works with
one complete cycle starting from the down po-
sition.

675,051
Albert Baumgarten
May 28, 1901
Baumgarten's second bar corkscrew patent is-
sued on the same day as the "SHOMEE" (No.
675,032) but applied for 6 months later. Claim-
ing to be simpler (the patent *is* shorter by 7
pages), the fulcrum of the lever arm is a slot
guide attached to the casing rather than a strut.
Since the throw of the lever does not go beyond
180 degrees, it is suitable for either bar or wall
mounting. One complete crank up and down
completes the operation. **a.** PULLMEE ROB-
ERT PICK & CO. CHICAGO, ILL. PAT MAY 28
1901 MADE IN U. S. A. The clamp-down model.
Also includes spring bottle clamp levers. **b.**
FAMLEE MANNING BOWMAN & CO.
MERIDEN, CONN. U. S. A. PAT... FOR ("AP-
PLIED" covered up) The corresponding wall
mount model.

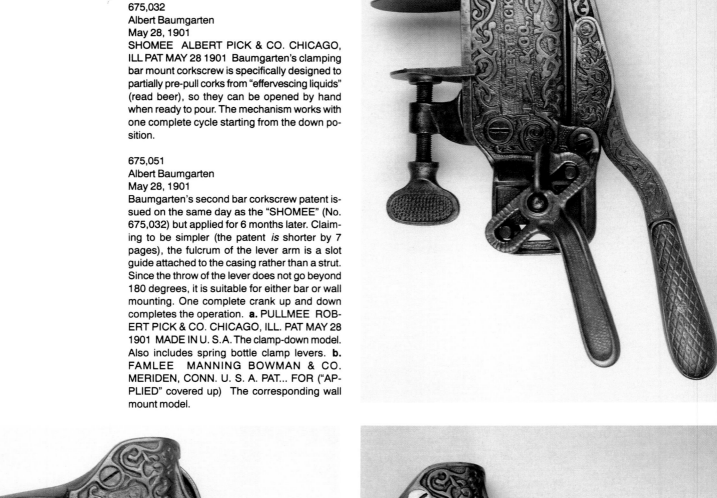

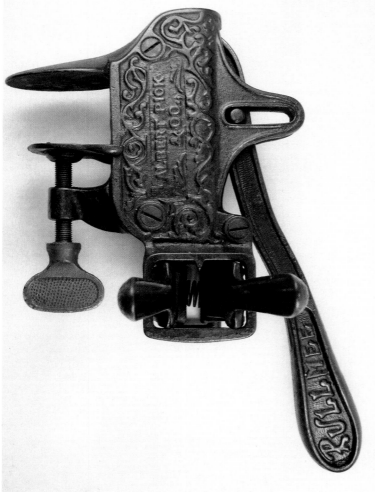

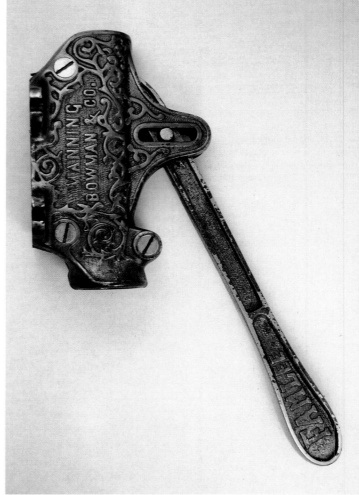

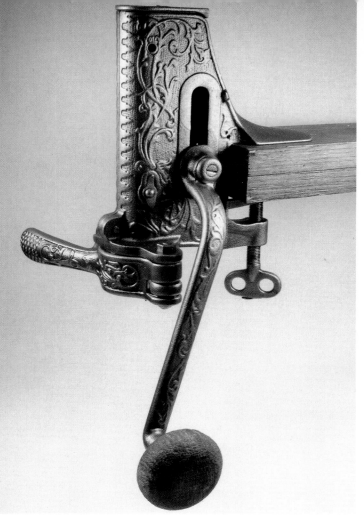

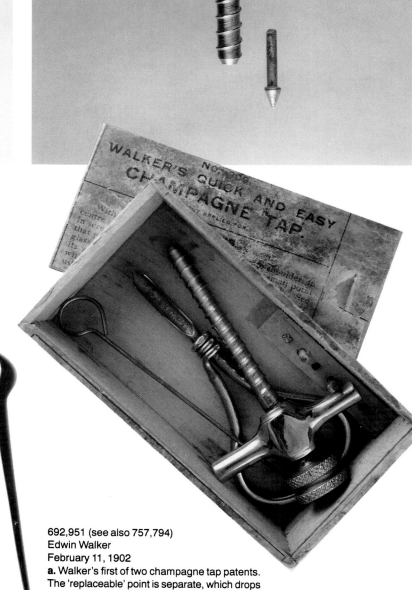

683,004
John Joseph Schermack, Assignor To Arcade Manufacturing Company
September 17, 1901
THE TRIUMPH PAT. APLD. FOR One of two Schermack bar corkscrew patents (the other is No. 686,908, not shown), both assigned to Arcade Manufacturing Company. The operation is completed in one cycle. Starting from a horizontal position, the lever arm is moved in an arc to the down position causing the pinion to travel down the fixed inner rack and the corkscrew to be inserted. Lifting the lever arm reverses the process. Schermack makes the specific point that the application of the power is in the direction of the result, an advantage over handles arranged to move in the opposite direction to the working parts, as for example the popular "Champion" whose extraction phase occurs while the handle is still moving down (No. 620,949).

702,001
Herbert H. Ham
June 10, 1902
PAT APPL'D FOR Like the name of its inventor, a very simple idea for a two-prong portable extractor; 3.6" closed.

692,951 (see also 757,794)
Edwin Walker
February 11, 1902
a. Walker's first of two champagne tap patents. The 'replaceable' point is separate, which drops into the bottle after insertion and has to be retrieved when empty. Since it is made of block tin, it often did not survive the first use. Hence the need for spares; 3.4" without point. b. Shown in original wooden box marked WALKER'S QUICK AND EASY CHAMPAGNE TAP with instructions. Includes gimlet, cleaning wire and spare points. *Courtesy of Ron MacLean.*

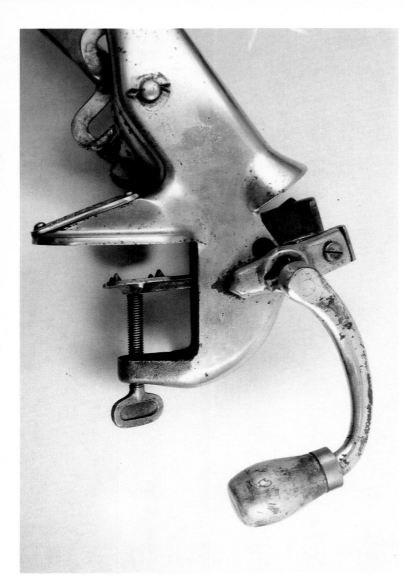

713,540
Edwin Walker
November 11, 1902
A bottle clamping mechanism for a bar mount corkscrew that Edwin Walker chose to take out as a separate patent. Raising the handle closes the jaws on the bottle and lifts it into the mouth of the puller.

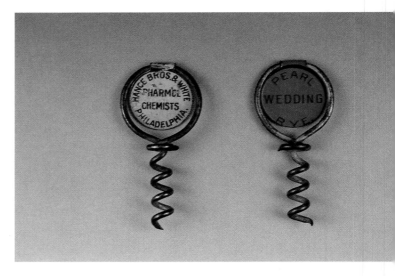

728,735
William J. Lowenstein
May 19, 1903
Wire corkscrews with advertising tags, which in this case are pawns in a "Bottle Attachment" patent taking two pages to describe. The corkscrew cannot be accessed "without first defacing the label, which renders it impossible to refill and use... a second time without detection." No patent marking, but the corkscrew is very likely manufactured by Clough; 1.8". *Courtesy of Bob Nugent.*

728,806
Charles Morgan, Assignor To Arcade Manufacturing Co.
May 19, 1903
PHOENIX PAT NOV 12 1895 SEP 7 1897 MAR 14 1899 Marked for prior patents (Nos. 549,607, 589,574 and 620,949), all connected with Arcade Manufacturing Company of Freeport, Illinois. The operation takes two pumps of the handle which causes the two 'over/under' catch levers to alternate engagement with the corkscrew nut. Note 'user friendly' bottle angle. Similar catch levers with an angled chassis appear on a "Williamsons New Era," the other of two rather different mechanisms with the same name, probably manufactured by Arcade under some arrangement with Williamson (not illustrated; see No. 620,949 for the other). *Courtesy of Jeffrey Mattson.*

747,351
Henry David Armstrong
December 22, 1903
'Lazy tongs' designed with long upper links to increase mechanical advantage. Note one less set of arms in comparison to patent drawings. Both types of shank mount are illustrated. Manufactured in England. **a.** H. D. ARMSTRONG. PATENT; 10.5" open. **b.** HEELEY'S ORIGINAL PATENT THE 'PULLEZI'; 10.0" open. *Both courtesy of Ron MacLean.*

757,794 (see also 692,951)
Edwin Walker
April 19, 1904
a. Walker's second of two champagne taps, improving on the former but making no reference to it in the specifications. The spout is angled and the point is formed of the tip of the hollow threaded shaft; 3.5". **b.** Shown in original wood box marked WALKER'S NO. 210 QUICK AND EASY CHAMPAGNE TAP PATENTED FEBRUARY 4TH, 1902. OTHER PATENTS ALLOWED. The date is one week prior to the earlier patent but the illustration clearly shows the later patent model. Contents include gimlet, spring ice pick and cleaning wire. *Courtesy of Bob Nugent.*

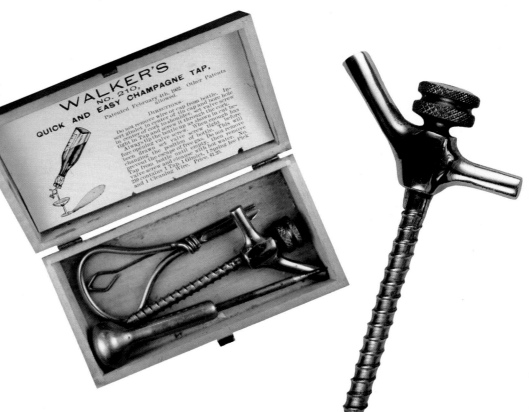

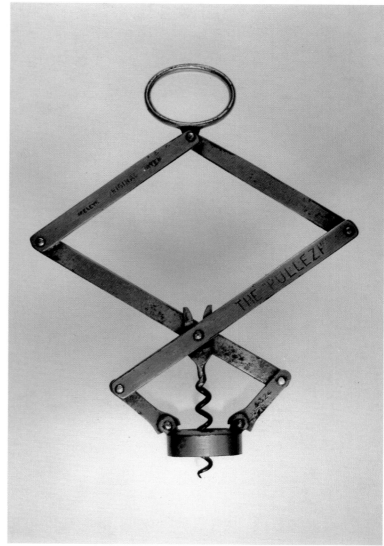

760,613
John M. Clark And John C. Crume
May 24, 1904
a. THE THOMAS MFG. CO. DAYTON, O. U.S.A. PAT FEB 11, 1902 Cans, bottles, jars, screws and careless fingers are no match for this attack tool by Clark & Crume. Marked for an only slightly less lethal earlier patent No. 692,828 which left out the corkscrew; 11.0". *Courtesy of Bob Nugent.* **b.** The earlier patent.

765,450
Frank White And Fred Winkler; Said Winkler Assignor To Said White
July 19, 1904
a. Three versions of a can opener patent armed with a corkscrew. Above: No. 95 "SURE-CUT" CAN & BOTTLE OPENER WITH CAP LIFTER (PAT. 7-19-04) Note fixed can piercing pivot spur and sliding adjustable blade; 6.3". Middle: "SURE-CUT" CAN OPENER PAT. 7-19-04 on flat shank, CAP LIFTER PATD CAN OPENER TEMPERED on fixed blade. Clough-type double loop wire corkscrew inserted at end of wood handle; 11.3". Below: No. 90 "SURE-CUT" CAN & BOTTLE OPENER WITH CAP LIFTER (PAT. 7-19-04) Note this lower number model is not equipped with sliding blade; 6.1". *Courtesy of Ron MacLean.* **b.** It's the American way: a later model does not measure up to the original, scaled down in all aspects although marked the same. Even the handle is unfinished. It was probably priced higher, though; original version 11.3", 'new and improved' version 10.1".

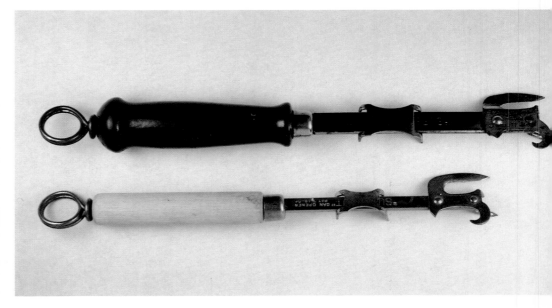

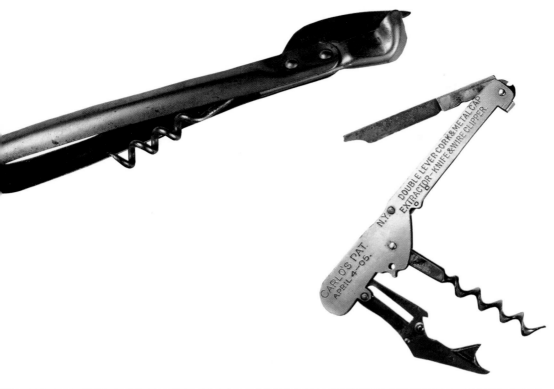

776,540
Graham C. Parish, Assignor To The W. G. Browne Manufacturing Company
December 6, 1904
PAT. APL'D FOR Patented by Graham Parish but assigned to W. G. Browne Manufacturing Co. Browne owned many can opener patents outright. Note the heavy handed manipulation of sheet metal. A specific claim is made for a loose pivot pin to hold the corkscrew, thus avoiding the need for one whole rivet!; 5.9". *Courtesy of Bob Nugent.*

786,492
Carlo F. Garimaldi
April 4, 1905
CARLO'S PAT APRIL 4-05. N. Y. DOUBLE LEVER CORK & METAL CAP EXTRACTOR - KNIFE & WIRE CLIPPER Carlo Garimaldi's highly engineered 'waiter's friend' and wire cutter, designed to adjust the lever fulcrum while in progress, allowing the cork to be pulled all the way out without causing stress to the bottle or having to finish the job manually; 5.0" closed. *Courtesy of Ron MacLean.*

789,103
Arthur Merton Parker
May 2, 1905
PAT. MAY 2, 05 AGT.S WANTED MERTON PARKER LOS ANGELES Often the manufactured piece differs in the details from the patent drawing. Includes fixed and sliding can opener blades, corkscrew and knife sharpener. Like any good 'kitchen-tool' there is also the indispensable glass cutter and breaker; 7.0".

794,057
James M. Sullivan, Assignor Of One-Half To George E. Caughey
July 4, 1905
HAYNES-BATES MF'G CO. HIGH GRADE TOOL STEEL WARRANTED PATENT PENDING This tool looks more useful on paper than it was in real life, especially the corkscrew. Of course, if it fails the axe might come in handy...; 13.0".

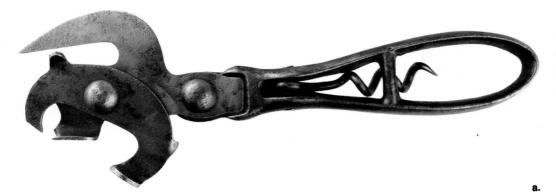

796,352
Julius Warren Quilling
August 1, 1905
Quilling's unmarked combination tool with cork-screw having both fixed and moveable jaws for opening cans and pulling tacks; 5.8".

a.

824,807 (see also 793,318)
Harry W. Noyes, Assignor To James A. MacLeod, Trustee
July 3, 1906
a. Noyes' patent with less conventional *center* pivot arm requiring downward pressure to lift cork. More significantly perhaps, it is an example of a corkscrew used as part of an ad campaign. Above and below: UNIVERSAL JUNE 27 '05 JULY 3 '06; 3.5" closed. Below only: Advertising GREEN RIVER THE WHISKEY WITHOUT A HEADACHE. **b.** The object of all the attention: an original bottle shown after having induced the non event. *Courtesy of Ron MacLean.* **c.** Metal advertising sign; 24.8" x 18.8". **d.** Blotter, watch fob and medallion. Advertising paraphernalia not shown is known to include ash trays and serving trays.

b.

d.

c.

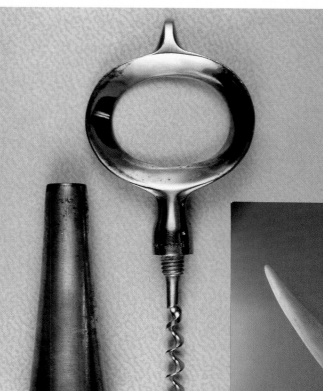

D-38,166
John Hasselbring
August 14, 1906
PAT. 1906 STERLING A Design patent for a "Bottle Opener" by Hasselbring incorporating a 'Baltimore Loop' seal cutter prong, often including a corkscrew, although none indicated in patent. **a.** Shown with sterling sheath; 4.9" closed. **b.** Antler types, made with and without corkscrew; 6.5" and 7.0" closed, respectively.

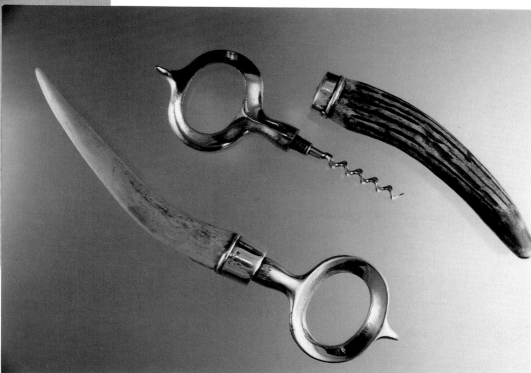

839,229
Charles G. Taylor
December 25, 1906
"YANKEE" CAN & BOTTLE OPENER PAT. JAN. 28, 02 DEC. 25, 06 on handle, THE TAYLOR MFG. CO. PAT. JAN. 28, 02-DEC. 25, 06 HARTFORD, CONN. on blade. Not to be confused with Raymond Gilchrist's "Yankee" series (No. 857,992), which also played on the dual connotation of pulling and patriotism. With all that marking 'sizzle', one would expect a patent of substance. In this case the 'steak' consists of the peculiar bending and riveting of the can rim guide. The earlier patent date applies to No. 692,045 for a can opener only (not on list); 5.5".

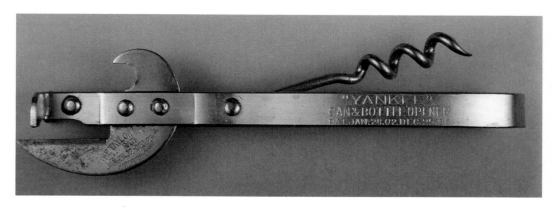

847,744
Albert Dudly, Sr.
March 19, 1907
DUDLY TOOL CO. MENOMINEE, MICH. PATENT PENDING A two-prong pocket cork extractor with one removable adjusting prong and one pivoting prong which deploys a cap prying "claw" when closed. **a.** In cork extracting mode. **b.** In 'pocket' and cap lifting mode, showing detail of "claw;" 3.7" closed. *Courtesy of Jeffrey Mattson.*

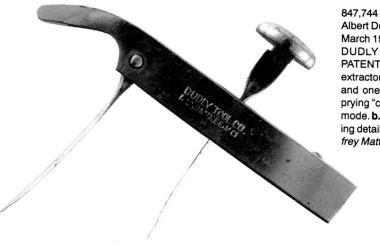

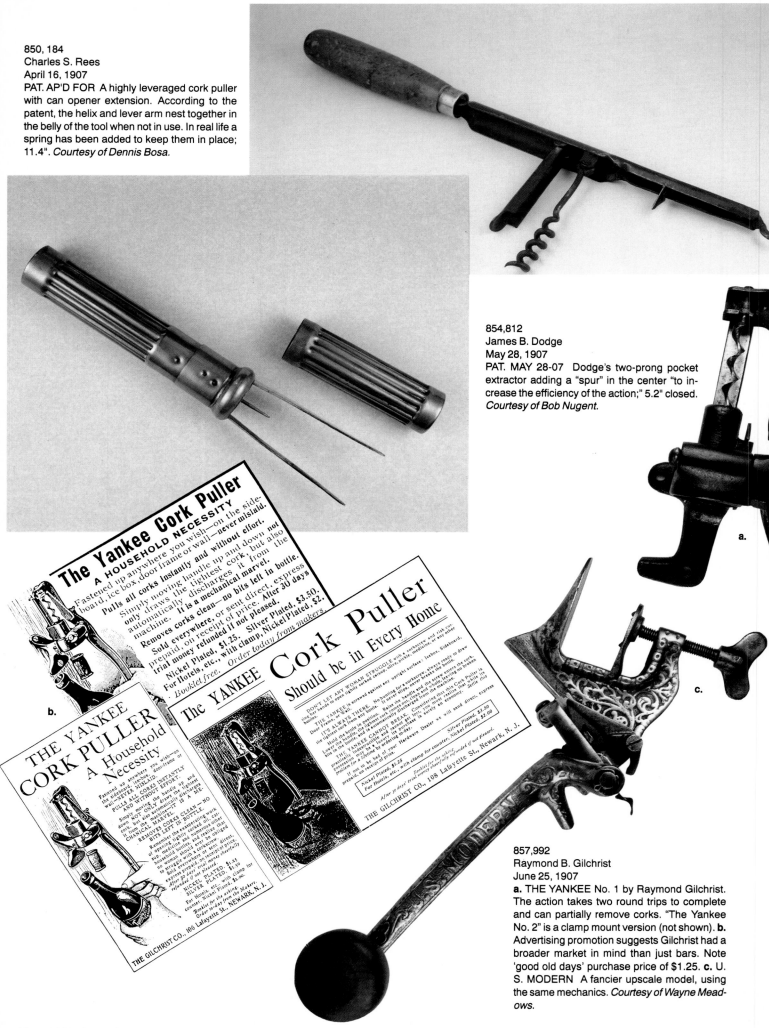

850, 184
Charles S. Rees
April 16, 1907
PAT. AP'D FOR A highly leveraged cork puller with can opener extension. According to the patent, the helix and lever arm nest together in the belly of the tool when not in use. In real life a spring has been added to keep them in place; 11.4". *Courtesy of Dennis Bosa.*

854,812
James B. Dodge
May 28, 1907
PAT. MAY 28-07 Dodge's two-prong pocket extractor adding a "spur" in the center "to increase the efficiency of the action;" 5.2" closed. *Courtesy of Bob Nugent.*

a.

c.

857,992
Raymond B. Gilchrist
June 25, 1907
a. THE YANKEE No. 1 by Raymond Gilchrist. The action takes two round trips to complete and can partially remove corks. "The Yankee No. 2" is a clamp mount version (not shown). **b.** Advertising promotion suggests Gilchrist had a broader market in mind than just bars. Note 'good old days' purchase price of $1.25. **c.** U. S. MODERN A fancier upscale model, using the same mechanics. *Courtesy of Wayne Meadows.*

883,988
William T. Vallandingham
April 7, 1908
A simple non-screw extractor and cap lifter in the format of a pocket knife. The patent also specifies it could be attached to a key ring or mounted to a handle. Unmarked; 6.3".

896,577 (see also 541,034)
Clark W. Reynolds, Assignor To The Browne & Dowd Mfg. Co.
August 18, 1908
A miniature is sandwiched by two normal size versions of Reynolds' "Combination Tool," well covered by patents and merchandised under the "King" logo. Like the earlier patent (No. 541,034), this patent is assigned to Browne & Dowd Mfg. Co. No version has yet been found with the cap lifter on the same side as the can opener blade, as pictured at the bottom of the patent. Above: KING PAT MAY 17-92 & JUNE 11-95 on handle, PAT. AUG. 18, 08" on cap lifter blade. The patent referenced by the earliest date (No. 475,222) does not include a corkscrew; 5.4". Middle: THE BROWNE LINE FROM KINGSTON Probably a salesman's sample; 3.1". Below: KING PAT. JUNE 11-95 & AUG 18-08 on handle; 5.4".

899,408 (see also 899,407)
Otto Kampfe
September 22, 1908
KAMPFE BROS. N. Y. PAT. SEP. 22,1908 In applications submitted 7 months apart, Kampfe received consecutive patents for a pocket combination tool. The second patent adds a can opener, which is the only function on the tool pictured. Nor, obviously is it for the pocket; 5.6".

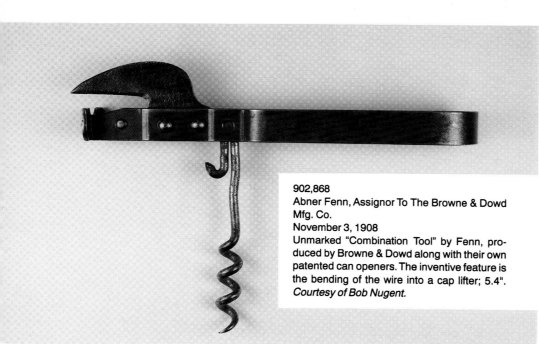

902,868
Abner Fenn, Assignor To The Browne & Dowd Mfg. Co.
November 3, 1908
Unmarked "Combination Tool" by Fenn, produced by Browne & Dowd along with their own patented can openers. The inventive feature is the bending of the wire into a cap lifter; 5.4".
Courtesy of Bob Nugent.

899,380
Sarah E. Braddock
September 22, 1908

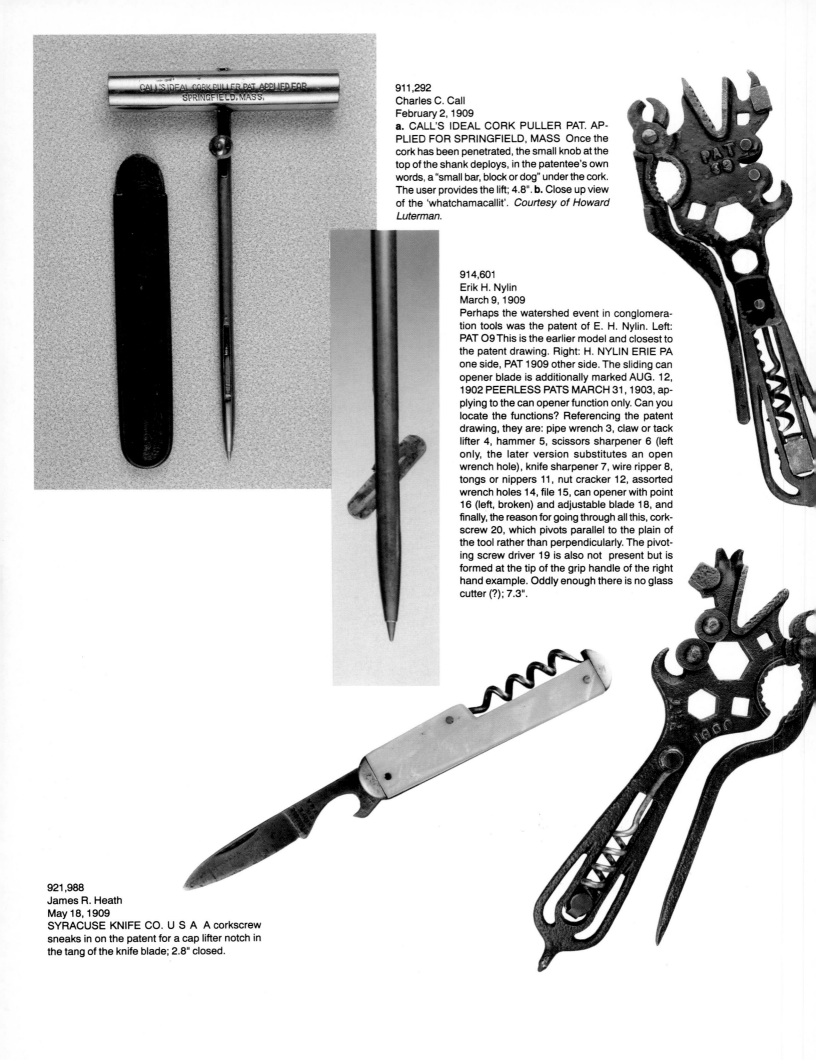

911,292
Charles C. Call
February 2, 1909
a. CALL'S IDEAL CORK PULLER PAT. AP-PLIED FOR SPRINGFIELD, MASS Once the cork has been penetrated, the small knob at the top of the shank deploys, in the patentee's own words, a "small bar, block or dog" under the cork. The user provides the lift; 4.8". **b.** Close up view of the 'whatchamacallit'. *Courtesy of Howard Luterman.*

914,601
Erik H. Nylin
March 9, 1909
Perhaps the watershed event in conglomeration tools was the patent of E. H. Nylin. Left: PAT O9 This is the earlier model and closest to the patent drawing. Right: H. NYLIN ERIE PA one side, PAT 1909 other side. The sliding can opener blade is additionally marked AUG. 12, 1902 PEERLESS PATS MARCH 31, 1903, applying to the can opener function only. Can you locate the functions? Referencing the patent drawing, they are: pipe wrench 3, claw or tack lifter 4, hammer 5, scissors sharpener 6 (left only, the later version substitutes an open wrench hole), knife sharpener 7, wire ripper 8, tongs or nippers 11, nut cracker 12, assorted wrench holes 14, file 15, can opener with point 16 (left, broken) and adjustable blade 18, and finally, the reason for going through all this, cork-screw 20, which pivots parallel to the plain of the tool rather than perpendicularly. The pivoting screw driver 19 is also not present but is formed at the tip of the grip handle of the right hand example. Oddly enough there is no glass cutter (?); 7.3".

921,988
James R. Heath
May 18, 1909
SYRACUSE KNIFE CO. U S A A corkscrew sneaks in on the patent for a cap lifter notch in the tang of the knife blade; 2.8" closed.

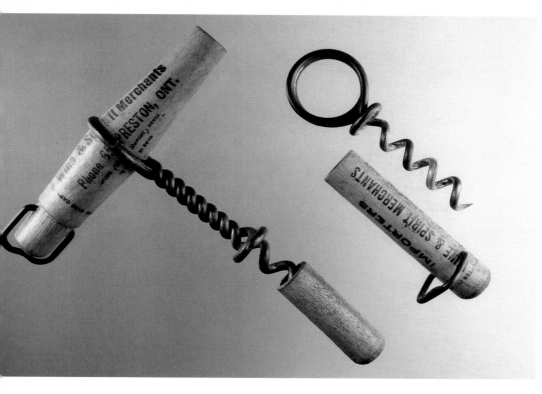

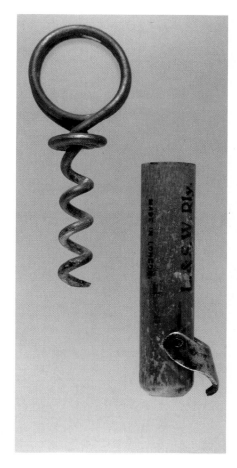

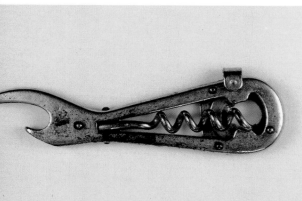

950,509
William Rockwell Clough
March 1, 1910
Another Clough patent, this time not for a cork-screw, but for a cap lifter attached to a wood handle or sheath. **a.** Left: "TRADE (DECAPITA-TOR) MARK" MADE IN U.S.A. under side of handle, (obscure...) LIFTER PAT. MAR. 1, 1910 at cap lifter end, advertising GUINNESS. BULL-DOG; 4.2". Right: PAT. MAR. 1, 1910, advertising SUNNY TIMES WHISKEY; 3.7" closed. *Courtesy of Ron MacLean.* **b.** L. & S. W. RLY. (sic.) REFRESHMENT DEPARTMENT MADE IN LONDON CORKSCREW AND CROWNCORE OPENER English made version illustrating a "saddle piece" cap lifter instead of a wire "stirrup piece;" 3.7" closed. *Courtesy of Dennis Bosa.*

958,092
Harry A. Chippendale, Assignor To James Sweeney
May 17, 1910
BESTEVER PAT. APPLIED FOR A smallish tool by Harry Chippendale which bases its claim of novelty on the cigar cutter; 3.0". *Courtesy of Bob Nugent.*

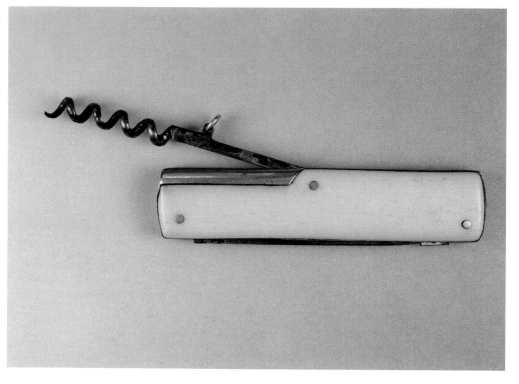

989,680
Carl Wilhelm Windhövel And Cuno Weÿer
April 18, 1911
A pocket knife with another patentable idea for a full length worm. This one is a 'J-hook' at the top of the shank which slides to the center until engaged by a fixed pin; 3.4" closed, 3.3" open. *Courtesy of Bob Nugent.*

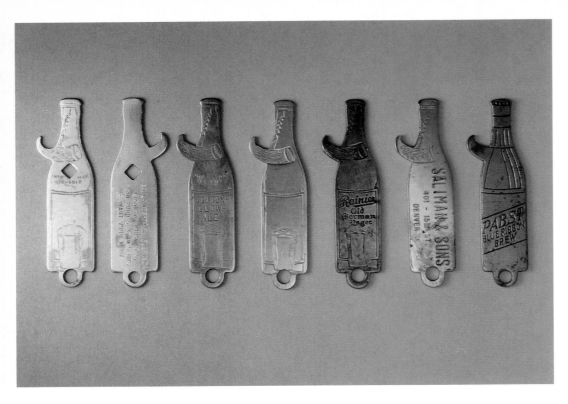

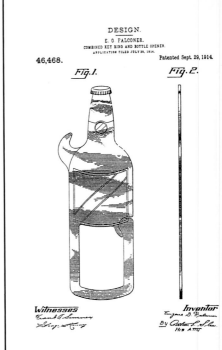

D-42,305
John L. Sommer, Assignor To J. L. Sommer Mfg. Co.
March 12, 1912
a. Sommer's "Bottle Opener" stamped out of sheet metal showing a progression of styles. From left: original patent form marked PATD MAR 12-1912, with square wrench hole, known as a "Prest-O-Lite" key for controlling the acetylene gas stored on the running board of automobiles, used for lighting the 'headlamps', and cartoon of 'label' and 'corkscrew'; flip side showing advertising on blank surface; original car-

toon with patent marking and no longer needed wrench hole eliminated; original generic cartoon with no patent mark or advertising; original cartoon with 'label' taken over for advertising; 'label' replaced with advertising but 'corkscrew' maintained; 'label' and 'corkscrew' replaced by different cartoon eliminating design rationale for cap lifter prong; 3.1". *Third from left courtesy of Ron MacLean.* **b.** Two years later E. G. Falconer patented a similar design which ignored the corkscrew cartoon altogether but added a key holder (No. D-46,468, not on master list).

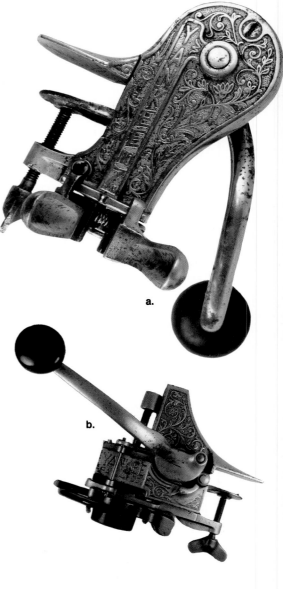

a.

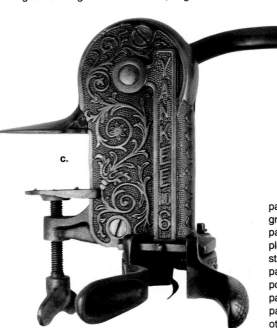

c.

1,058,361 (see also D-37,417, 823,678)
Raymond B. Gilchrist, Assignor To The Gilchrist Company
April 8, 1913
a. YANKEE NO 7 Three patents are combined in the culmination of the "Yankee" series, by Raymond Gilchrist (see No. 857,992 for Yankees No "1" and "2"). The Design patent (No. D-37,417) is for the looks of the casing. The utility

patent (No. 823,678) applies to the spring bottle grips. The meat and potatoes are in the later patent (No. 1,058,361). The mechanism completes its mission in one round trip of the handle, starting in the position pictured and traveling just past vertical before returning to the start/finish position. Gilchrist waited nearly 10 years for the patent to be issued, the longest of any corkscrew patent. By that time no wonder he had found other ways to make a living. **b.** YANKEE NO 6 Except for the bottle grips, no patent has been claimed or can be attributed to this less common model, but is included anyway for those keeping score. No evidence exists of a "3," "4" or "5". The action is the same as a YANKEE NO 7 except for having the opposite start/finish position. **c.** YANKEE PAT. APLD Gilchrist did patent a corking machine, predictably naming it "YANKEE" (No. 899,525, not on list). There is no evidence linking it to the "Yankee" series.

b.

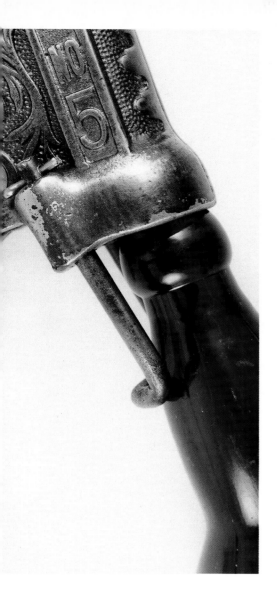

1,058,362
Raymond B. Gilchrist, Assignor To The Gilchrist Company
April 8, 1913
Close up of Gilchrist's patent for a "Bottle Holder," shown on a German made "HERO No 5".

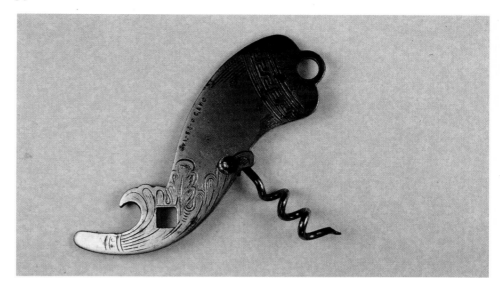

D-45,678
John L. Sommer, Assignor To J. L. Sommer Manufacturing Co.
April 28, 1914
Another common bottle opener stamped out of sheet metal, made rare by the addition of a corkscrew (D-34,096 had a similar conversion). Marked PAT'D 4-28-14; 3.1".

D-47,755
Charles Morgan, Assignor To Arcade Manufacturing Company
August 24, 1915
PIX ALBERT PICK & COMPANY CHICAGO, U. S. A. Charles Morgan's 'Champion' dressed up in 'modern' attire.

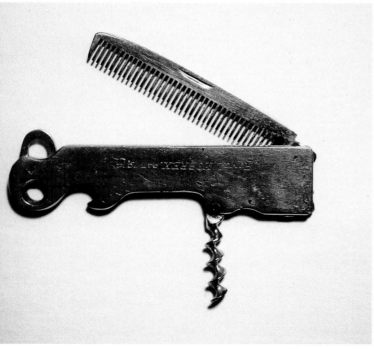

1,109,073
Joseph Charles Auguste Labrèche
September 1, 1914
ROYAL KOBREX. PAT. 1914 A tool of questionable utility even for its day. As a result, a great find for a cigar cutter, corkscrew or comb collector; length, 3.8".

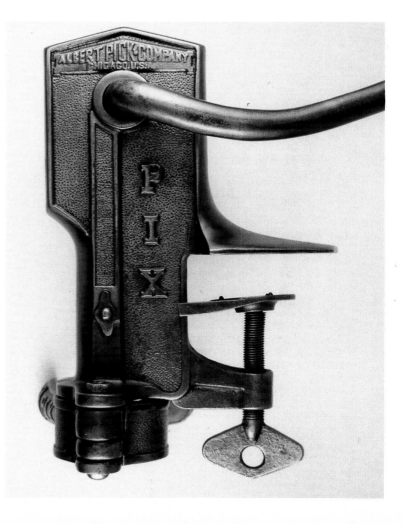

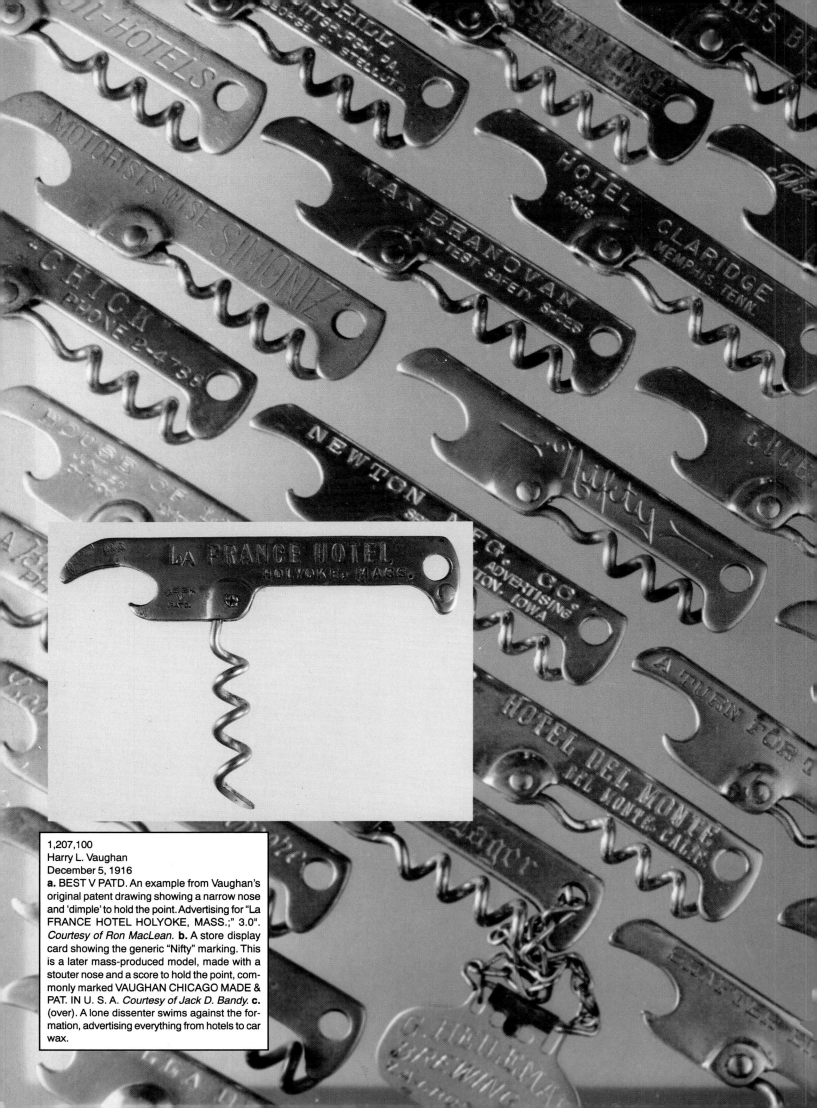

1,207,100
Harry L. Vaughan
December 5, 1916
a. BEST V PATD. An example from Vaughan's original patent drawing showing a narrow nose and 'dimple' to hold the point. Advertising for "La FRANCE HOTEL HOLYOKE, MASS.;" 3.0". *Courtesy of Ron MacLean.* **b.** A store display card showing the generic "Nifty" marking. This is a later mass-produced model, made with a stouter nose and a score to hold the point, commonly marked VAUGHAN CHICAGO MADE & PAT. IN U. S. A. *Courtesy of Jack D. Bandy.* **c.** (over). A lone dissenter swims against the formation, advertising everything from hotels to car wax.

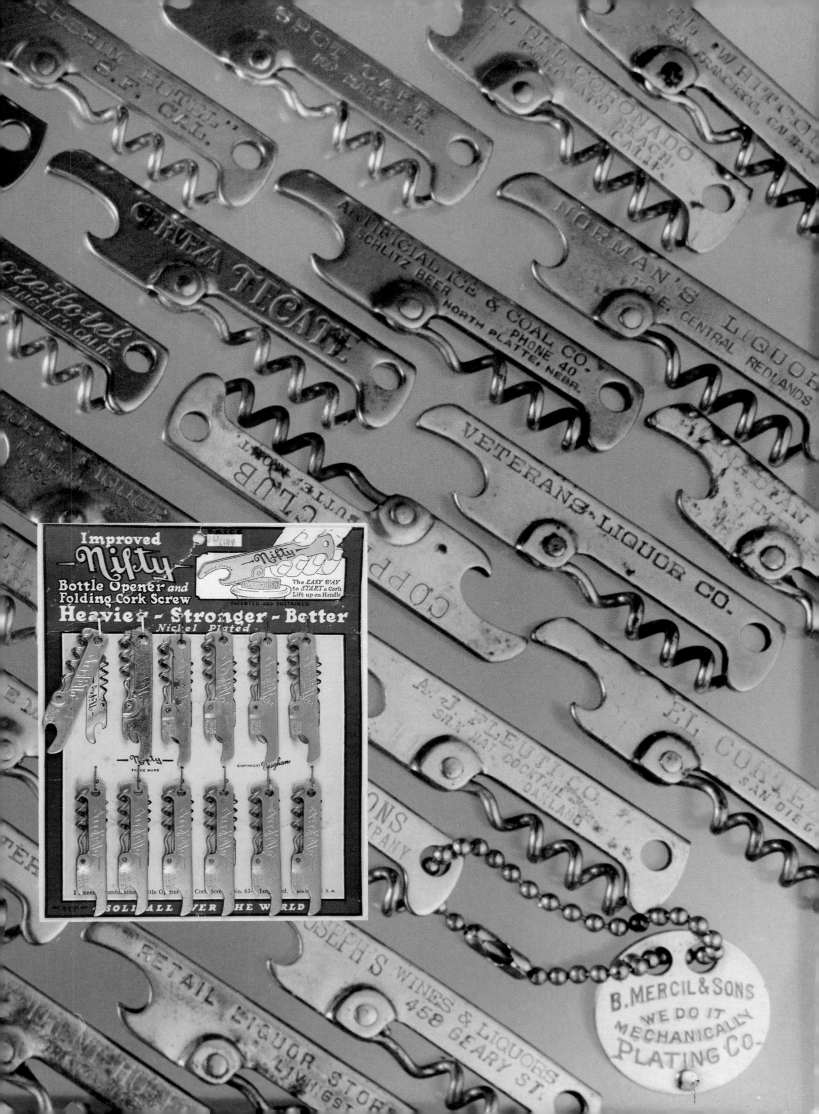

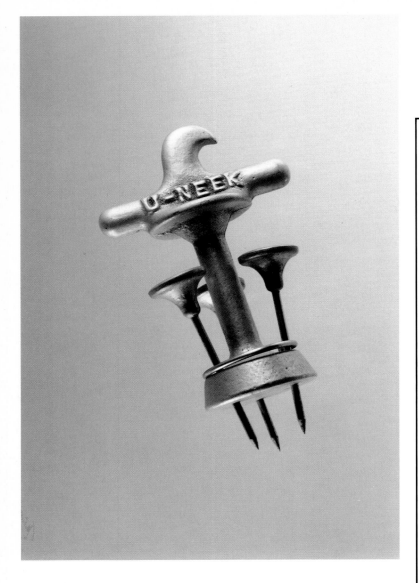

1,213,452
Wilson M. Brady
January 23, 1917
a. U-NEEK one side, PATD other side; 2.7". **b.** "Directions for Operating," which communicates all the same information as the patent specifications, only for a different audience.

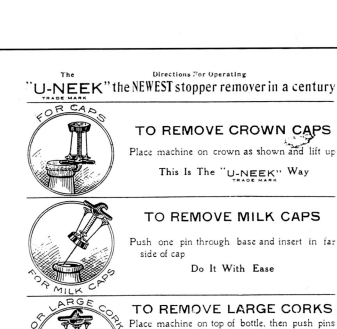

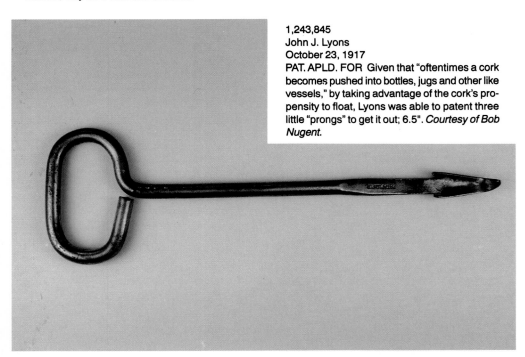

1,243,845
John J. Lyons
October 23, 1917
PAT. APLD. FOR Given that "oftentimes a cork becomes pushed into bottles, jugs and other like vessels," by taking advantage of the cork's propensity to float, Lyons was able to patent three little "prongs" to get it out; 6.5". *Courtesy of Bob Nugent.*

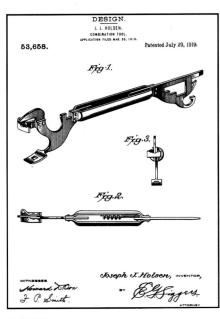

D-53,658
Joseph J. Holsen
July 29, 1919

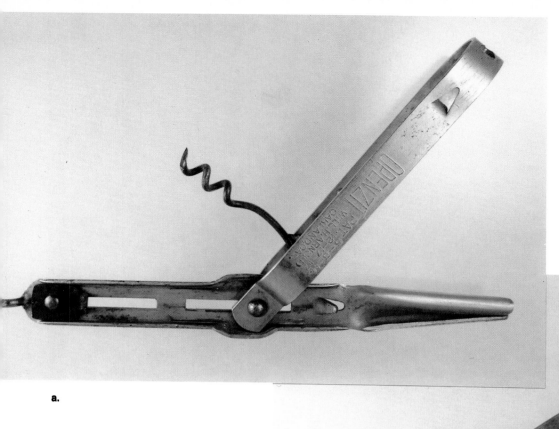

1,250,413
William H. Arnold
December 18, 1917
OPENZIT PAT 5-5-14 12-17-17 WILL H.
ARNOLD OAKLAND, CA. **a.** The patented ver-
sion; 7.3" closed. *Courtesy of Dennis Bosa.* **b.**
This example drops the main feature of the origi-
nal tool, which was to open roll-back cans, com-
monly used for sardines; 7.5". *Courtesy of Jack
D. Bandy.*

a.

1,258,035
William M. Moore
March 5, 1918
Moore's "Can Opener" in which he claims in his
own words, "I may here point out that it is the
unique construction associated with the blade...
(lower left) that constitutes the subject matter of
the present invention, and not any broad com-
bination of a plurality of old and well known tools."
Only the point, is the only point of the patent.
Advertising BJELLAND'S CANNED GOODS
and KING OSCAR SARDINES; 4.5" closed, 7.2"
open.

b.

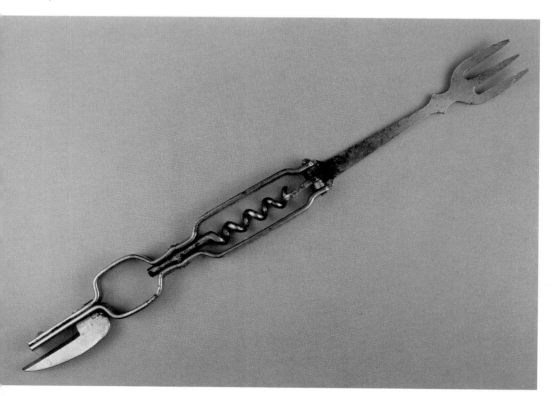

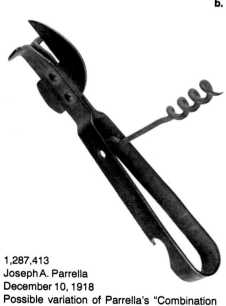

1,287,413
Joseph A. Parrella
December 10, 1918
Possible variation of Parrella's "Combination
Tool," unmarked; 5.8". *Courtesy of Bob Nugent.*

1919 - 1933 Prohibition

(Early 1930s) The Depression

March 4, 1933 Franklin Delano Roosevelt takes
office, introducing the New Deal in the
first 100 days

April 30, 1939 Opening of the New York World's
Fair - first glimpse of TV and nylon stock-
ings

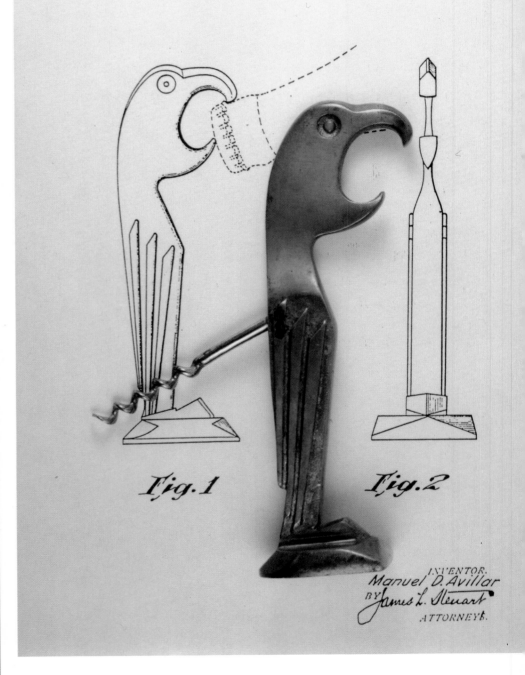

D-78,554
Manuel D. Avillar
May 21, 1929
WILLIAMSON'S on shank. Large version of the
Avillar 'parrot', equipped with a marked
Williamson worm. This polly is a bronze; 6.5".

CHAPTER 4
1920 THROUGH 1939

135 Corkscrew Patents

The victors were back home again only to find that while they were gone, the punch bowl had been stealthily removed by the 18th Amendment. While the United States had reluctantly entered World War I late in 1917, once the commitment was made, it prosecuted the conflict in characteristic fashion — with an all out mobilization of its resources. Men-boys fought in the trenches while at home the full ferocity of American industry produced the guns and tanks to support them.

The window of opportunity was not lost on the Temperance movement, whose decades of murmuring suddenly coalesced into a united strategy perpetrated onto a distracted nation. With some justification, the country was perceived as being in a collective drunken stupor. Fathers were more preoccupied with heads of beer than being heads of households. With most of the beer made by those of German extraction, the idea had patriotic overtones as well, for a vote for Prohibition was a vote against the Kaiser. Being of foreign heritage and largely centered in urban areas, the 'low-life' majority was no match for the moral fanaticism of the more vocal minority, which accomplished its mission when New Hampshire became the 36th state to ratify the 18th Amendment in 1919.

Corkscrew patenting was not a high priority, if not highly immoral and unpatriotic in the view of the circumstances. The crown cap had beaten back the bar mount corkscrew, do-it-yourself home carpenters found they didn't need a corkscrew on a building tool, and now wine and whiskey were illegal. That did not bode well for corkscrews.

In fact under the circumstances one would have expected the country to go into some kind of national funk. Instead they threw a party. Known as the "Roaring 20s," things might have been much tamer were it not for Prohibition. As opposed to the serious development of literature and industry of the prior 20 years, this was the period of mass frivolity. Talking pictures, the Charleston, George Gershwin, Irving Berlin, Richard Rogers, "Speakeasies," bathtub gin and gangsters became the national landscape. America was top dog, having seemingly put an end to tyranny once and for all, protected by two oceans that insulated the closed mind from having to deal with a still festering world. Leverage in the 1920s was what one used to buy stocks, not arm corkscrews. Bottles were being opened by a new method — the Federal Agent's axe — only to be replaced the next day through an underground nocturnal mass merchandising system, better known as "bootlegging." Fads came and went like a school of herring, flashing off in one direction then reversing with the slightest provocation, each individual conforming to the compulsive action of the school. Cab drivers were giving stock tips to bankers, corruption reached all the way to the White House in the Harding Administration and Charles Lindbergh became the first person to fly across the Atlantic alone. Harry Houdini performed death defying stunts, some by escaping an underwater grave from his own patented diver's suit (No. 1,370,316) and women earned the right to vote with the ratification of the 19th Amendment in 1920.

Like Houdini, corkscrew inventors refused to be held in bondage by Prohibition. Obviously no Government Agency was going to issue a patent condoning liquor consumption, so patents had to become dry too (never a problem for a good patent attorney!). Bottles simply ceased to contain alcohol. Pettingell's 1916 patent was the last of that! (No. 1,203,257). There would be no mention of wine, liquor, beer, etc. until the 1935 patent of D. F. Sampson, when "beer" was restored to the vocabulary (No. 1,996,550). Bottles became generic and descriptions spurious, to the point of being apologetic. Hence Roberts, "*If desired* a corkscrew... can be combined with the can opener..." (No. 1,461,162); Salomone, "*For convenience*, a cork-screw... is provided... " (No. 1,805,011); Vitali, "A corkscrew *is shown...*" but never, ever, n-e-v-e-r would it be used for opening an alcoholic beverage (No. 1,814,014)!

Albert Charbonneau, of Boston, Massachusetts obtained a patent for a "Compound Appliance" in 1931 (No. 1,814,895) whose only difference from a 1926 patent (No. 1,610,158) was the addition of a corkscrew. Aside from the generic title, here's how he danced around the forbidden implications of his idea:

"This invention... consists in utilizing certain of the essential portions of the (earlier) patented construction for the purpose of attaching and housing an *added instrumentality...*"

The corkscrew as an "added instrumentality" — spoken like a good patent attorney!

Another approach was to be very specific about the benign purpose of the 'major' parts of the tool while treating the corkscrew as an insignificant other. Henry Thompson, in the first of two nearly back-to-back patents had this to say:

"A primary object of the invention is to provide a simple and efficient device... which may be used either for removing bottle caps, jar covers generally found on olive jars, jam jars, etc., and also for withdrawing corks" (No. 1,930,492).

Note Thompson didn't tag on, "for beer bottles, wine bottles, etc.." There was no prohibition against olives and jam.

A glance at Thomas Harding's patent of August 14, 1928 (No. 1,680,291) suggests a straight forward, rather simple device, appropriately called "Corkscrew." Typical of patent language, there is everything to do with the minutia of construction and very little to do with the application of the invention. The phenomenon is attributable to patent legalese, exacerbated in this case by Prohibition phobia. A patent represents a compromise between the inventor who seeks the widest possible protection and the Patent Office which endeavors to limit the scope to a very tight criteria, thereby encouraging other patenting to follow and discouraging infringement contesting in court. A patent application with very little language describing the invention is immediately suspected of being too broad. Therefore, patent attorneys have developed a ritualistic style of describing inventions with as much verbosity as possible to avoid the red flag while at the same time attempting to obtain the maximum possible protection for

their client. It amounts to almost a tone poem of fluff with the least possible substance. Here is what Harding's good patent attorney had to say about his 'simple' corkscrew:

"This invention relates to a combined bottle cap remover and corkscrew of the type which include a body of sheet metal one end of which is shaped to form crown cap removing jaws and upon which is pivotally mounted at one end a corkscrew which is adapted normally to lie along one edge of the body in an out-of-way position and to serve as a gripping surface for operation of the bottle cap remover.

"One object of the present invention is to provide a device of this character including novel and improved means for covering the point of the corkscrew when the latter is in inoperative position and for holding the corkscrew against accidental pivotal movement from its inoperative position.

"Other objects are to provide a novel and improved manner of pivotally connecting the corkscrew to the body of the device whereby the corkscrew may be held in its inoperative position by frictional engagement of the corkscrew with the body; to provide such a device which will be simple and inexpensive in construction, and to obtain other results and advantages as may be brought out by the following description."

In other words, this is not a corkscrew invention, but rather an invention in which a corkscrew is used as a grip (possibly the only such use claimed in patent history), a corkscrew point is held in place, and the other end of a corkscrew is attached to a piece of stamped sheet metal. A comparison of Harding's patent to Harry L. Vaughan's earlier patent of 1916 (No. 1,207,100) suggests the reason Harding's attorney needed to be careful. The patents were too close for comfort. Neither claimed to have invented a means for hotels, liquor stores and breweries to advertise, but that is exactly what the two openers were used for.

A still further Prohibition avoidance mechanism for inventors (or attorneys of inventors) was to disclaim the corkscrew entirely if it was not deemed necessary to obtain the patent. If it sold better, you can bet it was manufactured with one. In describing his "Cover Remover," Joseph La Londe of Gilbert, Minnesota said,

"...it is provided with a folding cork screw... though (it does) not form part of my present invention..." (No. 1,515,395).

Thus Prohibition did not stand in the way of any inventor bent on patenting a corkscrew. They just called it by

another name and went about their drawings and specifications to neutralize the stigma of its implied relationship with alcoholic beverages.

Of course, there were other uses for a corkscrew than alcoholic beverages. The list, however, was getting shorter, as twist-off caps began to take over medicines and condiments, while the crown cap now dominated the soft drink industry. Increasingly, the most direct route to obtaining a patent seemed to be on the back of a kitchen tool rather than a general tool. It made more sense to combine a corkscrew with an ice pick than an axe. A jar lid wrench was closer kin to a corkscrew than a pipe wrench, as were can openers and ice tongs to saws and pliers, respectively. A knife/fork/spoon set was also preferable to a hammer/tack puller/screw driver set. Of the plain vanilla corkscrew there was very little patent activity, as can be gleaned from the patents themselves and their circuitous titles.

As Prohibition neared the end of its legal term, perhaps exacerbated by a nation-wide (and world-wide) Depression, corkscrew invention turned momentarily political. Rather than mechanical devices, corkscrews became expressions of satire, mocking the system for which there no longer was respect in the court of public opinion. Prohibition was personified in a fictitious tall thin figure with a long nose, dressed in a black coat, top hat and umbrella. This puritan symbol of an admonishing, self-righteous scolder begot only scorn for his efforts. He was depicted as a finger pointer turned beggar; a pathetic unwanted living corpse who got his just desserts by being laid to rest in his final coffin, unwept for, dishonored and shamed. Various names were given to him, such as "Mr. Dry," the "Old Codger," "The Reformer" and of course "Mr. Prohibition."

Corkscrew adaptations of the Prohibition figure exist in and out of the patent system. The only "utility" patent belongs to John R. Schuchardt of New York, New York, for his "Old Snifter," applied for one year after Prohibition was repealed and granted one year after that (No. 2,010,326). Because utility patents are granted for what the invention does, this patent provides the only tangible peek into the mind of the inventor. Of course it is *very* clear what the intention of the inventor was, but there is not one word of it in the patent. Instead were the usual word pictures:

"The combination in a bottle opener, of an elongated body, a core running through said body, a tubular member in said core having a head-like member fixedly mounted on said tubular member, the latter members being rotatably (sic) mounted within said statue

core, a spiral groove cut in said tubular member, a recess in said body, said recess running lengthwise of the body and communicating with said core, and a corkscrew pivotally mounted in said recess and having one end of said corkscrew slidably (sic) operable in said groove and angularly disposed with respect to the longitudinal axis of the corkscrew so that the turning of the head member causes said corkscrew to be extruded from said recess or locked into said recess in said body in accordance with the backward or forward facing or turning of said head respectively."

In this instance, the "recess" was created by coat tails and a cap lifter was formed of the hands holding the umbrella. Mr. Schuchardt must have been chuckling to himself all the way to the Patent Office. Whether the patent Examiner was taken in by the charade or played along with it willingly, we shall never know. It would not be the first time one Government Agency acted contrary to another. The fact that the corkscrew did not work with the sublime efficiency implied in the patent language and that it was fabricated of cheap pot metal betrays the real purpose behind Schuchardt's idea, which was to make a statement rather than a useful tool. "Old Snifters" still in circulation that have not been retired to collections should be examined carefully. The inner mechanism is often broken, rendering the head twist restricted, if not inoperative.[23]

Meanwhile, two Design patents joined in the lampoon — A. J. Flauder (No. D-87,567) and H. M. Bridgewater (D-87,618). As no description accompanies a Design patent (what you see is what you get), there can be no peek into the devilish minds of these two inventors, if indeed one were needed. Flauder's was manufactured in the format of a spoon, in which the handle depicts the body dressed in the usual coat and tails. The top hat is a jigger sitting atop a cap lifter formed of opposing faces, reprimanding on one side while the other is obviously 'feeling no pain'. Appropriate for the 'two-faced' attitude of the authorities, the body shows a lecturing finger one side and a spilling mug the other, asking the enlightened collector/user to fit the right 'face' to the right 'body'.

[23] An unpatented "Old Snifter" is also well known by collectors. While there are no mechanics involved, the inner space is instead used as a concealed flask, which can be accessed by *removing* the top hat. It too suffers from the pot metal syndrome, but, like the patented version, was never intended to be taken seriously.

CORKSCREW MYTHOLOGY?

With some justification, corkscrew collectors have long referred to "Old Snifters" colloquially as "Volsteads," naming them after the very real Congressman, Andrew Volstead, who spearheaded passage of the so-called "Volstead Act" of January 17, 1920, enforcing the 18th Amendment. Although Congressman Volstead was a dedicated Prohibitionist, the movement had more powerful and fanatical supporters outside of Government. By lending his name to their agenda, he wrote himself into corkscrew mythology. There is no evidence linking the "Old Snifter" or any corkscrew singularly to Volstead. It may be more appropriate to attribute the character to a political cartoonist by the name of Rollin Kirby, whose creation was a more general personification of the entire Prohibition debacle, from its preachy beginning to inglorious demise. Rather than becoming a National lightning rod, by the time Prohibition had been repealed with the ratification of the 21st Amendment in December, 1933 (ironically, Utah, still a semi-dry state, cast the vote that put the count over the top), Volstead had retired to local enforcement in his home state of Minnesota. He was defeated for re-election in 1922.

The Prohibitionists had a cartoon character of their own, reflecting the opposite point of view to the "wets." His name was John Barleycorn, and never was there depicted a more pathetic representative of the human species, all resulting of course from alcoholic drink. Like the patenters of corkscrews, the cartoonists of the wet side had their fun with Mr. Barleycorn too.

> This is John Barleycorn's grass-grown grave,
> Dug by fanatics, our country to save,
> Note how well kept! Right up to the minute!
> The only thing wrong is that John isn't in it!

Bridgewater's patent depicts a ghoulish figure in his final resting place with everything a tippler would need, including a cap lifter, jigger, corkscrew and cork stopper. The irony is about as subtle as a gulp of moonshine whiskey and the small miserable corkscrew about as pathetic as any to be found in the history of corkscrew making. No matter, it was intended to be symbolic rather than useful.

While Prohibition may have engendered politically motivated corkscrews, other types were patented which conveyed a more serious message. These were the poison bottle and medicine dosage indicators. As mentioned earlier, small wire corkscrews were generally kept in the cork for restoppering medicines and potions. Before tamper proof lids were invented, it was the practice to embellish the corkscrew with a reminder that supposedly prevented unintended consumption, by alerting either an unsuspecting user or the parent of a curious child. Thus we have bells (the ding-a-ling type), prickly things and skulls added to the corkscrew (Nos. 1,121,459, D-48,894, 1,245,736 and 1,502,620). Other common accessories were clock dials, measuring spoons and holders (Nos. 910,845, 1,352,967, 1,425,456, 1,443,861). Or was the corkscrew the accessory?

But by far the most characteristic vehicle for a corkscrew during this period was the can opener with almost a quarter of the patents claiming the ability to open at least a can and a bottle with the same tool. While the can opener was a significant 15% of the 1900-1919 patents, the former period was even more notorious for its general tools, as has been pointed out.

Other coat tails the corkscrew rode into patent history on were jar openers, utensil sets, key holders, ice picks and scissors. The mix of combinations was gradually evolving into tools that opened things and away from tools that were used for construction *and* lunch breaks.

The corkscrew joined the kitchen utensil industry through two manufacturing giants, "A & J" and "EKCO." The companies had a similar but independent rise until their eventual union. A & J began in 1908 when Edward H. Johnson purchased a patent for an egg beater for $500. That lofty sum was matched by his wife's uncle, Benjamin T. Ash (the "A" of the "A & J"), which put them in business in a small rented building behind Johnson's residence in Binghamton, New York. Within two decades A & J occupied a manufacturing facility that was producing the largest bulk of kitchen hardware in its class. Johnson bought out Ash in 1922 for $50,000, a very nice turn on $500 — the envy of any silent investor.

Meanwhile the familiar diamond logo was appearing on kitchen stuff from apple corers to utility brushes, lacking only (following vigorous research) tools beginning with the letters "v" to "z" (the "c" category was dominated by can openers). Johnson was a master of merchandising with "Mother's Little Helper" line of miniature utensils to lock in future housewives (no corkscrew in the kiddie line though), display trays and premium promotions.

Johnson had a knack for timing too, for in 1929, at the height of the national party, he sold his business to the company founded by Edward Katzinger, known as "EKCO." A native of Vienna, Austria, the young Katzinger set up business in the late 1880s to manufacture bakery pans. The place was Chicago. While A & J expanded their line significantly through the patent process, EKCO grew through acquisition of other companies, culminating in the A & J purchase. The company by that time was in the hands of Katzinger's son, Arthur, who had changed his last name to Keating and officially adopted the "EKCO" logo. In 1931 the Binghamton plant was closed and all manufacturing moved to Chicago. EKCO thus became the world's largest producer of kitchenware, a position which it still holds today as a division of American Home Products, with an astounding 3,500 item product line. Because of the high visibility of the A & J name, EKCO continued to market its products with the A & J logo well into the 1950s, when it was finally dropped and passed on to the collector world. No products are known to have been dually marked, but advertising cards did show both logos.

Corkscrews probably began to appear on A & J utensils first in the 1920s. The only known convergence of the two labels on a patent was the 1939 Design patent of M. J. Zimmer for a Can Opener (No. D-117,210). Earlier production (by EKCO) was marked with the A & J logo, while later production (presumably sometime in the 1950s) carried the EKCO logo. The rule-of-thumb for corkscrew collectors, therefore, is that the A & J mark generally signifies a piece produced prior to the 1950s and the EKCO after that. The identity as to who was the actual producer for any given piece marked with the A & J logo is left to the scholars of can openers to sort out.

After the frenetic bar mount cork-screw era had ended, a new type of mount began a run of its own. Ever since the Founding days, Americans have been on the move. In the beginning were the scouts and trappers, more intent on opening trails than opening bottles. After the scouts came the pioneers, first by wagon and boat, then by train. They would have brought along some of the unpatented T-screws (Fig. 1-2) and early patent types along with, of course, the necessities of eating and sleeping. 'Water holes' were literally that. By the turn of the century travel had become more civilized, with decent lodging and accommodations obtainable anywhere worth traveling to or through, and, with the advent of the 'horseless carriage', later known as the 'automobile', free-lance travel became a national passion. Whether it was for business or pleasure, the amenities were all available, which meant the corkscrew stayed home.

In the days before the twist-off cap and from the beginning of time for a corked bottle, there was — and still is — an absolute need for an opening tool. Who among us can claim to have never been in a far away place without an opener in time of need? What did the imagination come up with? A counter edge... a key... a coin... a belt buckle... a rock? Is this grist for the invention mill or what? Indeed, necessity mothered in the mind of Raymond M. Brown of Newport News, Virginia in his 1926 application for a patent:

> "Hotel operators have experienced considerable damage to furniture caused by patrons attempting to remove metal caps between the edges of drawers or between doors and door frames, also by placing such caps on the edges of furniture; also by placing corks in similar positions" (No. 1,702,149).

What, no teeth? Not to be outdone, Henry Thompson offered a *denouement* of his own:

> "In the past, when it became necessary to open a bottle and no bottle opener was found nearby, the cap of the bottle was placed against the nearest piece of furniture, window sill or any projection, and pounded, resulting in a marring of the furniture and in some instances, when the neck of the bottle broke, the ruining of rugs, curtains, etc. This was especially true in hotels where, if a bottle opener was placed by the management in each room, it soon became

Hotels and motels could not afford to wait the 50 years it would take for bottle cap technology to save their new Formica. So a lesser technology intervened: the wall mount opener. It is gen-

Fig. 4-1 **a.** The patent of Thomas Hamilton, No. 1,534,211, April 21, 1925, kicking off a run on the Patent Office for wall mount protection. Many of the models produced with and without corkscrews by Raymond Brown of Newport News, Virginia were nevertheless marked with this

erally recognized that Thomas Hamilton of Boston, Massachusetts was the Father of the wall mount. His patent No. 1,534,211, dated April 21, 1925 (Fig. 4-1), was filed some two years before Raymond Brown,[24] but it was Brown that turned the idea into an industry. Moreover, Hamilton's patent did not incorporate a corkscrew, which discriminated against the wine drinking occupant, possibly due to the influence of Prohibition. Anyone traveling the back roads of America can still find vestiges of the wall mount perhaps layered under many coats of enamel or silently witnessed to by two or three screw holes, depending on which model formerly occupied the spot.

To be successful, the wall mount had to be durable and cheap, rather than inventively clever. Once again, advertising made the difference between success and failure. For if the cost could be shared or completely paid for by the advertiser, the hotel/motel operator would reap a cheap solution to an expensive problem. Meanwhile, the advertiser would have a silent advocate always on duty to provide instant access to the beverage it hoped the room occupant would go out and buy *and* the inventor/manufacturer would sell openers. Thus many of the styles emanating from Newport News were factory cast with the advertiser's name, some of which are still prominent For-

[24] That's "Brown" without the "e." William G. Browne of a prior generation was a prolific patenter and manufacturer of can openers.

patent date, indicating that some 'arrangement' existed between the two. **b.** One of Brown's patents, 'coincidentally' obtained just as Hamilton's expired. There is an uncanny similarity between the two, to say the least.

tune 500 beverage companies today. Advertising opened the wall mount market to the small hotel/motel operators who could little afford to give away openers with their own name on it, as was the practice of many large hotels with the likes of Vaughan's "Nifty" (No. 1,207,100) and Harding's single plate version, assigned to J. L. Sommer Manufacturing Co. (No. 1,680,291).

The rush to patent a better wall mount was concentrated into the relatively brief period of 7 years from 1929 to 1935 when 17 patents were granted for wall mounts that included a corkscrew. Because of their mass production, many have survived and can be found in the collections of those who can see a different 'beauty' than that which appears on the surface. They are not classic corkscrews in the usual sense but like the combination tool, they are a bit of Americana, perhaps having had more exposure to the average person than any classic corkscrew. They were practical and that's all that mattered.

The 1930s cannot be left without comment on two patents which presaged the next generation of corkscrews. After having taken up temporary residence with any family of tools that the matchmaker inventors could dream up, the corkscrew faced one final marriage before its century-old jour-

ney would be complete, taking it full circle to the point where it all started — as a single-purpose tool. The penultimate family was quite logical: the bar group.

The kinfolk this time were jiggers, stir spoons, ice chippers, drink recipes, mullers, shakers, funnels and swizzle sticks. The two 'early' patents of the ilk were Walter and Howard Ballou's "Bottle Closure" dated December 20, 1927 (No. 1,653,490) and Richard Smythe's "Container Opener" dated April 26, 1938, better known as the "Hootch Owl" (No. 2,115,289), backed up with a Design patent dated March 17, 1936 (No. D-98,968). While the Ballou brothers were preoccupied with the repeated recorking of bottles, there could be no mistaking the kind of bottles they had in mind and what the supplementary advantages of their invention were, namely drinking, measuring, funneling, etc., as well as removing the original cork.

Without the constraints of Prohibition, Smythe on the other hand made his a frontal attack:

"One of the principal objects of the invention is to provide improved means for removing corks and other types of stoppers from containers of the above-mentioned types of containers (bottles, jars, cans and the like). Another object is to provide a device for removing the cork types of stoppers, which has an increased lifting power over those now known to me..." (editor's note: where did Smythe come from, an Ostrich farm? The double lever mechanism had been around for at least a hundred years).

"A further object is to provide in the same device an efficient means of unscrewing metallic screw caps from containers, and also means for lifting 'pressure-type' caps from food jars such as the "Anchor" type caps. Still another object is to provide a means in the same device for lifting ice cubes and other articles."

The mechanism is essentially a double-lever corkscrew dressed up like an owl with the lever arms ('wings') adapted to perform the other sundry functions. Thus with one tool, a host could serve wine, a dry Martini with choice of olive or onion and a Tom Collins topped with a cherry preserved from the back yard tree, all without touching anything or having to engage a supporting cast of utensils. The corkscrew is an absolute gem, arguably the definitive 'antique' corkscrew of the 20th century.

In making generalities about corkscrews in the 1930s, one must not lose sight of the dreadful state of the country and world. It came so suddenly to those who experienced it (only in hind-sight could one see the inevitable consequence of all that wacky dalliance). Life entered the doldrums in the singular event of the stock market crash of 1929, but the Great Depression took longer to seep into the pores of everyday life. The mighty were humbled, the imaginative were stifled, the crooks had nothing to steal. Even the weather became depressed, with drought, heat and wind wiping out farms and ranges that were the bounty of America. They were hard times for all, 'saved' in the final analysis by another World War.

Corkscrew patents, indeed all patent activity, was severely impaired by the Depression. The year 1938 saw only *two* corkscrew patents and that was only one less than 1936, 1937 and 1939. Based on projections through the end of the 20th century, more than 80% of all corkscrew patents had been issued by 1930, while patents over all had barely reached the one-third mark. Moreover, those corkscrews that were patented during the Depression were likely to have seen limited production runs. Collectors might reconsider their 'bias' for older patented corkscrews. Many of the Depression era and even modern day patented corkscrews can be considered an endangered species, worth setting aside for their eventual elevation to antique status. That time may come sooner than many think.

1,385,976 (see also 1,038,692, 1,150,083) Edwin Walker; Jessie Sterrett And Mary E. Steiner Administratrices Of Said Edwin Walker, Deceased
July 26, 1921
A series of three patents by Edwin Walker, including his last in this Realm and one from The Beyond. Each of the patents required three pages of specifications. The additional corkscrew identified as Fig. 9, "illustrates a modified form of composite crown opener and cork screw." Can you detect the "modification"? **a.** Unmarked example shown in all three patents; 3.0" *Courtesy of Ron MacLean.* **b.** Cap lifter affixed to the end of a wood handle marked WALKER. Note speed worm; 6.0". *Courtesy of Don Bull.* **c.** Combined with an unmarked ice shaver tool. The corkscrew stows in a hole at the end of the handle; 10.5".

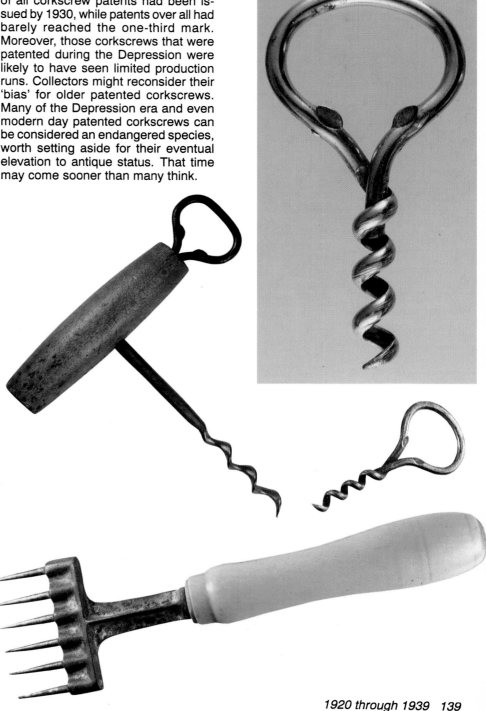

1,461,162
Lewis D. Roberts
July 10, 1923
Roberts' patent makes the most of stamping sheet metal, perhaps asking too much in this case. The cap pry is its weakest element. Side view above: OUR JEWEL PATENTED on handle, TOOL STEEL TEMPERED on blade. Top view below: PAT JULY 10 - 23 THE JEWEL CAN OPENER UNITED NOVELTIES, INC. YORK, PA. on handle, TOOL STEEL HARDENED on blade; 5.4".

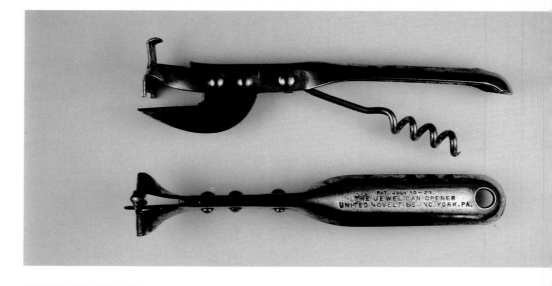

1,548,519
Alfred William Flint
August 4, 1925
a. The two peg-and-worm versions of Alfred Flint's corkscrew, patented on both sides of the Atlantic. Left: A.W. FLINT & Co MADE IN SHEFFIELD BRITISH PATENT NO 227628 PATENTED ALSO FRANCE GERMANY USA NO 708279, showing single prong cap lifter; 3.3" closed. Right: PATENT APPLIED FOR REGd No 708279 MADE IN SHEFFIELD ENGLAND, showing double prong cap lifter; 3.3" closed. *Courtesy of Howard Luterman.* **b.** REGISTERED No. 733435 Rare pocket knife version. *Photo courtesy of Ron MacLean.*

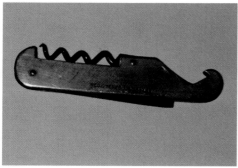

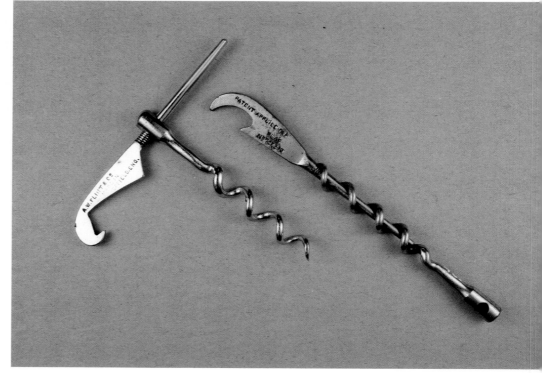

1,574,497
Robert J. McLean, Assignor To Sloan & Company
February 23, 1926
SECURITY STERLING PAT APLD FOR A neat little folding item for the watch chain or vest pocket by Robert McLean. It opens doors (for those who want to get ahead?), cigar boxes, seal-caps and bottles; 3.4" closed. *Courtesy of Bob Nugent.*

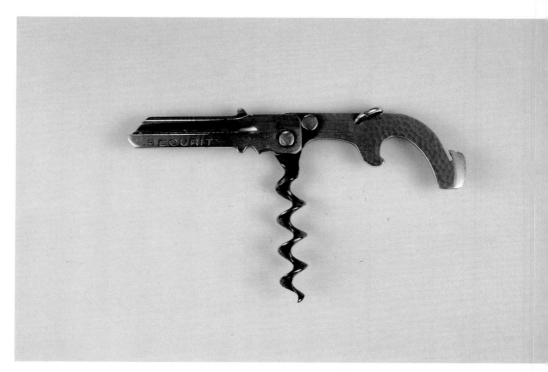

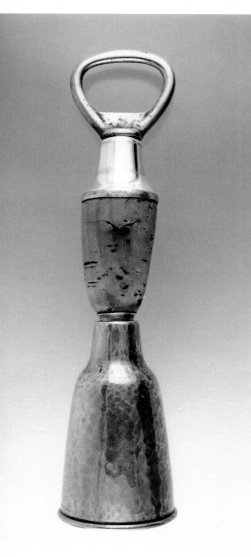

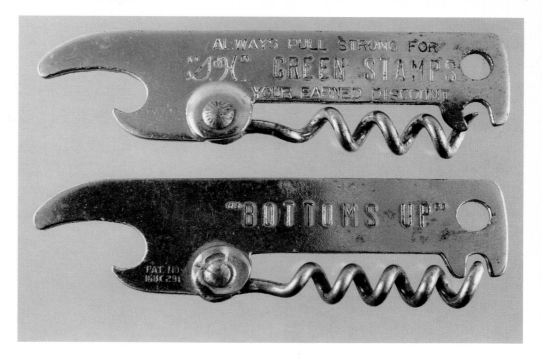

1,653,490
Walter B. Ballou And Howard M. Ballou
December 20, 1927
STERLING HAND HAMMERED A well organized device with a corkscrew, measure or drinking cup and permanent stopper for use after the original cork has been removed; 6.2" as shown.

1,680,291
Thomas Harding, Assignor To J. L. Sommer Manufacturing Co.
August 14, 1928
PAT. NO. 1680291 Harding's pocket opener, at first glance a knock-off of the "Nifty" (No. 1,207,100) but different in two respects. It is formed of a single unfolded stamped plate and the worm point is held in a notch. Above: Advertising "S. & H." GREEN STAMPS... Note the slight crook in the inside tab, which was found to work better and became the standard production version. Below: Stamped "BOTTOMS UP." Note flat tab and left-hand worm; 3.0".

1,680,876 (see also D-73,406)
Alfonso Oliveras Guerris
August 14, 1928
A 'high-tech' tap, but coming well past the prime time of champagne sipping. Both patents were applied for on June 7, 1926. **a.** INDUS PATENTADO; 5.9". **b.** Shown with accessories in original box.

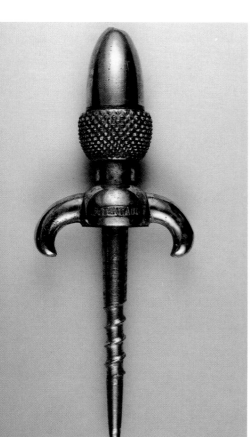

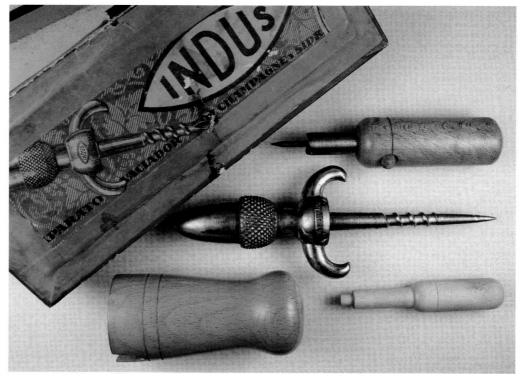

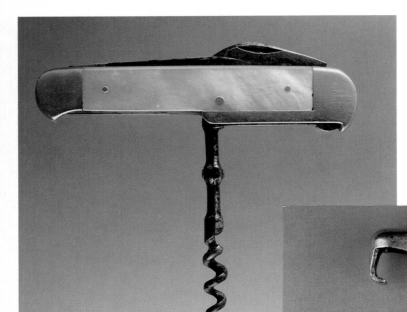

1,701,467
Carl W. Tillmanns, Assignor To Remington Arms Company, Inc.
February 5, 1929
Tillmanns' pocket knife with a double-pivoting-split-shank worm, which mysteriously took 6 years for the Patent Office to approve. It would seem to be quite novel as a means of extending its length; 3.6" closed, 3.8" open. *Courtesy of Bob Nugent.*

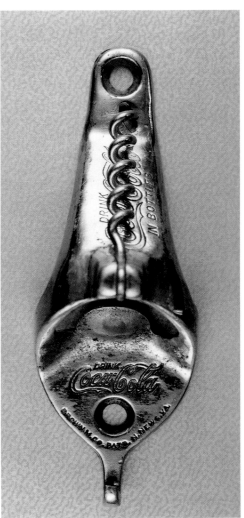

1,701,950 (see also 1,695,098)
William C. Hiering, Assignor To J. E. Mergott Co.
February 12, 1929
Hiering's "Pocket Corkscrew," assigned to J. E. Mergott Co. Although generally marked with the two patent dates, only the spring plate version appears to be extant. Nor does Hiering make reference to his earlier patent in the application for his second patent, filed less than 2 months later. Side view above: PATENTED DEC.11.28 FEB.12.29 JEMCO THE J. E. MERGOTT CO. NEWARK, N. J. with advertising ENJOY PRIMA BEER. Underside view below: PAT. APL. FOR J. E. MERGOTT CO. NEWARK, N. J. with advertising BOTTLE JEMCO OPENER; 3.8" closed.

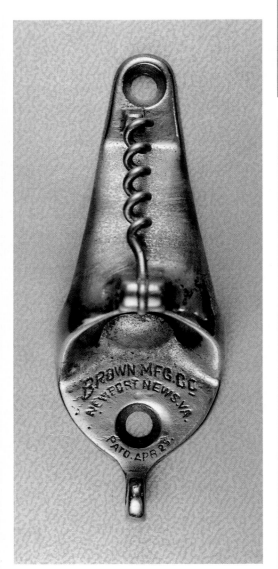

a.

b.

1,702,149
Raymond M. Brown
February 12, 1929
a. BROWN MFG. CO NEWPORT NEWS. VA. PATD. APR. 25 The ubiquitous "Newport News" cast wall mount opener by Raymond Brown. The lug at top is placed strategically off center, which locks in the point by slightly flexing the corkscrew. His concern over the "possibility of the cork screw being flexed beyond the limits of its flex" perhaps led to a slotted version shown in b., which was not patented. The date refers to the earlier patent of Thomas Hamilton on April 21, 1925 (No. 1,534,211) for which Brown obviously held the rights and continued to mark on all wall mounts produced by him, despite owning patents in his own name (Nos. 1,827,868 and 1,996,696). The hook at the bottom is for attaching a razor strop; 4.9". **b.** BROWN M. CO. PATD N. NEWS. VA. Advertising for Coca Cola; 4.9". *Both courtesy of Bob Nugent.*

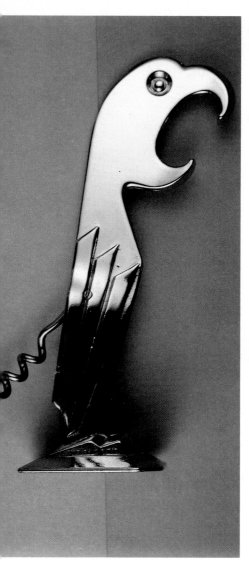

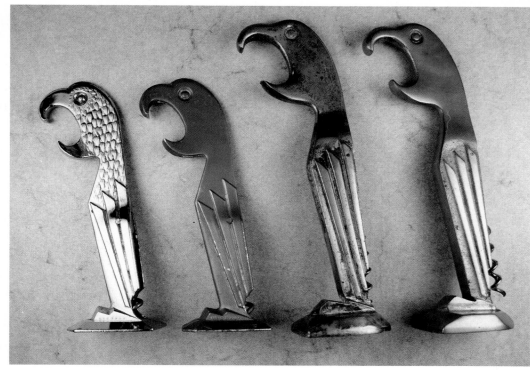

D-78,554
Manuel D. Avillar
May 21, 1929
a. NEGBAUR U. S. A. PAT'D Art Deco design of a parrot by Avillar, made with a corkscrew, although not indicated in the patent. 5.0". **b.** Parrots were manufactured in two known sizes and outfitted with a number of bird suits and *accouterments*; 'Regular' size 5.0", 'XL' 6.5". *Courtesy of Don Bull.*

1,715,524 (see also 2,018,083)
Harry L. Vaughan, Assignor To Vaughan Novelty Mfg. Co.
June 4, 1929
DART CAN OPENER Thumb plate marked PAT. IN U. S. A. JUNE 4, 1929 HAND GUARD, which is the patent arbitrarily chosen to represent this photo. Handle prominently marked VAUGHAN CHICAGO U. S. A. PAT. NO. 2,018,083, which applies to the cap pry; 5.6".

1,717,925
Carl Horix
June 18, 1929
BUDDY KNIFE REG. U. S. PAT. OFF. PAT. APD. FOR MF'D BY THE GREIST MFG. CO. NEW HAVEN, CONN. U.S.A. with advertising for NEW HOTEL RANDOLPH MILWAUKEE, WISC. Fancier cigar cutting tools existed but probably none so economical to produce. Hence its suitability as a promotional item; 3.6".

1,728,787
Joe De Bracht, Assignor Of One-Half To George P. Gable
September 17, 1929
PAT. NO. 1728787 A simple enough wall mount, obviously economical to produce, but the prominent patent marking took up advertising space, which might have made it more competitive during the 1930s wall mount sweepstakes; 4.3".

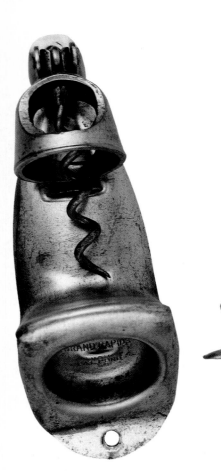

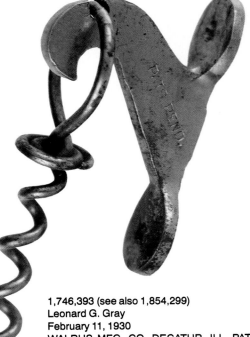

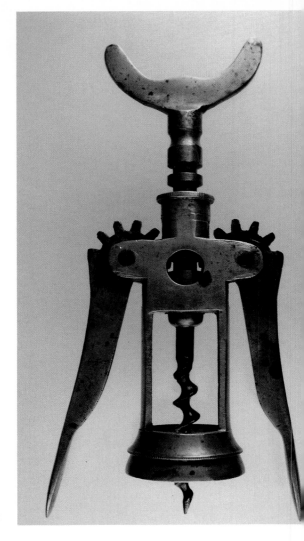

D-79,687
Frank A. Topping, Assignor To John M. Sweeney
October 22, 1929
UNIS MFG. GRAND RAPIDS MICH. PAT. PEND. A wall mount opener requiring a rather complex stamping of sheet metal; 5.4".

1,746,393 (see also 1,854,299)
Leonard G. Gray
February 11, 1930
WALRUS MFG. CO. DECATUR, ILL. PATS. PEND. A straight forward wall mount for hotel rooms, having little distinction and hence greater rarity than others of the period. A subsequent patent claimed to correct the problem of the corkscrew (patently called a "torsional extractor") being too easily removed from the slot, resulting in "...considerable annoyance and inconvenience to subsequent occupants of the room, as well as pecuniary loss to the hotel for necessary repairs and replacements." More evidence of how complicated life becomes when you can't find a corkscrew; 2.8".

1,753,026
Dominick Rosati
April 1, 1930
A classic double lever corkscrew, very characteristic of Italian manufacture. Enough similarities exist to suggest it could be the Rosati patent, although the lack of any marking makes it impossible to confirm; 7.0". *Courtesy of Ron MacLean.*

1,763,849 (see also 1,715,033, 1,775,164, 1,975,606)
Joseph A. Hoegger
June 17, 1930
a. HOEGGER INC JERSEY CITY N.J. PAT. APL'D FOR Joseph Hoegger produced five wall mount patents in as many years. Four were applied for in 1928, all having the characteristic cap lifter 'snout' (the first numbered patent is for the snout alone, which is not included in the master list). The patents differ with respect to the tweaking of the corkscrew mechanism; 5.1". *Courtesy of Bob Nugent.* **b.** The first patent.

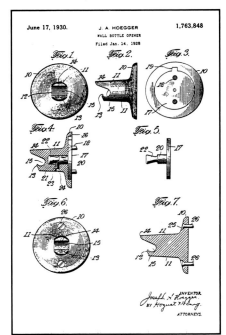

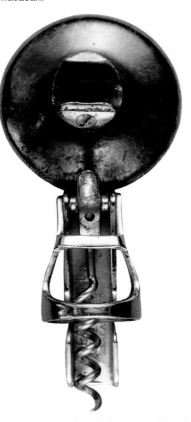

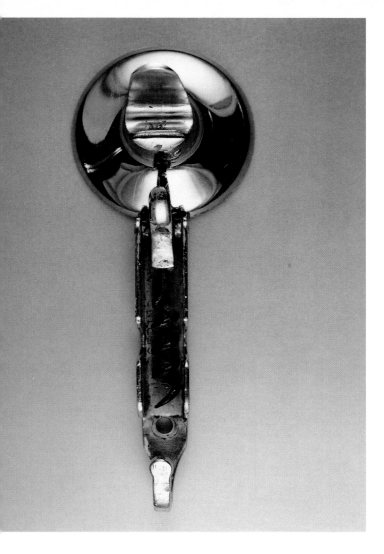

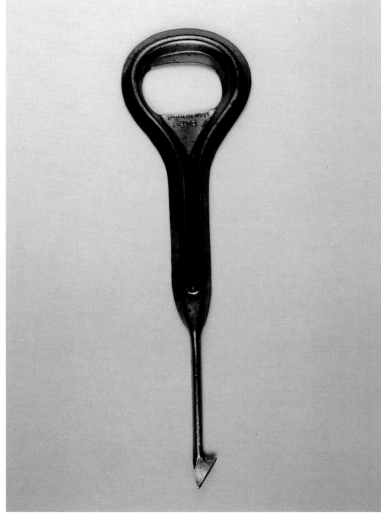

1,775,164 (see also 1,715,033, 1,763,849, 1,975,606)
Joseph A. Hoegger
September 9, 1930
HOEGGER INC. JERSEY CITY, N.J. PATENT APL'D FOR This Hoegger patent was applied for prior to but granted after No. 1,763,849, meaning the earlier patent is an 'improvement' of the later patent; 6.0".

1,779,170 (see also 1,570,306)
William Johnson
October 21, 1930
PAT. JAN 19, 1926 The date refers to the earlier patent. This is a combination cap lifter and cork puller whose novelty consists of a single piece of sheet metal, stamped with corrugations for strength. It also claims to be useful in sewing fowl; 6.0". *Courtesy of Bob Nugent.*

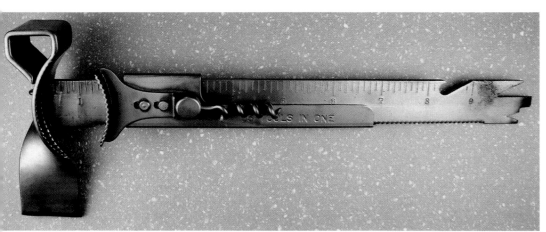

1,784,488
Nathan Jenkins
December 9, 1930
15 TOOLS IN ONE front side, PAT DEC 9 1930 back side; 10.7", as can be verified by one of the 15 functions. *Courtesy of Bob Nugent.*

1,805,011
Joseph Salomone
May 12, 1931
WORLD'S BEST CAN OPENER CO. PAT. NO. 1805011 TEMPERED BLADE MADE IN U.S.A. The flat slotted lever is a 'key' for patented rip-and-roll cans, in case the disposable key — itself under patent — becomes lost, proving that even the lowly sardine was not beneath the dignity of a determined inventor; 8.2".

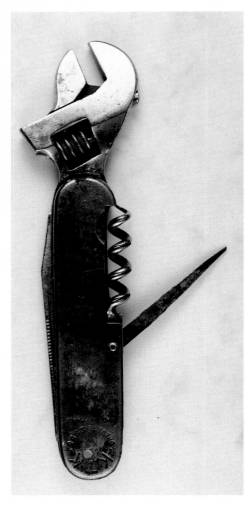

1,811,982
Jean Albert Soustre
June 30, 1931
BREVETE S.G.D.G. MADE IN FRANCE K. T. K. It might be said that Jean Albert Soustre threw a monkey wrench into the patenting of corkscrews; 5.2".

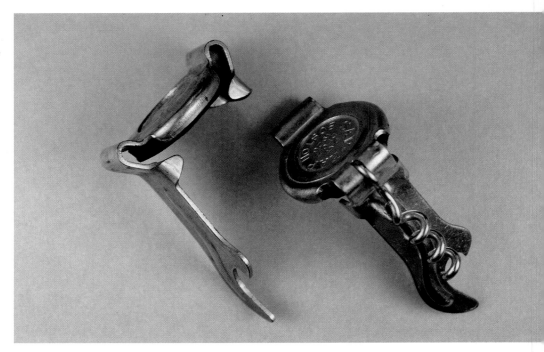

1,845,038
Frederick Jackson Alderson
February 16, 1932
U. S. PAT APLd FOR SERIAL 46481 Canadian inventor, Frederick Alderson's screw-driver, hammer, nail extractor, bottle opener, knife sharpener, corkscrew, weighing scale, can opener, rule, and door fastener or lock, all rolled up in one. If life were only that simple. The Serial Number is the number assigned to a patent application by the Patent Office. It is referred to until the patent is either rejected or approved, whereupon a patent number is issued; 8.0".

1,814,895
Albert W. Charbonneau, Assignor To The Roberts Specialty Manufacturing Company, Inc.
July 14, 1931
a. Left and right: SAV-KAP PAT. DEC. 7, 1926 BOSTON The date refers to an earlier patent by M. H. Roberts that provided no corkscrew (No. 1,610,158). The improved patent, which was assigned to the Roberts Specialty Manufacturing Co., added a corkscrew and nothing else to the advancement of science; 3.1". *Courtesy of Bob Nugent.* **b.** The original patent.

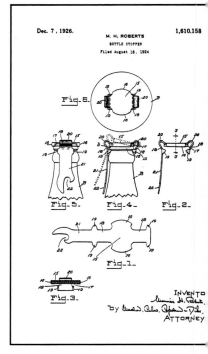

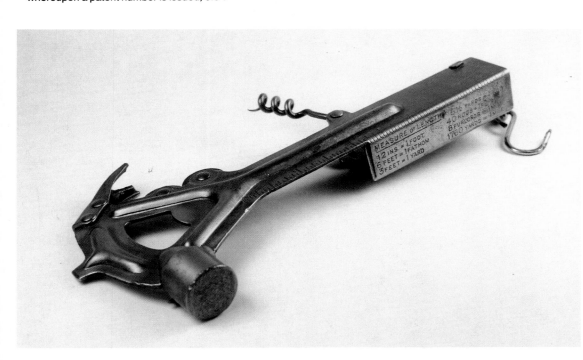

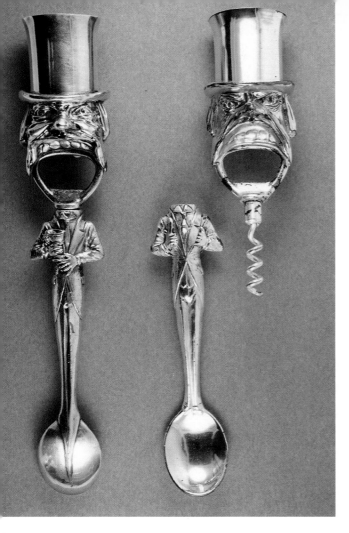

D-87,567
Alfred J. Flauder, Assignor To The Weidlich Bros. Mfg. Co.
August 16, 1932
W. B. MFG. CO. PAT 8-16-32 U. S. A. Flauder's 2-faced tribute to Prohibition, requiring the user to make the appropriate countenance match. Left: 'back' side featuring a 'feeling no pain' smile spilling an unsteady goblet of 'something' on sleeve. Right: 'front' side in separate sections, depicting an exaggerated finger pointing in the direction of self-righteousness personified; 9.7".

b.

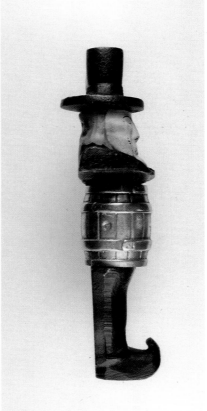

c.

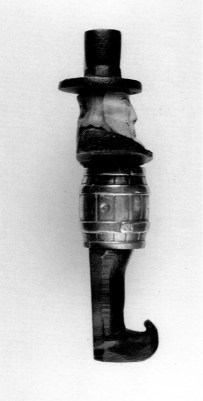

D-87,618
Horace M. Bridgewater, Assignor To The Artistic Bronze Company
August 23, 1932
a., **b.** and **c.** Bridgewater's satirical commemoration of the 'death' of Prohibition, not articulated in the Design patent, but very clear from the exploded pieces. The inner coffin lid is marked PATENT APP'D FOR COPYRIGHT 1932; 'coffin' 6.6" long.

a.

D-87,764
William T. Walker And Henry F. Orr
September 13, 1932
SILVER PLATE PAT'D A corkscrew on a spoon is not an unusual combination. This one, however, is less common than many of the unpatented versions; 8.6".

1,897,991
David B. Arnof
February 14, 1933
PAT. PEND. D. ARNOF N.Y.C. The patent enlists the corkscrew secondarily for ice cube tong duty. Looks older than it is; 4.7".

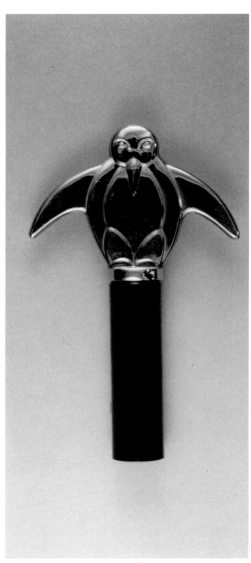

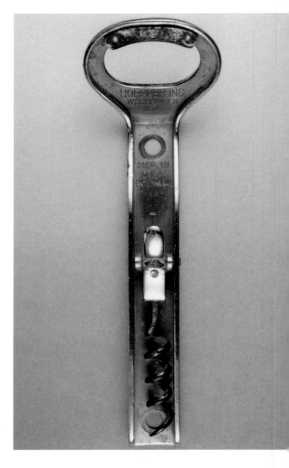

D-89,308
Kurt Rettich, Assignor, By Mesne Assignments, To The Reynolds Spring Company
February 21, 1933
a. and b. Unmarked Art Deco penguin design by Rettich; 3.0" corkscrew, 3.5" in sheath. *Courtesy of Bob Nugent.*

1,975,606 (see also 1,715,033, 1,763,849, 1,775,164)
Joseph A. Hoegger
October 2, 1934
HOEGGER INC WEEHAWKEN N.J. MFG. IN U.S.A. PAT 1,763,849 The patent mark refers to the earlier patent, but clearly this is the later patent. Note that the 'snout' cap lifter has been dropped; 5.3". *Courtesy of Bob Nugent.*

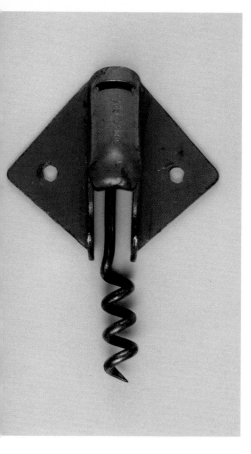

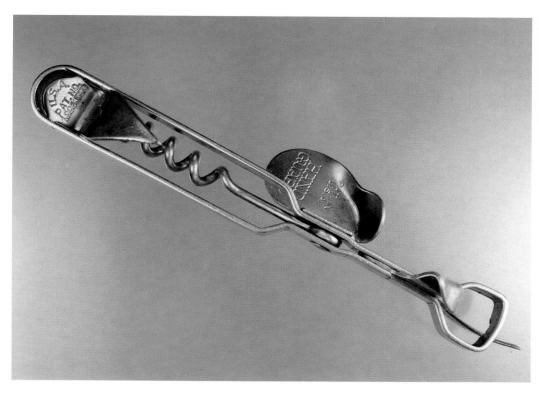

1,988,057 (see also 1,930,492)
Henry G. Thompson
January 15, 1935
WHAT CHEER front side, C.S. RIPLEY & CO
CLEVELAND, O. U.S.A. PAT. PEND. back. Both
patents are for the same piece. Thompson was
able to insert three additional claims to the lat-
ter, possibly shoring up his patent protection;
3.1". *Courtesy of Bob Nugent.*

1,996,696
Raymond M. Brown
April 2, 1935
STARR BROWN MFG. CO. NEWPORT
NEWS, VA. PATD APR. 1925 Another improve-
ment on a former patent by Raymond Brown
(No. 1,702,149), once again dated for Thomas
Hamilton's original patent (No. 1,534,211).
Brown cranked out so many wall mounts he
probably couldn't care less about having the right
patent date mark. In this patent the corkscrew
hangs in a slot between the sides; 4.8".

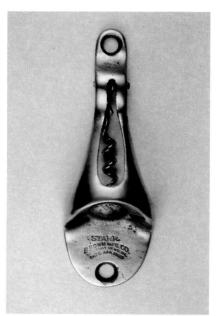

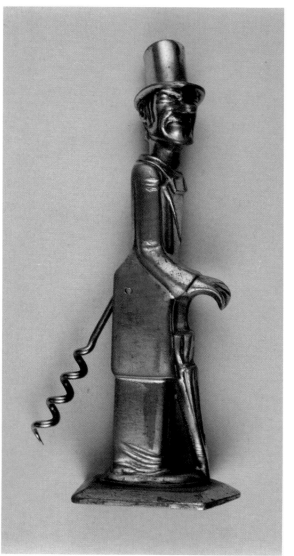

1,996,550 (see also 1,715,524, 2,018,083)
Dewitt F. Sampson And John M. Hothersall, As-
signors To American Can Company
April 2, 1935
VAUGHAN'S MADE IN U. S. A. A well marked
multi-patent combination tool by the prodigious
manufacturer, Harry Vaughan. The can piercer
marked U. S. A. PAT. NO. 1,996,550; thumb plate
marked PAT. IN U. S. A. HAND GUARD (attrib-
uted to 1,715,524); the cap lifter pry marked U.
S. A. PAT. NO. 2,018,083; the can opener blade
marked TEMPERED TOOL STEEL; 5.8".

2,010,326
John R. Schuchardt
August 6, 1935
OLD SNIFTER NEGBAUR, N. Y. MADE IN U.
S. A. PAT'D Schuchardt's timing was a little late
for Prohibition, but there is no mistaking the
message behind his amusing statuary. Literally.
A twist of the head pops out the corkscrew while
the umbrella handle handles bottle caps; 5.7".

2,018,083 (see also 1,715,524, 1,996,550)
James Andrew Murdock, Assignor To Vaughan
Novelty Mfg. Co.
October 22, 1935
VAUGHAN'S MADE IN U. S. A. TEMPERED
TOOL STEEL U. S. A. PAT. NO. 2,018,083 The
marked patent number applies to the cap pry
only. The tool itself is the same as shown under
the earlier patents (Nos. 1,996,550 and
1,715,524) but is without can piercer or thumb
plate. The patent is assigned to Vaughan Nov-
elty Mfg. Co.; 5.7".

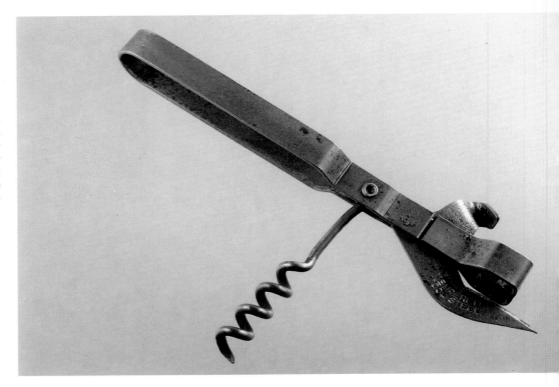

2,115,289 (see also D-98,968)
Richard G. Smythe
April 26, 1938
HOOTCH OWL PAT D-98968 PAT. APPd FOR
Called a "Container Opener" because of all the
things it claims to open, this is arguably the most
sought after American corkscrew of the 20th
century. A substantial piece that also pries crown
caps, grips screw caps and lifts ice cubes.
Smythe obtained his Design patent first before
applying for his utility patent. **a.** Owl shown
'sleeping'; 5.6". **b.** Opposite side, shown 'flying
high'; 'wing span'; 7.7".

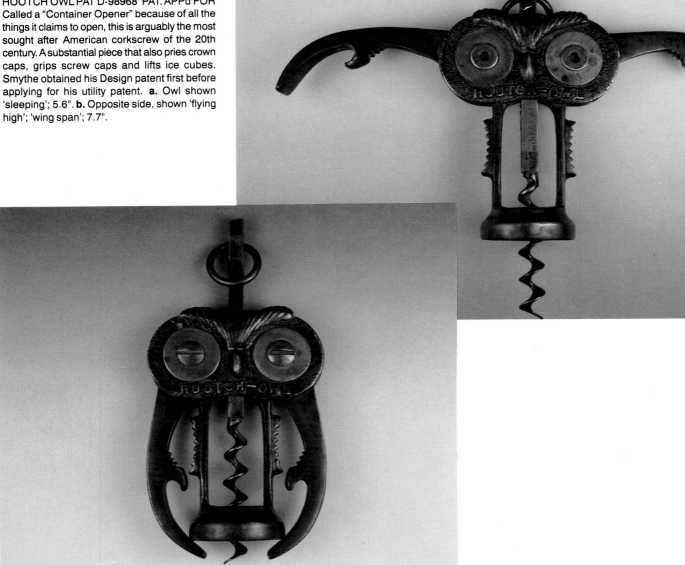

D-117,210
Myron J. Zimmer, Assignor To The Edward
Katzinger Company
October 17, 1939
Zimmer's Design patent assigned to The Ed-
ward Katzinger Company, who manufactured
under both the A & J logo and EKCO until the
1950s when A & J was discontinued. Above:
TEMPERED TOOL STEEL BLADE LEAVES A
SMOOTH SAFE EDGE ON CAN PAT. APLD.
FOR by A & J. Below: by EKCO; both 6.0".

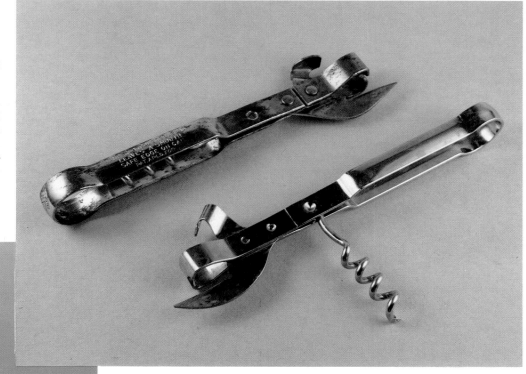

D-109,879
Walter Ruby
May 31, 1938
Ruby's Combination Pencil, Corkscrew, and
Bottle Opener. Uncannily similar to a later utility
patent by Knudsen (No. 2,164,191). Left: PAT.
NO. 109879 Note the absence of the prefix "D"
in front of the number, which may or may not
have been an oversight; 5.8". Center and right:
advertising "Carioca-Cooler"; 5.3".

2,164,191
Knud Knudsen, Assignor To Danbury-Knudsen
Incorporated
June 27, 1939
Unmarked pocket corkscrew and cap lifter pat-
ented by Knudsen, which was applied for one
year earlier but issued one year later than Ruby's
Design patent (D-109,879). Because Design
patents apply to appearance rather than func-
tion, there is generally less of a waiting period.
The main body acts as a sheath and inserts into
the top scroll of the 'S' to form a handle. The
bottom scroll is a cap lifter. Left: with sheath;
3.8". Right: corkscrew only; 3.5".

Dec. 24, 1940.

M. S. NEAL

BOTTLE OPENER

Filed March 18, 1940

Des. 124,223

Fig. 1

Fig. 2

Fig. 3

Fig. 4

Inventor

Marshall S. Neal

By Lyon & Lyon

Attorneys.

D-124,223
Marshall S. Neal
December 24, 1940
WILLIAMSON'S (on shank, although only
"...SON'S" is visible below the pivot pin). Pre-
sumably supplied to the bar tool manufacturer
by the then third generation Williamson, operat-
ing as a division of the Eastern Tool & Manufac-
turing Company (ETAMCO); 5.5".

CHAPTER 5
1940 THROUGH 1959

64 Corkscrew Patents

Boom, ban, bust... now it was bullets and bombast. With the corkscrew no longer needed for beer and booze, there was limited call for invention during the '40s and '50s, first because factories were producing armaments and second because hard liquor was 'In' while wine was 'Out' (or not yet 'In'). The travails did not stop the United States from becoming a world power militarily and economically, but a corkscrew leader the U. S. was not. No technological breakthrough took place, only further extension of old thinking. Some art and style were reflected (finally) in the Design patents, which numbered 44% of all patents — the highest ratio of any period. New materials were also introduced, in which plastic interacted with metal and light weight aluminum alloys became handles and barrels, following their success in war applications. But it is hard to find many serious corkscrews beyond the few highlighted here. Being that this was America, home of the brave and profit-minded, the only conclusion one can come to is that nobody needed a serious new corkscrew. No market, no patent — a perfect illustration of what drives the patent system.

Only two utility patents for corkscrews were applied for during the United States participation in the War. The lag effect caused no corkscrew patents to be issued in the odd years 1943, 1945 and 1947 with only one patent recorded in 1944, 1946 and 1948. Design patents were only slightly more active. Interestingly, 2 of the 6 Design patents issued during the war were to women (Nos. D-120,613 and D-140,622). The only patent issued to a foreign resident in all the 1940s was to a Newfoundlander (No. D-139,160). As for the usual source, Europe was in too much turmoil. Far East inventors had not yet been heard from.

All but one of the 1940s patentees were one-timers, the exception being Maximilian C. Frins who first filed for a "Can Opener" (with a separate Design application for just the head portion) on May 5, 1936. The Design patent was granted two month's later (No. D-100,469), but the utility patent was not issued until 1940 (No. 2,190,940). Frins refined his utility patent in 1955 (No. 2,718,055). It is obvious in looking at the patent (and the photograph), Mr. Frins was a can-opener kind of guy. His patent was one of the first to employ a "feed wheel" which could space itself from the cutter, "whereby application of the opener to the can and removal from the can is greatly facilitated." He might have revolutionized can opening at the time, but he did nothing to advance corkscrew technology.

Nor did Louis Strauss. Still hanging on to the pocket building-tool theme, Strauss came up with an idea for a "Utility Tool Kit" in which various tools could be individually deployed from a folding bow configuration (No. 2,478,063). The shanks were concave on one side, allowing them to align into a tight little device, with the emphasis on little. It could be used for doll house construction sooner than the use Strauss implied in his preamble:

"For the casual user of tools, it has been found to be quite expensive to purchase and maintain a complete set of individual tools, such as a hammer, saw, screw driver, and the like, it being also necessary to purchase or construct a tool box to contain and safeguard such tools. The present invention provides a combination tool or tool kit including a number of tool elements carried in a single frame which also serves as a handle."

Multi-tool folding bows go back to the 18th century. The functions have changed with the times, with hoof picks, carriage keys, button hooks, and punches eventually giving way to screw drivers and rasps, but rather than carrying on a proud tradition, Strauss' tool probably ended it. Collectors have discovered many variations of this tool, produced in Germany and England. Even Japan is known to have fielded an entry, although not with a corkscrew. Subtle differences exist in the shape of the hammer and the apparent absence of a can and bottle opener tool in the other models. Examples exist wielding six, seven, and eight tools, while the Strauss model has consistently been found to contain nine.

Fig. 5-1 Two 19th century English "King's Screws" using rack-and-pinion mechanics. Left: a brass barrel model with tablet. Both handles are bone. Right: a 'four-poster' with bone turning handle and metal rising handle.

Aside from the utility patents of Frins and Strauss, it is hard to make a case for any definitive corkscrew patent immerging from this period. If anything, the Design patents carried the load, producing a mix of functional and whimsical examples. The former is represented by M. T. McDowell's design for a rack-and-pinion corkscrew (remember, Design patents cover only the looks of an item, not its function) which is a modern version of the classic 150-year-old "King's Screw" (Fig. 5-1). Known as the "KORKMASTER," there is also a smaller "Korkmaster Jr.," making use of the love affair America had with aluminum (No. D-148,810).

The goofy corkscrew category saw two excellent representatives come forward. Howard Ross made use of a helix found in nature, namely a pig's tail, only slightly extended (No. D-154,880). A strategically formed snout and ears lifted caps. Meanwhile, Samuel Gerson personified a bar tool in his "Bar Bum," which was more politely titled "Bar Utensil" for the Patent Office (No. D-160,082). Obviously a post-Prohibition product, the metal cast "Lovable BAR BUM" conveniently pried off bottle caps (with a crinkled hat), cracked ice or nuts (with hammer-shaped ears), became a jigger (inside pants) after a muddler was removed, itself sheathing an ice pick or olive spear, along with the obligatory corkscrew, which pivoted out from a 1 1/2" handle, perhaps tied with Bridgewater for the most useless in all of corkscrew history (No. D-87,618). The "Bar Bum" also offers a reminder of the projected condition of the user should the piece be actually used to any excess.

With all due respect to the entries of M. S. Neal (No. D-124,223), G. S. Iskyan (No. D-160,605), J. N. Amigone (Nos. D-163,785 and D-173,600) and Carlo Gemelli (No. D-184,613), a pretty weak team of inventors took the field in the mid-20th century.

D-148,345
Paul Wyler
January 6, 1948
Unmarked 'key' combo at slight variance to the patented "Castle Key" (not shown), but from the same manufacturer; 8.3". *Courtesy of Ron MacLean.*

D-124,223
Marshall S. Neal
December 24, 1940
Unmarked combination bottle opener, ice muller and corkscrew by Neal. It is also made without the corkscrew, which is not nearly as hard to find; 5.6".

D-148,810
Marshall T. McDowell, Assignor To The Korkmaster Company
February 24, 1948
TRADE MARK KORKMASTER PAT. PENDING
A rack and pinion mechanical (see Fig. 5-1) by M. T. McDowell. It is made of aluminum, which became popularized in World War II; 6.8". *Courtesy of Bob Nugent.*

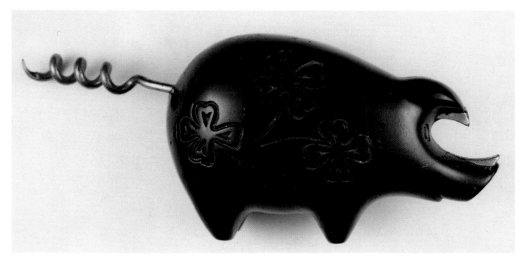

2,478,063
Louis Strauss
August 2, 1949
Unmarked 9-tool folding bow by Strauss. It is distinguishable from similar German and English models because of the can and bottle opener elements and round-nose hammer; 3.6".

D-150,957 .
Fritz Kahlen And Peter P. Jordan; Said Jordan Assignor To Said Kahlen
September 14, 1948
BOTTLE KING REG. PAT. PEND. Too bad there is no sheath for the sheath; 4.8" closed. *Courtesy of Nicholas F. D'Errico III.*

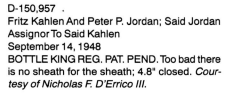

D-154,880
Howard L. Ross
August 16, 1949
Unmarked composition figural pig with cap lifter snout and anatomically correct corkscrew; 5.3". *Courtesy of Don Bull.*

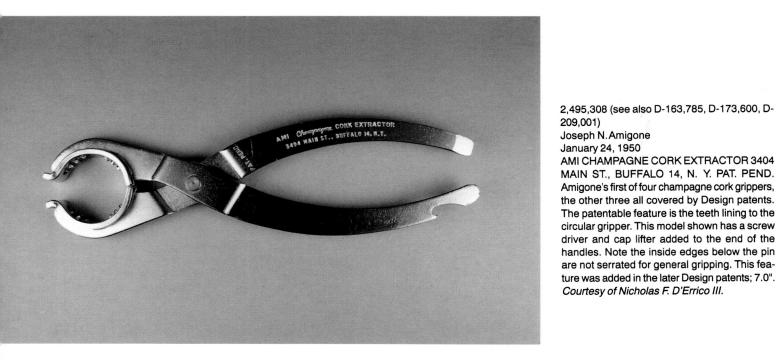

2,495,308 (see also D-163,785, D-173,600, D-209,001)
Joseph N. Amigone
January 24, 1950
AMI CHAMPAGNE CORK EXTRACTOR 3404 MAIN ST., BUFFALO 14, N. Y. PAT. PEND. Amigone's first of four champagne cork grippers, the other three all covered by Design patents. The patentable feature is the teeth lining to the circular gripper. This model shown has a screw driver and cap lifter added to the end of the handles. Note the inside edges below the pin are not serrated for general gripping. This feature was added in the later Design patents; 7.0". *Courtesy of Nicholas F. D'Errico III.*

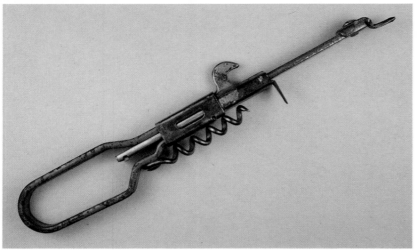

2,512,238
Richard Itaru Nakamura, Assignor To Yoshiko Nakamura
June 20, 1950
OLYMPIC FINE STEEL TIN CUTTER The cork-screw brings up the rear in the list of functions for this "Frame With Slidable Tool Bit." *Courtesy of Michael Wlochowski.*

D-160,082
Samuel L. Gerson
September 12, 1950
BAR-BUM cast metal figural by Gerson. **a.** Front view showing ice crushing 'ears' and cap lifting 'hat'; 6.9". **b.** Side view showing separate components including ice pick and worthless cork-screw. **c.** Shown in bronzed and aluminum finishes. *Courtesy of Don Bull.*

c.

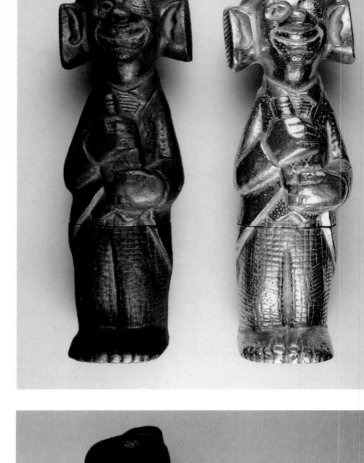

a.

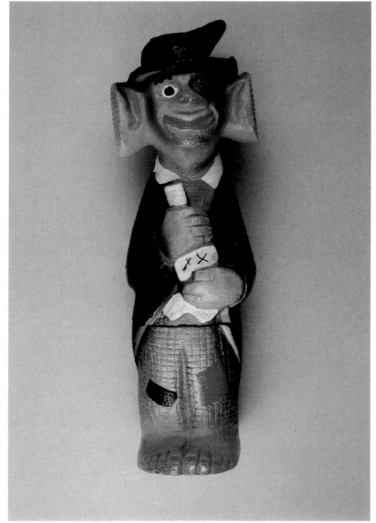

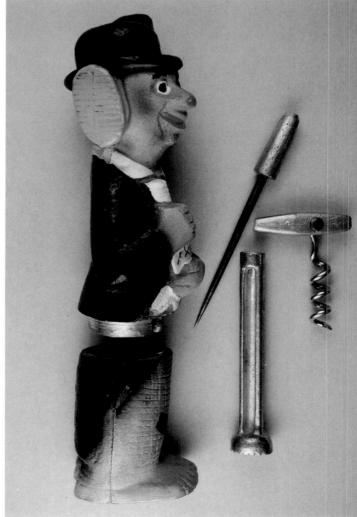

b.

D-164,909
Alvah W. Towler, Assignor To William A. Uttz
October 23, 1951
PAT. D-164909 CS5 DINE-A-BITE NATION-WIDE CO. ARLINGTON, TEXAS A can-piercing, cap-lifting spoon-fork. Even with corkscrew added it is of dubious utility. That is of no consequence to a Design patent; 7.0".

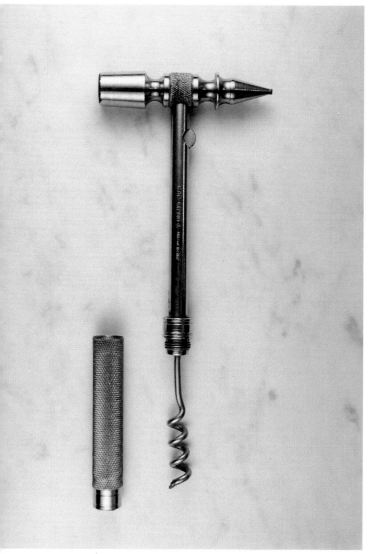

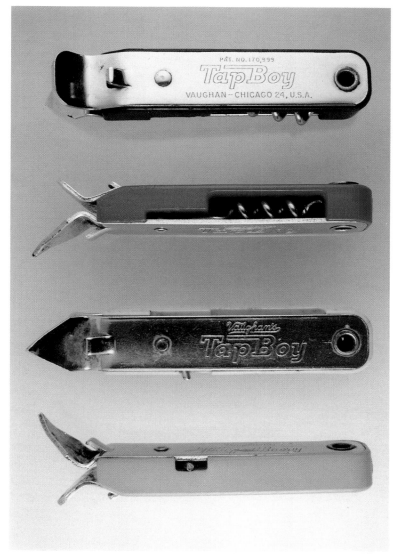

D-160,605
George S. Iskyan
October 24, 1950
BAR-GIZMO G. M. Co L. I. C., N. Y. TRADE MARK DESIGN PAT. PEND. A tool easily mistaken for a carpenter's rather than bartender's helper; 7.3". *Courtesy of Bob Nugent.*

D-170,999
Michael J. La Forte, Assignor To Vaughan Mfg. Co.
December 1, 1953
PAT. NO. 170,999 TAP BOY VAUGHAN - CHICAGO, U. S. A. Four colorful two-headed 'church keys' stack up to the patent drawing. Surely one is just right for your kitchen decor. Note the invisible "D" in the patent number; 4.5". *Top, courtesy of Dennis Bosa.*

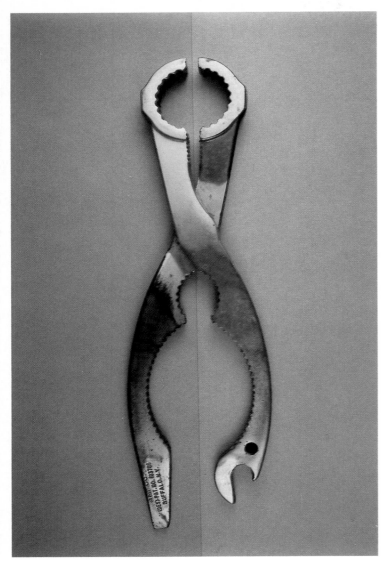

D-173,600 (see also 2,495,308, D-163,785, D-209,001)
Joseph N. Amigone
December 7, 1954
a. AMI CO. (DES) PAT. NO. 163,785 The third of four similar gripping tools patented by Joseph Amigone, marked with the earlier Design patent. The inner handle edges are serrated for general gripping; 8.0". **b.** AMI CO. PAT. NO. 163785 BUFFALO, N. Y. An identical tool showing invisible "D" marking, not that anyone would mistake this for an 1875 utility patent.

2,718,055 (see also 2,190,940)
Maximilian C. Frins, Assignor To Joseph A. Cahil, Doing Business As Cahil Manufacturing Company
September 20, 1955
a. "QUINTUPLET" REX 5-IN-1 CAN OPENER PAT No D 100,469 OTHERS PEND. with advertising SOLD ONLY AT REXAL STORES Frins hibernated 15 years before unveiling his slightly improved can opener mechanism. He also dropped the knife sharpener. The marked Design patent of July 21, 1936 applies to the head portion only; 8.0". **b.** The Design patent.

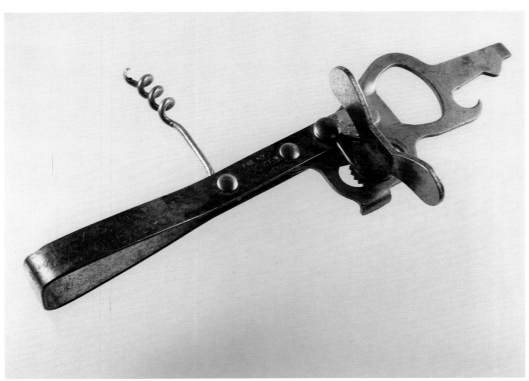

July 21, 1936. M. C. FRINS Des. 10

"COMBINED CAN, BOTTLE AND JAR OPENER, AND SCREW DRIVER"

Filed May 5, 1936

Fig.1 *Fig. 2*

INVENTOR.
Maximilian C. Frins,
BY *Boquet, Neary + Campbell,*
ATTORNEYS

D-184,613
Carlo Gemelli
March 17, 1959
Large flat aluminum double lever corkscrews
made in Italy, variously painted to honor the bar
service profession. **a.** Left: BARMAID MADE IN
ITALY (10.0") Right: BARMAN OPENER
BREVETTATO MADE IN ITALY; 10.9". **b.**
BBAARRMMAANN MMAADDEE IINN
IITTAALLYY; 10.5".

November 22, 1963 President Kennedy assas-
 sinated

1964 - 1975 The War in Vietnam

June 20, 1969 U. S. Astronaut, Neil Armstrong,
 walks on the moon

July 4, 1976 Bicentennial celebration

United States Patent

Des. 239,362
Patented Mar. 30, 1976

239,362

CORK SCREW

George Frederick Peterson, Boonton Township, N.J.,
assignor to Etamco Industries, Belleville, N.J.

Filed Sept. 16, 1974, Ser. No. 506,287

Term of patent 14 years

Int. Cl. D7—05

U.S. Cl. D8—42

FIG. 1

FIG. 2

FIG. 3

FIG. 4

FIG. 1 is a front elevational view of a cork screw show-
ing my new design;
 FIG. 2 is a side elevational view thereof;
 FIG. 3 is a bottom plan view thereof; and
 FIG. 4 is a top plan view thereof.
 I claim:
 The ornamental design for a cork screw, substantially
as shown.

References Cited

UNITED STATES PATENTS

D. 18,528	8/1888	Mersereau	D8—42
297,232	4/1884	Curley	81—3.45
476,777	6/1892	Beust	81—3.45
535,726	3/1885	Qvarnstrom	81—3.45

FOREIGN PATENTS

1,127,543	12/1956	France	81—3.45

WINIFRED E. HERRMANN, Primary Examiner

D-239,362
George Frederick Peterson, Assignor To Etamco
Industries
March 30, 1976
PAT. NO. 239,362 The president of ETAMCO,
parent company of C. T. Williamson Novelty Co.,
patented and produced this final example of a
"Williamson" corkscrew, drawing to a close more
than 100 years of continuous corkscrew manu-
facturing; 5.0".

CHAPTER 6
1960 THROUGH 1994

114 Corkscrew Patents

What goes around comes around. From its early promise as a dedicated tool, the corkscrew had finally 'arrived' back where it started its long odyssey, only now the tool is 'modern' and the bottles all contain wine. No longer would the corkscrew be held hostage to a bunch of second cousins on a combination tool. Not with the burgeoning new crop of 'boutique' wineries centered in the Napa Valley area of Northern California (Fig. 6-1). These were serious wine makers, intent on producing a product marketable for its taste and aesthetics not just its generic "Burgundy," "Chablis" or "Sherry," although plenty of that was made too, requiring but a twist-of-the-wrist to open and a brown bag to conceal the flavor. Style was the wine maker's creed with 'dry', 'tannin', 'aroma' becoming elements of discernment for a "Chardonnay," "Cabernet Sauvignon," "Zinfandel" or "Chenin Blanc." This was a new vocabulary for a consumer who had been raised on Martinis and Manhattans, if not bathtub gin, basement brew and "snake oil." Wine complemented life in moderation rather than complicating it with excess. Bottled excellence demanded corkscrew excellence and the inventor was clearly challenged.

The Patent Office, now the "U. S. Patent and Trademark Office" (or "P. T. O."), found it too was butting up against progress, unable to accommodate a 21st century inventor with a 19th century bureaucracy. Thus after a three-year conversion process, in the middle of the week's batch of patents for December 1, 1970 (why not the beginning patent of that week?... it's just one of those bureaucratic mysteries), a new era began in the formatting of patents, perhaps the most significant change since the inception of the Patent Office. Instead of a separate summary or claim arbitrarily excised for the OFFICIAL GAZETTE, a synopsis was incorporated into the patent itself, which became the basis for publication in the OFFICIAL GAZETTE. Known clumsily at first as the "Abstract of the Disclosure," which was placed at the beginning of the specifications section, the lead page itself eventually became the "Abstract" followed by the complete

HOW AMERICA TAKES TO ALCOHOL

Over the decades, tastes in alcoholic beverages change. Aside from the period of Prohibition (1919 to 1933) when, ahem, none of the stuff was officially consumed, there has been a gradual decline in the fondness for distilled spirits in favor of wine. Beer has held its own.

APPROXIMATE U. S. PER CAPITA ALCOHOL CONSUMPTION, 1871-1992

YEAR	BEER	%	WINE	%	SPIRITS	%	ALL BEVERAGES
1871-1880	0.56	33	0.14	8	1.02	59	1.72
1881-1890	0.90	45	0.14	7	0.95	48	1.99
1891-1900	1.18	55	0.10	5	0.86	40	2.14
1901-1910	1.39	56	0.15	6	0.95	38	2.49
1911-1919 Prohibition	1.28	57	0.13	6	0.85	37	2.26
1934-1939	0.73	53	0.11	8	0.53	39	1.37
1940-1949	1.01	51	0.19	10	0.77	39	1.97
1950-1959	1.01	50	0.22	11	0.78	39	2.01
1960-1969	1.04	46	0.24	11	0.98	43	2.26
1970-1979	1.24	47	0.31	12	1.09	41	2.64
1980-1989	1.35	52	0.36	14	0.91	34	2.62
1990-1992	1.31	56	0.31	13	0.74	31	2.36
Average		50		10		40	

Source: National Institute of Alcohol and Alcoholism.

Fig. 6-1 Some examples of California "boutique" wines of the 1960s and '70s, ushering in a new era of excellence in wine and corkscrew making.

drawings and specifications. Thus the OFFICIAL GAZETTE publication and the face page of the patent became one and the same. The reader will note the abrupt change with Gero Artmer's patent for a "Corkscrew," June 11, 1974 (No. 3,815,448). Note also the inclusion right up front of the assigned subclass, foreign applications and search references. The patent Examiner also steps out of obscurity for the first time.

Like Chapter 1, we once again address a period of greater than 20 years. This is due partly to the open-endedness of bringing the research up to date, and partly to the homogeneous nature of the corkscrews patented. The number of patents is not large, but the technology is revolutionary in terms of materials and new adaptations of old principles. The photographs leap off the page with color, exotic surfaces and streamlined shapes—elements not seen before in the relatively monochromatic history of corkscrew fabrication. Two patent types dominate the period: pressure injectors and Herbert Allen's "Screwpull," the latter elevating corkscrew technology to perhaps its highest form yet. There came also the first of the power driven corkscrews, taking some of the tactile sensation away from wine opening but fitting right in with the public's appliance-driven lust. There was also a resurgence of the 2-prong cork puller and cork retriever, both of which date back to the 19th century. Not represented in the list but related in a distant sense was the patenting of more than a score of champagne cork removers, particularly corks of the plastic variety (see Appendix Two). That so much patent activity occurred at the low end of the bubbly chain is surprising. Just how much demand could there be, one wonders, for a choice of tools to open cheap champagne, if in fact a tool was necessary in the first place?

The period started out innocently enough with *no* patents issued for a corkscrew the first two years and only one each of the next two. For all of the 1960s there was a total of 17 corkscrew patents. The 1970s were even less productive with 14. Most of the action occurred in the 1980s with 54 patents granted, over half of which went to foreign residents. Also by the 1980s cork pulling became the dominant, if not exclusive feature of the tool. Except for a couple of stragglers, the book on combination tool inventors was finally and mercifully closed, may their Eternity now be pure and simple.

The first of the modern era types — the pressure injector — may ultimately turn out to be a fad. While it is too soon to call in the historians, one has the sense that the inventors were more intent on developing the technology than producing a tool the public wanted. Either by hand pump or by re-

leasing non toxic gas from a cartridge, the device increased the pressure in the small air pocket between the wine and cork. Eventually something had to give—hopefully the cork. The results did not always work according to the drawing board and purists were quick to point out that body parts were not the only thing at risk. For, *sacre bleu!,* the pressure was thought to have the potential of 'injuring' the wine itself! Neither did the pressure injector have the nobility of a corkscrew, being more of a novelty befitting the profile of a Christmas gadget that lasted for as long as the original cartridge held out, if it even survived the Holiday Week. After that it went deep into the junk drawer. Try as they have to elevate the technology, the inventors have yet to overcome the stigma of extracting corks by inoculation, although novelty and impulse buying have great merchandising appeal. The relatively recent patent of George Federighi suggests a comeback for the pressure injector, at least in terms of cosmetics (No. 4,791,834). It is now clearly a tool of the 21st century, but 300 years of tradition is a lot to overcome.

On the other hand, the "Screwpull" has become a success story of epic proportions, giving us a modern day achiever in the tradition of Clough-Walker-Williamson and still going strong even past his mortal Assignment. For before his death in 1990, Herbert Allen of Houston, Texas had been named in 15 known wine related patents, of which 8 are included in the master list.[25] Two of the total are Design patents.

Born in 1907, Herbert Allen rose to a position of prominence in the state of Texas and in particular, Houston. He was an engineer by education and an inventor at heart with over 150 U. S. patents having been obtained in the oil field equipment field alone. Including foreign patents, it is estimated that he was granted over 400 total patents in his lifetime. The corkscrew patents were assigned to the Hallen Company, a company he founded to produce the "Screwpull." Anyone who has opened a bottle of wine with a "Screwpull" can attest to its unerring efficiency. Based on the amount of copycatting that has come since, he must have been on to something. It just may be the closest thing yet to the Holy Grail of corkscrew invention.

The consummate tinkerer, Allen was challenged by the 'weakness' he perceived in every corkscrew, namely the tendency of the worm to stray. Even if started dead center, the slightest angle of penetration or cork inconsistency could cause the point to reach glass, especially when taking on today's long corks. It exacerbated the leverage required to pull a tight cork which could

October 29, 1929 Stock market crash

do damage to the bottle, the corkscrew or the user. Other issues he tackled were the preventing of bits of cork from falling into the wine, reducing the amount of strength required, which was thought to be intimidating to the user (especially women, in the unenlightened pre-feminist times), and developing a modern design that would be in keeping with the household of today. He succeeded on all fronts.

His corkscrew patents tend to be very complex, revealing his engineering approach to problem solving. It is difficult to discern between patents as he closed in relentlessly on perfection. Whereas little if any attention had been given to the worm in over 100 years of patent history, Allen honed in on the *point alone*, conducting experiment after experiment on different shapes and grinds much like Edison pursuing the light bulb. Although the patents use terms like "vectors" and "compressive forces" "upward" or "downward" components and "wedging action," you can be sure many a point was tried on real corks before the final solution was reached, hopefully not prolonged by the notes taken after consumption of the contents. Also consistent with all his patents is a Teflon coating to reduce friction and a molded plastic body used as a bottle grip and centering device.

No summary can come close to describing the amount of engineering detail that went into the evolution of the "Screwpull," down to the smallest detail. A marvel of modern technology is the result, which anyone can use and appreciate without having to know how or why it works. It just does. Once again the role of the inventor through the patent system has touched our lives in a positive way. The tradition has been continued under a new organization, rendering the universe of earlier "Screwpulls" finite, but far from ripe for antique status. It is a corkscrew to use, not dust!

The success of the "Screwpull" and the fact that wine is now the corkscrew's singular mission in life, veils a significant amount of history when the corkscrew was a more universal tool. Particularly in the United States when the taste for fine wine lagged behind English and Continental palates, the corkscrew has taken a many-detoured and tortuous route through U. S. history. Very little of the mid-life patenting was inspired by wine and very little of the wine made during that time was intended to 'go with' the main course. That, coupled with America's love affair with distilled spirits and nostrums, gave the corkscrew anything but a glamorous life this side of the Atlantic. A young Nation busy experiencing the growing pains of independence, took a while to catch on to gracious living.

[25] Six patents are for accessories, technically not corkscrews, and are included in Appendix Two. The 15th was a Re-examination of an existing patent.

Although subject to fads and trends, thanks to the patent system corkscrew design could never be accused of staying in a rut. Not many inventors got rich, but no other history is as rich in diversity, imagination and market-driven productivity. It is hoped that this peek into one aspect of our colorful past will bring a greater appreciation for this indispensable tool, which has finally come to the table of good food and friendship. Whether the corkscrew or even the cork itself survives the next technology may not be ours to witness; yet, if the new age deprives our descendants of the opportunity to place a real working relic of history in their hands, as it is our present privilege to do, they are going to miss out on something very special.

D-209,001 (see also 2,495,308, D-163,785, D-173,600)
Joseph N. Amigone
October 24, 1967
AMI OPEN-ALL PAT. D-209001 BUFFALO, N. Y. 14214 The crown jewel of Joseph Amigone's four patents for a gripping tool, finally incorporating a corkscrew and marked correctly; 8.0".
Courtesy of Bob Nugent.

3,192,803 (see also 3,085,454)
George J. Federighi
July 6, 1965
CORK POPS PAT. PEND. Federighi's patents ignited a fad in pressure ejection. The directions claim 40 cork "boosts" to a cartridge. The earlier patent used non-toxic gas, which would sometimes escape through porous corks rather than lift them out. This was corrected in the second patent by using a liquid propellant. It might have solved the engineering problem but who wants Freon in their Cabernet? Shown with original box; 5.3". *Courtesy of Nicholas F. D'Errico III.*

D-214,078
Fred Steiner, Assignor To Bonny Products, Inc.
May 6, 1969
STAINLESS The 'in' color plastic blended with metal in a combination can piercer, cap lifter and corkscrew; 6.0". *Courtesy of Bob Nugent.*

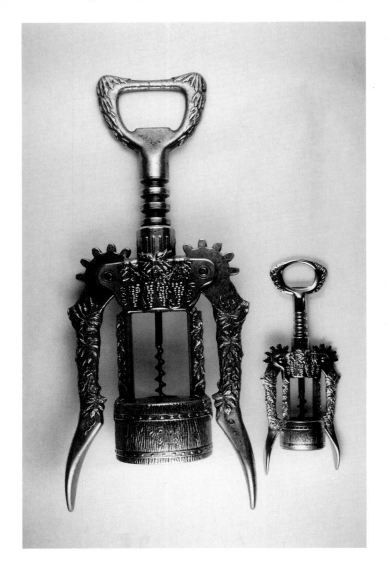

D-228,613
Cipriano Ghidini, Assignor To Ray Control Corp.
October 16, 1973
Unmarked classic double lever mechanisms decorated for Design patent purposes by Cipriano Ghidini of Brescia, Italy and assigned ɔ a U. S. manufacturer. Left: oversize demonstration model that 'works', if awkwardly, on conventional size bottles; 15.0". Right: ITALY; a more normal 8.0".

3,815,448
Gero Artmer
June 11, 1974
DESIGN GERO ARTMER VIENNA WORLD PATENTS DUPONT'S DELRIN A corkscrew which is given a gas pressure assist inside the mechanism rather than inside the bottle. *Courtesy of Michael Wlochowski.*

D-239,362
George Frederick Peterson, Assignor To Etamco Industries
March 30, 1976
A modern bell by George Peterson, President of Etamco Industries, last in the long heritage of producers of Williamson corkscrews. Left: PAT. PEND. (on shank). Right: PAT. NO. 239,362 (on bell). Like many of his predecessors, Peterson chose to leave off the "D," as in "Design" patent; 4.9".

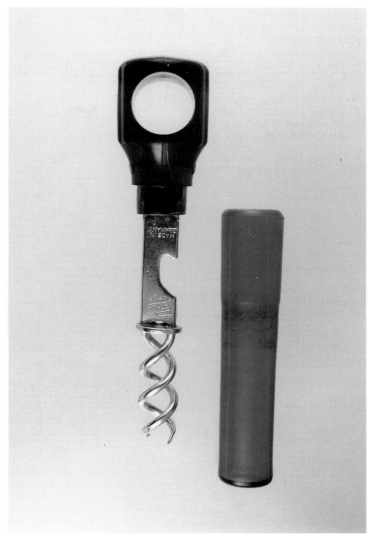

D-244,002
Bernard R. Bonin
April 12, 1977
U. S. PAT. No. D-244,002 A modern cork re-
triever carrying on a 100-year tradition, but do-
ing it with enough novelty to qualify for a Design
patent; 8.2".

D-247,279
Robert K. Marceca
February 21, 1978
MADE IN GERMANY PATHOS SUPER A mod-
ern see-through plastic pocket duplex screw with
sheath that deploys as handle; 4.6" closed.
Courtesy of Ron MacLean.

4,135,415
Johannes Liebscher and Rolf G. Schulein
January 23, 1979
LEIFHEIDT An offset swivel-over-collar mecha-
nism of questionable novelty. The citing of patent
No. 1,200,079 as a Reference would be fine in
a two-patent universe, but raises the question
of whether invention in the purest sense is in-
volved. Marked for the assignee; 6.3". *Courtesy
of Nicholas F. D'Errico III.*

4,253,351
Herbert Allen; Assignee: Hallen Company
March 3, 1981
SCREWPULL PATENTED PAT PEND A lever
"Screwpull" in which the bottle grips are held in
one hand while the other swings over the action
lever automatically turning the corkscrew then
lifting out the cork; 7.5" left to right. *Courtesy of
Nicholas F. D'Errico III.*

4,291,597 (see also 4,429,444)
Herbert Allen; Assignee: Hallen Company
September 29, 1981
The second in a series of patents by Herbert
Allen for a plastic grip corkscrew (the first, No.
4,276,789, is not shown). All were marketed as
the "Screwpull." Each patent advances the tech-
nology, such as these two in which the helix is
re-pointed and a layer of friction reducing poly-
meric material is added (the two patents are
identical except that the method of manufacture
is additionally claimed in the latter). Note the
absence of inner guides to receive the cork,
which became the basis for later improvements.
Left: SCREWPULL PAT. PEND.; 5.8". Right:
SCREWPULL This is the so-called "Pocket
Model" with modified 'T'-handle that becomes
sheath when not in use. Also includes hinged
knife blade; 5.5". *Courtesy of Nicholas F.
D'Errico III.*

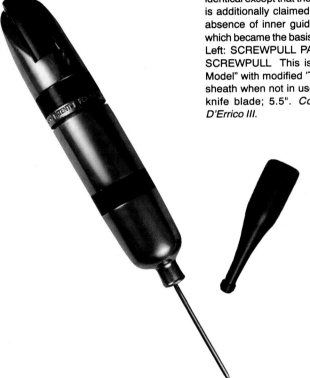

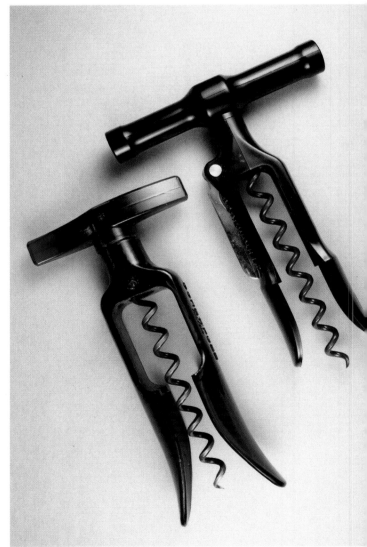

4,317,390
Michio Nakayama
March 2, 1982
CORK-ACE PATENTS PENDING A bottle
opener utilizing, in the patentee's own words, a
"bomb" to inject gas under pressure. But he says
it is safe. Also manufactured as SPARKLETS
CORKMASTER; 7.0" without sheath. *Courtesy
of Nicholas F. D'Errico III.*

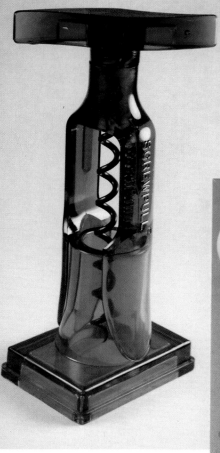

4,377,096
Herbert Allen; Assignee: Hallen Company
March 22, 1983
SCREWPULL PATENTED PAT. PEND The quintessential corkscrew of the modern era. The guides inside the plastic frame prevent the cork from turning as it emerges from the bottle. The only 'fault' is that the design of the grips prevent it from standing on its own. Hence the stand; 5.8".

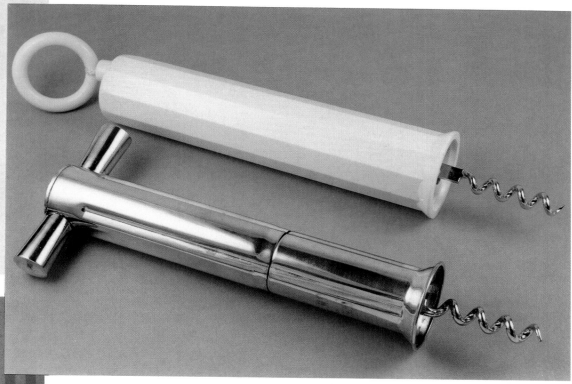

4,393,733 (see also D-307,102)
Bruno Desnoulez And Andre Dejoux
July 19, 1983
Below: a metal telescoping corkscrew is provided with "tackle reduction" by internal pulleys, which reduces the pulling power as the handle section separates from the barrel; 8.1" closed, 13.0" fully extended. Above: A plastic variant, also covered by the patent, eliminates the telescoping feature and provides a pull ring instead. This version was granted a Design patent seven years later (No. D-307,102); 10.0".

D-274,974
Aldo Colombo; Assignee: Aghifug S.a.S. di Bonomi Giacomo Marino and C.
August 7, 1984
SOMMELIER A good old fashioned double lever corkscrew dressed up in whimsical attire; 8.4".

D-281,855
Jacques Kuhn; Assignee: Heinrich Kuhn Metallwarenfabrik AG
December 24, 1985
KUHN RIKON MADE IN SWITZERLAND A high-tech corkscrew in the mold of the "Screwpull." Could that be the Swiss Cross formed in the negative space?; 6.1". *Courtesy of Bob Nugent.*

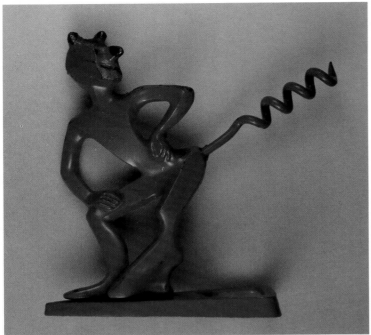

D-281,946
Gerald Youhanaie
December 31, 1985
Unmarked close approximation to the Design patent drawing. Marketed as the "Red Devil Bottle Opener and Corkscrew" which could also be used as a paperweight. A somewhat mystifying piece because it would appear to be older than the patent; 3.5".

4,580,303 (see also D-291,052)
Garry E. Henshaw
April 8, 1986
PATENT ITALY The sheath of this corkscrew doubles as a 'T'-handle. The tool also pries off caps, grips tight twist-tops and re-seals bottles. Both patents carry an application date of January 14, 1985. It is rare for the utility patent to makes it though ahead of the Design patent; 4.4". *Courtesy of Bob Nugent.*

4,570,512
Gunther Pracht; Assignee: August Reutershan GambH. & Co. KG
February 18, 1986
SIEGER-600 A full-fisted 'coaxer' with an internal spring action. Just keep on turning and the cork seems to leap out of the bottle; 4.8".

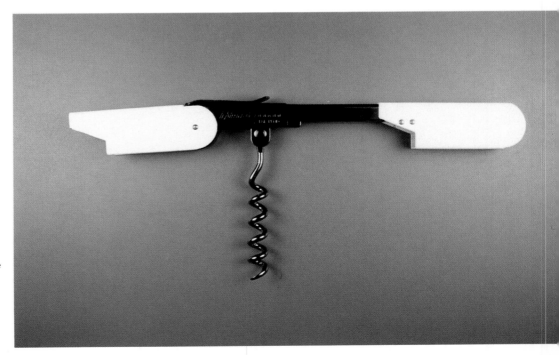

4,574,663
Bernard Delisle, Jr.
March 11, 1986
LIFTMASTER PAT. PEND. A corkscrew with a sliding sheath. One end functions as a lever; 4.6" closed, 6.0" left-to-right open. *Courtesy of Nicholas F. D'Errico III.*

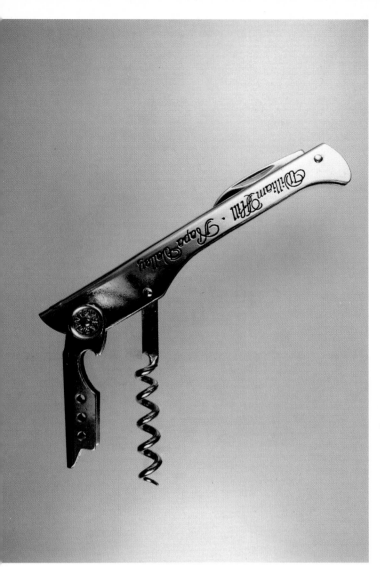

4,584,911
Ferdinando Cellini; Assignee: Farm DI F.S.a.s.
April 29, 1986
FARM PAT PEND E. B. ITALY The careful eye
will spot the end of a crescent-shaped groove
(could it be a smile?) in which the lever of this
'waiter's friendlier' can adjust to the angle of the
corkscrew. Advertising WILLIAM HILL NAPA
VALLEY; 5.1".

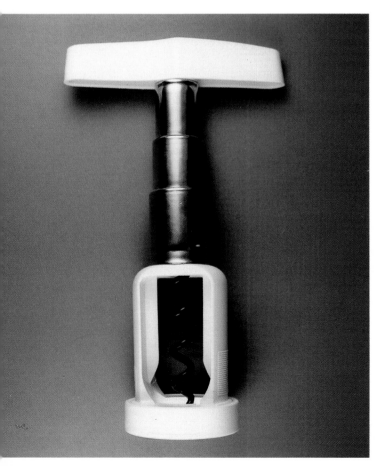

4,658,678
Gunther Pracht; Assignee: August Reutershan
GmbH. & Co. KG
April 21, 1987
SIEGER TELESKOP A "telescopic tube" com-
presses as the handle turns, giving an added
assist to lifting out the cork; 6.0". *Courtesy of
Nicholas F. D'Errico III.*

4,637,283 (see also D-288,521)
Leo Bertram, Romuald L. Bukoschek, Peter
Steiner; Assignee: U. S. Phillips Corporation
January 20, 1987
NORELCO The corkscrew goes electric, but
what if the power goes out? Thank God for
screw-top wine. Curiously, the Design patent
was applied for first by a different individual from
a different country! Both patents are assigned
to U. S. Phillips Corporation; 9.7".

D-290,682
Jay J. Rogers
July 7, 1987
A modern cork retriever. A magnifying glass
applied to the card will reward the curious of
either English or French persuasion; 8.6". *Cour-
tesy of Ron MacLean.*

D-291,174
Stephan Koziol
August 4, 1987
a. Unmarked faucet handle corkscrew. Also
comes in gold to match the most fastidious
tastes in bathroom decor; 4.1". *Courtesy of Bob
Nugent.* **b.** See? *Courtesy of Nicholas F.
D'Errico III.*

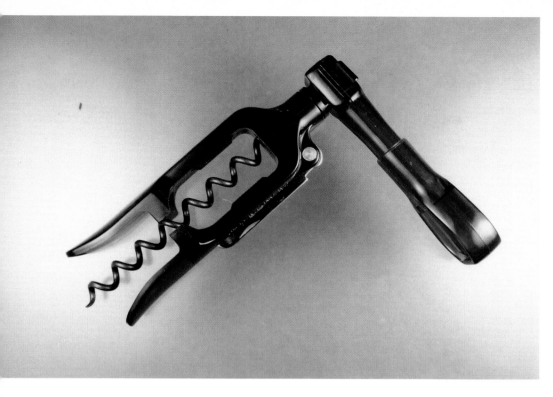

4,703,673 (see also D-293,414)
Herbert Allen; Assignee: Hallen Company
November 3, 1987
a. SCREWPULL PAT AND PAT PEND The next generation "Screwpull" with inside cork guides positioned midpoint in the frame. The sheath serves not only as a crank handle, but extends for one-finger turning. Marketed as a pocket model "for the convivial gourmet who is on the go and in the know." This is a rare instance of the utility patent for the same corkscrew being issued faster (by one month) than the Design patent; 5.9" closed. **b.** A 'T'-handle version, which also slips over the wire helix when not in use. It is similar to No. 4,291,597, right, except for the added cork guides; 5.9" closed.

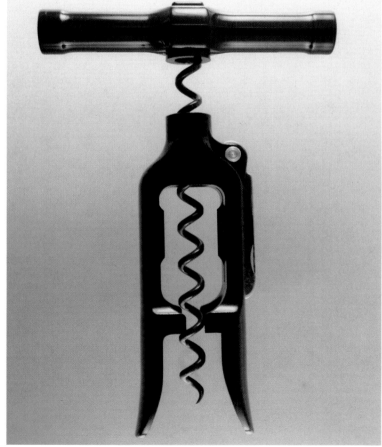

D-294,218
David B. Johnson
February 16, 1988
REG. DES. MADE IN ENGLAND A pocket corkscrew and cap lifter. Note uncanny similarity to No. D-301,113; 4.0" closed.

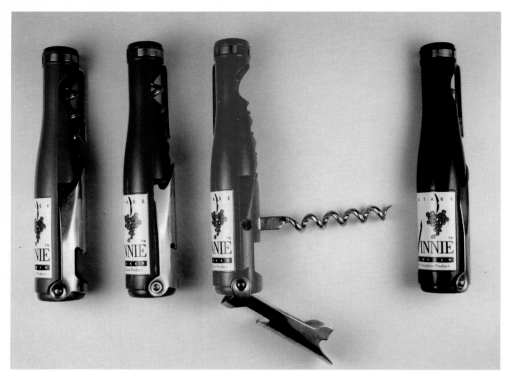

4,759,238
Germano Farfalli; Assignee: Marino Farfalli &
Figli s.n.c.
July 26, 1988
PAT. INT. 45751 ITALY A 'waiter's friend' that
invites winery advertising; 4.8".

4,791,834
George J. Federighi
December 20, 1988
CORK POPS II Federighi's next generation cork
ejector improving on No. 3,192,803. A measured
injection prevents waste and avoids "inadvertant
(sic) over-pressurization" while the added shield
further protects against "uncontrolled ejection".
Moreover, a warning label cautions against use
on "champagne, Chianti, or damaged bottles
(which) could cause (them) to explode." Perhaps
not the ideal opener for lawyers; 7.0".

D-301,113
Josh Lapsker; Assignee: Starline Industries inc.
May 16, 1989
STARLINE INDUSTRIES INC RD. 1987 MADE
IN CANADA Is it possible Lapsker and Johnson
(No. D-294,218) took separate routes in arriv-
ing at the same destination? Perhaps more sig-
nificant than the question of design originality is
the marking on the sheath. This corkscrew was
the hosts' favor for the 1988 Annual General
Meeting of the Canadian Corkscrew Collectors
Club in Mississauga, Ontario, Canada; 4.0"
closed. *Courtesy of Bob Nugent.*

4,955,261
Yung-Tung Chiang; Assignee: Chyuan How
Enterprise Co., Ltd.
September 11, 1990
U.S. PATENT NO. 4,955,261 A motorized cork-
screw that operates under battery power. It was
bound to happen: a corkscrew with an on/off
switch; 6.8" left to right, 5.0" top to bottom.

D-307,102 (see also 4,393,733)
Bruno Desnoulez; Assignee: Anne-Marie Prevos
April 10, 1990
LE SAUTE BOUCHEN KARIBA KARIBA PAT.
PEND. MADE IN FRANCE Adopting an ancient
technology, internal rope pulleys reduce the pull
force. This corkscrew is a variant covered by a
utility patent granted in 1983 (No. 4,393,773);
9.8". *Courtesy of Bob Nugent.*

4,838,128
Wolfgang Tischler
June 13, 1989
GERMANY A modern two-prong extractor, al-
though the patentee prefers to call them
"tongues." The device allows the user to insert
the two (sides) independently; 5.7".

4,996,895
Ramon Brucart Puig; Assignee: Puig Bonich
S.A.
March 5, 1991
a. PUIGPULL PAT & PAT PEND SPAIN A most
ingenious corkscrew that can become addictive
once mastered. After penetration the lever ratch-
ets up a toothed post; 5.1" closed. **b.** The
"Puigpull" in action.

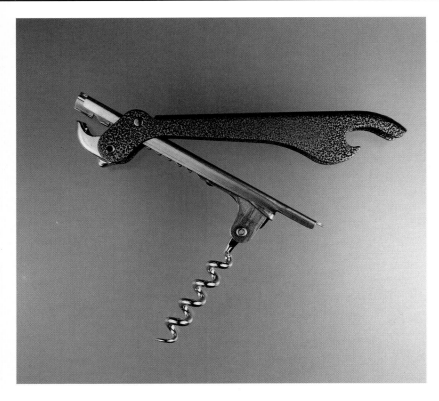

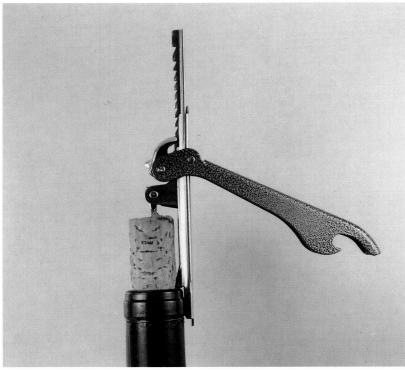

5,012,703
Helmut Reinbacher
May 7, 1991
POP A CORK Another pressure injector. The
model pictured works on a cartridge. The patent
claims it also works with an alternative inter-
changeable hand pump; 6.5". *Courtesy of Nicho-
las F. D'Errico III.*

D-319,170
Peter Franke
August 20, 1991
Unmarked golf ball with sheath concealing a corkscrew. Can be used as a 'T' or a 'tee'... possibly even to stir tea; 5.0". *Courtesy of Nicholas F. D'Errico III.*

5,363,725
Ferdinando Cellini
November 15, 1994
FRANMARA ITALY F.A.R.M. PATENT GENESIS PATENT A patent for cutting blades on a corkscrew, whose days of utility are surely numbered. With environmentally harmful foil fast approaching extinction (see Fig. E-1), it will likely revert back to being a modern 'waiter's friend' without a marketing edge; 5.3" closed. *Courtesy of Brother Timothy Diener, F. S. C.*

EPILOGUE

Crossing the threshold of history into the future, I am excited at the prospect of elevating the consciousness of corkscrews — particularly those produced in the United States — amongst collectors of such things. Non-collectors too are invited to the table, for antiques and wine embrace a greater audience than just us fanatics. While I hope there are legions of such readers in my universe, there is also an inner voice whispering to me that maybe, just maybe, something I have said or done will inspire another to actually *invent a corkscrew!* And why not? The opportunity is there. The door to the Patent Office is always open. The patent system is not just history, much of it quaint, but still a living pulsating organism functioning at the very core of the free enterprise system. There are neither shortages of wines or wine lovers (although it may not seem that way to wine makers). All it takes is the spark generated by an inquisitive mind rubbing against a rough surface, which could not be a better metaphor for this book. At the very least much of the "search" has been done for you (if not the patent Examiner?).

But before rushing to the Patent Office with application in hand, do take this cold bucket of water into account. While your patent application is welcome, your odds of obtaining a patent are about 6 in 10 and it will likely take three years to find out. Nearly three-quarters of all patents issued today are to corporations and nearly half go to foreign residents. If you meet or are willing to buck the profile and really do have a better idea, one that is not obvious to others "skilled in the art," we welcome a future collectible, if not a "new and useful" tool with which to better enjoy our favorite beverage. If by the end of the century there will be nearly 6,000,000 patents issued, is there not room for one with your name on it?

A more distant and potentially fatal threat to potential corkscrew inventors is the development of wine bottling technology that may do away with the cork altogether. Already everyday wines, requiring but a twist-of-the-wrist or a spigot to open, occupy a considerable amount of shelf space. Now a flared rim bottle for premium wines has

appeared with... can it be true, *no foil!* (Fig. E-1). Like the wire breakers of yesteryear, when the foil goes, so will go the foil cutter. With synthetic cork and aluminum closures in the experimental phase, one can only shiver at the implications for all wine service as we know it. Obviously consumer resistance to E-Z Open wine will be considerable, but time is on the side of technology, not tradition. The corkscrew itself may be on the endangered list, as the wine world faces its own version of the 'corkscrewless carriage'.

But in the meantime, let that not discourage the dreamer living in the here-and-now. It is not yet time for the paradigm reaper. Maybe it will be *your* corkscrew to which we will raise our glasses...

Fig. E-1 Bottling technology has leapfrogged would-be foil cutter inventors. Could the cork be next?

PATENT DRAWINGS

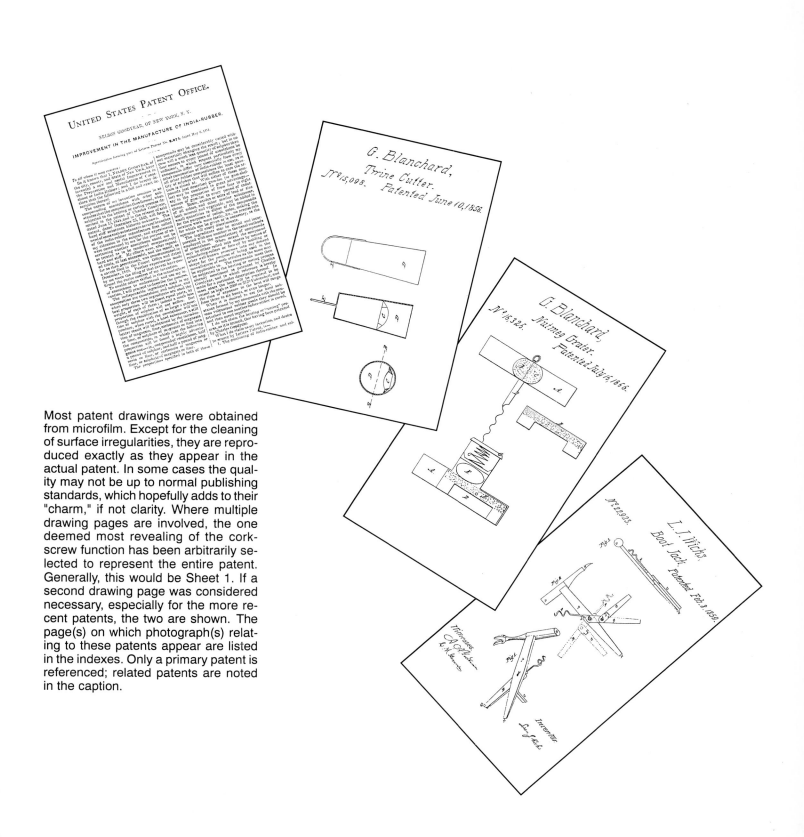

Most patent drawings were obtained from microfilm. Except for the cleaning of surface irregularities, they are reproduced exactly as they appear in the actual patent. In some cases the quality may not be up to normal publishing standards, which hopefully adds to their "charm," if not clarity. Where multiple drawing pages are involved, the one deemed most revealing of the corkscrew function has been arbitrarily selected to represent the entire patent. Generally, this would be Sheet 1. If a second drawing page was considered necessary, especially for the more recent patents, the two are shown. The page(s) on which photograph(s) relating to these patents appear are listed in the indexes. Only a primary patent is referenced; related patents are noted in the caption.

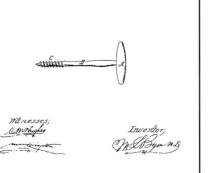

Witnesses;

Inventor;

Witnesses;

Inventor;

Witnesses

Inventor

Witnesses;

Inventor;

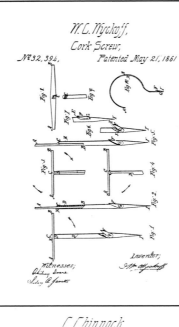

Witnesses;

Inventor;

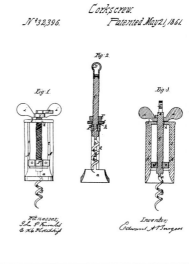

Witnesses;

Inventor;

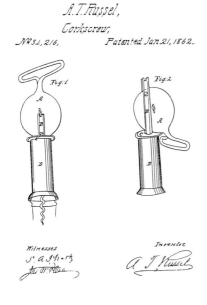

Witnesses

Inventor

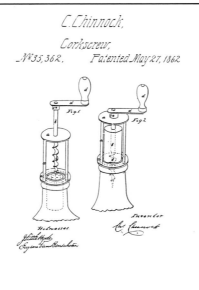

Witnesses

Inventor

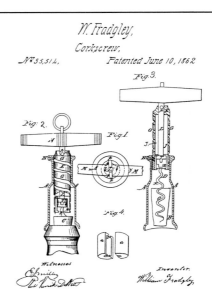

Witnesses

Inventor

H. W. Putnam.
Corkscrew.
Nº 36,528.　　　Patented Sept. 23, 1862.

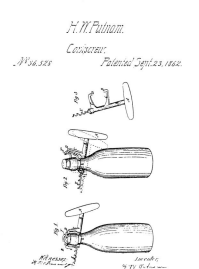

C. Chinnock.
Corkscrew,
Nº 38,147,　　　Patented Apr. 14, 1863.

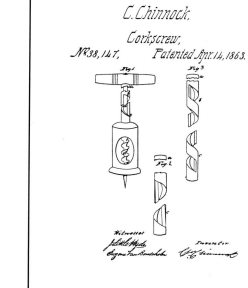

H. M. Creamer.
Corkscrew,
Nº 38,155,　　　Patented Apr. 14, 1863.

C. Chinnock.
Corkscrew,
Nº 40,674.　　　Patented Nov. 24, 1863.

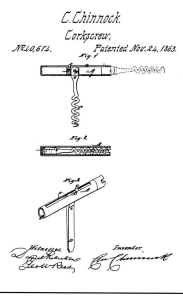

J. P. MIERS & J. GROENDYKE.
CORK EXTRACTOR.
No. 41,385.　　　Patented Jan. 26, 1864.

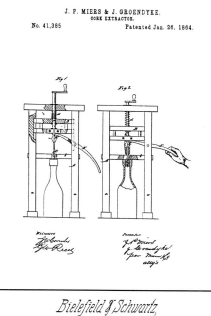

J. L. Morrill,
Cork Drawer.
Nº 42,784,　　　Patented May 17, 1864.

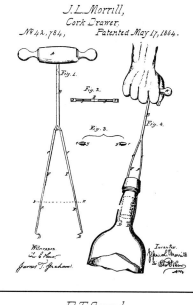

J. L. Clark
Corkscrew.
Nº 45,137.　　　Patented Nov. 22, 1864.

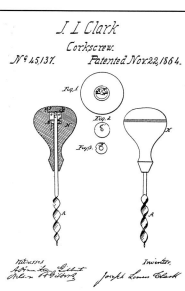

Bielefield & Schwartz,
Corkscrew,
Nº 47,161.　　　Patented Apr. 4, 1865.

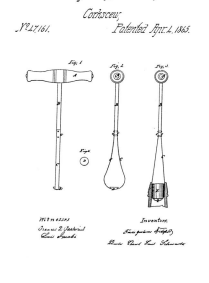

R. T. Osgood.
Bottle Stopper.
Nº 49,144.　　　Patented Aug. 1, 1865.

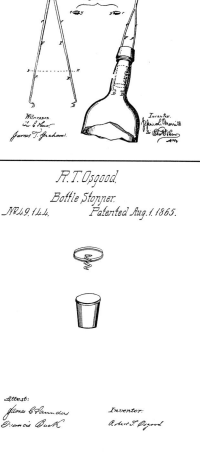

J. WOOLAVER.
INSTRUMENT FOR OPENING BOTTLES.
No. 50,868. Patented Nov. 7, 1865.

S. Swartz,
Corkscrew,
Nº 54,039, Patented Apr. 17, 1866.

J. Adt,
Corkscrew.
Nº 54,640. Patented May 8, 1866.

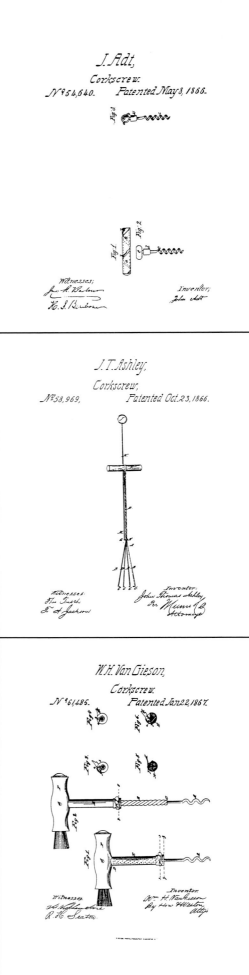

W. W. Meglone.
Bottle Faucet.
Nº 57,850. Patented Aug. 14, 1800.

C. Rosenberry,
Corkscrew.
Nº 58,889. Patented Oct. 16, 1866.

J. T. Ashley,
Corkscrew,
Nº 58,969, Patented Oct. 23, 1866.

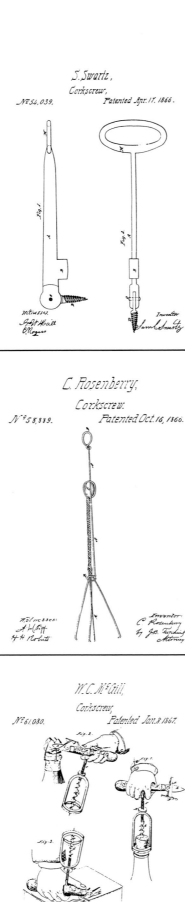

K. Loffler,
Corkscrew.
Nº 59,241. Patented Oct. 30, 1866.

W. C. McGill,
Corkscrew,
Nº 61,080. Patented Jan. 8, 1867.

W. H. Van Gieson,
Corkscrew.
Nº 61,485. Patented Jan. 22, 1867.

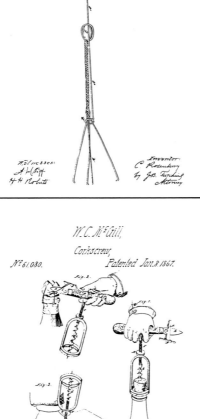

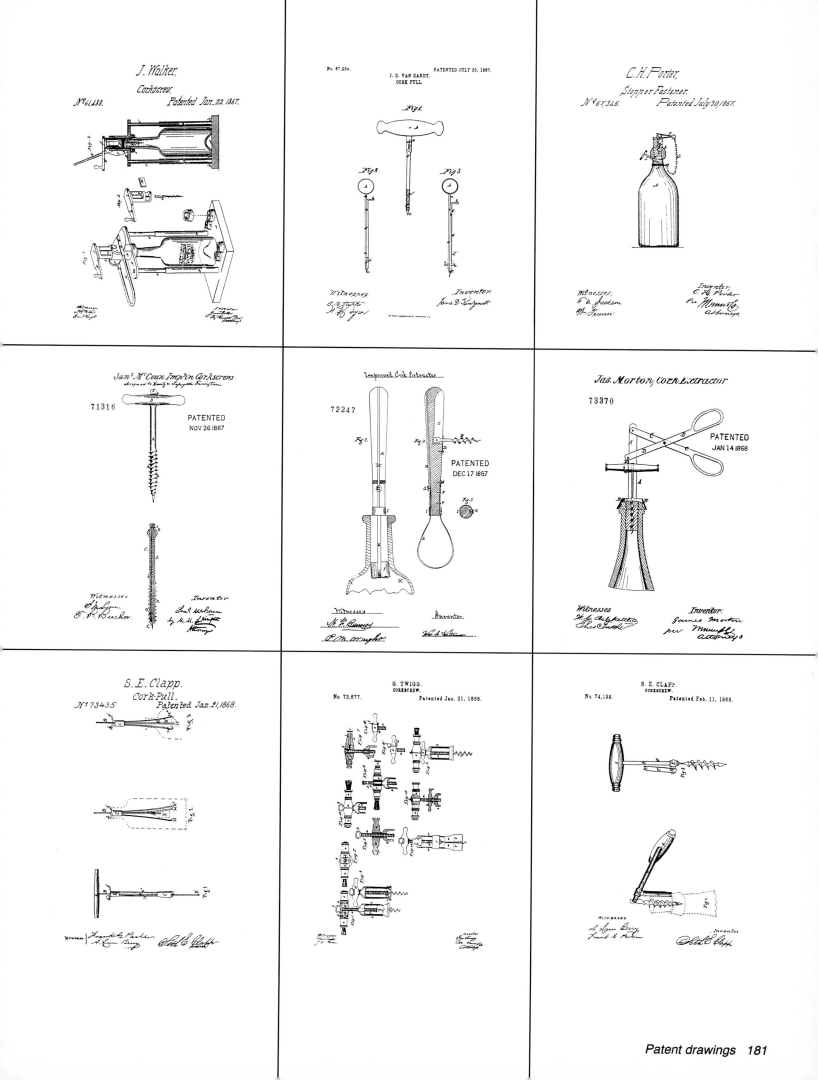

John Bussey.
Corkscrew.
Nº 74,495. Patented Feb. 18, 1868

David Williamson
Improvement in Cork Drawers
74966
PATENTED
FEB 25 1868

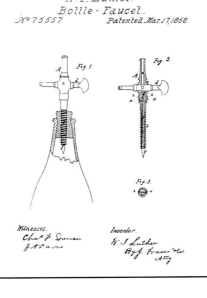

W. I. Luther.
Bottle - Faucet.
Nº 75557 Patented Mar. 17, 1868.

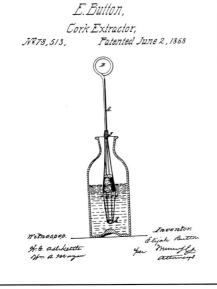

E. Button,
Cork Extractor,
Nº 78,513, Patented June 2, 1868

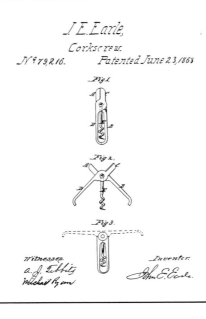

J. E. Earle,
Corkscrew.
Nº 79,216. Patented June 23, 1868

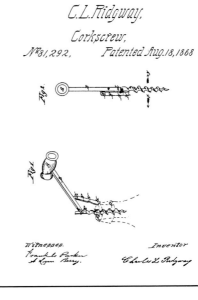

C. L. Ridgway,
Corkscrew,
Nº 81,292, Patented Aug. 18, 1868

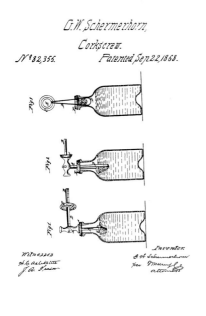

G. W. Schermerhorn,
Corkscrew.
Nº 82,355. Patented Sep. 22, 1868.

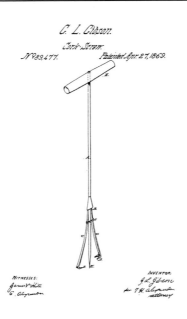

C. L. Gibson.
Cork-Screw.
Nº 88,477. Patented Apr. 27, 1869.

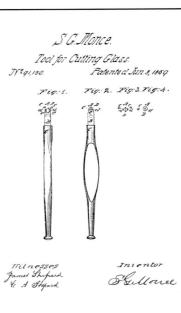

S. G. Monce.
Tool for Cutting Glass.
Nº 91,150. Patented Jun. 8, 1869

S.C.Currie.
Medicine Spoon.
NO. 92,278. Patented July 6, 1869.

Witnesses: Inventor:
 Per
 Attorneys

C. G. Wilson.
Cork Screw.
Nº 92,552 Patented Jul. 13, 1869.

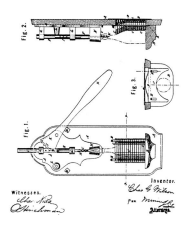

Fig. 2.

Fig. 3.

Fig. 1.

Inventor.
 Chas G. Wilson
Witnesses.
 per
 Attorney

C. Guch.
Cork Screw.
NO. 99,000. Patented Jan. 115. 1870.

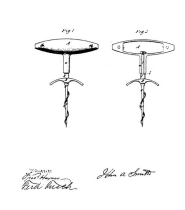

ATTEST. INVENTOR;
 Charles Guch
 By
 Attorney

J.T. Haviland.
Cork Screw.
NO. 104,453 Patented June 21. 1870.

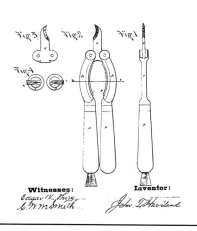

Fig. 3. Fig. 2. Fig. 1.

Fig. 4.

Witnesses: Inventor:
Edgar V. Thring
G. W. M Smith John T Haviland

W. Dickson,
Cork Screw.
NO. 106,036. Patented Aug. 9. 1870.

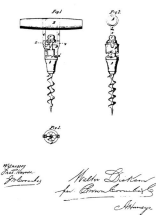

Fig 1. Fig. 2.

Fig. 3.

Witnesses
Fred Haynes
J. F. Crombie Walter Dickson
 per Crown Crombie
 Attorney

J.A. Smith,
Cork Screw.
NO. 109,958. Patented Dec. 6. 1870.

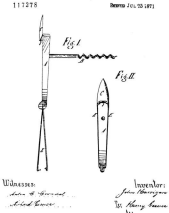

Fig. 1 Fig. 2

Witnesses John A Smith
Fred Haynes
Fred Such

W. DICKSON.
Improvement in Cork-Screw Attachments.
No. 115,585. Patented June 6, 1871.

Fig. 1. Fig. 2

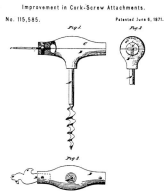

Fig. 3

Witnesses:
Fred Haynes Walter Dickson
J. F. Crombie per Crown Crombie
 Attorney

D. H. CHAMBERLAIN.
Improvement in Taps or Faucets for Bottles.
No. 116,155. Patented June 20, 1871.
Fig. 1. Fig. 2. Fig. 3.

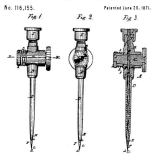

Fig. 4. Fig. 5.

Witnesses: Inventor:
 D. H. Chamberlain
 per Brown Brothers, Attys

John Harrigan, Fort Wadsworth, S.I. New York.
Combined Corkscrew, Can-Opener & Cork-Drawer.
117,278 PATENTED JUL 25 1871

Fig. I.

Fig. II.

Witnesses: Inventor:
 John Harrigan
 Per Harry Geener
 Attorney.

GEORGE JAY HILL.
Improvement in Bottle and Box Openers.

No. 118,453.

Patented Aug. 29, 1871.

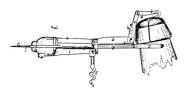

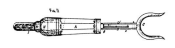

Witnesses.

Inventor. By
Geo Jay Hill
Burke Fraser & Osgood,
Attys Buffalo N.Y.

Lewis J. Jennens
Combined Watch Key. Cork-Screw.
And Watch-Opener

No. 118,456.

Patented Aug. 29, 1871.

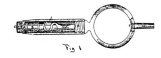

Witnesses:

Inventor.

By Sidney Saunders Atty.
Lewis J. Jennens

Charles T. Simpers
Cork Pull.

No. 120,830.

Patented Nov. 14, 1871.

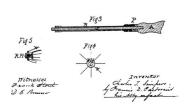

Witnesses
Frank Stout
D. E. Brewer

Inventor
Charles T. Simpers
by Francis D. Pastoriad
his Atty infact

JAMES SARGENT & LYMAN F. MUNGER.
Bottle Faucet

No. 121,201.

Patented Nov. 21, 1871.

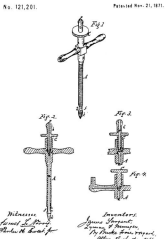

Witnesses.

Inventors.
James Sargent,
Lyman F. Munger
By Burke Fraser & Osgood,
attys. Rochester, N.Y.

(100.) **JOHN W. CURRIER.**
Improvement in Combined Tool.

No. 122,443.

Patented Jan. 2, 1872.

Witnesses:

Inventor:
John W. Currier
PER
Attorneys.

S. G. MONCE.
Glaziers' Tools.

No. 140,426.

Patented July 1, 1873.

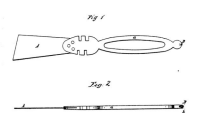

Witnesses.
O. D. Warner
C. A. Shepard

Inventor
Samuel G. Monce
By James Shepard
Atty

C. F. HUNT.
Cork-Extractors.

No. 140,706.

Patented July 8, 1873.

Attorneys.
Cha A. Smith,
Harold Serrell

Inventor
Charles F. Hunt,
for L. W. Serrell

J. SWAN.
Sportsmen's Pocket-Knives.

No. 149,806.

Patented April 14, 1874.

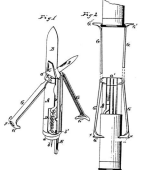

WITNESSES
C. L. Gust.

INVENTOR.
John Swan.
By
Alexander Morton
Attorney.

J. A. BRAGAW.
Cork-Screws.

No. 149,983.

Patented April 21, 1874.

Witnesses
John Decker
Fred Hagney

John A. Bragaw
Cyrus Attorneys
Brown & Allen

184 *Patent drawings*

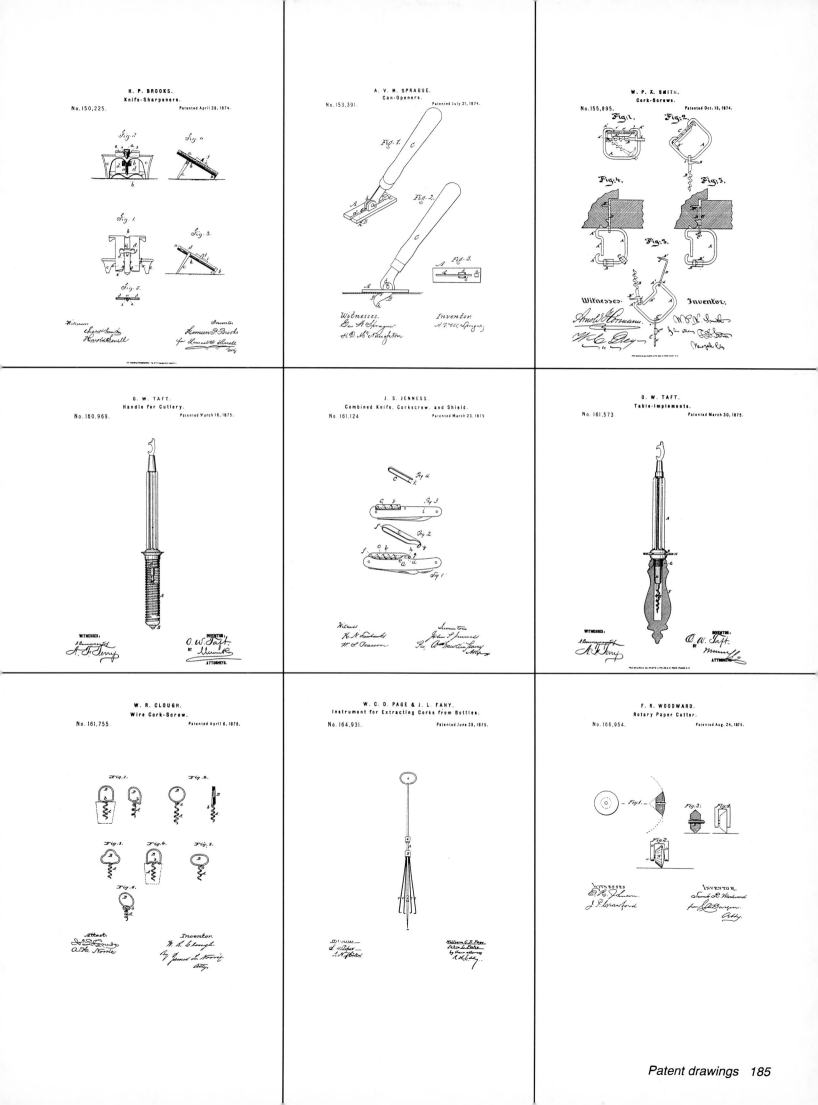

G. A. KIEHL & E. H. KOHLER.
Combined Bottle-Opener, Knife, Ice-Pick, Grater
and Cork-Screw.

No. 169,175. Patented Oct. 26, 1875.

P. T. WITTE.
CORK-SCREW.

No. 171,752. Patented Jan. 4, 1876.

W. ENGELSDORFF.
CORK-SCREW.

No. 172,104. Patented Jan. 11, 1876.

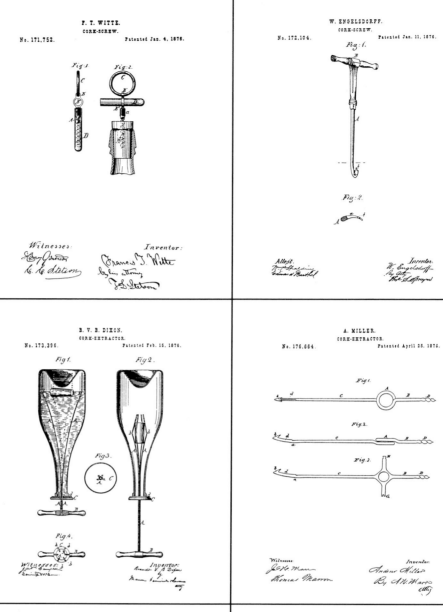

W. R. CLOUGH.
CORK-SCREW.

No. 172,868. Patented Feb. 1, 1876.

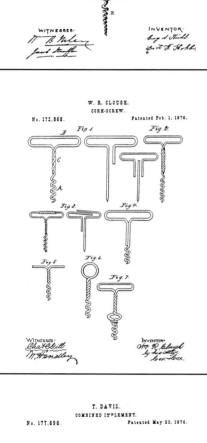

B. V. B. DIXON.
CORK-EXTRACTOR.

No. 173,396. Patented Feb. 15, 1876.

A. MILLER.
CORK-EXTRACTOR.

No. 176,664. Patented April 25, 1876.

T. DAVIS.
COMBINED IMPLEMENT.

No. 177,696. Patented May 23, 1876.

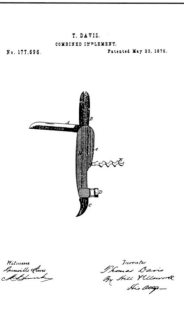

J. L. HYDE.
CORK-EXTRACTOR.

No. 178,854. Patented June 20, 1876.

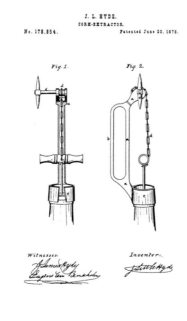

J. BARNES.
CORK-SCREW.

No. 179,093. Patented June 27, 1876.

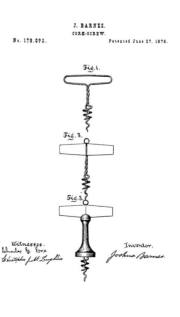

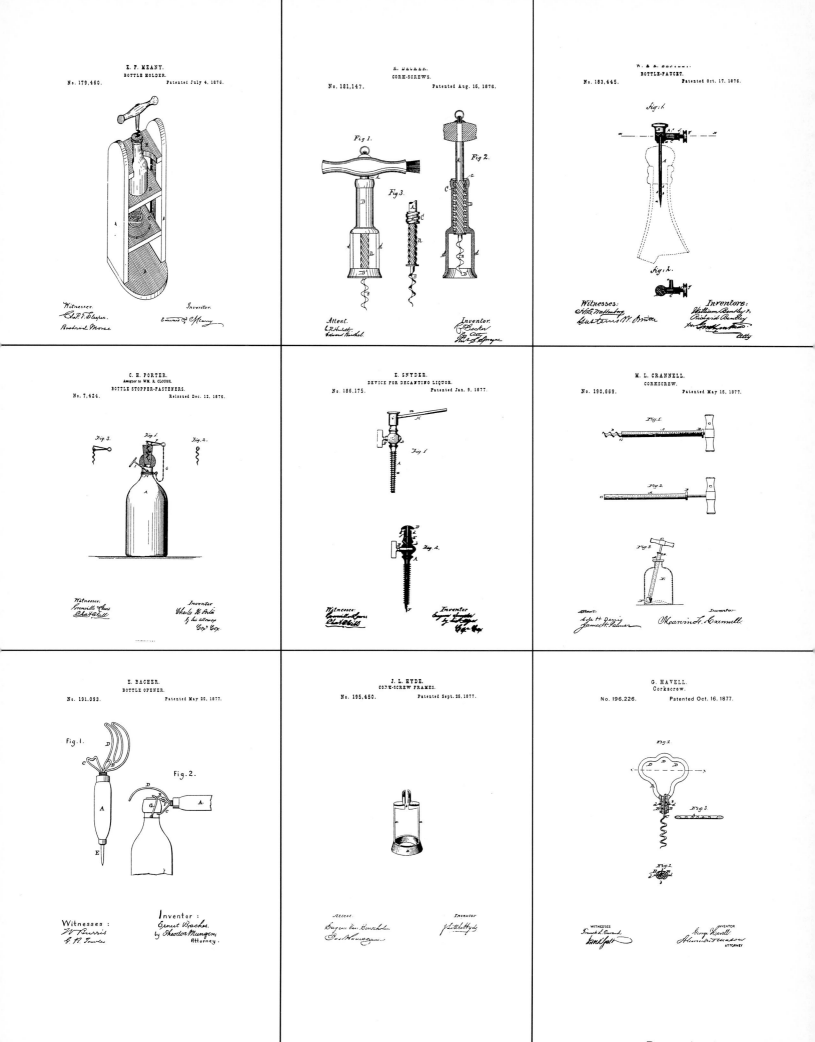

N. OAK.
Cork-Screw and Extractor Combined.
No. 196,761. Patented Nov. 6. 1877.

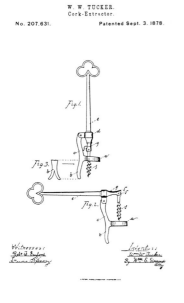

J. E. BAUM.
Cork-Screw.
No. 197,201. Patented Nov. 20, 1877.

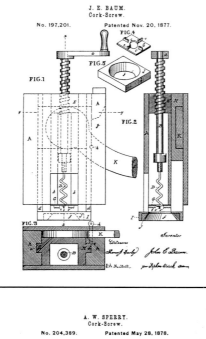

P. TYRER.
Cork-Extractor.
No. 199,760. Patented Jan. 29, 1878.

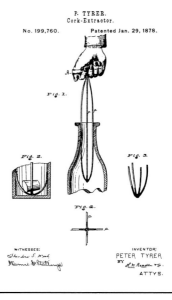

A. E. BARTHEL.
Combined Gun-Tool and Whistle.
No. 202,136. Patented April 9, 1878.

A. W. SPERRY.
Cork-Screw.
No. 204,389. Patented May 28, 1878.

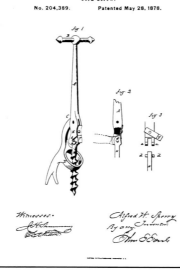

J. H. RICHARDSON & W. J. TAYLOR.
Cork-Extractor.
No. 206,134 Patented July 16, 1878.

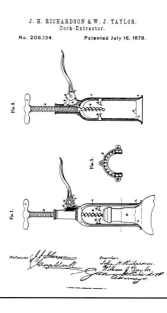

W. W. TUCKER.
Cork-Extractor.
No. 207.631. Patented Sept. 3. 1878.

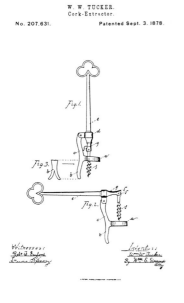

C. A. BABCOCK.
Combination Implement.
No. 209,599. Patented Nov. 5, 1878.

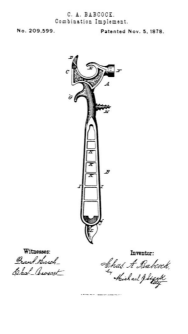

L. C. MUMFORD.
Cork-Extractor.
No. 212,863. Patented Mar. 4, 1879.

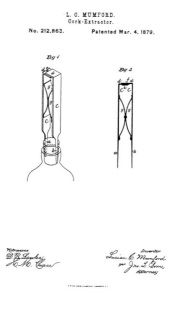

W. E. LANT.
Bottle-Faucet and Cork-Screw Combined.
No. 219,101. Patented Sept. 2, 1879.

Fig. 1. Fig. 2.

Fig. 3.

WITNESSES INVENTOR
 William E. Lant

B. N. SHELLEY.
Combination Tool.
No. 219,313. Patented Sept. 2, 1879.

FIG.1.

FIG.2.

WITNESSES: INVENTOR:
 ATTORNEYS.

B. F. ADAMS.
Revolving Glass Cutter.
No. 229,228. Patented June 29, 1880.

Fig 2 Fig 1

Witnesses Inventor
 Benjamin F. Adams
 By Harry A. Chapin

J. KOSSUTH.
Corkscrew.
No. 230,877. Patented Aug. 10, 1880.

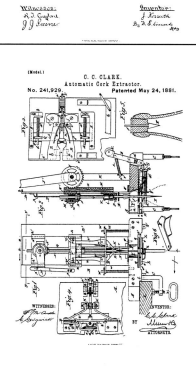

Witnesses: Inventor:
 J. Kossuth
 By W. E. Simonds

I. N. ARMENT.
Opener for Cans and Bottles.
No. 234,646. Patented Nov. 23, 1880.

FIG. 1.

FIG. 2.

FIG.3. FIG.4.

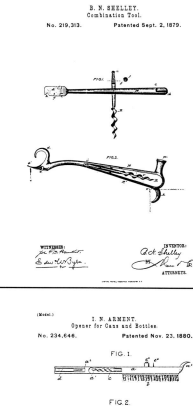

Witnesses. Inventor
M. M. Lacey Isaac Newton Arment
 By R. S. & A. P. Lacey Att'ys.

C. GRAEF.
Combined Nippers and Cork Extractor.
No. 235,427. Patented Dec. 14, 1880.

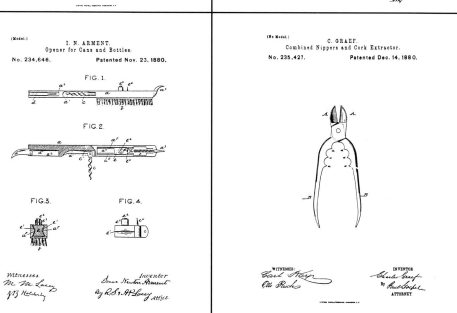

WITNESSES: INVENTOR
Carl Keyn Charles Graef
Otto Reische By Paul Goepel
 ATTORNEY

C. C. CLARK.
Automatic Cork Extractor.
No. 241,929. Patented May 24, 1881.

WITNESSES: INVENTOR:
 C. C. Clark
 BY
 ATTORNEYS.

W. R. CLOUGH.
Cork Screw.
No. 242,602. Patented June 7, 1881.

Fig. 1.

Fig. 2.

Witnesses; Inventor;
 W. Rockwell Clough
 By his Atty
 Rowland Cox

F. MANN.
CORK EXTRACTOR.
No. 245,301. Patented Aug. 9, 1881.

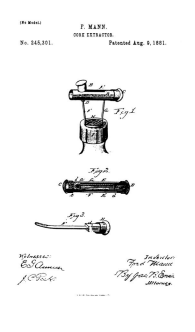

Fig 1

Fig 2

Fig 3.

Witnesses Inventor
 Fred Mann
 By Jas. T. Crair
 Attorneys.

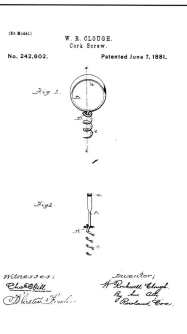

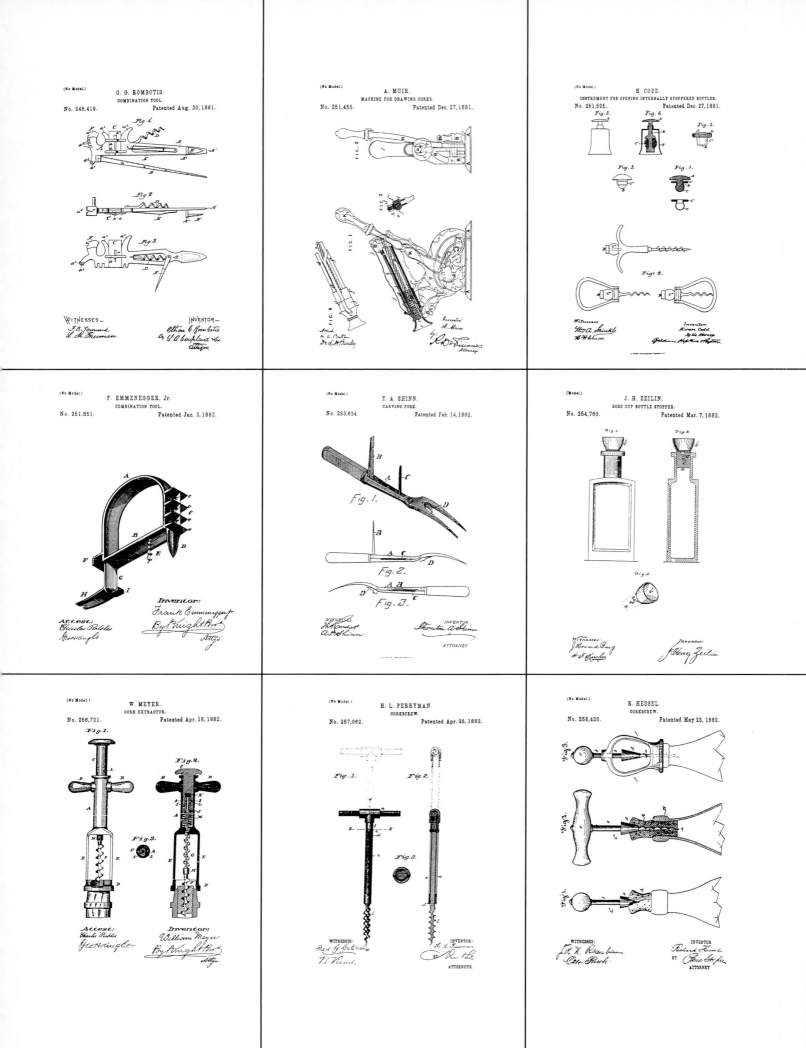

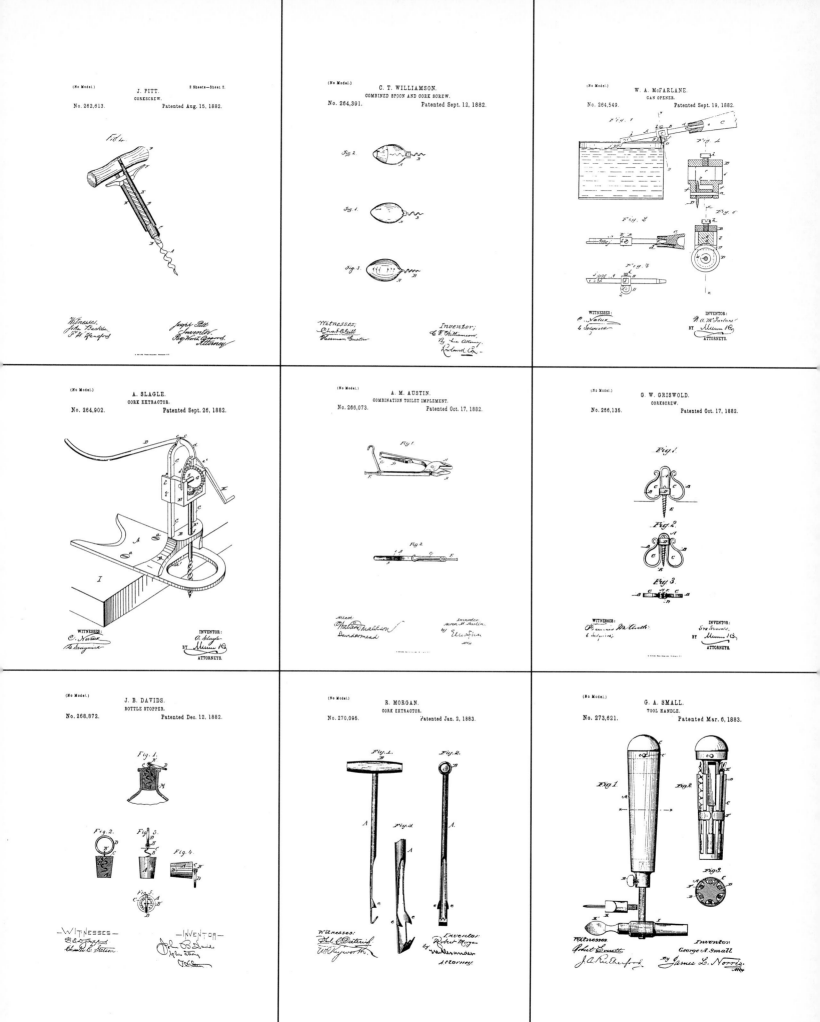

C. T. WILLIAMSON.
CORKSCREW.

No. 274,539. Patented Mar. 27, 1883.

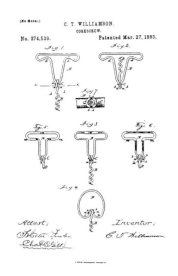

Attest;

Inventor;

M. GREEN.
CORKSCREW.

No. 276,804. Patented May 1, 1883.

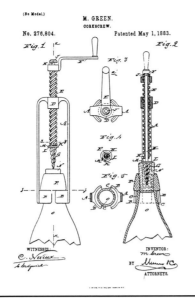

WITNESSES:

INVENTOR:
BY
ATTORNEYS.

W. BENNIT.
CORKSCREW.

No. 277,442. Patented May 15, 1883.

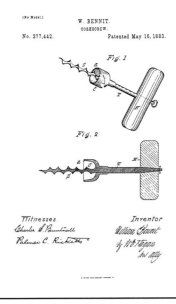

Witnesses

Inventor

H. HARTMAN.
COMBINATION CAN OPENER.

No. 278,951. Patented June 5, 1883.

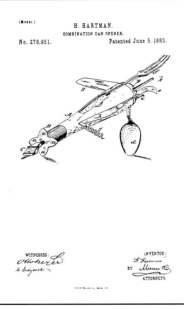

WITNESSES:

INVENTOR:
BY
ATTORNEYS.

T. M. STRAIT.
CORKSCREW.

No. 279,202. Patented June 12, 1883.

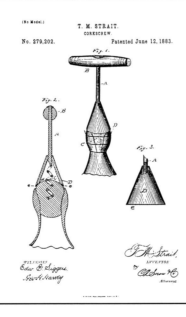

WITNESSES

INVENTOR

Attorneys.

T. M. STRAIT.
CORKSCREW.

No. 279,203. Patented June 12, 1883.

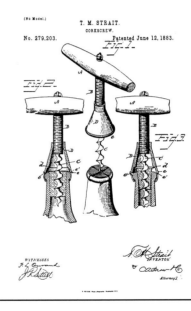

WITNESSES

INVENTOR

Attorneys.

2 Sheets—Sheet 1

J. E. BERLIEN.
MEANS FOR ATTACHING CORKSCREWS TO BOTTLES.

No. 279,216. Patented June 12, 1883.

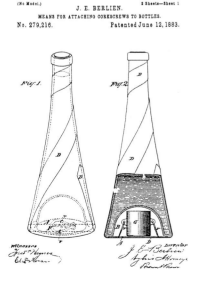

Witnesses

Inventor

J. W. WHITE.
CORKSCREW.

No. 280,697. Patented July 3, 1883.

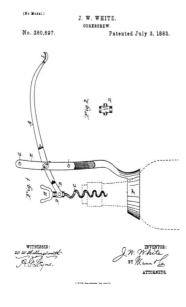

WITNESSES:

INVENTOR:
BY
ATTORNEYS.

C. F. A. WIENKE.
LEVER CORKSCREW.

No. 283,731. Patented Aug. 21, 1883.

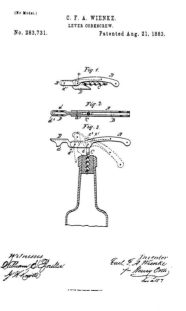

Witnesses

Inventor

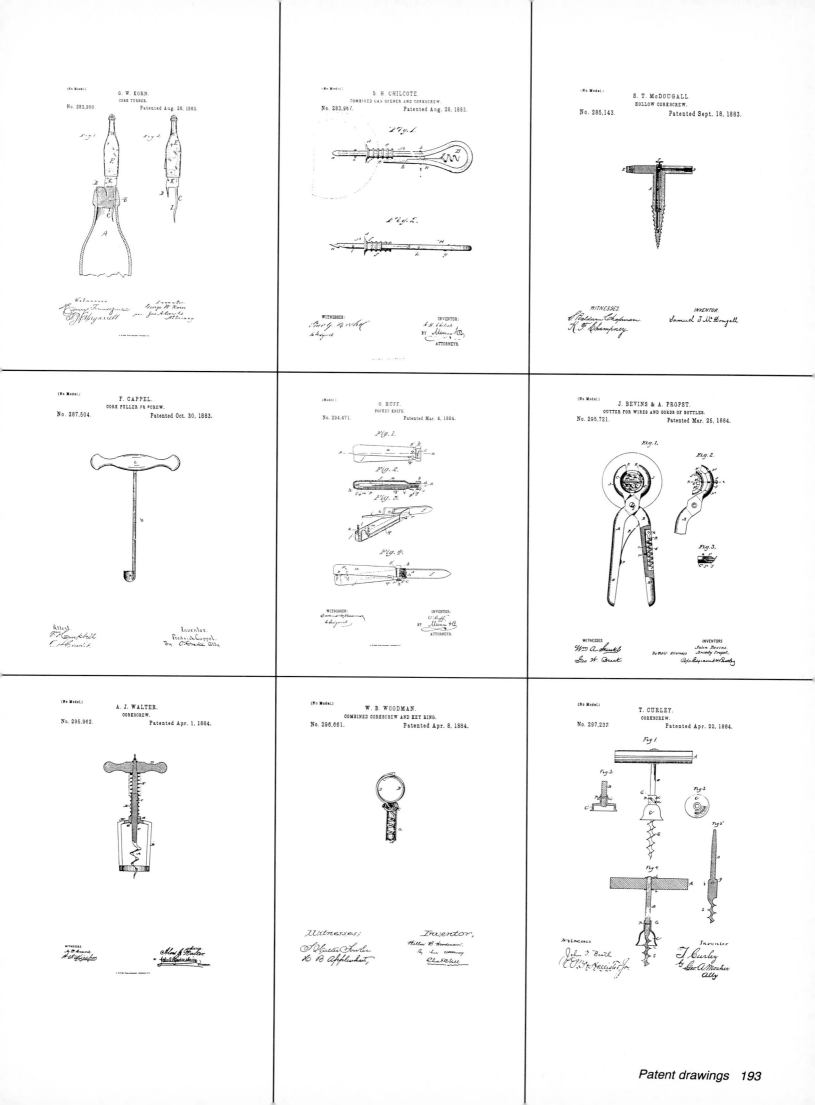

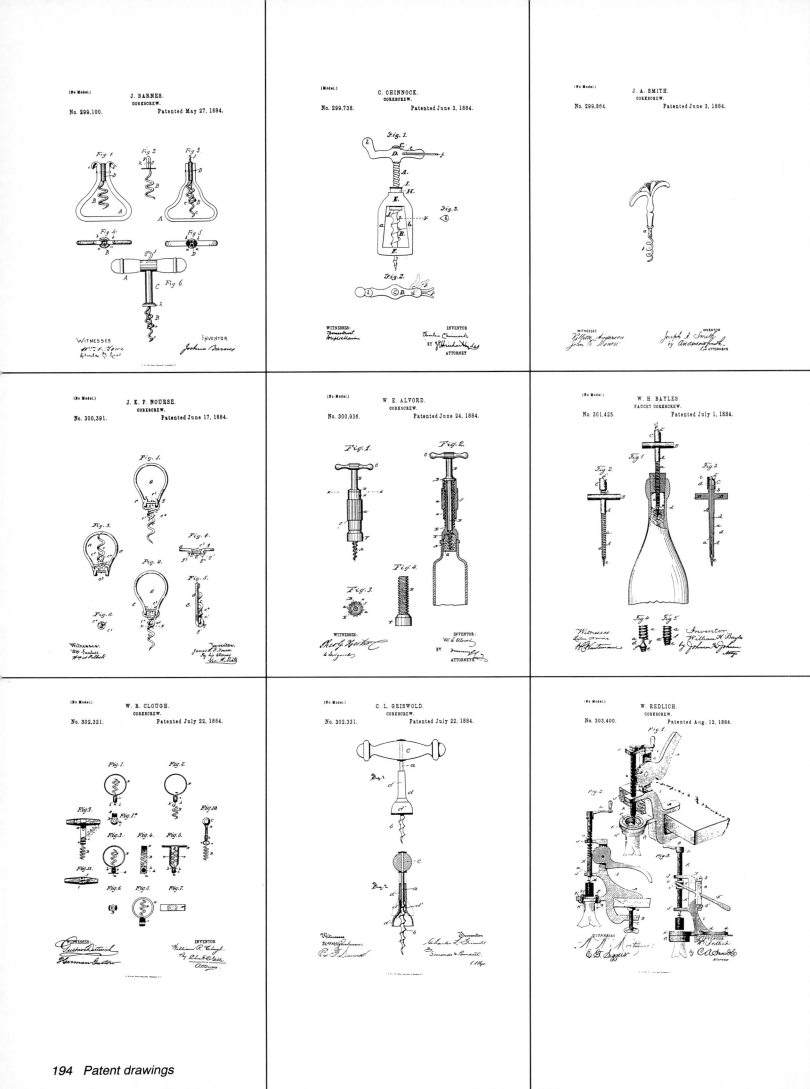

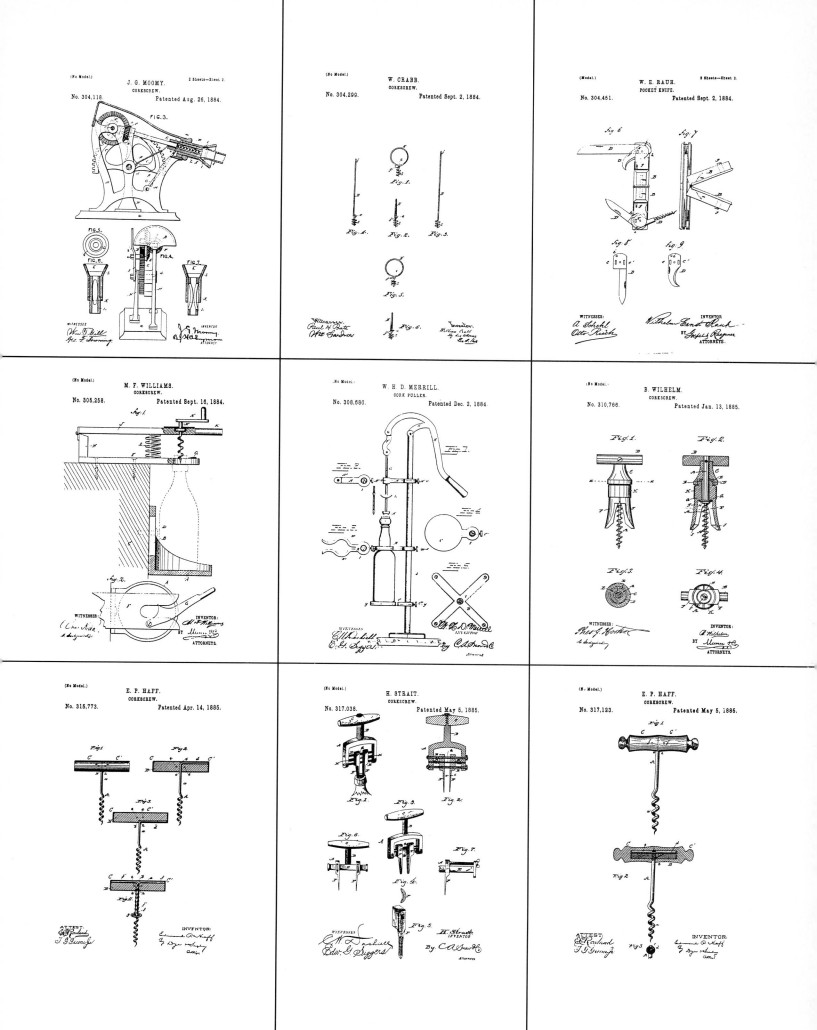

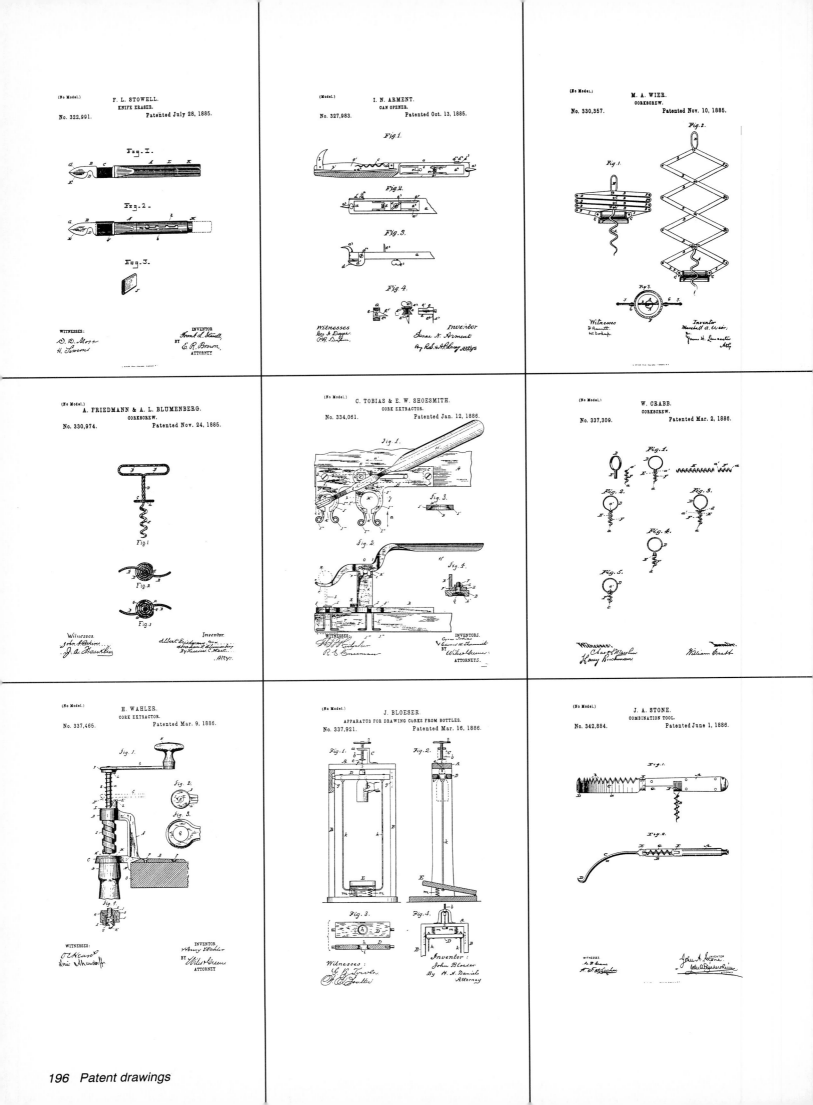

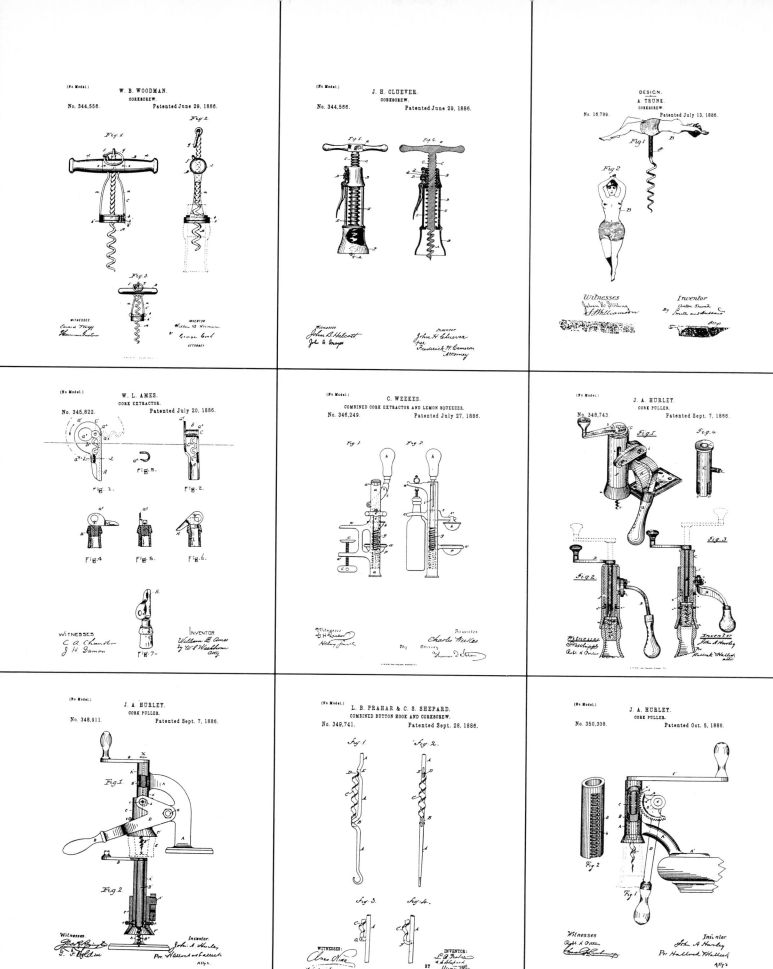

(No Model.)

W. R. NOE.
MEDICINE SPOON.

No. 350,499. Patented Oct. 12, 1886.

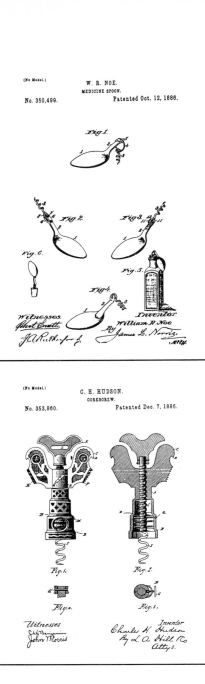

Witnesses. Inventor
 William R. Noe.
 By James G. Norris
 Atty.

(No Model.)

W. SCHOLLHORN.
CORKSCREW.

No. 350,702. Patented Oct. 12, 1886.

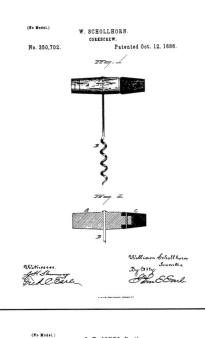

Witnesses. William Schollhorn
 Inventor
 By Atty
 John O. Earl.

(No Model.)

A. F. PETERSEN.
SIDEBOARD CORKSCREW.

No. 352,659. Patented Nov. 16, 1886.

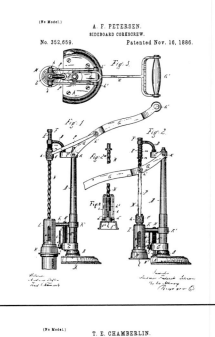

(No Model.)

C. H. HUDSON.
CORKSCREW.

No. 353,860. Patented Dec. 7, 1886.

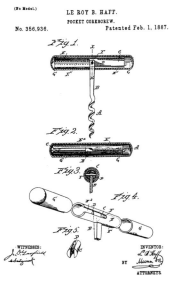

Witnesses Inventor
 Charles H. Hudson
 By L. A. Hill & Co
 Attys.

(No Model.)

C. T. JONES, Dec'd.
J. T. JONES, Administrator.

BOTTLE FAUCET.

No. 354,150. Patented Dec. 14, 1886.

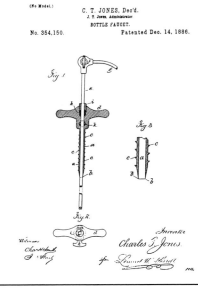

Witnesses Inventor
 Charles T. Jones.

(No Model.)

T. E. CHAMBERLIN.
COMBINATION TOOL.

No. 356,925. Patented Feb. 1, 1887.

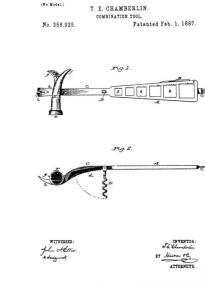

WITNESSES: INVENTOR:
 T. E. Chamberlin
 BY Munn & Co
 ATTORNEYS.

(No Model.)

LE ROY B. HAFF.
POCKET CORKSCREW.

No. 356,936. Patented Feb. 1, 1887.

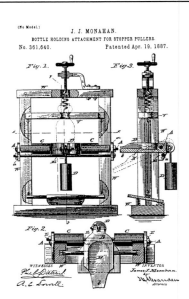

WITNESSES: INVENTOR:
 L. B. Haff
 BY Munn & Co
 ATTORNEYS.

(No Model.)

F. E. SCHMITT.
CORK EXTRACTING MACHINE.

No. 360,734. Patented Apr. 5, 1887.

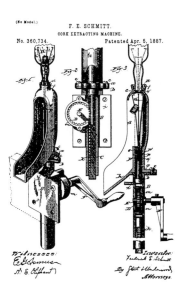

Witnesses: Inventor
 Frederick E. Schmitt
 By Atty
 Attorneys

(No Model.)

J. J. MONAHAN.
BOTTLE HOLDING ATTACHMENT FOR STOPPER PULLERS.

No. 361,640. Patented Apr. 19, 1887.

WITNESSES INVENTOR
 James J. Monahan
 by
 Attorney

198 Patent drawings

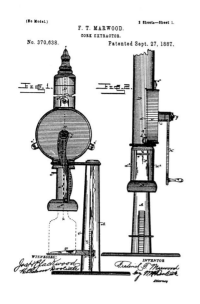

(No Model.)

F. T. MARWOOD.
CORK EXTRACTOR.
No. 370,638. Patented Sept. 27, 1887.

2 Sheets—Sheet 1.

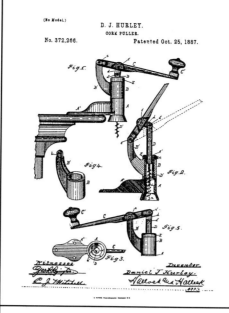

(No Model.)

D. J. HURLEY.
CORK PULLER.
No. 372,266. Patented Oct. 25, 1887.

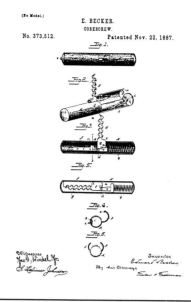

(No Model.)

E. BECKER.
CORKSCREW.
No. 373,512. Patented Nov. 22, 1887.

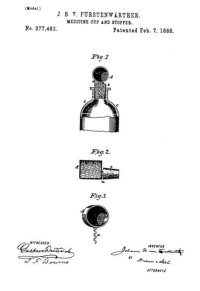

(No Model.)

E. D. WILLIAMS.
CORKSCREW.
No. 373,872. Patented Nov. 29, 1887.

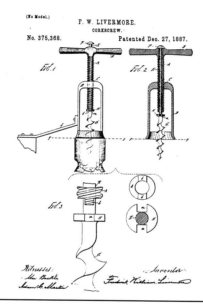

(No Model.)

F. W. LIVERMORE.
CORKSCREW.
No. 375,368. Patented Dec. 27, 1887.

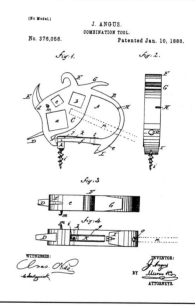

(No Model.)

J. ANGUS.
COMBINATION TOOL.
No. 376,058. Patented Jan. 10, 1888.

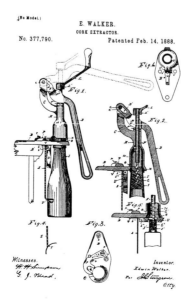

(Model.)

J. B. V. FURSTENWÄRTHER.
MEDICINE CUP AND STOPPER.
No. 377,483. Patented Feb. 7, 1888.

(No Model.)

E. WALKER.
CORK EXTRACTOR.
No. 377,790. Patented Feb. 14, 1888.

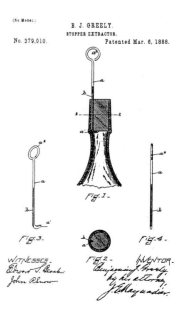

(No Model.)

B. J. GREELY.
STOPPER EXTRACTOR.
No. 379,010. Patented Mar. 6, 1888.

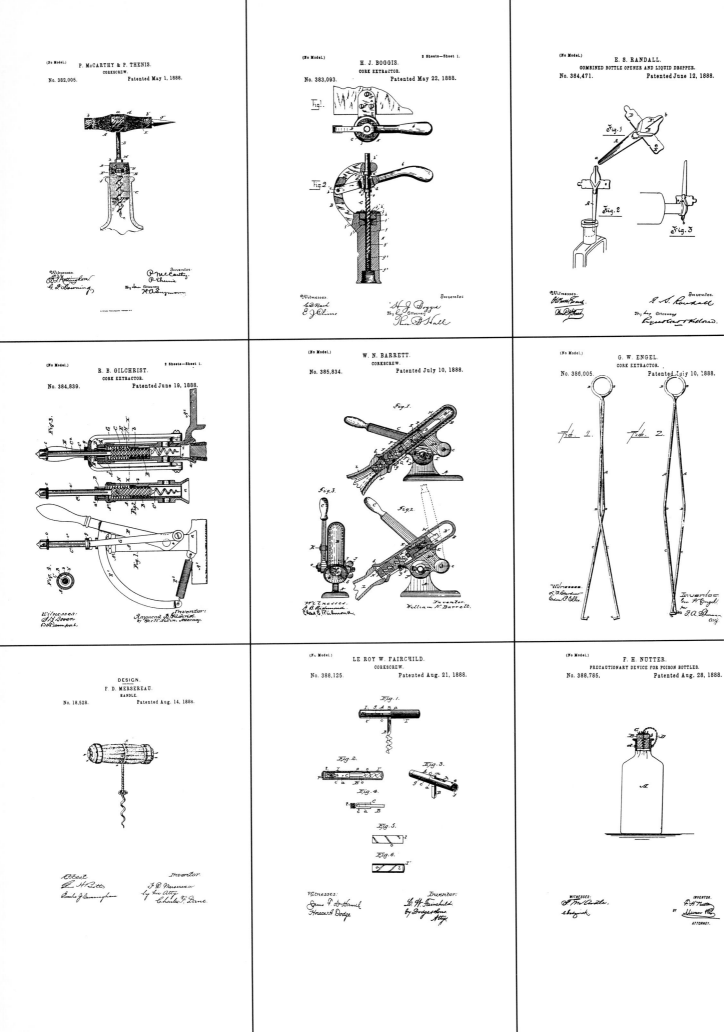

(No Model.)

P. McCARTHY & P. THENIS.
CORKSCREW.

No. 382,005. Patented May 1, 1888.

(No Model.) 2 Sheets—Sheet 1.

H. J. BOGGIS.
CORK EXTRACTOR.

No. 383,093. Patented May 22, 1888.

Fig.1.

Fig.2.

(No Model.)

E. S. RANDALL.
COMBINED BOTTLE OPENER AND LIQUID DROPPER.

No. 384,471. Patented June 12, 1888.

Fig. 1.

Fig. 2.

Fig. 3.

(No Model.) 2 Sheets—Sheet 1.

R. B. GILCHRIST.
CORK EXTRACTOR.

No. 384,839. Patented June 19, 1888.

W. N. BARRETT.
CORKSCREW.

No. 385,834. Patented July 10, 1888.

Fig.1.

Fig.3.

Fig.2.

(No Model.)

G. W. ENGEL.
CORK EXTRACTOR.

No. 386,005. Patented July 10, 1888.

Fig. 1.

Fig. 2.

DESIGN.
F. D. MERSEREAU.
HANDLE.

No. 18,528. Patented Aug. 14, 1888.

(No Model.)

LE ROY W. FAIRCHILD.
CORKSCREW.

No. 388,125. Patented Aug. 21, 1888.

Fig. 1.

Fig. 2.

Fig. 3.

Fig. 4.

Fig. 5.

Fig. 6.

(No Model.)

F. H. NUTTER.
PRECAUTIONARY DEVICE FOR POISON BOTTLES.

No. 388,785. Patented Aug. 28, 1888.

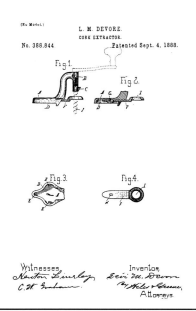

(No Model.)

L. M. DEVORE.
CORK EXTRACTOR.

No. 388,844 Patented Sept. 4, 1888.

Fig.1.

Fig.2.

Fig.3. Fig4.

Witnesses,
Inventor.

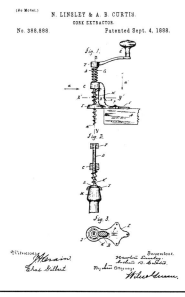

(No Model.)

N. LINSLEY & A. B. CURTIS.
CORK EXTRACTOR.

No. 388,888. Patented Sept. 4, 1888.

Fig.1.

Fig.2.

Fig.3.

Witnesses
Inventor.

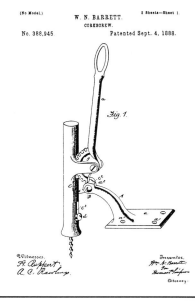

(No Model.) 2 Sheets—Sheet 1.

W. N. BARRETT.
CORKSCREW.

No. 388,945 Patented Sept. 4, 1888.

Fig. 1.

Witnesses.
Inventor.

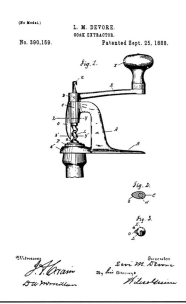

(No Model.)

L. M. DEVORE.
CORK EXTRACTOR.

No. 390,159. Patented Sept. 25, 1888.

Fig. 1.

Fig. 2.

Fig. 3.

Witnesses
Inventor.

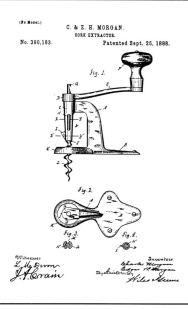

(No Model.)

C. & E. H. MORGAN.
CORK EXTRACTOR.

No. 390,183. Patented Sept. 25, 1888.

Fig. 1.

Fig. 2.

Fig. 3. Fig. 4.

Witnesses
Inventor.

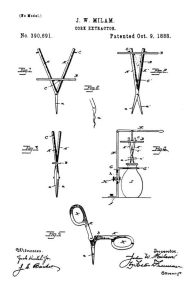

(No Model.)

J. W. MILAM.
CORK EXTRACTOR.

No. 390,691. Patented Oct. 9, 1888.

Fig.1 Fig.2.

Fig.5.

Fig.3. Fig.4.

Fig.5.

Witnesses.
Inventor.

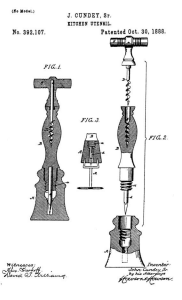

(No Model.)

J. CUNDEY, Sr.
KITCHEN UTENSIL.

No. 392,107. Patented Oct. 30, 1888.

FIG.1.

FIG.3. FIG.2.

Witnesses:
Inventor.
John Cundey, Sr.

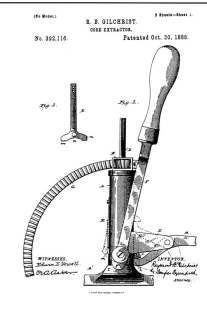

(No Model.) 2 Sheets—Sheet 1.

R. B. GILCHRIST.
CORK EXTRACTOR.

No. 392,116. Patented Oct. 30, 1888.

Fig. 3. Fig. 1.

WITNESSES.
INVENTOR.

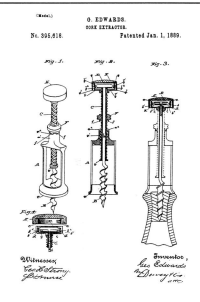

(Model.)

G. EDWARDS.
CORK EXTRACTOR.

No. 395,618. Patented Jan. 1, 1889.

Fig. 1. Fig. 2. Fig. 3.

Fig. 4.

Witnesses
Inventor,
Geo Edwards

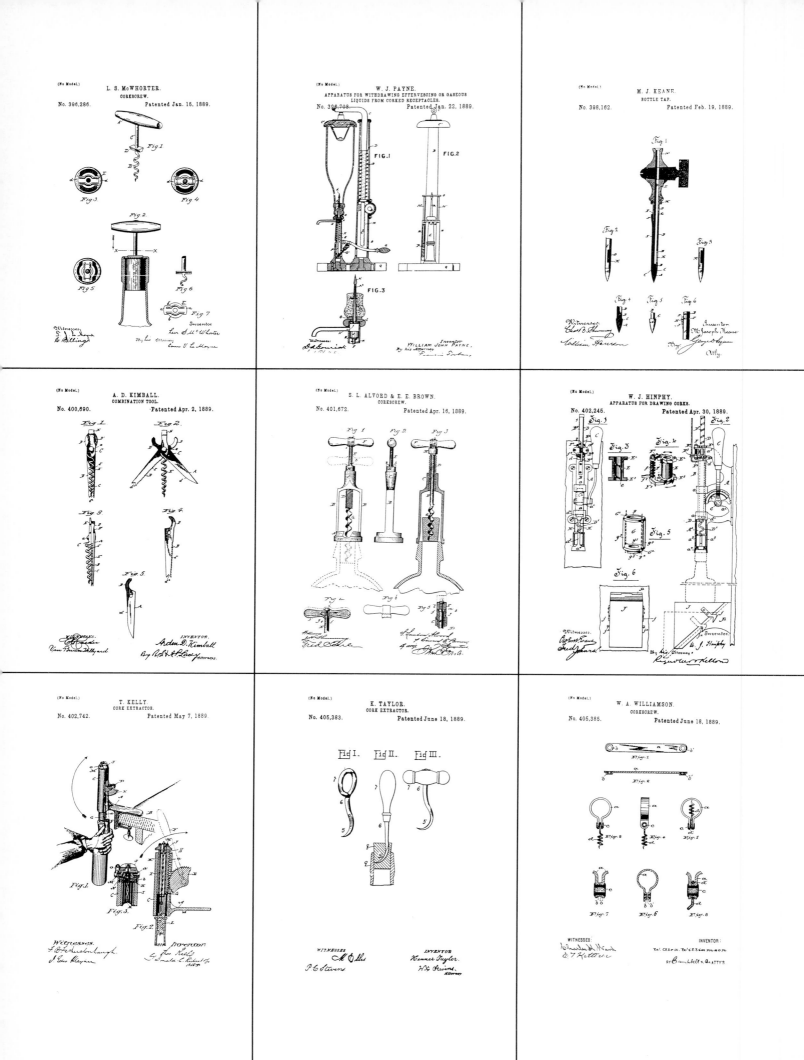

E. T. POLLARD & F. J. LUDINGTON.
CORKSCREW.

No. 406,304. Patented July 2, 1889.

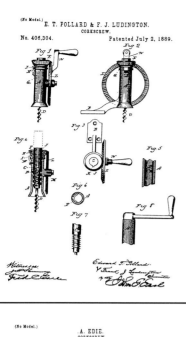

J. W. COLLINS.
STOPPER FOR BOTTLES.

No. 407,169. Patented July 16, 1889.

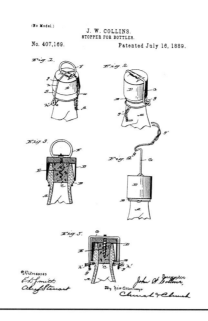

W. R. VAN VLIET.
COMBINATION TOOL.

No. 411,079. Patented Sept. 17, 1889.

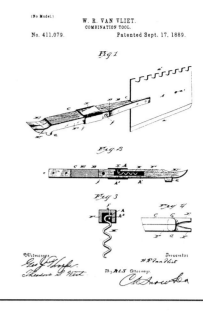

A. EDIE.
CORKSCREW.

No. 420,572. Patented Feb. 4, 1890.

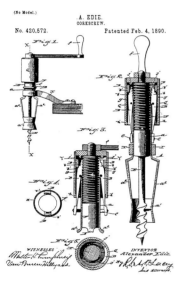

S. T. JULL.
CORK PULLER.

No. 422,348. Patented Feb. 25, 1890.

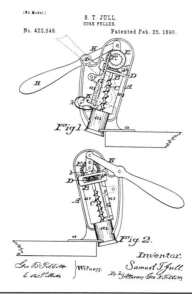

A. H. WALLACE.
SHEARS.

No. 422,670. Patented Mar. 4, 1890.

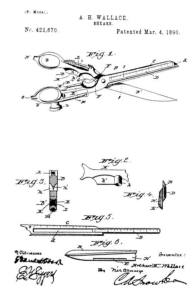

W. H. SUTTON.
COMBINED KNIFE AND BURGLAR ALARM.

No. 425,010. Patented Apr. 8, 1890.

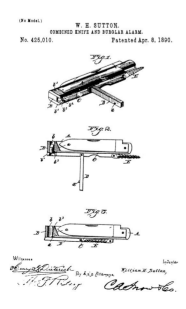

A. W. MESTON.
CHAMPAGNE TAP.

No. 425,480. Patented Apr. 15, 1890.

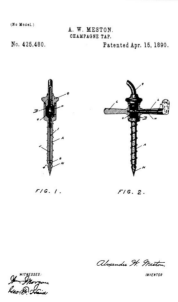

F. L. DOWNEND.
COMBINATION TOOL.

No. 426,409. Patented Apr. 22, 1890.

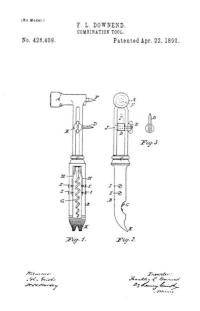

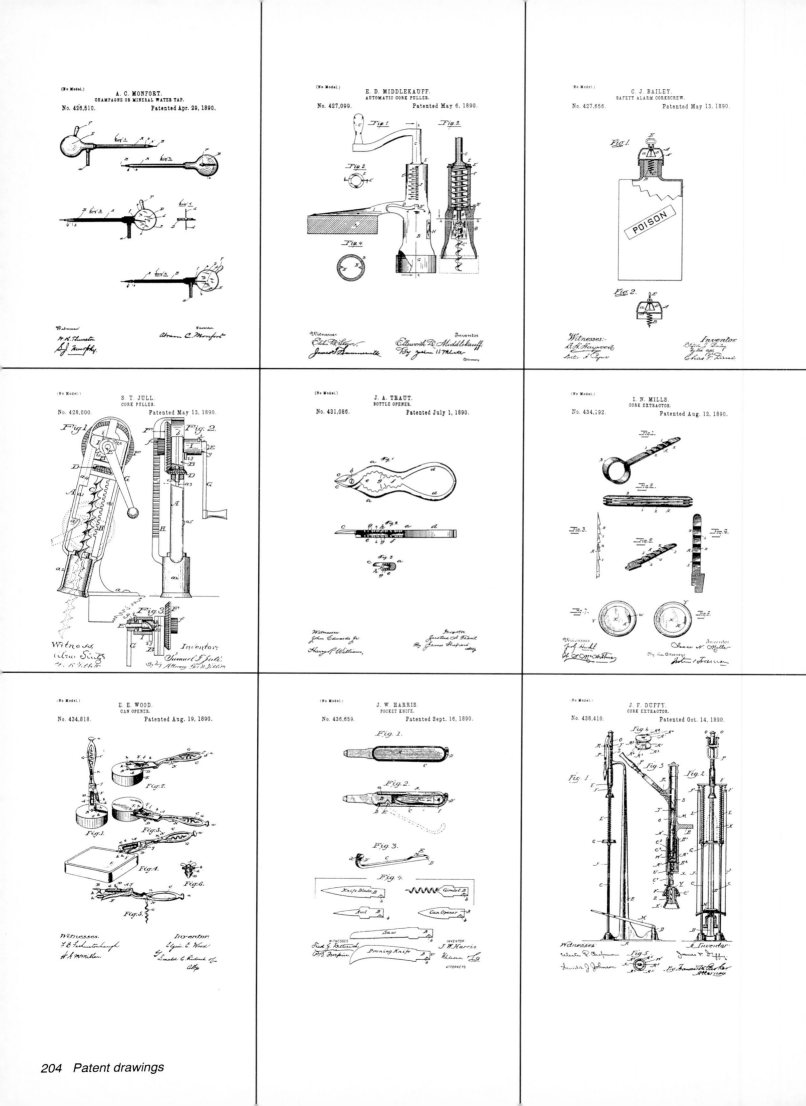

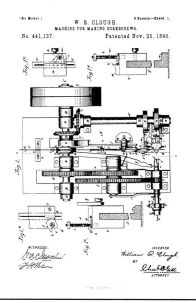

WITNESSES:
INVENTOR
William R. Clough.
BY
Chas. F. Gill
ATTORNEY

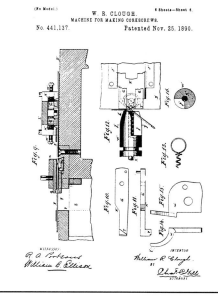

WITNESSES:
R. A. Porteous
William B. Ellison
INVENTOR
William R. Clough.
BY
Chas. F. Gill
ATTORNEY

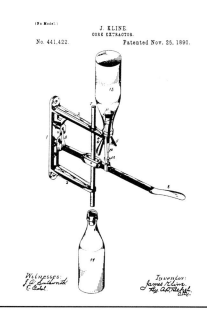

Witnesses:
J. A. Smithurst
E. Bobel
Inventor:
James Kline.
By A. A. Rachel
Atty.

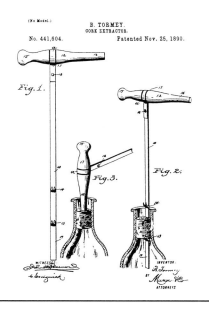

Fig. 1.
Fig. 3.
Fig. 2.

WITNESSES:
INVENTOR:
B. Tormey.
BY
Munn & Co.
ATTORNEYS

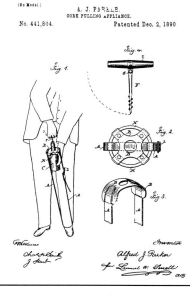

Fig. 1.
Fig. 4.
Fig. 2.
Fig. 3.

Witnesses:
Chas. J. Clark
J. Scott
Inventor:
Alfred J. Parker
by Lemuel W. Serrell
Atty.

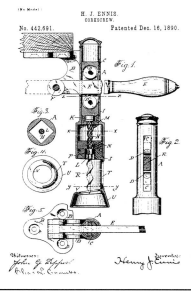

Fig. 1.
Fig. 3.
Fig. 2.
Fig. 4.
Fig. 5.

Witnesses:
John G. Ziffard
Alice L. Coombes
Inventor:
Henry J. Ennis

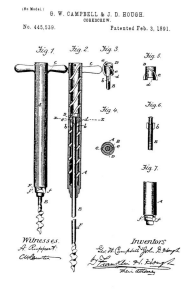

Fig. 1.
Fig. 2.
Fig. 3.
Fig. 5.
Fig. 4.
Fig. 6.
Fig. 7.

Witnesses:
A. Rappaert.
C. W. Counter
Inventors
Geo. W. Campbell, John D. Hough.
by L. Franklin
Their Attorney

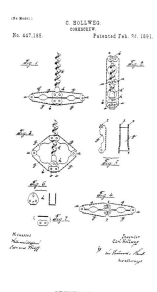

Fig. 1.
Fig. 2.
Fig. 3.
Fig. 5.
Fig. 6.
Fig. 7.
Fig. 4.

Witnesses:
William Wright
Edward Wolff
Inventor:
Carl Hollweg
by his Attorneys

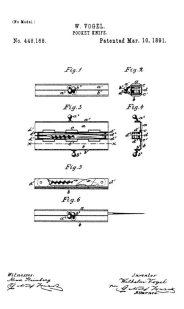

Fig. 1.
Fig. 2.
Fig. 3.
Fig. 4.
Fig. 5.
Fig. 6.

Witnesses:
Mora Steinberg
G. Adolf Kurtz
Inventor
Wilhelm Vogel
by G. Adolf Kurtz
Attorney

(No Model.) H. J. WILLIAMS. 2 Sheets—Sheet 1.
DEVICE FOR REMOVING CORKS FROM BOTTLES.
No. 450,957. Patented Apr. 21, 1891.

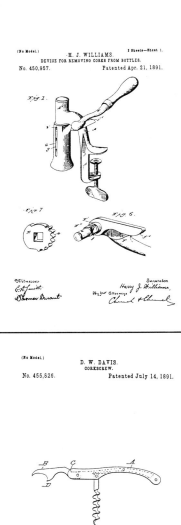

(No Model.) E. WALKER.
CORK PULLER.
No. 452,625. Patented May 19, 1891.

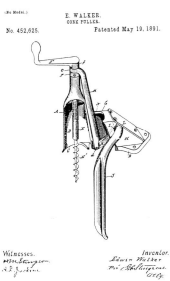

(No Model.) H. J. ENNIS.
CORKSCREW.
No. 454,725. Patented June 23, 1891.

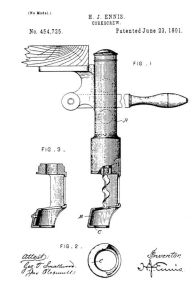

(No Model.) D. W. DAVIS.
CORKSCREW.
No. 455,626. Patented July 14, 1891.

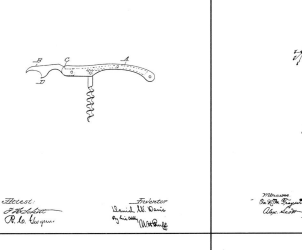

(No Model.) C. GERLACH.
POCKET KNIFE.
No. 456,811. Patented July 28, 1891.

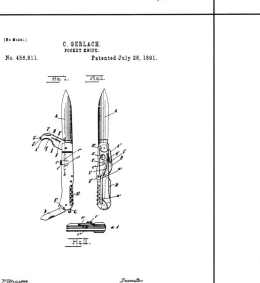

(No Model.) W. WILKINSON.
CORKSCREW.
No. 458,087. Patented Aug. 18, 1891.

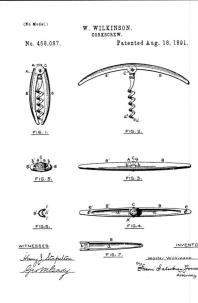

(No Model.) J. B. BAILY.
AUTOMATIC CORK PULLER.
No. 466,401. Patented Jan. 5, 1892.

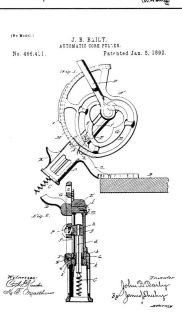

(No Model.) E. LEESER.
CORK EXTRACTOR.
No. 467,232. Patented Jan. 19, 1892.

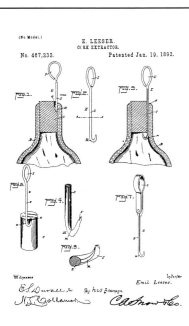

(No Model.) E. J. LUMLEY, S. D. WEBB & G. T. JACOBS.
DEVICE FOR REMOVING CORKS FROM BOTTLES.
No. 471,057. Patented Mar. 15, 1892.

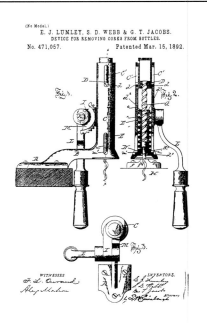

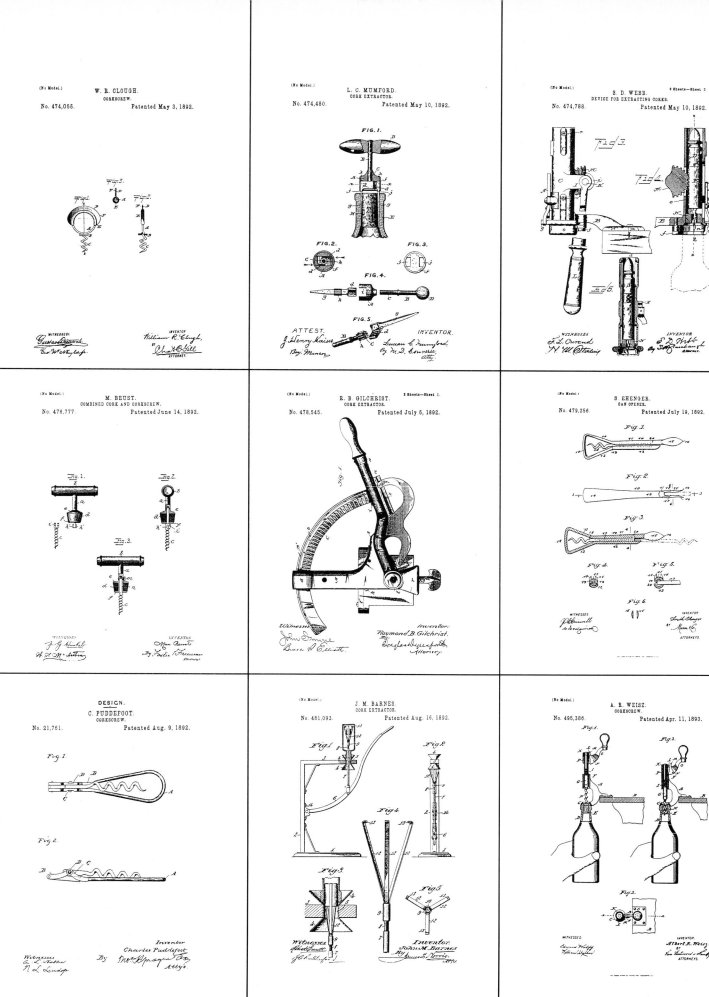

J. H. MATTHEWS.
DOOR SECURER.

No. 496,887. Patented May 9, 1893.

Witnesses. Inventor:
George Oldach Jeremiah H. Matthews.
Fred May Attorneys.

C. PUDDEFOOT.
CORKSCREW.

No. 501,468. Patented July 11, 1893.

Witnesses Inventor
 Charles Puddefoot
 By Thos. S. Sprague & Son,
 Att'ys.

E. WALKER.
CORKSCREW.

No. 501,975. Patented July 25, 1893.

Witnesses Inventor
A. L. Jackson Edwin Walker
F. Enzfeldt By H. Sturgeon
 att'y.

P. DEAN.
COMBINED CORKSCREW, MATCH HOLDER, &c.

No. 502,351. Patented Aug. 1, 1893.

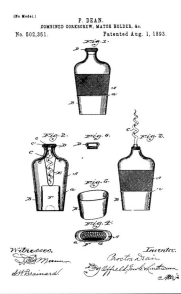

Witnesses, Inventor.
 Proctor Dean
 By Offield, Towle & Linthicum
 Att'ys

H. S. MARTIN.
CORK EXTRACTOR.

No. 505,920. Patented Oct. 3, 1893.

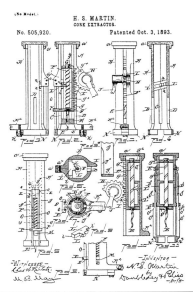

Witnesses— —Inventor—
 H. S. Martin
 Doubleday & Bliss
 Att'ys

C. MEERROTH.
CORKSCREW.

No. 509,819. Patented Nov. 28, 1893.

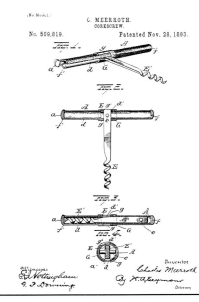

Witnesses Inventor
 Charles Meerroth
 By H. A. Seymour
 Attorney

W. PAINTER.
CAPPED BOTTLE OPENER.

No. 514,200. Patented Feb. 6, 1894.

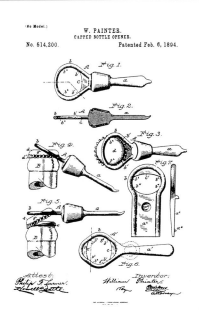

Attest. Inventor:
Philip F. Larner William Painter
 Attorney

E. WALKER.
AUTOMATIC CORK PULLER.

No. 515,411. Patented Feb. 27, 1894.

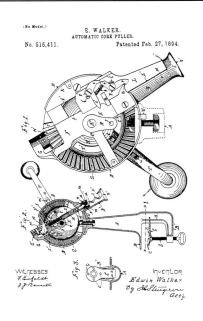

Witnesses Inventor
 Edwin Walker
 By H. Sturgeon
 Att'y.

E. WALKER.
CORK PULLER.

No. 515,412. Patented Feb. 27, 1894.

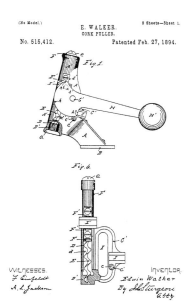

Witnesses Inventor
F. Enzfeldt Edwin Walker
A. L. Jackson By H. Sturgeon
 Att'y.

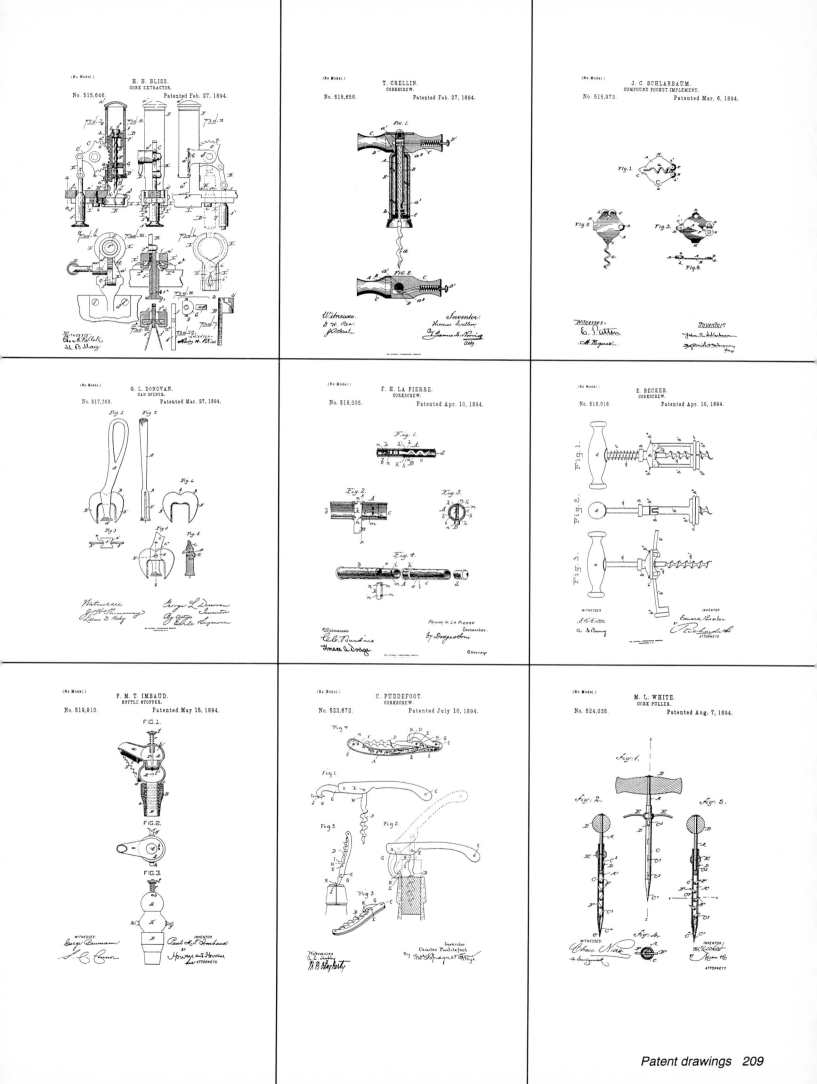

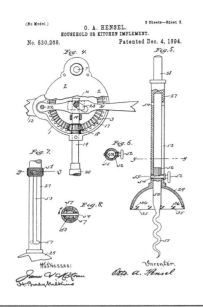

Fig. 4. Fig. 5.
Fig. 7. Fig. 6.
Fig. 8.

Witnesses: Inventor.

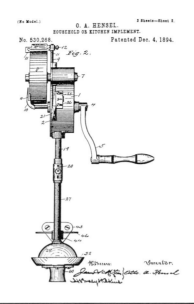

Fig. 2.

Witnesses: Inventor.

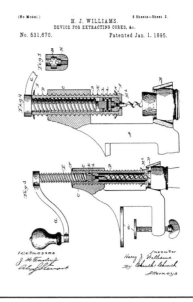

Witnesses Inventor
 Harry J. Williams
 By Church & Church
 Attorneys

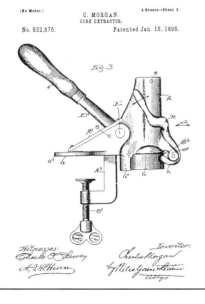

Fig. 3.

Witnesses Inventor
 Charles Morgan

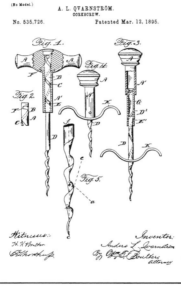

Fig. 1. Fig. 3. Fig. 4.
Fig. 2.
Fig. 5.

Witnesses Inventor
 Anders L. Qvarnström

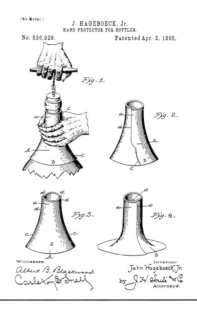

Fig. 1. Fig. 2.
Fig. 3. Fig. 4.

Witnesses: Inventor
Albert B. Blackwood John Hageboeck, Jr.
 by J. H. Siebe & Co.
 Attorneys

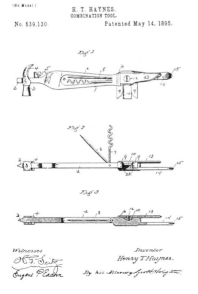

Fig. 1.
Fig. 2.
Fig. 3.

Witnesses Inventor
 Henry T. Haynes

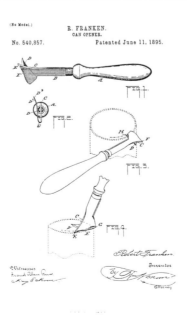

Fig. 1.
Fig. 2.
Fig. 3.
Fig. 4.

Witnesses Inventor
 Robert Franken

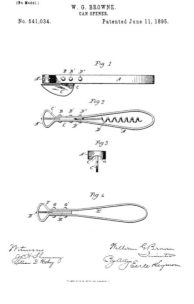

Fig. 1
Fig. 2
Fig. 3
Fig. 4

Witnesses Inventor
 William G. Browne
 By Attorney

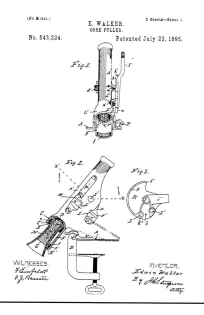

(No Model.)

E. WALKER.
CORK PULLER.

No. 543,224.
2 Sheets—Sheet 1.
Patented July 23, 1895.

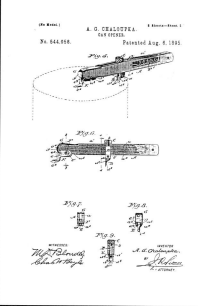

(No Model.)

A. G. CHALOUPKA.
CAN OPENER.
2 Sheets—Sheet 2.

No. 544,058.
Patented Aug. 6, 1895.

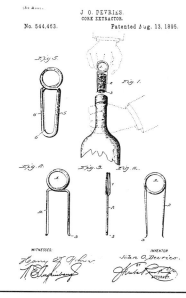

(No Model.)

J. O. DEVRIES.
CORK EXTRACTOR.

No. 544,463.
Patented Aug. 13, 1895.

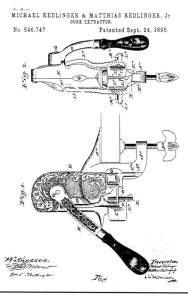

(No Model.)

MICHAEL REDLINGER & MATTHIAS REDLINGER, Jr.
CORK EXTRACTOR.

No. 546,747.
Patented Sept. 24, 1895.

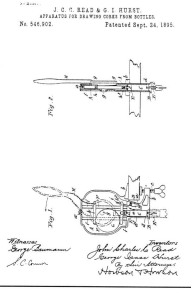

(No Model.)

J. C. C. READ & G. I. HURST.
APPARATUS FOR DRAWING CORKS FROM BOTTLES.

No. 546,902.
Patented Sept. 24, 1895.

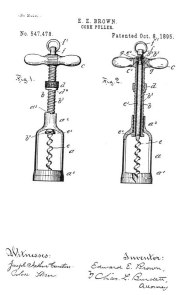

(No Model.)

E. E. BROWN.
CORK PULLER.

No. 547,478.
Patented Oct. 8, 1895.

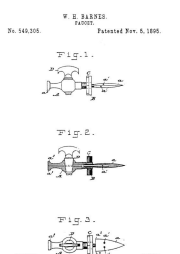

(No Model.)

W. H. BARNES.
FAUCET.

No. 549,305.
Patented Nov. 5, 1895.

Fig. 1.

Fig. 2.

Fig. 3.

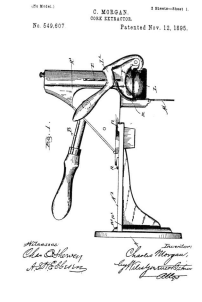

(No Model.)

C. MORGAN.
CORK EXTRACTOR.
3 Sheets—Sheet 1.

No. 549,607.
Patented Nov. 12, 1895.

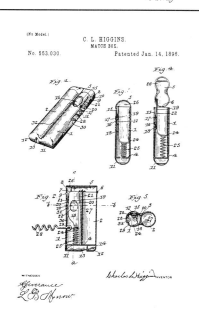

(No Model.)

C. L. HIGGINS.
MATCH BOX.

No. 553,030.
Patented Jan. 14, 1896.

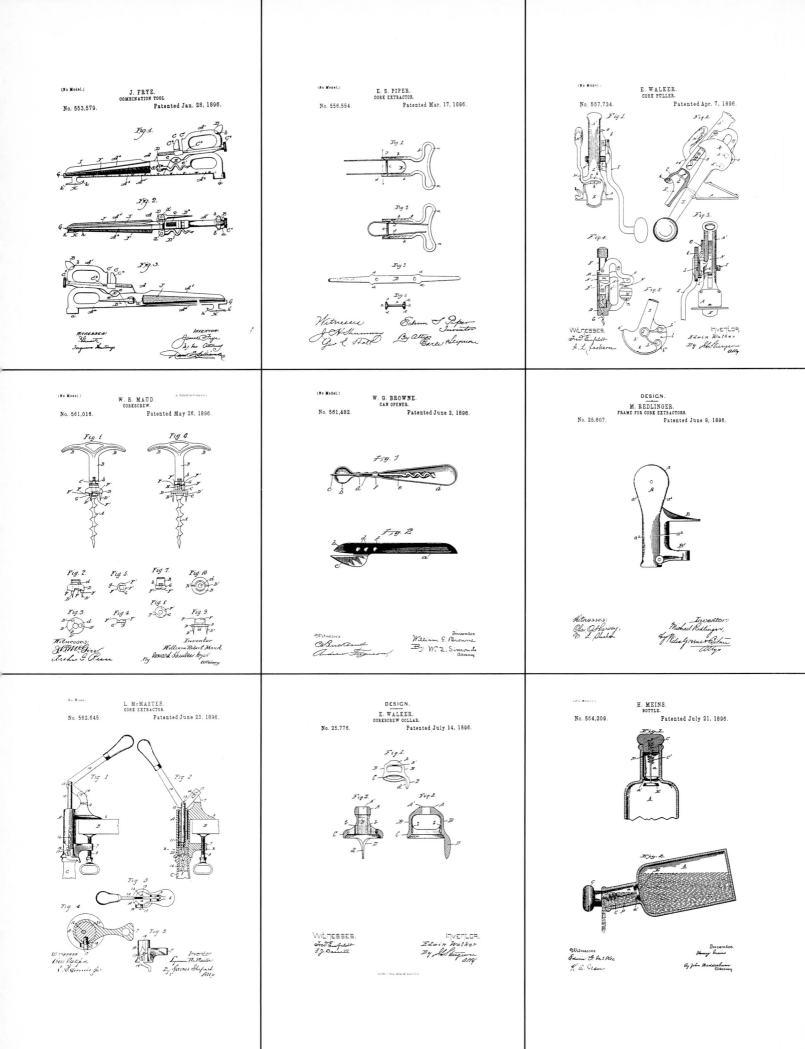

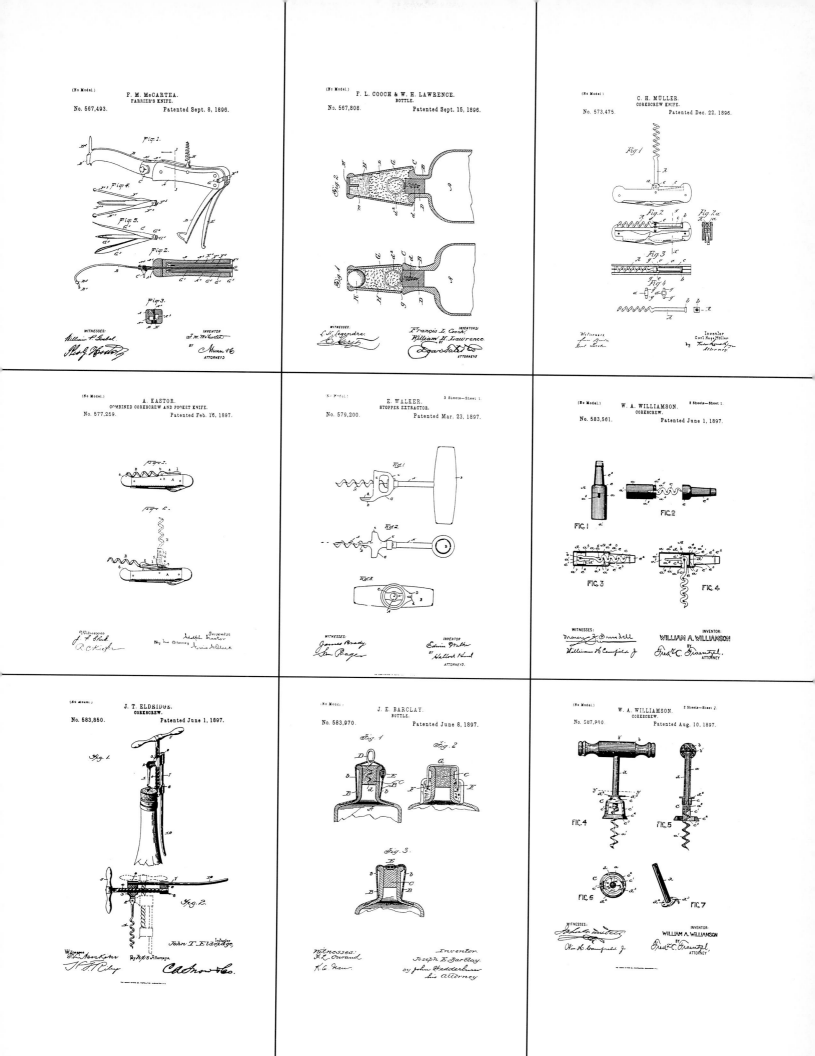

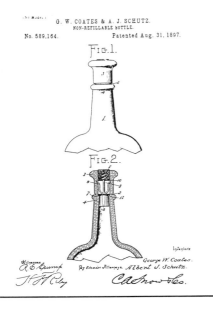

G. W. COATES & A. J. SCHUTZ.
NON-REFILLABLE BOTTLE.
No. 589,164. Patented Aug. 31, 1897.

FIG.1.

FIG.2.

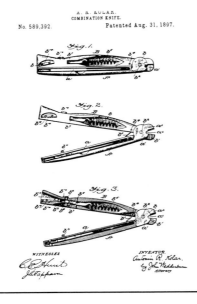

A. R. KOLAR.
COMBINATION KNIFE.
No. 589,392. Patented Aug. 31, 1897.

Fig.1.

Fig.2.

Fig.3.

M. REDLINGER.
CORK EXTRACTOR.
No. 589,574. Patented Sept. 7, 1897.

Fig 1

Fig. 3

Fig. 2

Fig. 4

A. DELL.
ATTACHED CAN OPENER, WIRE CUTTER, AND CORKSCREW.
No. 591,459. Patented Oct. 12, 1897.

Fig.1

Fig.2

L. C. STOLL.
CORKSCREW.
No. 593,698. Patented Nov. 16, 1897.

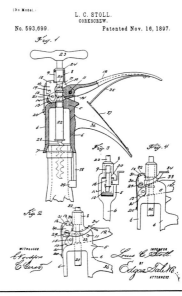

L. C. STOLL.
CORKSCREW.
No. 593,699. Patented Nov. 16, 1897.

Fig. 1

Fig. 3

Fig. 4

Fig. 2

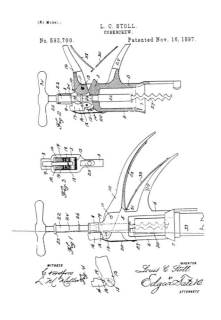

L. C. STOLL.
CORKSCREW.
No. 593,700. Patented Nov. 16, 1897.

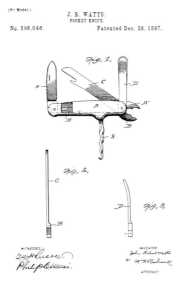

J. R. WATTS.
POCKET KNIFE.
No. 596,096. Patented Dec. 28, 1897.

Fig. 1.

Fig. 2.

Fig. 3.

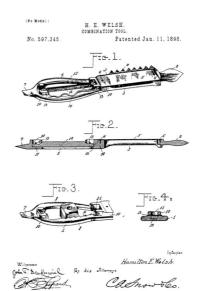

H. E. WELSH.
COMBINATION TOOL.
No. 597,345. Patented Jan. 11, 1898.

FIG.1.

FIG.2.

FIG.3.

FIG.4.

D. A. GILLIOM.
NON-REFILLING BOTTLE.

No. 597,767. Patented Jan. 25, 1898.

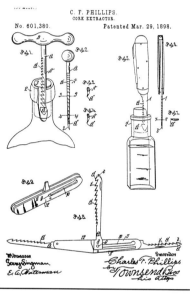

Witnesses
H. B. Hallock
S. S. Williamson

Inventor.
Daniel A. Gilliom
By
Geo. H. Holgate
Attorney

F. L. JOHNSON.
CORK PULLER.

No. 600,424 Patented Mar. 8, 1898.

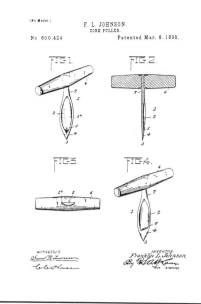

WITNESSES
Inventor.
Franklin L. Johnson.
By W. H. Macy
his Attorney.

H. L. BEDFORD.
KITCHEN UTENSIL.

No. 601,070. Patented Mar. 22, 1898.

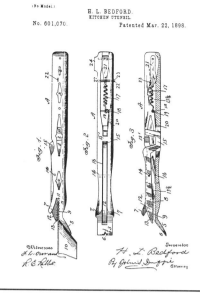

Witnesses
L. L. Orr and
L. E. Lilli.

Inventor
H. L. Bedford
By John W. Douglas
Attorney

C. F. PHILLIPS.
CORK EXTRACTOR.

No. 601,380. Patented Mar. 29, 1898.

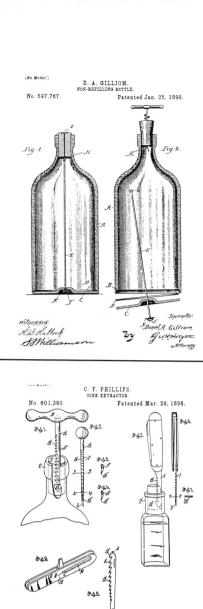

Witnesses
Harry Ingman
E. A. Potterman

Inventor
Charles F. Phillips
by Townsend Bros.
his Atty

A. B. SMITH.
COMBINATION TOOL.

No. 601,737 Patented Apr. 5, 1898.

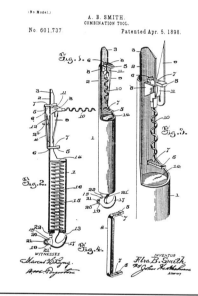

WITNESSES
Marcus H. Long
Inventor.
Elva B. Smith
By John Kochersperger
Attorney

C. W. MACKEY.
CORK PROTECTOR.

No. 601,776. Patented Apr. 5, 1898.

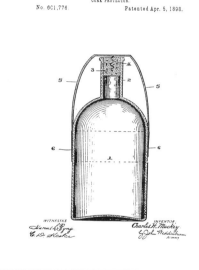

WITNESSES
Marcus H. Long
C. D. Hooker

INVENTOR
Charles W. Mackey
By John Widdicomb
Attorney

J. E. HAWKINS.
CORK PULLING MACHINE.

No. 603,950. Patented May 10, 1898.

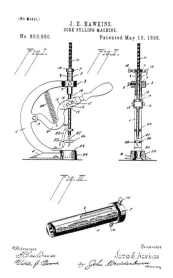

Witnesses
H. Clukowa
Victa J. Evans

Inventor
James E. Hawkins
By John Wedderburn
Attorney

DESIGN.

No. 29,231.
W. G. BROWNE.
CAN OPENER.
(Application filed July 6, 1898.)
Patented Aug. 16, 1898.

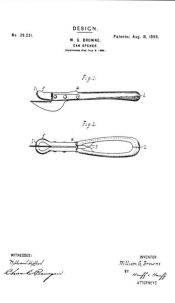

WITNESSES:
William Walker
Chas. E. Granger.

INVENTOR
William G. Browne
BY
Hauff & Hauff
ATTORNEYS

No. 610,530. Patented Sept. 13, 1898.

E. HAMMESFAHR.
POCKET CORKSCREW.
(Application filed Dec. 29, 1897.)

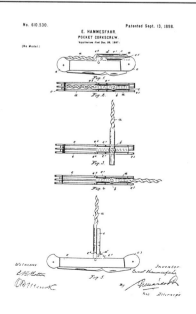

Witnesses
E. M. Batten
O. A. Munnick

Inventor
Ernst Hammesfahr
By
his Attorney

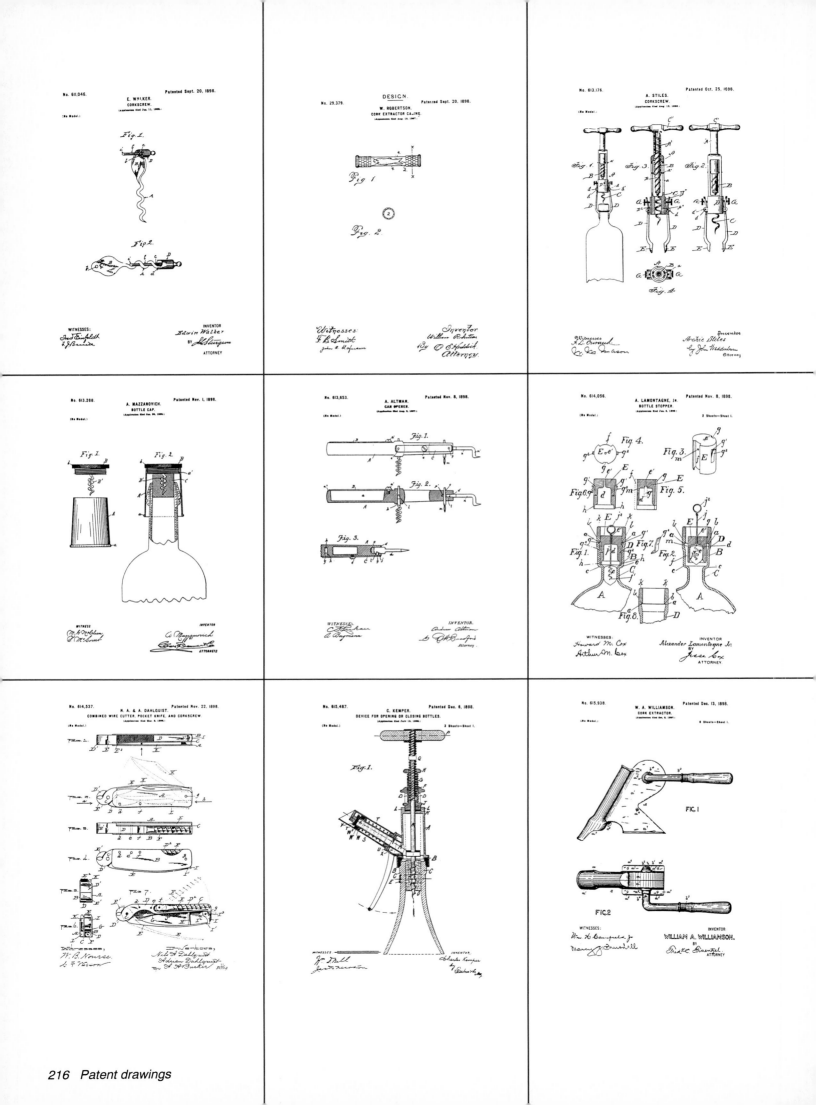

No. 29,798.
DESIGN.
W. A. WILLIAMSON.
CAP LIFT.
(Application filed Oct. 29, 1898.)
Patented Dec. 13, 1898.

FIG. 1
FIG. 2
FIG. 3
FIG. 4
FIG. 5

WITNESSES:
Walter H. Talmage.
B. Mortimer Tisdall.

INVENTOR:
WILLIAM A. WILLIAMSON
BY
Fred L. Graentzel,
ATTORNEY

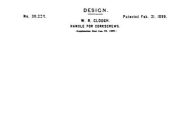

No. 619,648.
H. J. WILLIAMS.
CORK EXTRACTOR.
(Application filed Oct. 8, 1898.)
(No Model.)
Patented Feb. 14, 1899.
2 Sheets—Sheet 1.

WITNESSES:
J. K. Fowler Jr.
Thomas Durant.

INVENTOR:
Harry J. Williams,
BY
Church & Church
His Attorneys

No. 30,234.
DESIGN.
W. R. CLOUGH.
HANDLE FOR CORKSCREWS.
(Application filed Jan. 28, 1899.)
Patented Feb. 21, 1899.

WITNESSES:
Gustav Dietrich.
John Uhlenbruck.

INVENTOR
William R. Clough,
BY
Chas. O. Gill
ATTORNEY

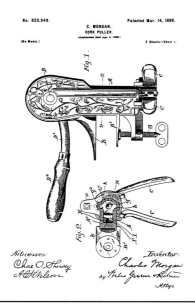

No. 620,949.
C. MORGAN.
CORK PULLER.
(Application filed Apr. 4, 1898.)
(No Model.)
Patented Mar. 14, 1899.
3 Sheets—Sheet 1.

Fig. 1
Fig. 2

Witnesses:
Chas. O. Harvey
A. H. Nelson

Inventor:
Charles Morgan
by Philo Grumo & Behm
Attys.

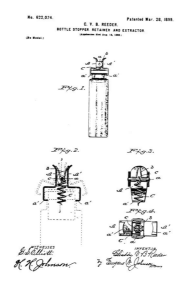

No. 622,074.
C. V. B. REEDER.
BOTTLE STOPPER, RETAINER AND EXTRACTOR.
(Application filed Aug. 15, 1898.)
(No Model.)
Patented Mar. 28, 1899.

Fig. 1
Fig. 2
Fig. 3
Fig. 4

WITNESSES:
G. S. Elliott.
H. R. Johnson.

INVENTOR
Celestin V. B. Reeder
by Eugene C. Johnson
Attorney

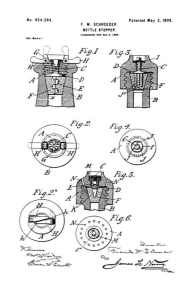

No. 624,384.
F. W. SCHROEDER.
BOTTLE STOPPER.
(No Model.)
Patented May 2, 1899.

Fig. 1
Fig. 2
Fig. 2ª
Fig. 3
Fig. 4
Fig. 5
Fig. 6

Inventor
Ferdinand W. Schroeder
by
James L. Norris

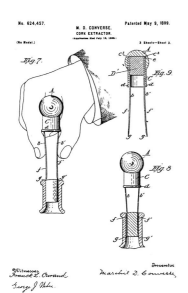

No. 624,457.
M. D. CONVERSE.
CORK EXTRACTOR.
(Application filed July 18, 1898.)
(No Model.)
Patented May 9, 1899.
3 Sheets—Sheet 3.

Fig. 7
Fig. 8
Fig. 9

Witnesses:
Franck L. Orcard
George J. Vobe.

Inventor
Marshal D. Converse.

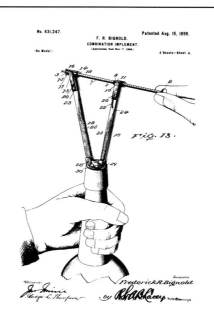

No. 631,247.
F. R. BIGNOLD.
COMBINATION IMPLEMENT.
(Application filed Mar. 7, 1899.)
(No Model.)
Patented Aug. 15, 1899.
4 Sheets—Sheet 4.

Fig. 13.

Witnesses:
Jno. Minnie
George L. Thompson.

Inventor
Frederick R. Bignold
by R. S. & B. Casey
Attorney

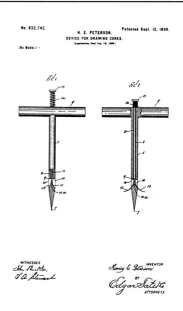

No. 632,742.
H. E. PETERSON.
DEVICE FOR DRAWING CORKS.
(Application filed Jan. 13, 1899.)
(No Model.)
Patented Sept. 12, 1899.

Fig. 1
Fig. 2

WITNESSES:
Chas. B. Mann
J. O. Stewart.

INVENTOR
Henry E. Peterson,
BY
Edgar Tate & Co.
ATTORNEYS

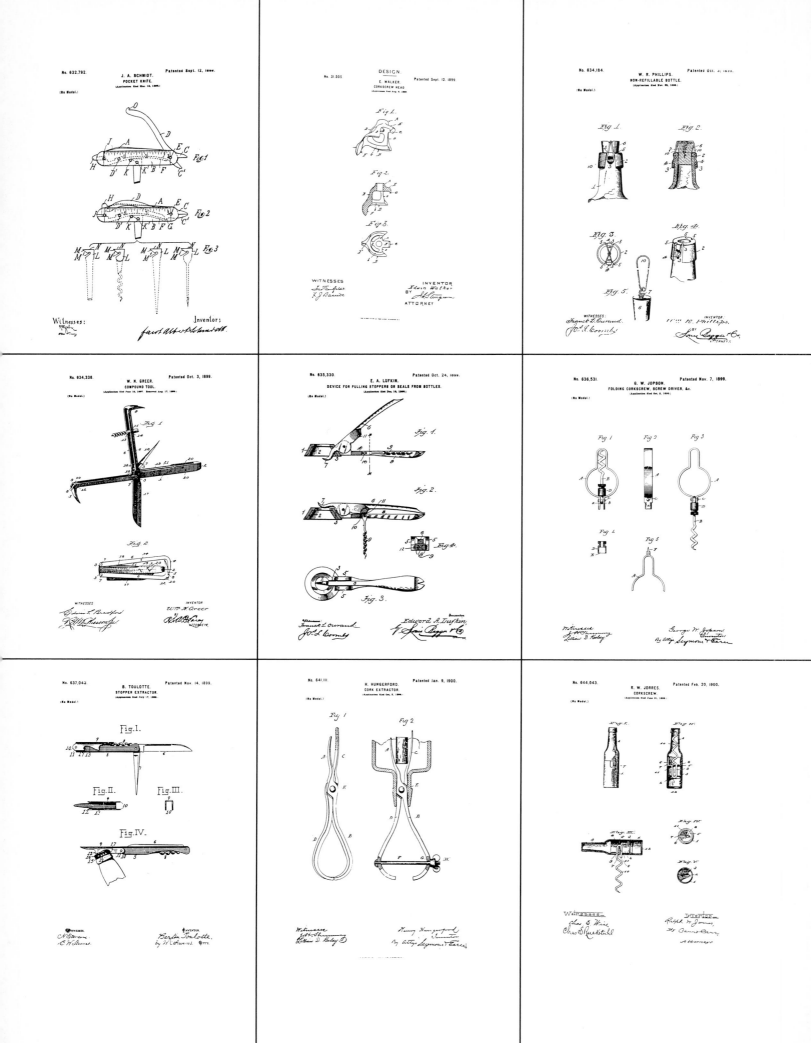

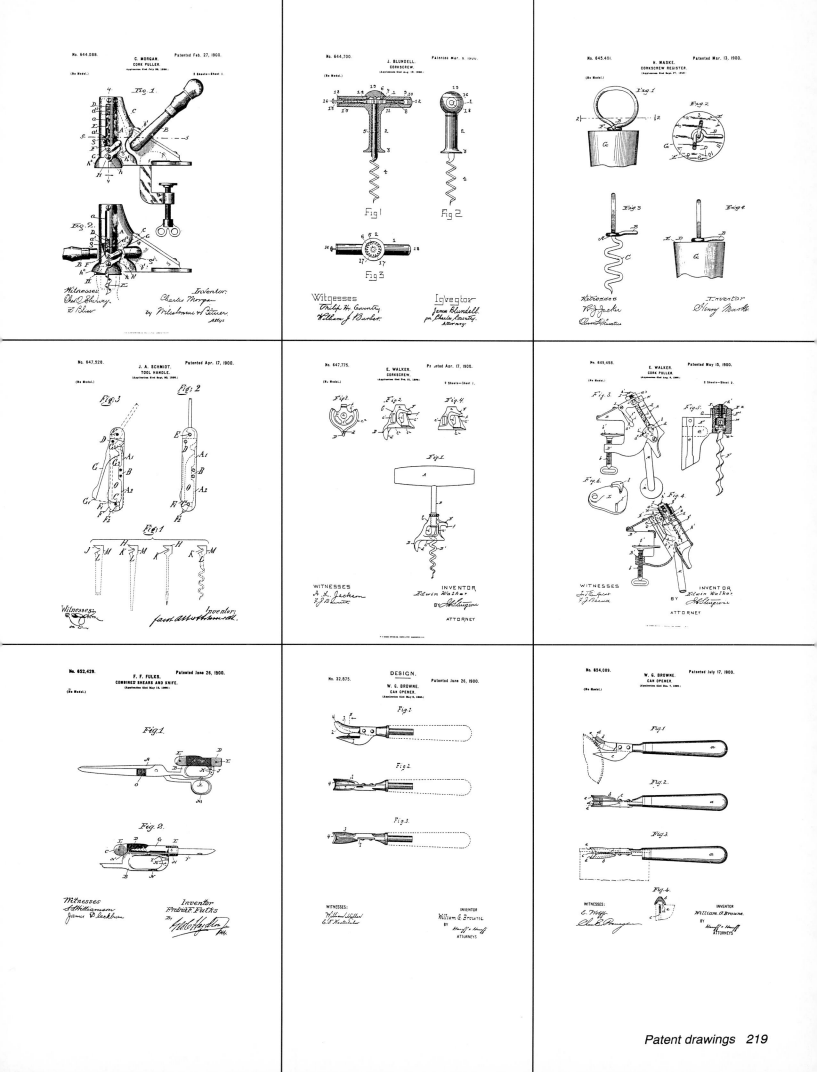

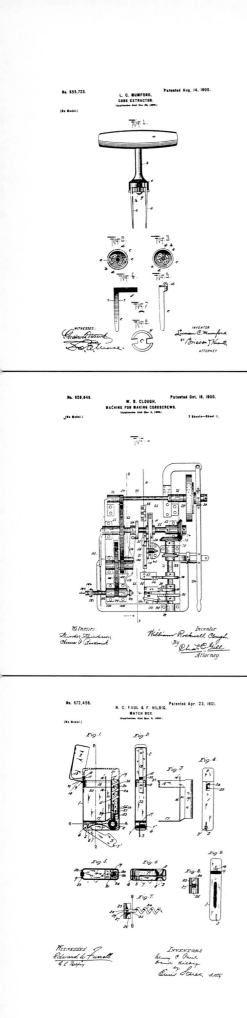

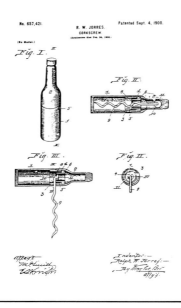

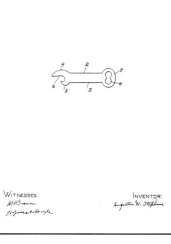

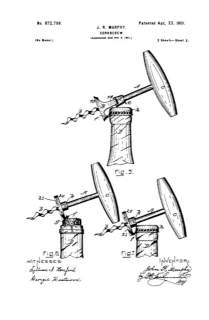

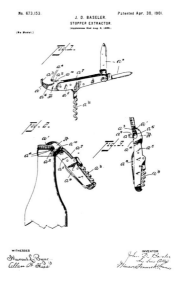

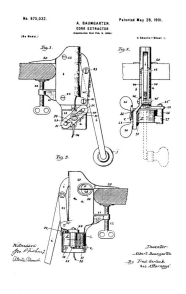

No. 675,032.
A. BAUMGARTEN.
CORK EXTRACTOR.
(Application filed Feb. 5, 1900.)
Patented May 28, 1901.

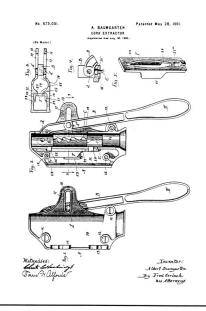

No. 675,051.
A. BAUMGARTEN.
CORK EXTRACTOR.
(Application filed Aug. 20, 1900.)
Patented May 28, 1901.

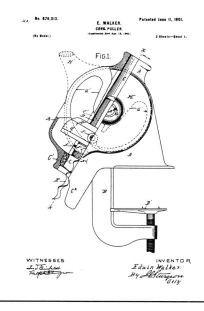

No. 676,013.
E. WALKER.
CORK PULLER.
(Application filed Apr. 19, 1901.)
Patented June 11, 1901.

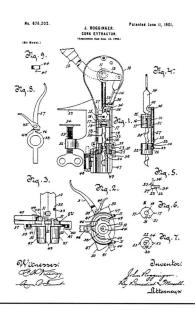

No. 676,205.
J. ROGGINGER.
CORK EXTRACTOR.
(Application filed Sept. 15, 1900.)
Patented June 11, 1901.

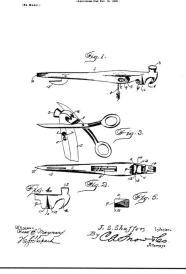

No. 677,105.
J. S. SHAFFER.
SCISSORS SHARPENER.
(Application filed Nov. 12, 1900.)
Patented June 25, 1901.

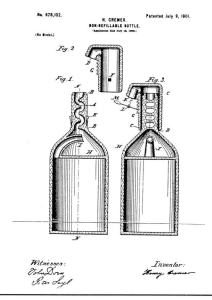

No. 678,102.
H. CREMER.
NON-REFILLABLE BOTTLE.
(Application filed July 18, 1900.)
Patented July 9, 1901.

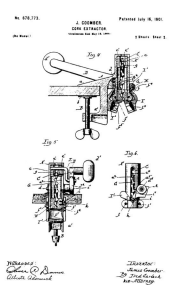

No. 678,773.
J. COOMBER.
CORK EXTRACTOR.
(Application filed May 18, 1900.)
Patented July 16, 1901.

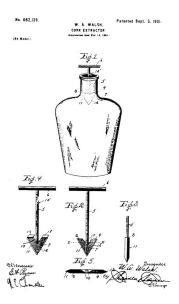

No. 682,129.
W. A. WALSH.
CORK EXTRACTOR.
(Application filed Feb. 14, 1901.)
Patented Sept. 3, 1901.

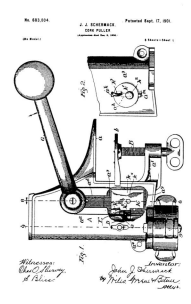

No. 683,004.
J. J. SCHERMACK.
CORK PULLER.
(Application filed Dec. 3, 1900.)
Patented Sept. 17, 1901.

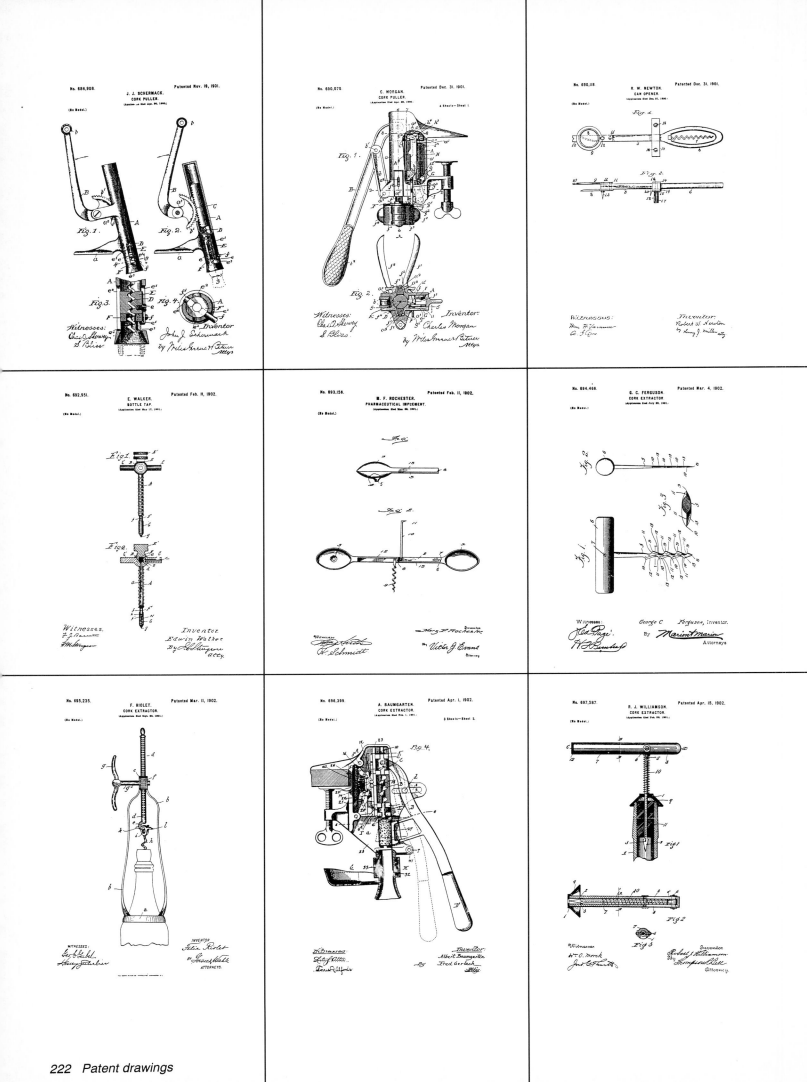

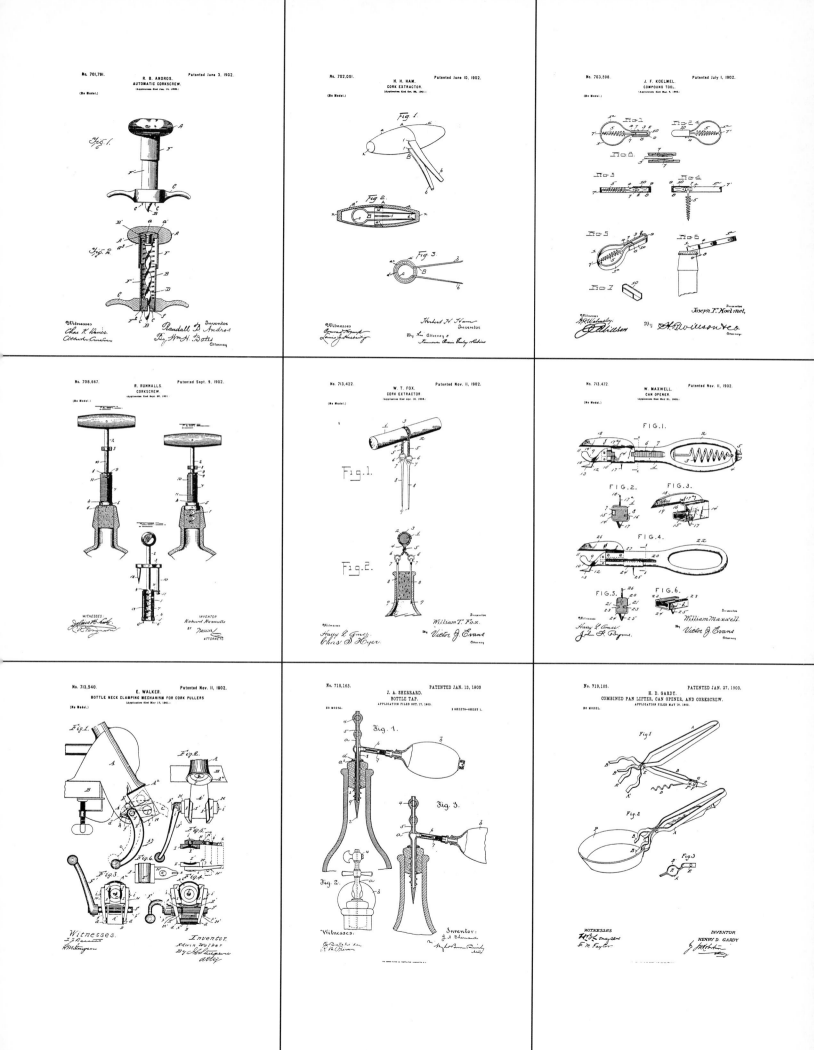

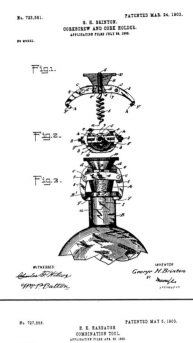

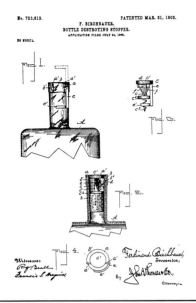

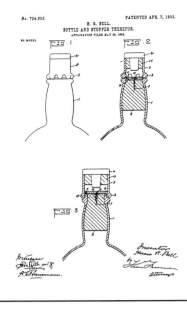

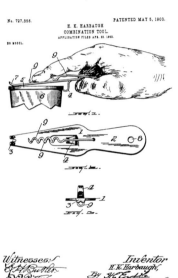

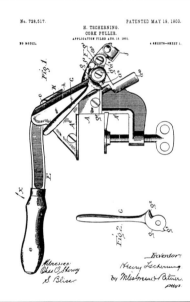

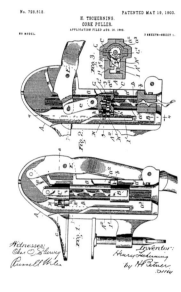

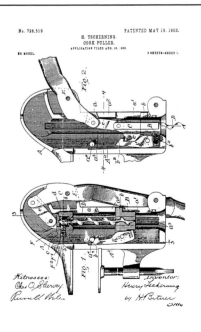

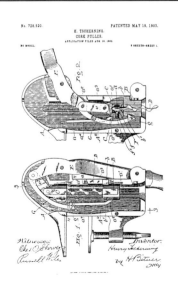

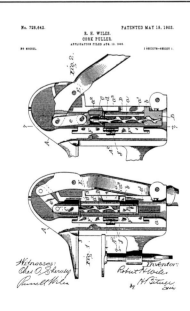

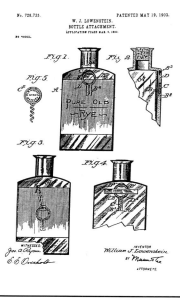

No. 728,735.
W. J. LOWENSTEIN.
BOTTLE ATTACHMENT.
APPLICATION FILED MAR. 9, 1903.
PATENTED MAY 19, 1903.
NO MODEL.

Fig.1. Fig.2. Fig.5. Fig.3. Fig.4.

WITNESSES:
Jas. A. Ryan.
E. S. Overholt.

INVENTOR
William J. Lowenstein.
BY Mason & Co.
ATTORNEYS.

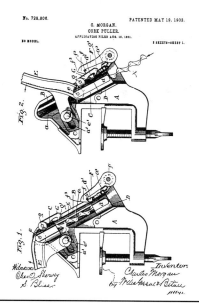

No. 728,806.
C. MORGAN.
CORK PULLER.
APPLICATION FILED AUG. 19, 1901.
PATENTED MAY 19, 1903.
NO MODEL.
2 SHEETS—SHEET 1.

Fig.2. Fig.1.

Witnesses:
Chas. O. Sherwy.
S. Bliss.

Inventor:
Charles Morgan
by Mason Fenwick & Lawrence
Attorneys.

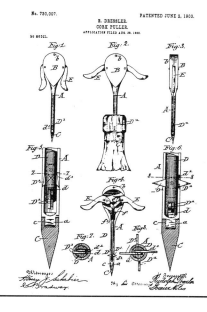

No. 730,007.
R. DRESSLER.
CORK PULLER.
APPLICATION FILED AUG. 20, 1902.
PATENTED JUNE 2, 1903.
NO MODEL.

Fig.1. Fig.2. Fig.3. Fig.5. Fig.6. Fig.4. Fig.8. Fig.7.

Witnesses:
Henry J. Schuster
E. Bradway

Inventor:
Rudolph Dressler
By his Attorneys

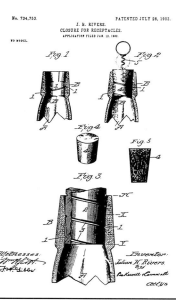

No. 734,753.
J. H. RIVERS.
CLOSURE FOR RECEPTACLES.
APPLICATION FILED JAN. 13, 1903.
PATENTED JULY 28, 1903.
NO MODEL.

Fig.1 Fig.2 Fig.4 Fig.5 Fig.3

Witnesses:
W. H. Forst
F. Gibbs

Inventor:
Julian H. Rivers
Rockwell Cornwell
Att'ys

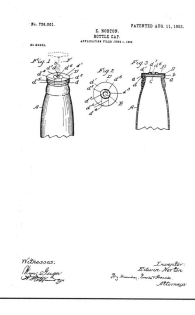

No. 736,001.
E. NORTON.
BOTTLE CAP.
APPLICATION FILED JUNE 1, 1903.
PATENTED AUG. 11, 1903.
NO MODEL.

Fig.1 Fig.2 Fig.3

Witnesses:

Inventor:
Edwin Norton
By Munday, Evarts & Adcock
Attorneys

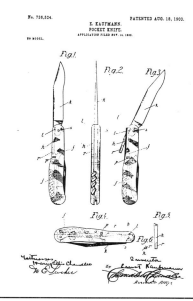

No. 736,524.
E. KAUFMANN.
POCKET KNIFE.
APPLICATION FILED NOV. 14, 1902.
PATENTED AUG. 18, 1903.
NO MODEL.

Fig.1. Fig.2. Fig.3. Fig.4. Fig.5. Fig.6.

Witnesses:
Francis W. Chandler
W. E. Tucker

Inventor:
Ernst Kaufmann
By Thomas G. Chandler
Associate Atty.

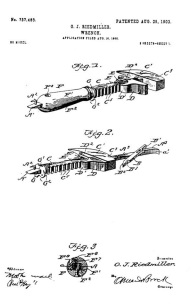

No. 737,483.
O. J. RIEDMILLER.
WRENCH.
APPLICATION FILED AUG. 18, 1902.
PATENTED AUG. 25, 1903.
NO MODEL.
2 SHEETS—SHEET 1.

Fig.1. Fig.2. Fig.3.

Witness:

Inventor:
O. J. Riedmiller
By Mead & Brock
Attorneys

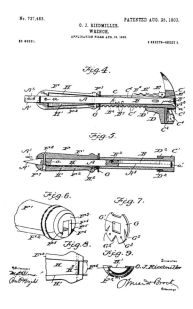

No. 737,483.
O. J. RIEDMILLER.
WRENCH.
APPLICATION FILED AUG. 18, 1902.
PATENTED AUG. 25, 1903.
NO MODEL.
2 SHEETS—SHEET 2.

Fig.4. Fig.5. Fig.6. Fig.7. Fig.8. Fig.9.

Witnesses:

Inventor:
O. J. Riedmiller
By Mead & Brock
Attorneys

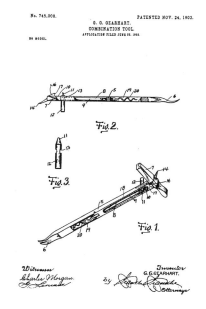

No. 745,008.
G. G. GEARHART.
COMBINATION TOOL.
APPLICATION FILED JUNE 22, 1903.
PATENTED NOV. 24, 1903.
NO MODEL.

Fig.2. Fig.3. Fig.1.

Witnesses:
Charles Morgan
S. Lawrence

Inventor:
G. G. Gearhart.
By Mason & Lawrence
Attorneys

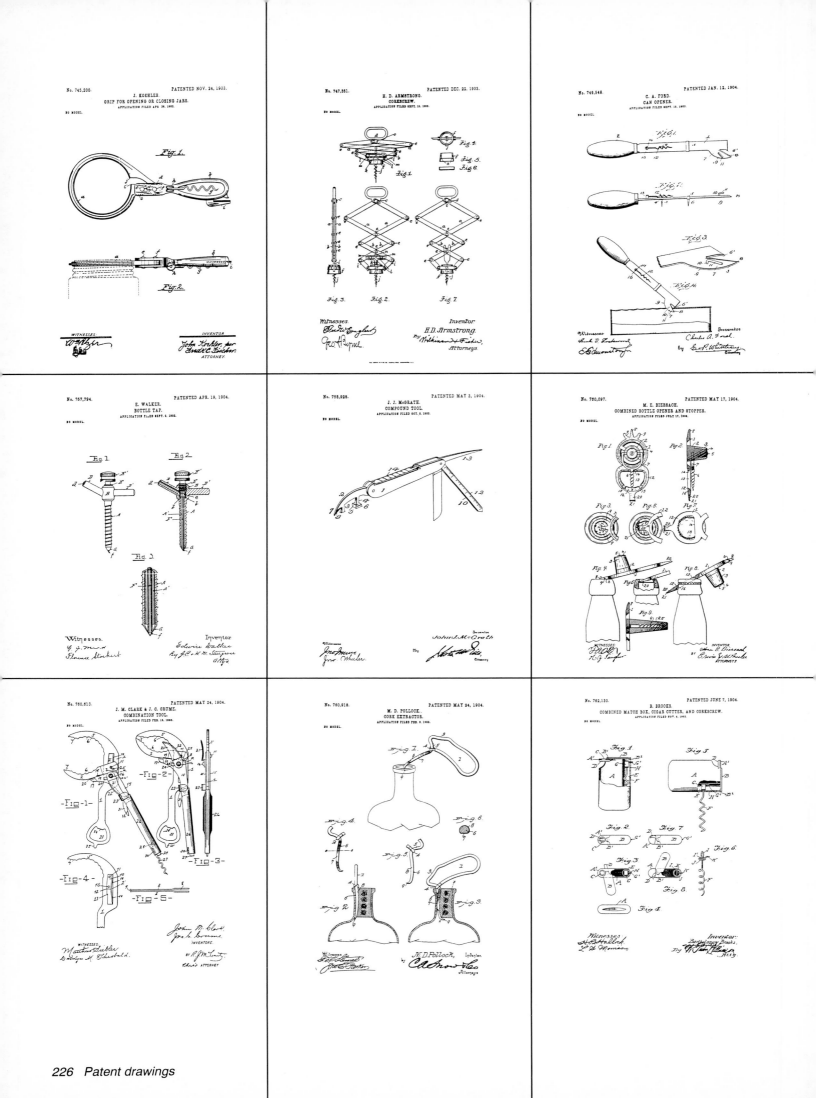

No. 766,450. **F. WHITE & F. WINKLER.** PATENTED JULY 19, 1904.
CAN OPENER.
APPLICATION FILED MAR. 28, 1903.

NO MODEL. 2 SHEETS—SHEET 1.

No. 771,728. **C. HOLT.** PATENTED OCT. 4, 1904.
ATTACHMENT FOR REVOLVERS.
APPLICATION FILED APR. 1, 1903.

NO MODEL.

No. 772,828. **J. KAISER.** PATENTED OCT. 18, 1904.
CORK EXTRACTOR.
APPLICATION FILED JAN. 16, 1904.

NO MODEL.

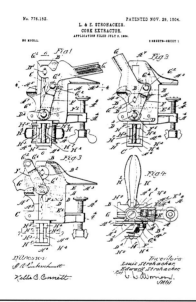

No. 776,152. **L. & E. STROHACKER.** PATENTED NOV. 29, 1904.
CORK EXTRACTOR.
APPLICATION FILED JULY 2, 1904.

NO MODEL. 2 SHEETS—SHEET 1.

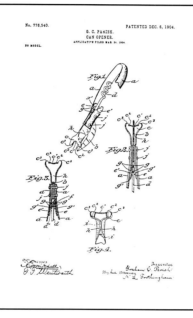

No. 776,540. **G. C. PARISH.** PATENTED DEC. 6, 1904.
CAN OPENER.
APPLICATION FILED MAR. 24, 1904.

NO MODEL.

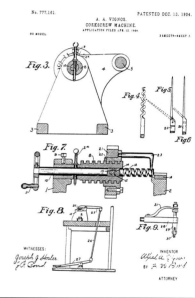

No. 777,161. **A. A. VIGNOS.** PATENTED DEC. 13, 1904.
CORKSCREW MACHINE.
APPLICATION FILED APR. 12, 1904.

NO MODEL. 2 SHEETS—SHEET 2.

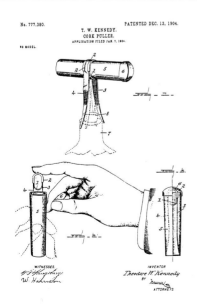

No. 777,380. **T. W. KENNEDY.** PATENTED DEC. 13, 1904.
CORK PULLER.
APPLICATION FILED JAN. 7, 1904.

NO MODEL.

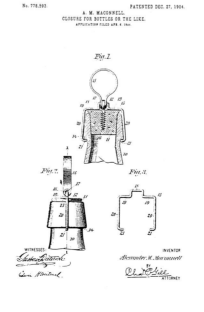

No. 776,593. **A. M. MACONNELL.** PATENTED DEC. 27, 1904.
CLOSURE FOR BOTTLES OR THE LIKE.
APPLICATION FILED APR. 6, 1904.

No. 783,800. **C. L. PORTER.** PATENTED FEB. 28, 1905.
COMBINATION TOOL.
APPLICATION FILED SEPT. 16, 1903.

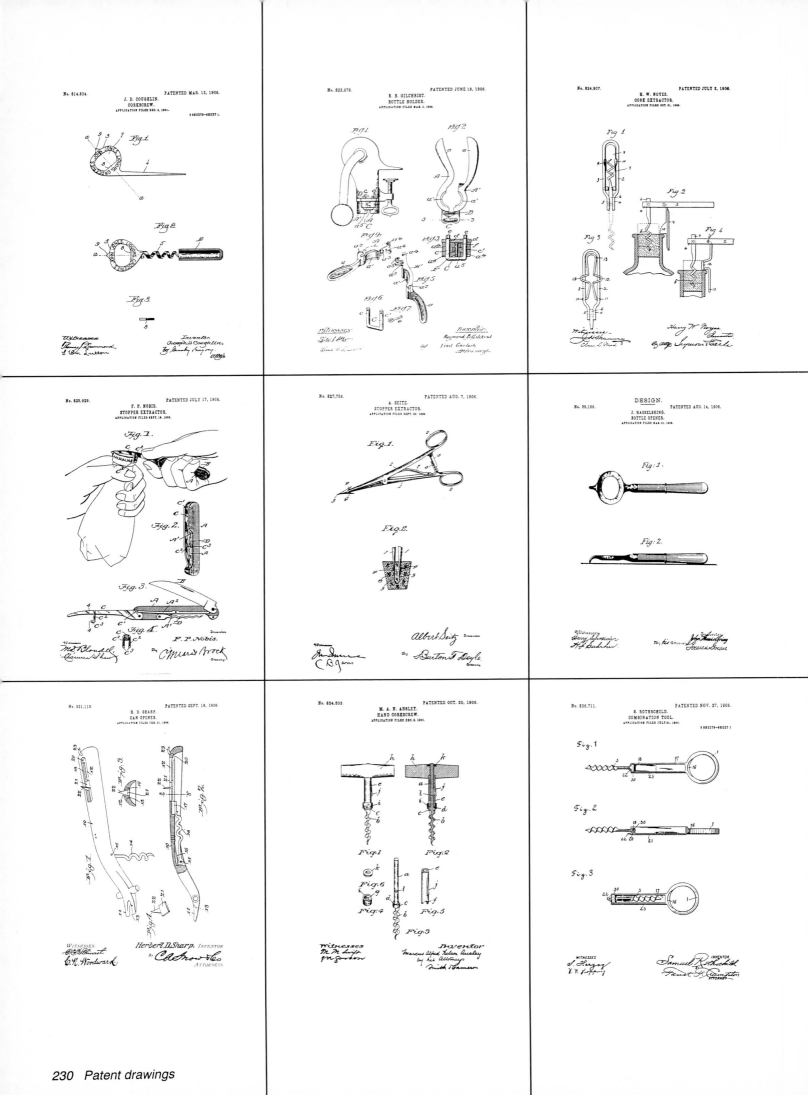

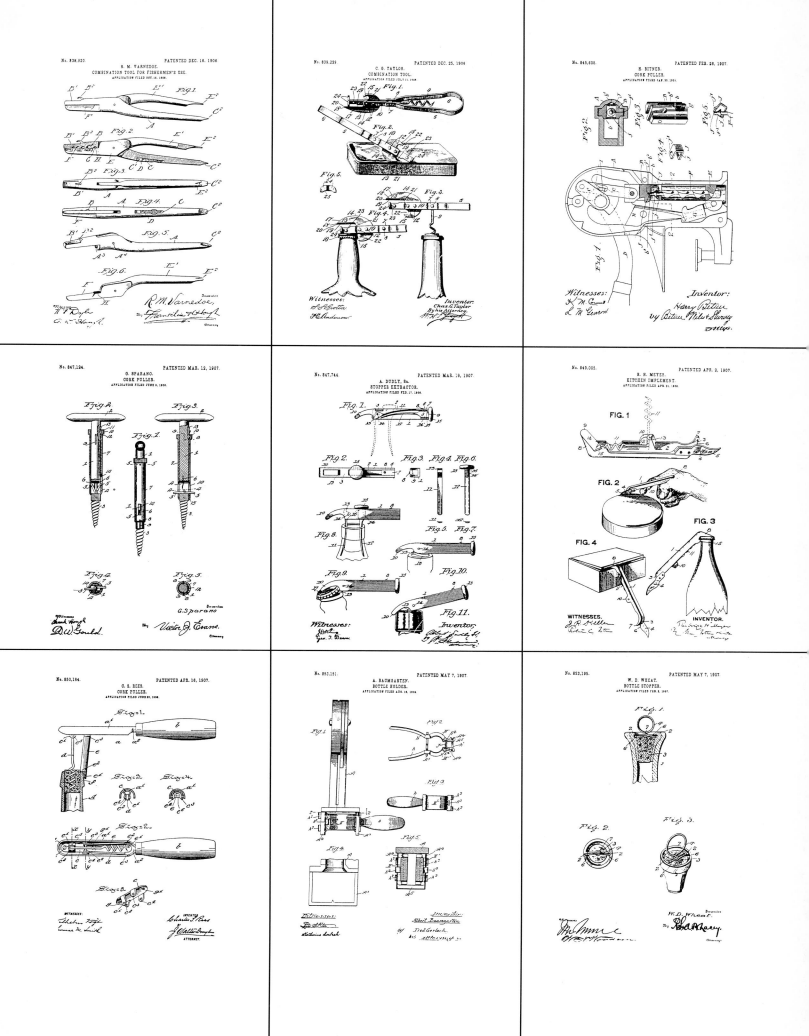

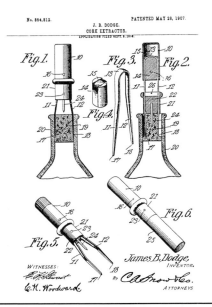

No. 854,812.

J. B. DODGE.

CORK EXTRACTOR.

APPLICATION FILED SEPT. 8, 1906.

PATENTED MAY 28, 1907.

Fig.1. *Fig.3.* *Fig.2.*

Fig.4.

Fig.5. *Fig.6.*

WITNESSES:

James B. Dodge, INVENTOR.

By CASnow&Co.

ATTORNEYS.

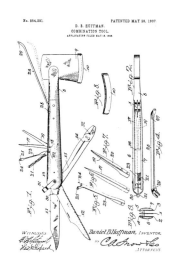

No. 854,991.

D. B. HUFFMAN.

COMBINATION TOOL.

APPLICATION FILED MAY 18, 1906.

PATENTED MAY 28, 1907.

WITNESSES:

Daniel B.Huffman, INVENTOR.

By CASnow&Co.

ATTORNEYS.

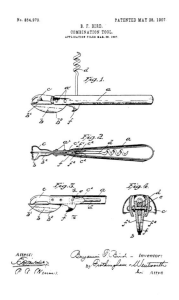

No. 854,979.

B. F. BIRD.

COMBINATION TOOL.

APPLICATION FILED MAR. 26, 1907.

PATENTED MAY 28, 1907.

Fig.1.

Fig.2.

Fig.3. *Fig.4.*

Attest:

Benjamin F.Bird. Inventor:

by Frothingham & Wentworth

his Attys.

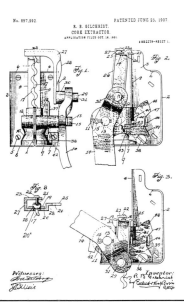

No. 857,992.

R. B. GILCHRIST.

CORK EXTRACTOR.

APPLICATION FILED OCT. 18, 1901.

PATENTED JUNE 25, 1907.

2 SHEETS—SHEET 1.

Fig.1. *Fig.2.*

Fig.3.

Fig.8

Witnesses:

Inventor:

R. B. Gilchrist,

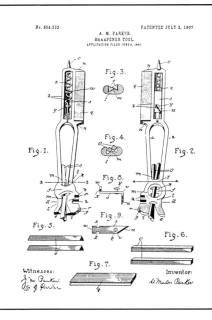

No. 858,532.

A. M. PARKER.

SHARPENER TOOL.

APPLICATION FILED JUNE 4, 1906.

PATENTED JULY 2, 1907.

Fig.3.

Fig.1. *Fig.2.*

Fig.4.

Fig.8.

Fig.5. *Fig.9.* *Fig.6.*

Fig.7.

Witnesses:

Inventor:

A. Morton Parker

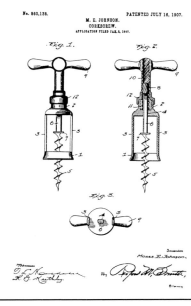

No. 860,138.

M. E. JOHNSON.

CORKSCREW.

APPLICATION FILED JAN. 26, 1907.

PATENTED JULY 16, 1907.

Fig.1. *Fig.2.*

Fig.3.

Witnesses:

Inventor

Moses E. Johnson,

By Rufus M. Smith,

Attorney

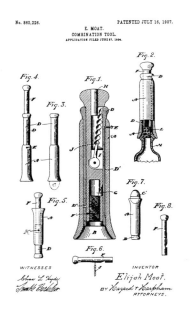

No. 860,226.

E. MOAT.

COMBINATION TOOL.

APPLICATION FILED JUNE 27, 1906.

PATENTED JULY 16, 1907.

Fig.4. *Fig.2.*

Fig.1. *Fig.3.*

Fig.7.

Fig.5. *Fig.8.*

Fig.6.

WITNESSES

INVENTOR

Elijah Moat.

BY Hazard & Harpham

ATTORNEYS.

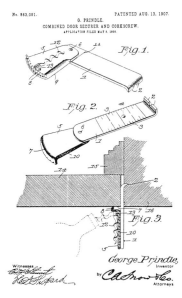

No. 863,091.

G. PRINDLE.

COMBINED DOOR SECURER AND CORKSCREW.

APPLICATION FILED MAY 5, 1905.

PATENTED AUG. 13, 1907.

Fig.1.

Fig.2.

Fig.3.

Witnesses

George Prindle,

Inventor

by CASnow&Co.

Attorneys

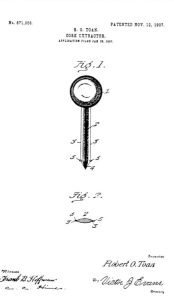

No. 871,006.

R. O. TOAN.

CORK EXTRACTOR.

APPLICATION FILED JAN. 23, 1907.

PATENTED NOV. 12, 1907.

Fig.1.

Fig.2.

Witnesses

Inventor

Robert O.Toan

by Victor J.Evans

Attorney

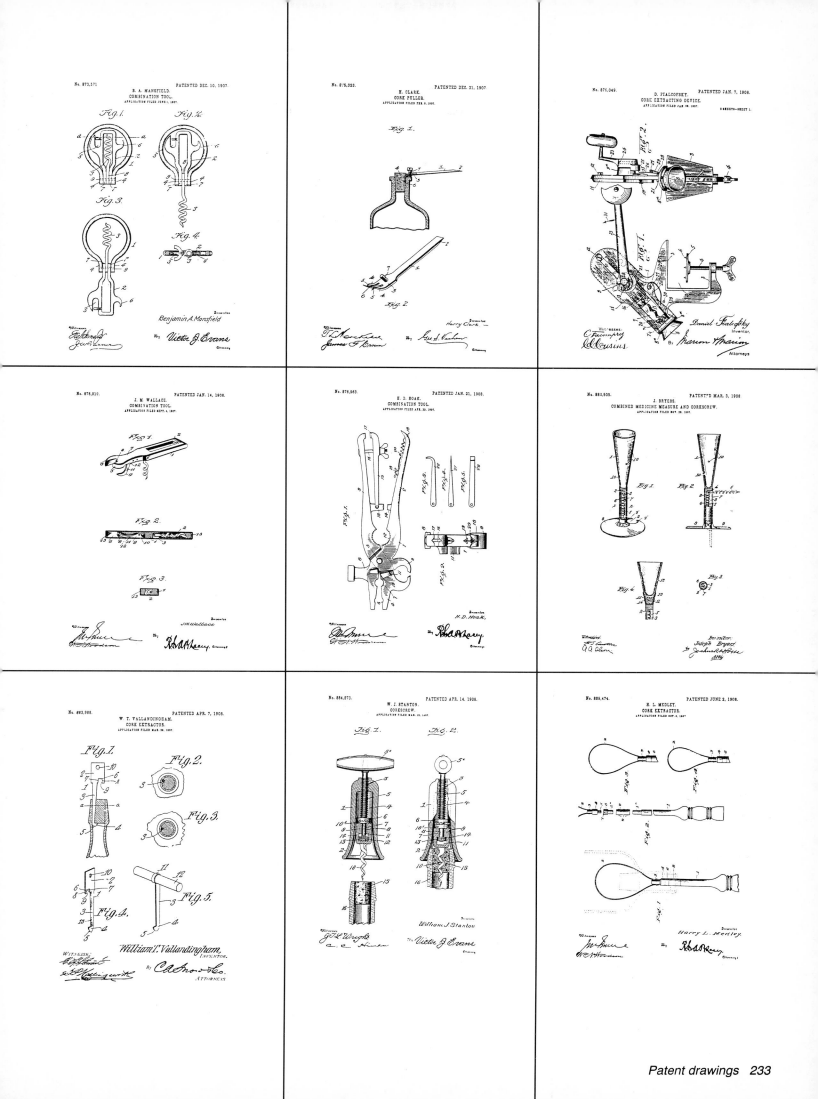

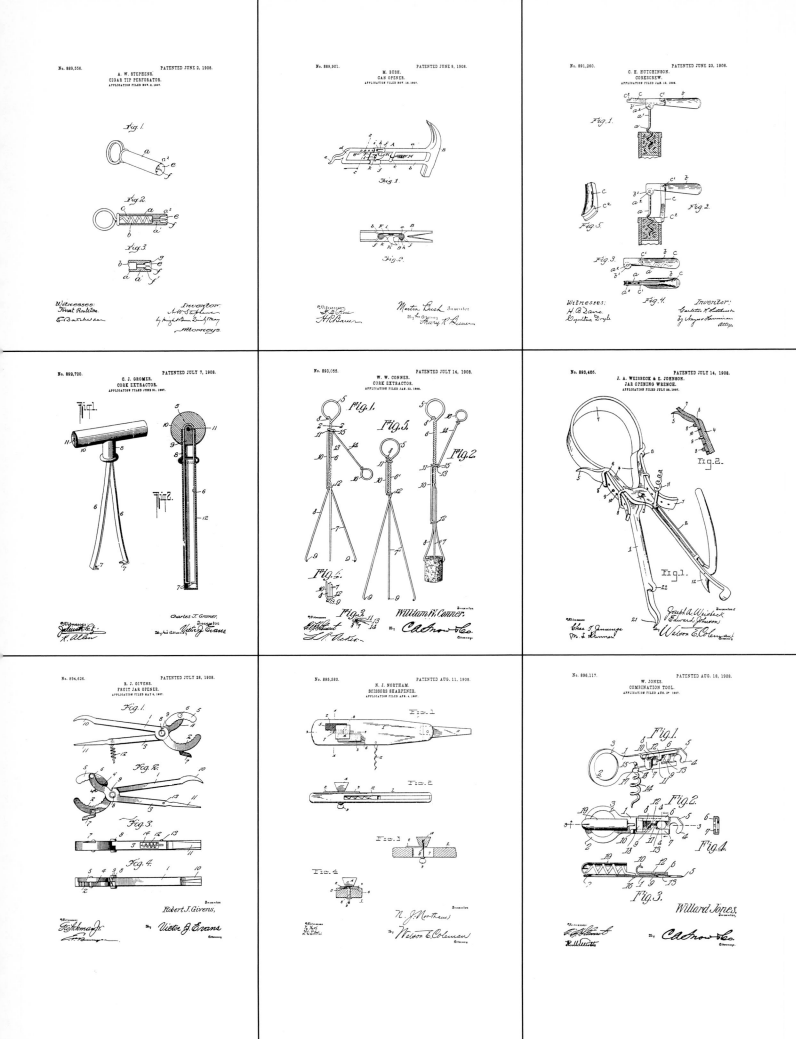

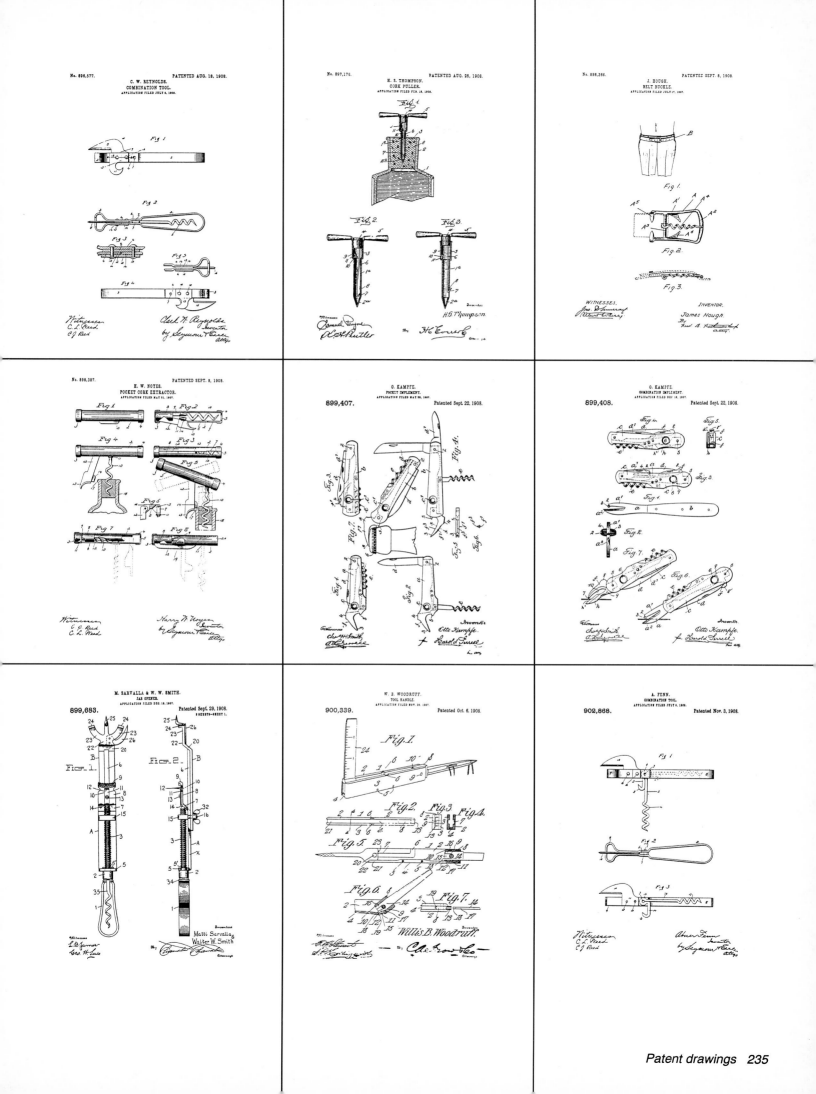

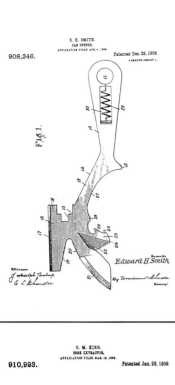

E. H. SMITH.
CAN OPENER.
APPLICATION FILED APR. 4, 1908.

908,346. Patented Dec. 29, 1908.

Fig. 1.

Edward H. Smith

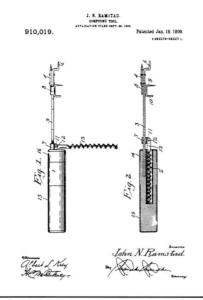

J. N. RAMSTAD.
COMPOUND TOOL.
APPLICATION FILED SEPT. 28, 1908.

910,019. Patented Jan. 19, 1909.

Fig. 1. Fig. 2.

John N. Ramstad.

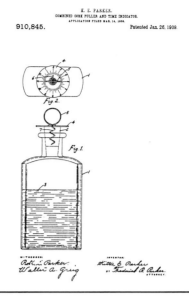

K. E. PARKER.
COMBINED CORK PULLER AND TIME INDICATOR.
APPLICATION FILED MAR. 14, 1908.

910,845. Patented Jan. 26, 1909.

Fig. 2.

Fig. 1.

C. M. KING.
CORK EXTRACTOR.
APPLICATION FILED MAR. 18, 1908.

910,923. Patented Jan. 26, 1909.

Fig. 1.

Fig. 2.

INVENTOR
Chauncey M. King

C. C. CALL.
CORK PULLING DEVICE.
APPLICATION FILED SEPT. 28, 1907.

911,292. Patented Feb. 2, 1909.

Fig. 1.

Fig. 3. Fig. 4.

Fig. 2.

B. F. BIRD.
COMBINATION TOOL.
APPLICATION FILED APR. 3, 1908.

913,191. Patented Feb. 23, 1909.

Fig. 1.

Fig. 2.

Inventor:
Benjamin F. Bird

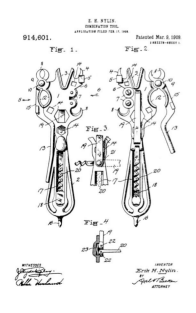

E. H. NYLIN.
COMBINATION TOOL.
APPLICATION FILED FEB. 17, 1908.

914,601. Patented Mar. 9, 1909.

Fig. 1. Fig. 2.

Fig. 3.

Fig. 4.

INVENTOR
Erik H. Nylin.

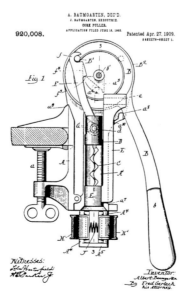

A. BAUMGARTEN, DEC'D.
J. BAUMGARTEN, EXECUTRIX.
CORK PULLER.
APPLICATION FILED JUNE 13, 1903.

920,008. Patented Apr. 27, 1909.

Fig. 1.

Inventor:
Albert Baumgarten

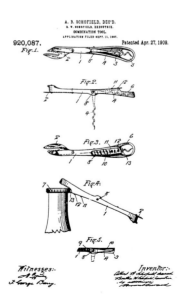

A. B. SCHOFIELD, DEC'D.
R. W. SCHOFIELD, EXECUTRIX.
COMBINATION TOOL.
APPLICATION FILED SEPT. 11, 1907.

920,087. Patented Apr. 27, 1909.

Fig. 1.

Fig. 2.

Fig. 3.

Fig. 4.

Fig. 5.

Inventor:

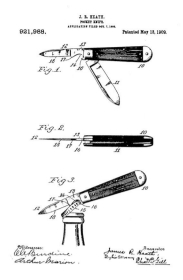

J. B. HEATH.
POCKET KNIFE.
APPLICATION FILED OCT. 7, 1908.

921,988. Patented May 18, 1909.

Fig.1.

Fig.2.

Fig.3.

Witnesses:
Eli Bundine.
Arthur Marion.

James R. Heath, Inventor.
By his Attorney Chas. P. Sill.

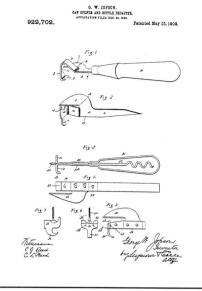

G. W. JOPSON.
CAN OPENER AND BOTTLE DECAPPER.
APPLICATION FILED DEC. 28, 1908.

922,702. Patented May 25, 1909.

Fig.1

Fig.2

Fig.3

Fig.4

Fig.7 Fig.6 Fig.5

Witnesses:
C. J. Reid
C. L. Reid

Geo. W. Jopson, Inventor.
by Seymour & Earle, Atty.

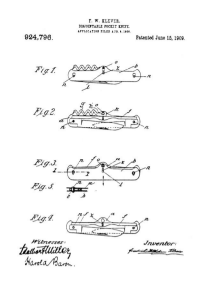

F. W. KLEVER.
DISJOINTABLE POCKET KNIFE.
APPLICATION FILED AUG. 9, 1908.

924,796. Patented June 15, 1909.

Fig.1.

Fig.2.

Fig.3.

Fig.5.

Fig.4.

Witnesses:
Arthur H. Miller
Harold Baron.

Inventor:

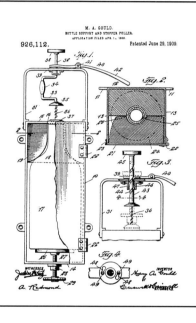

M. A. GOULD.
BOTTLE SUPPORT AND STOPPER PULLER.
APPLICATION FILED APR. 1, 1908.

926,112. Patented June 29, 1909.

Fig.1.

Fig.2.

Fig.3.

Fig.4.

Witnesses:
A. Redmond

Mary A. Gould, Inventor.

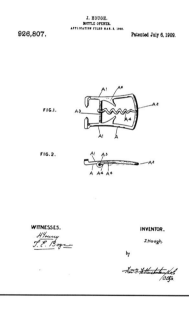

J. HOUGH.
BOTTLE OPENER.
APPLICATION FILED MAR. 2, 1908.

926,807. Patented July 6, 1909.

FIG.1.

FIG.2.

WITNESSES.
H. Young
J. E. Boyer

INVENTOR.
J. Hough.
by

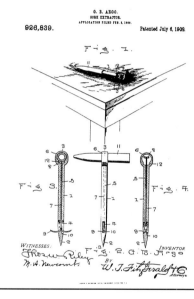

G. B. ARGO.
CORK EXTRACTOR.
APPLICATION FILED FEB. 2, 1909.

926,839. Patented July 6, 1909.

Fig.1.

Fig.2. Fig.3. Fig.4.

WITNESSES:
Thomas Riley
M. A. Newcomb.

INVENTOR
G. B. Argo
BY
W. J. Fitzgerald & Co. Attorneys

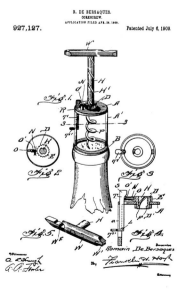

R. DE BERSAQUES.
CORKSCREW.
APPLICATION FILED APR. 26, 1909.

927,127. Patented July 6, 1909.

Fig.1.

Fig.2. Fig.3.

Fig.5. Fig.4.

Witnesses
A. L. Smith
C. R. Fowler

Romain De Bersaques, Inventor.
By Franklin D. Hoyt

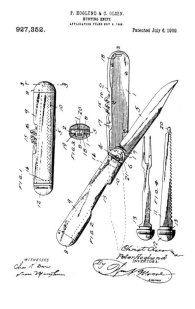

P. HOGLUND & C. OLSEN.
HUNTING KNIFE.
APPLICATION FILED NOV. 6, 1908.

927,352. Patented July 6, 1909.

Fig.1.

Fig.2.

Fig.3. Fig.4.

WITNESSES
Chas. H. Barr

Christ Olsen
Peter Hoglund, INVENTORS.
By Wm. H. Moore, Attorney.

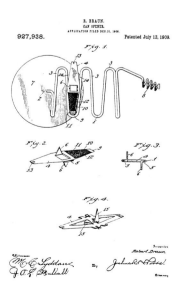

R. BRAUN.
CAN OPENER.
APPLICATION FILED DEC. 31, 1908.

927,938. Patented July 13, 1909.

Fig.1.

Fig.2. Fig.3.

Fig.4.

Witnesses
M. C. Syddan
J. O. E. Bramhall

Robert Braun, Inventor.
By

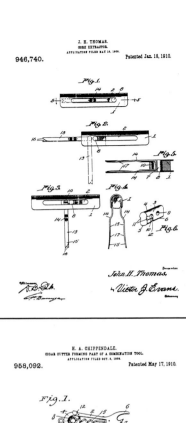

J. H. THOMAS.
CORK EXTRACTOR.
APPLICATION FILED MAY 18, 1909.

946,740. Patented Jan. 18, 1910.

Fig.1.
Fig.2.
Fig.5.
Fig.3. Fig.4.
 Fig.6.

John H. Thomas.
by Victor J. Evans.

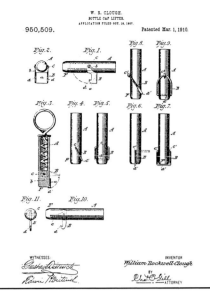

W. R. CLOUGH.
BOTTLE CAP LIFTER.
APPLICATION FILED OCT. 18, 1907.

950,509. Patented Mar. 1, 1910.

Fig.2. Fig.1. Fig.8. Fig.9.
Fig.3. Fig.4. Fig.5. Fig.6. Fig.7.
Fig.11. Fig.10.

WITNESSES: INVENTOR
William Rockwell Clough
BY
Chas. E. Gill ATTORNEY

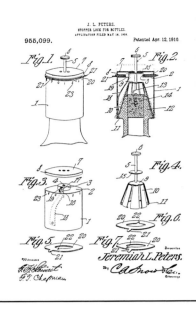

J. L. PETERS.
STOPPER LOCK FOR BOTTLES.
APPLICATION FILED MAY 18, 1909.

955,099. Patented Apr. 12, 1910.

Fig.1. Fig.2.
Fig.3. Fig.4.
Fig.5. Fig.7. Fig.6.

Jeremiah L. Peters.
By C. A. Snow & Co.

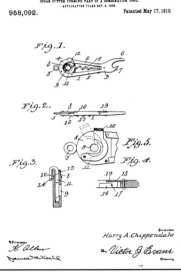

H. A. CHIPPENDALE.
CIGAR CUTTER FORMING PART OF A COMBINATION TOOL.
APPLICATION FILED OCT. 8, 1909.

958,092. Patented May 17, 1910.

Fig.1.
Fig.2.
Fig.3. Fig.5.
 Fig.4.

Harry A. Chippendale
by Victor J. Evans

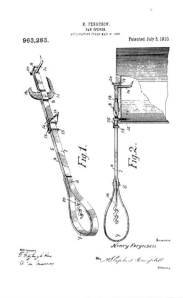

H. FERGUSON.
CAN OPENER.
APPLICATION FILED MAY 18, 1909.

963,283. Patented July 5, 1910.

Fig.1. Fig.2.

Henry Ferguson

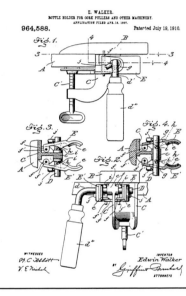

E. WALKER.
BOTTLE HOLDER FOR CORK PULLERS AND OTHER MACHINERY.
APPLICATION FILED APR. 18, 1907.

964,588. Patented July 19, 1910.

Fig.1.
Fig.3. Fig.4.
 Fig.2.

WITNESSES: INVENTOR
Edwin Walker
BY Griffin & Rombaut
ATTORNEYS

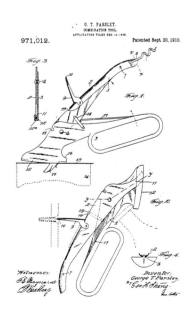

G. T. PARSLEY.
COMBINATION TOOL.
APPLICATION FILED DEC. 14, 1908.

971,012. Patented Sept. 20, 1910.

Fig.3.
Fig.1.
Fig.2.
Fig.4.

WITNESSES: Inventor:
George T. Parsley,
By Gerd Sherg

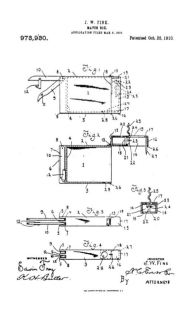

J. W. FINK.
MATCH BOX.
APPLICATION FILED MAR. 6, 1910.

973,930. Patented Oct. 25, 1910.

Fig.1.
Fig.2.
Fig.3.
Fig.5.
Fig.4.

WITNESSES: INVENTOR
Edwin Troy J. W. Fink
K. H. Butler BY
 ATTORNEYS

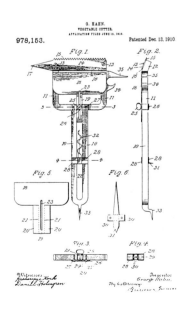

G. HAHN.
VEGETABLE CUTTER.
APPLICATION FILED JUNE 18, 1910.

978,153. Patented Dec. 13, 1910

Fig.1. Fig.2.
Fig.5. Fig.6.
Fig.3. Fig.4.

WITNESSES: Inventor:
Daniel Holmgren George Hahn
 by his Attorney

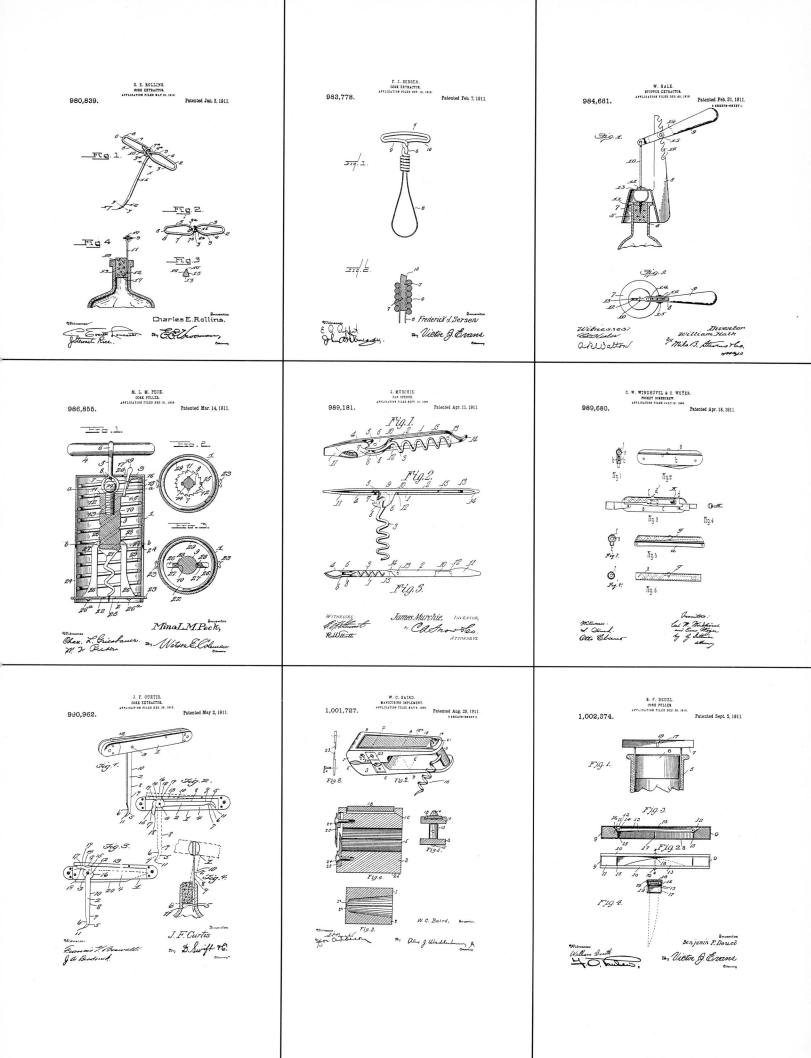

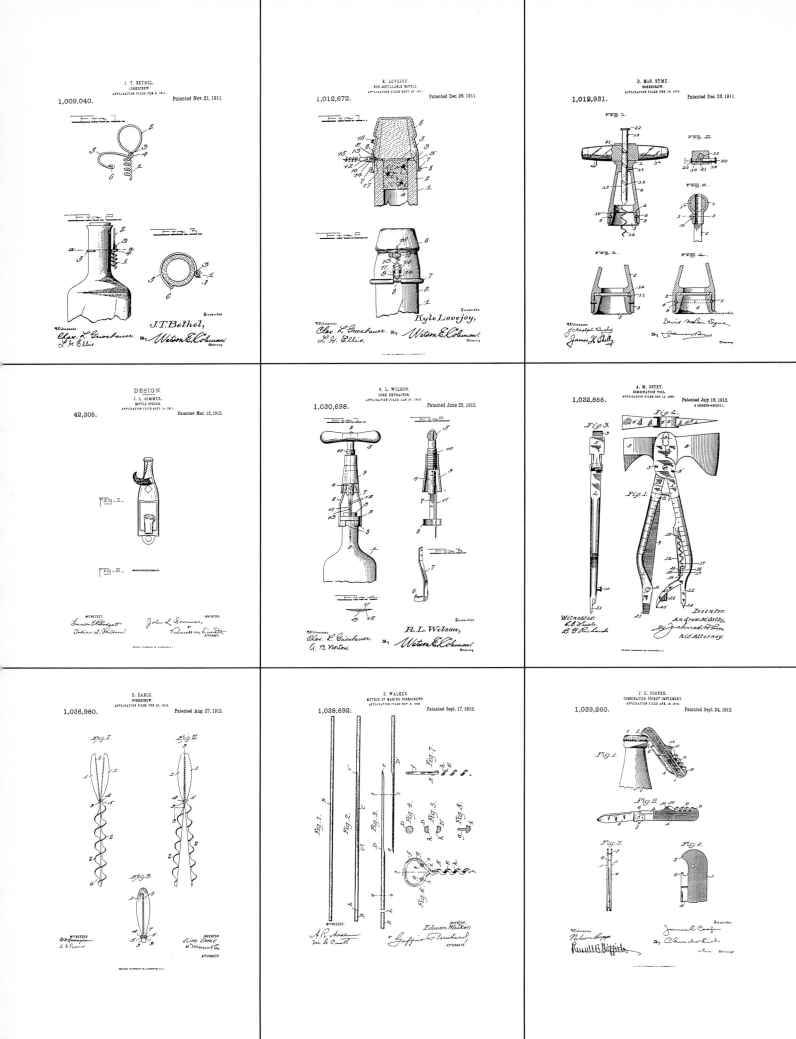

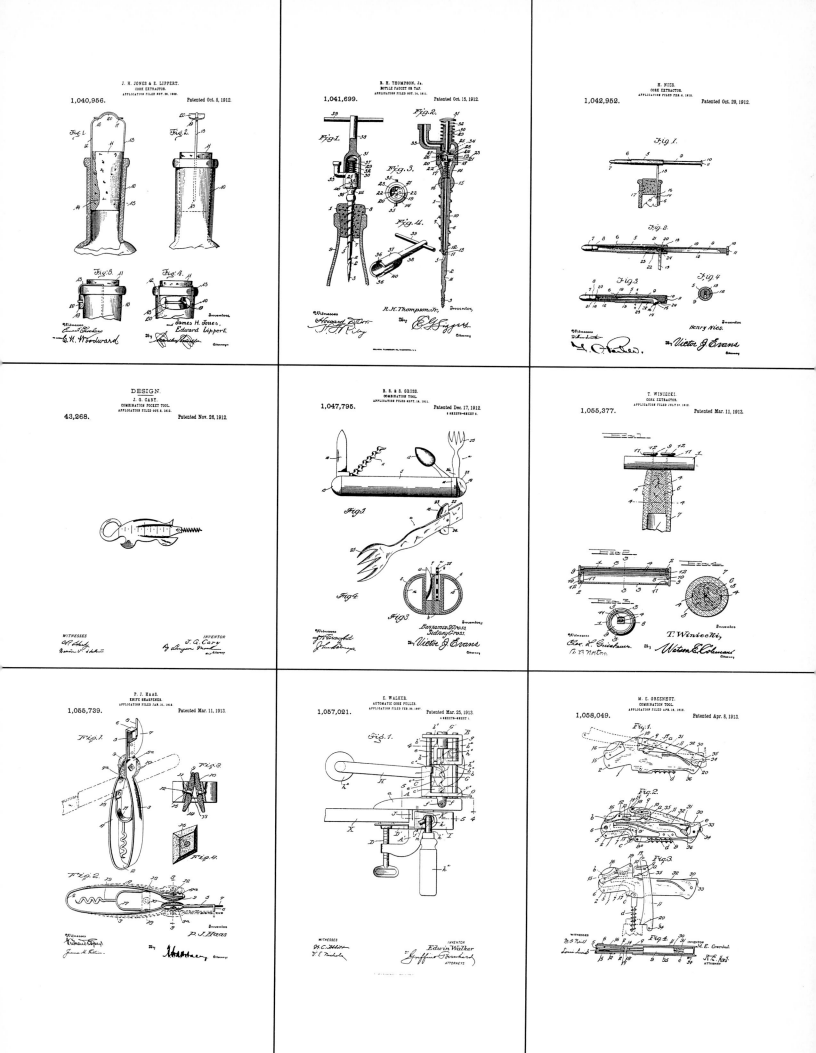

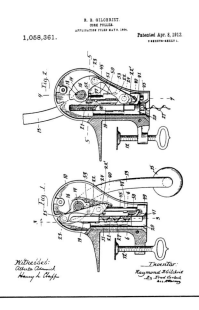

R. R. GILCHRIST.
CORK PULLER.
APPLICATION FILED MAY 9, 1904.

1,058,361. Patented Apr. 8, 1913.

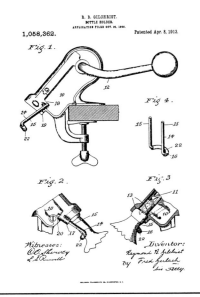

R. R. GILCHRIST.
BOTTLE HOLDER.
APPLICATION FILED OCT. 21, 1904.

1,058,362. Patented Apr. 8, 1913.

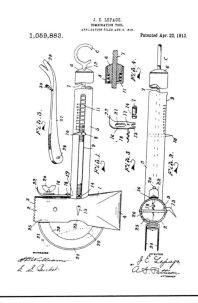

J. E. LEPAGE.
COMBINATION TOOL.
APPLICATION FILED AUG. 6, 1910.

1,059,883. Patented Apr. 22, 1913.

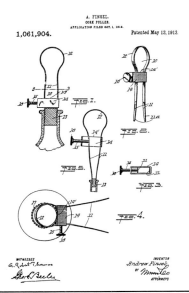

A. FINSEL.
CORK PULLER.
APPLICATION FILED OCT. 1, 1912.

1,061,904. Patented May 13, 1913.

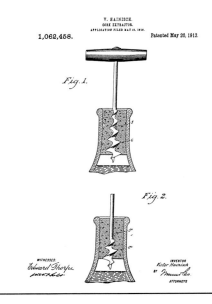

V. HAINISCH.
CORK EXTRACTOR.
APPLICATION FILED MAY 19, 1910.

1,062,458. Patented May 20, 1913.

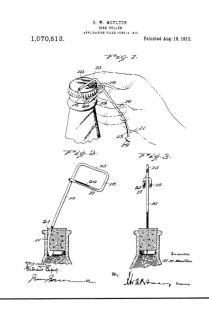

E. W. MOULTON.
CORK PULLER.
APPLICATION FILED JUNE 10, 1912.

1,070,513. Patented Aug. 19, 1913.

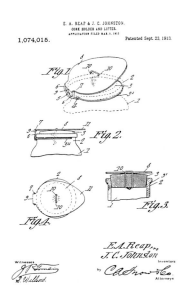

E. A. REAP & J. C. JOHNSTON.
CORK HOLDER AND LIFTER.
APPLICATION FILED MAR. 5, 1913.

1,074,015. Patented Sept. 23, 1913.

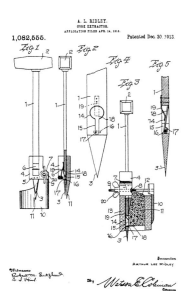

A. L. RIDLEY.
CORK EXTRACTOR.
APPLICATION FILED APR. 14, 1913.

1,082,555. Patented Dec. 30, 1913.

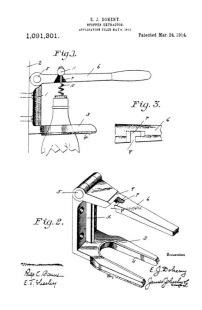

E. J. DOHENY.
STOPPER EXTRACTOR.
APPLICATION FILED MAY 4, 1913.

1,091,301. Patented Mar. 24, 1914.

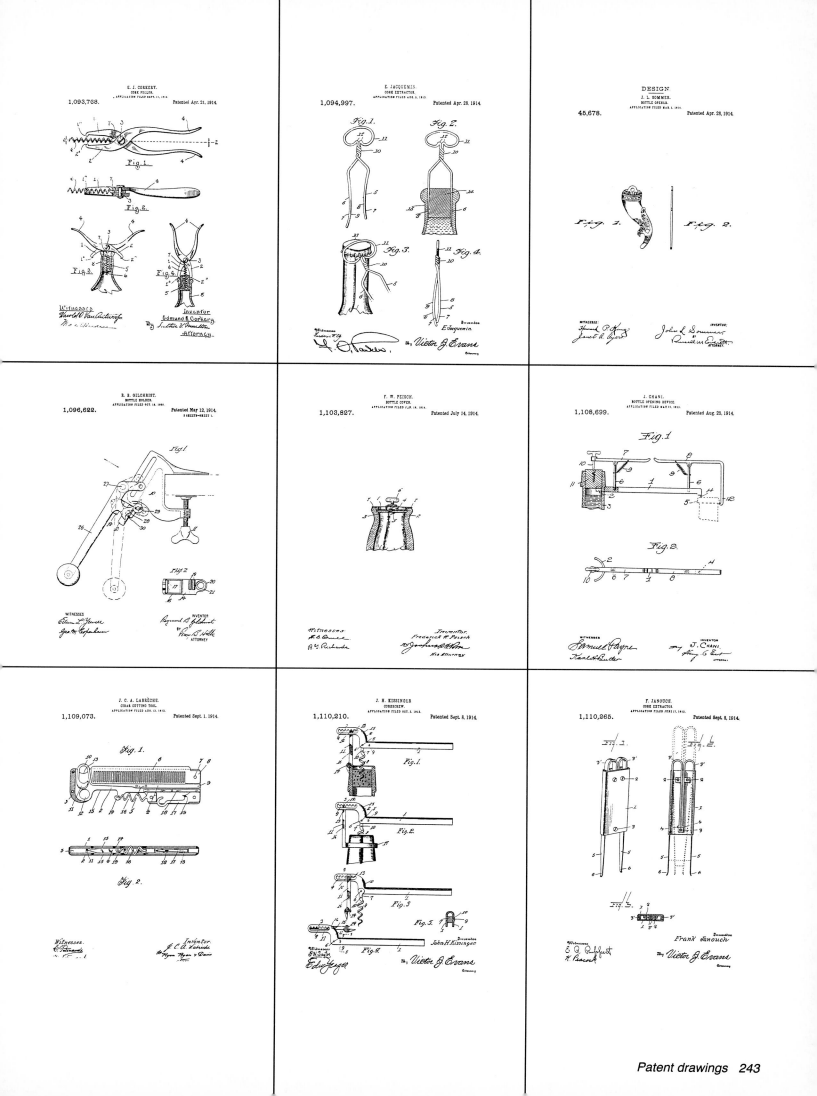

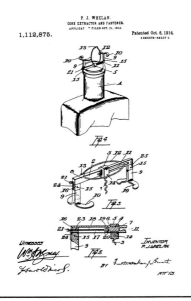

P. J. WHELAN.
CORE EXTRACTOR AND FASTENER.
APPLICATION FILED OCT. 21, 1913.

1,112,875. Patented Oct. 6, 1914.

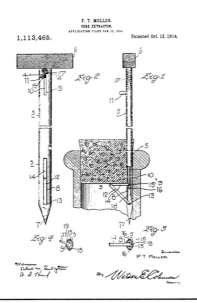

P. T. MOLLER.
CORE EXTRACTOR.
APPLICATION FILED JAN. 22, 1914.

1,113,465. Patented Oct. 13, 1914.

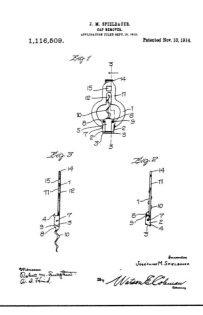

J. M. SPIELBAUER.
CAP REMOVER.
APPLICATION FILED SEPT. 18, 1913.

1,116,509. Patented Nov. 10, 1914.

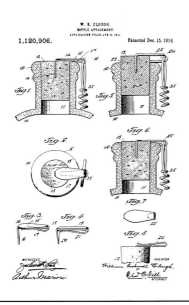

W. R. CLOUGH.
BOTTLE ATTACHMENT.
APPLICATION FILED APR. 8, 1911.

1,120,906. Patented Dec. 15, 1914.

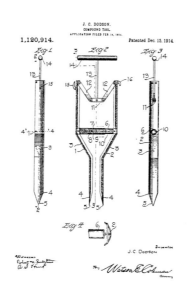

J. C. DODSON.
COMPOUND TOOL.
APPLICATION FILED FEB. 14, 1914.

1,120,914. Patented Dec. 15, 1914.

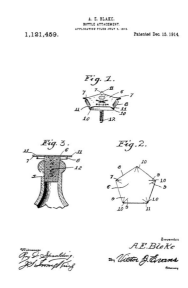

A. E. BLAKE.
BOTTLE ATTACHMENT.
APPLICATION FILED JULY 5, 1913.

1,121,459. Patented Dec. 15, 1914.

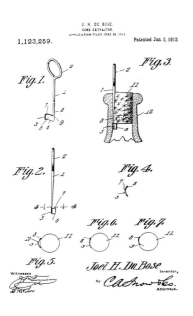

J. H. DU BOSE.
CORE EXTRACTOR.
APPLICATION FILED JUNE 28, 1912.

1,123,259. Patented Jan. 5, 1915.

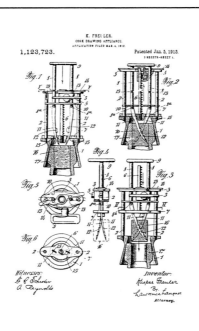

K. FREULER.
CORK DRAWING APPLIANCE.
APPLICATION FILED MAR. 4, 1912.

1,123,723. Patented Jan. 5, 1915.

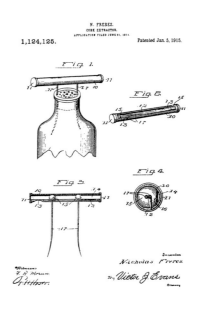

N. FRERES.
CORE EXTRACTOR.
APPLICATION FILED JUNE 21, 1914.

1,124,125. Patented Jan. 5, 1915.

244 Patent drawings

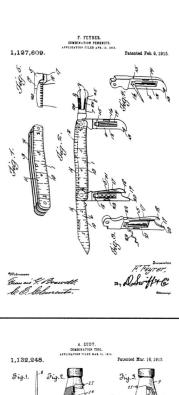
DESIGN.
A. WAKAO.
COMBINED KEY HOLDER AND CORK PULLER.
APPLICATION FILED NOV. 28, 1914.

46,935. Patented Feb. 9, 1915.

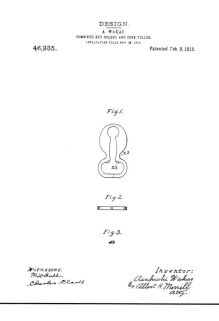

Fig.1.

Fig.2.

Fig.3.

Witnesses: Inventor:
M.D. Hull Asakichi Wakao
Charles Clark By Albert H. Merrill
 Atty.

F. W. BELLOIS.
BOTTLE CLOSURE.
APPLICATION FILED JAN. 16, 1914.

1,131,985. Patented Mar. 16, 1915

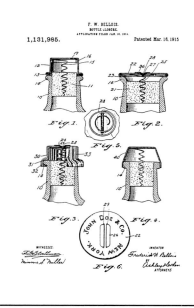

Fig.1. Fig.2.

Fig.3. Fig.4.

 Fig.6.

Witnesses: INVENTOR
 Frederick W. Bellois
 By Ashby & Locker
 ATTORNEYS

A. EUDY.
COMBINATION TOOL.
APPLICATION FILED MAR. 31, 1913.

1,132,248. Patented Mar. 16, 1915.

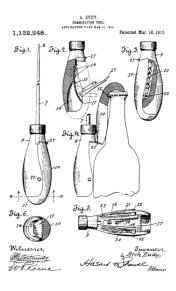

Fig.1. Fig.2. Fig.3.

Fig.4.

Fig.6. Fig.5.

Witnesses, Inventor.
 by Arch Eudy,
 Hazard & Frauds
 Attorney

J. H. A. STAPLEY.
CORK EXTRACTOR.
APPLICATION FILED MAR. 25, 1914.

1,140,082. Patented May 18, 1915.

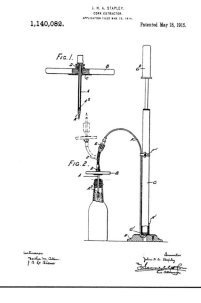

Fig.1.

Fig.2.

Witnesses Inventor
 John H. A. Stapley
 By Harrell & Son
 his attorney

O. N. PLANTE.
COMBINATION TOOL.
APPLICATION FILED FEB. 4, 1915.

1,141,141. Patented June 1, 1915.

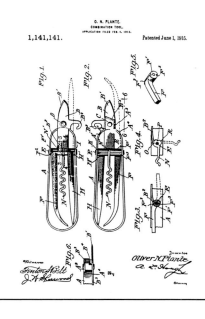

Fig.1. Fig.2. Fig.5.

 Fig.4.

Fig.3.

Fig.6.

Witnesses Inventor
 Oliver N. Plante
 By A. L. Hawley
 Attorney

J. OMAYE.
STOPPER EXTRACTOR.
APPLICATION FILED OCT. 19, 1914.

1,146,649. Patented July 13, 1915.

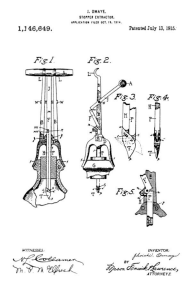

Fig.1. Fig.2.

 Fig.3. Fig.4.

 Fig.5.

WITNESSES: INVENTOR:
 Jikichi Omaye
 BY Mason Fenwick Lawrence,
 ATTORNEYS.

S. E. KINNAN.
NON-REFILLABLE BOTTLE.
APPLICATION FILED OCT. 18, 1913.

1,149,068. Patented Aug. 3, 1915.

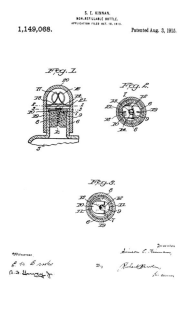

FIG.1.

FIG.2.

FIG.3.

Witnesses Inventor
 Simon E. Kinnan
 By Richard Eads
 his attorney

H. BECKLEY.
CORK EXTRACTOR.
APPLICATION FILED JUNE 10, 1913.

1,149,112. Patented Aug. 3, 1915.

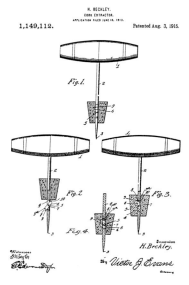

Fig.1.

Fig.2. Fig.3.

Fig.4.

Witnesses Inventor
 H. Beckley.
 By Victor J. Evans
 Attorney

E. WALKER.
CROWN OPENER.
APPLICATION FILED JULY 19, 1910.

1,150,083.
Patented Aug. 17, 1915.

WITNESSES

INVENTOR
Edwin Walker
ATTORNEYS

DESIGN.
T. K. PIGGOTT.
PAIR OF SCISSORS.
APPLICATION FILED OCT. 14, 1914.

47,735.
Patented Aug. 17, 1915.

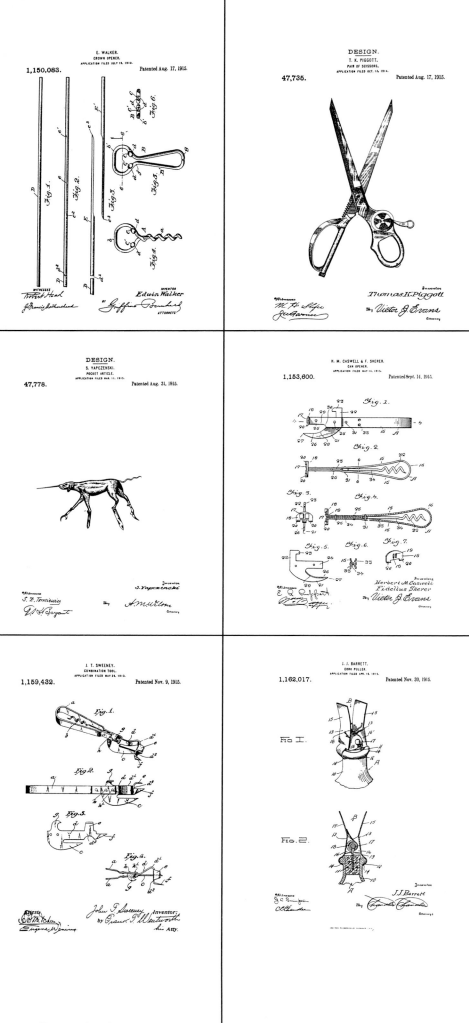

Witnesses

Inventor
Thomas K. Piggott
Victor J. Evans
Attorney

DESIGN.
C. MORGAN.
FRAME FOR CORK PULLERS.
APPLICATION FILED MAY 21, 1914.

47,755.
Patented Aug. 24, 1915.

WITNESSES:

INVENTOR.
Charles Morgan
BY Harry Otten
ATTORNEY.

DESIGN.
S. YAPCZENSKI.
POCKET ARTICLE.
APPLICATION FILED MAR. 11, 1915.

47,778.
Patented Aug. 31, 1915.

Inventor
S. Yapczenski
Witnesses

H. M. CASWELL & F. SHERER.
CAN OPENER.
APPLICATION FILED MAY 14, 1915.

1,153,600.
Patented Sept. 14, 1915.

Fig. 1.
Fig. 2.
Fig. 3.
Fig. 4.
Fig. 5.
Fig. 6.
Fig. 7.

Inventors
Herbert M. Caswell
Fidellus Sherer
Victor J. Evans
Attorney

E. BALTHAZAR.
CORK EXTRACTOR.
APPLICATION FILED JULY 11, 1914.

1,155,193.
Patented Sept. 28, 1915.

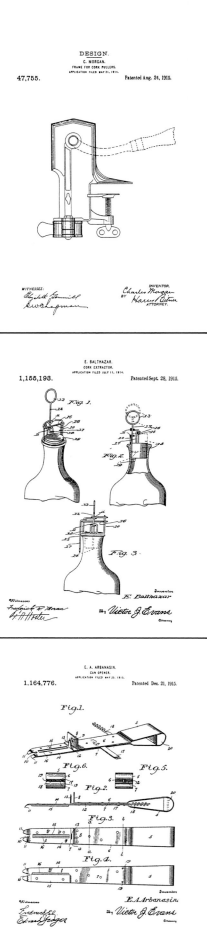

Fig. 1.
Fig. 2.
Fig. 3.

Inventor
E. Balthazar
Victor J. Evans
Attorney

J. T. SWEENEY.
COMBINATION TOOL.
APPLICATION FILED MAY 26, 1913.

1,159,432.
Patented Nov. 9, 1915.

Fig. 1.
Fig. 2.
Fig. 3.
Fig. 4.

John T. Sweeney
Inventor;
by Grant T. Wentworth
his Atty.

J. J. BARRETT.
CORK PULLER.
APPLICATION FILED APR. 14, 1915.

1,162,017.
Patented Nov. 30, 1915.

FIG I.
FIG 2.

Inventor
J. J. Barrett
Attorney

E. A. ARBANASIN.
CAN OPENER.
APPLICATION FILED MAY 25, 1915.

1,164,776.
Patented Dec. 21, 1915.

Fig. 1.
Fig. 6.
Fig. 5.
Fig. 2.
Fig. 3.
Fig. 4.

Inventor
E. A. Arbanasin
Victor J. Evans
Attorney

O. J. TURNER.
CAN OPENER.
APPLICATION FILED MAR. 3, 1915.

1,166,022. Patented Dec. 28, 1915.

Fig.1.

Fig.2.

Fig.3.

Fig.4.

Fig.6. Fig.5.

Witnesses Inventor.
 Oscar J.Turner
 By his Attorneys
 Williamson Merchant

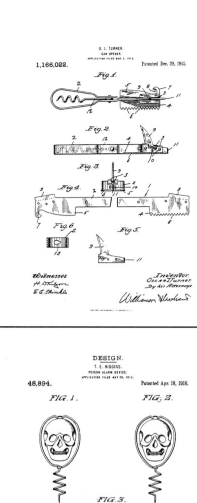

DESIGN.
M. WOICULA.
COMBINATION IMPLEMENT.
APPLICATION FILED NOV. 8, 1915.

48,539. Patented Feb. 8, 1916.

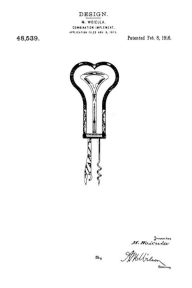

Inventor
M. Woicula

By
A.M. Wilson
Attorney

DESIGN.
F. PIOTROWSKI.
POCKET TOOL.
APPLICATION FILED FEB. 16, 1915.

48,871. Patented Apr. 11, 1916.

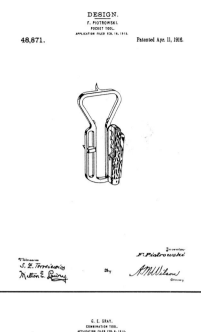

Inventor
F. Piotrowski

Witnesses
S. Z. Torciewicz
Melton E. Lowry

By
A.M. Wilson
Attorney

DESIGN.
T. E. HIGGINS.
POISON ALARM DEVICE.
APPLICATION FILED MAY 20, 1915.

48,894. Patented Apr. 18, 1916.

FIG.1. FIG.2.

FIG.3.

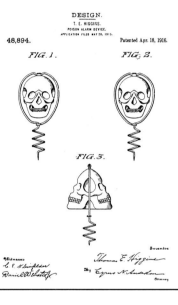

Witnesses Inventor
 Thomas E. Higgins
 By Cyrus N. Anderson
 Attorney

E. KAAS.
COMBINATION TOOL.
APPLICATION FILED MAY 29, 1915.

1,187,842. Patented June 20, 1916.
 2 SHEETS—SHEET 1.

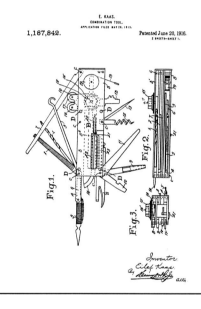

Fig.1. Fig.2. Fig.3.

Inventor
Eiler Kaas
By atty.

G. E. GRAY.
COMBINATION TOOL.
APPLICATION FILED FEB. 8, 1914.

1,188,931. Patented June 27, 1916.

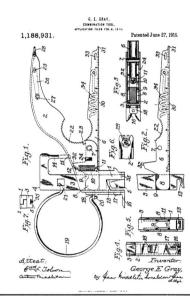

Fig.1. Fig.6. Fig.7. Fig.5. Fig.4.

Attest: Inventor:
E. F. Tolson George E. Gray,
 By Attys.

R. FLITSCH.
BOTTLE OPENER.
APPLICATION FILED NOV. 4, 1915.

1,190,883. Patented July 11, 1916.

Fig_1. Fig_2.

Fig_3. Fig_4.

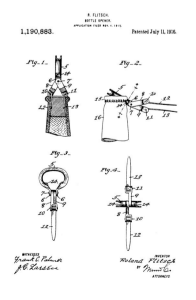

WITNESSES INVENTOR
Frank C. Palmer Roland Flitsch
J. C. Larsen BY
 ATTORNEYS

H. V. JONES & H. McNALLY.
COMBINATION TOOL.
APPLICATION FILED JUNE 26, 1915.

1,194,296. Patented Aug. 8, 1916.

Fig.1.

Fig.3. Fig.4.

Fig.2.

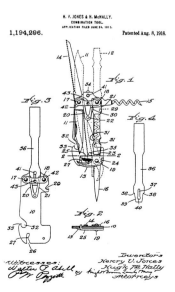

Witnesses: Inventors
Walter O. Abell Harry V. Jones
 Hugh McNally
 By
 Attorneys

B. JAWOISCH.
KNIFE OR TOOL.
APPLICATION FILED DEC. 31, 1915.

1,194,503. Patented Aug. 15, 1916.

Fig.1.

Fig.2.

Fig.3.

Fig.4.

Fig.5. Fig.6.

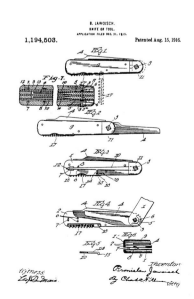

Witness Inventor
 Bronislaw Jawoisch
 By Chas. C.
 atty.

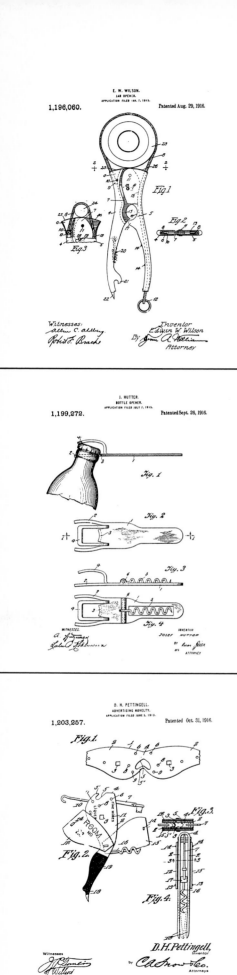

E. W. WILSON.
JAR OPENER.
APPLICATION FILED JAN. 7, 1915.

1,196,060.
Patented Aug. 29, 1916.

Fig.1
Fig.2
Fig.3

Witnesses:
allen C. alley
Robert F. Beach

Inventor
Edwin W. Wilson
By
Attorney

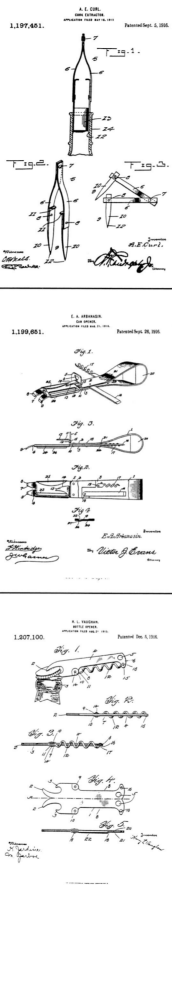

A. E. CURL.
CORK EXTRACTOR.
APPLICATION FILED MAY 18, 1915.

1,197,451.
Patented Sept. 5, 1916.

Fig.1.
Fig.2.
Fig.3.

Witnesses
C.A.Kell.

Inventor
A.E.Curl.
By
Attorney

I. F. GREEN.
CORK EXTRACTOR.
APPLICATION FILED APR. 6, 1914.

1,198,023.
Patented Sept. 12, 1916.

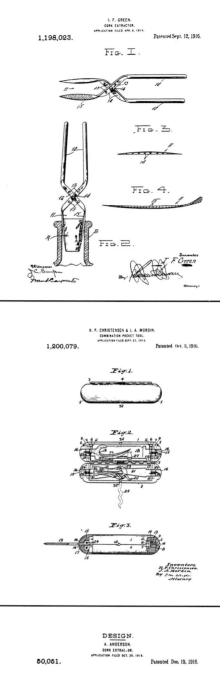

FIG. I.
FIG. 3.
FIG. 4.
FIG. 2.

Witnesses
L. Simpson
Frank Carpenter

Inventor
I. F. Green
By
Attorney

I. HUTTER.
BOTTLE OPENER.
APPLICATION FILED JULY 7, 1915.

1,199,272.
Patented Sept. 26, 1916.

Fig. 1.
Fig. 2.
Fig. 3.
Fig. 4.

WITNESSES
A.

INVENTOR
JOSEF HUTTER
By
ATTORNEY

E. A. ARBANASIN.
CAN OPENER.
APPLICATION FILED MAR. 21, 1915.

1,199,651.
Patented Sept. 26, 1916.

Fig. 1.
Fig. 3.
Fig. 2.
Fig. 4.

Witnesses

Inventor
E. A. Arbanasin.
By Victor J. Evans
Attorney

H. P. CHRISTENSEN & J. A. MORDIN.
COMBINATION POCKET TOOL.
APPLICATION FILED SEPT. 27, 1915.

1,200,079.
Patented Oct. 3, 1916.

Fig.1.
Fig.2.
Fig.3.

Inventors
H. P. Christensen,
J. A. Mordin.
By
Attorney

D. H. PETTINGELL.
ADVERTISING NOVELTY.
APPLICATION FILED JUNE 5, 1913.

1,203,257.
Patented Oct. 31, 1916.

Fig.1.
Fig.2.
Fig.3.
Fig.4.

Witnesses

D.H.Pettingell,
Inventor
by C.A.Snow & Co.
Attorneys

H. L. VAUGHAN.
BOTTLE OPENER.
APPLICATION FILED AUG. 27, 1915.

1,207,100.
Patented Dec. 5, 1916.

Fig. 1.
Fig. 2.
Fig. 3.
Fig. 4.
Fig. 5.

Witnesses

Inventor
Henry L. Vaughan

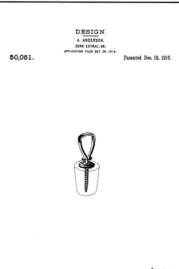

DESIGN.
A. ANDERSON.
CORK EXTRACTOR.
APPLICATION FILED OCT. 20, 1916.

50,051.
Patented Dec. 19, 1916.

Witnesses

Inventor
A. Anderson
By Victor J. Evans
Attorney

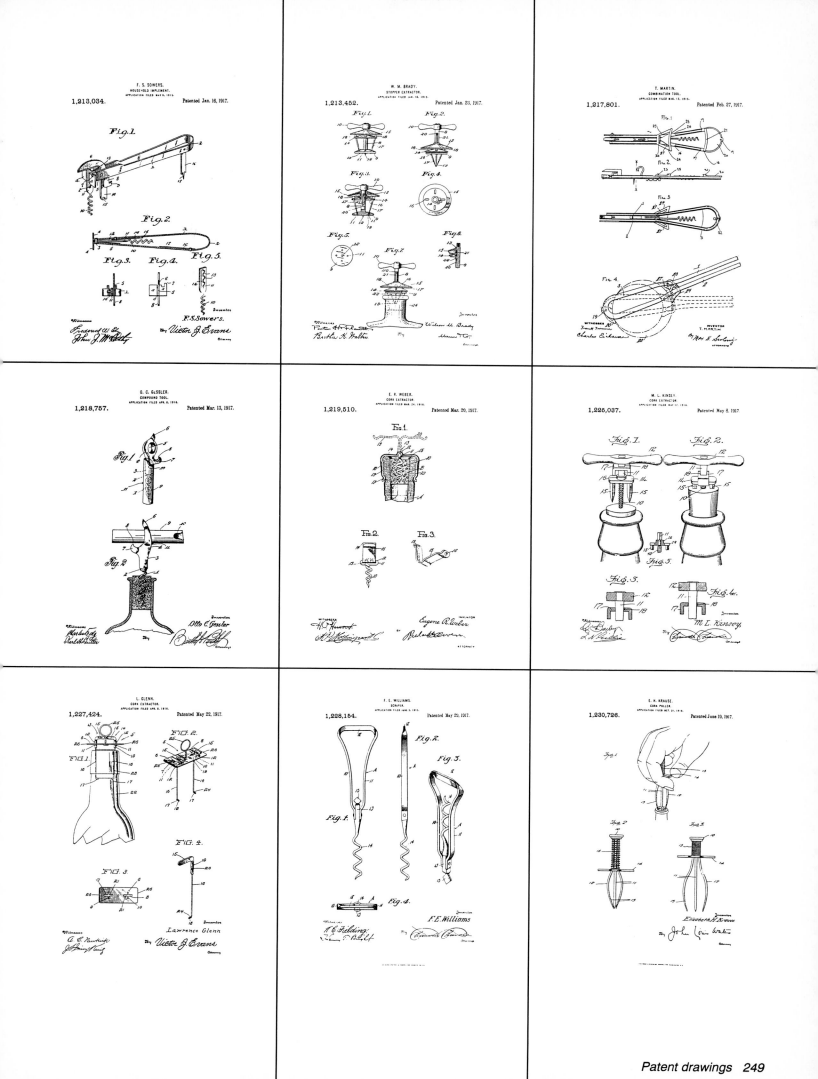

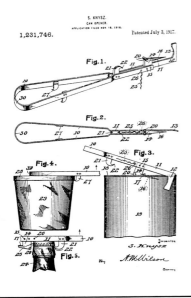

S. KNYSZ.
CAN OPENER.
APPLICATION FILED NOV. 19, 1916.

1,231,746. Patented July 3, 1917.

Fig.1.

Fig.2.

Fig.3.

Fig.4.

Fig.5.

S. Knysz
Inventor

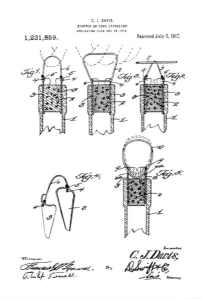

C. J. DAVIS.
STOPPER OR CORK EXTRACTOR.
APPLICATION FILED NOV. 29, 1916.

1,231,859. Patented July 3, 1917.

Fig.1. Fig.2. Fig.3.

Fig.4. Fig.5.

C. J. Davis,
Inventor

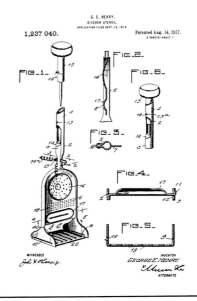

G. E. HENRY.
KITCHEN UTENSIL.
APPLICATION FILED SEPT. 13, 1916.
2 SHEETS—SHEET 1.

1,237 040. Patented Aug. 14, 1917.

FIG—1. FIG.2. FIG.6.

FIG.3.

FIG.4.

FIG.5.

GEORGE E. HENRY.
INVENTOR

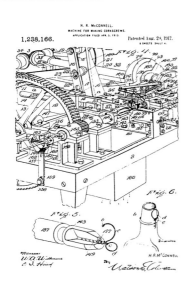

H. R. McCONNELL.
MACHINE FOR MAKING CORKSCREWS.
APPLICATION FILED APR. 3, 1913.
8 SHEETS—SHEET 4.

1,238,166. Patented Aug. 28, 1917.

Fig. 4.

Fig. 5. Fig. 6.

H. R. McConnell

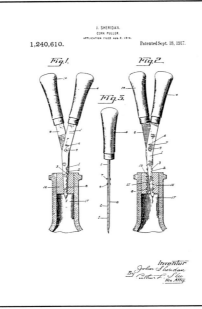

J. SHERIDAN.
CORK PULLER.
APPLICATION FILED AUG. 2, 1916.

1,240,610. Patented Sept. 18, 1917.

Fig.1. Fig.2.

Fig.3.

Inventor
John Sheridan

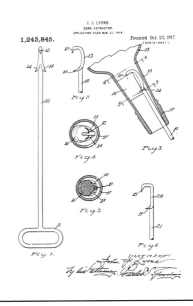

J. J. LYONS.
CORK EXTRACTOR.
APPLICATION FILED MAR. 21, 1916.
2 SHEETS—SHEET 1.

1,243,845. Patented Oct. 23, 1917.

Fig.1. Fig.2. Fig.3.

Fig.4. Fig.5. Fig.6.

Inventor

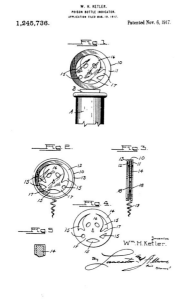

W. H. KETLER.
POISON BOTTLE INDICATOR.
APPLICATION FILED MAR. 19, 1917.

1,245,736. Patented Nov. 6, 1917.

Fig.1.

Fig.2. Fig.3.

Fig.4.

Fig.5

Wm. H. Ketler.

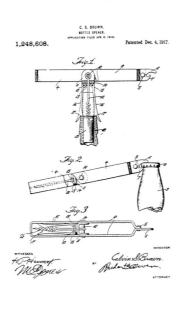

C. S. BROWN.
BOTTLE OPENER.
APPLICATION FILED APR. 8, 1916.

1,248,608. Patented Dec. 4, 1917.

Fig.1.

Fig.2.

Fig.3

INVENTOR
Calvin S. Brown

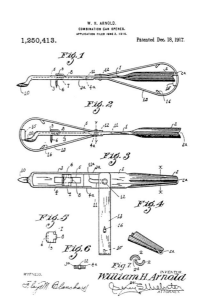

W. H. ARNOLD.
COMBINATION CAN OPENER.
APPLICATION FILED JUNE 2, 1916.

1,250,413. Patented Dec. 18, 1917.

Fig.1

Fig.2

Fig.3

Fig.4

Fig.5

Fig.6

Fig.7

INVENTOR
William H. Arnold

E. SHARP.
CORK PULLER.
APPLICATION FILED DEC. 4, 1916.

1,250,678.

Patented Dec. 18, 1917.

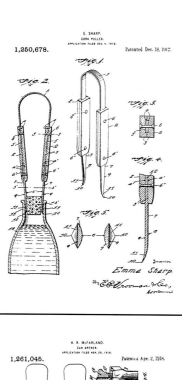

Emma Sharp.

J. KLAMER.
COMBINATION TOOL.
APPLICATION FILED MAY 10, 1917.

1,255,179.

Patented Feb. 5, 1918.

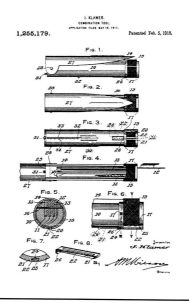

J. Klamer.

W. M. MOORE
CAN OPENER.
APPLICATION FILED AUG. 16, 1917.

1,258,035.

Patented Mar. 5, 1918.

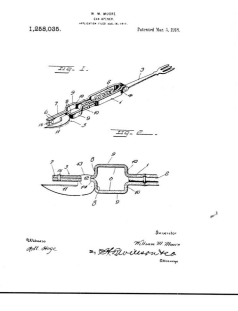

Witness

William M. Moore

H. R. McFARLAND.
CAN OPENER.
APPLICATION FILED NOV. 29, 1916.

1,261,045.

Patented Apr. 2, 1918.

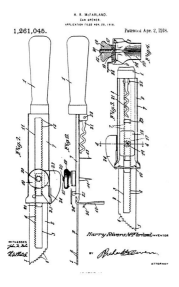

Harry Rivers McFarland, INVENTOR

ATTORNEY

J. H. CROWELL.
IMPLEMENT FOR OPENING BOTTLES.
APPLICATION FILED MAR. 12, 1917.

1,262,178.

Patented Apr. 9, 1918.

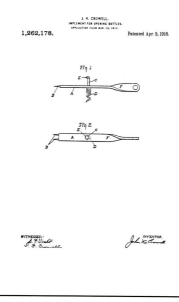

WITNESSES:

John H. Crowell INVENTOR

F. SUNDERLAND.
MEANS FOR THE REMOVAL OF BOTTLE AND LIKE CAPS OR STOPPERS.
APPLICATION FILED DEC. 5, 1916.

1,262,277.

Patented Apr. 9, 1918.

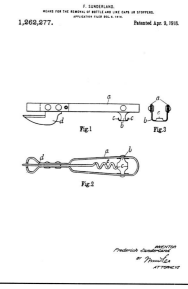

INVENTOR
Frederick Sunderland
BY
ATTORNEYS

F. M. GAYNOR.
CORK EXTRACTOR.
APPLICATION FILED APR. 7, 1916.

1,265,320.

Patented May 7, 1918.

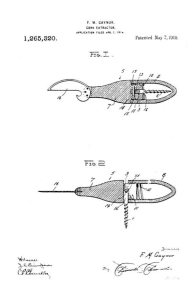

F. M. Gaynor

N. A. McMEEKIN.
TOOL.
APPLICATION FILED MAR. 14, 1916.

1,266,510.

Patented May 14, 1918.

WITNESSES

Norman A. McMeekin

BY

ATTORNEY

J. D. BISCAYART.
CAN OPENER.
APPLICATION FILED DEC. 18, 1917.

1,270,593.

Patented June 25, 1918.

Jules D. Biscayart.

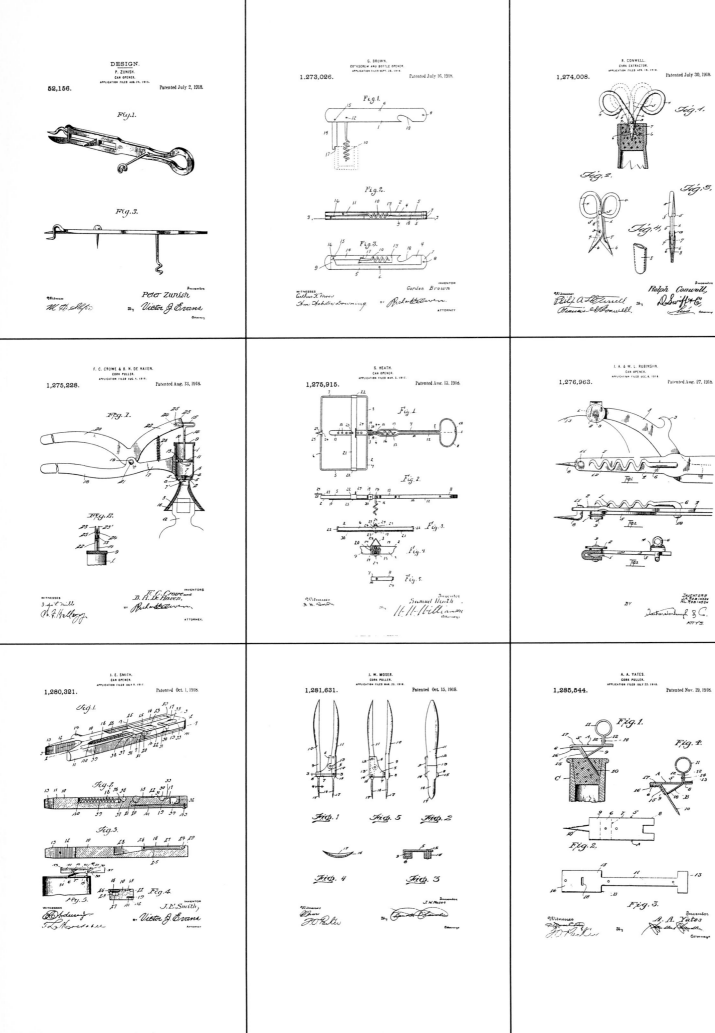

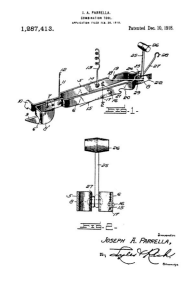

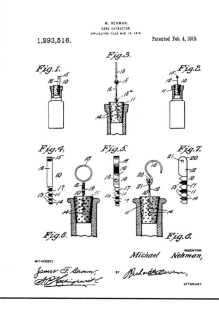

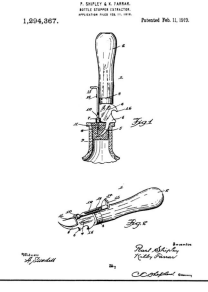

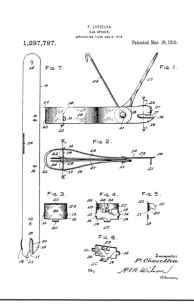

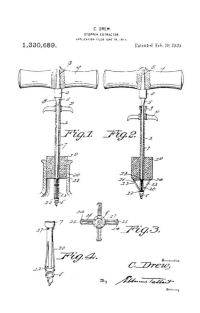

J. W. KEITH.
CORK PULLER.
APPLICATION FILED FEB. 18, 1919.

1,332,043. Patented Feb. 24, 1920.

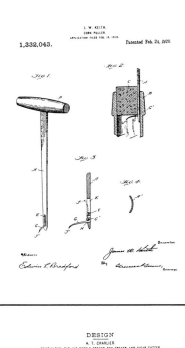

Witness Inventor
Edwin L. Bradford James W. Keith
 By Clarence Townsend
 Attorneys

W. R. CLOUGH.
POCKET IMPLEMENT.
APPLICATION FILED JUNE 28, 1919.

1,339,164. Patented May 4, 1920.

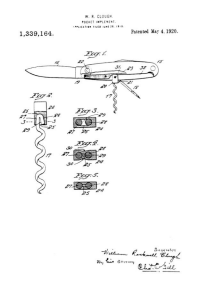

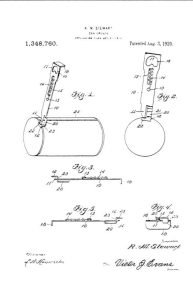

 Inventor
William Rockwell Clough
By his Attorney
 Obed C. Gill

C. T. MADSEN.
CORK EXTRACTOR.
APPLICATION FILED MAY 17, 1919.

1,340,551. Patented May 18, 1920.

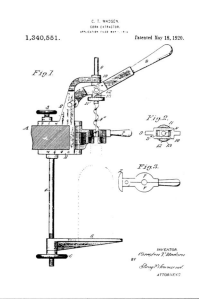

 INVENTOR
 Christen T. Madsen
 BY
 Strong & Townsend
 ATTORNEYS

DESIGN
A. T. CHARLIER.
COMBINATION CAP AND BOTTLE OPENER, BOX OPENER, AND CIGAR CUTTER.
APPLICATION FILED JULY 24, 1919.

55,843. Patented July 20, 1920.

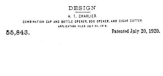

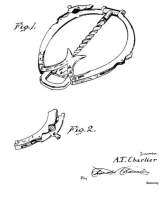

Fig. 2.

 Inventor
 A. T. Charlier
 By
 Attorney

R. M. STEWART.
CAN OPENER.
APPLICATION FILED OCT. 21, 1919.

1,348,760. Patented Aug. 3, 1920.

 Inventor
Witnesses R. M. Stewart
J. R. Heinrichs By Victor J. Evans
 Attorney

J. PALAHNIUK.
CORK EXTRACTOR.
APPLICATION FILED MAR. 14, 1919. RENEWED JUNE 2, 1920.

1,350,383. Patented Aug. 24, 1920.

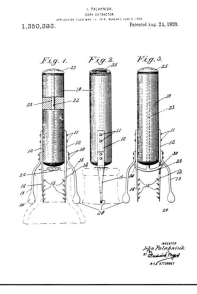

 INVENTOR
 John Palahniuk
 BY Frederick Myers
 HIS ATTORNEY

T. A. JOHNSON.
BOTTLE STOPPER PROTECTOR AND SUPPORTER.
APPLICATION FILED FEB. 14, 1920.

1,352,967. Patented Sept. 14, 1920.

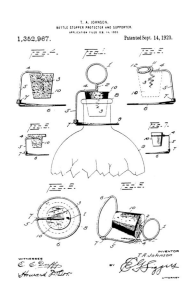

WITNESSES T. A. Johnson
E. E. Duffy INVENTOR
Howard P. Orr BY E. G. Siggers
 ATTORNEY

E. DE TEIXEIRA.
TABLE IMPLEMENT.
APPLICATION FILED OCT. 9, 1919.

1,353,090. Patented Sept. 14, 1920.
 2 SHEETS—SHEET 1.

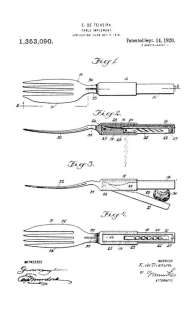

WITNESSES INVENTOR
 E. de Teixeira
 BY Munn & Co.
 ATTORNEYS

E. DE TEIXEIRA.
TABLE IMPLEMENT.
APPLICATION FILED OCT. 9, 1919.

1,353,090. Patented Sept. 14, 1920.
 2 SHEETS—SHEET 2.

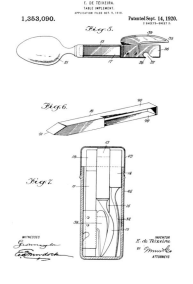

WITNESSES INVENTOR
 E. de Teixeira
 BY Munn & Co.
 ATTORNEYS

L. G. COPEMAN.
TOOL HOLDER.
APPLICATION FILED OCT. 21, 1919.

1,361,021.

Patented Dec. 7, 1920.

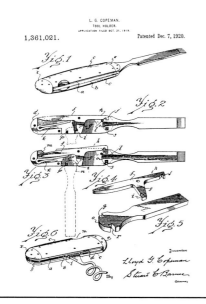

Lloyd G. Copeman
Inventor

C. J. CROSS
BOTTLE CASE AND SUPPORT
APPLICATION FILED DEC. 24, 1919.

1,361,752.

Patented Dec. 7, 1920.

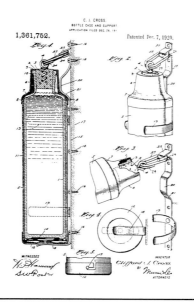

WITNESSES

INVENTOR
Clifford J. Cross.
BY
ATTORNEYS

C. E. HOLMES.
CAN OPENER.
APPLICATION FILED JULY 27, 1919.

1,361,859.

Patented Dec. 14, 1920.

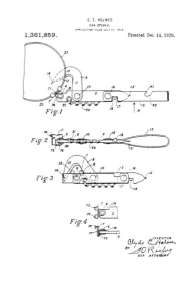

INVENTOR
Clyde E. Holmes
BY
HIS ATTORNEY

B. G. WORTHINGTON.
CAN OPENER.
APPLICATION FILED MAY 21, 1919.
2 SHEETS—SHEET 1.

1,364,016.

Patented Dec. 28, 1920.

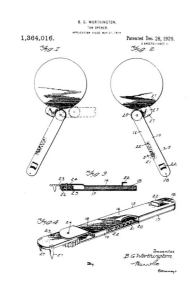

Inventor
B. G. Worthington
By
Attorneys

S. TEECE.
POISON BOTTLE TOP.
APPLICATION FILED MAR. 27, 1920.
2 SHEETS—SHEET 1.

1,367,841.

Patented Feb. 8, 1921.

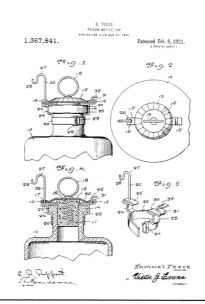

Samuel Teece
Inventor
Victor J. Evans
ATTORNEY

W. H. ROACH.
CONVERTIBLE CAN OPENER.
APPLICATION FILED MAY 24, 1919.

1,374,032.

Patented Apr. 5, 1921.

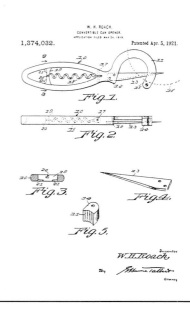

Inventor
W. H. Roach

By
Attorney

G. W. GOMBER.
CORK EXTRACTOR.
APPLICATION FILED JUNE 8, 1920.

1,375,382.

Patented Apr. 19, 1921.

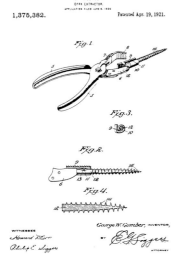

WITNESSES

George W. Gomber, INVENTOR
BY
ATTORNEY

F. ROSEN.
COMBINATION UTENSIL.
APPLICATION FILED NOV. 21, 1918.

1,381,339.

Patented June 14, 1921.

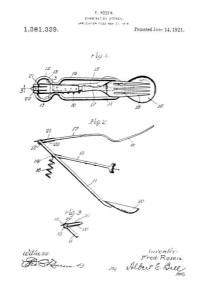

Witness

Inventor
Fred Rosen.
By
Albert E. Bell
ATTY

E. WALKER, DEC'D.
J. STERRETT AND M. E. STEINER, ADMINISTRATRICES
METHOD OF MAKING CROWN OPENERS.
APPLICATION FILED JULY 22, 1919.

1,385,976.

Patented July 26, 1921.

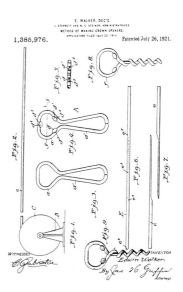

WITNESSES

INVENTOR
Edwin Walker.
By Jas. H. Griffin
Attorneys

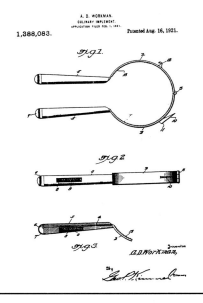

A. D. WORKMAN.
CULINARY IMPLEMENT.
APPLICATION FILED FEB. 1, 1921.

1,388,083. Patented Aug. 16, 1921.

G. D. MUNSING.
CAN OPENER.
APPLICATION FILED FEB. 1, 1919. RENEWED MAY 18, 1921.

1,397,537. Patented Nov. 22, 1921.
2 SHEETS—SHEET 2.

DESIGN.
M. GLOSSOP.
COMBINATION TOOL.
APPLICATION FILED JULY 13, 1921.

60,135. Patented Jan. 3, 1922.

L. CRANE.
NONREMOVABLE CORK.
APPLICATION FILED APR. 16, 1921.

1,416,616. Patented May 16, 1922.

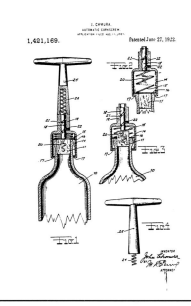

J. CHMURA.
AUTOMATIC CORKSCREW.
APPLICATION FILED AUG. 11, 1921.

1,421,169. Patented June 27, 1922.

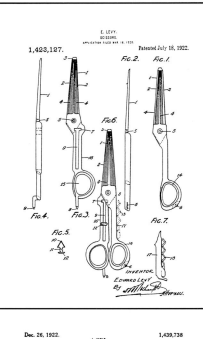

E. LEVY.
SCISSORS.
APPLICATION FILED MAR. 16, 1920.

1,423,127. Patented July 18, 1922.

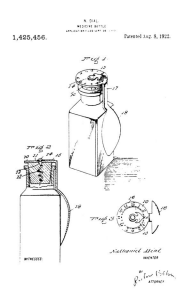

N. DIAL.
MEDICINE BOTTLE.
APPLICATION FILED SEPT. 16, 1917.

1,425,456. Patented Aug. 8, 1922.

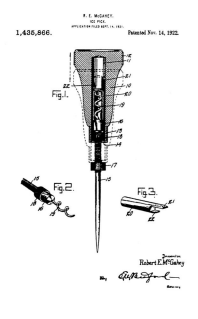

R. E. McGAHEY.
ICE PICK.
APPLICATION FILED SEPT. 14, 1921.

1,435,866. Patented Nov. 14, 1922.

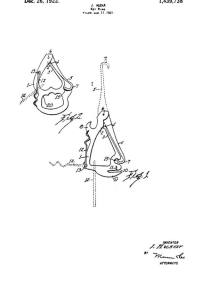

Dec. 26, 1922. J. HUSAR 1,439,738
 Key Ring
 FILED AUG 11, 1921

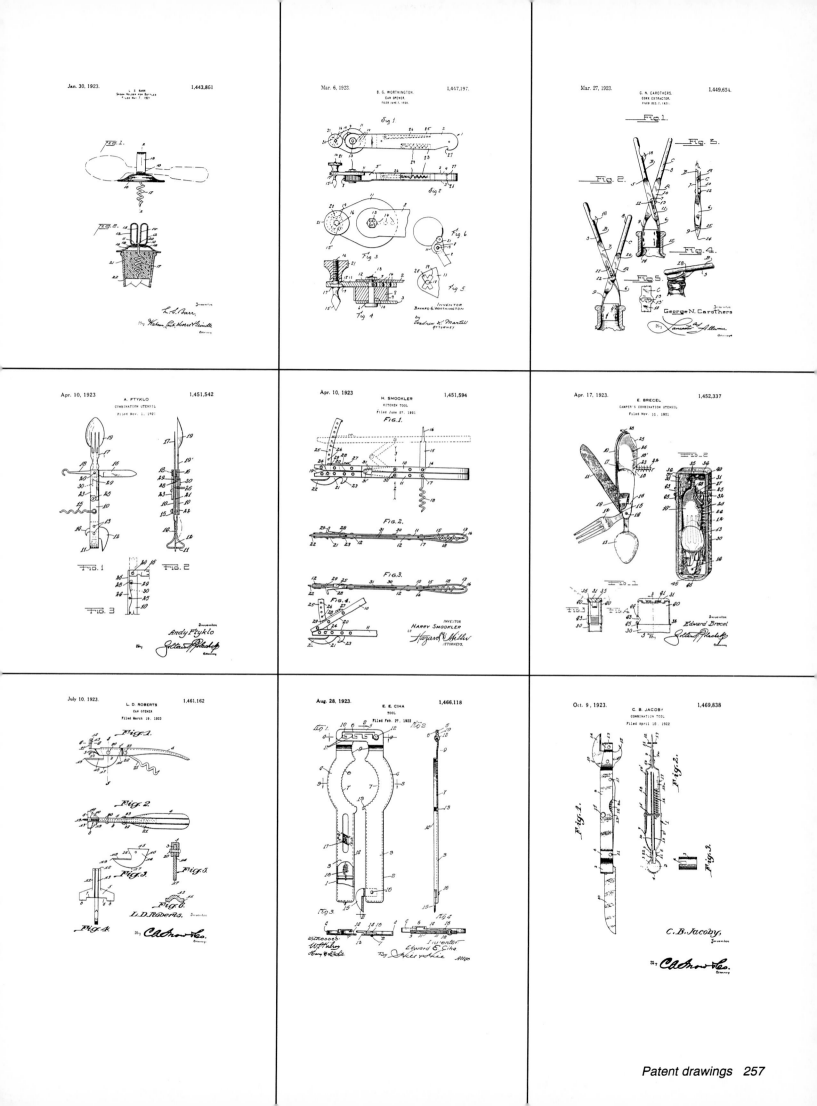

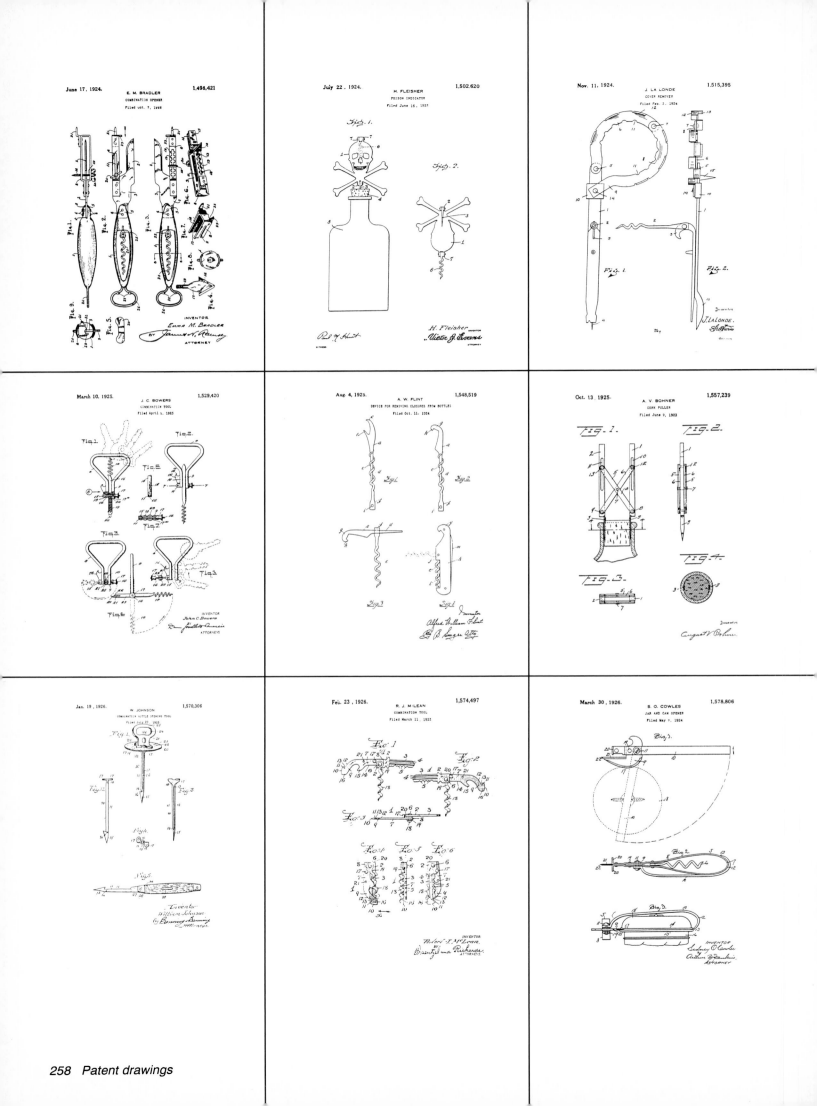

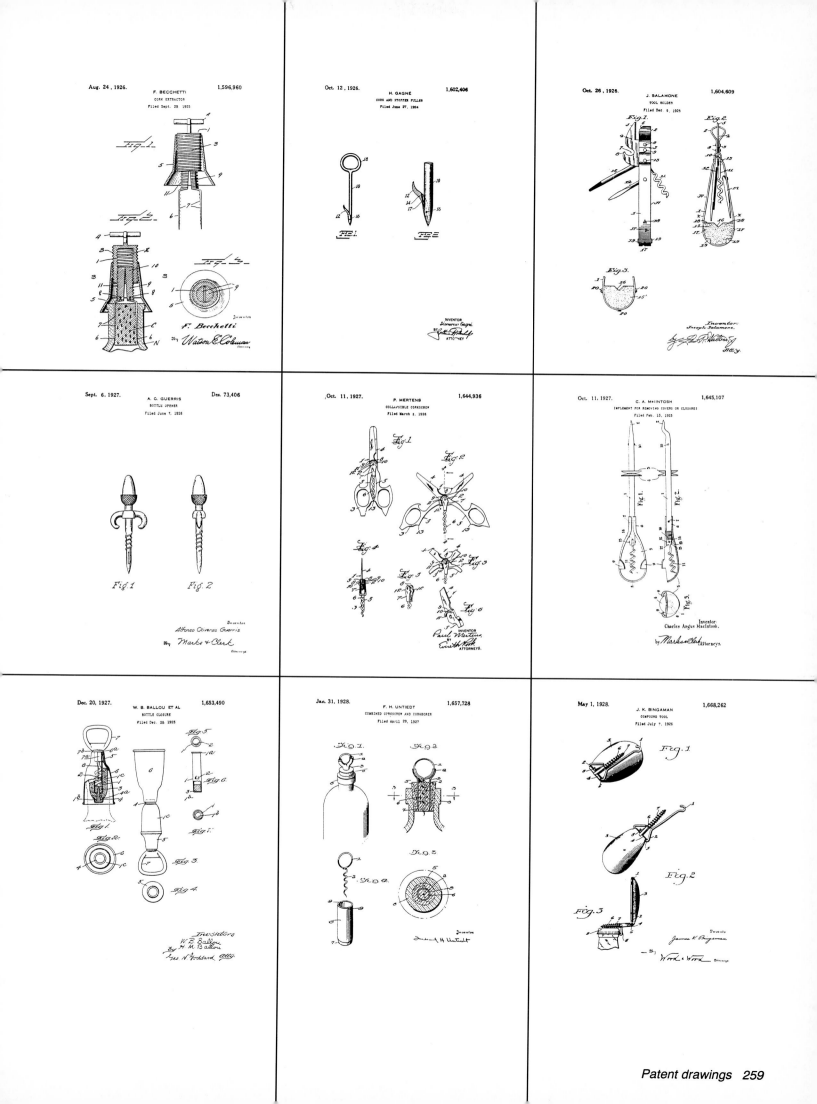

May 15, 1928.

E. E. LA SCHUM

1,670,199

COMBINATION NOVELTY

Filed Oct. 15, 1926

May 22, 1928.

G. T. SHELEY

1,670,828

JAR TOP REMOVING DEVICE

Filed June 10, 1927

GEORGE T. SHELEY

Aug. 14, 1928.

T. HARDING

1,680,291

CORKSCREW

Filed Feb. 20, 1926

INVENTOR
Thomas Harding
ATTORNEYS

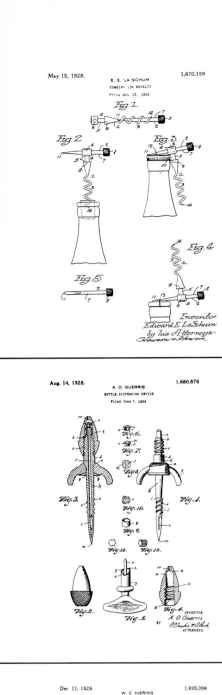

Aug. 14, 1928.

A. O. GUERRIS

1,680,876

BOTTLE DISPENSING DEVICE

Filed June 7, 1926

INVENTOR
A. O. Guerris
BY
ATTORNEYS

Sept. 18, 1928.

F. P. HARKER

1,684,622

COMBINATION KITCHEN UTENSIL

Original Filed Feb. 18, 1926

Inventor
F. P. Harker
by his Attorneys

Sept. 18, 1928.

J. J. HOELLE

1,684,829

DOMESTIC HAND TOOL

Filed Oct. 9, 1923

INVENTOR:

Dec. 11, 1928.

W. C. HIERING

1,695,098

BOTTLE OPENING IMPLEMENT

Filed Dec. 30, 1926

INVENTOR
William C. Hiering
ATTORNEY

Feb. 5, 1929.

C. W. TILLMANNS

1,701,467

HANDLED TOOL

Filed March 2, 1923

INVENTOR
CARL W. TILLMANNS
BY
ATTORNEYS

Feb. 12, 1929.

W. C. HIERING

1,701,950

POCKET CORKSCREW

Filed Feb. 16, 1927

Inventor
William C. Hiering
By his Attorney
Fred C. Fischer

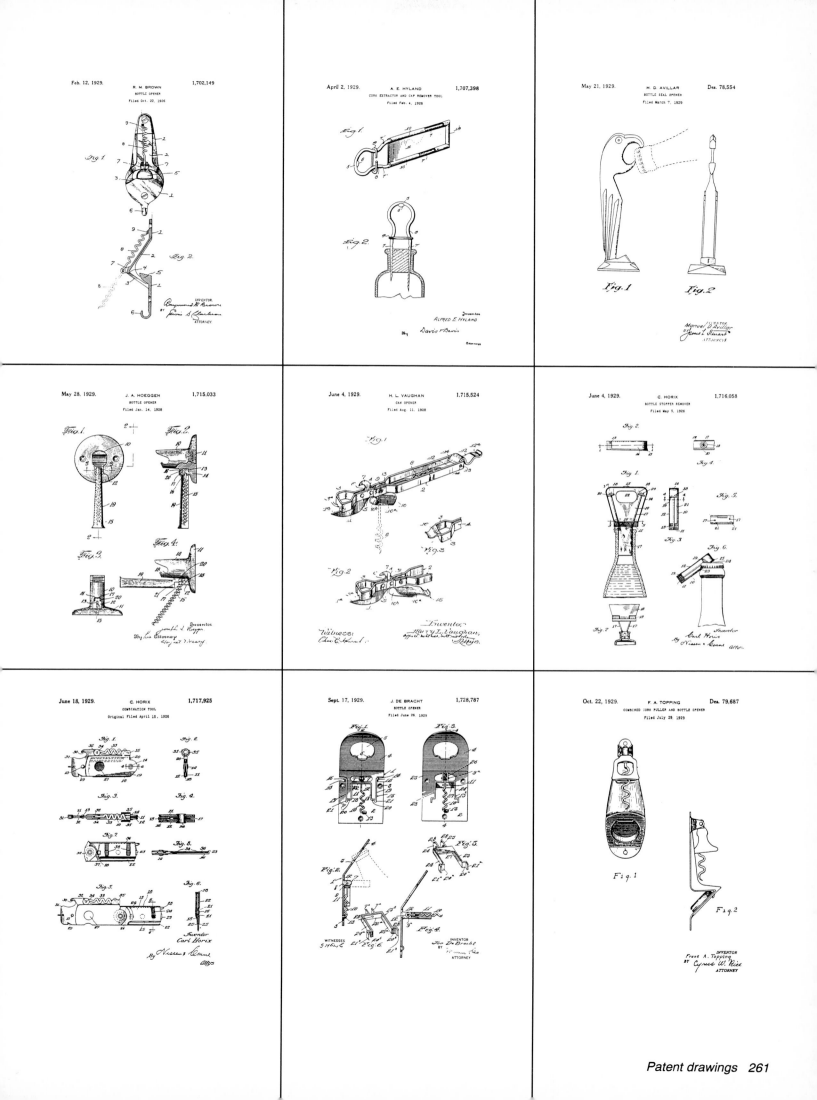

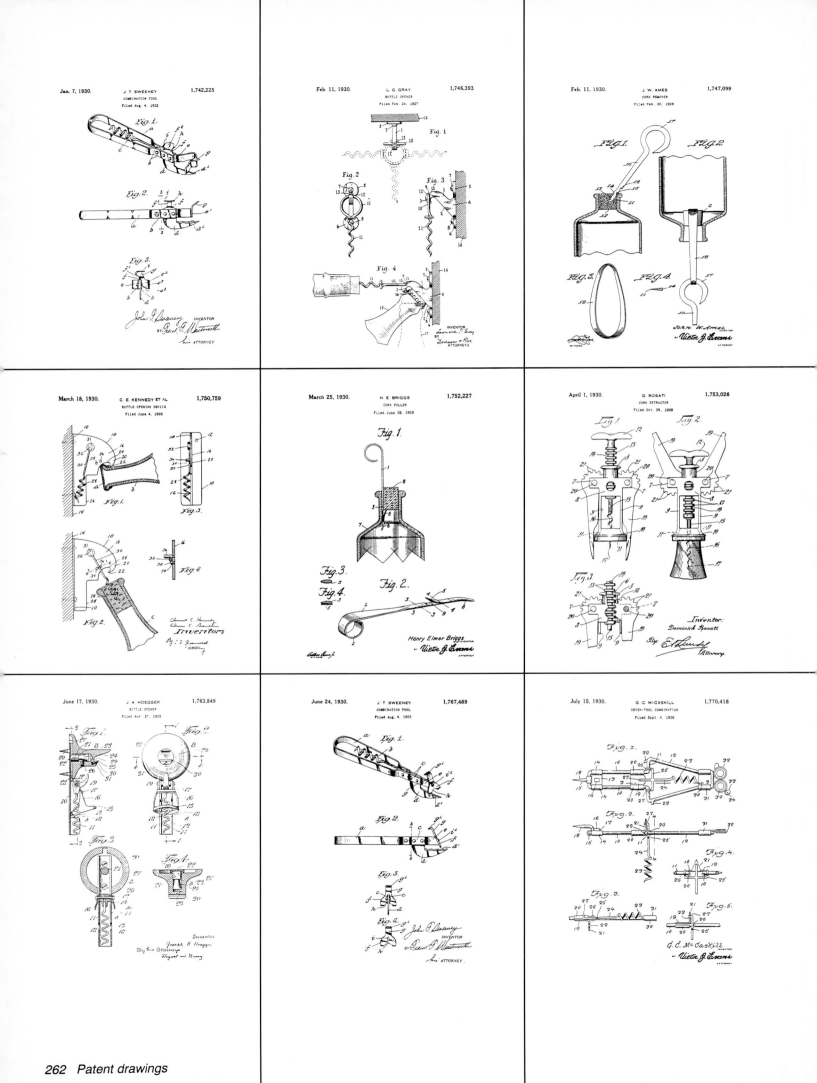

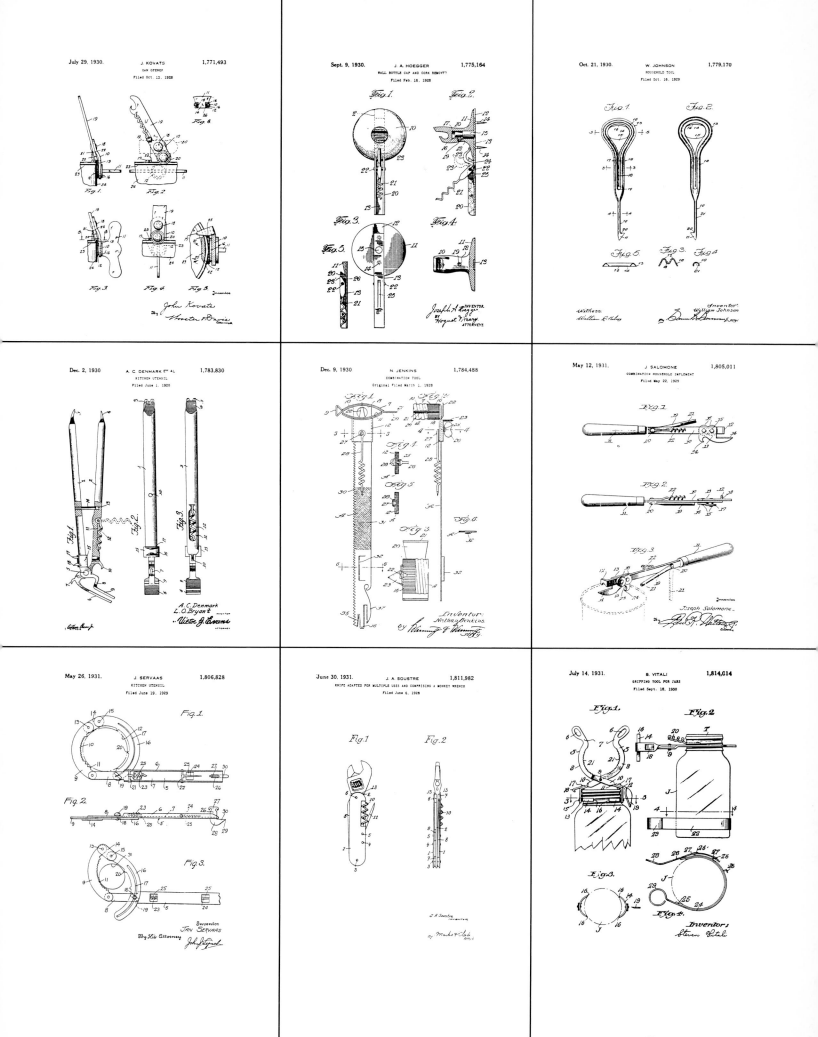

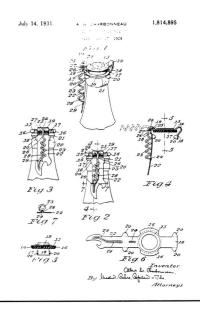

July 14, 1931. A. W. CHARBONNEAU 1,814,895

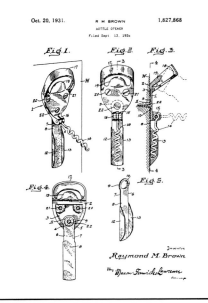

Oct. 20, 1931. R. M. BROWN 1,827,868
BOTTLE OPENER
Filed Sept. 13, 1926

Inventor
Raymond M. Brown

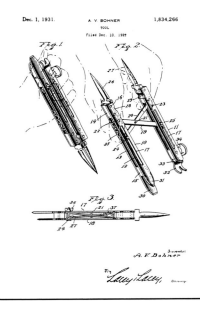

Dec. 1, 1931. A. V. BOHNER 1,834,266
TOOL
Filed Dec. 10, 1929

Inventor
A. V. Bohner

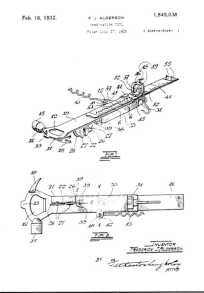

Feb. 16, 1932. F. J. ALDERSON 1,845,038
COMBINATION TOOL
Filed July 2, 1929 2 Sheets-Sheet 1

INVENTOR
FREDERICK J. ALDERSON

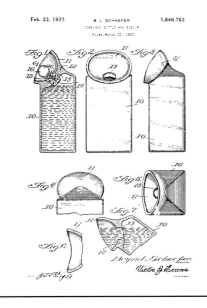

Feb. 23, 1932. B. L. SCHAEFER 1,846,763
COMBINED BOTTLE AND SIECUP
Filed March 22, 1929

Bryant L. Schaefer

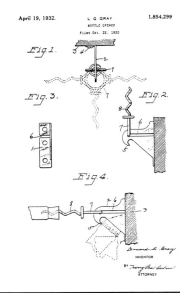

April 19, 1932. L. G. GRAY 1,854,299
BOTTLE OPENER
Filed Oct. 22, 1930

INVENTOR
ATTORNEY

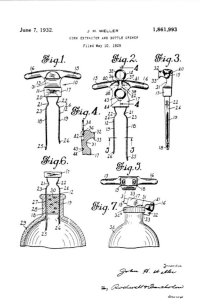

June 7, 1932. J. H. WELLER 1,861,993
CORK EXTRACTOR AND BOTTLE OPENER
Filed May 10, 1929

Inventor
John H. Weller

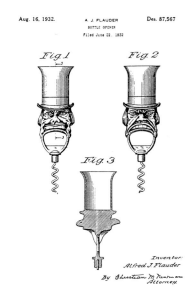

Aug. 16, 1932. A. J. FLAUDER Des. 87,567
BOTTLE OPENER
Filed June 22, 1932

Inventor:
Alfred J. Flauder
By Christian M. Newman
Attorney

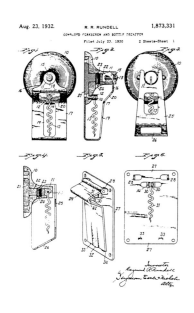

Aug. 23, 1932. R. R. RUNDELL 1,873,331
COMBINED CORKSCREW AND BOTTLE DECAPPER
Filed July 23, 1930 2 Sheets-Sheet 1

Inventor
Raymond R. Rundell

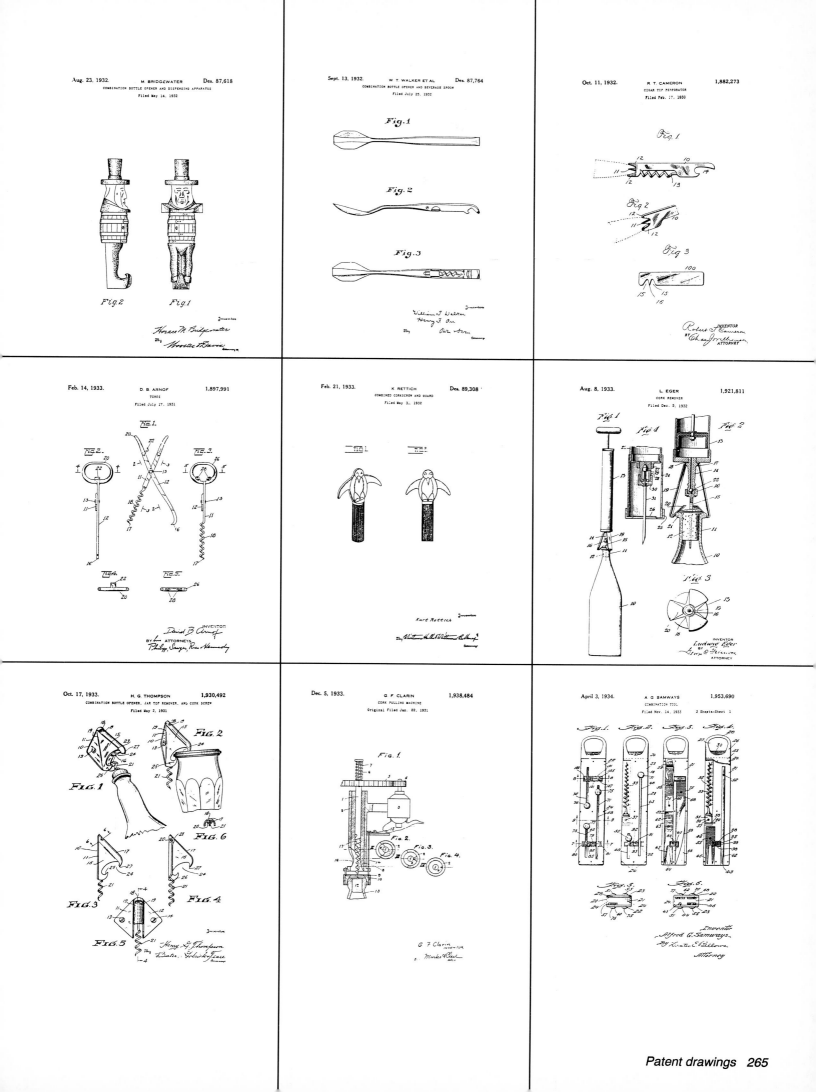

Aug. 23, 1932. M. BRIDGEWATER Des. 87,618
COMBINATION BOTTLE OPENER AND DISPENSING APPARATUS
Filed May 14, 1932

Sept. 13, 1932. W. T. WALKER ET AL Des. 87,764
COMBINATION BOTTLE OPENER AND BEVERAGE SPOON
Filed July 25, 1932

Oct. 11, 1932. R. T. CAMERON 1,882,273
CIGAR TIP PERFORATOR
Filed Feb. 17, 1930

Feb. 14, 1933. D. B. ARNOF 1,897,991
TONGS
Filed July 17, 1931

Feb. 21, 1933. K RETTICH Des. 89,308
COMBINED CORKSCREW AND GUARD
Filed May 3, 1932

Aug. 8, 1933. L. EGER 1,921,811
CORK REMOVER
Filed Dec. 5, 1932

Oct. 17, 1933. H. G. THOMPSON 1,930,492
COMBINATION BOTTLE OPENER, JAR TOP REMOVER, AND CORK SCREW
Filed May 2, 1931

Dec. 5, 1933. G. F. CLARIN 1,938,484
CORK PULLING MACHINE
Original Filed Jan. 22, 1931

April 3, 1934. A. G. SAMWAYS 1,953,690
COMBINATION TOOL
Filed Nov. 14, 1933 2 Sheets—Sheet 1

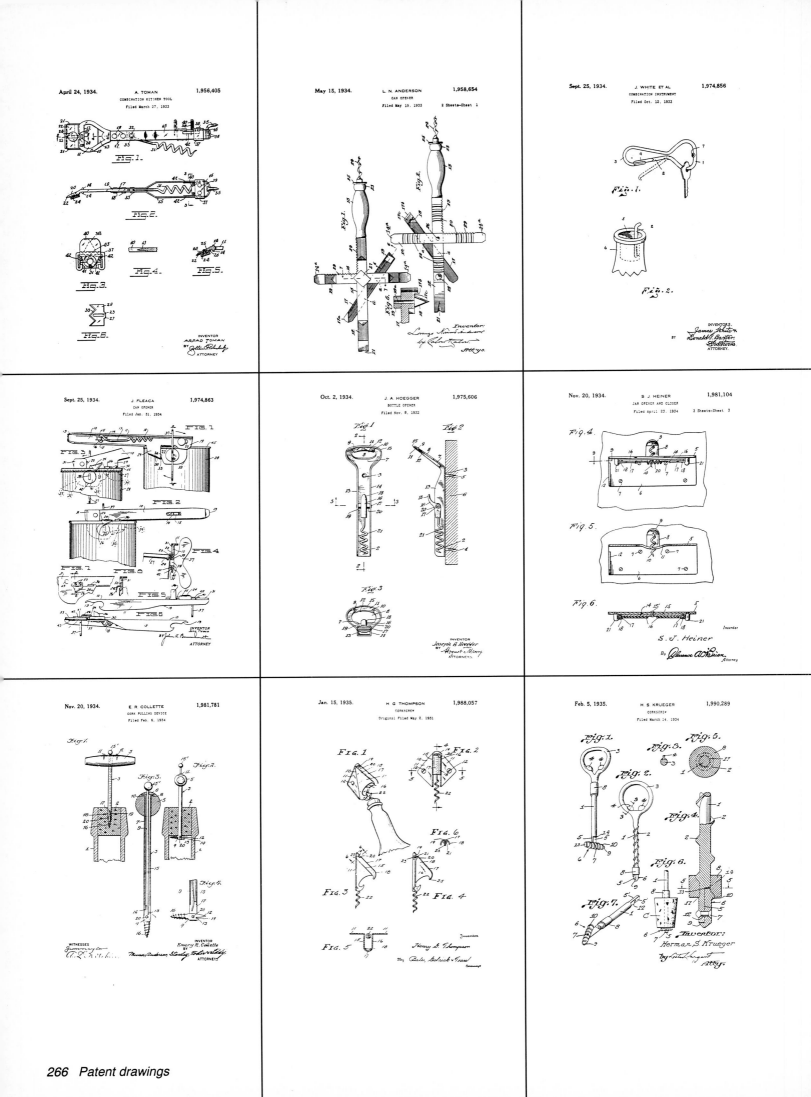

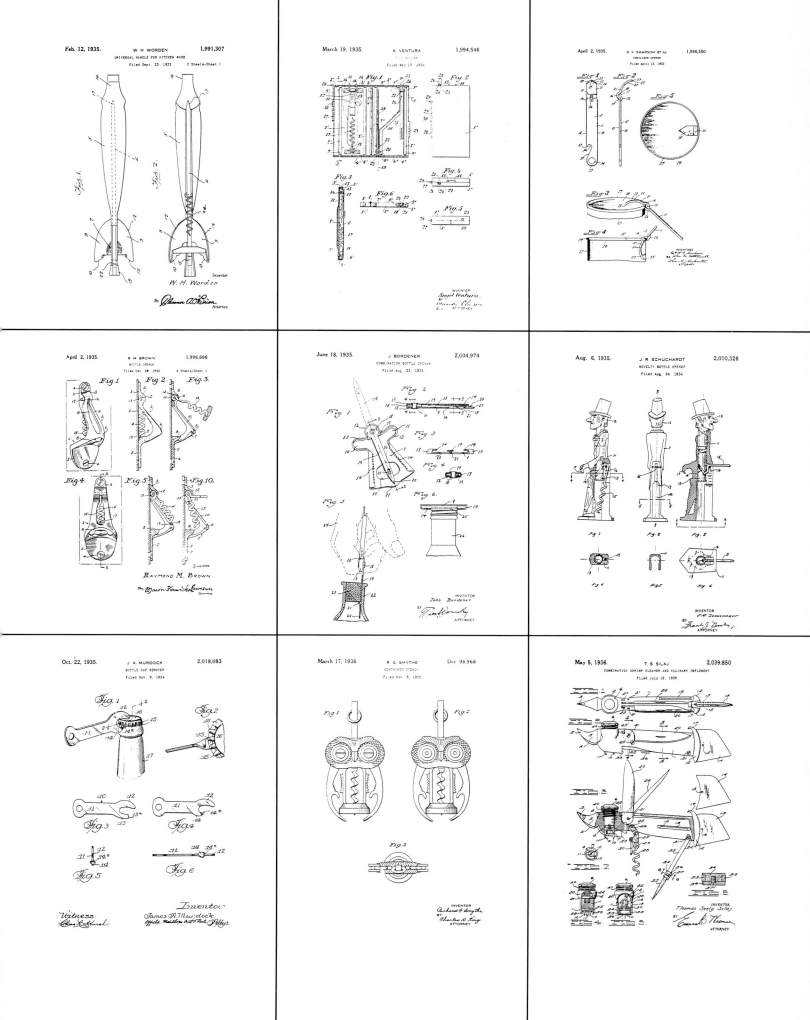

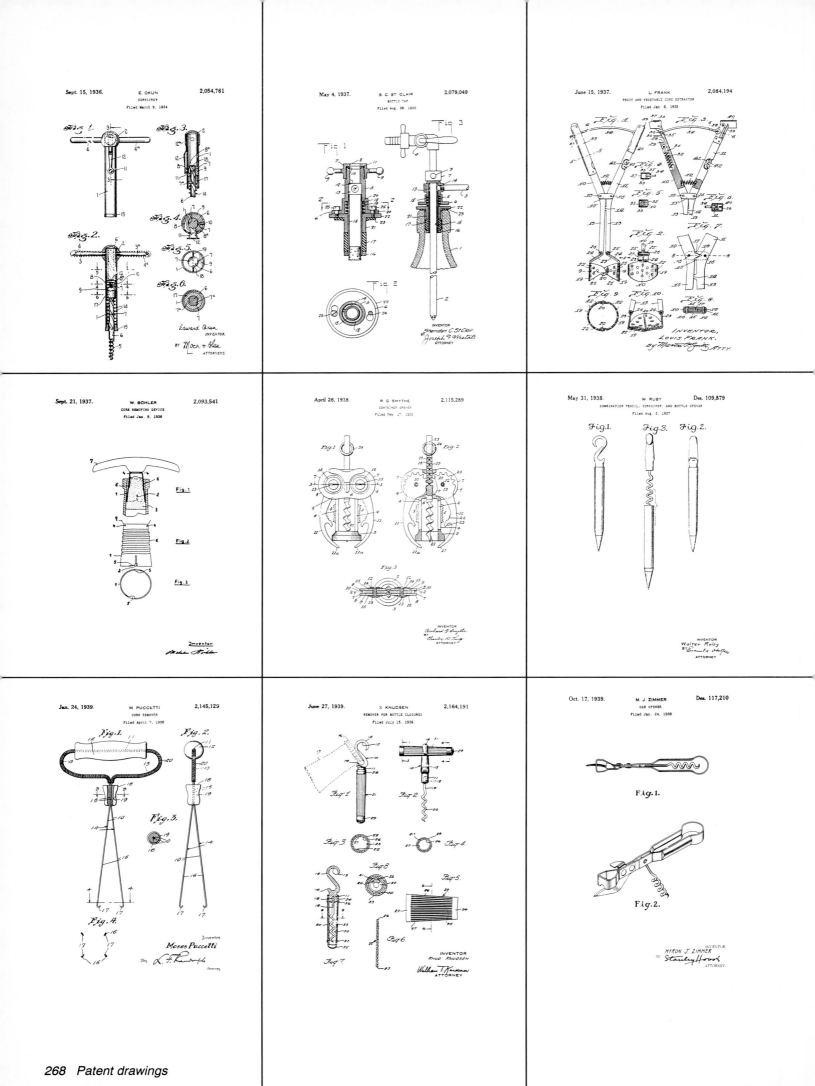

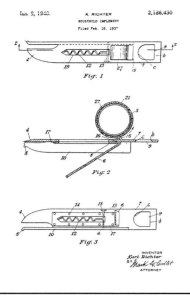

Jan. 9, 1940.　　K. RICHTER　　　2,186,430
HOUSEHOLD IMPLEMENT
Filed Feb. 16, 1937

Fig. 1

Fig. 2

Fig. 3

INVENTOR
Karl Richter
BY
ATTORNEY

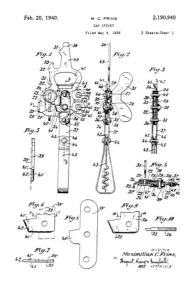

Feb. 20, 1940.　　M. C. FRINS　　　2,190,940
CAN OPENER
Filed May 5, 1936　　2 Sheets-Sheet 1

Fig. 1　Fig. 2　Fig. 3

Fig. 5

Fig. 4

Fig. 6　Fig. 8　Fig. 9　Fig. 10

Fig. 7

INVENTOR
Maximilian C. Frins,
ATTORNEYS

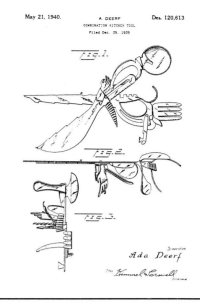

May 21, 1940.　　A. DEERF　　　Des. 120,613
COMBINATION KITCHEN TOOL
Filed Dec. 29, 1939

Fig. 1

Fig. 2

Fig. 3

Inventor
Ada Deerf

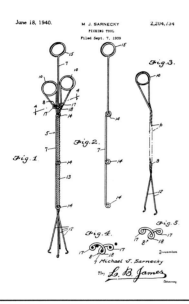

June 18, 1940.　　M. J. SARNECKY　　　2,204,734
PICKING TOOL
Filed Sept. 7, 1939

Fig. 3

Fig. 2

Fig. 1

Fig. 4　Fig. 5

Inventor
Michael J. Sarnecky
By L. B. James Attorney

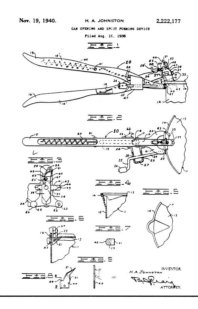

Nov. 19, 1940.　　H. A. JOHNSTON　　　2,222,177
CAN OPENING AND SPOUT FORMING DEVICE
Filed Aug. 16, 1938

FIG. 1

FIG. 2

FIG. 3　FIG. 4

FIG. 5

FIG. 6　FIG. 7

FIG. 8

INVENTOR
H. A. Johnston
ATTORNEY.

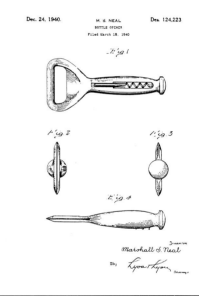

Dec. 24, 1940.　　M. S. NEAL　　　Des. 124,223
BOTTLE OPENER
Filed March 18, 1940

Fig 1

Fig 2　Fig 3

Fig 4

Inventor
Marshall S. Neal
By Lyon & Lyon Attorneys

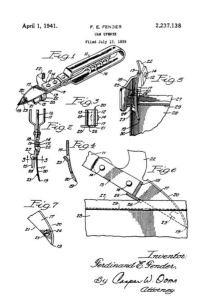

April 1, 1941.　　F. E. FENDER　　　2,237,138
CAN OPENER
Filed July 15, 1939

Fig. 1　Fig. 5

Fig. 3

Fig. 2　Fig. 4

Fig. 6

Fig. 7

Inventor
Ferdinand E. Fender,
By Casper W. Ooms
Attorney

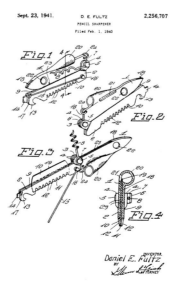

Sept. 23, 1941.　　D. E. FULTZ　　　2,256,707
PENCIL SHARPENER
Filed Feb. 1, 1940

Fig. 1

Fig. 2

Fig. 3

Fig. 4

Daniel E. Fultz
INVENTOR
BY
ATTORNEY

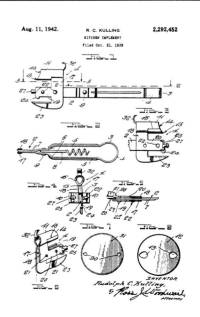

Aug. 11, 1942.　　R. C. KULLING　　　2,292,452
KITCHEN IMPLEMENT
Filed Oct. 21, 1939

Fig. 1

Fig. 2

Fig. 3

Fig. 4

Fig. 5

Fig. 6　Fig. 7　Fig. 8

INVENTOR
Rudolph C. Kulling,
By Ross J. Woodward
Attorney

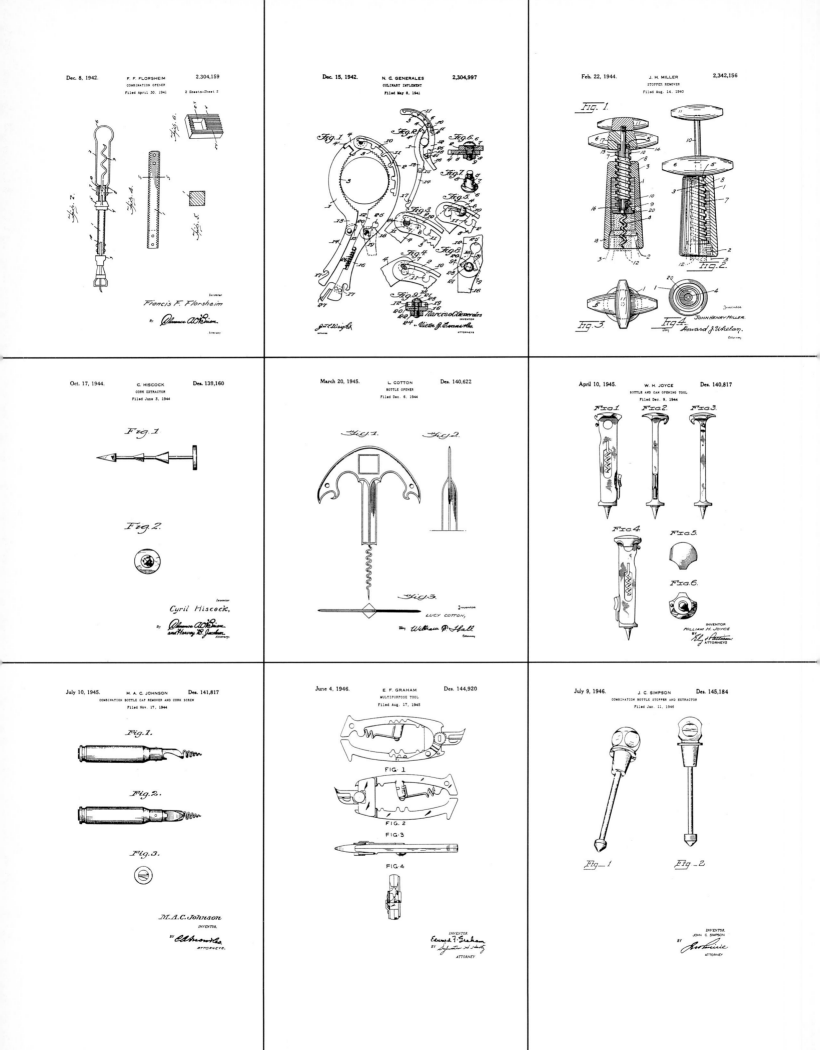

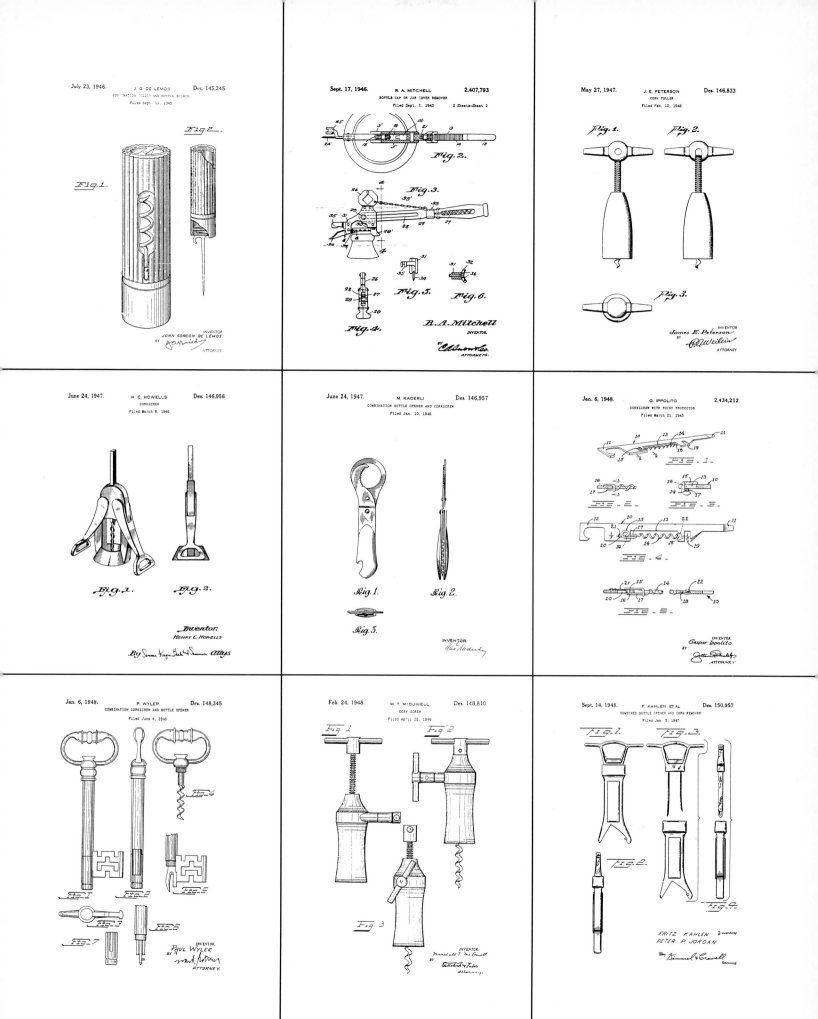

July 23, 1946. J. G. DE LEMOS Des. 145,245
COMBINATION TWEEZER AND BOTTLE OPENER
Filed Sept. 11, 1945

Fig.1. Fig.2.

INVENTOR
JOHN GORDON DE LEMOS
BY
ATTORNEY

Sept. 17, 1946. R. A. MITCHELL 2,407,793
BOTTLE CAP OR JAR COVER REMOVER
Filed Sept. 2, 1943 2 Sheets-Sheet 2

Fig.2.
Fig.3.
Fig.5. Fig.6.
Fig.4.

R. A. Mitchell
INVENTOR
BY
ATTORNEYS.

May 27, 1947. J. E. PETERSON Des. 146,833
CORK PULLER
Filed Feb. 12, 1946

Fig.1. Fig.2.
Fig.3.

INVENTOR
James E. Peterson
BY
ATTORNEY

June 24, 1947. H. C. HOWELLS Des. 146,956
CORKSCREW
Filed March 8, 1946

Fig.1. Fig.2.

Inventor.
HENRY C. HOWELLS
By
Attys.

June 24, 1947. M. KADERLI Des. 146,957
COMBINATION BOTTLE OPENER AND CORKSCREW
Filed Jan. 10, 1946

Fig.1. Fig.2.
Fig.3.

INVENTOR

Jan. 6, 1948. G. IPPOLITO 2,434,212
CORKSCREW WITH POINT PROTECTOR
Filed March 21, 1945

FIG.1.
FIG.2. FIG.3.
FIG.4.
FIG.5.

INVENTOR.
Gaspar Ippolito
BY
ATTORNEY.

Jan. 6, 1948. P. WYLER Des. 148,345
COMBINATION CORKSCREW AND BOTTLE OPENER
Filed June 4, 1946

FIG.4
FIG.1 FIG.2 FIG.3
FIG.7 FIG.6
FIG.7

INVENTOR
PAUL WYLER
BY
ATTORNEY.

Feb. 24, 1948. M. T. McDOWELL Des. 148,810
CORK SCREW
Filed April 25, 1946

Fig.1 Fig.2
Fig.3

INVENTOR
Marshall T. McDowell
BY
Attorneys.

Sept. 14, 1948. F. KAHLEN ET AL Des. 150,957
COMBINED BOTTLE OPENER AND CORK REMOVER
Filed Jan. 2, 1947

Fig.1. Fig.3.
Fig.2.
Fig.4.

FRITZ KAHLEN Inventors
PETER P. JORDAN
By
Attorneys

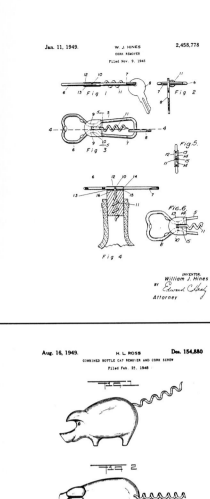

Jan. 11, 1949. W. J. HINES 2,458,778
CORK REMOVER
Filed Nov. 9, 1945

INVENTOR.
William J. Hines
BY
Attorney

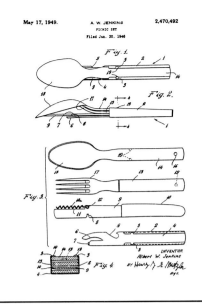

May 17, 1949. A. W. JENKINS 2,470,492
PICNIC SET
Filed Jan. 30, 1946

INVENTOR.
Albert W. Jenkins
BY

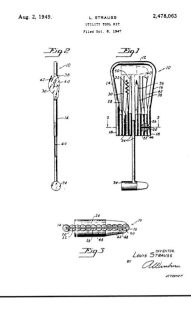

Aug. 2, 1949. L. STRAUSS 2,478,063
UTILITY TOOL KIT
Filed Oct. 8, 1947

INVENTOR.
Louis Strauss
BY
ATTORNEY

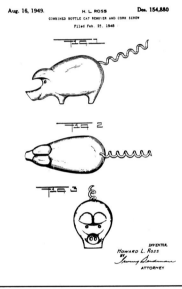

Aug. 16, 1949. H. L. ROSS Des. 154,880
COMBINED BOTTLE CAP REMOVER AND CORK SCREW
Filed Feb. 25, 1948

INVENTOR
Howard L. Ross
BY
ATTORNEY

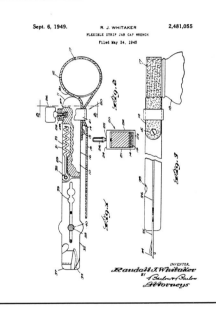

Sept. 6, 1949. R. J. WHITAKER 2,481,055
FLEXIBLE STRIP JAR CAP WRENCH
Filed May 24, 1945

INVENTOR
Randall J. Whitaker
BY
Attorneys

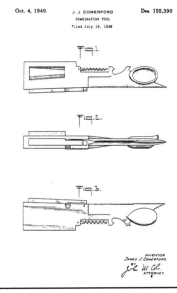

Oct. 4, 1949. J. J. COMERFORD Des. 155,390
COMBINATION TOOL
Filed July 16, 1948

INVENTOR
James J. Comerford
BY
ATTORNEY

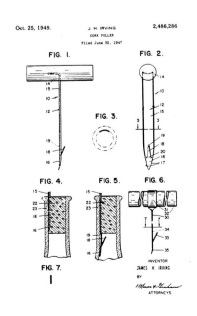

Oct. 25, 1949. J. H. IRVING 2,486,286
CORK PULLER
Filed June 30, 1947

INVENTOR
JAMES H. IRVING
BY
ATTORNEYS

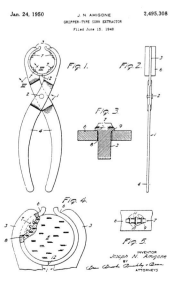

Jan. 24, 1950 J. N. AMIGONE 2,495,308
GRIPPER-TYPE CORK EXTRACTOR
Filed June 15, 1948

INVENTOR
Joseph N. Amigone
BY
ATTORNEYS

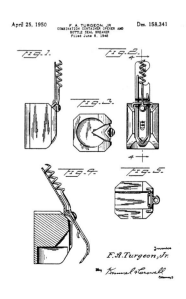

April 25, 1950 F. A. TURGEON, JR Des. 158,341
COMBINATION CONTAINER OPENER AND
BOTTLE SEAL BREAKER
Filed June 8, 1948

INVENTOR
F. A. Turgeon, Jr.
BY

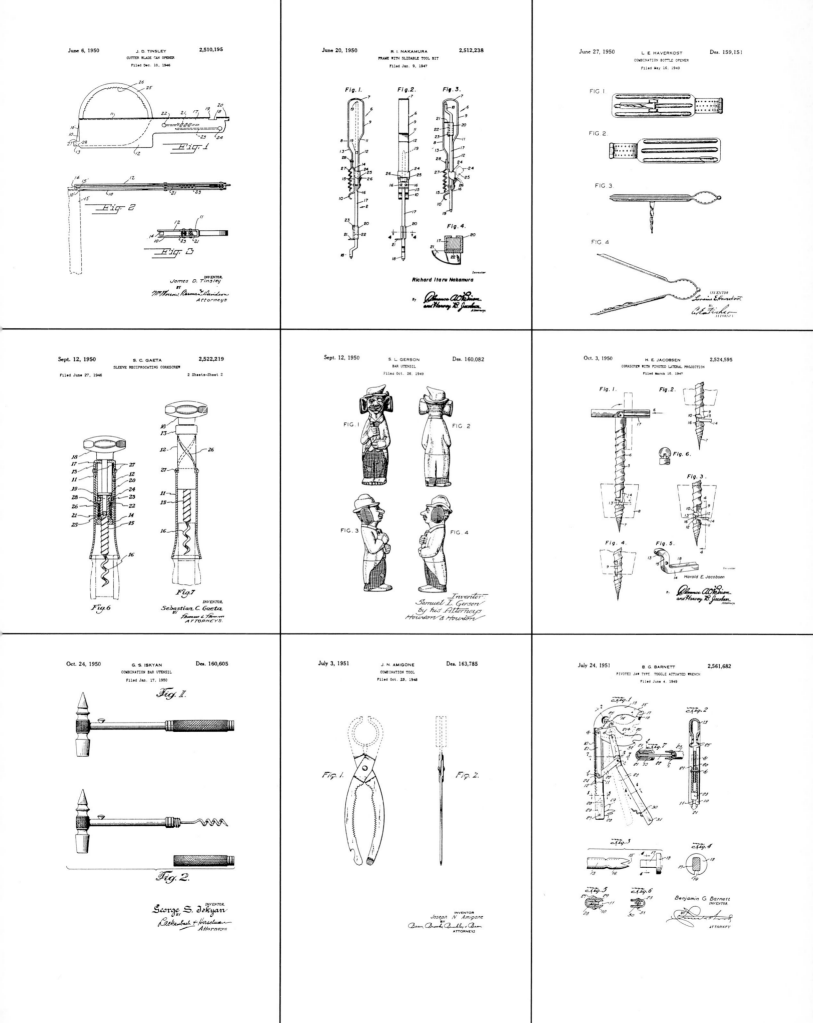

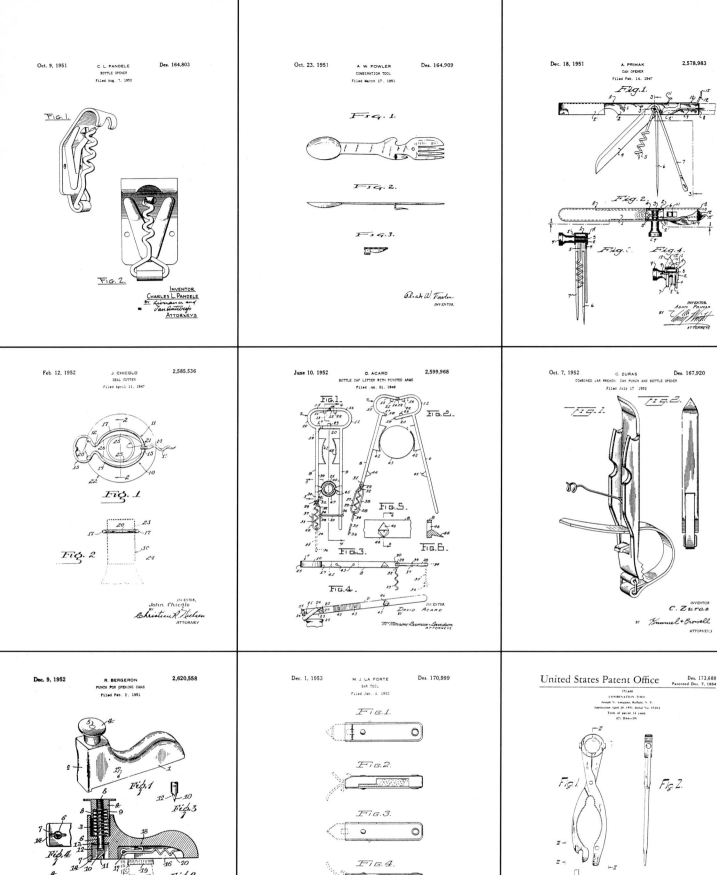

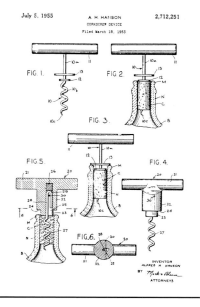

July 5, 1955 A. H. HANSON 2,712,251

CORKSCREW DEVICE

Filed March 18, 1953

INVENTOR
ALFRED H. HANSON

BY

ATTORNEYS

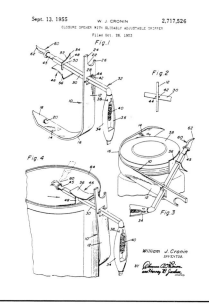

Sept. 13, 1955 W. J. CRONIN 2,717,526

CLOSURE OPENER WITH SLIDABLY ADJUSTABLE GRIPPER

Filed Oct. 26, 1953

William J. Cronin
INVENTOR.

BY

ATTORNEY

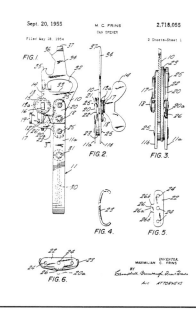

Sept. 20, 1955 M. C. FRINS 2,718,055

CAN OPENER

Filed May 18, 1954 2 Sheets-Sheet 1

INVENTOR.
MAXIMILIAN C. FRINS

BY

His ATTORNEYS

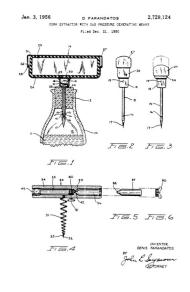

Jan. 3, 1956 D FARANDATOS 2,729,124

CORK EXTRACTOR WITH GAS PRESSURE GENERATING MEANS

Filed Dec. 21, 1950

INVENTOR.
DENIS FARANDATOS

BY

ATTORNEY

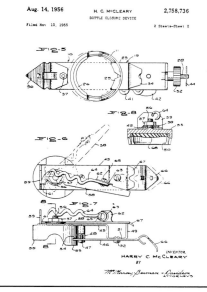

Aug. 14, 1956 H. C. McCLEARY 2,758,736

BOTTLE CLOSURE DEVICE

Filed Nov. 10, 1955 2 Sheets-Sheet 2

INVENTOR.
HARRY C. McCLEARY

BY

ATTORNEYS

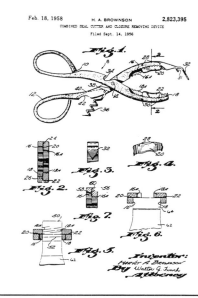

Feb. 18, 1958 H. A. BROWNSON 2,823,395

COMBINED SEAL CUTTER AND CLOSURE REMOVING DEVICE

Filed Sept. 14, 1956

INVENTOR.
Harold A. Brownson

BY Walter G. Finch
ATTORNEY

June 10, 1958 H. A. BERKMAN 2,837,946

CLOSURE REMOVER WITH VENTING MEANS

Filed July 31, 1956

Inventor
Herbert A. Berkman
By M. G. Funkenstein
Attorney

United States Patent Office Des. 184,613
Patented Mar. 17, 1959

184,613

BOTTLE OPENER

Carlo Gemelli, Milan, Italy

Application June 13, 1958, Serial No. 51,352

Claims priority, application, Italy April 23, 1958

Term of patent 14 years

(Cl. D44—19)

Fig. 1 is a perspective view of one face of a bottle
opener, showing my new design; and
Fig. 2 is a perspective view of the opposite face there-
of.

I claim:
The ornamental design for a bottle opener, as shown.

References Cited in the file of this patent
UNITED STATES PATENTS
D. 160,082 Gerson Sept. 12, 1950
OTHER REFERENCES
Bar-Mart, bar accessories catalog, © 1951, rec'd Apr.
16, 1952, page 14, wing lever corkscrew, right center.

May 19, 1959 A. H. HANSON 2,883,994

COMBINATION BAR TOOL

Filed Aug. 30, 1956 2 Sheets-Sheet 2

INVENTOR.
ALFRED H. HANSON

BY

ATTORNEYS

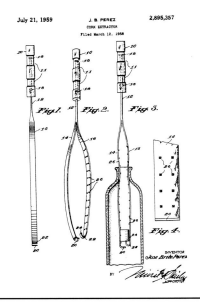

July 21, 1959 J. B. PEREZ 2,895,357
CORK EXTRACTOR
Filed March 12, 1958

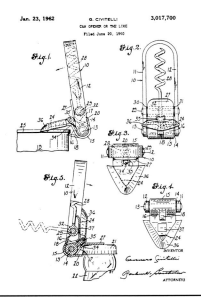

Jan. 23, 1962 G. CIVITELLI 3,017,700
CAN OPENER OR THE LIKE
Filed June 20, 1960

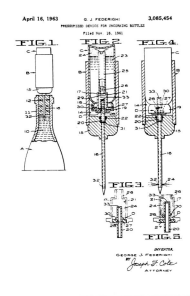

April 16, 1963 G. J. FEDERIGHI 3,085,454
PRESSURIZED DEVICE FOR UNCORKING BOTTLES
Filed Nov. 16, 1961

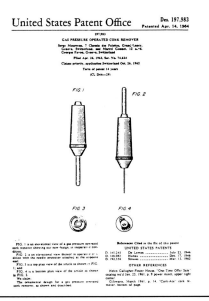

United States Patent Office Des. 197,983
Patented Apr. 14, 1964

GAS PRESSURE OPERATED CORK REMOVER

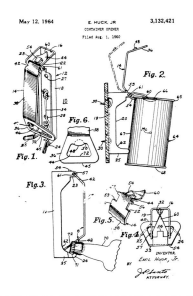

May 12, 1964 E. HUCK, JR 3,132,421
CONTAINER OPENER
Filed Aug. 1, 1960

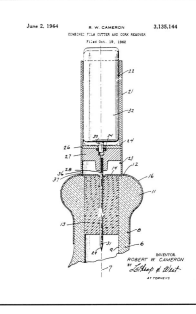

June 2, 1964 R. W. CAMERON 3,135,144
COMBINED FILM CUTTER AND CORK REMOVER
Filed Oct. 19, 1962

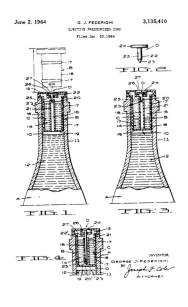

June 2, 1964 G. J. FEDERIGHI 3,135,410
EJECTIVE PRESSURIZED CORK
Filed Jan. 20, 1964

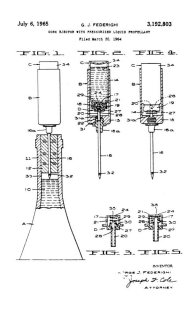

July 6, 1965 G. J. FEDERIGHI 3,192,803
CORK EJECTOR WITH PRESSURIZED LIQUID PROPELLANT
Filed March 30, 1964

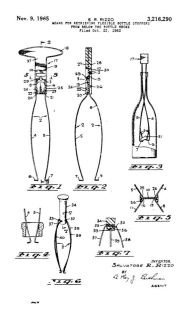

Nov. 9, 1965 S. R. RIZZO 3,216,290
MEANS FOR RETRIEVING FLEXIBLE BOTTLE STOPPERS
FROM BELOW THE BOTTLE NECKS
Filed Oct. 22, 1962

June 21, 1966 M. DEL PICCOLO 3,256,756

BOTTLE CORK EXTRACTOR

Filed March 17, 1964

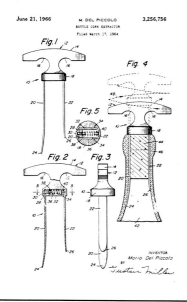

INVENTOR

Mario Del Piccolo

BY

June 28, 1966 D STAMPLER 3,257,873

CORK EXTRACTOR

Filed Oct. 7, 1964

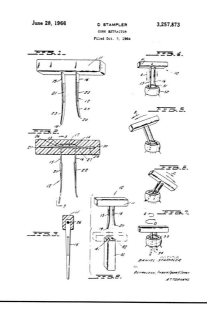

INVENTOR

DANIEL STAMPLER

ATTORNEYS

United States Patent Office Des. 205,407
Patented August 2, 1966

205,407

BOTTLE CORK REMOVER

Kurt M. Vogel, 84 Fanton Road, Westport, Conn.
Filed Nov. 22, 1965, Ser. No. 88,169
Term of patent 14 years
(Cl. D44—29)

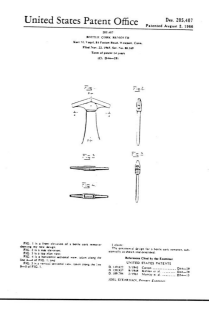

FIG. 1 is a front elevation of a bottle cork remover showing my new design;
FIG. 2 is a side elevation;
FIG. 3 is a top plan view;
FIG. 4 is a horizontal sectional view, taken along the line 4—4 of FIG. 1; and
FIG. 5 is a vertical sectional view, taken along the line 5—5 of FIG. 1.

I claim:
The ornamental design for a bottle cork remover, substantially as shown and described.

References Cited by the Examiner
UNITED STATES PATENTS

D. 149,622	5/1945	Conon	D44—29
D. 150,937	9/1948	Kahlen et al.	D44—29
D. 189,796	2/1961	Murray et al.	D54—13

JOEL STEARMAN, Primary Examiner.

United States Patent Office Des. 205,408
Patented August 2, 1966

205,408

BOTTLE CORK REMOVER

Kurt M. Vogel, 84 Fanton Road, Westport, Conn.
Filed Nov. 22, 1965, Ser. No. 88,170
Term of patent 14 years
(Cl. D44—29)

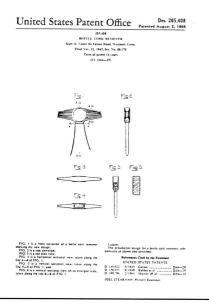

FIG. 1 is a front elevation of a bottle cork remover showing my new design;
FIG. 2 is a side elevation;
FIG. 3 is a top plan view;
FIG. 4 is a horizontal sectional view, taken along the line 4—4 of FIG. 1; and
FIG. 5 is a vertical sectional view, taken along the line 5—5 of FIG. 1; and
FIG. 6 is a vertical sectional view on an enlarged scale, taken along the line 6—6 of FIG. 1.

I claim:
The ornamental design for a bottle cork remover, substantially as shown and described.

References Cited by the Examiner
UNITED STATES PATENTS

D. 149,622	5/1945	Conon	D44—29
D. 150,937	9/1948	Kahlen et al.	D44—29
D. 189,796	2/1961	Murray et al.	D54—13

JOEL STEARMAN, Primary Examiner.

United States Patent Office Des. 205,409
Patented August 2, 1966

205,409

BOTTLE CORK REMOVER

Kurt M. Vogel, 84 Fanton Road, Westport, Conn.
Filed Nov. 22, 1965, Ser. No. 88,171
Term of patent 14 years
(Cl. D44—29)

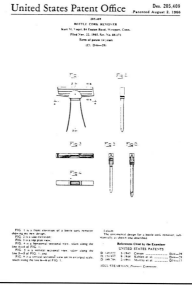

FIG. 1 is a front elevation of a bottle cork remover showing my new design;
FIG. 2 is a side elevation;
FIG. 3 is a top plan view;
FIG. 4 is a horizontal sectional view, taken along the line 4—4 of FIG. 1; and
FIG. 5 is a vertical sectional view, taken along the line 5—5 of FIG. 1.

I claim:
The ornamental design for a bottle cork remover, substantially as shown and described.

References Cited by the Examiner
UNITED STATES PATENTS

D. 149,622	5/1945	Conon	D44—29
D. 150,937	9/1948	Kahlen et al.	D44—29
D. 189,796	2/1961	Murray et al.	D54—13

JOEL STEARMAN, Primary Examiner.

United States Patent Office Des. 209,001
Patented Oct. 24, 1967

209,001

COMBINATION TOOL

Joseph N. Amigone, 3404 Main St., Buffalo, N.Y. 14214
Filed Dec. 8, 1965, Ser. No. 109
Term of patent 14 years
(Cl. D44—29)

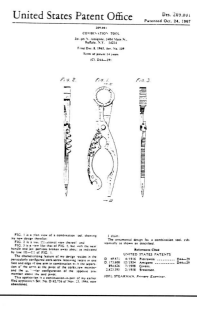

FIG. 1 is a plan view of a combination tool, showing my new design therefor;
FIG. 2 is a side elevational view thereof; and
FIG. 3 is a view like that of FIG. 2, but with the near handle and jaw portions broken away shown as indicated by line III—III of FIG. 1.

The characterizing feature of my design resides in the particularly configured cork-screw receiving recess in one face and edge of one arm in combination with the separation of the arms at the pivot of the corkscrew member and the particular configuration of the opposite arm member above the said pivot.

This application is a continuation-in-part of my earlier filed application Ser. No. D 82,736 of Nov. 23, 1964, now abandoned.

I claim:
The ornamental design for a combination tool, substantially as shown and described.

References Cited
UNITED STATES PATENTS

D. 48,671	4/1916	Piotrowski	D44—29
D. 173,600	12/1954	Amigone	D44—29
894,616	7/1908	Givens	
2,823,395	2/1958	Brownson	

JOEL STEARMAN, Primary Examiner.

Dec. 26, 1967 K M VOGEL 3,359,838

CORK PULLER AND PROTECTIVE SHEATH THEREFOR

Filed May 31, 1966

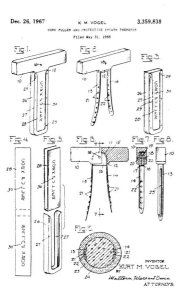

INVENTOR

KURT M. VOGEL

BY

Mathews Mattern, Ware and Davis

ATTORNEYS.

United States Patent Office Des. 214,078
Patented May 6, 1969

214,078

COMBINED CONTAINER OPENER AND CORKSCREW

Fred N. Steiner, Woodmere, N.Y., assignor to Bonny Products, Inc., Lynbrook, N.Y., a corporation of New York
Filed Apr. 17, 1968, Ser. No. 11,484
Term of patent 14 years
U.S. Cl. D44—29 Int. Cl. D8—02

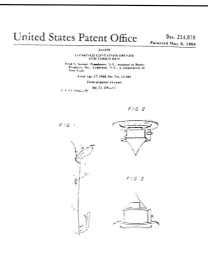

June 24, 1969 A V DEAVER 3,451,076

SUBMERGED CORK RECOVERY DEVICE

Filed Oct. 10, 1966

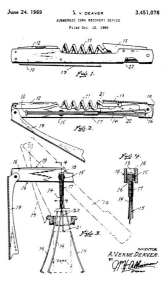

INVENTOR

A. VERNE DEAVER.

BY

ATTORNEY

Jan. 5, 1971 W. STEINER 3,552,241
APPARATUS FOR OPENING OF BOTTLES, CANS, CONTAINERS, CASES, AND
THE LIKE
Filed Dec. 11, 1968 4 Sheets-Sheet 1

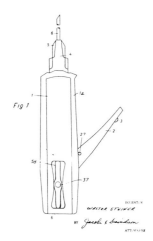

Fig 1

INVENTOR
WALTER STEINER
BY Jacobi & Davidson
ATTORNEYS

March 16, 1971 W. STEINER 3,570,027
COMPENSATION DEVICE FOR OPENING OF BOTTLES, CANS, CONTAINERS
AND CASES OF ALL TYPES
Filed Nov. 4, 1968 4 Sheets-Sheet 1

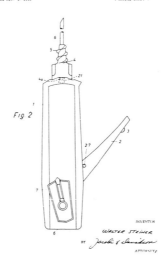

Fig 2

INVENTOR
WALTER STEINER
BY Jacobi & Davidson
ATTORNEYS

United States Patent Office Des. 228,613
Patented Oct. 16, 1973

228,613
CORKSCREW
Cipriano Ghidini, Brescia, Italy, assignor to Ras Control Corp., New York, N.Y.
Filed Aug. 31, 1972, Ser. No. 285,167
Term of patent 14 years
Int. Cl. ——
U.S. Cl. D8—42

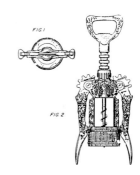

FIG 1

FIG. 2

United States Patent [19]
Artmer

[11] 3,815,448
[45] June 11, 1974

[54] CORKSCREW
[76] Inventor: Gero Artmer, Parkgasse 2, A-1030 Vienna, Austria
[22] Filed: Oct. 16, 1972
[21] Appl. No.: 296,245

[30] Foreign Application Priority Data
Oct 22, 1971 U.S.S.R.

[52] U.S. Cl.
[51] Int. Cl.
[58] Field of Search

[56] References Cited
UNITED STATES PATENTS

FOREIGN PATENTS OR APPLICATIONS

Primary Examiner—Al Lawrence Smith
Assistant Examiner—Roscoe V. Parker
Attorney, Agent, or Firm—Woodhams, Blanchard & Flynn

[57] ABSTRACT
A bottle opener has two parts which are slidable relative to one another and between which there is a pressure chamber. A corkscrew extends from one of these parts which has a cavity therein accommodating a valve and a gas cartridge. When the corkscrew is embedded in a cork in the neck of a bottle and the valve is actuated gas flows from the gas cartridge to the pressure chamber to move the two parts away from one another so that the cork is extracted.

7 Claims, 5 Drawing Figures

United States Patent [19]
Cantales

[11] 3,909,860
[45] Oct. 7, 1975

[54] COMBINATION CAN-OPENER TOOL
[76] Inventor: Joseph Cantales, 640 Pelham Rd., New Rochelle, N.Y. 10802
[22] Filed: Sept. 3, 1974
[21] Appl. No.: 502,402

[52] U.S. Cl.
[51] Int. Cl.
[58] Field of Search

[56] References Cited
UNITED STATES PATENTS

Primary Examiner—Al Lawrence Smith
Assistant Examiner—Roscoe V. Parker
Attorney, Agent, or Firm—Spellman & Joel

[57] ABSTRACT
A combination can opener-type tool is essentially made from a single stamping. The combination tool comprises at one end a bottle opener and can piercer facing in opposite directions and separated by a lid opener which lies substantially in the main plane of the tool. The intermediate section of the tool includes a cut-out portion with gripping edges which serves as an opening device for various bottles and the like, a raised mounting portion about which a corkscrew is hinged and a pair of projecting guards extending outwardly therefrom which also may be used for peeling potatoes and the like. The other end of the tool includes a can opening portion including a piercing and cutting blade and a vegetable peeler.

7 Claims, 3 Drawing Figures

U.S. Patent Oct. 7, 1975 3,909,860

FIG. 1

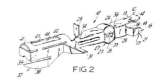

FIG. 2

FIG. 3

United States Patent [19]
Szumacher

[11] 3,926,076
[45] Dec. 16, 1975

[54] CORK PULLER
[76] Inventor: Boleslaw Szumacher, 2708 N. Richmond Ave., Chicago, Ill. 60647
[22] Filed: Apr. 14, 1975
[21] Appl. No.: 567,518

[52] U.S. Cl.
[51] Int. Cl.
[58] Field of Search

[56] References Cited
UNITED STATES PATENTS

Primary Examiner—Al Lawrence Smith
Assistant Examiner—Roscoe V. Parker
Attorney, Agent, or Firm—John J. Kowalik

[57] ABSTRACT
A cork remover having a spring-steel U-shaped prong member comprising a bight and a pair of outwardly diverging cork-embracing prongs. The prong member is formed to fit lengthwise into a pair of tubular telescoping handle portions when the prongs are pressed toward each other. Each handle portion has an axial slot to enhance the radial resiliency thereof so as to permit alignable detents on the walls to interlock and release attendant to deflection of the walls as the handle portions are telescoped and separated. In addition, the U-shaped bight is formed to be wedged diametrically of the handle portions with the prongs extended through the slots which are radially aligned. The wedging action deflects the walls outwardly and interengages the detents which are brought into alignment by adjusting the axial position of the handle portions relative to each other.

10 Claims, 5 Drawing Figures

United States Patent

Des. 239,362
Patented Mar. 30, 1976

239,362
CORK SCREW
George Frederick Peterson, Boonton Township, N.J., assignor to Eramco Industries, Belleville, N.J.
Filed Sept. 3, 1974, Ser. No. 396,257
Term of patent 14 years
Int. Cl. D7—05
U.S. Cl. D8—42

FIG. 1 FIG. 2

FIG. 3

FIG. 4

FIG. 1 is a front elevational view of a cork screw showing my new design.
FIG. 2 is a side elevational view thereof;
FIG. 3 is a bottom plan view thereof; and
FIG. 4 is a top plan view thereof.
I claim:
The ornamental design for a cork screw, substantially as shown.

References Cited
UNITED STATES PATENTS

FOREIGN PATENTS

WINIFRED E. HERRMANN, Primary Examiner

United States Patent [19]
Soldano

[11] 3,967,512
[45] July 6, 1976

[54] CORK REMOVER
[76] Inventor: Michael J. Soldano, Monsey, N.Y.
[73] Assignee: Lawrence Peska Associates, Inc., New York, N.Y. a part interest
[22] Filed: May 19, 1975
[21] Appl. No.: 579,038

[52] U.S. Cl.
[51] Int. Cl.
[58] Field of Search

[56] References Cited
FOREIGN PATENTS OR APPLICATIONS

Primary Examiner—Al Lawrence Smith
Assistant Examiner—Roscoe V. Parker

[57] ABSTRACT
An apparatus for removing corks accidently forced into wine bottles is disclosed comprising an elongated probe having an end that projects inwardly from the probe and which is adapted to fit under corks so that they may be removed without any substantial fragmentation. A handle is provided on the probe which allows it to be manipulated with one hand.

2 Claims, 3 Drawing Figures

United States Patent [19]

Bonin

[11] **Des. 244,002**
[45] **Apr. 12, 1977**

[54] **CORK RETRIEVER**

[76] Inventor: **Bernard R. Bonin**, 7 Linden Ave., Westbrook, Conn. 06498

[**] Term: 14 Years
[21] Appl. No.: 625,371
[22] Filed: Oct. 24, 1975
[51] Int. Cl. D7—06
[52] U.S. Cl. D8/42
[58] Field of Search D8/33–43; 81/3.48, 3.49

[56] **References Cited**
U.S. PATENT DOCUMENTS

59,241	10/1866	Loffler	81/3.49
434,192	8/1890	Mills	81/3.49
601,380	3/1898	Phillips	81/3.49
D. 18,528	8/1888	Mersereau	D8/42

FOREIGN PATENT DOCUMENTS

2,260 2/1888 United Kingdom 81/3.49

Primary Examiner—Winifred E. Herrmann
Attorney, Agent, or Firm—Theodore R. Paulding

[57] **CLAIM**

The ornamental design for a cork retriever, as shown and described.

DESCRIPTION

FIG. 1 is a front perspective view of a cork retriever showing my new design.
FIG. 2 is a front elevational view thereof.
FIG. 3 is a rear elevational view thereof.
FIG. 4 is a top plan view thereof.
FIG. 5 is a bottom plan view thereof.
FIG. 6 is a right side view thereof.
FIG. 7 is a left side view thereof.

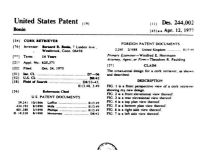

United States Patent [19]

Bozzo

[11] **4,063,473**
[45] **Dec. 20, 1977**

[54] **METHOD OF ASSEMBLING MECHANICAL CORK PULLER**

[75] Inventor: **George J. Bozzo**, New Milford, N.J.
[73] Assignee: Irriware Division of Beatrice Foods Company, Astoria, N.Y.
[21] Appl. No.: 647,784
[22] Filed: Jan. 9, 1976
[51] Int. Cl. B67B 7/32
[52] U.S. Cl. 29/453; 29/434; 29/450; 74/422; 403/159
[58] Field of Search 29/453, 434; 81/3.1 A, 81/3.37; 74/422, 524, 534, 535, 536; 403/157, 159, 254/12, 95

[56] **References Cited**
U.S. PATENT DOCUMENTS

1,753,026	4/1930	Rosati	81/3.37
2,305,562	12/1942	Thompson et al.	403/159
2,675,606	4/1954	Lawson	29/453 X
2,896,992	12/1954	Foley	403/157
3,242,564	3/1966	Longbau	29/453 X
3,353,372	11/1967	Rapoport	29/453 X

Primary Examiner—Charlie T. Moon
Attorney, Agent, or Firm—Morgan, Finnegan, Pine, Foley & Lee

[57] **ABSTRACT**

An improved mechanical cork puller wherein the pivot holes of the lever arms receive and pivot about one or more ribs formed on the inner surfaces of the opposed pairs of support ears, resulting in no visible sign of a pivot support on the outer surfaces of the support ears providing free meshing movement between the toothed sectors of the lever arms and the cork puller shaft. To manufacture, elongated rib members are initially die-cast on the inner surfaces of the support ears and there-after cut away to the desired length to form the pivot support for the lever arms. As cast, the inner surfaces of the support ears diverge outwardly and thereafter the outer ends of the support ears are bent toward each other so that the inner surfaces thereof diverge in-wardly. The lever arms are thereafter assembled by merely force fitting them onto place between the sup-port ears.

4 Claims, 8 Drawing Figures

United States Patent [19]

Marceca

[11] **Des. 247,279**
[45] ** Feb. 21, 1978**

[54] **COMBINED CORKSCREW AND CAN OPENER OR SIMILAR ARTICLE**

[76] Inventor: **Robert K. Marceca**, 246 E. 58th St., New York, N.Y. 10022

[**] Term: 14 Years
[21] Appl. No.: 697,326
[22] Filed: June 18, 1976
[51] Int. Cl. D7—06
[52] U.S. Cl. D8/42
[58] Field of Search D8/33, 39, 40, 41, 42, D8/43; 81/3.45, 338 A, 3.47, 3.48 R, 3.1 A, 3.1 C, 3.48

[56] **References Cited**
U.S. PATENT DOCUMENTS

847,775	4/1900	Walker	81/3.1 A
1,359,305	11/1920	Adels	7/14.25

FOREIGN PATENT DOCUMENTS

1,258,334 2/1959 France 81/3.45
1,205,152 3/1952 Italy 81/3.65

Primary Examiner—Winifred E. Herrmann
Attorney, Agent, or Firm—Charles E. Temko

[57] **CLAIM**

The ornamental design for a combined corkscrew and can opener or similar article, substantially as shown.

DESCRIPTION

FIG. 1 is a side elevational view of a combined cork-screw and can opener or similar article showing my new design;
FIG. 2 is a side elevational view thereof as seen from the right hand portion of FIG. 1;
FIG. 3 is a side elevational view thereof as seen from the side opposite that seen in FIG. 1;
FIG. 4 is a side elevational view thereof as seen from the side opposite that seen in FIG. 2;
FIG. 5 is a bottom plan view thereof; and
FIG. 6 is a top plan view thereof.

United States Patent [19]

Bozzo

[11] **4,097,980**
[45] **Jul. 4, 1978**

[54] **METHOD OF MANUFACTURE OF A MECHANICAL CORK PULLER**

[75] Inventor: **George J. Bozzo**, New Milford, N.J.
[73] Assignee: Irriware Division of Beatrice Foods Company, Astoria, N.Y.
[21] Appl. No.: 773,169
[22] Filed: Mar. 1, 1977

Related U.S. Application Data

[62] Division of Ser. No. 647,784, Jan. 9, 1976.
[51] Int. Cl. B23P 19/00
[52] U.S. Cl. 29/434; 29/453; 81/3 A; 403/159
[58] Field of Search 29/434, 453, 416, 418; 403/157, 159, 254/12, 95; 81/3.37; 74/422, 524, 534, 535, 536; 403/157, 159, 254/12, 95

[56] **References Cited**
U.S. PATENT DOCUMENTS

1,753,026	4/1930	Rosati	81/3.37
2,305,562	12/1942	Thompson et al.	403/159
2,675,606	4/1954	Lawson	29/453 X

Primary Examiner—Charlie T. Moon
Attorney, Agent, or Firm—Morgan, Finnegan, Pine, Foley & Lee

[57] **ABSTRACT**

An improved mechanical cork puller wherein the pivot holes of the lever arms receive and pivot about one or more ribs formed on the inner surfaces of the opposed pairs of support ears, resulting in no visible sign of a pivot support on the outer surfaces of the support ears. The support ears have an inwardly diverging taper providing free meshing movement between the toothed sectors of the lever arms and the cork puller shaft. To manufacture, elongated rib members are initially die-cast on the inner surfaces of the support ears and there-after cut away to the desired length to form the pivot support for the lever arms. As cast, the inner surfaces of the support ears diverge outwardly and thereafter the outer ends of the support ears are bent toward each other so that the inner surfaces thereof diverge in-wardly. The lever arms are thereafter assembled by merely forcing fitting them onto place between the sup-port ears.

7 Claims, 8 Drawing Figures

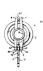

U.S. Patent

July 4, 1978 Sheet 1 of 2 **4,097,980**

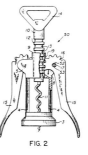

FIG. 1 (PRIOR ART) FIG. 2

FIG. 4 FIG. 8

United States Patent [19]

Liebscher et al.

[11] **4,135,415**
[45] **Jan. 23, 1979**

[54] **CORKSCREW**

[75] Inventors: **Johannes Liebscher**, Nassau (Lahn), **Rolf G. Schmizz**, Singhofen, both of Fed. Rep. of Germany
[73] Assignee: Leifheit International Guter Leifheit GmbH, Nassau (Lahn), Fed. Rep. of Germany
[21] Appl. No.: 807,752
[22] Filed: Jun. 17, 1977
[30] **Foreign Application Priority Data**
Jun. 24, 1976 [DE] Fed. Rep. of Germany 2628352
[51] Int. Cl. B67B 7/00
[52] U.S. Cl. 81/3.38 A; 81/3.1 A
[58] Field of Search 81/3.1 A, 3.38 A, 81/3.35, 3.36, 3.37, 3.38 R, 3.38 A, 3.45, 3.46 R, 3.46 A, 3.47, 3.48, 3.49

[56] **References Cited**
U.S. PATENT DOCUMENTS

D. 146,433	3/1947	Petersen	D8/42
515,414	2/1894	Crellin	81/3.38 A
1,200,079	10/1916	Christensen et al	81/3.35

FOREIGN PATENT DOCUMENTS

556099	1/1957	Belgium	81/3.38 A	
606621	3/1892	Fed. Rep. of Germany	81/3.38 R	
713083	11/1931	France	81/3.38 R	
201	of	1897	United Kingdom	81/3.35
1194179	6/1970	United Kingdom	81/3.45	

Primary Examiner—Al Lawrence Smith
Assistant Examiner—James G. Smith
Attorney, Agent, or Firm—Michael J. Striker

[57] **ABSTRACT**

A corkscrew includes a support consisting of a support-ing ring adapted to engage a neck of a bottle, and a support bracket connected to the supporting ring. An elongated spindle having a cork-engaging helix at its leading end and a threaded portion at its trailing end is mounted on the support for turning relative thereto and also for longitudinal displacement. A nut engages the threaded portion of the spindle and has handgrip por-tions, and a locking element embraces the nut and a probable relative thereto between a locking position in which it connects the nut to the spindle for joint turning and longitudinal displacement, and an unlocking posi-tion in which it releases the spindle for longitudinal displacement during the further turning of the nut. The locking element has an actuating portion which engages an abutment surface of the support when the helix has penetrated into a cork to the desired extent, the engage-ment of the actuating portion with the surface preventing the locking elements onto its unlocking position where-upon the catch is drawn out of the bottle. A biasing arrangement, such as a torsion spring, is superposed between the nut and the locking element, urging the latter towards its locking position. The supporting ring has an elastic lining which contacts the neck of the bottle.

13 Claims, 6 Drawing Figures

United States Patent [19]

Essig

[11] **Des. 252,972**
[45] ** Sep. 25, 1979**

[54] **CORE EXTRACTOR**

[76] Inventor: **Ted Essig**, 108-D Shoreline Ct., Noblesville, Ind. 46060

[**] Term: 14 Years
[21] Appl. No.: 810,932
[22] Filed: Jan. 29, 1977
[51] Int. Cl. D07—06
[52] U.S. Cl. D8/42; D7/106
[58] Field of Search 30/164.3, 164.9; 81/3.36, 3.46, 3.48, 3.47; D8/41, 42, 40, 33; D7/106, 101

[56] **References Cited**
U.S. PATENT DOCUMENTS

D. 26,420 1/1898 Rowley D8/41

166,108	7/1867	Derby	30/164.9
1,435,846	11/1922	McCahey	30/164.3
1,649,309	2/1923	Tyler	81/3.47
1,305,132	5/1930	Loewek	30/164.9

Primary Examiner—Winifred E. Herrmann
Attorney, Agent, or Firm—Harold R. Woodard

[57] **CLAIM**

The ornamental design for a cork extractor, as shown and described.

DESCRIPTION

FIG. 1 is a side elevational view of a cork extractor showing my new design, the unit opposite being a mir-ror image thereof.
FIG. 2 is a front elevational view thereof.
FIG. 3 is a rear elevational view thereof.
FIG. 4 is a bottom plan view thereof; and
FIG. 5 is a top plan view thereof.

United States Patent [19]

Ailen

[11] **4,253,351**
[45] **Mar. 3, 1981**

[54] **CORK EXTRACTOR**

[75] Inventor: **Herbert Ailen**, Houston, Tex.
[73] Assignee: Hallen Company, Houston, Tex.
[21] Appl. No.: 56,281
[22] Filed: Jul. 9, 1979
[51] Int. Cl. B67B 7/00
[52] U.S. Cl. 81/3.38 A
[58] Field of Search 81/3.37, 3.38 A, 3.48

[56] **References Cited**
U.S. PATENT DOCUMENTS

532,575	1/1895	Morgan	81/3.31
562,641	6/1896	McMaster	81/3.38 A
593,691	11/1897	Stoll	81/3.33
620,949	3/1899	Morgan	81/3.33
644,081	2/1900	Morgan	81/3.33
676,225	6/1901	Koppinger	81/3.33
678,771	7/1901	Coomber	81/3.33
716,152	11/1904	Strohacker et al	81/3.33
845,606	2/1907	Bisner	81/3.31

FOREIGN PATENT DOCUMENTS

2340898 9/1977 France 81/3.48

Primary Examiner—James G. Smith
Attorney, Agent, or Firm—Browning, Bushman & Zamecki

[57] **ABSTRACT**

Apparatus for extracting a cork from a bottle compris-ing a corkscrew rotatably mounted on a carrier, the carrier in turn being mounted for longitudinal recipro-cation on a frame. The apparatus further includes a control nut having a screw passage positioned to re-ceive the corkscrew and configured to mate with the configuration of the corkscrew whereby, upon longitu-dinal movement of the corkscrew in the screw passage, rotational movement will be imparted to the corkscrew. A latch, engageable and releasable independently of the force of gravity is provided for releasably latching the control nut to the frame to restrain relative longitudinal movement therebetween. Relative rotation between the control nut and the frame is also prevented. A bottle-engaging assembly is connected to the frame for posi-tioning a bottle with respect to the frame in longitudinal alignment with the screw passage. The bottle-engaging assembly is associated with the latch and, when a bottle is engaged therein, is operative cooperatively with the engaged bottle to release the latch. The apparatus fur-ther comprises guide means laterally spaced from the corkscrew and cooperative between the frame and the carrier for guiding the latter in a longitudinal path. Means are also provided for restricting rotation of the corkscrew as it is raised from the bottle with the cork.

31 Claims, 26 Drawing Figures

United States Patent [19]

MacNeill

[11] **Des. 259,698**
[45] ** Jun. 30, 1981**

[54] **HANDLE FOR A GOLF SPIKE WRENCH, SCREW DRIVER, CORKSCREW AND OTHER DEVICES**

[76] Inventor: **Arden B. MacNeill**, Garrison House La., Sudbury, Mass. 01776

[**] Term: 14 Years
[21] Appl. No.: 26,033
[22] Filed: Apr. 2, 1979
[51] Int. Cl. D8—06
[52] U.S. Cl. D8/107; D8/83; 81/177 R
[58] Field of Search D8/83, 107; 81/177 R, 145/61 R, 61 C

[56] **References Cited**
U.S. PATENT DOCUMENTS

28,691 5/1898 Swartz D8/83

51,641	1/1918	Hargrave	D8/83
107,007	11/1937	Cashmore	D8/83
D. 111,158	11/1939	Cashmore	D8/83
1,980,087	11/1934	Rose	145/61 R
2,930,746	8/1960	Towne	145/61 C

Primary Examiner—Veronica O'Keefe
Attorney, Agent, or Firm—Herbert L. Gatewood

[57] **CLAIM**

The ornamental design for a handle for a golf spike wrench, screw driver, corkscrew and other devices as shown.

DESCRIPTION

FIG. 1 is a side view of a handle for a golf spike wrench, screw driver, corkscrew and other devices showing my new design;
FIG. 2 is a front view thereof;
FIG. 3 is a rear view thereof;
FIG. 4 is a top view thereof; and
FIG. 5 is a bottom view thereof.

United States Patent [19]
Allen
[11] 4,377,096
[45] * Mar. 22, 1983

[54] CORK EXTRACTOR
[75] Inventor: Herbert Allen, Houston, Tex.
[73] Assignee: Hallen Company, Houston, Tex.

FOREIGN PATENT DOCUMENTS
Primary Examiner—James G. Smith
Attorney, Agent, or Firm—Browning, Bushman, Zamecki & Anderson

United States Patent [19]
Desnoulez et al.
[11] 4,393,733
[45] Jul. 19, 1983

[54] CORKSCREWS WITH TACKLE REDUCTION

U.S. Patent Jul. 19, 1983 Sheet 1 of 3 4,393,733

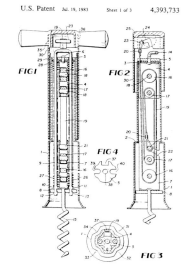

FIG 1 FIG 2 FIG 4 FIG 3

United States Patent [19]
Cuppett
[11] 4,399,720
[45] Aug. 23, 1983

[54] CORK PULLER
[75] Inventor: Darrell J. Cuppett, New York, N.Y.
[73] Assignee: Towle Manufacturing Company, Boston, Mass.

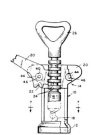

United States Patent [19]
Allen
[11] 4,429,444
[45] Feb. 7, 1984

[54] CORK EXTRACTOR

U.S. Patent Feb. 7, 1984 Sheet 1 of 2 4,429,444

FIG 1 FIG 2

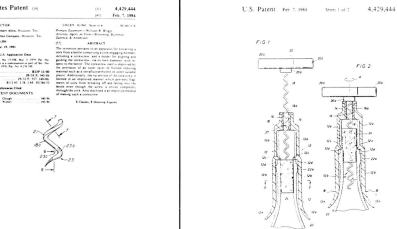

United States Patent [19]
Dejous et al.
[11] 4,437,359
[45] Mar. 20, 1984

[54] WINE WAITER'S CORKSCREWS

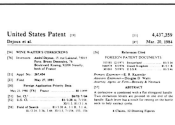
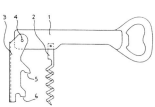

United States Patent [19]
Colombo
[11] Patent Number: Des. 274,974
[45] Date of Patent: ** Aug. 7, 1984

[54] CORKSCREW

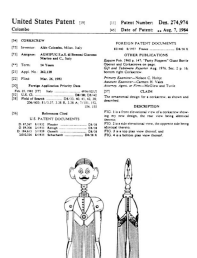

United States Patent [19]
Hashimoto
[11] Patent Number: 4,464,956
[45] Date of Patent: Aug. 14, 1984

[54] CORK-EXTRACTING DEVICE

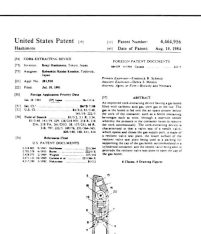

United States Patent [19]
Ravreby
[11] Patent Number: Des. 276,788
[45] Date of Patent: ** Dec. 18, 1984

[54] CORK EJECTOR
[75] Inventor: Fred A. Ravreby, Framingham, Mass.
[73] Assignee: Alon Products Inc., New York, N.Y.
[**] Term: 14 Years
[21] Appl. No.: 352,413
[22] Filed: Feb. 26, 1982
[52] U.S. Cl. D8/42
[58] Field of Search D8/33, 36, 40, 41, 42, D8/43, 81/3, 2

[56] References Cited
U.S. PATENT DOCUMENTS

Primary Examiner—Carmen H. Vales
Assistant Examiner—
Attorney, Agent, or Firm—Millen & Whor

[57] CLAIM
The ornamental design for a cork ejector, substantially as shown and described.

DESCRIPTION
FIG. 1 is a top perspective view of a cork ejector showing my new design;
FIG. 2 is a bottom perspective view thereof;
FIG. 3 is a left side elevational view, the right side being a mirror image thereof.
FIG. 4 is a front elevational view thereof;
FIG. 5 is a rear elevational view thereof;
FIG. 6 is a top plan view thereof; and
FIG. 7 is a bottom plan view thereof.

United States Patent [19]
Kuhn
[11] Patent Number: Des. 281,855
[45] Date of Patent: ** Dec. 24, 1985

[54] CORKSCREW
[75] Inventor: Jacques Kuhn, Rikon, Switzerland
[73] Assignee: Heinrich Kuhn Metallwarenfabrik AG, Rikon, Switzerland
[**] Term: 14 Years
[21] Appl. No.: 560,853
[22] Filed: Dec. 12, 1983
[52] U.S. Cl. D8/42
[58] Field of Search D8/42, 18, 38, 33, 45, 81/3.1 R, 3.1 A, 3.34, 3.38 A, 2.37, 3.45, 7/134, 155

[56] References Cited
U.S. PATENT DOCUMENTS

FOREIGN PATENT DOCUMENTS

Primary Examiner—Bernard Ansher
Assistant Examiner—Terry Pfeifer
Attorney, Agent, or Firm—Wood, Dalton, Phillips, Mason & Rowe

[57] CLAIM
The ornamental design for the corkscrew, as shown and described.

DESCRIPTION
FIG. 1 is a front elevation of the corkscrew showing my new design, the opposite side being a mirror image;
FIG. 2 is a top elevation thereof, the opposite side being a mirror image;
FIG. 3 is a left side plan view thereof; and
FIG. 4 is a bottom plan view thereof.

United States Patent [19]
Youhanaie
[11] Patent Number: Des. 281,946
[45] Date of Patent: ** Dec. 31, 1985

[54] CORKSCREW
[76] Inventor: Gerald Youhanaie, 948 E. Redfield Rd., Tempe, Ariz. 85283
[**] Term: 14 Years
[21] Appl. No.: 503,886
[22] Filed: Jun. 13, 1983
[92] U.S. Cl. D8/38
[58] Field of Search D8/38, 18, 42, 81/3.1 A, 3.38 A, 3.45, 7/155, 154, D11/160

[56] References Cited
U.S. PATENT DOCUMENTS

FOREIGN PATENT DOCUMENTS

OTHER PUBLICATIONS
Gilt & Art Buyer Catalog, 5/07, p. 81, Corkscrews.

Primary Examiner—Bernard Ansher
Assistant Examiner—Terry Pfeffer
Attorney, Agent, or Firm—H. Gordon Shields

[57] CLAIM
The ornamental design for a corkscrew, as shown and described.

DESCRIPTION
FIG. 1 is a front elevational view of my new design for a corkscrew;
FIG. 2 is a rear elevational view thereof;
FIG. 3 is a top plan view thereof;
FIG. 4 is a bottom plan view thereof;
FIG. 5 is a right side elevation thereof; and
FIG. 6 is a left side elevation thereof.

United States Patent [19]
Pracht
[11] Patent Number: 4,570,512
[45] Date of Patent: Feb. 18, 1986

[54] CORK SCREW HAVING A BELL-SHAPED HOUSING
[75] Inventor: Gunther Pracht, Solingen, Fed. Rep. of Germany
[73] Assignee: August Reuterhan GmbH. & Co. KG, Solingen, Fed. Rep. of Germany
[21] Appl. No.: 679,423
[22] Filed: Dec. 4, 1984
[30] Foreign Application Priority Data
Dec. 22, 1983 [DE] Fed. Rep. of Germany
[51] Int. Cl.³ B67B 7/18
[52] U.S. Cl. 81/3.29
[58] Field of Search 81/3.29, 3.45, 3.36, 3.37, 3.48, 7/155

[56] References Cited
U.S. PATENT DOCUMENTS

FOREIGN PATENT DOCUMENTS

Primary Examiner—James L. Jones, Jr.
Attorney, Agent, or Firm—John C. Smith, Jr.

[57] ABSTRACT
With a cork screw having a bell-shaped housing with which a cork can be lifted out of the neck of a bottle without reversing the turning direction of the corkscrew blade and which is provided with a sleeve-like body with which the cork screw is firmly put on the neck of the bottle to be uncorked in order to lift out the cork, the lifting of the cork out of the bottle to be uncorked is often made difficult because the cork-screw blade is not centered. In order to avoid this disadvantage, there is guided in the sleeve-like body, a spring-loaded piston which is located near the lower end of the sleeve-like body, when the cork-screw blade is driven into the cork and through which the cork-screw blade passes centrally with a slight clearance.

2 Claims, 5 Drawing Figures

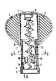

United States Patent [19]
Lee
[11] Patent Number: 4,572,034
[45] Date of Patent: Feb. 25, 1986

[54] CORK SCREW
[76] Inventor: Wen-Hua Lee, 4th Fl., No. 61, Lin Hu-I Rd., Kaohsiung City, Taiwan
[21] Appl. No.: 673,441
[22] Filed: Nov. 21, 1984
[51] Int. Cl.³ B67B 7/18
[52] U.S. Cl. 81/3.29; 81/3.45
[58] Field of Search 81/3.48

[56] References Cited
U.S. PATENT DOCUMENTS

Primary Examiner—James L. Jones, Jr.
Attorney, Agent, or Firm—Millen & Whor

[57] ABSTRACT
An improved cork screw, which comprises a rotary handle and a cork penetrating spiral member encased in an upper hollow shank and a lower bell-shaped pedestal which can be seated on a bottle. A cork pulling lever is attached to the top of the spiral member and threaded through two diametrically opposite longitudinal apertures provided in the wall of the hollow shank. It is upwardly fitted to the bottom side of the handle and movable up-and-on downward along the longitudinal apertures. When the cork is to be pulled out, the user may hold the handle with his one hand and pull the lever towards the handle with his own fingers, thereby facilitating the cork's removal.

6 Claims, 3 Drawing Figures

United States Patent [19]
Jones
[11] Patent Number: 4,574,662
[45] Date of Patent: Mar. 11, 1986

[54] DEVICE FOR REMOVING A CORK OR OTHER RESILIENT STOPPER FROM THE NECK OF A BOTTLE
[75] Inventor: Marvin R. Jones, 414 Flintdale, Houston, Tex. 77024
[73] Assignee: Marvin R. Jones, Houston, Tex.
[21] Appl. No.: 696,757
[22] Filed: Jan. 31, 1985
[51] Int. Cl.³
[52] U.S. Cl. 81/3.45; 81/3.48
[58] Field of Search 81/3.43, 3.48, 3.47

[56] References Cited
U.S. PATENT DOCUMENTS

FOREIGN PATENT DOCUMENTS

Primary Examiner—Roscoe V. Parker
Attorney, Agent, or Firm—Vaden, Eickenroht, Thompson & Jamison

[57] ABSTRACT
There are disclosed several embodiments of a device for use in removing a cork or other resilient stopper from the neck of a bottle, wherein each such device comprises helical spring including at least one helical spring adapted to fit closely within the bottle neck and having a handle at one end by which the spring may be rotated in one directional sense, as it is inserted and forced axially inwardly between the cork and neck, and then pulled axially outwardly so as to remove the cork and spring from the neck.

8 Claims, 14 Drawing Figures

United States Patent [19]
Delisle, Jr.
[11] Patent Number: 4,574,663
[45] Date of Patent: Mar. 11, 1986

[54] CORK EXTRACTOR
[76] Inventor: Bernard Delisle, Jr., P.O. Box 1185, Edgartown, Mass. 02554
[21] Appl. No.: 606,384
[22] Filed: May 2, 1984
[51] Int. Cl.³ B67B 7/00
[52] U.S. Cl. 81/3.48; 81/3.09
[58] Field of Search 81/3.48, 3.49, 3.1 A, 7/155, 156

[56] References Cited
U.S. PATENT DOCUMENTS

FOREIGN PATENT DOCUMENTS

Primary Examiner—James G. Smith
Attorney, Agent, or Firm—Barlow & Barlow, Ltd.

[57] ABSTRACT
An improved cork extractor is disclosed which has a corkscrew secured to a body member in a pivoting relationship thereto, with a fulcrum member pivoted to one end of the body member in co-act with the corkscrew. The fulcrum member is also provided with a knife portion for cutting the seals about bottle tops, and a cover is slidably arranged on the body member to cover the corkscrew, when the same is pivoted into parallel relationship with the body member to make a convenient case for the cork extractor.

4 Claims, 6 Drawing Figures

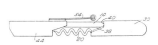

United States Patent [19]
Henshaw
[11] Patent Number: 4,580,303
[45] Date of Patent: Apr. 8, 1986

[54] BOTTLE OPENER AND RESEALER
[76] Inventor: Garry E. Henshaw, 6616 St. Estaban, Tujunga, Calif. 91042
[21] Appl. No.: 691,512
[22] Filed: Jan. 14, 1985
[30] Foreign Application Priority Data
Apr. 5, 1984 [DE] Fed. Rep. of Germany
Apr. 7, 1984 [DE] Fed. Rep. of Germany
[51] Int. Cl.³ B67B 7/44; B67B 7/16
[52] U.S. Cl. 81/3.55; 81/3.45, 215/226
[58] Field of Search 81/3.07, 3.09, 3.4, 81/3.45, 3.55, 3.57, 7/151, 155, 215/226, 227, 237, 364

[56] References Cited
U.S. PATENT DOCUMENTS

FOREIGN PATENT DOCUMENTS

Primary Examiner—Roscoe V. Parker
Attorney, Agent, or Firm—Jack C. Munro

[57] ABSTRACT
A bottle opener and resealer which is combined into a single unit wherein there is incorporated a head member having both a bottle opening recess and a bottle cap revealing recess. A corkscrew member extends from its head member. A removable protective sheath is located about the corkscrew member when not in use. A stopper for a bottle is mounted about the protective sheath which is to be used within the neck of a bottle to close such. The protective sheath is to be removable and associated with the head in order to function as a handle to facilitate operation of the corkscrew member.

5 Claims, 8 Drawing Figures

U.S. Patent Apr. 8, 1986 Sheet 1 of 2 4,580,303

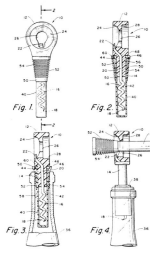

Fig. 1.
Fig. 2.
Fig. 3.
Fig. 4.

United States Patent [19]
Cellini

[11] Patent Number: 4,584,911
[45] Date of Patent: Apr. 29, 1986

[54] CORKSCREW DEVICE
[75] Inventor: Ferdinando Cellini, Maniago, Italy
[73] Assignee: Farm DI F.S.a.s., Maniago, Italy
[21] Appl. No.: 652,907
[22] Filed: Sep. 21, 1984
[30] Foreign Application Priority Data
Oct. 29, 1983 [IT] Italy 84476/83[U]
[51] Int. Cl.⁴ B67B 7/04; B67B 7/16
[52] U.S. Cl. 81/3.36; 81/3.09; 81/3.55
[58] Field of Search 81/3.36, 81/3.44, 3.1 R, DR/40, 42; 81/3.46 R, 3.44, 3.1 R

[56] References Cited
U.S. PATENT DOCUMENTS
4,447,359 3/1984 Dejean et al. 81/3.36 A
FOREIGN PATENT DOCUMENTS
571372 2/1943 Fed. Rep. of Germany
6570 of 1909 United Kingdom
Primary Examiner—Roscoe V. Parker
Attorney, Agent, or Firm—Wegner & Bretschneider

[57] ABSTRACT
A corkscrew having a lever of the second order that is rotatably connected to each of a support to engage a bottle and a screw. The corkscrew is so configured that one can vary the distance between a point of the screw and a rotatable connection pin between the lever and the support.

12 Claims, 6 Drawing Figures

United States Patent [19]
Hagedorn et al.

[11] Patent Number: Des. 286,483
[45] Date of Patent: Nov. 4, 1986

[54] RACK FOR CORKSCREW
[75] Inventors: Leonhard Hagedorn, Niedernrnsen; Rolf-Günter Schulein, Singhofen, both of Fed. Rep. of Germany
[73] Assignee: Leifheit AG, Nassau, Fed. Rep. of Germany
[**] Term: 14 Years
[21] Appl. No.: 785,059
[22] Filed: Oct. 4, 1985

Related U.S. Application Data
[62] Division of Ser. No. 664,115, Oct. 27, 1984, which is a division of Ser. No. 251,586, Apr. 6, 1981, Pat. No. Des. 276,018.
[30] Foreign Application Priority Data
Oct. 31, 1980 [DE] Fed. Rep. of Germany ... GMR 1061
[52] U.S. Cl. D6/553
[58] Field of Search D6/552-554, D6/767, 526, 534, 211/60.1, 70.7, 248/37.6, 314

[56] References Cited
U.S. PATENT DOCUMENTS
D. 141,647 7/1946 Chandler D4/39
D. 226,348 2/1973 van der Kroft D8/29
D. 231,422 4/1974 Berend D6/567
D. 243,426 2/1977 Joreyn D6/567
D. 251,391 11/1979 Dreyer D8/29
1,937,424 11/1933 Champlin 248/37.6
1,305,100 2/1947 Champlin 248/37.6
3,580,394 3/1971 Elliott 248/37.6
Primary Examiner—Bernard Ansher
Assistant Examiner—Terry Pfeffer
Attorney, Agent, or Firm—Fishauf & Partners

[57] CLAIM
The ornamental design for a rack for corkscrew, as shown and described.

DESCRIPTION
FIG. 1 is an elevational view of the front side of a rack for corkscrew, showing my new design, the rear surface thereof being flat and unornamented.
FIG. 2 is a left side view thereof.
FIG. 3 is a right side view thereof.
FIG. 4 is a bottom side view thereof, and
FIG. 5 is a top side view thereof.

United States Patent [19]
Bertram et al.

[11] Patent Number: 4,637,283
[45] Date of Patent: Jan. 20, 1987

[54] CORKSCREW DEVICE
[75] Inventors: Leo Bertram, Stolberg, Fed. Rep. of Germany; Romuald L. Bukowitsch, Peter Steiner, both of Klagenfurt, Austria
[73] Assignee: U.S. Philips Corporation, New York, N.Y.
[21] Appl. No.: 738,131
[22] Filed: May 24, 1985
[30] Foreign Application Priority Data
Jun. 1, 1984 [AT] Austria 38X 84
[51] Int. Cl.⁴ B67B 7/04
[52] U.S. Cl. 81/3.2, 81/3.29
[58] Field of Search 81/3.29, 3.48, 3.10/41, 318/136, 280, 778, 466-468

[56] References Cited
U.S. PATENT DOCUMENTS
1,938,454 12/1911 Clark 81/3.2
1,988,971 1/1935 Munro et al. 81/3.29
2,064,211 6/1933 Massinger 81/3.2
1,073,176 2/1981 Dongvlan 310/41 X
3,179,236 4/1965 Troop 310/41 X
3,473,059 10/1969 Leengard et al. 310/41 X
2,814,492 10/1957 Yasuhira 310/41
3,748,594 7/1973 Woolley 310/41
3,842,296 10/1974 Getber 310/41

FOREIGN PATENT DOCUMENTS
309361 5/1909 Fed. Rep. of Germany 81/3.2
129326 11/1964 Fed. Rep. of Germany 81/3.29
3037781 5/1982 Fed. Rep. of Germany
Primary Examiner—Frederick R. Schmidt
Assistant Examiner—Debra S. Meislin
Attorney, Agent, or Firm—Rolf S. Schneider

[57] ABSTRACT
A corkscrew comprises a sleeve coaxial with a corkscrew spiral and formed to cooperate with a bottleneck provided with a cork. An electric motor drives the corkscrew spiral by means of a reduction gear, the corkscrew spiral being capable of being screwed into the cork in one direction of rotation with the cork being drawn from the bottleneck without the direction of rotation being reversed, the reduction gear providing a reduction ratio of 60:1 to 100:1, the electric motor being a self-starting two-pole single-phase synchronous motor with a diametrically magnetized permanent-magnet rotor. A reversible unidirectional latch is situated at the driven side of the corkscrew spiral for defining the direction of rotation of the motor, such unidirectional latch cooperating with a part of the reduction gear driven by the motor with an integral reduction ratio. Provision is made to reverse the blocking direction of the unidirectional latch to select one of the two directions of rotation of the motor.

16 Claims, 2 Drawing Figures

United States Patent [19]
Van Asten

[11] Patent Number: Des. 288,521
[45] Date of Patent: Mar. 3, 1987

[54] ELECTRIC CORK REMOVER
[75] Inventor: Jan F. Van Asten, Leek, Netherlands
[73] Assignee: U.S. Philips Corporation, New York, N.Y.
[**] Term: 14 Years
[21] Appl. No.: 644,584
[22] Filed: Aug. 27, 1984
[30] Foreign Application Priority Data
Mar. 2, 1984 [XB] Benelux 38278-00
[52] U.S. Cl. D8/42
[58] Field of Search D8/42, 36, 40, 41, 18, D8/33, 34; 81/3.36; 7/151, 154-155

[56] References Cited
U.S. PATENT DOCUMENTS
D. 145,245 7/1946 De Lemos D4/34
D. 268,245 3/1983 Makino et al. 81/2.2 X
Primary Examiner—Bernard Ansher
Assistant Examiner—Terry Pfeffer
Attorney, Agent, or Firm—Rolf E. Schneider

[57] CLAIM
The ornamental design for a electric cork remover, as shown.

DESCRIPTION
FIG. 1 is a front, bottom and right side perspective view of the electric cork remover, showing my new design;
FIG. 2 is a right side elevational view thereof;
FIG. 3 is a left side elevational view thereof,
FIG. 4 is a front elevational view thereof,
FIG. 5 is a rear elevational view thereof,
FIG. 6 is a top plan view thereof,
FIG 7 is a bottom plan view thereof.

United States Patent [19]
Pracht

[11] Patent Number: 4,658,678
[45] Date of Patent: Apr. 21, 1987

[54] CORK SCREW FURNISHED WITH A BELL-SHAPED HOUSING
[75] Inventor: Günter Pracht, Solingen, Fed. Rep. of Germany
[73] Assignee: August Reutershan GmbH. & Co. KG, Solingen, Fed. Rep. of Germany
[21] Appl. No.: 785,121
[22] Filed: Oct. 7, 1985
[30] Foreign Application Priority Data
Nov. 28, 1984 [DE] Fed. Rep. of Germany ...
[51] Int. Cl.⁴ B67B 7/04
[52] U.S. Cl. 81/3.29, 81/3.45
[58] Field of Search 81/3.47, 3.36, 3.29, 3.36

[56] References Cited
U.S. PATENT DOCUMENTS
2,522,214 9/1950 Gaeta 81/3.48
4,276,789 7/1981 Allen 81/3.45
4,570,512 2/1986 Pracht 81/3.29

FOREIGN PATENT DOCUMENTS
831575 1/1973 Canada 81/3.48
0056011 7/1982 European Pat. Off.
1346414 11/1987 Fed. Rep. of Germany
2360090 6/1977 France
7701133 8/1977 Netherlands
8409994 10/1985 Netherlands
Primary Examiner—Frederick R. Schmidt
Assistant Examiner—Debra R. Meislin
Attorney, Agent, or Firm—John C. Smith, Jr.

[57] ABSTRACT
In order to constructionally simplify a cork screw having a bell-shaped housing with which a cork can be lifted out of the bottle neck without re-using the turning direction of the cork-screw blade, the cork screw blade projects in a known manner with one of its ends out of the closed end of the bell-shaped housing and is firmly connected to a tommy handle. A telescopic tube is arranged between the bell-shaped housing and the tommy handle and encompasses a section of the cork screw blade; said telescopic tube being firmly connected with one of its ends to the bell-shaped housing and with its other end to the tommy handle.

11 Claims, 3 Drawing Figures

United States Patent [19]
Lee

[11] Patent Number: 4,677,883
[45] Date of Patent: Jul. 7, 1987

[54] CORK SCREW
[76] Inventor: Wen-Hus Lee, 4th Fl., No. 61, Lu-Ho 1 Road, Kaohsiung City, Taiwan
[21] Appl. No.: 872,121
[22] Filed: Jun. 9, 1986
[51] Int. Cl.⁴ B67B 7/04
[52] U.S. Cl. 81/3.37; 81/3.29
[58] Field of Search 81/3.29, 3.33, 3.36, 81/3.37, 3.45, 3.07, 3.08, 3.48, 3.31, 3.32, 3R/40, 42

[56] References Cited
U.S. PATENT DOCUMENTS
344,566 6/1886 Cluever 81/3.29
420,572 2/1890 Eate 81/3.33

OTHER PUBLICATIONS
Tire-Bouchon, Par M. Perrile, Pl. II, FIG. 7, Apr. 15, 1876, 81/3.37
Primary Examiner—Frederick R. Schmidt
Assistant Examiner—Debra S. Meislin
Attorney, Agent, or Firm—Jack C. Munro

[57] ABSTRACT
A cork screw which has a screw stem with a rotary handle incorporating a penetrating screw, and a hollow pedestal to be seated on a bottle sleeved movably on the stem and encasing the penetrating screw. Dog members are fulcrumed on the pedestal and engage releasably with a helical groove of the screw stem. Upon rotation of the handle, the penetrating screw penetrates into the cork and subsequently pulls out the cork from the bottle.

3 Claims, 5 Drawing Figures

United States Patent [19]
Rogers

[11] Patent Number: Des. 290,682
[45] Date of Patent: Jul. 7, 1987

[54] CORK RETRIEVER
[76] Inventor: Jay J. Rogers, 205-470 Granville Street, Vancouver, British Columbia, Canada, V6C 1V5
[**] Term: 14 Years
[21] Appl. No.: 696,409
[22] Filed: Jan. 30, 1985
[30] Foreign Application Priority Data
Aug. 10, 1984 [CA] Canada 10-08-84-12
[52] U.S. Cl. D8/42
[58] Field of Search D8/33, 18, 38, 40-43; 81/3.4, 3.07, 3.41, 3.48

[56] References Cited
U.S. PATENT DOCUMENTS
D. 244,002 4/1977 Bonin D8/42
FOREIGN PATENT DOCUMENTS
668912 7/1929 France 81/3.07
Primary Examiner—Bernard Ansher
Assistant Examiner—Terry Pfeffer
Attorney, Agent, or Firm—Klarquist, Sparkman, Campbell, Leigh & Whinston

[57] CLAIM
The ornamental design for a cork retriever, as shown and described.

DESCRIPTION
FIG. 1 is a front view of a cork retriever showing my new design;
FIG. 2 is a perspective view thereof; and
FIG. 3 is a top view thereof.

United States Patent [19]
Deinero

[11] Patent Number: 4,679,467
[45] Date of Patent: Jul. 14, 1987

[54] BROKEN CORK REMOVER
[76] Inventor: Thomas V. Deinero, 423 49th St., Apt. #1, West Palm Beach, Fla. 33407
[21] Appl. No.: 841,824
[22] Filed: Mar. 20, 1986
[51] Int. Cl.⁴ B67B 7/10
[52] U.S. Cl. 81/3.07, 3.44
[58] Field of Search 81/3.07, 3.09, 7/15

[56] References Cited
U.S. PATENT DOCUMENTS
47,161 4/1865 Burkfield et al. 81/3.07
189,474 4/1906 Medley 81/3.07
983,778 2/1911 Serter 81/3.07

FOREIGN PATENT DOCUMENTS
329671 8/1921 Fed. Rep. of Germany 81/3.4
27341 of 1904 United Kingdom 81/3.4
Primary Examiner—Roscoe V. Parker
Attorney, Agent, or Firm—Harvey B. Jacobson

[57] ABSTRACT
A tool for removing broken corks from bottles has an elongate transverse handle with a smaller end for pushing a cork into a bottle and a larger stem end for gripping in the hand. Between the ends of the handle is a transverse stem to which is attached opposite ends of a hand forming a cork removing loop. The opposite ends of the hand have internal projections which fit in recesses in the stem and are covered by a sleeve which can slide on the outside of the stem. Thus provides a particularly convenient form of attachment as between the hand and the stem allowing for ready replacement of broken hands.

2 Claims, 4 Drawing Figures

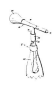

United States Patent [19]
Henshaw

[11] Patent Number: Des. 291,052
[45] Date of Patent: Jul. 28, 1987

[54] COMBINATION BOTTLE OPENER AND RESEALER
[76] Inventor: Garry E. Henshaw, 6616 St. Esteban, Tujunga, Calif. 91042
[**] Term: 14 Years
[21] Appl. No.: 691,413
[22] Filed: Jan. 14, 1985
[52] U.S. Cl. D8/40; D8/18
[58] Field of Search D8/18, 33, 34, 38, 40-43; 81/3.09, 3.4, 3.45, 3.55, 3.07, 7/151, 155; 215/226, 355

[56] References Cited
U.S. PATENT DOCUMENTS
D. 141,245 5/1946 DeLeeuw D8/34

514,200 2/1894 Painter 215/226 X
1,132,931 3/1915 Hamilton 215/226
2,043,341 6/1937 Böhler 81/3.4
Primary Examiner—Bernard Ansher
Assistant Examiner—Terry Pfeffer

[57] CLAIM
The ornamental design for a combination bottle opener and resealer, substantially as shown and described.

DESCRIPTION
FIG. 1 is a front elevational view of a combination bottle opener and resealer showing my new design;
FIG. 2 is a side elevational view thereof;
FIG. 3 is a rear elevational view thereof;
FIG. 4 is a top plan view thereof;
FIG. 5 is a bottom plan view thereof.

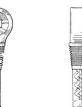

Koziol

[11] Patent Number: Des. 291,174
[45] Date of Patent: ·· Aug. 4, 1987

[54] CORKSCREW
[76] Inventor: Stephan Koziol, 6120 Michelstadt/Odenwald, Fed. Rep. of Germany
[**] Term: 14 Years
[21] Appl. No.: 642,063
[23] Filed: Aug. 17, 1984
[30] Foreign Application Priority Data
Feb. 21, 1984 [DE] Fed. Rep. of Germany ... M8-799
[52] U.S. Cl. D8/38, D8/42
[58] Field of Search D8/38, 42, 36, 40, 41, D8/18, 33,34; 81/3.45; 7/155, 154, 151; D21/51; D23/28
[56] References Cited
U.S. PATENT DOCUMENTS
D. 70,800 8/1926 McDonald D21/51

OTHER PUBLICATIONS
Giftware Business, 4/82, p. 21, simulated Screw Cork-screw, bottom, left corner.

Primary Examiner—Bernard Ansher
Assistant Examiner—Terry Pfeffer
Attorney, Agent, or Firm—Michael J. Striker

[57] CLAIM
The ornamental design for a corkscrew, substantially as shown and described.

DESCRIPTION
FIG. 1 is a bottom perspective view of a cork screw showing my new design.
FIG. 2 is a top plan view thereof.
FIG. 3 is a top perspective view thereof.
FIG. 4 is a side plan view thereof, which accurately represents the opposite side thereof, and
FIG. 5 is a bottom plan view thereof.

Kerti

[11] Patent Number: Des. 291,960
[45] Date of Patent: ·· Sep. 22, 1987

2,614,320 10/1952 Rosenberry 30/418

[54] CAN OPENER
[76] Inventor: Peter Kerti, 45 Bromey Crescent, Toronto, Ontario, M*A 3X1
[**] Term: 14 Years
[21] Appl. No.: 588,315
[22] Filed: Mar. 12, 1984
[30] Foreign Application Priority Data
Sep. 14, 1982 [CA] Canada (40981)
[52] U.S. Cl. D8/33
[58] Field of Search D8/42, 30/418, 426, 441; 7/13, 132, 154.6

References Cited
U.S. PATENT DOCUMENTS
902,818 11/1908 Foss 81/3.09 X
2,554,4.20 5/1951 Okey 81/3.44 X

OTHER PUBLICATIONS
Hong Kong Enterprise, 11/82, p. 157, Can Opener, upper, left corner.

Primary Examiner—Bernard Ansher
Assistant Examiner—Terry Pfeffer
Attorney, Agent, or Firm—David W. Wong

[57] CLAIM
The ornamental design of a can opener as shown and described.

DESCRIPTION
FIG. 1 is a right side elevational view of a can opener showing my invention.
FIG. 2 is a left side plan view thereof.
FIG. 3 is a top plan view thereof.
FIG. 4 is a bottom plan view thereof, and
FIG. 5 is an enlarged front elevational view thereof.

Allen

[11] Patent Number: 4,703,673
[45] Date of Patent: ·· Nov. 3, 1987

[54] CORK-EXTRACTING APPARATUS
[75] Inventor: Herbert Allen, Houston, Tex.
[73] Assignee: Hallen Company, Houston, Tex.
[21] Appl. No.: 721,235
[22] Filed: Apr. 8, 1985
[51] Int. Cl.⁴ B67B 7/04
[52] U.S. Cl. 81/3.29; 81/3.45
[58] Field of Search 81/3.29, 3.34, 3.48, 81/177.2, 3.45, 16/113

References Cited
U.S. PATENT DOCUMENTS

OTHER PUBLICATIONS
Corkscrews for Collectors, Bernard M. Watney and

[57] ABSTRACT
Apparatus for extracting a cork from a bottle comprises a movable portion, a handle, and a holder. The movable portion includes a helical corkscrew. The handle includes at least one elongate arm and is associated with the movable portion such that the arm may extend radially outwardly with respect to the corkscrew in an approaching position of the handle. The arm has a restraining formation disposed distal the corkscrew in the gripping position and adapted to engage a human finger and restrain it against movement radially outwardly. The holder is engageable with a bottle and defines an opening for receipt of a cork as it emerges from the bottle. The holder has a guide which allows rotational and longitudinal movement of the movable portion relative to the holder whereby the corkscrew can be driven downwardly into the cork and to a lowered position with respect to the holder upon rotation of the movable portion at a first direction. The movable portion and the holder have force transmitting formations interengageable, when the movable portion is in its lowered position, and adapted to cause the cork to be removed from the bottle upon further rotation of the movable portion.

33 Claims, 18 Drawing Figures

U.S. Patent Nov. 3, 1987 Sheet 1 of 5 4,703,673

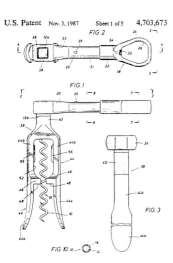

FIG. 2
FIG. 1
FIG. 3
FIG. 10

Barone

[11] Patent Number: Des. 293,200
[45] Date of Patent: ·· Dec. 15, 1987

[54] CORK PULLER
[76] Inventor: Charles A. Barone, 44 Lesley La., New Castle, Del. 19720
[**] Term: 14 Years
[21] Appl. No.: 694,805
[22] Filed: Jan. 25, 1985
[52] U.S. Cl. D8/42, D8/18
[58] Field of Search ... D8/18, 33, 34, 38, 40-43; 81/3.07, 3.09, 3.45
[56] References Cited
U.S. PATENT DOCUMENTS
D. 50,051 12/1916 Anderson D8/42
D. 59,403 10/1921 Bennett D8/34

185,556 6/1908 Stephens 81/3.09 X
1,990,289 2/1935 Krueger 81/3.45

Primary Examiner—Bernard Ansher
Assistant Examiner—Terry Pfeffer
Attorney, Agent, or Firm—Abramo & Abramo

[57] CLAIM
The ornamental design for a cork-puller, as shown and described.

DESCRIPTION
FIG. 1 is a right side elevational view of a cork puller showing my new design;
FIG. 2 is a top plan view thereof.
FIG. 3 is a front elevational view thereof;
FIG. 4 is a bottom plan view thereof; and
FIG. 5 is a left side elevational view thereof.

Allen

[11] Patent Number: Des. 293,414
[45] Date of Patent: ·· Dec. 29, 1987

[54] CORKSCREW
[75] Inventor: Herbert Allen, Houston, Tex.
[73] Assignee: Hallen Company, Houston, Tex.
[**] Term: 14 Years
[21] Appl. No.: 726,114
[22] Filed: Apr. 23, 1985
[52] U.S. Cl. D8/42; D8/43
[58] Field of Search D8/18, 33, 34, 38, 42, D8/43; 7/151, 154-155; 81/3.45, 3.29, 3.36, 3.48
[56] References Cited
U.S. PATENT DOCUMENTS
310,766 1/1885 Wilhelm 81/3.29
4,253,351 3/1981 Allen .
4,276,789 7/1981 Allen .
4,291,797 9/1981 Allen .
4,377,096 3/1983 Allen .
4,429,444 2/1984 Allen .
4,437,359 3/1984 Deyssa et al. 7/154 X

OTHER PUBLICATIONS
The Wonderful Screwpull, brochure by Hallen Company, Sep. 1981.

Primary Examiner—Bernard Ansher
Assistant Examiner—Terry Pfeffer
Attorney, Agent, or Firm—Browning, Bushman, Zamecki & Anderson

[57] CLAIM
The ornamental design for a corkscrew, as shown and described.

DESCRIPTION
FIG. 1 is a top plan view of a corkscrew showing my new design;
FIG. 2 is a front elevational view thereof;
FIG. 3 is a right side elevational view thereof;
FIG. 4 is a left side elevational view thereof;
FIG. 5 is a bottom plan view thereof;
FIG. 6 is a front elevational view thereof, shown in a storage position;
FIG. 7 is a right side elevational view thereof, shown in a storage position;
FIG. 8 is a top plan view thereof, shown in a storage position; and
FIG. 9 is a bottom plan view thereof, shown in a storage position.

Johnson

[11] Patent Number: Des. 294,218
[45] Date of Patent: ·· Feb. 16, 1988

[54] CORKSCREW
[76] Inventor: David B. Johnson, 245 New Road, Croxley Green, Rickmansworth, Hertfordshire WD3 3HE, England
[**] Term: 14 Years
[21] Appl. No.: 707,568
[22] Filed: Mar. 4, 1985
[30] Foreign Application Priority Data
Sep. 5, 1984 [GB] United Kingdom 1021910
[52] U.S. Cl. D8/42
[58] Field of Search D8/18, 33, 34, 40-43; 81/3.09, 3.45, 3.55, 3.07; 7/151, 155
[56] References Cited
U.S. PATENT DOCUMENTS
D. 247,279 2/1978 Marocca D8/43 X

FOREIGN PATENT DOCUMENTS
3302279 7/1984 Fed. Rep. of Germany .. 81/3.09
473156 7/1952 Italy 81/3.45

OTHER PUBLICATIONS
Gifts & Tableware Reporter, 8/76, p. 16, sec. 1, Corkscrew, top, right side.

Primary Examiner—Bernard Ansher
Assistant Examiner—Terry Pfeffer
Attorney, Agent, or Firm—Cushman, Darby & Cushman

[57] CLAIM
The ornamental design for a corkscrew, as shown and described.

DESCRIPTION
FIG. 1 is a top, front, left side perspective view of a corkscrew showing my new design;
FIG. 2 is a top, rear, right side perspective view thereof;
FIG. 3 is a perspective view thereof, shown in an open position; and
FIG. 4 is a bottom plan view thereof.

Lee

[11] Patent Number: 4,727,779
[45] Date of Patent: ·· Mar. 1, 1988

[54] CORK SCREW
[76] Inventor: Wen-Hsin Lee, 4th Fl., No. 61, Lzu-Ho 1 Road, Kaohsiung, Taiwan
[21] Appl. No.: 33,171
[22] Filed: Apr. 1, 1987
Related U.S. Application Data
[63] Continuation-in-part of Ser. No. 172,121, Jun. 9, 1986, Pat. No. 4,677,881.
[51] Int. Cl.⁴ B67B 7/04
[52] U.S. Cl. 81/3.37; 81/3.29; 81/3.45
[58] Field of Search 81/3.07, 3.29, 3.45, 81/3.33, 3.36, 3.07, 3.08, 3.48, 3.31, 3.22, D8/40, 42
[56] References Cited
U.S. PATENT DOCUMENTS
344,306 6/1886 Cluever 81/3.29

OTHER PUBLICATIONS
Tire-Bouchon, Par. M. Perille, Pl. II, FIG. 7, Apr. 13, 1876.

Primary Examiner—Debra Meislin

[57] ABSTRACT
A cork screw which comprises a pedestal and a rotary handle incorporating a stem and a penetrating screw wherein the pedestal incorporates a dog member to engage with a helical groove of the stem and a spring to engage with the helical groove when the handle is turned at a certain direction and disengage therefrom when a cork is pulled entirely out of a bottle. A holding member is incorporated in the pedestal to hold a cork after it has been pulled out of a bottle.

7 Claims, 7 Drawing Figures

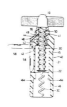

U.S. Patent Mar. 1, 1988 Sheet 3 of 4 4,727,779

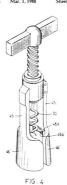

FIG. 4

United States Patent [19]

Kuhn

[11] Patent Number: **Des. 294,449**
[45] Date of Patent: **∗∗ Mar. 1, 1988**

[54] COMBINATION-OPENER, CAPSULE HOLDER AND CORK-SCREW

[75] Inventor: Jacques Kuhn, Rikon, Switzerland

[73] Assignee: Heinrich Kuhn Metallwarenfabrik AktiengesellschaIt, Switzerland

[∗∗] Term: 14 Years

[21] Appl. No.: 731,370

[22] Filed: Mar. 7, 1968

[30] Foreign Application Priority Data

Nov. 1, 1984 [XH] Hogue DMA/00327

[52] U.S. Cl. D8/34
[58] Field of Search D8/34, 18, 33, 38, 39, D8/40, 42, 43, 41, 30/400, 406, 416, 42)–426

[56] References Cited

U.S. PATENT DOCUMENTS

D. 214,079 5/1969 Steiner D8/42

D. 277,926 3/1985 Chow D8/41
D. 289,362 4/1987 Lee D8/41

Primary Examiner—Bernard Ansher
Attorney, Agent, or Firm—Ladas & Parry

[57] CLAIM

The ornamental design for combination tin-opener, capsule holder and cork-screw, as shown.

DESCRIPTION

FIG. 1 is a perspective view of a combination tin-opener, capsule holder and cork-screw showing my new design;
FIG. 2 is a top plan view thereof;
FIG. 3 is a bottom plan view thereof;
FIG. 4 is a right side elevational view thereof;
FIG. 5 is a left side elevational view thereof;
FIG. 6 is a front elevational view thereof;
FIG. 7 is a rear elevational view thereof;
FIG. 8 is a bottom plan view thereof.

United States Patent [19]

Eayds

[11] Patent Number: Des. 296,666
[45] Date of Patent: ∗∗ Jul. 19, 1988

[54] CORK REMOVER

[76] Inventor: Keary Eayds, 1108-2004 Fullerton Avenue, North Vancouver, British Columbia, Canada, V7P 1B8

[∗∗] Term: 14 Years

[21] Appl. No.: 803,918

[22] Filed: Nov. 5, 1985
[58] U.S. Cl. D8/42
[58] Field of Search D8/18, 33, 34, 40, 42, 81/3.07, 3.09, 3.55

[56] References Cited

U.S. PATENT DOCUMENTS

1,370,306 1/1926 Johnson 81/3.49 X
2,486,286 10/1949 Irving 81/3.49
2,641,756 6/1954 Warmbrodt 81/3.48 X

FOREIGN PATENT DOCUMENTS

668912 7/1929 France 81/3.07

Primary Examiner—Bernard Ansher
Assistant Examiner—Terry Pfeffer
Attorney, Agent, or Firm—Geoffrey C. Clark

[57] CLAIM

The ornamental design for a cork remover, substantially as shown and described.

DESCRIPTION

FIG. 1 is an isometric view of a cork remover showing my new design;
FIG. 2 is a front elevational view thereof;
FIG. 3 is a rear elevational view thereof;
FIG. 4 is a right side elevational view thereof;
FIG. 5 is a left side elevational view thereof;
FIG. 6 is a top plan view thereof; and
FIG. 7 is a bottom plan view thereof.

United States Patent [19]

Farfalli

[11] Patent Number: **4,759,238**
[45] Date of Patent: **Jul. 26, 1988**

[54] POCKET CORKSCREW

[75] Inventor: Germano Farfalli, Maniago, Italy

[73] Assignee: Marino Farfalli & Figli s.a.s., Maniago, Italy

[21] Appl. No.: 33,764

[22] Filed: Apr. 3, 1987

[30] Foreign Application Priority Data

Nov. 17, 1986 [IT] Italy 45751 A/86

[51] Int. Cl.⁴ B67B 7/44
[52] U.S. Cl. 81/3.09; 7/154
[58] Field of Search 81/3.07, 3.09, 3.36, 81/3.45, 3.55, 3.35, 7/154, 151

[56] References Cited

FOREIGN PATENT DOCUMENTS

97766 1/1940 Sweden 7/154

Primary Examiner—Roscoe V. Parker
Attorney, Agent, or Firm—Scrivener and Clarke

ABSTRACT

Corkscrew of the type having folding tools (2,2) in a handle (4), such as a screw-type means of insertion in a cork (2) and a fulcrum lever extension means such as mounting lever (3) having a slot seat for crown caps as well, and the additional function of supporting by a notched end on the inside ledge of the bottle's neck together with said means of screw insertion (2), both hinged to one end of the handle at a convenient distance from each other, characterized in that the handle (4) is of plastic material, and the fulcrum lever extension means such as counter-lever (3) is of a semitubular form having a slot seat (3') through its back with an undercut to engage a crown through its back with an undercut to engage a crown complementary with the slot so as to make it screws enable whether the counter-lever is closed or a completely open in alignment, or nearly so, with the handle (4)

3 Claims, 1 Drawing Sheet

United States Patent [19]

Poehlmann

[11] Patent Number: **4,765,206**
[45] Date of Patent: **Aug. 23, 1988**

[54] CORKSCREW

[76] Inventor: Paul W. Poehlmann, 6440 Panoramic Hwy., Stinson Beach, Calif. 94970

[21] Appl. No.: 58,151

[22] Filed: Jun. 4, 1987

[51] Int. Cl.⁴ B67B 7/04
[52] U.S. Cl. 81/3.37; 81/3.29
[58] Field of Search 81/3.37, 3.4, 3.41, 3.42, 254/18, 108, 269/68, 212

[56] References Cited

U.S. PATENT DOCUMENTS

593,698 11/1897 Still 81/3.37

463,004 9/1901 Schermacs 81/3.37

Primary Examiner—Debra Massie
Attorney, Agent, or Firm—Lothrop & West

[57] ABSTRACT

A cork extractor for a cork in a bottle has a frame adapted to engage the bottle and around the axis of the cork and has a rod slidable and rotatable in the frame in line with the cork. A lever pivoted on the frame has a yielding pawl adapted individually to engage and successively to ride over each one of a series of stops on the rod, in this way incrementally extracting the cork with each actuation of the lever.

10 Claims, 1 Drawing Sheet

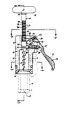

United States Patent [19]

Sechen

[11] Patent Number: **4,766,780**
[45] Date of Patent: **Aug. 30, 1988**

[54] AUTOMATIC CORKSCREW

[76] Inventor: Frank Sechen, 120 Havenside Dr., San Francisco, Calif. 94132

[21] Appl. No.: 99,049

[22] Filed: Sep. 21, 1987

[51] Int. Cl.⁴ B67B 7/04
[52] U.S. Cl. 81/3.92
[58] Field of Search 81/3.36; 81/3.2, 3.33

[56] References Cited

U.S. PATENT DOCUMENTS

1,918,484 12/1935 Clune 81/3.36
1,988,971 1/1935 Morris et al. 81/3.36
2,004,211 6/1935 Munzinger 81/3.36

FOREIGN PATENT DOCUMENTS

797517 6/1979 Fed. Rep of Germany ... 81/3.2

Primary Examiner—Roscoe V. Parker
Attorney, Agent, or Firm—Townsend and Townsend

first penetrates and thereafter extracts a cork from the braced top of a wine bottle. The platform, on which the auger is rotatably mounted, moves to and from a position of full penetration of the auger into the cork. A ball screw moves the platform and provides through a chain for reason of a normally disengaged thrust closed clutch. Initially the platform moves downwardly to a position where the auger fully penetrates the cork. During the downward motion, the auger is thrust into engagement with the cork, closed the normally disengaged clutch and rotates the auger so that the auger flight advances into the cork at the same speed the platform descends. At full penetration, the platform trips a motor reversing switch and re-vises direction and ascends. The normally disengaged clutch is opened. The auger thus remains stationary with respect to the cork. Withdrawal of the cork occurs with the cork engaged by the full length of the auger flight. When cork extraction is completed, continued manual removal of the intact cork from the auger staples presentation of the cork with the wine to the consumer

8 Claims, 2 Drawing Sheets

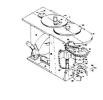

United States Patent [19]

Federighi

[11] Patent Number: **4,791,834**
[45] Date of Patent: **Dec. 20, 1988**

[54] PRESSURE METERING CORK EXTRACTOR

[76] Inventor: George J. Federighi, 70–13th St., San Francisco, Calif. 94103

[21] Appl. No.: 826,334

[22] Filed: Feb. 3, 1986

[51] Int. Cl.⁴ B67B 7/06
[52] U.S. Cl. 81/3.2
[58] Field of Search 81/3, 3.29, 3.45, 81/3.48

[56] References Cited

U.S. PATENT DOCUMENTS

D. 197,983 4/1964 Mouritzen D44/29
1,234,206 3/1920 Weishaupt 81/3.2
1,471,427 10/1923 Towle 81/3.2
2,729,121 1/1956 Fernandeez 81/3.2
2,892,576 6/1959 Ward 222/394
2,941,309 6/1960 Saganti 222/394
2,971,509 2/1961 Cohen 128/216
2,985,454 4/1961 Sussman et al. 81/3.2
3,085,454 4/1963 Federighi 81/3.2
3,125,146 4/1964 Gaterman 81/3.2
3,192,803 7/1965 Federighi 81/3.2
3,232,488 12/1965 Federighi 81/3.2
3,815,448 6/1974 Armier 81/3.2
3,870,175 3/1975 Diseza 114/306
4,317,290 3/1982 Nakamura 81/3.2
4,466,556 3/1984 Hashimoto 81/3.2

FOREIGN PATENT DOCUMENTS

588703 12/1959 Canada 81/3.2
692612 6/1964 Canada 81/3.2
3090 9/1983 European Pat. Off. ... 81/3.2
337928 9/1922 Fed. Rep of Germany ... 81/3.2

Primary Examiner—Roscoe V. Parker
Attorney, Agent, or Firm—Harris Zimmerman; Howard Cohen

ABSTRACT

A device for extracting corks from wine bottles or the like includes a body and pressurized fluid container, a hollow needle extending from the body for penetration through the cork and valve mechanism for selectively injecting pressurized fluid into the wine bottle through the needle to generate gas pressure which expels the cork from the bottle. The valve mechanism has a metering action which injects a predetermined amount of pressurized fluid in response to each valve actuation thereby avoiding inadvertent over-pressurization of the bottle. Propellant fluid is also conserved to prolong periods between recharging of the extractor. In a preferred embodiment, a shielding member restrains unwanted ejection of a cork and/or needle fragment which can otherwise occur if the needle is accidentally broken during operation.

6 Claims, 2 Drawing Sheets

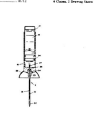

United States Patent [19]

Barnett

[11] Patent Number: **Des. 299,001**
[45] Date of Patent: **∗∗ Dec. 20, 1988**

[54] CORKSCREW

[75] Inventor: David J. Barnett, Hemel Hempstead, United Kingdom

[73] Assignee: Denso Anstalt Limited, Gagot, Liechtenstein

[∗∗] Term: 14 Years

[21] Appl. No.: 765,408

[22] Filed: Aug. 13, 1985

[30] Foreign Application Priority Data

Feb. 19, 1985 [GB] United Kingdom ... 1025108
[52] U.S. Cl. D8/42
[58] Field of Search D8/18, 33, 34, 40, 42, 81/3.4, 3.07, 3.48, 3.49

[56] References Cited

U.S. PATENT DOCUMENTS

D. 145,245 7/1946 De Limon D8/34 X

Primary Examiner—Bernard Ansher
Attorney, Agent, or Firm—Townsend and Townsend

[57] CLAIM

The ornamental design for a corkscrew, as shown.

DESCRIPTION

FIG. 1 is a top, front, right side perspective view of a corkscrew showing my new design;
FIG. 2 is a left side elevational view thereof;
FIG. 3 is a rear elevational view thereof;
FIG. 4 is a bottom plan view thereof; and
FIG. 5 is a perspective view thereof in an alternate position.

United States Patent [19]

Allen

[11] Patent Number: **4,800,784**
[45] Date of Patent: **Jan. 31, 1989**

[54] APPARATUS FOR REMOVING CORKS FROM BOTTLES

[75] Inventor: Herbert Allen, Houston, Tex.

[73] Assignee: Hailes Company, Houston, Tex.

[21] Appl. No.: 168,163

[22] Filed: Mar. 15, 1988

[51] Int. Cl.⁴ B67B 7/02
[52] U.S. Cl. 81/3.36; 81/3.4
[58] Field of Search 81/3.36, 3.48, 3.07, 81/3.4

[56] References Cited

U.S. PATENT DOCUMENTS

4,276,789 7/1981 Allen 81/3.36
4,291,597 9/1981 Allen 81/3.48
4,429,444 2/1984 Allen 140/90

Primary Examiner—Roscoe V. Parker
Attorney, Agent, or Firm—Browning, Bushman, Zamecki & Anderson

[57] ABSTRACT

An apparatus for removing corks from bottles is adapted to allow for automatic ejection of the cork from the apparatus after the cork has been withdrawn from the bottle, by reverse rotation of the corkscrew. The apparatus comprises a corkscrew having a first helical section with a first outer diameter and a second helical section disposed below the first section and with a second outer diameter greater than the first outer diameter so that an upwardly directed screw shoulder is formed between the sections. A handle is fixed to the upper end of the corkscrew. The corkscrew is longitudinally movable with respect to a guide frame therefor. The guideframe includes stops for abutting the top of a bottle and spacers extending upwardly from the stops and defining a cork receiving space for receipt of a cork as it is withdrawn from a bottle by the apparatus. Catches are connected to the spacers and disposed in the cork receiving space, the catches being engageable with a cork to prevent rotation thereof. Up-and movement of the corkscrew shoulder with respect to the spacer means is limited by the screw

32 Claims, 4 Drawing Sheets

United States Patent [19]

Lapsker

[11] Patent Number: **Des. 301,113**
[45] Date of Patent: **∗∗ May 16, 1989**

[54] COMPACT COMBINATION CORKSCREW BOTTLE OPENER

[75] Inventor: Josh Lapsker, Thornhill, Canada

[73] Assignee: Starline Industries Inc., Concord, Canada

[∗∗] Term: 14 Years

[21] Appl. No.: 880,907

[22] Filed: Jul. 1, 1986
[52] U.S. Cl. D8/42
[58] Field of Search D8/42, 18, 33, 40, 81/3.09, 3.45, 3.55, 3.55, 7/151, 155

[56] References Cited

FOREIGN PATENT DOCUMENTS

56119 4/1986 Canada .

OTHER PUBLICATIONS

Gift & Tableware Reporter, 8/76, Sec. 2, p. 16, Corkscrew #2.

Primary Examiner—Bernard Ansher
Assistant Examiner—Terry Pfeffer
Attorney, Agent, or Firm—Bachman & LaPointe

[57] CLAIM

The ornamental design for the compact combination corkscrew bottle opener, as shown and described.

DESCRIPTION

FIG. 1 is a front perspective view of a compact combination corkscrew bottle opener showing my new design;
FIG. 2 is a front elevational view thereof;
FIG. 3 is a right side elevational view thereto;
FIG. 4 is a rear elevational view thereof;
FIG. 5 is a top plan view thereof;
FIG. 6 is a bottom plan view thereof; and
FIG. 7 is a perspective view thereof in an open position.

FIG.7

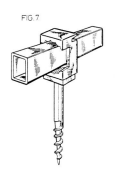

United States Patent [19] [11] Patent Number: 4,836,060
Kiefbeck [45] Date of Patent: Jun. 6, 1989

[54] ENERGY EFFICIENT CORK EXTRACTOR

[76] Inventor: Robert J. Kiefbeck, 3 Dresden Ct.,
Albany, N.Y 12203

[21] Appl. No.: 189,476

[22] Filed: May 2, 1988

[51] Int. Cl.⁴ B67B 7/02
[52] U.S. Cl. 81/3.29; 81/3.45
[58] Field of Search 81/3.45, 3.27, 3.36,
81/3.29, 3.48

[56] References Cited
U.S. PATENT DOCUMENTS
4,172,034 1/1986 Lee 81/3.45
FOREIGN PATENT DOCUMENTS
68601 1/1981 European Pat. Off. 81/3.29

[57] ABSTRACT
A device for providing a simple and effortless removal
of a cork or stopper from its container. The present
invention comprises a partially threaded cylindrical
shaft, said shaft adapted at one end to support a pin
placed through and protruding from its diameter. The
shafts opposite end is provided with a common cork-
screw, tip and a ball shaped housing to accommodate
varying container rims. A threaded and slotted ball is
used to communicate with said pin and shaft threadings,
whereby a continuous clockwise rotation of the ball
penetrates and removes the cork or stopper.

6 Claims, 1 Drawing Sheet

United States Patent [19] [11] Patent Number: 4,838,128
Tischler [45] Date of Patent: Jun. 13, 1989

[54] CORKSCREW

[76] Inventor: Wolfgang Tischler, Weinbergstrasse
33, D-6740 Bad Neustadt/Saale, Fed.
Rep. of Germany

[21] Appl. No.: 170,238

[22] Filed: Mar. 18, 1988

[30] Foreign Application Priority Data
Mar. 18, 1987 [DE] Fed. Rep. of Germany 8704087U

[51] Int. Cl.⁴ B67B 7/06
[52] U.S. Cl. 81/3.48; 81/3.49
[58] Field of Search 81/3.48, 3.49, 3.47

[56] References Cited
U.S. PATENT DOCUMENTS
3,256,756 6/1966 Del Piccolo 81/3.48

FOREIGN PATENT DOCUMENTS

[57] ABSTRACT
Corkscrew, consisting substantially of two handle parts
each provided with a metal tongue and being mutually
slidable within a common guide sleeve. For uncorking
a bottle, the two metal tongues are successively intro-
duced between the cork and the bottle neck, under
automatic centering. Thus the cork is clamped between
the two metal tongues and can without damage thereto
be pulled out of the bottle neck, combined with a rota-
tory motion.

4 Claims, 2 Drawing Sheets

FIG. 1

United States Patent [19] [11] Patent Number: Des. 301,532
Hölterscheidt [45] Date of Patent: ** Jun. 13, 1989

[54] COMBINATION COASTER SET,
CORKSCREW AND BOTTLE OPENER

[75] Inventor: Siegfried Hölterscheidt,
Huckelhoven, Fed. Rep. of Germany

[73] Assignee: Walter Henkels GmbH, Fed. Rep. of
Germany

[**] Term: 14 Years

[21] Appl. No.: 851,403

[22] Filed: Apr. 10, 1986

[30] Foreign Application Priority Data
Jan. 6, 1986 [DE] Fed. Rep. of Germany MR 165
[52] U.S. Cl. D7/45; D8/34
[58] Field of Search D7/45, D8/34, 40, 42-45;
81/3.09, 3.55, 3.48, 215/100.5, 220/85 H;
248/346.1

[56] References Cited
U.S. PATENT DOCUMENTS
D. 162,258 2/1951 Sturm D7/45
D. 236,576 9/1975 Press D7/45

OTHER PUBLICATIONS
Gift & Tableware Reporter, 3/76 Sec. 2, p. 16, Cork-
screw #2

Primary Examiner—Bernard Ansher
Assistant Examiner—Terry Pfeffer
Attorney, Agent, or Firm—Diller, Ramik & Wight

[57] CLAIM
The ornamental design for a combination coaster set,
corkscrew and bottle opener, as shown and described.

DESCRIPTION
FIG. 1 is an exploded perspective view of a combina-
tion coaster set, corkscrew and bottle opener showing
my new design;
FIG. 2 is a top plan view of the coaster;
FIG. 3 is a front elevational view of the corkscrew and
bottle opener;
FIG. 4 is a front elevational view of the corkscrew and
bottle opener in a user position;
FIG. 5 is a front elevational view thereof;
FIG. 6 is a top plan view thereof;
FIG. 7 is a left-side elevational view thereof;
FIG. 8 is a right-side elevational view thereof;
FIG. 9 is a bottom plan view thereof; and
FIG. 10 is a top plan view of the corkscrew in a user
position, the bottle being shown in broken lines for
illustrative purposes only.
FIGS. 3, 4 and 5 of the claimed design are shown sepa-
rately for clarity of illustration.

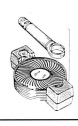

U.S. Patent Jun. 13, 1989 Sheet 1 of 3 D301,532

FIG.10 FIG.1

FIG.2 FIG.4

FIG.3

United States Patent [19] [11] Patent Number: Des. 301,539
Cheung [45] Date of Patent: ** Jun. 13, 1989

[54] COMBINED CAN OPENER, CORKSCREW
AND BOTTLE OPENER

[75] Inventor: Po W. Cheung, Kowloon, Hong
Kong

[73] Assignee: Mike & Kremmel Limited, Kowloon,
Hong Kong

[**] Term: 14 Years

[21] Appl. No.: 869,119

[22] Filed: May 30, 1986

[30] Foreign Application Priority Data
Dec. 9, 1985 [GB] United Kingdom 1030991
[52] U.S. Cl. D8/41; D8/42
[58] Field of Search D8/33, 34, 36, 39, 40,
D8/41, 42, 30/400, 416-418, 422, 426

[56] References Cited
U.S. PATENT DOCUMENTS
D. 277,926 3/1985 Chow D8/41

Primary Examiner—Melvin B. Feifer
Assistant Examiner—Terry Pfeffer
Attorney, Agent, or Firm—Townsend & Townsend

[57] CLAIM
The ornamental design for a combined can opener,
corkscrew and bottle opener, as shown and described.

DESCRIPTION
FIG. 1 is a top plan view of a combined can opener,
corkscrew and bottle opener showing my new design;
FIG. 2 is a rear elevational view thereof;
FIG. 3 is a front elevational view thereof;
FIG. 4 is a left side elevational view thereof, the oppo-
site side being a mirror image;
FIG. 5 is a bottom plan view thereof;
FIG. 6 is a top plan view thereof in an alternate posi-
tion; and
FIG. 7 is a bottom perspective view thereof in an alter-
nate position.

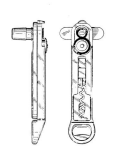

United States Patent [19] [11] Patent Number: Des. 302,233
Barnett [45] Date of Patent: ** Jul. 18, 1989

[54] CORKSCREW

[75] Inventor: David J. Barnett, Hemel Hempstead,
England

[73] Assignee: Dessel Anstalt Limited, Gaogot,
Liechtenstein

[**] Term: 14 Years

[21] Appl. No.: 822,433

[22] Filed: Jan. 27, 1986

[30] Foreign Application Priority Data
Aug. 9, 1985 [GB] United Kingdom 1028445
[52] U.S. Cl. D8/42
[58] Field of Search D8/42, 33, 40, 81/3.07,
81/3.45

[56] References Cited
U.S. PATENT DOCUMENTS
D. 148,810 3/1948 McDowell D8/42

Primary Examiner—Bernard Ansher
Assistant Examiner—Terry Pfeffer
Attorney, Agent, or Firm—Townsend & Townsend

[57] CLAIM
The ornamental design for a corkscrew, as shown and
described.

DESCRIPTION
FIG. 1 is a top, front, left side perspective view of a
corkscrew showing my new design;
FIG. 2 is a right side elevational view thereof;
FIG. 3 is a rear elevational view thereof;
FIG. 4 is a top plan view thereof;
FIG. 5 is a bottom plan view thereof;
FIG. 6 is a perspective view thereof in an alternate
position; and
FIG. 7 is a perspective view thereof in an alternate
position.

U.S. Patent Jul. 18, 1989 Sheet 2 of 2 D302,233

FIG 7

FIG 6

United States Patent [19]

Chow

[11] Patent Number: Des. 303,203
[45] Date of Patent: ⋆⋆ Sep. 5, 1989

[54] COMBINATION CORKSCREW AND STAND

[75] Inventor: Yip C. Chow, Kwai Chung, Hong Kong

[73] Assignee: Basso Anstalt, Balzers, Liechtenstein

[**] Term: 14 Years

[21] Appl. No.: 894,541

[22] Filed: Aug. 13, 1986

[30] Foreign Application Priority Data

Feb. 20, 1986 [GB] United Kingdom 1032372

[52] U.S. Cl. D7/42
[58] Field of Search D7/18, 33, 34, 40, 42, 81/3.07, 3.45, 3.4, 3.48, 3.49

[56] References Cited

U.S. PATENT DOCUMENTS

1,921,811 8/1933 Eger D8/42 X

Primary Examiner—Bernard Ansher
Assistant Examiner—Terry A. Pfeffer
Attorney, Agent, or Firm—Townsend and Townsend

[57] CLAIM

The ornamental design for a combination corkscrew and stand as shown.

DESCRIPTION

FIG. 1 is a front, top, left side perspective view of a combination corkscrew and stand showing my new design;
FIG. 2 is a bottom plan view thereof;
FIG. 3 is a right side elevational view thereof;
FIG. 4 is a rear elevational view thereof; and
FIG. 5 is an exploded front, top, left side perspective view thereof.

U.S. Patent Sep. 5, 1989 Sheet 3 of 3 D303,203

FIG. 5.

United States Patent [19]

Williams

[11] Patent Number: Des. 306,549
[45] Date of Patent: ⋆⋆ Mar. 13, 1990

[54] CORKSCREW

[76] Inventor: Dennis M. Williams, 54 West Street, Crows Nest, New South Wales, 2065, Australia

[**] Term: 14 Years

[21] Appl. No.: 24,251

[22] Filed: Mar. 10, 1987

[52] U.S. Cl. D7/42
[58] Field of Search D7/33, 34, 38, 42, 367, 81/3.45, 3.48, 3.37, 7/154–155

[56] References Cited

U.S. PATENT DOCUMENTS

D. 115,773 7/1939 Strand D8/367
2,164,191 6/1939 Knudsen 81/3.09

Primary Examiner—Terry A. Pfeffer
Attorney, Agent, or Firm—Christie, Parker & Hale

[57] CLAIM

The ornamental design for a corkscrew as shown.

DESCRIPTION

FIG. 1 is a side elevational view of a corkscrew showing my new design;
FIG. 2 is a front elevational view thereof;
FIG. 3 is a rear elevational view thereof;
FIG. 4 is a top plan view thereof; and
FIG. 5 is a bottom plan view thereof.

United States Patent [19]

Desmoulez

[11] Patent Number: Des. 307,102
[45] Date of Patent: ⋆⋆ Apr. 10, 1990

[54] CORKSCREW

[75] Inventor: Bruno Desmoulez, Neuilly, France

[73] Assignee: Anne-Marie Prevost, Paris, France

[**] Term: 14 Years

[21] Appl. No.: 23,731

[22] Filed: Mar. 9, 1987

[52] U.S. Cl. D8/42
[58] Field of Search D8/33, 34, 42, 81/3.45, 81/3.37, 3.48, 7/154–155

[56] References Cited

U.S. PATENT DOCUMENTS

D. 59,641 11/1921 Foote D8/43
D. 143,245 7/1946 De Lesso D8/43 X

189,556 6/1906 Stephens 81/3.09 X

Primary Examiner—Bernard Ansher
Assistant Examiner—Terry A. Pfeffer
Attorney, Agent, or Firm—Townsend & Townsend

[57] CLAIM

The ornamental design for a corkscrew, as shown and described.

DESCRIPTION

FIG. 1 is a perspective view of a corkscrew showing my new design;
FIG. 2 is a front elevational view thereof;
FIG. 3 is a side elevational view thereof;
FIG. 4 is a bottom plan view thereof; and
FIG. 5 is a perspective view thereof in an alternate position.

United States Patent [19]

Yen

[11] Patent Number: 4,916,985
[45] Date of Patent: Apr. 17, 1990

[54] APPARATUS FOR REMOVING A SOFT STOPPER FROM A CONTAINER

[76] Inventor: Richard C. K. Yen, 4261 Chase Ave., Los Angeles, Calif. 90064

[21] Appl. No.: 401,184

[22] Filed: Aug. 31, 1989

[51] Int. Cl.⁵ B67B 7/02
[52] U.S. Cl. 81/3.45
[58] Field of Search 81/3.09, 3.07, 3.44

[56] References Cited

U.S. PATENT DOCUMENTS

2,093,341 9/1937 Bolster 81/3.45
4,574,662 3/1986 Jones 81/3.45

Primary Examiner—Roscoe V. Parker
Attorney, Agent, or Firm—Thomas I. Rozsa

[57] ABSTRACT

An apparatus for removing a soft stopper such as a cork from a container such as a bottle. The apparatus includes a hollow cylinder having a slit along its length and a handle attached to the top of the cylinder. The interior surface of the cylinder includes a spiral wound thread having a flat upper surface. The cylinder is inserted between the outer circumference of the cork and the interior wall of the bottle and is rotated so that the threads are embedded in the outer wall of the cork and serve to compress the cork inwardly as the apparatus is screwed into the container. A stop ring serves to limit the penetration of the apparatus into the bottle and when the apparatus has reached its maximum penetration, the apparatus begins to force the cork out of the bottle as the turning motion of the cork continues. In an alternative embodiment, the cylinder includes a hinge which permits the two halves of the cylinder to be opened after the cork is removed from the bottle to thereby enable the cork to be removed from the opened cylinder.

22 Claims, 1 Drawing Sheet

United States Patent [19]

Chiang

[11] Patent Number: 4,955,261
[45] Date of Patent: Sep. 11, 1990

[54] AUTOMATIC CORKSCREW

[75] Inventor: Yung-Tsang Chiang, Chung Ho, Taiwan

[73] Assignee: Chyuan How Enterprise Co., Ltd., Taipei Hsien, Taiwan

[21] Appl. No.: 495,724

[22] Filed: Mar. 19, 1990

[51] Int. Cl.⁵ B67B 7/04
[52] U.S. Cl. 81/3.2; 81/3.29
[58] Field of Search 81/3.2, 3.25, 3.33, 81/3.45, 3.48, 3.29, 3.36

[56] References Cited

U.S. PATENT DOCUMENTS

4,617,213 1/1917 Bertram 81/3.2

FOREIGN PATENT DOCUMENTS

06930 11/1987 European Pat. Off. 81/3.2

Primary Examiner—Roscoe V. Parker
Attorney, Agent, or Firm—Morton J. Rosenberg; David I. Klein

[57] ABSTRACT

This disclosure relates to an automatic corkscrew and in particular to one which utilizes a motor in association with a ferrule and a drawing tube to rotate a worm into a cork of a bottle and draw it out automatically. Then, the corkscrew may also withdraw the cork automatically by switching a conversion button.

1 Claim, 3 Drawing Sheets

United States Patent [19]

Segato

[11] Patent Number: Des. 312,032
[45] Date of Patent: ⋆⋆ Nov. 13, 1990

[54] CORKSCREW

[76] Inventor: Sergio Segato, Via Raffaello 23, 33080 Fiume Veneto (PN), Italy

[**] Term: 14 Years

[21] Appl. No.: 144,857

[22] Filed: Jan. 15, 1988

[30] Foreign Application Priority Data

Aug. 25, 1987 [IT] Italy 60414/87[U]

[52] U.S. Cl. D8/42
[58] Field of Search D8/42, 33–36, 81/3.07, 3.45, 3.48, 7/154–155

[56] References Cited

U.S. PATENT DOCUMENTS

D. 197,983 4/1964 Mountross D8/33
D. 302,233 7/1989 Barnett D8/42
4,574,464 3/1983 Tillmoier 81/3.48 X

Primary Examiner—Bernard Ansher
Assistant Examiner—Terry A. Pfeffer
Attorney, Agent, or Firm—Flynn, Thiel, Boutell & Tanis

[57] CLAIM

The ornamental model for a corkscrew, as shown and described.

DESCRIPTION

FIG. 1 is a front perspective view of a corkscrew showing my new design;
FIG. 2 is an enlarged top plan view thereof;
FIG. 3 is an enlarged bottom plan view thereof; and
FIG. 4 is a rear perspective view thereof.

United States Patent [19]

Brucart Puig

[11] Patent Number: 4,996,895
[45] Date of Patent: Mar. 5, 1991

[54] POCKET HAND CORKSCREW

[75] Inventor: Ramon Brucart Puig, Sabadell, Spain

[73] Assignee: Puig Bonich S.A., Sabadell, Spain

[21] Appl. No.: 437,043

[22] Filed: Nov. 15, 1989

[30] Foreign Application Priority Data

Nov. 25, 1988 [ES] Spain 8803307[U]

[51] Int. Cl.⁵ B67B 7/64
[52] U.S. Cl. 81/3.09; 81/3.37;
[58] Field of Search 81/3.09, 3.37, 3.29, 7/154; 7/155 81/3.48; 7/154–155

[56] References Cited

U.S. PATENT DOCUMENTS

984,661 2/1911 Halt 81/3.37
2,512,238 6/1950 Nakamura 81/3.37

4,574,662 6/1990 Deluis, Jr. 81/3.09

Primary Examiner—Frederick R. Schmidt
Assistant Examiner—Lawrence Cruz
Attorney, Agent, or Firm—Sughrue, Mion, Zinn, Macpeak and Seas

[57] ABSTRACT

The invention provides a pocket hand corkscrew having an operating lever with a bottom and two flanges, attached to a channel-like guideway which may pivot from a position wherein it is applied against the bottom. A slide member may slide along the guideway, is attached to a helical corkscrew member and has teeth. A dog rotatably attached to the slide member and has teeth when the lever is operated, providing smooth, comfortable movement of the slide member and consequently of the helical screw member previously driven into a stopper.

4 Claims, 2 Drawing Sheets

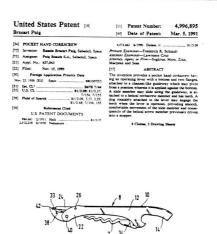

United States Patent [19]

Mackey

[11] Patent Number: 5,005,446
[45] Date of Patent: Apr. 9, 1991

[54] PRESSURIZED CORK-REMOVAL APPARATUS FOR WINE BOTTLES AND OTHER CONTAINERS

[76] Inventor: Edward R. Mackey, 28 Nottingham Rd., Dracut, Mass. 01826

[21] Appl. No.: 222,143

[22] Filed: Jul. 21, 1988

Related U.S. Application Data

[63] Continuation of Ser. No. 2,871, Jan. 13, 1987, abandoned.

[51] Int. Cl.⁵ B67B 7/04
[52] U.S. Cl. 81/3.45; 141/19
[58] Field of Search 81/3.39, 3.48, 3.49; 222/5, 220/3, X04, 206/19; 14/3/229, 19

[56] References Cited

U.S. PATENT DOCUMENTS

986,855 3/1911 Peck 81/3.29
1,421,169 6/1922 Chavers 81/3.29
3,860,654 11/1958 Duncan et al. 222/5

4,317,390 3/1982 Nakayama 81/3.2
4,637,281 1/1987 Bertram et al. 81/3.2
4,694,150 9/1987 Furuno 222/1

Primary Examiner—James G. Smith
Attorney, Agent, or Firm—Pearson & Pearson

[57] ABSTRACT

Cork removal apparatus of the type in which gas under pressure is directed into a container thereby to eject a cork or like stopper. The apparatus directs gas from a gas cylinder into a gas reservoir sealed by a valve. The gas pressure provides the sealing force. When an actuator opens the seal, gas passes through a series of passages and a hollow needle that penetrates the stopper to exit within the container to eject the stopper. When the stopper is ejected it remains on the needle within the cover. Tabs extending through the cover enable the disk to be returned to its original position thereby removing stopper and enclosing the needle.

2 Claims, 5 Drawing Sheets

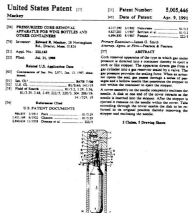

United States Patent [19]
Cellini

[11] Patent Number: 5,007,310
[45] Date of Patent: Apr. 16, 1991

[54] SCREW WITH DIFFERENTIATED SECTIONS FOR CORKSCREWS

[76] Inventor: Ferdinando Cellini, Via Percoto 11, Manago (PN), Italy, 33085

[21] Appl. No.: 474,303
[22] Filed: Feb. 5, 1990

Related U.S. Application Data
[63] Continuation of Ser. No. 281,833, Dec. 13, 1988, abandoned.

[30] Foreign Application Priority Data
Dec. 22, 1987 [IT] Italy 83517 A/87
[51] Int. Cl. B67B 7/00
[52] U.S. Cl. 81/3.45; 81/3.07; 7/155
[58] Field of Search 81/3.45, 3.07; 7/155

[56] References Cited
U.S. PATENT DOCUMENTS

[57] ABSTRACT
Screw (15) with differentiated sections for corkscrews (10) which consists of a pivotal (14) element (17) for connection to a lever body (11) of the corkscrew (10), a screw body (18) formed with a plurality of helices (19) and a point (20), the screw body (18) comprising at least two segments of a desired length (L1-L2), which contain a desired number (n1-n2) of helices (19) and consist of helices (19) having sections of a differentiated size (S1-S2), the section S2 being smaller than the section S1 by a desired value.

3 Claims, 1 Drawing Sheet

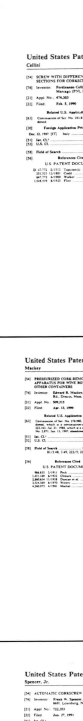

United States Patent [19]
Yen

[11] Patent Number: 5,010,790
[45] Date of Patent: Apr. 30, 1991

[54] APPARATUS FOR REMOVING A SOFT STOPPER FROM A CONTAINER

[76] Inventor: Richard C.K. Yen, 1440 E. Comstock Ave., Glendora, Calif. 91740

[21] Appl. No.: 500,991
[22] Filed: Mar. 29, 1990

[57] ABSTRACT
An apparatus for removing a soft stopper such as a cork from a container such as a bottle.

37 Claims, 3 Drawing Sheets

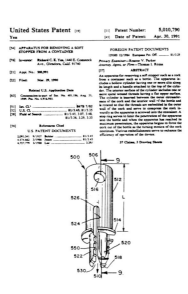

United States Patent [19]
Reinbacher

[11] Patent Number: 5,012,703
[45] Date of Patent: May 7, 1991

[54] CORK REMOVAL APPARATUS

[76] Inventor: Helmut Reinbacher, 20135 Kenwick St., Apt., Canoga Park, Calif.

[21] Appl. No.: 474,943
[22] Filed: Feb. 5, 1990

[57] ABSTRACT
An improved apparatus for extracting a cork from a bottle, such as a wine bottle.

4 Claims, 4 Drawing Sheets

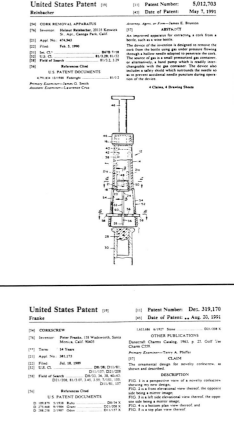

United States Patent [19]
Mackey

[11] Patent Number: 5,020,395
[45] Date of Patent: Jun. 4, 1991

[54] PRESSURIZED CORK-REMOVAL APPARATUS FOR WINE BOTTLES AND OTHER CONTAINERS

[76] Inventor: Edward R. Mackey, 28 Nottingham Rd., Dracut, Mass. 01826

[21] Appl. No.: 509,315
[22] Filed: Apr. 13, 1990

[57] ABSTRACT
Stopper removal apparatus of the type in which gas under pressure is directed into a container thereby to eject a cork or like stopper.

9 Claims, 6 Drawing Sheets

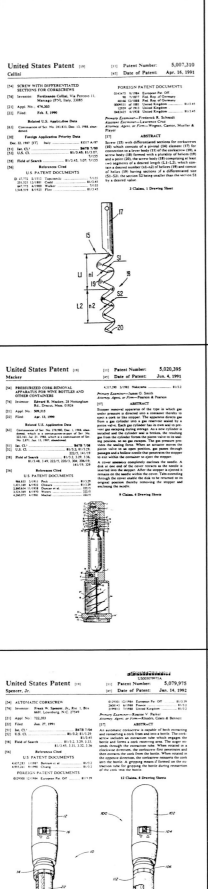

United States Patent [19]
Rydgren

[11] Patent Number: 5,031,486
[45] Date of Patent: Jul. 16, 1991

[54] CORKSCREW

[75] Inventor: Jan Rydgren, Vestby, Norway
[73] Assignee: Rydgren Promotion A/S, Vestby, Norway

[21] Appl. No.: 477,635
[22] Filed: Feb. 9, 1990

[57] ABSTRACT
Corkscrew comprising a handle and a helically-shaped screw part.

5 Claims, 2 Drawing Sheets

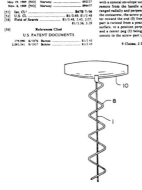

United States Patent [19]
Franke

[11] Patent Number: Des. 319,170
[45] Date of Patent: Aug. 20, 1991

[54] CORKSCREW

[76] Inventor: Peter Franke, 158 Wadsworth, Santa Monica, Calif. 90405

[**] Term: 14 Years
[21] Appl. No.: 381,173
[22] Filed: Jul. 18, 1989

[57] CLAIM
The ornamental design for novelty corkscrew, as shown and described.

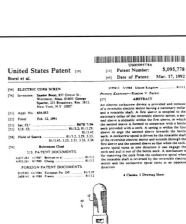

United States Patent [19]
Spencer, Jr.

[11] Patent Number: 5,079,975
[45] Date of Patent: Jan. 14, 1992

[54] AUTOMATIC CORKSCREW

[76] Inventor: Frank W. Spencer, Jr., Box 1, Box 66H, Louisburg, N.C. 27549

[21] Appl. No.: 722,203
[22] Filed: Jun. 27, 1991

[57] ABSTRACT
An automatic corkscrew is capable of both extracting and reinserting a cork from and into a bottle.

12 Claims, 8 Drawing Sheets

United States Patent [19]
Leung et al.

[11] Patent Number: 5,086,675
[45] Date of Patent: Feb. 11, 1992

[54] CORKSCREW

[76] Inventors: Tai L. Leung; T. Leung, both of Hong Kong

[21] Appl. No.: 568,176
[22] Filed: Aug. 16, 1990

[57] ABSTRACT
The corkscrew comprises a housing (12) in which is screw-engaged a barrel (14).

12 Claims, 3 Drawing Sheets

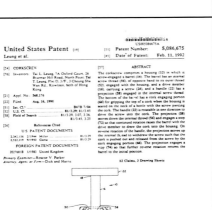
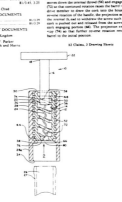

United States Patent [19]
Bocsi et al.

[11] Patent Number: 5,095,778
[45] Date of Patent: Mar. 17, 1992

[54] ELECTRIC CORK SCREW

[76] Inventors: Sandor Bocsi, Worcester, Mass.; George Spencer, New York, N.Y.

[21] Appl. No.: 654,083
[22] Filed: Feb. 12, 1991

[57] ABSTRACT
An electric corkscrew device is provided and consists of a reversible electric motor.

4 Claims, 1 Drawing Sheet

[11] Patent Number: Des. 327,615
[45] Date of Patents: ⋆⋆ Jul. 7, 1992

[54] BENDING CORKSCREW
[76] Inventor: Paul Fenner, 16 The Crossways, Onslow Village, Guildford, Surrey, England

[11] Patent Number: 5,134,906
[45] Date of Patent: Aug. 4, 1992

[54] CORK REMOVAL DEVICE
[76] Inventor: Howard A. Sit, 244 Citrus Ave., Daly City, Calif. 94014

[11] Patent Number: 5,220,855
[45] Date of Patent: Jun. 22, 1993

[54] CORKSCREW

[11] Patent Number: 5,253,553
[45] Date of Patent: Oct. 19, 1993

[54] APPARATUS AND METHOD FOR REMOVING A STOPPER FROM A BOTTLE
[76] Inventor: Michael Mothershead, 1713 Avon Way, Forest Grove, Oreg. 97116

[11] Patent Number: 5,257,565
[45] Date of Patent: Nov. 2, 1993

[54] CORKSCREW
[76] Inventor: Jui-Ching Hung, No. 29, Chang-Hsing Rd., Chieh-Shou Li, Changhua City, Taiwan

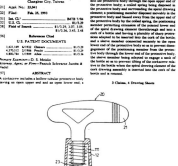

[11] Patent Number: Des. 347,775
[45] Date of Patent: ⋆⋆ Jun. 14, 1994

[54] CORK SCREW OPENER

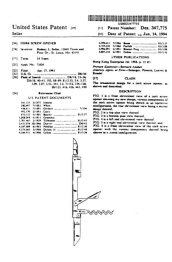

[11] Patent Number: 5,347,889
[45] Date of Patent: Sep. 20, 1994

[54] MULTI-PURPOSE WINE BOTTLE STOPPER DEVICE
[76] Inventor: Andrew R. St. Denis, 5331-5th Concession, Amherstburg, Ontario, Canada, N9V 2Y9

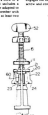

[11] Patent Number: 5,351,579
[45] Date of Patent: Oct. 4, 1994

[54] RECHARGEABLE ELECTRIC CORKSCREW

[11] Patent Number: 5,361,652
[45] Date of Patent: Nov. 8, 1994

[54] CORKSCREW
[76] Inventor: Diego Andina, Via Sale, 25064 Gussago Brescia, Italy

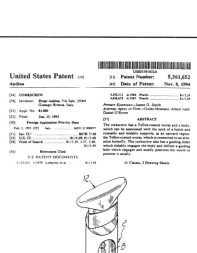

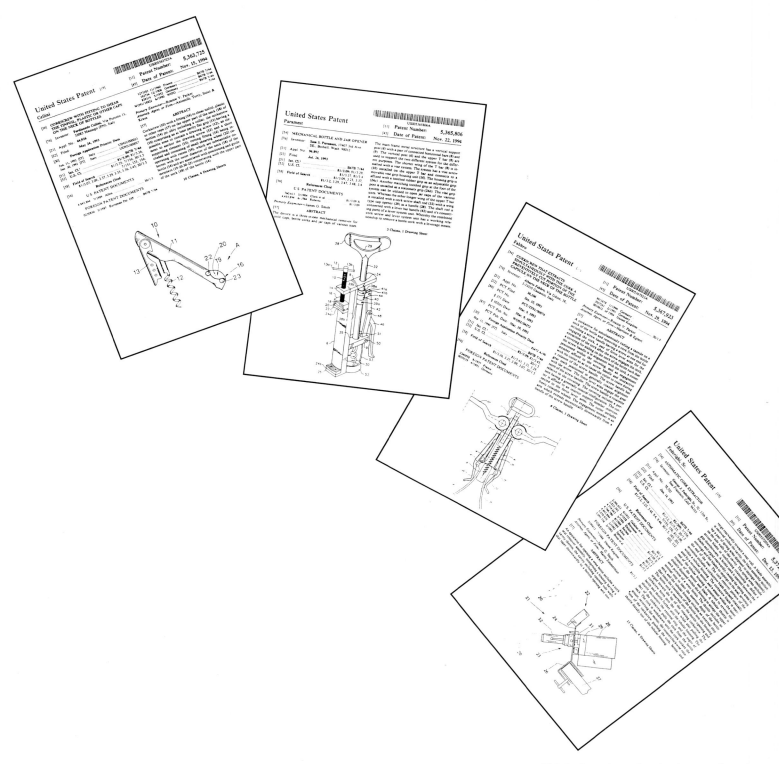

Printed copies of patents may be obtained by mail. The fee is currently $3.00 for each patent, regardless of length. Send request to:

Commissioner of Patents and Trademarks
Box 9
Washington, DC 20231

Appendix One

PATENT WANNABES

E. S. M. CO. ERIE, PA. WALKER PAT. APPLIED FOR Advertising for SCHLITZ MILWAUKEE U. S. A.

Just as a patent does not guarantee success, neither does the absence of a patent preordain failure. Either way the market rules. All patents, whether ultimately approved or ultimately rejected go through a formal application process during which time an invention is held in a state if limbo, neither insulated from shark attack nor without recourse once the patent is finally granted. An inventor could wait it out pending the final outcome, but more likely would opt to go into production first and ask questions later. The mechanism by which applicants can put their competition on notice is the placing of a tattoo on their hatchling, generally "PATENT APPLIED FOR," in earlier times, or "PATENT PENDING," in use today. This does not give the inventor legal pre-patent grounds for suing a knock-off operator but might give a competitor pause, for once the patent is official, the inventor has full recourse through the courts. Having a duly marked invention strengthens the case considerably and explains it's prevalence on so many manufactured products, past and present.

But what happens if the patent is never issued? Nothing. Life goes on and so does production, as long as there are ready buyers and unsuccessful suers. Corkscrews abound which have all the earmarks of a patent, yet none exists. Perhaps the Examiner found that a prior patent was too close for comfort and rejected the patent. Perhaps the applicant failed to pay the application fee or respond adequately to Examiner inquiry. Perhaps a patent was issued but such significant changes were made to the final production model that it becomes difficult to match it up with the patent. Although the mark theoretically can be used only if an application is actually made, there is plenty of gray between intention and action. The result is a host of corkscrews having the magic word "PATENT" implanted in some context on the surface, but lacking the confirmation of a patent. Once the patent is granted the inventor is free to change the mark, adding date and/or patent number, although not likely before using up current stock (to the best of anyone's knowledge, no marking has ever been found signifying "patent re-

jected"). It is all very legal, very suggestive, perhaps very intimidating to a rival and could be very not patented in the final analysis.

Perhaps the most beautiful, coveted and rare example of an unconfirmed corkscrew patent is the stunning FRARY PATENT APD FOR 5 AVENUE (Fig. A1-1, Contents). Because the marking is imposingly rendered in the casting itself and conveniently split, causing "FRARY PATENT" to appear alone on one side, a very suggestive psychological message is conveyed implying the existence of a patent. Alas, too much searching has come up empty for that to be true (besides, how would that explain the obverse side?). Patents are not the property of the CIA; they are public records open to all comers, of which there have been plenty, both of inventor and researcher stock. That does not detract from the piece itself, which is held in the highest esteem by the collector community, judging by the infrequency with which seekers have been able to dislodge a "Frary" from its fortunate owner.

No one knows how many corkscrews may be suspended in this perpetual state of betwixt and between. Most of them will never be reborn, not because they lack merit, but because they probably did not see patent light-of-day in the first place. There has to be some comfort from the accumulated knowledge of searches past and present, that the odds are now stacked overwhelmingly against them. Since a negative can not be proven by the absence of a positive, there will always be uncertainty. But at least the wishful thinking level should now be *lower*.

The following pages do not represent a complete round-up of the wannabees, but is, rather, an eclectic sampling. Where a patent is 'in the neighborhood', it is shown, hopefully inviting further research. Regardless of their patent status, these corkscrews have their own appeal, carrying a value set by a totality of factors, like everything else. Should perchance one pop to the surface waving a patent flag, it should not, by that event alone, impact its collectibility. I for one, however, will be the first to salute it and reach for the color film.

PAT PEND HOTEL GOWMAN 2ND AT STEWART SEATTLE, WN.

H. R. RANSOM & CO. DETROIT, MICH. RE-CAP-O PRESS TO RECAP PAT. PEND. RELEASE CORKSCREW TAP END TEMPERED STEEL

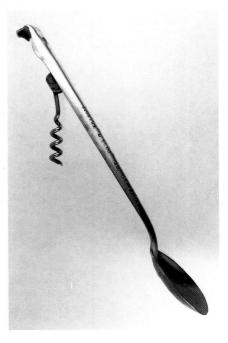

Oct. 31, 1950
LE EMMETTE V. DE FEE
Des. 160,695
COMBINATION CAN OPENER, BOTTLE
OPENER, AND SPOON
Filed Feb. 10, 1949

FIG. 1.

FIG. 2.

FIG. 3.

FIG. 4.

INVENTOR.
LeEmmette V. deFee
BY
ATTORNEY

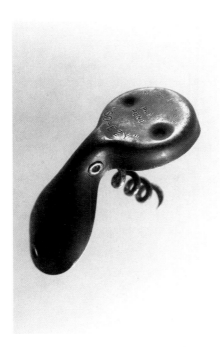

PAT. APL'D. FOR BOTTLE OPENER WHELAN
CO. - MALT- FILLMORE 4397

PAT. APL'D FOR

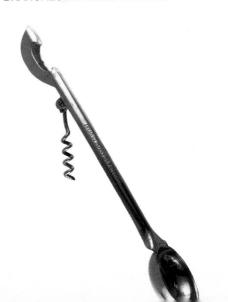

Feb. 4, 1936.
M E TROLLEN
Des. 98,486
COMBINED BOTTLE CAP AND OPENER
Filed March 22, 1935

Fig. 1

Fig. 2

Fig. 3

Fig. 4

Martin E. Trollen

B. & B. ST. PAUL, MINN. DES. PAT. PDG. a.
Advertising STIRRING UP BUSINESS
AMUNDSON INSURANCE AGENCY EAST
STANDWOOD, WASH. b. Advertising
SINCLAIR & VALENTINE COMPANY INKS
BRANCHES IN PRINCIPAL CITIES

"SO-EZY" PAT. PEND. MADE IN U. S. A.

ZIP R. S. PRODUCTS CORP. PHILA, PA. PAT.
PEND.

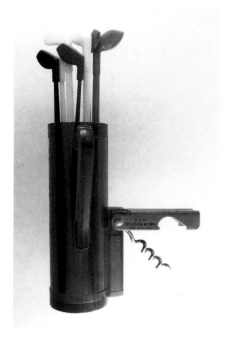

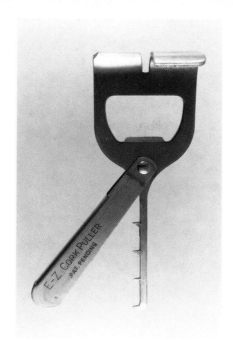

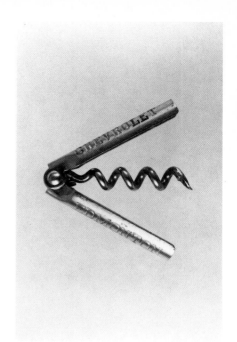

EPP 225 5TH AVE. N. Y. CITY PAT APP FOR

E-Z CORK PULLER PAT. PENDING

EDMONTON MOTORS LTD NEW CHEVROLET (generally marked "DAINTY FOLDING CORKSCREW VAUGHAN CHICAGO PAT APPL'D.")

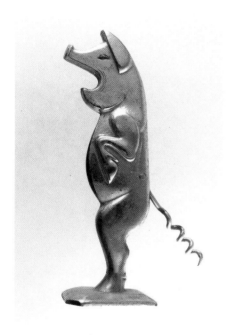

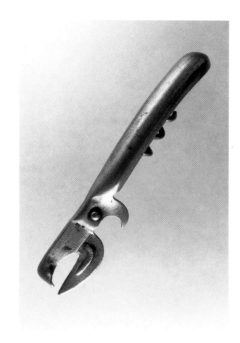

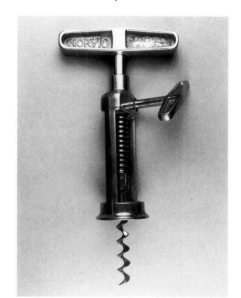

NEGBAUR PAT. PEND.

KING OF CUTTERS CAN OPENER PAT. APPLD FOR MADE IN U. S. A.

NORVIC PAT. PEND. U. S. A.

COLONIAL CRAFTS PAT. PENDING

THE BEST BROWNE LAKE PAT. 7-11-10 (not a patent date)

() SPECIALTY WORKS 87 MAIN ST W. ROCHESTER, N. Y. PATENTED

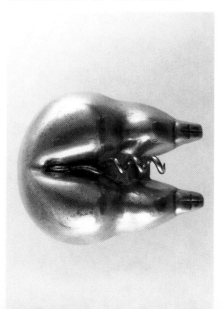

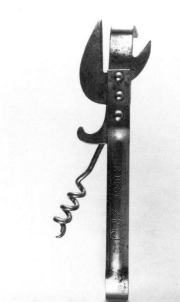

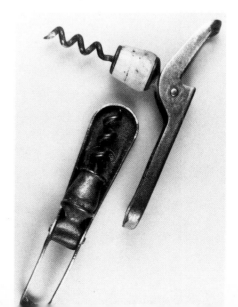

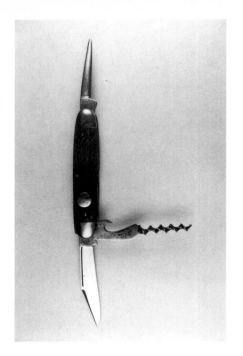

BOKER PATENT APPLIED FOR

COLUMBUS SCREW 1492 CHICAGO 1892 PAT. APPLD. FOR

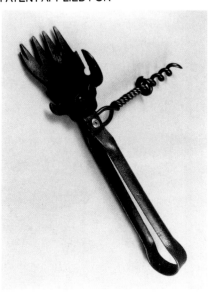

NEGBAUR U. S. A. PAT. PEND.

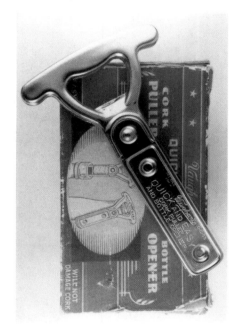

PAT. APLD FOR VAUGHAN'S CHICAGO QUICK AND EASY CORK PULLER AND BOTTLE OPENER

DOUBLE ACTION CAN OPENER CUTS UP OR DOWN PAT. APPL'D FOR GELLMAN MFG. CO. ROCK ISLAND, ILL. TEMPERED STEEL (with advertising)

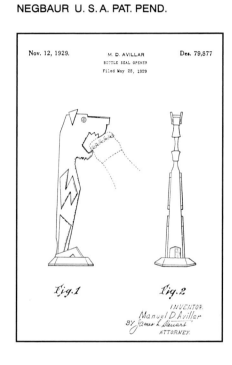

PAT. PENDING

PAT PEND

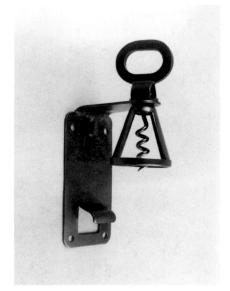

PATENT APPLIED FOR

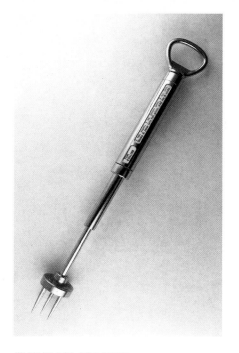

CHIP CHOP PAT. PEND.

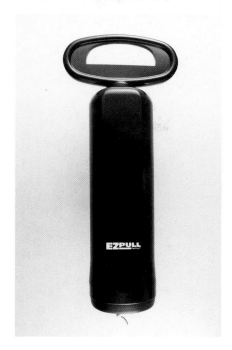

E Z PULL U. S. PATENT PENDING

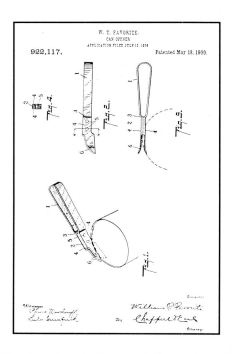

DICO WAKEFIELD MASS PAT. PEND.

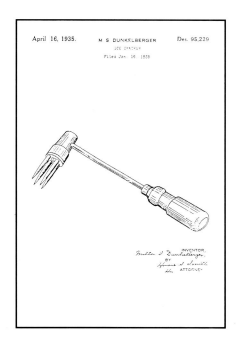

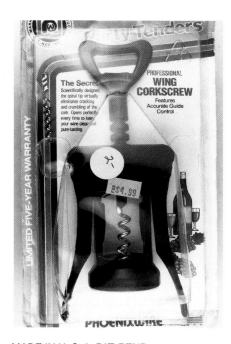

MADE IN U. S. A. PAT. PEND.

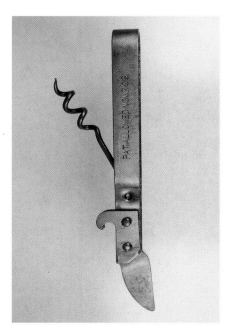

PAT. ALLOWED NOV. 7, 08.

ROBERTS SPEC MFG CO. PAT. APP. FOR

BAR BOY PAT. APPL'D. FOR

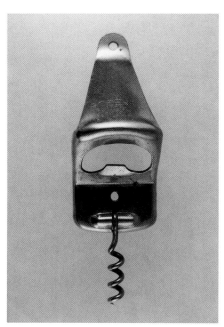

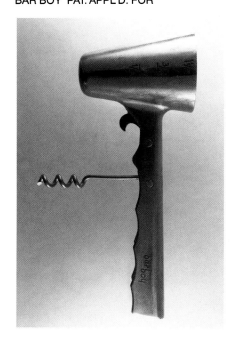

Appendix Two
RELATED PATENTS

Pity the poor cork stopper. Not only is it shaped in a torture device (Fig. A2-1), but it is destined for sacrifice on the capital end of a tool. It has also had to face extinction for over two centuries from clever inventors dreaming of substitutes. The result has been the development and maturation of complete industries that have become a part of everyday life today — such as the bottle cap — or flash-in-the-pan industries — such as the Codd bottle or Baltimore loop seal. Along the way many other would-be technologies fizzled and died on the launching pad, leaving a paper trail but little else to show for drawing breath, however promising. The patent records are replete in ideas for supplementing or eliminating the cork, either way obviating the need for a corkscrew. Those patents rightfully belong outside the purview of a book on corkscrew patents, but on the other hand, neither do they deserve eternal banishment to the patent tomb. Indeed, they deserve to be on a list of their own, if for no other reason than to remind us that nothing is forever.

Stoppers with integral hooks, loops, pins, straps, etc., plastic "corks," wire, foil... all dot the historical landscape, requiring appropriate gadgets for overcoming whatever obstacle they represent on the way to extraction.

What follows is by no means an exhaustive list, but does serve to illustrate the energy, if sometimes misdirected, that has gone into the search for alternatives. It may also interest the reader to note that some tools were curiously called "corkscrew," although one would be hard pressed to find anything curly in, around or about the premises.

Some would argue that many of these patents belong on the 'first team' so to speak, and that many of the latter's marginal patents represent a counter-culture in their own right. Perhaps. The point is these patented ideas were considered antidotes, or at least accessories to the corkscrew. Because they have found no constituency, like in the case of the bottle opener crowd, that is not sufficient reason to dilute the sanctity of the main list.

Some day the cork and the beloved corkscrew will meet their mutual fate on the field of technology. In the meantime these examples of a 'better idea' shall remain where they rightfully belong — in the Appendix.

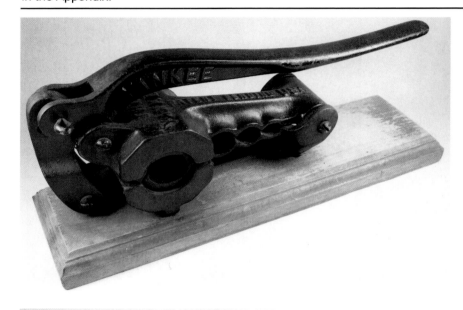

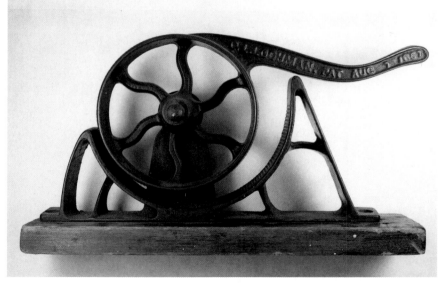

Fig. A2-1 Two examples of a cork press. **a.** Placed in the grip appropriate for its size, the cork is wrenched-pressed under extreme leverage until rendered small enough to be forced into a bottle. **b.** Perhaps a little more sophisticated, the sizing with this press can be incrementalized. For the cork, however, the end game is the same.

H.S.Carley.
Stopper Fastener.
Nº68,484. Patented Sept.3, 1867.

Witnesses;
Tho Swale
Wm Irwin

Inventor;
H.S. Carley
Per Mum & Co
Attorneys

J. AUTENRIETH.
CORK EXTRACTOR.
No. 81,728. Patented Sept. 1, 1868.

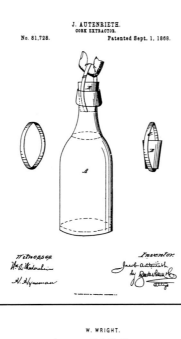

Witnesses
Wm D Wadenbein
H. Hyneman

Inventor:
Jacob Autenrieth
by Munn & Co
Attys

J.A. Trout,
Cork Screw.
No. 107,125. Patented Sept. 6, 1870.

Witness
E.N Veteli & B
Jeremy W.& H

Inventor
James A. Trout

C. B. TRIMBLE.
Improvement in. Bottle Openers.
No. 119,802. Patented Oct. 10, 1871.

Fig.1.

Fig.2.

Witnesses:
Gustave Dietrich
Francis Mc Cadle

Inventor:
C.B. Trimble
per Munn & Co
Attorneys

W. WRIGHT.
Improvement in Bottle Stoppers.
No. 120,923. Patented Nov. 14, 1871.

Fig.1.

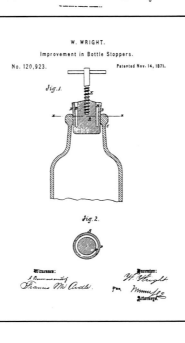

Fig. 2.

Witnesses:
J Commerent
Francis Mc Cadle

Inventor:
W. Wright
per Munn & Co
Attorneys

J. F. PEACOCK.
Gimlet Ventiduct.
No. 131,408. Patented Sep. 17, 1872.

Fig.1.

Fig 2

Witnesses
J.S. Brown
George Hurst Jr.

Inventor
Job F Peacock
per Brown & Co
Attys

H. W. LOVE & J. TALLEY. Jr.
Liquid Vents.
No. 152,565. Patented June 30, 1874.

Fig.1.

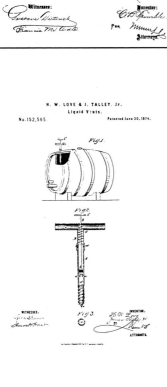

Fig.2.

Fig.3

WITNESSES:
Inventor
ATTORNEYS

W. E. HAWKINS.
Bottle-Stoppers.
No.155,833. Patented Oct. 13, 1874.

Fig.1

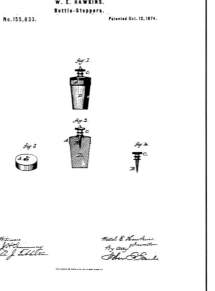

Fig.2.

Fig.3

Fig.4.

Witnesses
Jno Summerall
A. J. Littleton

Wltel E Hawkins
By atty Inventor
John B. Earle

G. A. POTTER.
Device for Removing Wire Fastenings from Corks.
No. 160,950 Patented March 16, 1875.

Fig.1.

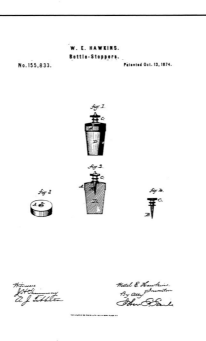

Fig.2

Witnesses:
J.B. Marr
Jno H. Krom

Inventor
Geo. A. Potter
By A.A. Maud
Atty

M. S. VALENTINE.
BOTTLE-NECK.
No. 173,089.
Patented Feb. 1, 1876.

FIG. 1.

FIG. 2.

WITNESSES:
INVENTOR
Mann. S. Valentine

J. FRANZ.
DEVICE FOR REMOVING WIRES FROM BOTTLE CORKS.
No. 176,852.
Patented May 2, 1876.

Fig. 1.

Fig. 2.

WITNESSES:
INVENTOR:
ATTORNEYS.

J. S. SAUNDERS.
CORK EXTRACTORS.
No. 183,709.
Patented Oct. 24, 1876.

Fig. 1.

Witnesses
Inventor
John S. Saunders
by Bewey & Co.
Att'ys

F. DEMING & P. BACHER.
Bottle-Stopper and Stopper-Fastener.
No. 210,926.
Patented Dec. 17, 1878.

Fig. 1.

Fig. 2.

Fig. 3.

Witnesses:
Inventors:

A. C. SCHULZ.
Bottle Stopper.
No. 231,451.
Patented Aug. 24, 1880.

FIG. 1.

FIG. 3.

FIG. 4.

FIG. 2.

FIG. 5.

Witnesses
Inventor

A. WALKER.
Bottle Stopper.
(Model.)
No. 233,303.
Patented Oct. 12, 1880.

Fig. 1.

Fig. 2.

Fig. 3.

WITNESSES:
INVENTOR:
A. Walker
BY
ATTORNEYS.

J. A. SCHMIDT.
NIPPERS FOR OPENING BOTTLES.
(No Model.)
No. 257,982.
Patented May 16, 1882.

Fig. 1.

Fig. 2.

WITNESSES:
INVENTOR
J. Albert Schmidt
BY
ATTORNEY

F. W. RUSSELL.
MEANS FOR WITHDRAWING CORKS OR BUNGS FROM BOTTLES, CASKS, &c.
(No Model.)
No. 273,897.
Patented Mar. 13, 1883.

Fig. 1.

Fig. 2.

Fig. 3.

Fig. 4.

Fig. 5.

Fig. 6.

Attest:
Inventor,
F. W. Russell
Att'ys.

J. E. BERLIEN.
MEANS FOR DRAWING CORKS FROM BOTTLES.
(No Model.)
No. 278,388.
Patented May 29, 1883.

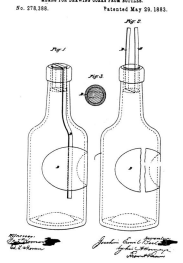

Fig. 1

Fig. 2

Fig. 3

Witnesses
Inventor

(No Model.) 1 Sheets—Sheet 1.

H. CODD.
APPARATUS FOR OPENING BOTTLES USED FOR CONTAINING AERATED
LIQUIDS AND WHICH ARE FITTED WITH INTERNAL STOPPERS.

No. 326,630. Patented Sept. 22, 1885.

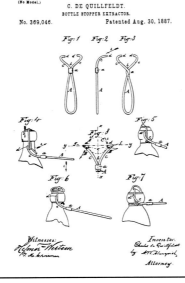

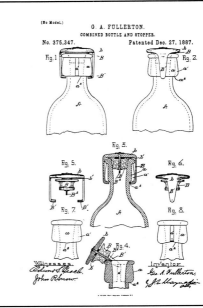

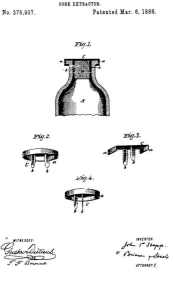

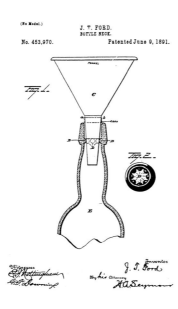

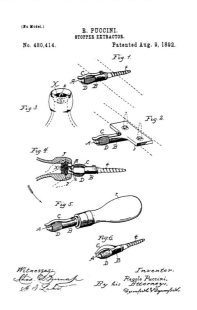

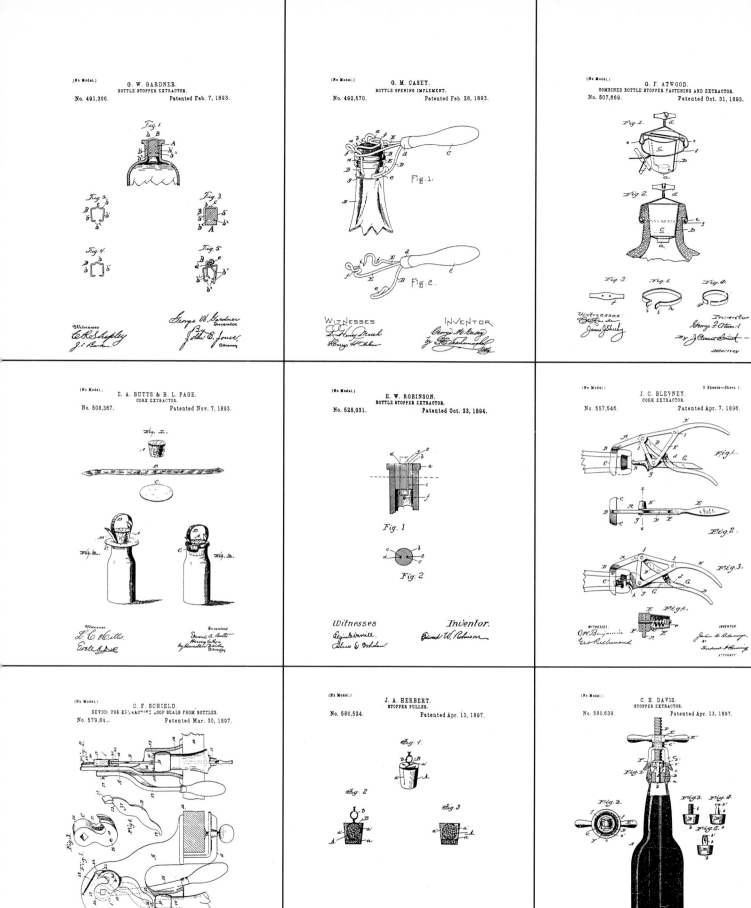

(No Model.) **J. H. KONOLD & M. D. CASPER.**
DOSING CORK.
No. 584,941. Patented June 22, 1897.

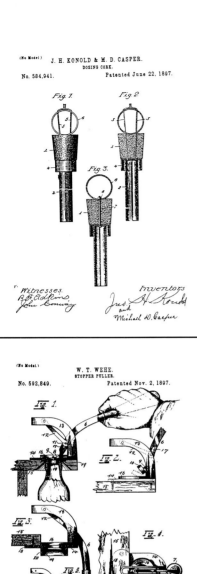

Fig. 1.

Fig. 2.

Fig. 3.

Witnesses.

Inventors.

(No Model.) **G. WEAR.**
STOPPER FOR BOTTLES OR SIMILAR VESSELS.
No. 587,350 Patented Aug. 3, 1897.

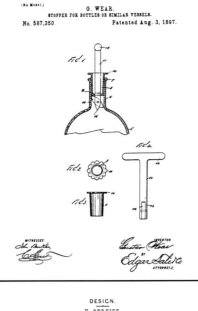

Fig. 1.

Fig. 2.

Fig. 3.

WITNESSES

INVENTOR
Gustav Wear
BY Edgar Sate
ATTORNEYS.

(No Model.) **J. McMURTRIE.**
COMBINED CORK AND EXTRACTOR THEREFOR.
No. 587,751. Patented Aug. 10, 1897.

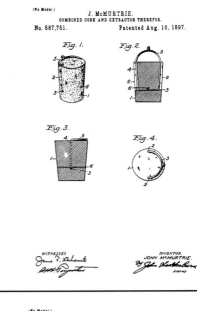

Fig. 1.

Fig. 2.

Fig. 3.

Fig. 4.

WITNESSES

INVENTOR
JOHN McMURTRIE.
BY John
Attorney

(No Model.) **W. T. WEHE.**
STOPPER PULLER.
No. 592,849. Patented Nov. 2, 1897.

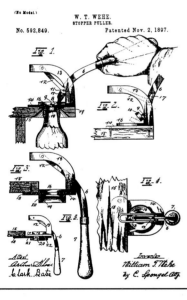

Fig. 1.

Fig. 2.

Fig. 3.

Fig. 4.

Fig. 5.

Attest

Inventor
William T. Wehe
by C. George Atty.

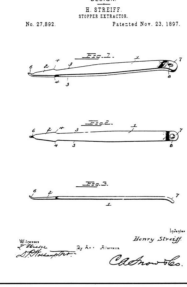

Fig. 1.

Fig. 2.

Fig. 3.

Witnesses

Inventor
Henry Streiff.

(No Model.) **E. R. BUHRMAN.**
BOTTLE STOPPER REMOVER.
No. 597,874. Patented Jan. 25, 1898.

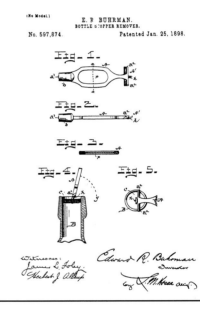

Fig. 1.

Fig. 2.

Fig. 3.

Fig. 4.

Fig. 5.

WITNESSES:
James L. Foley.
Herbert J. Allen

Edward R. Buhrman
Inventor
by L. M. Knee atty

(No Model.) **G. S. FOSTER.**
CORK EXTRACTOR.
No. 602,503. Patented Apr. 19, 1898.

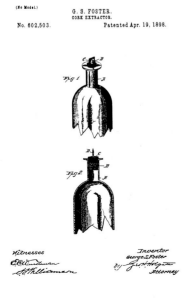

Fig. 1.

Fig. 2.

Witnesses

Inventor
George S. Foster
by G. H. Attorney

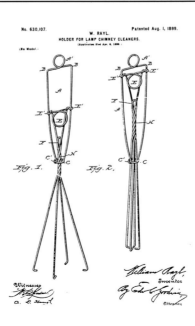

Fig. 1.

Fig. 2.

Witnesses

Inventor
William Rayl,
by Goodwin
Attorneys

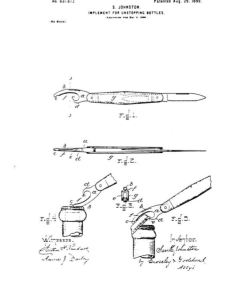

Fig. 1.

Fig. 2.

Fig. 3.

Fig. 4.

Fig. 5.

WITNESSES

Inventor.
Saville Johnston
by Crosley & Goddard
Attys

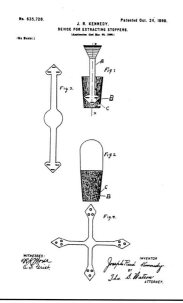

No. 635,728. Patented Oct. 24, 1899.
J. R. KENNEDY.
DEVICE FOR EXTRACTING STOPPERS.
(No Model.)

WITNESSES: INVENTOR,
 Joseph Read Kennedy
 BY
 John S. Waters
 ATTORNEY.

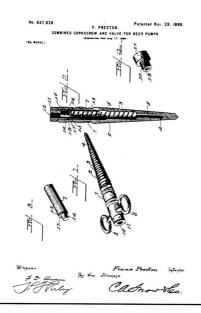

No. 637,826. Patented Nov. 28, 1899.
F. PRESTON.
COMBINED CORKSCREW AND VALVE FOR BEER PUMPS.
(Application filed Aug. 17, 1899.)
(No Model.)

Witnesses Franz Preston Inventor
 By his Attorneys
 C. A. Snow & Co.

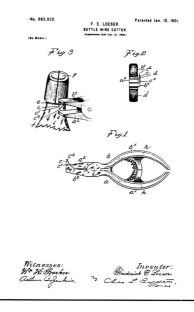

No. 665,920. Patented Jan. 15, 1901.
F. C. LOESER.
BOTTLE WIRE CUTTER.
(Application filed Jan. 19, 1900.)
(No Model.)

Witnesses: Inventor:
 Frederick C. Loeser
 By
 Chas. L. Burdett
 Attorney

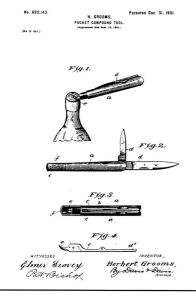

No. 690,143. Patented Dec. 31, 1901.
H. GROOMS.
POCKET COMPOUND TOOL.
(Application filed Sept. 10, 1901.)
(No Model.)

WITNESSES: INVENTOR,
Elmer Seavey Herbert Grooms,
R. N. Bishop By Davis & Davis,
 Attorneys.

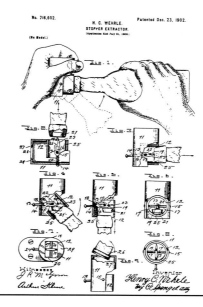

No. 716,602. Patented Dec. 23, 1902.
H. C. WEHRLE.
STOPPER EXTRACTOR.
(Application filed July 31, 1902.)
(No Model.)

Witnesses: Inventor:
J. R. McGowan Henry C. Wehrle
Arthur Kline By C. Spengel atty

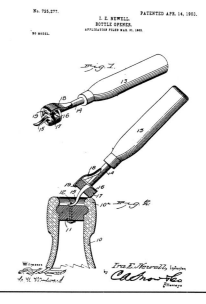

No. 725,277. PATENTED APR. 14, 1903.
I. E. NEWELL.
BOTTLE OPENER.
APPLICATION FILED MAR. 31, 1903.
NO MODEL.

Witnesses Ira E. Newell, Inventor
 by
 C. A. Snow & Co.
 Attorneys

No. 725,273. PATENTED APR. 28, 1903.
R. T. FETROW.
CORK EXTRACTOR.
APPLICATION FILED JULY 17, 1902.
NO MODEL.

Witnesses Inventor
Louis D. Heinrichs Robert T. Fetrow
R. A. Monson By his Attorneys

No. 752,049. PATENTED FEB. 16, 1904.
M. A. DUNN.
BOTTLE, STOPPER, AND OPENER.
APPLICATION FILED JAN. 26, 1903.
NO MODEL.

Witnesses: Inventor:
Adrian Moser Mary Agnes Dunn
Chas H. Davids By her Attorney,
 J. R. Littell

No. 759,714. PATENTED MAY 10, 1904.
E. B. JELKS.
SPATULA AND CORK EXTRACTOR.
APPLICATION FILED FEB. 8, 1904.
NO MODEL.

WITNESSES: INVENTOR
 Edwin B. Jelks
 By Marsh & Co.
 ATTORNEYS

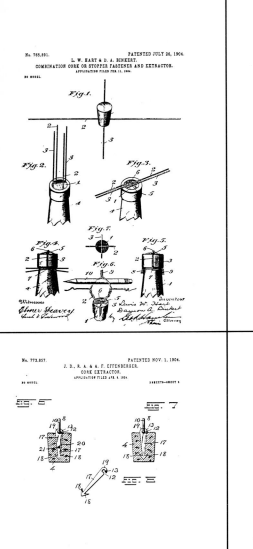

No. 765,891.
L. W. HART & D. A. BINKERT.
COMBINATION CORK OR STOPPER FASTENER AND EXTRACTOR.
APPLICATION FILED FEB. 11, 1904.
NO MODEL.
PATENTED JULY 26, 1904.

WITNESSES
Elmer Feavey

INVENTOR
Lewis W. Hart
Damon A. Binkert
by

No. 771,345.
E. M. WILCOX.
STOPPER PULLER.
APPLICATION FILED NOV. 28, 1903.
NO MODEL.
PATENTED OCT. 4, 1904.

WITNESSES:

INVENTOR
Edward M. Wilcox.
By

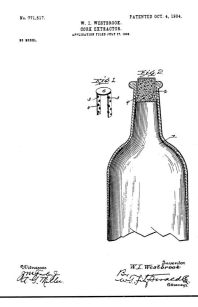

No. 771,517.
W. I. WESTBROOK.
CORK EXTRACTOR.
APPLICATION FILED JULY 27, 1903.
NO MODEL.
PATENTED OCT. 4, 1904.

Witnesses

Inventor
W. I. Westbrook
By

No. 773,857.
J. D., R. A. & A. F. EFFENBERGER.
CORK EXTRACTOR.
APPLICATION FILED APR. 9, 1904.
NO MODEL.

WITNESSES:

INVENTORS:
JOSEPH D. EFFENBERGER,
EMIL A. EFFENBERGER &
AUGUST F. EFFENBERGER.
BY

No. 783,858.
A. P. WATT.
COMBINED BOTTLE STOPPER AND EXTRACTOR.
APPLICATION FILED AUG. 2, 1904.
PATENTED FEB. 28, 1905.

Witnesses

Andrew P. Watt.
Inventor
by
Attorneys

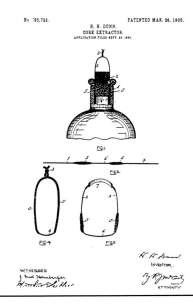

No. 785,722.
H. H. DUNN.
CORK EXTRACTOR.
APPLICATION FILED SEPT. 23, 1904.
PATENTED MAR. 28, 1905.

WITNESSES

H. H. Dunn
INVENTOR
By
ATTORNEY

No. 788,398.
J. B. FLADBY.
EXTRACTING TOOL.
APPLICATION FILED OCT. 3, 1904.
PATENTED APR. 25, 1905.

Witnesses

John B. Fladby
Inventor
by
Attorney

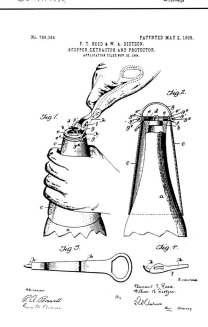

No. 789,064.
F. T. REED & W. A. DIETZEN.
STOPPER EXTRACTOR AND PROTECTOR.
APPLICATION FILED NOV. 22, 1904.
PATENTED MAY 2, 1905.

Witnesses

INVENTORS
Francis T. Reed,
William A. Dietzen.
By
Attorney

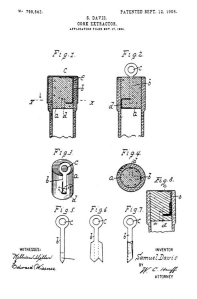

No. 799,543.
S. DAVIS.
CORK EXTRACTOR.
APPLICATION FILED NOV. 17, 1904.
PATENTED SEPT. 12, 1905.

WITNESSES:
William Miller
Edward Wiesner

INVENTOR
Samuel Davis
By
ATTORNEY

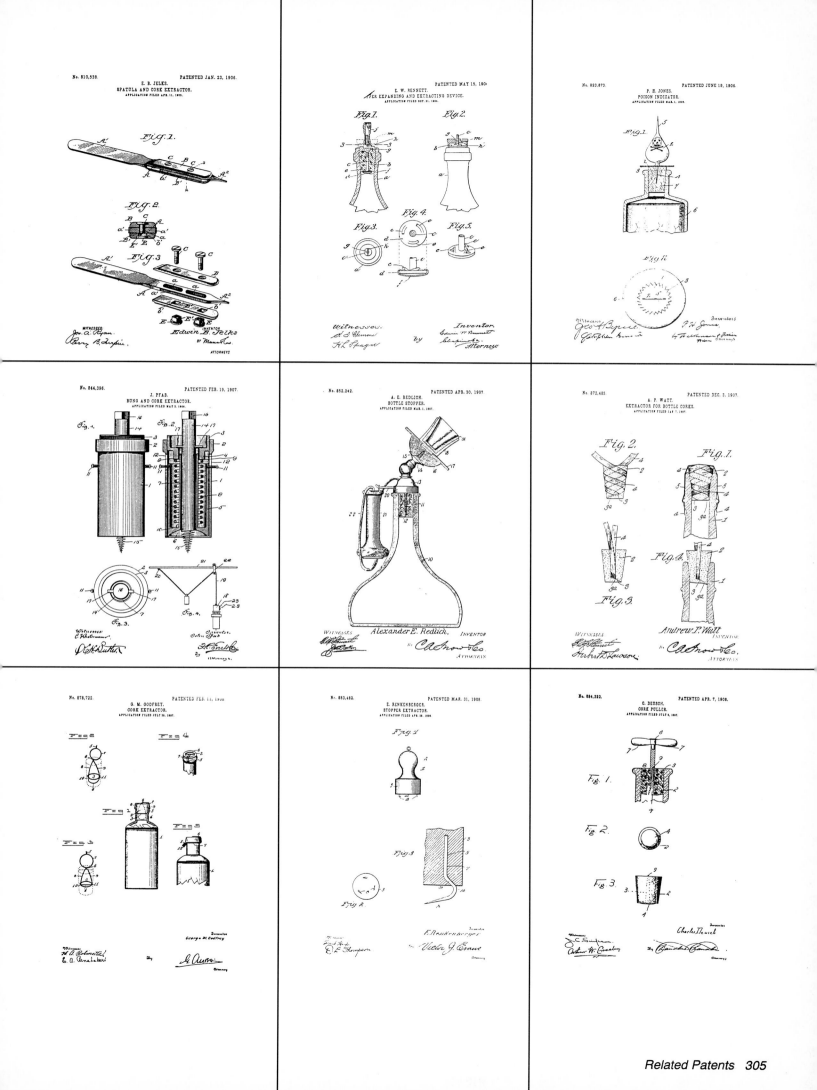

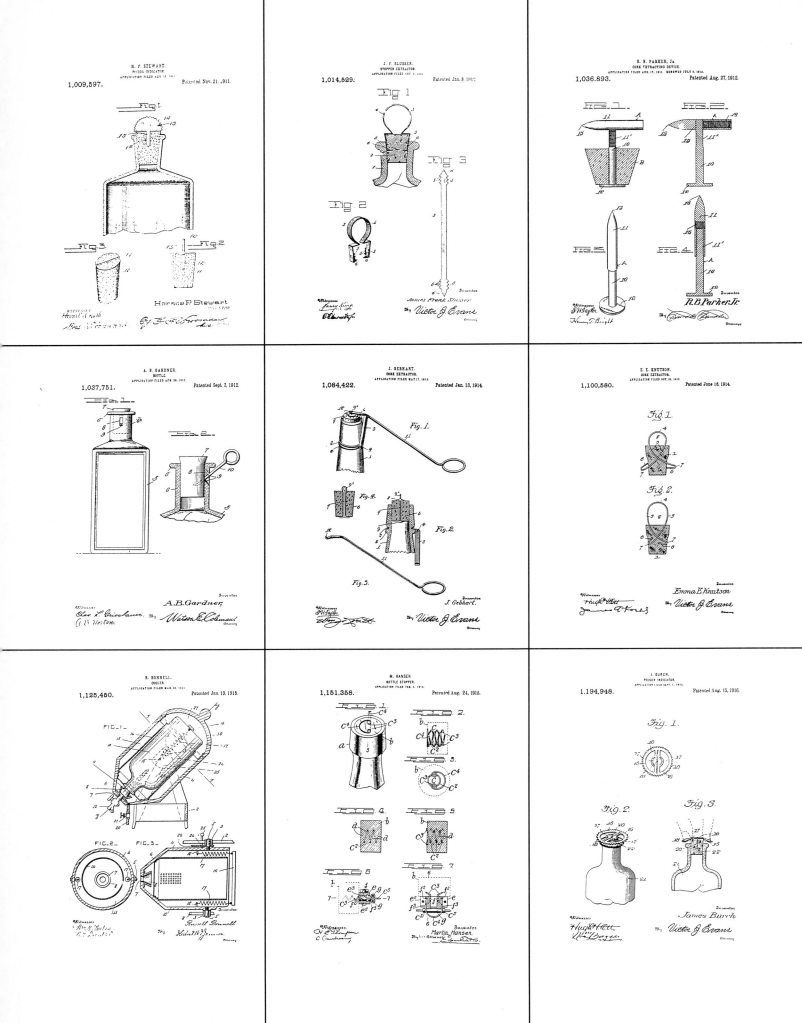

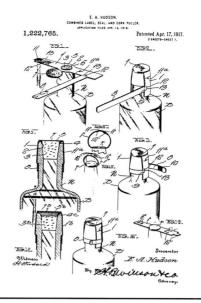

E. A. HUDSON.
COMBINED LABEL, SEAL, AND CORK PULLER.
APPLICATION FILED APR. 13, 1916.

1,222,765.

Patented Apr. 17, 1917.
2 SHEETS—SHEET 1.

Inventor
E. A. Hudson

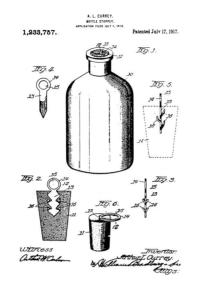

A. L. CURREY.
BOTTLE STOPPER.
APPLICATION FILED JULY 7, 1916.

1,233,757.

Patented July 17, 1917.

Inventor
Arthur L. Currey

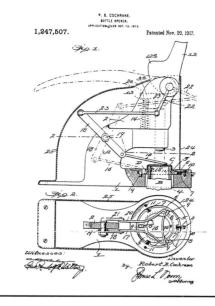

R. B. COCHRANE.
BOTTLE OPENER.
APPLICATION FILED OCT. 13, 1915.

1,247,507.

Patented Nov. 20, 1917.

Inventor
Robert B. Cochrane

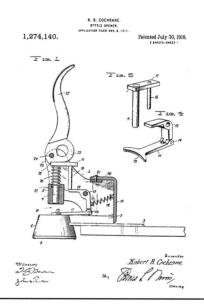

R. B. COCHRANE.
BOTTLE OPENER.
APPLICATION FILED NOV. 9, 1917.

1,274,140.

Patented July 30, 1918.
2 SHEETS—SHEET 1.

Inventor
Robert B. Cochrane

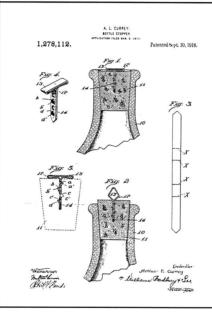

A. L. CURREY.
BOTTLE STOPPER.
APPLICATION FILED MAR. 3, 1917.

1,278,112.

Patented Sept. 10, 1918.

Inventor
Arthur L. Currey

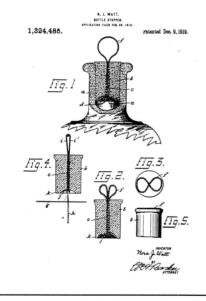

N. J. WATT.
BOTTLE STOPPER.
APPLICATION FILED FEB. 26, 1919.

1,324,485.

Patented Dec. 9, 1919.

INVENTOR
Nora J. Watt

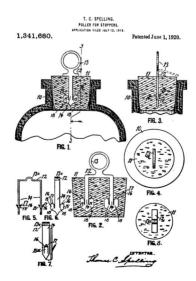

T. C. SPELLING.
PULLER FOR STOPPERS.
APPLICATION FILED JULY 12, 1918.

1,341,680.

Patented June 1, 1920.

INVENTOR
Thomas C. Spelling

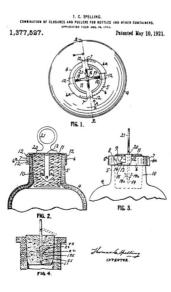

T. C. SPELLING.
COMBINATION OF CLOSURES AND PULLERS FOR BOTTLES AND OTHER CONTAINERS.
APPLICATION FILED AUG. 14, 1919.

1,377,527.

Patented May 10, 1921.

INVENTOR
Thomas C. Spelling

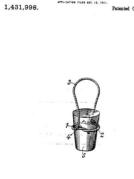

M. VOGLMAYER.
UNCORKING DEVICE.
APPLICATION FILED OCT. 12, 1921.

1,431,998.

Patented Oct. 17, 1922.

Inventor
Maximilian Voglmayer

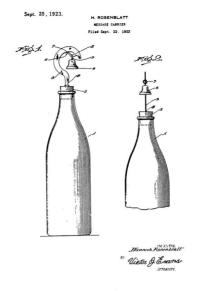

Sept. 25, 1923. H. ROSENBLATT
MESSAGE CARRIER
Filed Sept. 22, 1922

INVENTOR
Hannah Rosenblatt
BY Victor J. Evans
ATTORNEY.

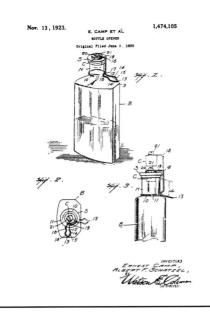

Nov. 13, 1923. E. CAMP ET AL 1,474,105
BOTTLE OPENER
Original Filed June 5, 1920

INVENTORS
ERNEST CAMP,
ALBERT F. SCHATZEL,
ATTORNEY.

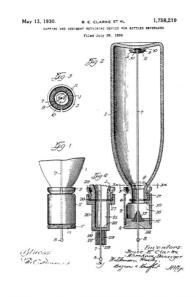

May 13, 1930. B. E. CLARKE ET AL 1,758,219
CAPPING AND SEDIMENT RETAINING DEVICE FOR BOTTLED BEVERAGES
Filed July 28, 1926

Inventors:
Bruce E. Clarke
Abraham Innozer
BY

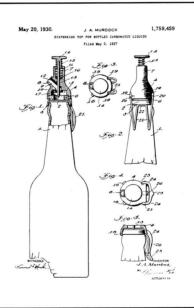

May 20, 1930. J. A. MURDOCK 1,759,459
DISPENSING TOP FOR BOTTLED CARBONATED LIQUIDS
Filed May 2, 1927

INVENTOR
J. A. Murdock
ATTORNEYS

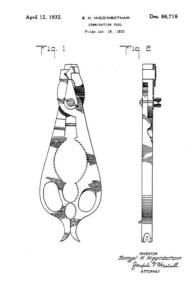

April 12, 1932. S. H. HIGGINBOTHAM Des. 86,718
COMBINATION TOOL
Filed Jan. 16, 1932

Fig. 1 Fig. 2

INVENTOR
Samuel H. Higginbotham
Joseph F. Westall
ATTORNEY

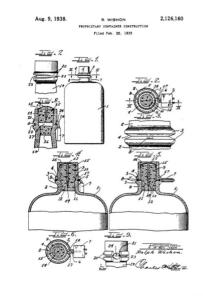

Aug. 9, 1938. R. WISHON 2,126,160
PROPRIETARY CONTAINER CONSTRUCTION
Filed Feb. 25, 1935

INVENTOR
Ralph Wishon.

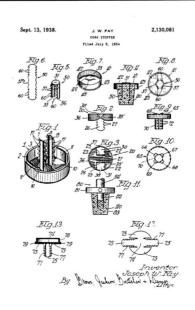

Sept. 13, 1938. J. W. FAY 2,130,081
CORK STOPPER
Filed July 5, 1934

Inventor
Joseph W. Fay.
By

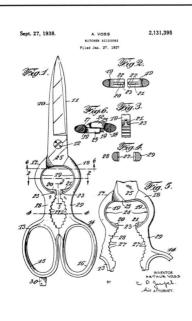

Sept. 27, 1938. A. VOSS 2,131,395
KITCHEN SCISSORS
Filed Jan. 27, 1937

INVENTOR
ARTHUR VOSS
BY
his ATTORNEY.

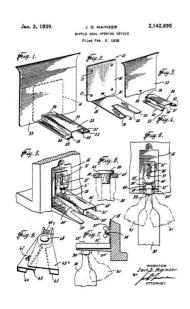

Jan. 3, 1939. J. D. MAINZER 2,142,695
BOTTLE SEAL OPENING DEVICE
Filed Feb. 5, 1938

INVENTOR
Jack D. Mainzer
BY
ATTORNEY

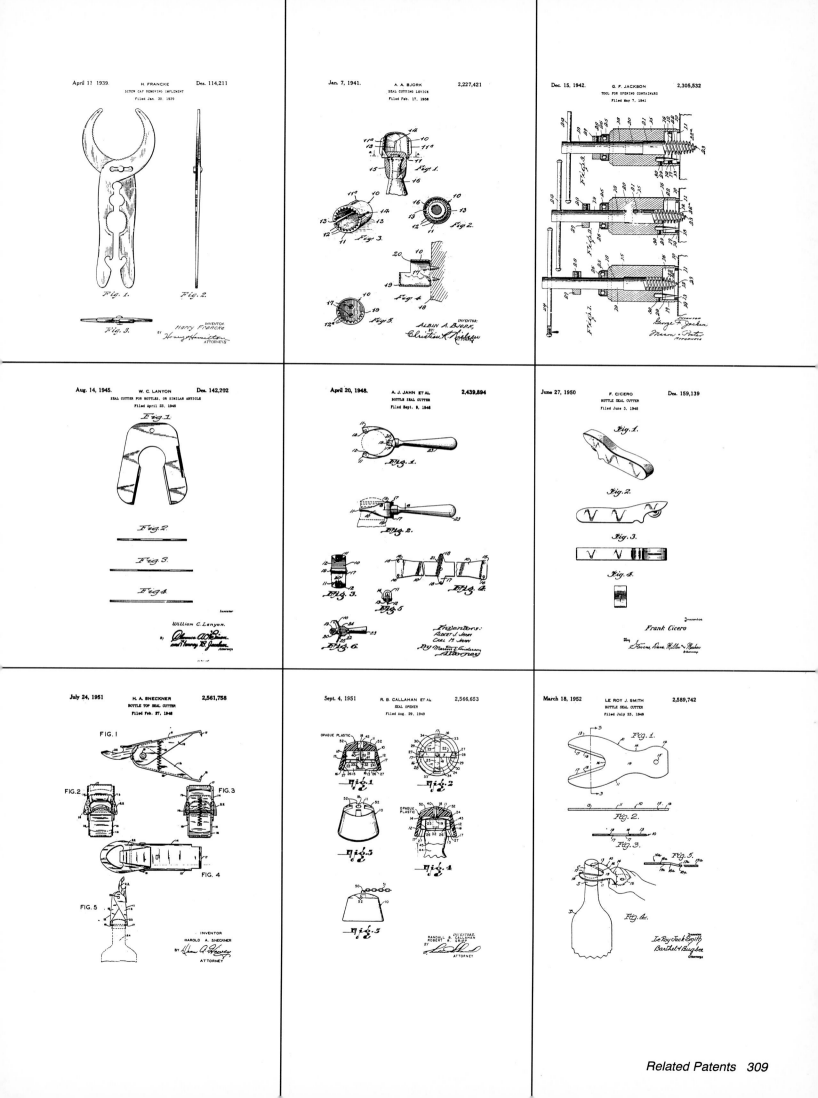

April 11. 1939. H. FRANCKE Des. 114,211
SCREW CAP REMOVING IMPLEMENT
Filed Jan. 30, 1939

Fig. 1.
Fig. 2.
Fig. 3.

INVENTOR
Harry Francke
BY
ATTORNEYS

Jan. 7, 1941. A. A. BJORK 2,227,421
SEAL CUTTING DEVICE
Filed Feb. 17, 1938

Fig. 1.
Fig. 2.
Fig. 3.
Fig. 4.
Fig. 5.

INVENTOR:
ALBIN A. BJORK,
BY

Dec. 15, 1942. G. F. JACKSON 2,305,532
TOOL FOR OPENING CONTAINERS
Filed May 7, 1941

George F. Jackson

Aug. 14, 1945. W. C. LANYON Des. 142,292
SEAL CUTTER FOR BOTTLES, OR SIMILAR ARTICLE
Filed April 23, 1945

Fig. 1.
Fig. 2.
Fig. 3.
Fig. 4.

William C. Lanyon.
BY

April 20, 1948. A. J. JAHN ET AL 2,439,894
BOTTLE SEAL CUTTER
Filed Sept. 9, 1946

Fig. 1.
Fig. 2.
Fig. 3.
Fig. 4.
Fig. 5.
Fig. 6.

Inventors:
ALBERT J. JAHN,
CARL M. JAHN
BY
ATTORNEY

June 27, 1950. F. CICERO Des. 159,139
BOTTLE SEAL CUTTER
Filed June 3, 1948

Fig. 1.
Fig. 2.
Fig. 3.
Fig. 4.

Inventor
Frank Cicero

July 24, 1951 H. A. SNECKNER 2,561,758
BOTTLE TOP SEAL CUTTER
Filed Feb. 27, 1948

FIG. 1
FIG. 2
FIG. 3
FIG. 4
FIG. 5

INVENTOR
HAROLD A. SNECKNER
BY
ATTORNEY

Sept. 4, 1951 R. B. CALLAHAN ET AL 2,566,653
SEAL OPENER
Filed Aug. 29, 1949

OPAQUE PLASTIC
Fig. 1
Fig. 2
Fig. 3
OPAQUE PLASTIC
Fig. 4
Fig. 5

INVENTORS.
RANDALL B. CALLAHAN
ROBERT R. GRIPP
BY
ATTORNEY

March 18, 1952 LE ROY J. SMITH 2,589,742
BOTTLE SEAL CUTTER
Filed July 23, 1948

Fig. 1.
Fig. 2.
Fig. 3.
Fig. 5.
Fig. 4.

LeRoy Jack Smith
Barthel & Bugbee
ATTORNEYS

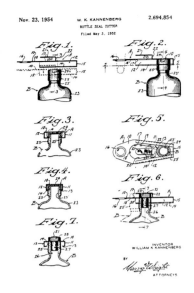

Nov. 23, 1954 W. K. KANNENBERG 2,694,854
BOTTLE SEAL CUTTER
Filed May 3, 1952

Fig.1. Fig.2. Fig.3. Fig.5. Fig.4. Fig.6. Fig.7.

INVENTOR
WILLIAM K. KANNENBERG
BY
ATTORNEYS

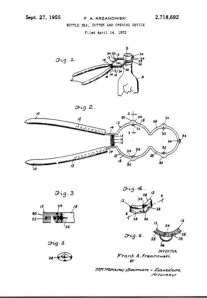

Sept. 27, 1955 F. A. KRZANOWSKI 2,718,692
BOTTLE SEAL CUTTER AND OPENING DEVICE
Filed April 14, 1953

Fig.1. Fig.2. Fig.3. Fig.4. Fig.5. Fig.6.

INVENTOR
Frank A. Krzanowski
BY
Attorneys

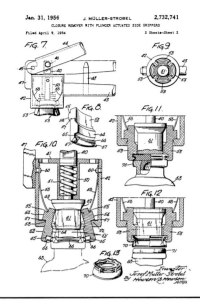

Jan. 31, 1956 J. MÜLLER-STROBEL 2,732,741
CLOSURE REMOVER WITH PLUNGER ACTUATED SIDE GRIPPERS
Filed April 9, 1954 2 Sheets-Sheet 2

FIG.7 FIG.8 FIG.9 FIG.10 FIG.11 FIG.12 FIG.13

Inventor
Josef Müller-Strobel
Attys.

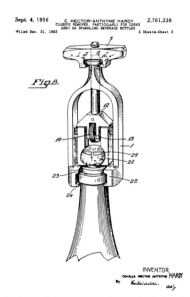

Sept. 4, 1956 C. HECTOR-ANTHYME HARDY 2,761,338
CLOSURE REMOVER, PARTICULARLY FOR CORKS
USED ON SPARKLING BEVERAGE BOTTLES
Filed Dec. 21, 1953 3 Sheets-Sheet 3

Fig.8.

INVENTOR
CHARLES HECTOR ANTHYME HARDY
BY

United States Patent [19] [11] 3,722,327
Strassel [45] Mar. 27, 1973

[54] PLIER-LIKE CHAMPAGNE CORK REMOVER

[76] Inventor: Anna Maria Scharwat aus Strassel, 86 Friedberger Landstrasse, Frankfurt, am Main, Germany
[22] Filed: Apr. 5, 1972
[21] Appl. No.: 241,197

[30] Foreign Application Priority Data
Apr. 6, 1971 Germany P 21 16 768.0

[52] U.S. Cl.81/3.1 B, 81/3.36, 7/5.2
[51] Int. Cl.B67b 7/44, B25b 7/22
[58] Field of Search81/3.36, 3.1, 3.1 R, 3.34, 81/3.44, 3.49, 7/5.1, 3.2, 5.4, 5.5, 14.6, 6.2, 30/1.5

[56] References Cited
UNITED STATES PATENTS
1,942,918 1/1934 Dash81/3.1

FOREIGN PATENTS OR APPLICATIONS
15,940 9/1889 Great Britain81/3.44
283,408 10/1913 Germany30/1.5

OTHER PUBLICATIONS
German Printed Application, Scharwat, 1,176,017, August 1964

Primary Examiner—Robert C. Riordon
Assistant Examiner—Roscoe V. Parker, Jr.
Attorney—Neil F. Markva et al.

[57] ABSTRACT
A plier-like champagne cork remover comprises means for gripping the free end of the cork of a champagne bottle, means for guiding the neck of the bottle when the cork secured in the bottle by a wire is being removed, and means for cutting through the cork securing wire when the cork is being removed, the free end of the cork are being moved towards each other, the arrangement being such that the means for guiding the bottle neck and the means for cutting through the wire move in synchronism with the movement of the means for gripping the free end of the cork.

2 Claims, 3 Drawing Figures

United States Patent [19] [11] 3,800,345
Feliz [45] Apr. 2, 1974

[54] CHAMPAGNE CORK EXTRACTOR AND WIRE CUTTER

[76] Inventor: Jack M. Feliz, 24-808 Via Echo, Palm Springs, Calif. 92262
[22] Filed: Sept. 13, 1972
[21] Appl. No.: 288,643

[52] U.S. Cl.7/14.6, 81/3.1 R, 81/3.1 B, 81/3.37
[51] Int. Cl.B25f 1/00, B67b 7/44, B67b 7/32
[58] Field of Search81/3.1 R, 3.1 B, 3.2, 3.36, 81/3.37, 3.38 R, 3.45; 7/14.6

[56] References Cited
UNITED STATES PATENTS
2,761,338 9/1956 Hardy81/3.38

Primary Examiner—James L. Jones, Jr.
Attorney, Agent, or Firm—Harris, Kern, Wallen & Tinsley

[57] ABSTRACT
A champagne cork extractor comprising a wire cutter and a cork remover which are operated by gripping the bottle neck and a wire cutter handle in one hand and turning a cork extractor crank with the other hand.

7 Claims, 7 Drawing Figures

United States Patent [19] [11] 4,018,110
Spriggs [45] Apr. 19, 1977

[54] STOPPER REMOVER
[76] Inventor: Samuel C. Spriggs, 1076 Shadow Lane, Mount Pleasant, S.C. 29464
[22] Filed: July 13, 1976
[21] Appl. No.: 704,779
[52] U.S. Cl.81/3.1 B, 81/3.46 R, 81/302
[51] Int. Cl.²B67B 7/02
[58] Field of Search29/239, 268; 81/3.1 B, 81/3.34, 3.36, 3.37, 3.38 R, 3.44, 3.46 R, 302

[56] References Cited
UNITED STATES PATENTS
58,820 10/1966 Hazard81/3.36
2,351,311 5/1951 Talbot81/3.46 R
1,722,457 11/1955 Lacey29/268 X
3,821,940 7/1974 Shreads29/268

Primary Examiner—Al Lawrence Smith
Assistant Examiner—James G. Smith
Attorney, Agent, or Firm—Dennison, Dennison, Meserole & Pollack

[57] ABSTRACT
A hand manipulable device for removing bottle stoppers comprising upper and lower bifurcated jaws engageable about the neck of a bottle between the shoulder and mouth of the bottle for engagement of the upper jaw below the overhanging stopper head whereby a spreading of the jaws effects an upward withdrawal of the stopper. A retaining arm is fixed to the upper jaw and extends generally centrally thereover in outwardly spaced relation thereto for engagement over the head of the stopper in a manner so as to retain the stopper subsequent to release thereof from the bottle.

6 Claims, 5 Drawing Figures

United States Patent [19] [11] 4,296,653
Lundgren et al. [45] Oct. 27, 1981

[54] METHOD AND A DEVICE FOR REMOVING CORKS FROM VESSELS
[75] Inventors: Sture L. Lundgren, Luleå, Leif E. L. Rehnberg, Boden, both of Sweden
[73] Assignee: Kem-Intressen AB, Sundhyberg, Sweden
[21] Appl. No.: 118,803
[22] PCT Filed: Nov. 8, 1978
[86] PCT No.: PCT/SE78/00070
§ 371 Date: Jan. 20, 1979
§ 102(e) Date: Jan. 20, 1979
[87] PCT Pub. No.: WO79/00268
PCT Pub. Date: May 17, 1979

[30] Foreign Application Priority Data
Nov. 10, 1977 [SE] Sweden7712690

[51] Int. Cl.³B67B 7/00
[52] U.S. Cl.81/3.46 R; 81/3.1 B
[58] Field of Search30/304, 81/3.1 R, 3.1 B, 81/3.1 J, 3.46 R, 3.46 A, 3.47, 3.49

[56] References Cited
U.S. PATENT DOCUMENTS
2,759,182 8/1956 Mrazek81/3.46 A
3,143,904 8/1964 Yerian81/3.46 R X
4,085,632 4/1978 Hogan et al.81/3.1 P

FOREIGN PATENT DOCUMENTS
49076 7/1934 Denmark81/3.46 R

Primary Examiner—James G. Smith
Attorney, Agent, or Firm—Fred Philpott

[57] ABSTRACT
A method and a device for removing corks from vessels. The device comprises a pair of knives and a holder for the knives, which holder fixes the position of the knife-edges relative to each other and with a spacing between the knife-edges, which spacing a smaller than the diameter of the cork to be removed from a vessel measured immediately above the position on the cork where it is intended to be gripped between the knives. By use of the device the cork is removed by moving the vessel with the attached cork towards the knives at a level suitable to position the portion of the cork that extends above the vessel between the knife-edges and moving the vessel away from the knives.

9 Claims, 7 Drawing Figures

United States Patent [19] [11] 4,387,609
Polsfuss [45] Jun. 14, 1983

[54] PLASTIC CORK LIFTER
[76] Inventor: Marvin F. Polsfuss, 676 Silver Ave., San Francisco, Calif. 94134
[21] Appl. No.: 334,622
[22] Filed: Dec. 28, 1981
[51] Int. Cl.³B67B 7/02
[52] U.S. Cl.81/3.46 A; 81/3.46 A
[58] Field of Search81/3.46 A, 3.46 R, 3.34, 81/3.36, 3.37

[56] References Cited
U.S. PATENT DOCUMENTS
961,224 6/1910 Fischer81/3.34
1,130,210 9/1914 Hawkins81/3.37
1,250,448 12/1917 Green81/3.36
1,339,629 11/1920 Bastian81/3.36
1,596,821 10/1925 Hodge81/3.36
1,654,753 9/1953 Weber215/46
3,722,327 3/1973 Strassel81/3.1 R
4,018,110 4/1977 Spriggs81/3.1 B

FOREIGN PATENT DOCUMENTS
1576017 8/1966 Fed. Rep. of Germany
1519035 2/1968 France81/3.46 A

Primary Examiner—Roscoe V. Parker

Attorney, Agent, or Firm—David Pressman

[57] ABSTRACT
A prying device, most useful as a plastic cork lifter, comprises an elongated member (10) having a handle section (12) at one end and a prying section (14) at the other end. The prying section comprises a fork with separated dual tines (16/18) having narrowed inner edges which fit into the groove between the cork (20) and bottle (22), below the head of the cork above the neckband of the bottle. A wire hoop (24) extends out from the prying section. The wire hoop is looped around the top of the bottle, just below the cork. The hoop is springably retracted toward the prying section for storage and for aiding in positioning the dual tines in the groove between the bottle and the cork. The hoop is vertically pivotable at the prying section and is bent by about 90 degrees to form an upright "V" (34) at approximately midway out from the prying section. The bend forms a fulcrum point which rests against the side of the bottle at a location slightly down from the cork so the handle can be rotated down about the fulcrum point, causing the fork to rotate up and lift the cork by multiplied lever force.

4 Claims, 8 Drawing Figures

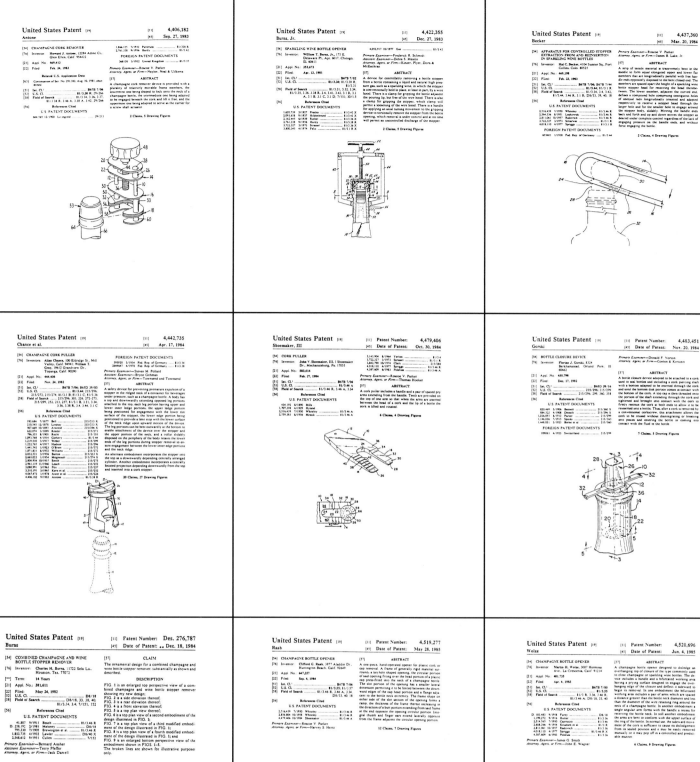

United States Patent [19]
Antone

[11] 4,406,182
[45] Sep. 27, 1983

[54] CHAMPAGNE CORK REMOVER

United States Patent [19]
Burns, Jr.

[11] 4,422,355
[45] Dec. 27, 1983

[54] SPARKLING WINE BOTTLE OPENER

United States Patent [19]
Becker

[11] 4,437,360
[45] Mar. 20, 1984

[54] APPARATUS FOR CONTROLLED STOPPER EXTRACTION FROM AND REINSERTION IN SPARKLING WINE BOTTLES

United States Patent [19]
Chance et al.

[11] 4,442,735
[45] Apr. 17, 1984

[54] CHAMPAGNE CORK PULLER

United States Patent [19]
Shoemaker, III

[11] Patent Number: 4,479,406
[45] Date of Patent: Oct. 30, 1984

[54] CORK PULLER

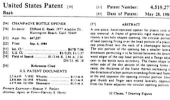

United States Patent [19]
Gorski

[11] Patent Number: 4,483,451
[45] Date of Patent: Nov. 20, 1984

[54] BOTTLE CLOSURE DEVICE

United States Patent [19]
Burns

[11] Patent Number: Des. 276,787
[45] Date of Patent: Dec. 18, 1984

[54] COMBINED CHAMPAGNE AND WINE BOTTLE STOPPER REMOVER

United States Patent [19]
Raab

[11] Patent Number: 4,519,277
[45] Date of Patent: May 28, 1985

[54] CHAMPAGNE BOTTLE OPENER

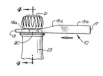

United States Patent [19]
Wolze

[11] Patent Number: 4,520,696
[45] Date of Patent: Jun. 4, 1985

[54] CHAMPAGNE BOTTLE OPENER

United States Patent [19]
Drosky

[11] Patent Number: 4,527,450
[45] Date of Patent: Jul. 9, 1985

[54] STOPPER EXTRACTOR
[76] Inventor: Billy J. Drosky, 719 Circle Ct., San Francisco, Calif. 94080
[21] Appl. No.: 549,108
[22] Filed: Nov. 7, 1983
[51] Int. Cl.³ B67B 7/00
[52] U.S. Cl. 81/3.29; 81/3.31;
[58] Field of Search 81/3.37, 81/3.08, 81/3.56
81/3.38 R, 81/3.1, 3.46 R,
81/3.1 B, 3.37

[56] References Cited
U.S. PATENT DOCUMENTS

34,216	1/1862	Russel	81/3.37
1,767,018	12/1930	Porr	81/3.38 R
2,548,697	4/1951	Reipelz et al	81/3.46
2,761,338	9/1956	Hardy	81/3.38
4,305,182	9/1982	Axene	81/3.38 R

FOREIGN PATENT DOCUMENTS
52187 1/1911 Switzerland 81/3.37

Primary Examiner—Frederick R. Schmidt
Assistant Examiner—J. T. Zatarga
Attorney, Agent, or Firm—Townsend and Townsend

[57] ABSTRACT
A stopper extractor includes a housing having an open end and a closed end and a side-facing cutout on one side of the housing wall with a grip disposed for axial movement within the housing. The grip has an axially disposed circular flange, a side-facing cutout and an axial extension which passes through the closed housing end. The side-facing cutouts are sized to allow the enlarged head of a stopper to be inserted laterally into the grip. A crescent shaped cam is pivotally mounted to the extension and bears against the outer surface of the closed end. A handle is used to pivot the cam which pulls the grip axially upwardly. A spring between the grip and the housing, biases the grip axially toward the open housing end. The extractor is mounted over the stopper with the open end against the container and the grip under the lower edge of the cork head. Rocking the handle pivots the cam to raise the grip. This causes the open end to bear downwardly against the container and the grip to move axially upwardly within the housing to pull the cork from the container and into the housing.

2 Claims, 5 Drawing Figures

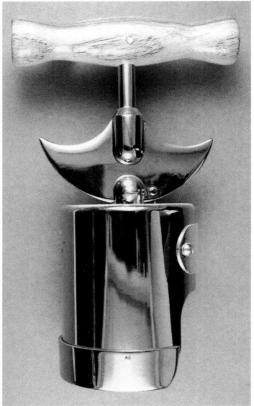

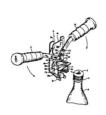

United States Patent [19]
Olson

[11] Patent Number: 4,590,821
[45] Date of Patent: May 27, 1986

[54] BOTTLE CAP REMOVER
[76] Inventor: James C. Olson, 7555 NE 33rd Dr., Portland, Oreg. 97211
[21] Appl. No.: 670,327
[22] Filed: Nov. 9, 1984
[51] Int. Cl.³ B67B 7/02
[52] U.S. Cl. 81/3.37; 81/3.29;
81/3.25
[58] Field of Search 81/3.29, 3.25, 3.31, 81/3.27, 3.36, 3.37, 3.4, 3.42, 3.07, 3.56

[56] References Cited
U.S. PATENT DOCUMENTS

1,366,125	3/1932	Patterson	81/3.29
2,091,190	8/1937	Lee	81/3.29
2,559,945	7/1951	Blair	81/3.25
2,761,338	9/1956	Hardy	81/3.29
3,800,345	4/1974	Feliz	81/3.29
4,422,355	12/1983	Anton	81/3.29
4,442,735	4/1984	Chance et al	81/3.29
4,527,450	7/1985	Drosky	81/3.37

FOREIGN PATENT DOCUMENTS
1027241 2/1957 France 81/3.56

Primary Examiner—Roscoe V. Parker
Attorney, Agent, or Firm—Klarquist, Sparkman, Campbell, Leigh & Whinston

[57] ABSTRACT
A stopper removing device mountable on a bottle. A carriage on the frame of the remover has a removing lip disposed beneath the head of the stopper. Upon downward movement of the levers, the carriage is driven upwardly to extract the stopper S. The levers have handles which are disposed approximately horizontally just after application of the stopper removing device to the neck of a bottle, such handles being gripped and forced downwardly to effect upward movement of the carriage and the stopper relative to the bottle. The levers have open slots slidably engaging studs on the carriage. The carriage has three sets of slides alternatively engaging the opposite sides of a frame to mount the carriage in place. A shield is carried by the carriage and disposed above the head of the stopper to prevent the stopper, under gaseous pressure from the interior of the bottle, from being popped upwardly clear of the removing device and into the face of the user.

7 Claims, 5 Drawing Figures

United States Patent [19]
Baum

[11] Patent Number: 4,598,613
[45] Date of Patent: Jul. 8, 1986

[54] CHAMPAGNE BOTTLE OPENER
[76] Inventor: Frederick W. Baum, 22710 Oxnard St., Woodland Hills, Calif. 91364
[21] Appl. No.: 739,950
[22] Filed: Jul. 29, 1985
[51] Int. Cl.³ B67B 7/32
[52] U.S. Cl. 81/3.37; 81/3.55
[58] Field of Search 81/3.35, 3.37, 3.29, 81/3.55, 3.56, 3.47, 3.48, 29/267

[56] References Cited
U.S. PATENT DOCUMENTS

280,697	7/1883	White	81/3.37
2,761,338	9/1956	Hardy	81/3.29
4,074,611	2/1978	Willard et al	29/267
4,254,575	10/1982	Lenowsky	29/267

Primary Examiner—James L. Jones, Jr.

[57] ABSTRACT
A device for controllably removing a stopper from a bottle, such as a champagne bottle, so as to prevent the uncontrolled discharge of the stopper from the bottle opening. The device has a brace means selectively securable to a portion of the bottle beneath the stopper, chuck means or alternatively a socket for engaging the stopper, and actuator means operatively connected to the brace means and chuck means or socket for raising the chuck means or socket relative to the brace and thereby removing the stopper from the bottle. The chuck means and stopper securely engage the stopper and thereby prevent its uncontrolled discharge from the bottle opening.

23 Claims, 13 Drawing Figures
Attorney, Agent, or Firm—Pretty Schroeder Brueggemann & Clark

United States Patent [19]
Veverka et al.

[11] Patent Number: 4,606,245
[45] Date of Patent: Aug. 19, 1986

[54] OPENING MECHANISM FOR BOTTLES HAVING CLOSURE ELEMENTS
[76] Inventors: Joseph F. Veverka, P.O. Box 324; Jarred L. Williams, P.O. Box 326, both of Prairie City, Iowa 50228
[21] Appl. No.: 717,016
[22] Filed: Mar. 28, 1985
[51] Int. Cl.³ B67B 7/02
[52] U.S. Cl. 81/3.29; 81/3.4, 3.37 29/262
[58] Field of Search 81/3.4, 3.42, 3.44, 29/261, 262, 215/303

[56] References Cited
U.S. PATENT DOCUMENTS

559,805	5/1896	Johnson	29/262
580,639	4/1897	Davis	29/262
2,467,982	4/1949	Marta	29/262
2,684,043	2/1950	Males	29/262
2,718,801	9/1955	Finley	
2,732,741	1/1956	Muller et al	
2,761,338	9/1956	Hector et al	

4,422,355	12/1983	Burns	
4,442,735	4/1984	Chance et al	
4,522,069	6/1985	Aivi	81/3.42

Primary Examiner—Roscoe V. Parker
Attorney, Agent, or Firm—Zarley, McKee, Thomte, Voorhees & Sease

[57] ABSTRACT
An opening mechanism for bottles having closure elements including a brace positionable against the bottle with leverage structure operatively associated with the brace and being movable oppositely against the brace. A grasping clevis is a movable in response to the leverage structure. A control having an actuation portion is connected to the brace and positioned so that the grasping clevis abuts the actuation portion of the control at least when the grasping clevis is a grasping the closure member of the bottle, the actuation portion being associated with the portion of the closure element which causes the grasping clevis to close when the closure element is moved to a grasping position.

10 Claims, 6 Drawing Figures

United States Patent [19]
Brewton et al.

[11] Patent Number: 4,653,355
[45] Date of Patent: Mar. 31, 1987

[54] DEVICE FOR REMOVING CHAMPAGNE CORKS FROM BOTTLES
[75] Inventors: Nolan Brewton; Gerhard J. Weiser, both of Walnut Creek; Helmut Rauch, Martinez, all of Calif.
[73] Assignee: Mt. Diablo Tool and Die, Inc., Walnut Creek, Calif.
[21] Appl. No.: 711,784
[22] Filed: Mar. 14, 1985
[51] Int. Cl.³ B67B 7/06
[52] U.S. Cl. 81/3.44, 111, DIG 9;
[58] Field of Search 81/3.44, 111, DIG 9, 81/3.29, 3.42, 3.55, 3.56

[56] References Cited
U.S. PATENT DOCUMENTS

1,784,717	4/1930	Hughes	81/DIG. 9
3,741,047	6/1973	Lenowsky	81/111 X
4,275,621	6/1981	Merva	81/3.44
4,442,735	4/1984	Chance et al	81/3.44

Primary Examiner—Roscoe V. Parker
Attorney, Agent, or Firm—Townsend and Townsend

[57] ABSTRACT
A device having a pair of hollow, shell-like members pivotally coupled to each other for movement into and out of positions adjacent to each other. When the members are adjacent to each other, they form a hollow space for receiving the cork at the neck of a champagne bottle, the members having flanges for defining an opening for receiving the cork and surrounding the neck and underlying the annular lower extremity of the cork. A pair of resilient tabs are secured to the opposite ends of the members for releasably holding the same in their closed positions. A handle on one of the members is provided to allow for an outward force to be exerted on the members away from the bottle to move the cork out of the bottle when the cork is in the closed space formed by the members. The device can be formed of metal or plastic.

3 Claims, 4 Drawing Figures

United States Patent [19]
Feliz

[11] Patent Number: 4,680,993
[45] Date of Patent: Jul. 21, 1987

[54] CHAMPAGNE BOTTLE OPENER
[76] Inventor: Jack M. Feliz, 2110 Southridge Dr., Palm Springs, Calif. 92264
[21] Appl. No.: 874,785
[22] Filed: Jan. 20, 1986
[51] Int. Cl.³ B67B 7/02
[52] U.S. Cl. 81/3.37; 81/3.29
[58] Field of Search 81/3.07, 3.37, 3.36, 3.55, 3.56, 29/267

[56] References Cited
U.S. PATENT DOCUMENTS

3,800,345	4/1974	Feliz	81/3.37
4,527,450	7/1985	Drosky	81/3.37
4,590,821	5/1986	Olson	81/3.37

FOREIGN PATENT DOCUMENTS
4,598,613 7/1986 Baum 81/3.37
1604955 12/1985 European Pat. Off. 81/3.07

Attorney, Agent, or Firm—Harris, Kern, Wallen & Tinsley

[57] ABSTRACT
An improved champagne bottle opener comprising a flanged yoke-shaped cork extractor pivotally connected to a levered actuator and further pivotally connected to a flanged yoke-shaped platform which engages the flanged neck of a champagne bottle.

3 Claims, 7 Drawing Figures

United States Patent [19]
Powis, Jr.

[11] Patent Number: Des. 289,361
[45] Date of Patent: ** Apr. 21, 1987

[54] CHAMPAGNE STOPPER REMOVER
[76] Inventor: George S. Powis, Jr., P.O. Box 594, Hatfield, Pa. 19440
[**] Term: 14 Years
[21] Appl. No.: 637,029
[22] Filed: Aug. 2, 1984
[52] U.S. Cl. D8/18
[58] Field of Search D8/18, 40, 42, 43, 33, D8/34; 81/3.4, 3.41, 3.43, 3.44; 7/151

[56] References Cited
U.S. PATENT DOCUMENTS

D. 142,202	8/1945	Lanyon	D8/18
D. 152,060	12/1948	Campion	D8/41
4,509,784	4/1985	Vollers	D8/40 X

Primary Examiner—Bernard Ansher
Attorney, Agent, or Firm—D. Max Klevit

[57] CLAIM
The ornamental design of a champagne stopper remover, as shown.

DESCRIPTION
FIG. 1 is a top, front, left side perspective view of a champagne stopper remover showing my new design;
FIG. 2 is a front elevational view thereof;
FIG. 3 is a rear elevational view thereof;
FIG. 4 is a top plan view thereof;
FIG. 5 is a bottom plan view thereof; and
FIG. 6 is a right side elevational view thereof looking from the right of FIG. 2.

United States Patent [19]
Friedline

[11] Patent Number: Des. 292,478
[45] Date of Patent: ** Oct. 27, 1987

[54] CHAMPAGNE BOTTLE OPENER
[76] Inventor: Floyd W. Friedline, R.R. 1, Box 390, Moro, Ill. 62067
[**] Term: 14 Years
[21] Appl. No.: 739,053
[22] Filed: May 29, 1985
[52] U.S. Cl. D8/13, 18, 42, 40, 34;
[58] Field of Search D8/18; 7/151, 154, 155; 81/3.09

[56] References Cited
U.S. PATENT DOCUMENTS

| D. 148,810 | 3/1948 | McDowell | D8/42 |
| D. 174,838 | 5/1955 | Green et al | D8/33 |

Primary Examiner—Bernard Ansher
Assistant Examiner—Terry Pfeffer
Attorney, Agent, or Firm—Don E. Ferrell

[57] CLAIM
The ornamental design for a champagne bottle opener, as shown and described.

DESCRIPTION
FIG. 1 is a perspective view of a champagne bottle opener showing my new design;
FIG. 2 is a front elevational view thereof;
FIG. 3 is a top plan view thereof;
FIG. 4 is a bottom plan view thereof.

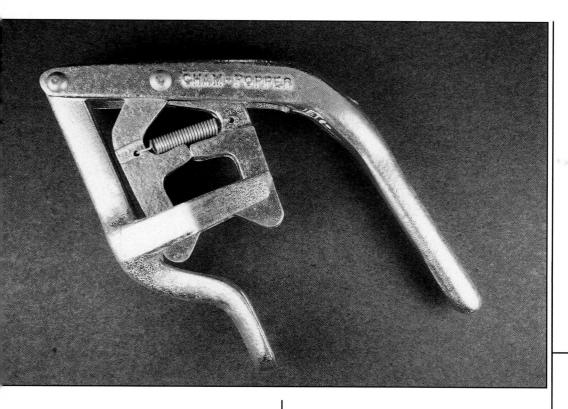

United States Patent [19]

Eash

[11] Patent Number: 4,708,033

[45] Date of Patent: Nov. 24, 1987

[54] STOPPER REMOVER

[76] Inventor: Lester E. Eash, 7134 S. Marina Pacifica, Long Beach, Calif. 90803

[21] Appl. No.: 615,270

[22] Filed: May 30, 1984

[51] Int. Cl.⁴ B67B 7/32

[52] U.S. Cl. 81/3.37; 81/3.41;

[58] Field of Search 81/3.34, 3.36, 3.37, 81/3.4, 3.41, 3.44, 3.46 R, 3.3 R, 3.31, 3.33, 3.38 R

[56] References Cited

U.S. PATENT DOCUMENTS

ABSTRACT

A tool for removing headed stoppers from bottles such as champagne bottles, includes a base having a two fingered yoke and a side support, sized and shaped to engage the upper lip and the side of the neck of the bottle respectively, so that when a handle, pivotally attached to the base, is lowered toward the bottle, a pair of inwardly biased jaws slide down over the head of the stopper to engage its undersurface between the fingers of the yoke. Thereafter, the handle is lifted extracting the stopper while inwardly facing extensions positioned above the stopper on the jaws restrict upward motion of the stopper to prevent uncontrolled motion thereof.

18 Claims, 7 Drawing Figures

United States Patent [19]

Giebeler

[11] Patent Number: 4,729,267

[45] Date of Patent: Mar. 8, 1988

[54] CHAMPAGNE BOTTLE OPENER

[76] Inventor: Ben F. Giebeler, P.O. Box XX024, San Bernardino, Calif. 92412

[21] Appl. No.: 769,842

[22] Filed: Aug. 26, 1985

[51] Int. Cl.⁴ B67B 7/06

[52] U.S. Cl. 81/3.27; 81/3.29

[58] Field of Search 81/3.29, 3.4, 3.41, 2.44, 3.35-3.36, 3.39, 3.31-3.33, 125

[56] References Cited

U.S. PATENT DOCUMENTS

FOREIGN PATENT DOCUMENTS

ABSTRACT

A device for the controlled removal and re-insertion of the cork used with the conventional champagne bottle. The device has a first member having a cavity which is sized and shaped to straddle the neck of the bottle, and specifically the circumferential rib which the conventional champagne bottle has near the spout. A second member is sized and shaped to slide onto the head of the cork. Various types of handles, linkages and gears are shown to move the two members apart, linearly, and under leverage, so that the cork can be removed and re-inserted with ease.

12 Claims, 19 Drawing Figures

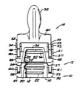

United States Patent [19]

Sweatt

[11] Patent Number: 4,750,391

[45] Date of Patent: Jun. 14, 1988

[54] OPENER FOR REMOVING CHAMPAGNE-TYPE CORKS

[75] Inventor: Stanley L. Sweatt, Downey, Calif.

[73] Assignee: Stus Dee, Incorporated, Downey, Calif.

[21] Appl. No.: 848,382

[22] Filed: Apr. 4, 1986

[51] Int. Cl.⁴ B67B 7/06

[52] U.S. Cl. 81/3.27; 81/3.29

[58] Field of Search 81/3.34, 3.27, 3.07, 81/3.08, 3.29, 3.31, 3.33, 3.29, 3.4, 3.41, D4/18, 33, 39, 40, 42

[56] References Cited

U.S. PATENT DOCUMENTS

FOREIGN PATENT DOCUMENTS

ABSTRACT

An opener (10) for removing a cork (34) from a champagne-type bottle (12)is a generally straight line comprises a frame (20, 22) contactable with the bottle by a pivotable annulus (60) so that the opener can be maintained generally immobile with respect to the bottle during removal of the cork. A pair of tongs (32) are slidable in channels within arms (30) so that the tongs may be moved towards and from the mouth of the bottle. The tongs are pivotable with respect to one another so that, when they are moved upwardly from the mouth of the bottle by a rack (44) engaging gear segments (50) on handle (84), the tongs can pivot towards one another to secure better engagement with the cork to effect movement of the tongs and the cork engaged thereby in a direction away from the bottle. The tongs are also pivotable to accommodate corks of different sizes, and the wires binding the cork to the bottle.

14 Claims, 2 Drawing Sheets

United States Patent [19]

Valtri et al.

[11] Patent Number: 4,756,214

[45] Date of Patent: Jul. 12, 1988

[54] APPARATUS FOR REMOVING A STOPPER FROM A BOTTLE

[75] Inventors: Frank J. Valtri, Warminster; Matthew D. Marbelba, Southampton, both of Pa.

[73] Assignee: Levaco Industries, Inc., Ivyland, Pa.

[21] Appl. No.: 3,272

[22] Filed: Jan. 14, 1987

[51] Int. Cl.⁴ B67B 7/00

[52] U.S. Cl. 81/3.41; 81/3.36

[58] Field of Search 81/3.44, 3.45, 3.37, 3.07, 3.08, 3.36, 29/218, 260, 261, 265, 259, 262

[56] References Cited

U.S. PATENT DOCUMENTS

ABSTRACT

An apparatus for removing a stopper from a bottle comprising a threaded shaft member, a bottle-gripping member, and a stopper-gripping member threadedly mounted on the shaft member. The bottle-gripping and stopper-gripping members are rigidly constructed and relatively flexible, but are instrumed and made rigid and operative by their cooperation with a slidable collar which surrounds them and may selectively be positioned for proper removal or for application of the apparatus to a bottle for stopper insertion.

20 Claims, 3 Drawing Sheets

United States Patent [19]

Allen

[11] Patent Number: Des. 297,201

[45] Date of Patent: ** Aug. 16, 1988

[54] FOIL CUTTER FOR WINE BOTTLES

[75] Inventor: Herbert Allen, Houston, Tex.

[73] Assignee: Hallen Company, Houston, Tex.

[**] Term: 14 Years

[21] Appl. No.: 790,262

[22] Filed: Oct. 22, 1985

[52] U.S. Cl. D7/99; D8/18

[58] Field of Search D7/77; D8/40-42, D8/18; 81/3.4, 3.44

[56] References Cited

U.S. PATENT DOCUMENTS

CLAIM

The ornamental design for a foil cutter for champagne bottles, as shown and described.

DESCRIPTION

FIG. 1 is a top, front, right side perspective view of a foil cutter for champagne bottles; and
FIG. 2 is a bottom, rear, left side perspective view thereof.

United States Patent [19]

Foster

[11] Patent Number: 4,798,106

[45] Date of Patent: Jan. 17, 1989

[54] CHAMPAGNE BOTTLE CORK PULLER AND INSERTING APPARATUS

[76] Inventor: Milton E. Foster, 2733 Almendra Ct., Fullerton, Calif. 92024

[21] Appl. No.: 941,206

[22] Filed: Dec. 12, 1986

[51] Int. Cl.⁴ B67B 7/02

[52] U.S. Cl. 81/3.29; 29/240

[58] Field of Search 81/3.27, 29/246, 206

[56] References Cited

U.S. PATENT DOCUMENTS

ABSTRACT

A champagne bottle cork puller and insertion apparatus for controllably pulling and inserting a champagne cork. The apparatus includes a cork engager, an engager casing and lower device, and a single piece body which is attached to the casing and lowering device. The body includes a groove which fits around a champagne bottle spout rim and keeps the body essentially vertically immovable with respect to the champagne bottle during operation. The apparatus includes relatively few parts and is inexpensive to manufacture and assemble.

4 Claims, 2 Drawing Sheets

United States Patent [19]

Allen

[11] Patent Number: 4,800,783

[45] Date of Patent: Jan. 31, 1989

[54] METHOD AND APPARATUS FOR REMOVING A CORK OR PLASTIC STOPPER FROM A CHAMPAGNE BOTTLE

[76] Inventor: Herbert Allen, 2207 Groveland, Houston, Tex. 77019

[21] Appl. No.: 58,566

[22] Filed: Jun. 5, 1987

[51] Int. Cl.⁴ B67B 7/04

[52] U.S. Cl. 81/3.4

[58] Field of Search 81/3.4, 3.27, 3.07, 3.44

OTHER PUBLICATIONS

Advertisement for the Champagne Key, undated, one page.
Wine Ambiance catalog by America's Wineland Crafts, 1986 Edition, p. 8.
The Wine Enthusiast catalog, 1986 Edition, pp. 2 and one page.
Advertisement for the Uncorker, dated 10/31, one page.

U.S. PATENT DOCUMENTS

FOREIGN PATENT DOCUMENTS

ABSTRACT

Apparatus and method for removing a stopper from a bottle having an internal pressure greater than the ambient pressure surrounding the bottle, e.g. a champagne bottle. At least one generally vertical edge of the apparatus is placed in a generally vertical groove in the periphery of the stopper, at some cases cutting the groove simultaneously as it is moved downward over the stopper. The apparatus is then oscillated or rotated whereupon the internal pressure in the bottle can overcome the sliding friction between the stopper and the bottle. The apparatus is also adapted to control the stopper, once expelled.

34 Claims, 3 Drawing Sheets

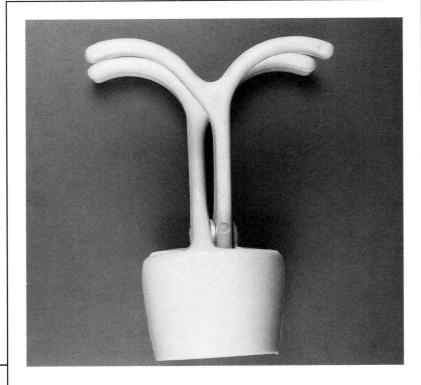

United States Patent [19]

Allen

[11] Patent Number: 4,845,844

[45] Date of Patent: Jul. 11, 1989

[54] FOIL CUTTER

[75] Inventor: Herbert Allen, Houston, Tex.

[73] Assignee: Hallen Company, Houston, Tex.

[21] Appl. No.: 238,988

[22] Filed: Aug. 24, 1988

Related U.S. Application Data

[63] Continuation of Ser. No. 790,243, Oct. 22, 1985, abandoned.

[51] Int. Cl.⁴ B67B 7/00

[52] U.S. Cl. 30/1.5; 30/102

[58] Field of Search 30/1.5, 101, 102, 253, 7/156

[56] References Cited

U.S. PATENT DOCUMENTS

FOREIGN PATENT DOCUMENTS

Primary Examiner—Douglas D. Watts

Attorney, Agent, or Firm—Browning, Bushman, Zamhecki & Anderson

ABSTRACT

A cutting device for cutting material covering wine bottle necks comprising cutters defining at least three cutting surfaces and a frame carrying the cutters. The frame has an axis and positions the cutters such that the cutting surfaces are radially spaced from the axis, aligned transversely in the axis and circumferentially spread with the angular displacement between each cutting surface and the two adjacent cutting surfaces less than 180°, whereby, upon rotation of the frame about the axis by an amount less than 180°, the cutting surfaces respectively define contiguous arcs of a common circle. The frame further permits the cutting surfaces to so define a plurality of such common circles of different diameters.

31 Claims, 5 Drawing Sheets

United States Patent [19]

Crudgington, Jr.

[11] Patent Number: 4,875,394

[45] Date of Patent: Oct. 24, 1989

[54] CHAMPAGNE BOTTLE OPENER

[76] Inventor: Cleveland B. Crudgington, Jr., 222 N. Myrtle Ave., Monrovia, Calif. 91016

[21] Appl. No.: 895,204

[22] Filed: Jan. 11, 1986

Related U.S. Application Data

[63] Continuation-in-part of Ser. No. 786,345, Oct. 11, 1985, abandoned.

[51] Int. Cl.⁴ B67B 7/02

[52] U.S. Cl. 81/3.08; 81/3.36

[58] Field of Search 81/3.36, 3.08, 3.37, 81/3.39, 3.55, 3.09, 302, 413, 416, 417, 29/264

[56] References Cited

U.S. PATENT DOCUMENTS

FOREIGN PATENT DOCUMENTS

Primary Examiner—Roscoe V. Parker

ABSTRACT

Improvements in a hand manipulable device with bifurcated jaws for removing mushroom shaped stoppers from sparkling beverage bottles wherein each jaw contains a recess enabling the device to be repositioned directly around the stopper's stem and on top of the bottle when the stopper has been partially removed, thereby providing a means for additional leverage and lift capability; pivotally interconnected upper and lower levels which are interlocked, thereby eliminating the likelihood that the pivot action might be either too tight or too loose, and enabling the insertion of a hidden spring which eliminates the need for an exposed and perhaps hazardous spring between the handles; and without an exposed spring, grip means is permitted beneath the handles that provides an alternate method of stopper removal; the addition of clips to the upper jaw to prevent the stopper from ricocheting out from under the remaining arm; and a retaining arm which is either flexible or movable thereby permitting a downwardly directed and manually exerted counter force to be applied to said stopper, enabling the stopper to be removed slowly, if desired.

14 Claims, 2 Drawing Sheets

United States Patent [19]

Forrest

[11] Patent Number: 4,848,191

[45] Date of Patent: Jul. 18, 1989

[54] STOPPER REMOVAL APPARATUS

[76] Inventor: Stuart E. Forrest, 494 Ash, Winnetka, Ill. 60093

[21] Appl. No.: 302,471

[22] Filed: Jan. 26, 1989

Related U.S. Application Data

[63] Continuation-in-part of Ser. No. 07/152,988 Feb. 1, 1988, abandoned.

[51] Int. Cl.⁴ B67B 7/02

[52] U.S. Cl. 81/3.44

[58] Field of Search 81/3.44, 3.4, 3.07, 81/3.14, 3.49

[56] References Cited

U.S. PATENT DOCUMENTS

FOREIGN PATENT DOCUMENTS

Primary Examiner—Roscoe V. Parker

Attorney, Agent, or Firm—McAndrews, Held & Malloy, Ltd.

ABSTRACT

A stopper removal apparatus for safely and easily removing a cork and other plastic types of stoppers from a glass bottle containing a beverage under pressure. The apparatus comprises two molded curved members coupled together at a fulcrum point between their ends and operated in a scissor-like manner. Each molded member has an integral jaw adjacent to its lower end for substantially encircling the stopper. The jaws include a plurality of integral evenly spaced, sharply pointed prongs or tines that deeply penetrate the stopper and thus provide a secure, non-slip grip so that the stopper may be easily and safely removed without breaking or becoming a projectile capable of causing injury.

5 Claims, 2 Drawing Sheets

United States Patent [19]

Daviddi

[11] Patent Number: 4,887,497

[45] Date of Patent: Dec. 19, 1989

[54] BOTTLE CORK REMOVER

[76] Inventor: Ivo Daviddi, 15244 Michigan Ave., Dearborn, Mich. 48126

[21] Appl. No.: 292,481

[22] Filed: Dec. 30, 1988

[51] Int. Cl.⁴ B67B 7/06

[52] U.S. Cl. 81/3.27; 81/3.36

[58] Field of Search 81/3.08, 3.37, 3.36, 81/3.37, 3.29, 3.4, 3.56

[56] References Cited

U.S. PATENT DOCUMENTS

Primary Examiner—D. S. Meslin

Attorney, Agent, or Firm—Charles W. Chandler

ABSTRACT

A mechanism for removing a cork from a champagne bottle, wherein a manual force is applied along the bottle axis, so as to avoid side thrust forces that might cause the bottle to slip out of the person's hand. A lazy tong linkage is utilized to apply a magnified force onto the undersurface of the cork, whereby the person is able to exert a smooth controlled manual force on the mechanism, as opposed to a massive abrupt force that might tend to cause the bottle to drop or tip over.

7 Claims, 1 Drawing Sheet

United States Patent [19]

Giebeler

[11] Patent Number: 4,947,711

[45] Date of Patent: Aug. 14, 1990

[54] CHAMPAGNE BOTTLE OPENER

[76] Inventor: Ben F. Giebeler, 2670 El Camino, San Bernardino, Calif. 92404

[21] Appl. No.: 295,888

[22] Filed: Jan. 11, 1989

[51] Int. Cl.⁴ B67B 7/06

[52] U.S. Cl. 81/3.27; 81/3.29

[58] Field of Search 81/3.29, 3.37, 3.36

[56] References Cited

U.S. PATENT DOCUMENTS

Primary Examiner—Roscoe V. Parker

Attorney, Agent, or Firm—Lyon & Lyon

ABSTRACT

A device for the controlled removal and re-insertion of the cork used with the conventional champagne bottle. The device has a first member having a cavity which is sized and shaped to straddle the neck of the bottle, with a plastic insert to specifically fit the circumferential rib which the conventional champagne bottle has near the apex. A second member contains annular ridges to slide onto and grip the head of the cork. A single handle utilizes a rack-gear mechanism to move the two members apart, linearly and under leverage, so that the cork can be removed and re-inserted with ease.

9 Claims, 1 Drawing Sheet

United States Patent [19]

Bergmeister

[11] Patent Number: 5,000,062

[45] Date of Patent: Mar. 19, 1991

[54] COLLET-TYPE CORK REMOVER WITH THUMB RECEIVING RECESS

[76] Inventor: Josef J. Bergmeister, P.O. Box 640347, San Francisco, Calif. 94164

[21] Appl. No.: 524,974

[22] Filed: May 18, 1990

[51] Int. Cl.⁴ B67B 7/06

[52] U.S. Cl. 81/3.07; 3.4, 3.44

[58] Field of Search 81/3.25, 3.41, 3.09

[56] References Cited

U.S. PATENT DOCUMENTS

FOREIGN PATENT DOCUMENTS

Primary Examiner—Roscoe V. Parker

Attorney, Agent, or Firm—Flehr, Jacobson, Cohn, Price, Holman & Stern

ABSTRACT

An elongated plastic body is provided including first and second ends. The first end includes an enlarged head thereon provided with a recess therein opening outwardly generally along a radius of the longitudinal axis of the body and the other end of the body includes end-wise outwardly projecting elongated collet fingers defining a recess therebetween in which to receive the second end of a cork bottle, the inner surfaces of the collet fingers being provided with a plurality of projections for increasing the frictional grip of the collet fingers on an associated cork and the recess being of a size and depth to receive the free end of the thumb of a hand encircling the body.

9 Claims, 1 Drawing Sheet

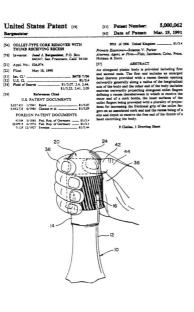

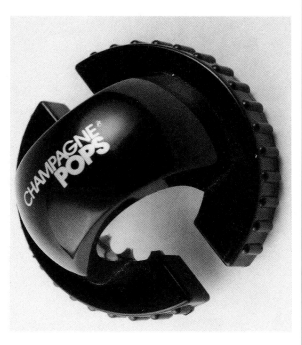

United States Patent [19]
Federighi, Sr.

[11] Patent Number: 5,000,063
[45] Date of Patent: Mar. 19, 1991

[54] BOTTLE STOPPER PULLER

[76] Inventor: George Federighi, Sr., 70 - 13th St., San Francisco, Calif. 94103

[21] Appl. No.: 488,986
[22] Filed: Mar. 5, 1990

[51] Int. Cl.⁵ B67B 7/06
[52] U.S. Cl. 81/3.37; 81/3.44
[58] Field of Search 81/3.36, 3.37, 3.29, 81/3.4, 3.41, 3.44, 3.48

[56] References Cited
U.S. PATENT DOCUMENTS

4,063,483	12/1977	Bozzo	81/3.37
4,399,720	8/1983	Coppeti	81/3.37

4,227,430	7/1985	Drosky	81/3.37
4,730,391	6/1988	Suvari	81/3.29
4,756,214	7/1988	Valin	81/3.45
4,794,106	1/1989	Foster	81/3.29

Primary Examiner—Roscoe V. Parker, Jr.
Attorney, Agent, or Firm—Harris Zimmerman

[57] ABSTRACT

A stopper remover and piercing pin for champagne bottles, and the like, which has grasping jaws and a piercing pin on an operative shaft, wherein the operative shaft is moved by lever-driven gears inward toward the bottle to pierce the stopper and outward away from the bottle to remove the stopper.

14 Claims, 2 Drawing Sheets

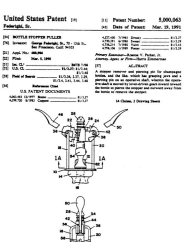

United States Patent [19]
Saveland

[11] Patent Number: 5,016,499
[45] Date of Patent: May 21, 1991

[54] BEVERAGE BOTTLE STOPPER REMOVER

[76] Inventor: Lee Saveland, P.O. Box 7893, Auburn, Calif. 95604

[21] Appl. No.: 579,565
[22] Filed: Sep. 10, 1990

[51] Int. Cl.⁵ B67B 7/06
[52] U.S. Cl. 81/3.37; 81/3.29
[58] Field of Search 81/3.37, 3.07, 3.4, 81/3.36, 3.29, 29/267

[56] References Cited
U.S. PATENT DOCUMENTS

280,697	7/1881	White	81/3.29
2,761,238	9/1956	Hardy	81/3.37
3,800,345	4/1974	Felit	81/3.37
4,359,613	7/1982	Baum	81/3.37
4,680,993	7/1987	Petal	81/3.37
4,729,267	3/1988	Giebeler	81/3.37
4,794,106	1/1989	Foster	81/3.29
4,947,711	8/1990	Giebeler	81/3.37

FOREIGN PATENT DOCUMENTS

10606 9/1901 Norway 81/3.37

Primary Examiner—Roscoe V. Parker
Attorney, Agent, or Firm—Mark C. Jacobs

[57] ABSTRACT

An opener for the easy removal of a stopper from a champagne-type bottle unidirectionally, which opener comprises a frame having a closed front and an open rear, a first shaft at the forward end, and a second shaft at the forward end. The second shaft is coupled to a rack at one end and to a platform adapted to engage the underside of a stopper at the other end. The rack is raised by the downward movement of a handle having a pinion at one end which engages the rack and thereby simultaneously pushes the platform upwardly on the stopper to remove it.

7 Claims, 2 Drawing Sheets

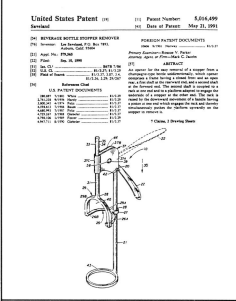

United States Patent [19]
Giebeler

[11] Patent Number: Des. 318,405
[45] Date of Patent: ** Jul. 23, 1991

[54] CHAMPAGNE BOTTLE OPENER

[76] Inventor: Ben F. Giebeler, 1670 El Carino, San Bernardino, Calif. 92404

[**] Term: 14 Years
[21] Appl. No.: 296,422
[22] Filed: Jan. 12, 1989

[52] U.S. Cl. D8/33
[58] Field of Search D8/33, 34, 40, 42, 43; 7/15; 81/3.07, 3.4, 3.36, 3.37, 3.29, 3.45

[56] References Cited
U.S. PATENT DOCUMENTS

4,441,735 4/1984 Chance et al. 81/3.09 X
4,794,106 1/1989 Foster 81/3.29

Primary Examiner—Terry A. Pfeffer
Attorney, Agent, or Firm—Lyon & Lyon

[57] CLAIM

The ornamental design for a champagne bottle opener, as shown and described.

DESCRIPTION

FIG. 1 is a top, front, right side perspective view of a champagne bottle opener showing my new design;
FIG. 2 is a left side elevational view thereof;
FIG. 3 is a side elevational view thereof in a closed position;
FIG. 4 is a top plan view thereof;
FIG. 5 is a front elevational view thereof;
FIG. 6 is a rear elevational view thereof;
FIG. 7 is a bottom plan view thereof.

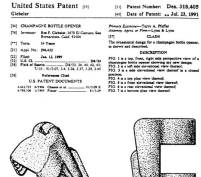
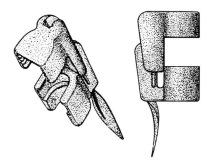

United States Patent [19]
Allen

[11] Patent Number: 5,042,331
[45] Date of Patent: Aug. 27, 1991

[54] METHOD AND APPARATUS FOR REMOVING A CORK OR PLASTIC STOPPER FROM A CHAMPAGNE BOTTLE

[75] Inventor: Herbert Allen, Houston, Tex.
[73] Assignee: Hallen Company, Houston, Tex.
[21] Appl. No.: 189,997
[22] Filed: May 4, 1988

Related U.S. Application Data

[63] Continuation-in-part of Ser. No. 58,566, Jun. 5, 1987, Pat. No. 4,800,783.

[51] Int. Cl.⁵ B67B 7/02
[52] U.S. Cl. 81/3.4
[58] Field of Search 81/3.4, 3.07, 3.44, 81/3.09

[56] References Cited
U.S. PATENT DOCUMENTS

2,493,508	1/1950	Amigone	81/3.44
2,588,096	3/1952	Eckenboy	
2,599,693	1/1952	Krus	
2,641,945	6/1953	Krus, Jr.	
2,600,982	6/1971	Thoies	81/3.4
4,432,197	2/1984	Rowland	81/3.09

FOREIGN PATENT DOCUMENTS

628521 4/1936 Fed. Rep. of Germany .

655401	1/1938	Fed. Rep. of Germany .
3304910	1/1974	Fed. Rep. of Germany .
2347699	1/1976	France .
WO8302265	1/1983	PCT Int'l Appl. .
646173	3/1955	Sweden 81/3.4
10192	of 1889	United Kingdom 81/3.44
27612	of 1910	United Kingdom 81/3.44
446080	12/1935	United Kingdom .
190299	2/1937	United Kingdom .
2084549	8/1981	United Kingdom .

Primary Examiner—Roscoe V. Parker
Attorney, Agent, or Firm—Browning, Bushman, Anderson & Brookhart

[57] ABSTRACT

Apparatus and method for removing a stopper from a bottle having an internal pressure greater than the ambient pressure surrounding the bottle, e.g. a champagne bottle. At least one generally vertical edge of the apparatus is placed in a generally vertical groove in the periphery of the stopper, in some cases cutting the groove simultaneously as it is moved downward over the stopper. The apparatus is then oscillated or rotated, whereupon the internal pressure in the bottle can overcome the sliding friction between the stopper and the bottle. The apparatus is also adapted to control the stopper, once expelled.

25 Claims, 5 Drawing Sheets

United States Patent [19]
Allen, deceased et al.

[11] Patent Number: 5,056,676
[45] Date of Patent: Oct. 15, 1991

[54] BOTTLE CAP FOR REPEATABLE AIRTIGHT SEALING

[76] Inventors: Herbert Allen, deceased, late of Houston, by Virginia D. Sealford, executrix, 5800 Lumberdale #64, Houston, both of Tex. 77092

[21] Appl. No.: 638,178
[22] Filed: Jan. 4, 1991

[51] Int. Cl.⁵ B45D 45/24
[52] U.S. Cl. 215/284; 215/280; 215/287; 220/254, 220/233
[58] Field of Search 215/284, 287, 280, 293, 215/354, 220/254, 234, 233, 262, 90.4

[56] References Cited
U.S. PATENT DOCUMENTS

1,644,457	10/1927	Yancey	215/787
1,681,076	8/1928	Grosky	215/293
2,038,489	4/1936	Guest	215/284 X
2,170,531	8/1954	Kahn	215/280 X
2,329,817	11/1990	Russell	220/254 X
2,649,220	8/1953	Vassano et al	
2,966,277	12/1960	Bean	220/233
3,183,232	5/1965	Gremmins	
3,317,071	5/1967	Tester	
4,009,794	3/1977	Zapp	215/210
4,190,173	2/1980	Mason et al	215/203
4,367,994	2/1986	Hofmann	220/254
4,691,836	9/1987	Wassloff	220/234 X
4,770,307	9/1988	Guglielmi	
4,942,976	7/1990	Spencer	220/254

OTHER PUBLICATIONS

Device "D"—2 photographs of prior art device.
Device "E"—3 photographs of prior art device.
Device "F"—3 photographs of prior art device.
Device "B"—2 photographs of prior art device.
Device "C"—2 photographs of prior art device.

Primary Examiner—Stephen Marcus
Assistant Examiner—Vanessa M. Roberts
Attorney, Agent, or Firm—Browning, Bushman, Anderson & Brookhart

[57] ABSTRACT

An improved bottle cap is provided for repeatedly obtaining airtight sealing engagement with a bottle having an annular external lip. The cap of the present invention is particularly well suited for sealing bottles containing sparkling wine or champagne, since such bottles conventionally include an external lip and since the cap of the present invention is able to seal gases within the bottle. The cap includes a housing having a central aperture for positioning over the neck of the bottle and having a radially inward directed flange for fitting beneath the external lip on the bottle. An activating carrier is movable within the aperture in the housing, and a ring-shaped pad holder and elastomeric pad are mounted on and are axially movable with respect to the carrier. A biasing spring is provided for acting on the holder and the pad to bias the pad toward sealing engagement with the bottle, which is rotatably secured to the housing, and includes a cam lobe for engaging the carrier and thereby energizing the spring to force the pad into sealing engagement with the bottle. An improved method is provided for fabricating a bottle cap for sealing engagement with a bottle having an annular external lip.

20 Claims, 1 Drawing Sheet

United States Patent [19]
Bergmeister

[11] Patent Number: Des. 319,957
[45] Date of Patent: ** Sep. 17, 1991

[54] CORK REMOVER

[76] Inventor: Josef J. Bergmeister, P.O. Box 640347, San Francisco, Calif. 94164

[**] Term: 14 Years
[21] Appl. No.: 405,851
[22] Filed: Sep. 11, 1989

[52] U.S. Cl. D8/42; D8/40
[58] Field of Search D8/42, D8/40, D8/40-43; 81/3.07, 3.27, 3.29, 3.4, 3.45, 3.55; 7/151, 155

[56] References Cited
U.S. PATENT DOCUMENTS

1,227,421	1/1941	Bjork	81/3.07 X
2,631,442	1/1953	Rauchart	81/3.4

| 3,812,741 | 5/1974 | Heine | 7/151 X |
| 4,726,264 | 2/1988 | Boss | 81/3.4 |

Primary Examiner—Terry A. Pfeffer
Attorney, Agent, or Firm—Fiett, Jacobson, Cohn, Price, Holman & Stern

[57] CLAIM

The ornamental design for a cork remover, as shown and described.

DESCRIPTION

FIG. 1 is a front perspective view of a cork remover showing my new design;
FIG. 2 is a side elevational view thereof;
FIG. 3 is a top plan view thereof;
FIG. 4 is a bottom plan view thereof; and
FIG. 5 is a vertical sectional view taken along line 5—5 of FIG. 3.

Appendix Three

THE UNIVERSAL CORKSCREW

Which came first? It is likely the original "bottlescrew" was adapted from a gun tool (Fig. A3-1). But there are many other uses for the helical form, from ground stakes to hay forks to surgical instruments, which may have contributed to or been adapted from the bottle opening tool. A sampling of those that made it into the U. S. patent records is presented here.

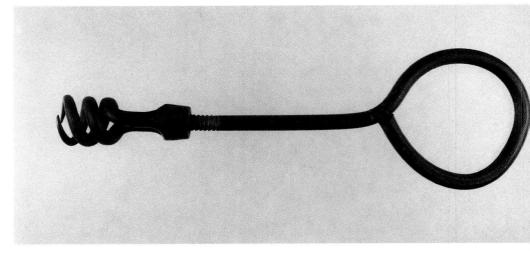

Fig. A3-1 A 19th century gun tool. Early gun tools were thought to have given rise to the bottle corkscrew.

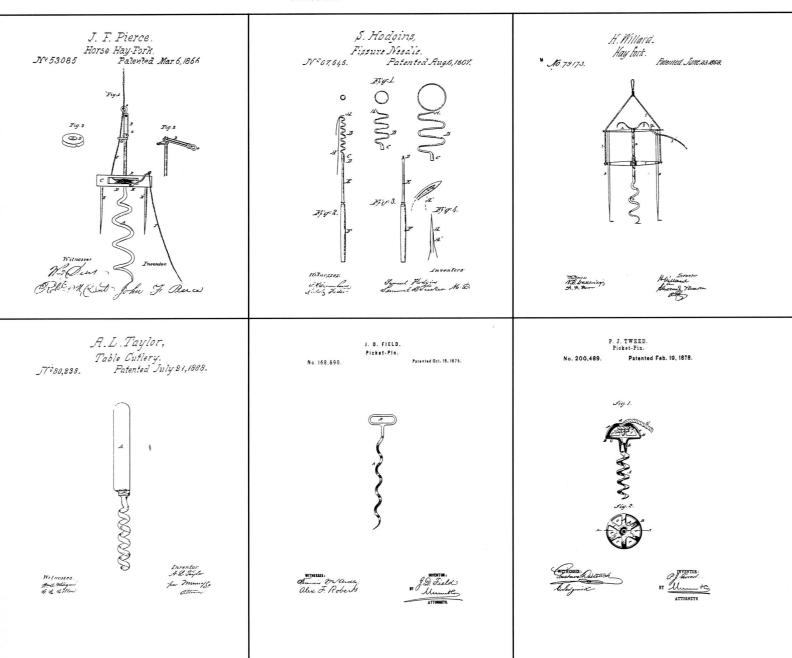

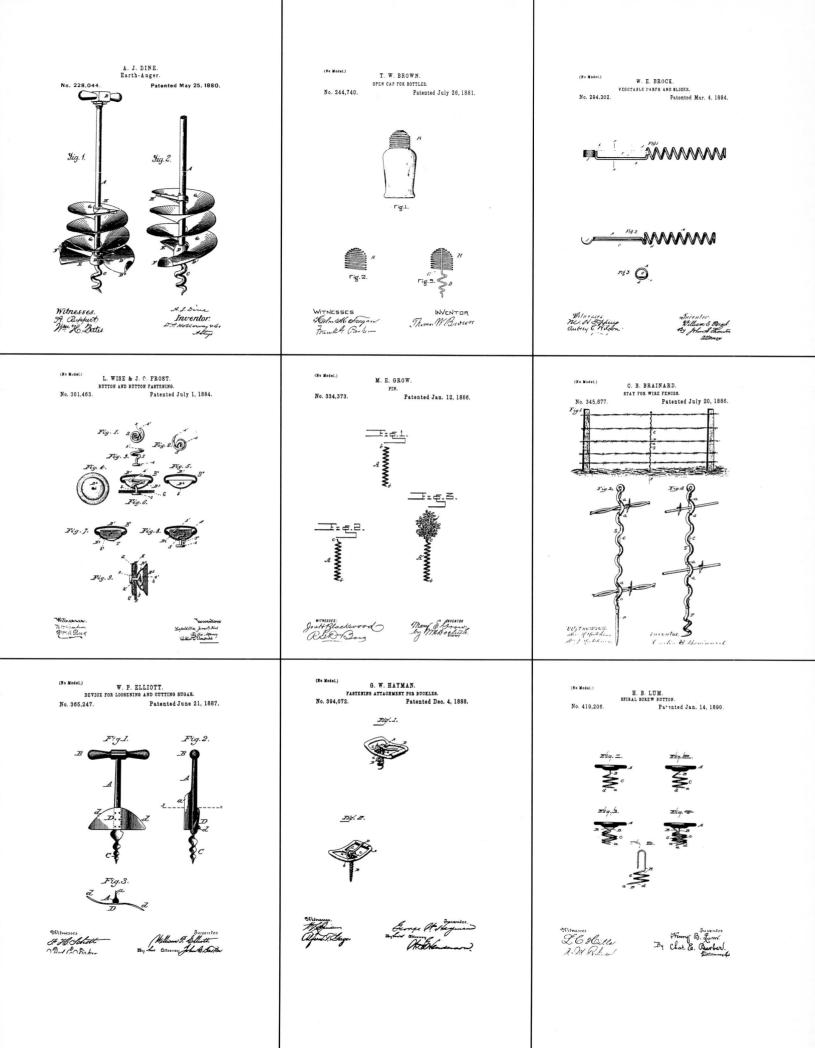

A. J. DINE.
Earth-Auger.
No. 228,044. Patented May 25, 1880.

(No Model.)
T. W. BROWN.
OPEN CAP FOR BOTTLES.
No. 244,740. Patented July 26, 1881.

(No Model.)
W. E. BROCK.
VEGETABLE PARER AND SLICER.
No. 294,302. Patented Mar. 4, 1884.

(No Model.)
L. WISE & J. C. FROST.
BUTTON AND BUTTON FASTENING.
No. 301,463. Patented July 1, 1884.

(No Model.)
M. E. GROW.
PIN.
No. 334,373. Patented Jan. 12, 1886.

(No Model.)
C. B. BRAINARD.
STAY FOR WIRE FENCES.
No. 345,877. Patented July 20, 1886.

(No Model.)
W. P. ELLIOTT.
DEVICE FOR LOOSENING AND CUTTING SUGAR.
No. 365,247. Patented June 21, 1887.

(No Model.)
G. W. HAYMAN.
FASTENING ATTACHMENT FOR BUCKLES.
No. 394,072. Patented Dec. 4, 1888.

(No Model.)
H. B. LUM.
SPIRAL SCREW BUTTON.
No. 419,206. Patented Jan. 14, 1890.

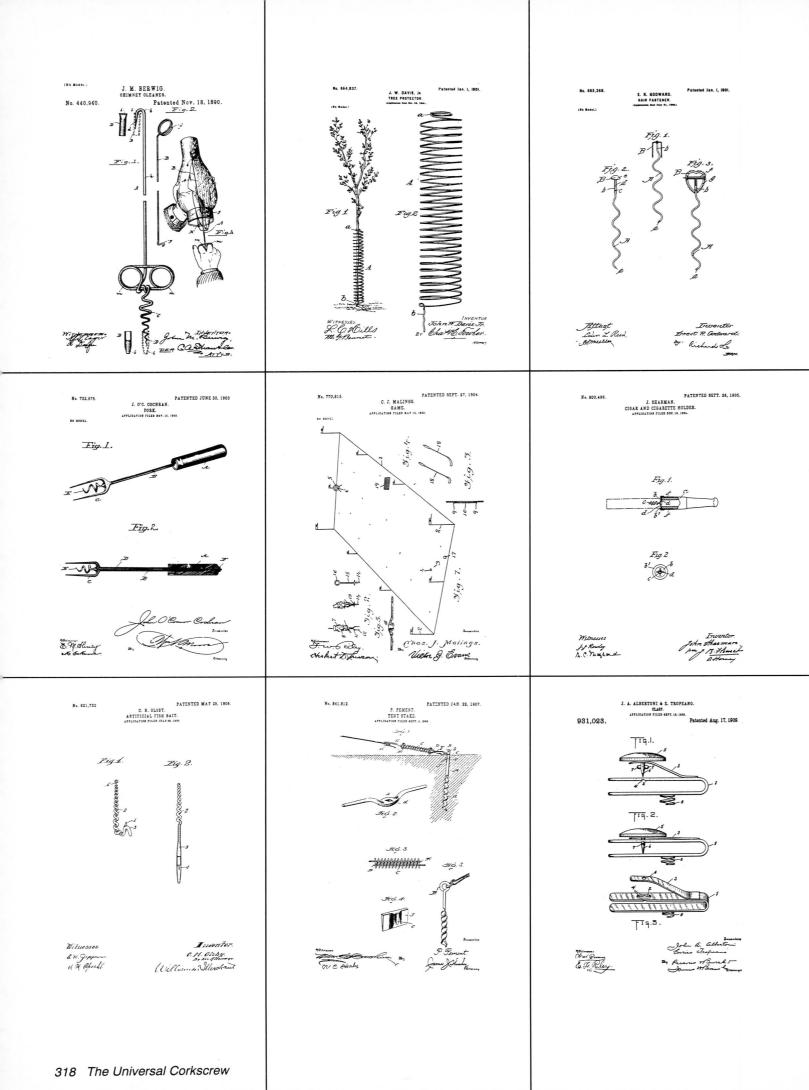

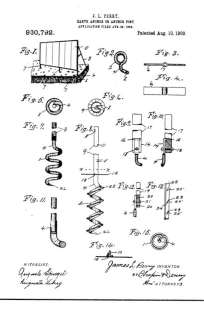

J. L. PERRY.
EARTH ANCHOR OR ANCHOR POST.
APPLICATION FILED AUG. 28, 1908.

930,792. Patented Aug. 10, 1909.

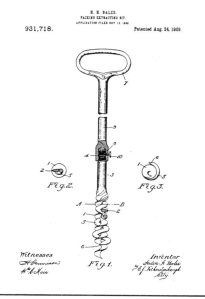

H. H. BALES.
PACKING EXTRACTING BIT.
APPLICATION FILED NOV 17, 1908.

931,718. Patented Aug. 24, 1909.

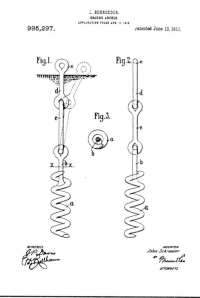

J. SCHROEDER.
GROUND ANCHOR.
APPLICATION FILED APR. 14, 1910.

995,297. Patented June 13, 1911.

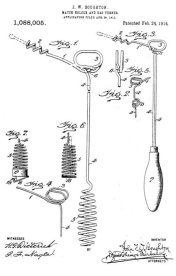

J. W. BOUGHTON.
MATCH HOLDER AND GAS TURNER.
APPLICATION FILED APR. 29, 1912.

1,088,005. Patented Feb. 24, 1914.

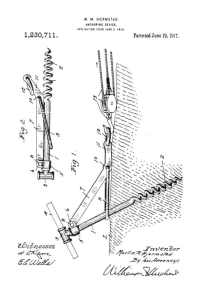

M. M. HJERMSTAD.
ANCHORING DEVICE.
APPLICATION FILED JUNE 5, 1916.

1,230,711. Patented June 19, 1917.

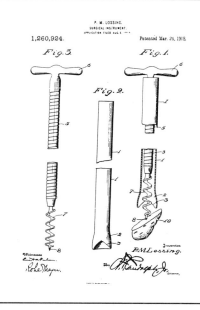

P. M. LOSSING.
SURGICAL INSTRUMENT.
APPLICATION FILED AUG. 5, 1916.

1,260,924. Patented Mar. 26, 1918.

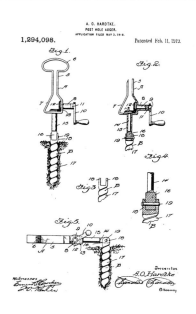

A. O. HARDTKE.
POST HOLE AUGER.
APPLICATION FILED MAY 3, 1916.

1,294,098. Patented Feb. 11, 1919.

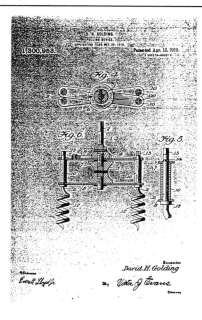

H. H. GOLDING.
PULLING DEVICE.
APPLICATION FILED OCT. 29, 1918.

1,300,953. Patented Apr. 15, 1919.

DESIGN.
A. T. PAGE.
STICKPIN.
APPLICATION FILED APR. 24, 1922.

61,600. Patented Oct. 24, 1922.

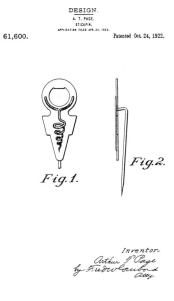

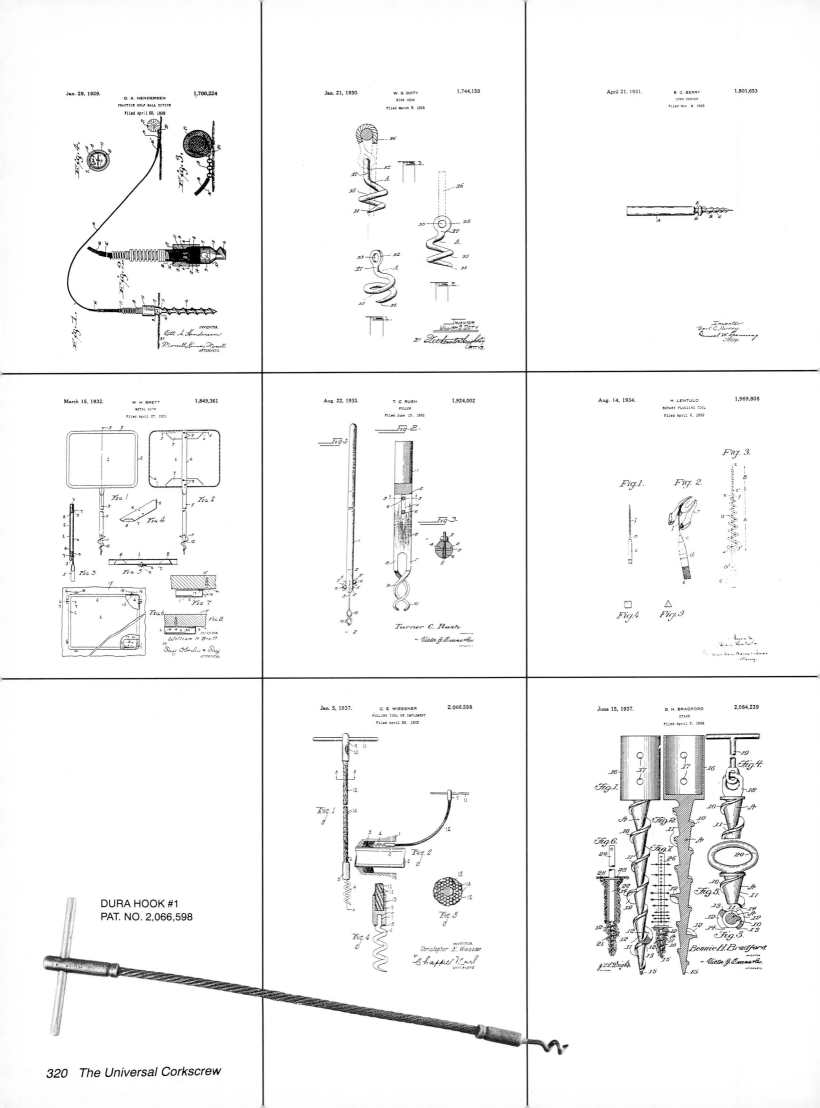

Jan. 29, 1929. O. A. HENDERSEN 1,700,224
PRACTICE GOLF BALL DEVICE
Filed April 20, 1928

Jan. 21, 1930. W. S. DOTY 1,744,159
RING HOOK
Filed March 8, 1928

April 21, 1931. B. C. BERRY 1,801,653
CORN SERVER
Filed Nov. 11, 1929

March 15, 1932. W. H. BRETT 1,849,361
METAL SIGN
Filed April 27, 1931

Aug. 22, 1933. T. C. RUSH 1,924,002
PULLER
Filed June 15, 1932

Aug. 14, 1934. H. LENTULO 1,969,808
ROTARY PLUGGING TOOL
Filed April 2, 1932

Jan. 5, 1937. C. E. WIESSNER 2,066,598
PULLING TOOL OR IMPLEMENT
Filed April 29, 1935

June 15, 1937. B. H. BRADFORD 2,084,239
STAKE
Filed April 3, 1936

DURA HOOK #1
PAT. NO. 2,066,598

April 26, 1938. S. D. COHEN 2,115,664
CHRISTMAS TREE ORNAMENT
Filed March 12, 1937

WITNESS
INVENTOR
SOL D. COHEN
BY
ATTORNEYS

Nov. 22, 1938. K. L. SPRINGER 2,137,311
PROCESS AND APPARATUS FOR THE RECOVERY OF SULPHUR
DIOXIDE FROM SULPHITE LIQUORS
Filed March 26, 1936

Karl L Springer Inventor
By Ph. Young Attorney

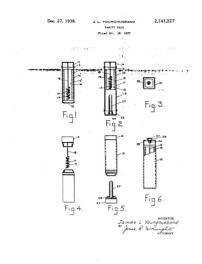

Dec. 27, 1938. J. L. YOUNGHUSBAND 2,141,327
VANITY CASE
Filed Oct. 18, 1937

INVENTOR
James L Younghusband
Jesse R McKnight
ATTORNEY

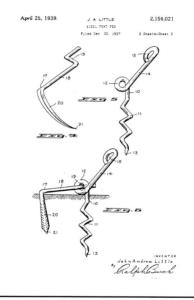

April 25, 1939. J. A. LITTLE 2,156,021
STEEL TENT PEG
Filed Dec. 30, 1937 2 Sheets-Sheet 2

INVENTOR
John Andrew Little
By
Ralph Burch

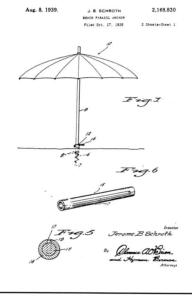

Aug. 8, 1939. J. B. SCHROTH 2,168,830
BEACH PARASOL ANCHOR
Filed Oct. 17, 1938 2 Sheets-Sheet 1

Inventor
Jerome B Schroth
By
and Hyman Berman
Attorneys

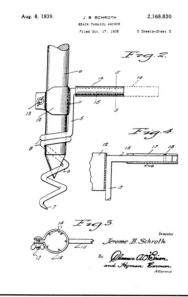

Aug. 8, 1939. J. B. SCHROTH 2,168,830
BEACH PARASOL ANCHOR
Filed Oct. 17, 1938 2 Sheets-Sheet 2

Inventor
Jerome B Schroth
By
and Hyman Berman
Attorneys

Oct. 30, 1951. A. E. KOPLAR Des. 165,010
CLOCK
Filed July 12, 1951

Inventor
by
Attorney

Jan. 1, 1952. G. VAN TUYL Des. 165,616
ANIMAL TOY FIGURE
Filed June 21, 1951 2 Sheets-Sheet 1

INVENTOR
Gertrude Van Tuyl
By
Attorney

United States Patent [19]
Di Domenico et al.

[11] Patent Number: 4,972,848
[45] Date of Patent: Nov. 7, 1990

[54] MEDICAL ELECTRICAL LEAD WITH POLYMERIC MONOLITHIC CONTROLLED RELEASE DEVICE AND METHOD OF MANUFACTURE

[75] Inventors: Edward D. Di Domenico, Anoka; Christopher M. Hobot, Tonka Bay; Kenneth B. Stokes, Minneapolis; Arthur J. Coury, St. Paul; Phong D. Doan, Shoreview; Richard D. Ravenscroft, Annandale, all of Minn.

[73] Assignee: Medtronic, Inc., Minneapolis, Minn.

[21] Appl. No.: 398,220

[22] Filed: Aug. 23, 1989

[51] Int. Cl.⁵ A61N 1/05
[52] U.S. Cl. 128/785; 128/419 F
[58] Field of Search 128/785, 419 F, 783, 128/784, 786, 642

[56] References Cited
U.S. PATENT DOCUMENTS

ABSTRACT

INVENTOR

9 Claims, 1 Drawing Sheet

Appendix Four

U. S. CORKSCREW PATENT TRIVIA

Shortest wait for a corkscrew patent: 15 days by A. W. Sperry (No. 204,389).

Longest wait for a corkscrew patent: 9 years, 11 months by R. B. Gilchrist (No. 1,058,361).

Distribution of patents by individual:

Number of patents per individual	Number of individuals	Total
1	758	758
2	57	114
3	10	30
4	5	20
5	4	20
8	2	16
9	1	9
11	1	11
22	1	22
		1,000

Longest patents:
Overall length: 17 pages by McConnell (No. 1,238,166).
Most drawings: 7 pages by Clough (No. 659,649).

For a bar corkscrew overall: 12 pages by Williamson (No. 615,938).
For a hand-held corkscrew overall: 14 pages by Allen (No. 4,703,673).

Longest time lapse between consecutive corkscrew patents for an individual:
Charles Chinnock, over 20 years from November 24, 1863 (No. 40,674) until June 3, 1884 (No. 299,738).

Longest time between first and last corkscrew patent for an individual:
William Rockwell Clough, 45 years from April 6, 1875 (No. 161,755) until May 4, 1920 (No. 1,339,164).

Longest "dry" period for corkscrew patents after 1860:
Thirty months from July 21, 1959 to January 23, 1962.

Estimated percentage of corkscrew patentees that are females:
Under 2%.

Longest corkscrew patent title:
"Corkscrew That Extracts Simultaneously With The Cork A Preventively Cut Portion Of The Capsule On The Neck Of The Bottle" (No. 5,367,923).

Number of corkscrew patents issued posthumously: 4

There are over 100,000 subclassifications of things that are patentable at the U. S. Patent and Trademark Office. Corkscrews have been found in over 100 of them.

The average patent search is estimated to take about 15 hours. Corkscrew patent research for this book extended over nearly 3 years.

"Oddities":
Unofficial "best" name for a corkscrew patentee: Three-way tie between Curley (No. 297,232), Corkery (No. 1,093,768) and Dial (No. 1,425,456). If D-47,735 and D-154,880 could swap ownership, it would have made a foursome. Curl (No. 1,197,451), for want of a "y" and anything twisted to his invention, gets an Honorable Mention.

Patentees with the same name and residence: Newton (No. 690,118) and Thomas (No. 946,740) of Newton Center, Massachusetts and Thomasville, North Carolina, respectively.

Smythe lists different residences for the same invention (No. D-98,968/Valley Stream, New York and No. 2,115,289/New York, New York).

Hardest name and residence for the Spell Checker to handle: S. Knysz of Hamtramck, Michigan (No. 1,231,746).

N. Linsley had five "8's" in his patent number (No. 388,888). The year was 1888.

U. S. Corkscrew Patents: Chronological & Index to Illustrations

NUMBER	ISSUE DATE	FILE DATE	NAME	RESIDENCE	STATE/COUNTRY	TITLE	ILLUSTRATIONS ON PAGE
8,075	May 6, 1851		Goodyear, N.	New York	New York	Manufacture Of India-Rubber	32
15,098	June 10, 1856		Blanchard, G.	New York	New York	Twine Cutter	
15,325	July 15, 1856		Blanchard, G.	New York	New York	Nutmeg-Grater	
22,923	February 8, 1859		Wicks, L. J.	Racine	Wisconsin	Boot Jack	
27,615	March 27, 1860		Byrn, M. L.	New York	New York	Corkscrew	32
27,665	March 27, 1860		Blake, P.	New Haven	Connecticut	Corkscrew	32, 33
29,539	August 7, 1860		Alexander, C.	Washington	DC	Corkscrew	
30,920	December 18, 1860		Hiney, J.	Hartford	Connecticut	Bottle Faucet	
32,394	May 21, 1861		Wyckoff, W. C.	Brooklyn	New York	Cork Screw	
32,396	May 21, 1861		Burgess, E. A.	New Haven	Connecticut	Corkscrew	
34,216	January 21, 1862		Russel, A. T.	New York	New York	Corkscrew	33
35,362	May 27, 1862		Chinnock, C.	Brooklyn	New York	Corkscrew	33
35,514	June 10, 1862		Fradgley, W.	Greenbush	New York	Corkscrew	
36,528	September 23, 1862		Putnam, H. W.	Cleveland	Ohio	Corkscrew	
38,147	April 14, 1863		Chinnock, C.	Brooklyn	New York	Corkscrew	34
38,155	April 14, 1863		Creamer, H. M.	Brooklyn	New York	Corkscrew	
40,674	November 24, 1863		Chinnock, C.	Brooklyn	New York	Corkscrew	
41,385	January 26, 1864		Miers, J. P. &	Lebanon	New Jersey	Cork Extractor	
42,784	May 17, 1864		Morrill, J. L.	New York	New York	Cork Extractor	
45,137	November 22, 1864		Clark, J. L.	Chester	Connecticut	Cork Screw	
47,161	April 4, 1865		Bielefeld, F. G. &	Berlin	Germany	Cork Pull	
49,144	August 1, 1865		Osgood, R. T.	Orland	Maine	Bottle Stopper	
50,868	November 7, 1865		Woolaver, J.	Suisun	California	Instrument For Opening Bottles	
54,039	April 17, 1866		Swartz, S.	Buffalo	New York	Corkscrew	
54,640	May 8, 1866		Adt, J.	Wolcottville	Connecticut	Corkscrew	34
57,256	August 14, 1866		Meglone, W. W.	Nashville	Tennessee	Bottle Faucet	
58,889	October 16, 1866		Rosenberry, C.	Chicago	Illinois	Corkscrew	
58,969	October 23, 1866		Ashley, J. T.	Brooklyn	New York	Corkscrew	
59,241	October 30, 1866		Loffler, K.	Hoboken	New Jersey	Corkscrew	34
61,080	January 8, 1867		McGill, W. C.	Cincinnati	Ohio	Corkscrew	34
61,485	January 22, 1867		Van Gieson, W. H.	Passaic	New Jersey	Corkscrew	35
61,488	January 22, 1867		Walker, J.	Cincinnati	Ohio	Corkscrew	
67,234	July 30, 1867		Van Zandt, J. D.	Brooklyn	New York	Cork Pull	
67,346	July 30, 1867		Porter, C. H.	Albany	New York	Stopper Fastener	
71,316	November 26, 1867		McCoun, S.	Stamford	Connecticut	Corkscrew	
72,247	December 17, 1867		Waterman, W. G.	Middletown	Connecticut	Cork Extractor	
73,370	January 14, 1868		Morton, J.	Philadelphia	Pennsylvania	Cork Extractor	
73,435	January 21, 1868		Clapp, S. E.	Cambridge	Massachusetts	Cork-Pull	
73,677	January 21, 1868		Twigg, G.	Birmingham	England	Corkscrew	35
74,199	February 11, 1868		Clapp, S. E.	Cambridge	Massachusetts	Corkscrew	36
74,495	February 18, 1868		Bussey, J.	Cincinnati	Ohio	Corkscrew	
74,966	February 25, 1868		Williamson, D.	New York	New York	Cork Drawer	
75,557	March 17, 1868		Luther, W. I.	Rochester	New York	Bottle Faucet	
78,513	June 2, 1868		Button, E.	Annapolis	Maryland	Cork Extractor	

NUMBER	ISSUE DATE	FILE DATE	NAME	RESIDENCE	STATE/COUNTRY	TITLE	ILLUSTRATIONS ON PAGE
79,216	June 23, 1868		Earle, J. E.	New Haven	Connecticut	Corkscrew	
81,292	August 18, 1868		Ridgway, C. L.	Boston	Massachusetts	Corkscrew	
82,355	September 22, 1868		Schermerhorn, G. W.	East Limington	Maine	Corkscrew	
89,477	April 27, 1869		Gibson, G. L.	Concord	North Carolina	Cork-Screw	
91,150	June 8, 1869		Monce, S. G.	Bristol	Connecticut	Tool For Cutting Glass	36
92,278	July 6, 1869		Currie, S. C.	New York	New York	Medicine Spoon	
92,552	July 13, 1869		Wilson, C. G.	Brooklyn	New York	Cork Screw	
99,080	January 25, 1870		Gooch, C.	Cincinnati	Ohio	Cork Screw	
104,453	June 21, 1870		Haviland, J. T.	San Francisco	California	Cork Screw	
106,036	August 2, 1870		Dickson, W.	Albany	New York	Cork Screw	36
109,958	December 6, 1870		Smith, J. A.	Brooklyn	New York	Cork Screw	
115,585	June 6, 1871		Dickson, W.	Albany	New York	Cork-Screw Attachments	37
116,155	June 20, 1871		Chamberlain, D. H.	West Roxbury	Massachusetts	Tap Or Faucet For Bottles	
117,278	July 25, 1871		Harrigan, J.	Fort Wadsworth	New York	Combined Corkscrew, Can-Opener & Cork-Drawer	
118,453	August 29, 1871		Hill, G. J.	Buffalo	New York	Bottle And Box-Opener	
118,456	August 29, 1871		Jenner, L. J.	Chicopee Falls	Massachusetts	Combined Watch-Key, Corkscrew And Watch-Opener	37
120,830	November 14, 1871		Simpers, C. T.	Philadelphia	Pennsylvania	Cork Pull	
121,201	November 21, 1871		Sargent, J. &	Rochester	New York	Bottle Faucet	
122,443	January 2, 1872		Currier, J. W.	Newbury	Vermont	Combined Tool	
140,426	July 1, 1873	December 1, 1870	Monce, S. G.	Bristol	Connecticut	Glaziers' Tools	37
140,706	July 8, 1873	June 21, 1873	Hunt, C. F.	Brooklyn	New York	Cork-Extractor	
149,806	April 14, 1874	March 19, 1874	Swan, J.	Baltimore	Maryland	Sportsmen's Pocket-Knives	
149,983	April 21, 1874	March 10, 1874	Bragaw, J. A.	Kingston	New York	Corkscrew	37
150,225	April 28, 1874	February 6,1874	Brooks, H. P.	Waterbury	Connecticut	Knife-Sharpeners	38
153,391	July 21, 1874	April 16, 1874	Sprague, A. V. M.	Rochester	New York	Can-Openers	38
155,895	October 13, 1874	April 20, 1874	Smith, W. P. X.	New York	New York	Cork-Screws	
160,969	March 16, 1875	January 25, 1875	Taft, O. W.	New York	New York	Handle For Cutlery	
161,124	March 23, 1875	July 2, 1874	Jenness, J. S.	Bangor	Maine	Combined Knife, Corkscrew, & Shield	
161,573	March 30, 1875	January 18, 1875	Taft, O. W.	New York	New York	Table-Implements	
161,755	April 6, 1875	March 17, 1875	Clough, W. R.	Newark	New Jersey	Wire Cork-Screw	38, 39
164,931	June 29, 1875	October 22, 1874	Page, W. C. D. &	East Cambridge	Massachusetts	Instrument For Extracting Corks From Bottles	
166,954	August 24, 1875	March 5, 1875	Woodward, F. R.	Hill	New Hampshire	Rotary Paper Cutter	39
169,175	October 26, 1875	August 25, 1875	Kiehl, G. A. &	Lancaster	Pennsylvania	Combined Bottle-Opener, Knife, Ice-Pick, Grater And Cork-Screw	40
171,752	January 4, 1876	December 6, 1875	Witte, F. T.	Brooklyn	New York	Cork-Screw	
172,104	January 11, 1876	June 3, 1875	Engelsdorff, W.	Chicago	Illinois	Cork-Screw	
172,868	February 1, 1876	November 1, 1875	Clough, W. R.	Newark	New Jersey	Cork-Screw	18, 40
173,396	February 15, 1876	July 14, 1875	Dixon, B. V. B.	St. Louis	Missouri	Cork-Extractor	
176,664	April 25, 1876	February 1, 1876	Miller, A.	Guntersville	Alabama	Cork-Extractor	
177,696	May 23, 1876	April 28, 1876	Davis, T.	Scranton	Pennsylvania	Combined Implement	
178,854	June 20, 1876	October 19, 1875	Hyde, J. L.	New York	New York	Cork-Extractor	
179,090	June 27, 1876	March 27, 1876	Barnes, J.	Brooklyn	New York	Cork-Screw	41
179,460	July 4, 1876	May 31, 1876	Meany,	E. F.	Boston	Massachusetts Bottle Holder	41
181,147	August 15, 1876	July 1, 1876	Decker, R.	Zella St. Basil, Saxe-Coburg-Gotha	Germany	Cork-Screws	
183,445	October 17, 1876	September 25, 1876	Bentley, W. &	New York	New York	Bottle-Faucet	41
R7,424	December 12, 1876	August 7, 1876	Porter, C. H.	Albany	New York	Bottle Stopper Fasteners (Reissue of No. 67,346)	
186,175	January 9, 1877	December 15, 1876	Snyder, E.	Harrisburg	Pennsylvania	Device For Decanting Liquor	
190,669	May 15, 1877	January 22, 1877	Crannell, M. L.	Troy	New York	Corkscrew	
191,093	May 22, 1877	April 12, 1877	Bacher, E.	Findlay	Ohio	Bottle Opener	
195,450	September 25, 1877	February 12, 1877	Hyde, J. L.	New York	New York	Cork-Screw-Frames	
196,226	October 16, 1877	August 9, 1877	Havell, G.	Newark	New Jersey	Corkscrew	42
196,761	November 6, 1877	September 12, 1877	Oak, N.	Exeter	Maine	Cork-Screw And Extractor Combined	
197,201	November 20, 1877	October 20, 1877	Baum, J .E.	Freeland	Pennsylvania	Cork-Screw	
199,760	January 29, 1878	May 9, 1877	Tyrer, P.	Melborne	Australia	Cork-Extractor	
202,136	April 9, 1878	April 11, 1877	Barthel, A. E.	Detroit	Michigan	Combined Gun-Tool And Whistle	
204,389	May 28, 1878	May 13, 1878	Sperry, A. W.	Wallingford	Connecticut	Cork-Screw	42
206,134	July 16, 1878	April 13, 1878	Richardson, J. H. &	Marinette	Wisconsin	Cork-Extractor	
207,631	September 3, 1878	April 8, 1878	Tucker, W. W.	Hartford	Connecticut	Cork-Extractor	43
209,599	November 5, 1878	February 26, 1878	Babcock, C. A.	Buffalo	New York	Combination Implement	
212,863	March 4, 1879	December 9, 1878	Mumford, L. C.	San Francisco	California	Cork-Extractor	
219,101	September 2, 1879	February 20, 1879	Lant, W. E.	Lancaster	Pennsylvania	Bottle-Faucet And Cork-Screw Combined	43
219,313	September 2, 1879	March 13, 1879	Shelley, B. N.	Anderson	Indiana	Combination Tool	
229,228	June 29, 1880	May 28, 1880	Adams, B. F.	Springfield	Massachusetts	Revolving glass Cutter	61
230,877	August 10, 1880	June 19, 1880	Kossuth, J.	New Britain	Connecticut	Corkscrew	
234,646	November 23, 1880	September 24, 1880	Arment, I. N.	Dayton	Washington	Opener For Cans And Bottles	
235,427	December 14, 1880	April 20, 1880	Graef, C.	Brooklyn	New York	Combined Nippers And Cork Extractor	
241,929	May 24, 1881	April 16, 1881	Clark, C. C.	Brownwood	Texas	Automatic Cork Extractor	
242,602	June 7, 1881	March 25, 1881	Clough, W. R.	Brooklyn	New York	Cork Screw	61
245,301	August 9, 1881	February 16, 1881	Mann, F.	Milwaukee	Wisconsin	Cork Extractor	62
246,419	August 30, 1881	July 22, 1881	Rombotis, O. G.	Chicago	Illinois	Combination Tool	
251,455	December 27, 1881	August 22, 1881	Muir, A.	Harborne	England	Machine For Drawing Corks	
251,525	December 27, 1881	November 29, 1881	Codd, H.	London	England	Instrument For Opening Internally Stoppered Bottles	62
251,851	January 3, 1882	November 8, 1881	Emmenegger,Jr., F.	St. Louis	Missouri	Combination Tool	
253,634	February 14, 1882	October 22, 1881	Shinn, T. A.	Philadelphia	Pennsylvania	Carving Fork	
254,760	March 7, 1882	August 5, 1881	Zeilin, J. H.	Philadelphia	Pennsylvania	Dose Cup Bottle Stopper	63
256,721	April 18, 1882	January 25, 1882	Meyer, W.	St. Louis	Missouri	Cork Extractor	
257,062	April 25, 1882	February 28, 1882	Perryman, H. L.	Lincoln	Nebraska	Corkscrew	
258,420	May 23, 1882	April 7, 1882	Hessel, R.	Berlin	Germany	Corkscrew	63
262,613	August 15, 1882	July 6, 1882	Pitt, J.	Brooklyn	New York	Corkscrew	63
264,391	September 12, 1882	June 12, 1882	Williamson, C. T.	Newark	New Jersey	Combined Spoon And Cork Screw	64
264,549	September 19, 1882	April 28, 1882	McFarlane, W. A.	Ivanpah	California	Can Opener	
264,902	September 26, 1882	March 1, 1882	Slagle, A.	London	Ohio	Cork Extractor	
266,073	October 17, 1882	July 20, 1882	Austin, A. M.	Rockland	Maine	Combination Toilet Implement	64
266,135	October 17, 1882	September 2, 1882	Griswold, G. W.	Pottersville	New York	Corkscrew	
268,872	December 12, 1882	February 16, 1882	Davids, J. B.	New York	New York	Bottle Stopper	
270,095	January 2, 1883	November 6, 1882	Morgan, R.	Stockton	California	Cork Extractor	
273,621	March 6, 1883	December 27, 1882	Small, G. A.	Jeffersonville	Indiana	Tool Handle	
274,539	March 27, 1883	December 8, 1882	Williamson, C. T.	Newark	New Jersey	Corkscrew	64
276,804	May 1, 1883	March 21, 1883	Green, M.	Brooklyn	New York	Corkscrew	
277,442	May 15, 1883	April 12, 1883	Bennit, W.	Troy	New York	Corkscrew	65
278,951	June 5, 1883	March 19, 1883	Hartman, H.	Salt Lake City	Utah	Combination Can Opener	
279,202	June 12, 1883	March 21, 1883	Strait, T. M.	Troy	New York	Corkscrew	
279,203	June 12, 1883	April 30, 1883	Strait, T. M.	Troy	New York	Corkscrew	65
279,216	June 12, 1883	May 10, 1883	Berlien, J. E.	Altona	Germany	Means For Attaching Corkscrews To Bottles	
280,697	July 3, 1883	May 18, 1883	White, J. W.	Brighton	Iowa	Corkscrew	65
283,731	August 21, 1883	May 23, 1883	Wienke, C. F. A.	Rostock-Mecklenburg	Germany	Lever Corkscrew	66
283,900	August 28, 1883	October 9, 1882	Korn, G. W.	New York	New York	Cork Turner	66
283,967	August 28, 1883	May 1, 1883	Chilcote, S. H.	Sego	Ohio	Combined Can Opener And Corkscrew	
285,143	September 18, 1883	July 7, 1883	McDougall, S. T.	Brooklyn	New York	Hollow Corkscrew	

NUMBER	ISSUE DATE	FILE DATE	NAME	RESIDENCE	STATE/COUNTRY	TITLE	ILLUSTRATIONS ON PAGE
287,504	October 30, 1883	April 14, 1883	Cappel, F.	Hoboken	New Jersey	Cork Puller Or Screw	
294,471	March 4, 1884	July 12, 1883	Huff, O.	Lyman	Maine	Pocket Knife	
295,721	March 25, 1884	January 22, 1884	Bevins, J. &	New York	New York	Cutter For Wires And Cords Of Bottles	
295,962	April 1, 1884	December 20, 1883	Walter, A. J.	Philadelphia	Pennsylvania	Corkscrew	
296,661	April 8, 1884	November 24, 1883	Woodman, W. B.	Newark	New Jersey	Combined Corkscrew And Key Ring	66
297,232	April 22, 1884	February 21, 1884	Curley, T.	Troy	New York	Corkscrew	66, 67
299,100	May 27, 1884	January 19, 1884	Barnes, J.	Brooklyn	New York	Corkscrew	67
299,738	June 3, 1884	January 17, 1883	Chinnock, C.	New York	New York	Corkscrew	67
299,864	June 3, 1884	October 8, 1883	Smith, J. A.	Deep River	Connecticut	Corkscrew	68
300,391	June 17, 1884	November 17, 1883	Nourse, J. K. P.	West Medway	Massachusetts	Corkscrew	
300,936	June 24, 1884	December 1, 1883	Alvord, W. H.	Appleton	Wisconsin	Corkscrew	
301,425	July 1, 1884	April 30, 1884	Bayles, W. H.	Port Jefferson	New York	Faucet Corkscrew	
302,321	July 22, 1884	December 26, 1883	Clough, W. R.	Brooklyn	New York	Corkscrew	68, 69
302,331	July 22, 1884	May 31, 1884	Griswold, C. L.	Chester	Connecticut	Corkscrew	70
303,400	August 12, 1884	July 5, 1884	Redlich, W.	Chicago	Illinois	Corkscrew	70
304,118	August 26, 1884	July 3, 1884	Moomy, J. G.	Erie	Pennsylvania	Corkscrew	
304,299	September 2, 1884	July 5, 1884	Crabb, W.	Newark	New Jersey	Corkscrew	
304,451	September 2, 1884	July 2, 1883	Rauh, W. E.	Solingen	Germany	Pocket Knife	
305,258	September 16, 1884	July 23, 1884	Williams, M. F.	Bastrop	Louisiana	Corkscrew	
308,686	December 2, 1884	May 2, 1884	Merrill, W. H. D.	Colorodo Springs	Colorado	Cork Puller	
310,766	January 13, 1885	July 14, 1884	Wilhelm, B.	Appleton	Wisconsin	Corkscrew	
315,773	April 14, 1885	November 13, 1884	Haff, E. P.	Brooklyn	New York	Corkscrew	70, 71
317,038	May 5, 1885	December 9, 1884	Strait, H.	Troy	New York	Corkscrew	
317,123	May 5, 1885	December 31, 1884	Haff, E. P.	Brooklyn	New York	Corkscrew	70, 71
322,991	July 28, 1885	June 23, 1884	Stowell, F. L.	New York	New York	Knife Eraser	72
327,983	October 13, 1885	September 13, 1881	Arment, I. N.	Dayton	Washington	Can Opener	
330,357	November 10, 1885	November 12, 1884	Wier, M. A.	Upper Norwood County of Surrey	England	Corkscrew	72
330,974	November 24, 1885	August 18, 1885	Friedmann, A. &	Milwaukee	Wisconsin	Corkscrew	
333,697	January 5, 1886	September 3, 1885	Thiéry, E. A. &	Newark	New Jersey	Article Of Jewelry And Method Of Ornamenting The Same	73
334,061	January 12, 1886	June 26,1885	Tobias, C. &	Freeport	Illinois	Cork Extractor	
337,309	March 2, 1886	August 11, 1884	Crabb, W.	Newark	New Jersey	Corkscrew	74
337,465	March 9, 1886	October 9, 1885	Wahler, H.	Freeport	Illinois	Cork Extractor	
337,921	March 16, 1886	August 1, 1885	Bloeser, J.	St. Louis	Missouri	Apparatus For Drawing Corks From Bottles	74
342,884	June 1, 1886	September 17, 1885	Stone, J. A.	Philadelphia	Pennsylvania	Combination Tool	
344,556	June 29, 1886	September 19, 1885	Woodman, W. B.	Newark	New Jersey	Corkscrew	75
344,566	June 29, 1886	November 10, 1885	Cluever, J. H.	Albany	New York	Corkscrew	
D-16,799	July 13, 1886	April 15,1886	Trunk, A.	Bridgeport	Connecticut	Corkscrew	75
345,822	July 20, 1886	September 17, 1885	Ames, W. L.	Terre Haute	Indiana	Cork Extractor	
346,249	July 27, 1886	March 19, 1886	Weekes, C.	Dublin	Ireland	Combined Cork Extractor And Lemon Squeezer	
348,743	September 7, 1886	October 5, 1885	Hurley, J. A.	Erie	Pennsylvania	Cork Puller	
348,911	September 7, 1886	April 10, 1886	Hurley, J. A.	Erie	Pennsylvania	Cork Puller	
349,741	September 28, 1886	January 25, 1886	Prahar, L. B. &	Brooklyn	New York	Combined Button Hook And Corkscrew	
350,308	October 5, 1886	June 26, 1886	Hurley, J. A.	Erie	Pennsylvania	Cork Puller	76
350,499	October 12, 1886	July 10, 1886	Noe, W. R.	Newark	New Jersey	Medicine Spoon	
350,702	October 12, 1886	May 10, 1886	Schollhorn, W.	New Haven	Connecticut	Corkscrew	
352,659	November 16, 1886	November 23, 1885	Petersen, A. F.	Nykjobing	Denmark	Sideboard Corkscrew	
353,860	December 7, 1886	January 8, 1886	Hudson, C. H.	New York	New York	Corkscrew	
354,150	December 14, 1886	February 8, 1886	Jones, C. T., Dec'd	Utica	New York	Bottle Faucet	
356,925	February 1, 1887	August 21, 1886	Chamberlin, T. E.	Arkansas City	Kansas	Combination Tool	
356,936	February 1, 1887	October 5, 1886	Haff, L. B.	Englewood	New Jersey	Pocket Corkscrew	76
360,734	April 5, 1887	December 21, 1886	Schmitt, F. E.	Milwaukee	Wisconsin	Cork Extracting Machine	
361,640	April 19, 1887	February 14, 1887	Monahan, J. J.	Fort Supply	Indian Territory	Bottle Holding Attachment For Stopper Pullers	
370,638	September 27, 1887	July 20, 1885	Marwood, F. T.	Blackburn County of Lancaster	England	Cork Extractor	
372,266	October 25, 1887	July 9, 1886	Hurley, D. J.	Erie	Pennsylvania	Cork Puller	76
373,512	November 22, 1887	April 4, 1887	Becker, E.	Solingen	Germany	Corkscrew	77
373,872	November 29, 1887	January 31, 1887	Williams, E. D.	Boston	Massachusetts	Corkscrew	
375,368	December 27, 1887	June 28, 1887	Livermore, F. W.	New York	New York	Corkscrew	
376,058	January 10, 1888	April 21, 1887	Angus, J.	St. Catharines, Ontario	Canada	Combination Tool	
377,483	February 7, 1888	May 26, 1887	Fürstenwärther, J. B. V.	Brooklyn	New York	Medicine Cup And Stopper	
377,790	February 14, 1888	May 27, 1887	Walker, E.	Erie	Pennsylvania	Cork Extractor	77
379,010	March 6, 1888	September 3, 1887	Greely, B. J.	Boston	Massachusetts	Stopper Extractor	78
382,005	May 1, 1888	October 22, 1887	McCarthy, P. &	North Vernon	Indiana	Corkscrew	
383,093	May 22, 1888	October 31, 1887	Boggis, H. J.	Cleveland	Ohio	Cork Extractor	
384,471	June 12, 1888	May 2, 1888	Randall, E. S.	Dayton	Ohio	Combined Bottle Opener And Liquid Dropper	
384,839	June 19, 1888	January 5, 1888	Gilchrist, R. B.	Peoria	Illinois	Cork Extractor	
385,834	July 10, 1888	October 6, 1886	Barrett, W. N.	Meadville	Pennsylvania	Corkscrew	
386,005	July 10, 1888	February 27, 1888	Engel, G. W.	Ashland	Pennsylvania	Cork Extractor	
D-18,528	August 14, 1888	June 8, 1888	Mersereau, F. D.	Orange	New Jersey	Handle	
388,125	August 21, 1888	April 28, 1888	Fairchild, L. W.	New York	New York	Corkscrew	78, 79
388,785	August 28, 1888	April 11, 1888	Nutter, F. H.	Minneapolis	Minnesota	Precautionary Device For Poison Bottles	
388,844	September 4, 1888	October 7, 1887	Devore, L. M.	Freeport	Illinois	Cork Extractor	
388,888	September 4, 1888	March 19, 1886	Linsley, N. &	Freeport	Illinois	Cork Extractor	
388,945	September 4, 1888	November 12, 1887	Barrett, W. N.	Meadville	Pennsylvania	Corkscrew	
390,159	September 25, 1888	April 3, 1886	Devore, L. M.	Freeport	Illinois	Cork Extractor	
390,183	September 25, 1888	April 3, 1886	Morgan, C. &	Freeport	Illinois	Cork Extractor	79
390,691	October 9, 1888	December 19, 1887	Milam, J. W.	Frankfort	Kentucky	Cork Extractor	
392,107	October 30, 1888	January 17, 1888	Cundey, Sr., J.	Bristol	Pennsylvania	Kitchen Utensil	
392,116	October 30, 1888	May 19, 1888	Gilchrist, R. B.	Jersey City	New Jersey	Cork Extractor	79
395,618	January 1, 1889	May 12, 1888	Edwards, G.	Berkeley	California	Cork Extractor	
396,286	January 15, 1889	August 29, 1888	McWhorter, L. S.	Chicago	Illinois	Corkscrew	
396,708	January 22, 1889	April 28. 1888	Payne, W. J.	London	England	Apparatus For Withdrawing Effervescing Or Gaseous Liquids From Corked Receptacles	
398,162	February 19, 1889	July 18, 1888	Keane, M. J.	New Haven	Connecticut	Bottle Tap	
400,690	April 2, 1889	December 3, 1888	Kimball, A. D.	Miles	Iowa	Combination Tool	
401,672	April 16, 1889	September 3, 1888	Alvord, S. L. &	West Winsted	Connecticut	Corkscrew	80
402,245	April 30, 1889	July 9, 1888	Hinphy, W. J.	Montreal, Quebec	Canada	Apparatus For Drawing Corks	
402,742	May 7, 1889	May 21, 1888	Kelly, T.	Elmvale, Ontario	Canada	Cork Extractor	
405,383	June 18, 1889	March 11, 1888	Taylor, K.	Frankfort	Kentucky	Cork Extractor	
405,385	June 18, 1889	January 12, 1888	Williamson, W. A.	Newark	New Jersey	Corkscrew	80
406,304	July 2, 1889	December 14, 1888	Pollard, E. T. &	Richmond	Virginia	Corkscrew	
407,169	July 16, 1889	May 13, 1889	Collins, J. W.	Washington	DC	Stopper For Bottles	
411,079	September 17, 1889	September 26, 1888	Van Vliet, W. R.	East Stroudsburg	Pennsylvania	Combination Tool	
420,572	February 4, 1890	June 29, 1889	Edie, A.	Butte City	Montana	Corkscrew	
422,348	February 25, 1890	July 6, 1889	Jull, S. T.	Meadville	Pennsylvania	Cork Puller	
422,670	March 4, 1890	February 28, 1889	Wallace, A. H.	Houghton	Michigan	Shears	
425,010	April 8, 1890	June 4, 1889	Sutton, W. H.	Fordyce	Arizona	Combined Knife And Burglar Alarm	

NUMBER	ISSUE DATE	FILE DATE	NAME	RESIDENCE	STATE/COUNTRY	TITLE	ILLUSTRATIONS ON PAGE
601,070	March 22, 1898	June 22, 1897	Bedford, H. L.	Bailey	Tennessee	Kitchen Utensil	
601,380	March 29, 1898	July 26, 1897	Phillips, C. F.	Los Angeles	California	Cork Extractor	
601,737	April 5, 1898	March 12, 1897	Smith, A. B.	Oakland	Tennessee	Combination Tool	
601,776	April 5, 1898	August 26, 1896	Mackey, C. W.	Moravia	New York	Cork Protector	
603,950	May 10, 1898	August 23, 1897	Hawkins, J. E.	St. Louis	Missouri	Cork Pulling Machine	
D-29,231	August 16, 1898	July 9, 1898	Browne, W. G.	Kingston	New York	Can Opener	98
610,530	September 13, 1898	December 29, 1897	Hammesfahr, E.	Foche	Germany	Pocket Corkscrew	98
611,046	September 20, 1898	January 11, 1898	Walker, E.	Erie	Pennsylvania	Corkscrew	98
D-29,379	September 20, 1898	August 15, 1897	Robertson, W.	Buffalo	New York	Cork Extractor Casing	
613,176	October 25, 1898	August 13, 1896	Stiles, A.	Baton Rouge	Louisiana	Corkscrew	
613,288	November 1, 1898	January 29, 1898	Mazzanovich, A.	New York	New York	Bottle Cap	
613,653	November 8, 1898	August 2, 1897	Altman, A.	Elizabeth	New Jersey	Can Opener	
614,056	November 8, 1898	January 5, 1898	Lamontagne, Jr., A.	Chicago	Illinois	Bottle Stopper	
614,537	November 22, 1898	March 9, 1898	Dahlquist, N. A. &	Worcester	Massachusetts	Combined Wire Cutter, Pocket Knife, And Corkscrew	
615,487	December 6, 1898	July 15, 1898	Kemper, C.	Brussels	Belgium	Device For Opening Or Closing Bottles	
615,938	December 13, 1898	October 2, 1897	Williamson, W. A.	Newark	New Jersey	Cork Extractor	
D-29,798	December 13, 1898	October 25, 1898	Williamson, W. A.	Newark	New Jersey	Cap Lift	99
619,648	February 14, 1899	October 6, 1898	Williams, H. J.	Meriden	Connecticut	Cork Extractor	
D-30,234	February 21, 1899	January 25, 1899	Clough, W. R.	Alton	New Hampshire	Handle For Corkscrews	99
620,949	March 14, 1899	April 4, 1898	Morgan, C.	Freeport	Illinois	Cork Puller	100, 101
622,074	March 28, 1899	August 18, 1898	Reeder, C. V. B.	Evergreen	California	Bottle Stopper Retainer And Extractor	
624,384	May 2, 1899	December 5, 1898	Schroeder, F. W.	London	England	Bottle Stopper	
624,457	May 9, 1899	July 12, 1898	Converse, M. D.	New York	New York	Cork Extractor	101
631,247	August 15, 1899	November 7, 1898	Bignold, F. R.	Ewing	Nebraska	Combination Implement	
632,742	September 12, 1899	January 10, 1899	Peterson, H. E.	St. Paul	Minnesota	Device For Drawing Corks	
632,792	September 12, 1899	March 13, 1899	Schmidt, J. A.	Solingen	Germany	Pocket Knife	
D-31,505	September 12, 1899	August 9, 1899	Walker, E.	Erie	Pennsylvania	Corkscrew Head	
634,184	October 3, 1899	November 28, 1898	Phillips, W. R.	Trenton	New Jersey	Non-Refillable Bottle	
634,336	October 3, 1899	June 10, 1897	Greer, W. N.	Watertown	South Dakota	Compound Tool	
635,330	October 24, 1899	December 16, 1898	Lufkin, E. A.	Beloit	Wisconsin	Device For Pulling Stoppers Or Seals From Bottles	
636,531	November 7, 1899	October 2, 1899	Jopson, G. W.	Meriden	Connecticut	Folding Corkscrew, Screw Driver, &c.	101
637,048	November 14, 1899	July 17, 1899	Toulotte, B.	Far Hills	New Jersey	Stopper Extractor	
641,111	January 9, 1900	October 2, 1899	Hungerford, H.	New Haven	Connecticut	Cork Extractor	
644,043	February 20, 1900	June 21, 1899	Jorres, R. W.	St. Louis	Missouri	Corkscrew	
644,088	February 27, 1900	July 29, 1899	Morgan, C.	Freeport	Illinois	Cork Puller	
644,700	March 6, 1900	August 19, 1898	Blundell, J.	Southport	England	Corkscrew	
645,401	March 13, 1900	September 27, 1899	Maske, H.	Chicago	Illinois	Corkscrew Register	
647,528	April 17, 1900	September 30, 1899	Schmidt, J. A.	Solingen	Germany	Tool Handle	
647,775	April 17, 1900	February 21, 1899	Walker, E.	Erie	Pennsylvania	Corkscrew	108-111
649,498	May 15, 1900	August 9, 1899	Walker, E.	Erie	Pennsylvania	Cork Puller	112
652,429	June 26, 1900	May 15, 1899	Fulks, F. F.	Buckner	Texas	Combined Shears And Knife	
D-32,875	June 26, 1900	May 9, 1900	Browne, W. G.	Kingston	New York	Can Opener	
654,089	July 17, 1900	December 7, 1899	Browne, W. G.	Kingston	New York	Can Opener	112
655,725	August 14, 1900	December 20, 1899	Mumford, L. C.	New York	New York	Cork Extractor	
657,421	September 4, 1900	February 24, 1900	Jorres, R. W.	St. Louis	Missouri	Corkscrew	102, 112
658,393	September 25, 1900	October 5, 1899	Paul, H. C.	St. Louis	Missouri	Match Box	
659,649	October 16, 1900	March 5, 1900	Clough, W. R.	Alton	New Hampshire	Machine For Making Corkscrews	113, 114
666,720	January 29, 1901	April 28, 1900	Wetmore, R. P.	Washington	DC	Combined Match Box And Tool Holder	
D-34,096	February 19, 1901	January 21, 1901	Stephens, A. W.	Cambridge	Massachusetts	Bottle Seal Remover	115
672,456	April 23, 1901	March 3, 1900	Paul, H. C. &	St. Louis	Missouri	Match Box	
672,796	April 23, 1901	February 2, 1901	Murphy, J. R.	Harvard	Massachusetts	Corkscrew	115
673,153	April 30, 1901	August 8, 1899	Baseler, J. D.	Richmond	Virginia	Stopper Extractor	115
675,032	May 28, 1901	February 2, 1900	Baumgarten, A.	Freeport	Illinois	Cork Extractor	116
675,051	May 28, 1901	August 20, 1900	Baumgarten, A.	Freeport	Illinois	Cork Extractor	116
676,013	June 11, 1901	April 18, 1900	Walker, E.	Erie	Pennsylvania	Cork Puller	
676,205	June 11, 1901	September 13, 1900	Rogginger, J.	Milwaukee	Wisconsin	Cork Extractor	
677,105	June 25, 1901	November 15, 1900	Shaffer, J. S.	Sonora	California	Scissors Sharpener	
678,102	July 9, 1901	July 18, 1900	Cremer, H.	Chicago	Illinois	Non-Refillable Bottle	
678,773	July 16, 1901	May 19, 1900	Coomber, J.	Chicago	Illinois	Cork Extractor	
682,129	September 3, 1901	February 14, 1901	Walsh, W. A.	Fredericton, New Brunswick	Canada	Cork Extractor	
683,004	September 17, 1901	December 3, 1900	Schermack, J. J.	Freeport	Illinois	Cork Puller	117
686,908	November 19, 1901	April 30, 1900	Schermack, J. J.	Freeport	Illinois	Cork Puller	
690,070	December 31, 1901	April 30, 1900	Morgan, C.	Freeport	Illinois	Cork Puller	
690,118	December 31, 1901	December 31, 1900	Newton, R. W.	Newton Center	Massachusetts	Can Opener	
692,951	February 11, 1902	May 17, 1901	Walker, E.	Erie	Pennsylvania	Bottle Tap	117
693,156	February 11, 1902	March 28, 1901	Rochester, M. F.	Ingleside	Maryland	Pharmaceutical Implement	
694,466	March 4, 1902	July 22, 1901	Ferguson, G. C.	Fredericton, New Brunswick	Canada	Cork Extractor	
695,235	March 11, 1902	September 20, 1901	Riolet, F.	Geneva	Switzerland	Cork Extractor	
696,399	April 1, 1902	February 1, 1901	Baumgerten, A.	Freeport	Illinois	Cork Extractor	
697,587	April 15, 1902	February 23, 1901	Williamson, R. J.	Montmorenci	Indiana	Cork Extractor	
701,791	June 3, 1902	January 14, 1902	Andros, R. B.	Boston	Massachusetts	Automatic Corkscrew	
702,001	June 10, 1902	October 28, 1901	Ham, H. H.	New York	New York	Cork Extractor	117
703,598	July 1, 1902	March 6, 1902	Koelmel, J. F.	Crookston	Minnesota	Compound Tool	
708,667	September 9, 1902	September 20, 1901	Runnalls, R.	Westerly	Rhode Island	Corkscrew	
713,422	November 11, 1902	April 15, 1902	Fox, W. T.	Winchester	Kentucky	Cork Extractor	
713,472	November 11, 1902	May 21, 1902	Maxwell, W.	Pittsburgh	Pennsylvania	Can Opener	
713,540	November 11, 1902	May 17, 1901	Walker, E.	Erie	Pennsylvania	Bottle Neck Clamping Mechanism For Cork Pullers	118
718,163	January 13, 1903	October 17, 1902	Sherrard, J. A.	Boston	Massachusetts	Bottle Tap	
719,105	January 27, 1903	May 19, 1902	Gardy, H. D.	Philadelphia	Pennsylvania	Combined Pan Lifter, Can Opener And Corkscrew	
723,581	March 24, 1903	July 30, 1902	Brinton, G. H.	Elwyn	Pennsylvania	Corkscrew And Cork Holder	
723,812	March 31, 1903	July 24, 1902	Birchbauer, F.	Baltimore	Maryland	Bottle Destroying Stopper	
724,655	April 7, 1903	May 20, 1902	Beli, H. R.	Lyttelton	New Zealand	Bottle And Stopper Therefor	
727,356	May 5, 1903	April 22, 1902	Harbaugh, H. K.	Pittsburgh	Pennsylvania	Combination Tool	
728,517	May 19, 1903	August 15, 1901	Tscherning, H.	Freeport	Illinois	Cork Puller	
728,518	May 19, 1903	August 16, 1902	Tscherning, H.	Freeport	Illinois	Cork Puller	
728,519	May 19, 1903	August 16, 1902	Tscherning, H.	Freeport	Illinois	Cork Puller	
728,520	May 19, 1903	August 16, 1902	Tscherning, H.	Freeport	Illinois	Cork Puller	
728,642	May 19, 1903	August 13, 1902	Wiles, R. H.	Chicago	Illinois	Cork Puller	
728,735	May 19, 1903	March 5, 1903	Lowenstein, W. J.	Statesville	North Carolina	Bottle Attachment	118
728,806	May 19, 1903	August 15, 1901	Morgan, C.	Freeport	Illinois	Cork Puller	118
730,007	June 2, 1903	August 30, 1902	Dressler, R.	New York	New York	Cork Puller	
734,753	July 28, 1903	January 13, 1903	Rivers, J. H.	St. Louis	Missouri	Closure For Receptacles	
736,001	August 11, 1903	June 1, 1903	Norton, E.	New York	New York	Bottle Cap	
736,524	August 18, 1903	November 14, 1902	Kaufmann, E.	Solingen	Germany	Pocket Knife	
737,483	August 25, 1903	August 16, 1902	Riedmiller, O. J.	Scranton	Pennsylvania	Wrench	
745,008	November 24, 1903	June 22, 1903	Gearhart, G. G.	Cazenovia	Illinois	Combination Tool	
745,200	November 24, 1903	April 26, 1902	Koehler, J.	Newark	New Jersey	Grip For Opening Or Closing Jars	
747,351	December 22, 1903	September 15, 1902	Armstrong, H. D.	London	England	Corkscrew	119
749,548	January 12, 1904	September 15, 1903	Ford, C. A.	Madison	Indiana	Can Opener	
757,794	April 19, 1904	September 2, 1903	Walker, E.	Erie	Pennsylvania	Bottle Tap	119

NUMBER	ISSUE DATE	FILE DATE	NAME	RESIDENCE	STATE/COUNTRY	TITLE	ILLUSTRATIONS ON PAGE
758,928	May 3, 1904	October 2, 1903	McGrath, J. J.	New York	New York	Compound Tool	
760,097	May 17, 1904	July 17, 1903	Biersach, M. E.	Milwaukee	Wisconsin	Combined Bottle Opener And Stopper	
760,613	May 24, 1904	February 13, 1903	Clark, J. M. &	Dayton	Ohio	Combination Tool	120
760,918	May 24, 1904	February 9, 1903	Pollock, M. D.	Decatur	Illinois	Cork Extractor	
762,130	June 7, 1904	November 6, 1903	Brooks, B.	Philadelphia	Pennsylvania	Combined Match Box, Cigar Cutter And Corkscrew	
765,450	July 19, 1904	March 26, 1903	White, F. &	Newark	New Jersey	Can Opener	120
771,728	OctoЬer 4, 1904	April 1, 1903	Holt, C.	Abbeville	Alabama	Attachment For Revolvers	
772,888	October 18, 1904	January 15, 1904	Kaiser, J.	San Francisco	California	Cork Extractor	
776,152	November 29, 1904	July 2, 1904	Strohacker, L. &	Chicago	Illinois	Cork Extractor	
776,540	December 6, 1904	March 24, 1904	Parish, G. C.	Kingston	New York	Can Opener	120
777,161	December 13, 1904	April 12, 1904	Vignos, A. A.	Canton	Ohio	Corkscrew Machine	
777,380	December 13, 1904	January 7, 1904	Kennedy, T. W.	Hackensack	New Jersey	Cork Puller	
778,593	December 27, 1904	April 6, 1904	Maconnell, A. M.	New York	New York	Closure For Bottles Or The Like	
783,800	February 28, 1905	September 19, 1902	Porter, C. L.	Chicago	Illinois	Combination Tool	
784,688	March 14, 1905	June 2, 1904	Kleiser, G. L.	Christiania	Norway	Corkscrew	
784,868	March 14, 1905	June 9, 1904	Leu, J. A.	Montreal, Quebec	Canada	Bottle Support And Protector	
786,492	April 4, 1905	November 14, 1904	Garimaldi, C. F.	Baltimore	Maryland	Bottle Stopper Extractor	121
D-37,417	April 25, 1905	March 27, 1905	Gilchrist, R. B.	Newark	New Jersey	Cork Extractor Case	
789,103	May 2, 1905	March 26, 1903	Parker, A. M.	Mexico	Pennsylvania	Combination Tool	121
790,432	May 23, 1905	August 14, 1903	Heilrath, C.	Sacramento	California	Combination Tool	
793,318	June 27, 1905	October 24, 1904	Noyes, H. W.	New Haven	Connecticut	Cork Extractor	
793,724	July 4, 1905	September 2, 1904	Irby, A. M.	Vernonhill	Virginia	Corkscrew And Spoon Holder	
794,057	July 4, 1905	July 29, 1904	Sullivan, J. M.	Chicago	Illinois	Combination Tool	121
794,952	July 18, 1905	September 16, 1903	Schroeder, F. W.	London	England	Ratchet Spanner For Screw Bolts, &c.	
796,145	August 1, 1905	November 12, 1904	Parish, G. C.	Kingston	New York	Can Opener	
796,352	August 1, 1905	August 1, 1904	Quilling, J. W.	Ursa	Illinois	Compound Tool	122
799,109	September 12, 1905	April 1, 1905	Sturm, H.	New York	New York	Corkscrew	
800,682	October 3, 1905	December 12, 1904	Robertson, P. L.	Canfield	Canada	Corkscrew	
801,791	October 10, 1905	February 10, 1905	Herwig, G. J.	St. Louis	Missouri	Pocket Knife	
802,265	October 17, 1905	February 6, 1904	Brown, J.	Peekskill	New York	Cork Puller	
805,048	November 21, 1905	December 28, 1904	Wernitz, J.	Odessa	Russia	Bottle Seal	
814,641	March 6, 1906	January 28, 1903	Coomber, J.	New York	New York	Cork Extractor	
814,834	March 13, 1906	December 6, 1904	Coughlin, J. D.	Boston	Massachusetts	Corkscrew	
823,678	June 19, 1906	March 3, 1905	Gilchrist, R. B.	Newark	New Jersey	Bottle Holder	
824,807	July 3, 1906	October 21, 1905	Noyes, H. W.	New Haven	Connecticut	Cork Extractor	122
825,929	July 17, 1906	September 19, 1903	Nobis, F. P.	Philadelphia	Pennsylvania	Stopper Extractor	
827,756	August 7, 1906	September 23, 1905	Seitz, A.	McMinnville	Tennessee	Stopper Extractor	
D-38,166	August 14, 1906	March 21, 1906	Hasselbring, J.	New York	New York	Bottle Opener	123
831,110	September 18, 1906	February 21, 1906	Sharp, H. D.	Sandusky	Ohio	Can Opener	
834,603	October 30, 1906	December 8, 1905	Ansley, M. A. N.	Toronto, Ontario	Canada	Hand Corkscrew	
836,711	November 27, 1906	July 21, 1906	Rothschild, S.	Little Falls	New York	Combination Tool	
838,920	December 18, 1906	October 15, 1906	Varnedoe, R. M.	Thomasville	Georgia	Combination Tool For Fishermen's Use	
839,229	December 25, 1906	July 11, 1906	Taylor, C. G.	Hartford	Connecticut	Combination Tool	123
845,608	February 26, 1907	January 20, 1905	Bitner, H.	Berwyn	Illinois	Cork Puller	
847,124	March 12, 1907	June 9, 1906	Sparano, G.	Philadelphia	Pennsylvania	Cork Puller	
847,744	March 19, 1907	February 17, 1906	Dudly, Sr., A.	Menominee	Michigan	Stopper Extractor	123
849,005	April 2, 1907	April 21, 1906	Meyer, R. H.	Knoxville	Pennsylvania	Kitchen Implement	
850,184	April 16, 1907	June 20, 1906	Rees, C. S.	Philadelphia	Pennsylvania	Cork Puller	124
853,151	May 7, 1907	August 19, 1905	Baumgarten, A.	Freeport	Illinois	Bottle Holder	
853,195	May 7, 1907	February 2, 1907	Wheat, W. D.	Jamestown	Kentucky	Bottle Stopper	
854,812	May 28, 1907	September 5, 1906	Dodge, J. B.	Jacksonville	Florida	Cork Extractor	124
854,891	May 28, 1907	May 16, 1906	Huffman, D. B.	White	Idaho	Combination Tool	
854,979	May 28, 1907	March 28, 1907	Bird, B. F.	Kingston	New York	Combination Tool	
857,992	June 25, 1907	October 16, 1901	Gilchrist, R. B.	Chicago	Illinois	CorkExtractor	124
858,532	July 2, 1907	June 6, 1905	Parker, A. M.	Los Angeles	California	Sharpener Tool	
860,138	July 16, 1907	January 2, 1907	Johnson, M. E.	Pittsburgh	Pennsylvania	Corkscrew	
860,226	July 16, 1907	June 27, 1904	Moat, E.	Los Angeles	California	Combination Tool	
863,091	August 13, 1907	May 5, 1905	Prindle, G.	Ogden	Utah	Combined Door Securer And Corkscrew	
871,006	November 12, 1907	January 23, 1907	Toan, R. O.	Jackson	Michigan	Cork Extractor	
873,571	December 10, 1907	June 1, 1907	Mansfield, B. A.	Salem	Massachusetts	Combination Tool	
875,323	December 31, 1907	February 5, 1907	Clark, H.	Menominee	Wisconsin	Cork Puller	
876,049	January 7, 1908	January 28, 1907	Fialcofsky, D.	Sorel, Quebec	Canada	Cork Extracting Device	
876,919	January 14, 1908	September 4, 1907	Wallace, J. M.	Spartanberg	South Carolina	Combination Tool	
876,963	January 21, 1908	April 30, 1907	Hoak, H. D.	Grass Valley	California	Combination Tool	
880,505	March 3, 1908	November 20, 1907	Bryers, J.	Chicago	Illinois	Combined Medicine Measure And Corkscrew	
883,988	April 7, 1908	March 29, 1907	Vallandingham, W. T.	Oskaloosa	Iowa	Cork Extractor	125
884,873	April 14, 1908	March 12, 1907	Stanton, W. J.	Bayonne	New Jersey	Corkscrew	
889,474	June 2, 1908	October 9, 1907	Medley, H. L.	Cosmopolis	Washington	Cork Extractor	
889,556	June 2, 1908	November 8, 1907	Stephens, A. W.	Waltham	Massachusetts	Cigar Tip Perforator	
889,901	June 9, 1908	November 16, 1907	Bush, M.	Monroe	New York	Can Opener	
891,260	June 23, 1908	January 13, 1908	Hutchinson, C. H.	Boston	Massachusetts	Corkscrew	
892,720	July 7, 1908	June 21, 1907	Gromer, C. J.	New York	New York	Cork Extractor	
893,055	July 14, 1908	January 23, 1908	Conner, W. W.	Niles	Ohio	Cork Extractor	
893,405	July 14, 1908	July 25, 1907	Weisbeck, J. A. &	Alden	New York	Jar Opening Wrench	
894,626	July 28, 1908	May 6, 1907	Givens, R. J.	Enterprise	Idaho	Fruit Jar Opener	
895,580	August 11, 1908	April 4, 1907	Northam, N. J.	Wrightsville	South Carolina	Scissors Sharpener	
896,117	August 18, 1908	August 28, 1907	Jones, W.	Auburn	Maine	Combination Tool	
896,577	August 18, 1908	July 6, 1908	Reynolds, C. W.	Meriden	Connecticut	Combination Tool	125
897,176	August 25, 1908	February 18, 1908	Thompson, H. S.	Sheridanville	Pennsylvania	Cork Puller	
898,366	September 8, 1908	July 17, 1907	Hough, J.	Guelph, Ontario	Canada	Belt Buckle	
898,387	September 8, 1908	May 31, 1907	Noyes, H. W.	West Haven	Connecticut	Pocket Cork Extractor	
899,380	September 22, 1908	May 13, 1908	Braddock, S. E.	Brooklyn	New York	Cork Extractor	125
899,407	September 22, 1908	May 28, 1907	Kampfe, O.	New York	New York	Pocket Implement	
899,408	September 22, 1908	December 16, 1907	Kampfe, O.	New York	New York	Combination Implement	125
899,683	September 29, 1908	December 19, 1907	Sarvalla, M. &	DeKalb	Illinois	Jar Opener	
900,339	October 6, 1908	November 30, 1907	Woodruff, W. B.	Cadiz	Kentucky	Tool Handle	
902,868	November 3, 1908	July 6, 1908	Fenn, A.	Meriden	Connecticut	Combination Tool	125
908,346	December 29, 1908	April 4, 1908	Smith, E. H.	Ceredo	West Virginia	Can Opener	
910,019	January 19, 1909	September 25, 1908	Ramstad, J. N.	Valdez	Alaska	Compound Tool	
910,845	January 26, 1909	March 14, 1906	Parker, K. E.	LaFayette	Indiana	Combined Cork Puller And Time Indicator	
910,923	January 26, 1909	March 18, 1908	King, C. M.	Derby	Connecticut	Cork Extractor	
911,292	February 2, 1909	September 28, 1907	Call, C. C.	Springfield	Massachusetts	Cork Pulling Device	126
913,191	February 23, 1909	April 2, 1908	Bird, B. F.	Kingston	New York	Combination Tool	
914,601	March 9, 1909	February 17, 1908	Nylin, E. H.	New York	New York	Combination Tool	126
920,008	April 27, 1909	June 15, 1903	Baumgarten, A., Dec'd	Freeport	Illinois	Cork Puller	
920,087	April 27, 1909	September 11, 1907	Schofield, A. B., Dec'd	New York	New York	Combination Tool	
921,988	May 18, 1909	October 7, 1908	Heath, J. R.	Newark	New Jersey	Pocket Knife	126
922,702	May 25, 1909	December 28, 1908	Jopson, G. W.	Meriden	Connecticut	Can Opener And Bottle Decapper	
924,796	June 15, 1909	August 9, 1906	Klever, F. W.	Solingen	Germany	Disjointable Pocket Knife	
926,112	June 29, 1909	April 11, 1908	Gould, M. A.	New York	New York	Bottle Support And Stopper Puller	
926,807	July 6, 1909	March 2, 1908	Hough, J.	Guelph, Ontario	Canada	Bottle Opener	
926,839	July 6, 1909	February 2, 1909	Argo, G. B.	Perlee	Iowa	Cork Extractor	
927,127	July 6, 1909	April 26, 1909	De Bersaques, R.	Washington	DC	Corkscrew	

NUMBER	ISSUE DATE	FILE DATE	NAME	RESIDENCE	STATE/COUNTRY	TITLE	ILLUSTRATIONS ON PAGE
927,352	July 6, 1909	November 6, 1908	Hoglund, P. &	Duluth	Minnesota	Hunting Knife	
927,938	July 13, 1909	December 31, 1908	Braun, R.	Philadelphia	Pennsylvania	Can Opener	
946,740	January 18, 1910	May 19, 1909	Thomas, J. H.	Thomasville	North Carolina	Cork Extractor	
950,509	March 1, 1910	October 16, 1907	Clough, W. R.	Alton	New Hampshire	Bottle Cap Lifter	127
955,099	April 12, 1910	May 18, 1909	Peters, J. L.	Allentown	Pennsylvania	Stopper Lock For Bottles	
958,092	May 17, 1910	October 5, 1909	Chippendale, H. A.	New London	Connecticut	Cigar Cutter Forming Part Of A Combination Tool	127
963,283	July 5, 1910	May 18, 1909	Ferguson, H.	Sheriden	Wyoming	Can Opener	
964,588	July 19, 1910	April 16, 1907	Walker, E.	Erie	Pennsylvania	Bottle Holder For Cork Pullers And Other Machinery	
971,012	September 20, 1910	December 14, 1908	Parsley, G. T.	Hornbrook	California	Combination Tool	
973,930	October 25, 1910	March 5, 1910	Fink, J. W.	Pittsburgh	Pennsylvania	Match Box	
978,153	December 13, 1910	June 15, 1910	Hahn, G.	New York	New York	Vegetable Cutter	
980,839	January 3, 1911	May 19, 1910	Rollins, C. E.	Mattoon	Wisconsin	Cork Extractor	
983,778	February 7, 1911	October 19, 1910	Sersen, F. J.	Milwaukee	Wisconsin	Cork Extractor	
984,661	February 21, 1911	December 22, 1910	Halk, W.	Mount Pleasant	Pennsylvania	Stopper Extractor	
986,855	March 14, 1911	December 21, 1910	Peck, M. L. M.	Hamilton	New York	Cork Puller	
989,181	April 11, 1911	September 16, 1909	Murchie, J.	Traverse City	Michigan	Can Opener	
989,680	April 18, 1911	July 15, 1909	Windhövel, C. W. &	Solingen	Germany	Pocket Corkscrew	127
990,962	May 2, 1911	December 30, 1910	Curtis, J. F.	Macclenny	Florida	Cork Extractor	
1,001,727	August 29, 1911	May 6, 1909	Baird, W. C.	Colorado Springs	Colorado	Manicuring Implement	
1,002,374	September 5, 1911	December 20, 1910	Deuel, B. F.	Mahaffrey	Pennsylvania	Cork Puller	
1,009,040	November 21, 1911	February 9, 1911	Bethel, J. T.	Manchester	Virginia	Corkscrew	
1,012,672	December 26, 1911	September 30, 1911	Lovejoy, K.	Hurley	New Mexico	Non-Refillable Bottle	
1,012,931	December 26, 1911	February 10, 1910	Syme, D. M.	Newport	Rhode Island	Corkscrew	
D-42,305	March 12, 1912	September 14, 1911	Sommer, J. L.	Newark	New Jersey	Bottle Opener	128
1,030,698	June 25, 1912	January 27, 1912	Wilson, R. L.	Chicago	Illinois	Cork Extractor	
1,032,855	July 16, 1912	October 13, 1910	Ostby, A. M.	Chicago	Illinois	Combination Tool	
1,036,980	August 27, 1912	February 27, 1912	Earle, E.	Townville	South Carolina	Corkscrew	
1,038,692	September 17, 1912	November 8, 1909	Walker, E.	Erie	Pennsylvania	Method Of Making Corkscrews	
1,039,260	September 24, 1912	April 18, 1910	Cooper, J. E.	Perry	New York	Combination Pocket Implement	
1,040,956	October 8, 1912	November 20, 1909	Jones, J. H. &	Cincinnati	Ohio	Cork Extractor	
1,041,699	October 15, 1912	October 14, 1911	Thompson, Jr., R. H.	Portland	Oregon	Bottle Faucet Or Tap	
1,042,952	October 29, 1912	February 6, 1912	Nies, H.	Mount Rainier	Maryland	Cork Extractor	
D-43,268	November 26, 1912	October 2, 1912	Cary, J. G.	Jackson	Tennessee	Combination Pocket Tool	
1,047,795	December 17, 1912	September 19, 1911	Gross, B. S. &	Birmingham	Alabama	Combination Tool	
1,055,377	March 11, 1913	July 24, 1912	Winiecki, T.	Raymond	Washington	Cork Extractor	
1,055,739	March 11, 1913	January 31, 1912	Haas, P. J.	York	Nebraska	Knife Sharpener	
1,057,021	March 25, 1913	February 20, 1907	Walker, E.	Erie	Pennsylvania	Automatic Cork Puller	
1,058,049	April 8, 1913	April 19, 1912	Greenhut, M. E.	Hartford	Connecticut	Combination Tool	
1,058,361	April 8, 1913	May 9, 1904	Gilchrist, R. B.	Newark	New Jersey	Cork Puller	128
1,058,362	April 8, 1913	October 25, 1906	Gilchrist, R. B.	Newark	New Jersey	Bottle Holder	129
1,059,883	April 22, 1913	August 9, 1910	Lepage, J. E.	Two Harbors	Minnesota	Combination Tool	
1,061,904	May 13, 1913	October 1, 1912	Finsel, A.	Elizabeth	New Jersey	Cork Puller	
1,062,458	May 20, 1913	May 12, 1910	Hainisch, V.	Vienna	Austria-Hungaria	Cork Extractor	
1,070,513	August 19, 1913	June 10, 1912	Moulton, E. W.	Roxbury	Massachusetts	Cork Puller	
1,074,015	September 23, 1913	March 5, 1913	Reap, E. A. &	Enid	Oklahoma	Cork Holder And Lifter	
1,082,555	December 30, 1913	April 14, 1913	Ridley, A. L.	Searsport	Maine	Cork Extractor	
1,091,301	March 24, 1914	May 8, 1913	Doheny, E. J.	Woonsocket	Rhode Island	Stopper Extractor	
1,093,768	April 21, 1914	September 11, 1913	Corkery, E. J.	Grand Rapids	Michigan	Cork Puller	
1,094,997	April 28, 1914	August 5, 1913	Jacquemin, E.	Kent	Washington	Cork Extractor	
D-45,678	April 28, 1914	March 3, 1914	Sommer, J. L.	Newark	New Jersey	Bottle Opener	129
1,096,622	May 12, 1914	October 18, 1905	Gilchrist, R. B.	Newark	New Jersey	Bottle Holder	
1,103,827	July 14, 1914	January 19, 1914	Peisch, F. W.	Chicago	Illinois	Bottle Cover	
1,108,699	August 25, 1914	May 15, 1913	Chani, J.	Canal Dover	Ohio	Bottle Opening Device	
1,109,073	September 1, 1914	August 13, 1913	Labrèche, J. C. A.	Edmonton, Alberta	Canada	Cigar Cutting Tool	129
1,110,210	September 8, 1914	October 3, 1913	Kissinger, J. H.	Spokane	Washington	Corkscrew	
1,110,265	September 8, 1914	June 17, 1913	Janouch, F.	Lincoln	Nebraska	Cork Extractor	
1,112,875	October 6, 1914	October 31, 1913	Whelan, P. J.	Douglas, Ontario	Canada	Cork Extractor And Fastener	
1,113,465	October 13, 1914	January 13, 1914	Moller, P. T.	Seattle	Washington	Cork Extractor	
1,116,509	November 10, 1914	September 15, 1913	Spielbauer, J. M.	Seattle	Washington	Cap Remover	
1,120,906	December 15, 1914	April 6, 1911	Clough, W. R.	Alton	New Hampshire	Bottle Attachment	
1,120,914	December 15, 1914	February 14, 1914	Dodson, J. C.	Ramah	Colorado	Compound Tool	
1,121,459	December 15, 1914	July 5, 1912	Blake, A. E.	Rochester	New York	Bottle Attachment	
1,123,259	January 5, 1915	June 29, 1914	Du Bose, J. H.	Clarkesville	Georgia	Cork Extractor	
1,123,723	January 5, 1915	March 4, 1912	Freuler, K.	Zurich	Switzerland	Cork Drawing Appliance	
1,124,125	January 5, 1915	June 21, 1914	Freres, N.	Racine	Wisconsin	Cork Extractor	
1,127,609	February 9, 1915	April 13, 1912	Feyrer, F.	Westoff	Texas	Combination Penknife	
D-46,935	February 9, 1915	November 28, 1914	Wakao, A.	Los Angeles	California	Combined Key Holder And Cork Puller	
1,131,985	March 16, 1915	January 10, 1914	Bellois, F. W.	New York	New York	Bottle Closure	
1,132,248	March 16, 1915	March 31, 1913	Eudy, A.	Riverside	California	Combination Tool	
1,140,082	May 18, 1915	March 25, 1914	Stapley, J. H. A.	Horley	England	Cork Extractor	
1,141,141	June 1, 1915	February 4, 1915	Plante, O. N.	Lowville	New York	Combination Tool	
1,146,649	July 13, 1915	October 19, 1914	Omaye, J.	Seattle	Washington	Stopper Extractor	
1,149,068	August 3, 1915	October 18, 1913	Kinnan, S. E.	Lake Helen	Florida	Non-Refillable Bottle	
1,149,112	August 3, 1915	June 10, 1913	Beckley, H.	Cincinnati	Ohio	Cork Extractor	
1,150,083	August 17, 1915	July 19, 1910	Walker, E.	Erie	Pennsylvania	Crown Opener	
D-47,735	August 17, 1915	October 17, 1914	Piggott, T. K.	Puyallup	Washington	Pair Of Scissors	
D-47,755	August 24, 1915	May 21, 1914	Morgan, C.	Freeport	Illinois	Frame For Cork Pullers	129
D-47,778	August 31, 1915	March 11, 1915	Yapczenski, S.	Chrome	New York	Pocket Article	
1,153,600	September 14, 1915	May 14, 1915	Caswell, H. M. &	Oatman	Arizona	Can Opener	
1,155,193	September 28, 1915	July 11, 1914	Balthazar, E.	Pawnee	Louisiana	Cork Extractor	
1,159,432	November 9, 1915	May 26, 1913	Sweeney, J. T.	Kingston	New York	Combination Tool	
1,162,017	November 30, 1915	April 16, 1915	Barrett, J. J.	Maspeth	New York	Cork Puller	
1,164,776	December 21, 1915	May 25, 1915	Arbanasin, E. A.	Truckee	California	Can Opener	
1,166,022	December 28, 1915	March 3, 1915	Turner, O. J.	Minneapolis	Minnesota	Can Opener	
D-48,539	February 8, 1916	November 8, 1915	Woicula, M.	Wilmington	Delaware	Combination Implement	
D-48,871	April 11, 1916	February 16, 1915	Piotrowski, F.	New York	New York	Pocket-Tool	
D-48,894	April 18, 1916	May 20, 1915	Higgins, T. E.	Philadelphia	Pennsylvania	Poison Alarm Device	
1,187,842	June 20, 1916	May 26, 1915	Kaas, E.	Kongsberg	Norway	Combination Tool	
1,188,931	June 27, 1916	February 6, 1914	Gray, G. E.	Des Moines	Iowa	Combination Tool	
1,190,883	July 11, 1916	November 4, 1915	Flitsch, R.	Miner	North Dakota	Bottle Opener	
1,194,296	August 8, 1916	June 24, 1913	Jones, H. V. &	Newton	Massachusetts	Combination Tool	
1,194,503	August 15, 1916	December 31, 1915	Jawoisch, B.	Chicago	Illinois	Knife Or Tool	
1,196,060	August 29, 1916	January 7, 1915	Wilson, E. W.	Chicago	Illinois	Jar Opener	
1,197,451	September 5, 1916	May 18, 1915	Curl, A. E.	Collierville	Tennessee	Cork Extractor	
1,198,023	September 12, 1916	April 6, 1914	Green, I. F.	Kinmundy	Illinois	Cork Extractor	
1,199,272	September 26, 1916	July 7, 1915	Hutter, J.	New York	New York	Bottle Opener	
1,199,651	September 26, 1916	March 21, 1916	Arbanasin, E. A.	Truckee	California	Can Opener	
1,200,079	October 3, 1916	September 27, 1915	Christensen, H. P. &	San Francisco	California	Combination Pocket Tool	
1,203,257	October 31, 1916	June 5, 1913	Pettingell, D. H.	Golconda	Nevada	Advertising Novelty	
1,207,100	December 5, 1916	August 21, 1915	Vaughan, H. L.	Chicago	Illinois	Bottle Opener	130, 131
D-50,051	December 19, 1916	October 20, 1916	Anderson, A.	Dassel	Minnesota	Cork Extractor	
1,213,034	January 16, 1917	May 8, 1915	Sowers, F. S.	Oak Park	Illinois	Household Implement	
1,213,452	January 23, 1917	January 16, 1915	Brady, W. M.	Baltimore	Maryland	Stopper Extractor	132
1,217,801	February 27, 1917	March 12, 1915	Martin, T.	Homestead	Pennsylvania	Combination Tool	

NUMBER	ISSUE DATE	FILE DATE	NAME	RESIDENCE	STATE/COUNTRY	TITLE	ILLUSTRATIONS ON PAGE
1,218,757	March 13, 1917	April 8, 1916	Gessler, O. C.	Detroit	Michigan	Compound Tool	
1,219,510	March 20, 1917	March 24, 1916	Weber, E. R.	Rochester	New York	Cork Extractor	
1,225,037	May 8, 1917	May 17, 1916	Kinsey, M. L.	Dos Palos	California	Cork Extractor	
1,227,424	May 22, 1917	April 8, 1916	Glenn, L.	Sparta	Illinois	Cork Extractor	
1,228,154	May 29, 1917	June 3, 1915	Williams, F. E.	Hartford	Connecticut	Scraper	
1,230,726	June 19, 1917	October 31, 1916	Krause, E. H.	Portland	Oregon	Cork Puller	
1,231,746	July 3, 1917	November 18, 1916	Knysz, S.	Hamtramck	Michigan	Can Opener	
1,231,859	July 3, 1917	November 29, 1916	Davis, C. J.	Hardinsburg	Kentucky	Stopper Or Cork Extractor	
1,237,040	August 14, 1917	September 13, 1916	Henry, G. E.	Philadelphia	Pennsylvania	Kitchen Utensil	
1,238,166	August 28, 1917	April 5, 1915	McConnell, H. R.	Richmond	Virginia	Machine For Making Corkscrews	
1,240,610	September 18, 1917	August 8, 1916	Sheridan, J.	San Francisco	California	Cork Puller	
1,243,845	October 23, 1917	March 21, 1917	Lyons, J. J.	Brookline	Massachusetts	Cork Extractor	132
1,245,736	November 6, 1917	March 19, 1917	Ketler, W. H.	Camden	New Jersey	Poison Bottle Indicator	
1,248,608	December 4, 1917	April 8, 1916	Brown, C. S.	Trenton	New Jersey	Bottle Opener	
1,250,413	December 18, 1917	June 2, 1916	Arnold, W. H.	Oakland	California	Combination Can Opener	133
1,250,678	December 18, 1917	December 4, 1916	Sharp, E.	Sherwood	Oregon	Cork Puller	
1,255,179	February 5, 1918	May 10, 1917	Klamer, J.	Stevens Point	Wisconsin	Combination Tool	
1,258,035	March 5, 1918	August 16, 1917	Moore, W. M.	Newark	Ohio	Can Opener	133
1,261,045	April 2, 1918	November 29, 1916	McFarland, H. R.	Seattle	Washington	Can Opener	
1,262,178	April 9, 1918	March 13, 1917	Crowell, J. H.	Tisbury	Massachusetts	Implement For Opening Bottles	
1,262,277	April 9, 1918	December 6, 1916	Sunderland, F.	Birmingham	England	Means For The Removal Of Bottle And Like Caps Or Stoppers	
1,265,320	May 7, 1918	April 7, 1916	Gaynor, F. M.	Jersey City	New Jersey	Cork Extractor	
1,266,510	May 14, 1918	March 14, 1916	McMeekin, N. A.	Woodsville	New Hampshire	Tool	
1,270,593	June 25, 1918	December 10, 1917	Biscayart, J. D.	Atlanta	Georgia	Can Opener	
D-52,156	July 2, 1918	August 24, 1915	Zunish, P.	Jenkins	Kentucky	Can Opener	
1,273,026	July 16, 1918	September 26, 1916	Brown, G.	Chicago	Illinois	Corkscrew And Bottle Opener	
1,274,008	July 30, 1918	April 19, 1918	Conwell, R.	Big Piney	Wyoming	Cork Extractor	
1,275,228	August 13, 1918	August 4, 1916	Crowe, F. C. &	Pittsburgh	Pennsylvania	Cork Puller	
1,275,915	August 13, 1918	March 3, 1917	Heath, S.	Roxborough	Pennsylvania	Can Opener	
1,276,963	August 27, 1918	December 6, 1916	Robinson, J. A. &	Ottawa, Ontario	Canada	Can Opener	
1,280,321	October 1, 1918	July 9, 1917	Smith, J. E.	Madisonville	Louisiana	Can Opener	
1,281,631	October 15, 1918	March 25, 1918	Moser, J. W.	Byers	Texas	Cork Puller	
1,285,544	November 19, 1918	July 22, 1918	Yates, A. A.	Rensselaer	New York	Cork Puller	
1,287,413	December 10, 1918	February 20, 1918	Parrella, J. A.	Washington	DC	Combination Tool	133
1,293,516	February 4, 1919	March 19, 1918	Nehman, M.	Detroit	Michigan	Cork Extractor	
1,294,367	February 11, 1919	February 11, 1918	Shipley, P. &	London	Ohio	Bottle Stopper Extractor	
1,297,797	March 18, 1919	August 8, 1918	Cheselka, P.	Fairbank	Pennsylvania	Can Opener	
D-53,161	April 1, 1919	October 21, 1916	Vicario, J.	New York	New York	Combination Tool	
1,307,892	June 24, 1919	May 10, 1918	Bet, M. M.	Moose Jaw, Saskatchewan	Canada	Can Opener	
1,311,028	July 22, 1919	April 11, 1917	Wiley, H. W.	Black Lick	Pennsylvania	Can Opener	
D-53,658	July 29, 1919	March 20, 1919	Holsen, J. J.	Manitowoc	Wisconsin	Combination Tool	132
1,319,597	October 21, 1919	August 16, 1918	Lung, B. F.	Benzonia	Michigan	Can-Opener	
1,330,689	February 10, 1920	June 19, 1919	Drew, C.	King's Lynn	England	Stopper Extractor	
1,332,043	February 24, 1920	February 18, 1918	Keith, J. W.	Lynchburgh	Virginia	Cork Puller	
1,339,164	May 4, 1920	June 28, 1918	Clough, W. R.	Alton	New Hampshire	Pocket Implement	
1,340,551	May 18, 1920	May 1, 1918	Madsen, C. T.	Oakland	California	Cork Extractor	
D-55,843	July 20, 1920	July 24, 1919	Charlier, A. T.	Luxembourg	Wisconsin	Combination Cap And Bottle Opener, Box Opener, And Cigar Cutter	
1,348,760	August 3, 1920	October 27, 1919	Stewart, R. M.	Chicago	Illinois	Can Opener	
1,350,383	August 24, 1920	March 14, 1919	Palahniuk, J.	Brule Mines, Alberta	Canada	Cork Extractor	
1,352,967	September 14, 1920	February 14, 1920	Johnson, T. A.	Rockford	Illinois	Bottle Stopper Protector And Supporter	
1,353,090	September 14, 1920	October 9, 1918	de Teixeira, E.	Setauket	New York	Table Implement	
1,361,021	December 7, 1920	October 31, 1919	Copeman, L. G.	Flint	Michigan	Tool Holder	
1,361,752	December 7, 1920	December 26, 1919	Cross, C. J.	New York	New York	Bottle Case And Support	
1,361,859	December 14, 1920	July 27, 1918	Holmes, C. E.	Elyria	Ohio	Can Opener	
1,364,016	December 28, 1920	May 21, 1919	Worthington, B. G.	Medford	Oregon	Can Opener	
1,367,841	February 8, 1921	March 27, 1920	Teece, S.	Enderby, B.C.	Canada	Poison Bottle Top	
1,374,032	April 5, 1921	May 24, 1919	Roach, W. H.	Lindsay	California	Convertible Can Opener	
1,375,382	April 19, 1921	June 8, 1920	Gomber, G. W.	Conyngham	Pennsylvania	Cork Extractor	
1,381,339	June 14, 1921	November 21, 1918	Rosen, F.	Chicago	Illinois	Combination Utensil	
1,385,976	July 26, 1921	July 22, 1915	Walker, E., Dec'd	Erie	Pennsylvania	Method Of Making Crown Openers	139
1,388,083	August 16, 1921	February 1, 1921	Workman, A. D.	Knoxville	Tennessee	Culinary Implement	
1,397,537	November 22, 1921	February 1, 1919	Munsing, G. D.	New York	New York	Can Opener	
D-60,135	January 3, 1922	July 13, 1921	Glossop, M.	Seattle	Washington	Combination Tool	
1,416,616	May 16, 1922	April 16, 1921	Crane, L.	New York	New York	Nonremovable Cork	
1,421,169	June 27, 1922	August 11, 1921	Chmura, J.	Marmarth	North Dakota	Automatic Corkscrew	
1,423,127	July 18, 1922	March 16, 1920	Levy, E.	London	England	Scissors	
1,425,456	August 8, 1922	September 30, 1919	Dial, N.	New York	New York	Medicine Bottle	
1,435,866	November 14, 1922	September 14, 1921	McGahey, R. E.	Alexandria	Virginia	Ice Pick	
1,439,738	December 26, 1922	August 11, 1921	Husar, J.	Chicago	Illinois	Key Ring	
1,443,861	January 30, 1923	May 7, 1921	Barr, L. S.	Washington	DC	Spoon Holder For Bottles	
1,447,197	March 6, 1923	June 7, 1920	Worthington, B. G.	Los Angeles	California	Can Opener	
1,449,654	March 27, 1923	December 7, 1921	Carothers, G. N.	Cutler	Ohio	Cork Extractor	
1,451,542	April 10, 1923	November 1, 1921	Ftyklo, A.	Braznell	Pennsylvania	Combination Utensil	
1,451,594	April 10, 1923	June 27, 1921	Smookler, H.	Los Angeles	California	Kitchen Tool	
1,452,337	April 17, 1923	November 16, 1921	Brecel, E.	Brooklyn	New York	Camper's Combination Utensil	
1,461,162	July 10, 1923	March 19, 1923	Roberts, L. D.	Washington	DC	Can Opener	140
1,466,118	August 28, 1923	February 27, 1922	Ciha, E. E.	Chicago	Illinois	Tool	
1,469,838	October 9, 1923	April 18, 1922	Jacoby, C. B.	Nanticoke	Pennsylvania	Combination Tool	
1,498,421	June 17, 1924	October 7, 1922	Bradler, E. M.	Cincinnati	Ohio	Combination Opener	
1,502,620	July 22, 1924	June 16, 1922	Fleisher, H.	Gambrills	Maryland	Poison Indicator	
1,515,395	November 11, 1924	February 2, 1924	La Londe, J.	Gilbert	Minnesota	Cover Remover	
1,529,420	March 10, 1925	April 5, 1923	Bowers, J. C.	Norway	Maine	Combination Tool	
1,548,519	August 4, 1925	October 11, 1924	Flint, A. W.	London	England	Device For Removing Closures From Bottles	140
1,557,239	October 13, 1925	June 9, 1923	Bohner, A. V.	Big Sandy	Montana	Cork Puller	
1,570,306	January 19, 1926	July 20, 1925	Johnson, W.	Chicago	Illinois	Combination Bottle Opening Tool	
1,574,497	February 23, 1926	March 11, 1925	McLean, R. J.	New York	New York	Combination Tool	140
1,578,806	March 30, 1926	May 7, 1924	Cowles, S. O.	Salisbury	Connecticut	Jar And Can Opener	
1,596,960	August 24, 1926	September 29, 1925	Becchetti, F.	Dawson	New Mexico	Cork Extractor	
1,602,406	October 12, 1926	June 27, 1924	Gagne, H.	Manchester	New Hampshire	Cork And Stopper Puller	
1,604,609	October 26, 1926	December 9, 1925	Salamone, J.	Brooklyn	New York	Tool Holder	
D-73,406	September 6, 1927	June 7, 1926	Guerris, A. O.	Barcelona	Spain	Bottle Opener	
1,644,936	October 11, 1927	March 2, 1926	Mertens, P.	Newark	New Jersey	Collapsible Corkscrew	
1,645,107	October 11, 1927	February 13, 1925	MacIntosh, C. A.	Spencerport	New York	Implement For Removing Covers Or Closures	
1,653,490	December 20, 1927	December 28, 1925	Ballou, W. B. &	North Attleboro	Massachusetts	Bottle Closure	141
1,657,728	January 31, 1928	April 29, 1927	Untiedt, F. H.	Washington	DC	Combined Corkscrew And Corkborer	
1,668,262	May 1, 1928	July 7, 1926	Bingaman, J. K.	Cincinnati	Ohio	Compound Tool	
1,670,199	May 15, 1928	October 15, 1926	La Schum, E. E.	New York	New York	Combination Novelty	
1,670,828	May 22, 1928	June 10, 1927	Sheley, G. T.	Indianapolis	Indiana	Jar Top Removing Device	
1,680,291	August 14, 1928	February 20, 1926	Harding, T.	Newark	New Jersey	Corkscrew	141
1,680,876	August 14, 1928	June 7, 1926	Guerris, A. O.	Barcelona	Spain	Bottle Dispensing Device	141

NUMBER	ISSUE DATE	FILE DATE	NAME	RESIDENCE	STATE/COUNTRY	TITLE	ILLUSTRATIONS ON PAGE
1,684,622	September 18, 1928	February 18, 1926	Harker, F. P.	Bridgeport	Connecticut	Combination Kitchen Utensil	
1,684,829	September 18, 1928	October 9, 1923	Hoelle, J. J.	Sydney	Australia	Domestic Hand Tool	
1,695,098	December 11, 1928	December 30, 1926	Hiering, W. C.	Newark	New Jersey	Bottle Opening Implement	
1,701,467	February 5, 1929	March 5, 1923	Tillmanns, C. W.	Bridgeport	Connecticut	Handled Tool	142
1,701,950	February 12, 1929	February 16, 1927	Hiering, W. C.	Newark	New Jersey	Pocket Corkscrew	142
1,702,149	February 12, 1929	October 22, 1926	Brown, R. M.	Newport News	Virginia	Bottle Opener	142
1,707,398	April 2, 1929	February 4, 1928	Hyland, A. E.	Keeseville	New York	Cork Extractor And Cap Remover Tool	
D-78,554	May 21, 1929	March 7, 1929	Avillar, M. D.	New York	New York	Bottle Seal Opener	134, 143
1,715,033	May 28, 1929	January 14, 1928	Hoegger, J. A.	Jersey City	New Jersey	Bottle Opener	
1,715,524	June 4, 1929	August 11, 1928	Vaughan, H. L.	Chicago	Illinois	Can Opener	143
1,716,058	June 4, 1929	May 5, 1926	Horix, C.	Chicago	Illinois	Bottle Stopper Remover	
1,717,925	June 18, 1929	December 30, 1926	Horix, C.	Chicago	Illinois	Combination Tool	143
1,728,787	September 17, 1929	June 26, 1929	De Bracht, J.	Everett	Pennsylvania	Bottle Opener	143
D-79,687	October 22, 1929	July 29, 1929	Topping, F. A.	Grand Rapids	Michigan	Combined Cork Puller And Bottle Opener	144
1,742,225	January 7, 1930	August 4, 1922	Sweeney, J. T.	Kingston	New York	Combination Tool	
1,746,393	February 11, 1930	February 24, 1927	Gray, L. G.	Decatur	Illinois	Bottle Opener	144
1,747,099	February 11, 1930	February 20, 1928	Ames, J. W.	Wilmington	Delaware	Cork Remover	
1,750,759	March 18, 1930	June 4, 1926	Kennedy, C. E. &	Swampscott	Massachusetts	Bottle Opening Device	
1,752,227	March 25, 1930	June 28, 1929	Briggs, H. E.	Columbia Falls	Montana	Cork Puller	
1,753,026	April 1, 1930	October 29, 1928	Rosati, D.	Chicago	Illinois	Cork Extractor	144
1,763,849	June 17, 1930	August 27, 1928	Hoegger, J. A.	Jersey City	New Jersey	Bottle Opener	144
1,767,489	June 24, 1930	August 4, 1922	Sweeney, J. T.	Kingston	New York	Combination Tool	
1,770,418	July 15, 1930	September 4, 1928	McCaskill, G. C.	Hutchinson	Kansas	Seven-Tool Combination	
1,771,493	July 29, 1930	October 13, 1928	Kovats, J.	Bridgeport	Connecticut	Can Opener	
1,775,164	September 9, 1930	February 16, 1928	Hoegger, J. A.	Jersey City	New Jersey	Wall Bottle Cap And Cork Remover	145
1,779,170	October 21, 1930	October 16, 1929	Johnson, W.	Chicago	Illinois	Household Tool	145
1,783,830	December 2, 1930	June 1, 1928	Denmark, A. C. &	Austin	Texas	Kitchen Utensil	
1,784,488	December 9, 1930	March 1, 1928	Jenkins, N.	Chicago	Illinois	Combination Tool	145
1,805,011	May 12, 1931	May 22, 1929	Salomone, J.	Brooklyn	New York	Combination Household Implement	145
1,806,828	May 26, 1931	June 19, 1929	Servaas, J.	Brooklyn	New York	Kitchen Utensil	
1,811,982	June 30, 1931	June 6, 1928	Soustre, J. A.	Cendrieux	France	Knife Adapted For Multiple Uses And Comprising A Monkey Wrench	146
1,814,014	July 14, 1931	September 18, 1930	Vitali, S.	Plains	Pennsylvania	Gripping Tool For Jars	
1,814,895	July 14, 1931	November 17, 1928	Charbonneau, A. W.	Boston	Massachusetts	Compound Appliance	146
1,827,868	October 20, 1931	September 13, 1928	Brown, R. M.	Newport News	Virginia	Bottle Opener	
1,834,266	December 1, 1931	December 10, 1929	Bohner, A. V.	Great Falls	Montana	Tool	
1,845,038	February 16, 1932	July 27, 1925	Alderson, F. J.	Kingston, Ontario	Canada	Combination Tool	146
1,846,763	February 23, 1932	March 22, 1930	Schaefer, B. L.	Detroit	Michigan	Combined Bottle And Eyecup	
1,854,299	April 19, 1932	October 22, 1930	Gray, L. G.	Decatur	Illinois	Bottle Opener	
1,861,993	June 7, 1932	May 10, 1929	Weller, J. H.	New Haven	Connecticut	Cork Extractor And Bottle Opener	
D-87,567	August 16, 1932	June 22, 1932	Flauder, A. J.	Trumbull	Connecticut	Bottle Opener	147
1,873,331	August 23, 1932	July 23, 1930	Rundell, R. R.	Waterbury	Connecticut	Combined Corkscrew And Bottle Decapper	
D-87,618	August 23, 1932	May 14, 1932	Bridgewater, H. M.	Stratford	Connecticut	Combination Bottle Opener And Dispensing Apparatus	147
D-87,764	September 13, 1932	July 25, 1932	Walker, W. T. &	Toledo	Ohio	Combination Bottle Opener And Beverage Spoon	148
1,882,273	October 11, 1932	February 17, 1930	Cameron, R. T.	Memphis	Tennessee	Cigar Tip Perforator	
1,897,991	February 14, 1933	July 17, 1931	Arnof, D. B.	New York	New York	Tongs	148
D-89,308	February 21, 1933	May 31, 1932	Rettich, K.	Toledo	Ohio	Combined Corkscrew And Guard	148
1,921,811	August 8, 1933	December 5, 1932	Eger, L.	New York	New York	Cork Remover	
1,930,492	October 17, 1933	May 2, 1931	Thompson, H. G.	East Cleveland	Ohio	Combination Bottle Opener, Jar Top Remover And Cork Screw	
1,938,484	December 5, 1933	January 22, 1931	Clarin, G. F.	Stockholm	Sweden	Cork Pulling Machine	
1,953,690	April 3, 1934	November 14, 1933	Samways, A. G.	Providence	Rhode Island	Combination Tool	
1,956,405	April 24, 1934	March 27, 1933	Toman, A.	New York	New York	Combination Kitchen Tool	
1,958,654	May 15, 1934	May 19, 1933	Anderson, L. N.	Hawkinsville	Georgia	Can Opener	
1,974,856	September 25, 1934	October 12, 1933	White, J. &	Duluth	Minnesota	Combination Instrument	
1,974,863	September 25, 1934	January 31, 1934	Fleaca, J.	Cleveland	Ohio	Can Opener	
1,975,606	October 2, 1934	November 8, 1932	Hoegger, J. A.	Jersey City	New Jersey	Bottle Opener	148
1,981,104	November 20, 1934	April 23, 1934	Heiner, S. J. &	Scranton	Pennsylvania	Jar Opener And Closer	
1,981,781	November 20, 1934	February 6, 1934	Collette, E. R.	New York	New York	Cork Pulling Device	
1,988,057	January 15, 1935	September 19, 1933 (Division)	Thompson, H. G.	East Cleveland	Ohio	Corkscrew	149
1,990,289	February 5, 1935	March 14, 1934	Krueger, H. S.	Niagara Falls	New York	Corkscrew	
1,991,307	February 12, 1935	September 23, 1933	Worden, W. H.	Harrisonburg	Louisiana	Universal Handle For Kitchen Ware	
1,994,546	March 19, 1935	May 10, 1934	Ventura, A.	New York	New York	Tool Holder	
1,996,550	April 2, 1935	April 13, 1933	Sampson, D. F. &	Elmhurst	Illinois	Container Opener	149
1,996,696	April 2, 1935	December 28, 1932	Brown, R. M.	Newport News	Virginia	Bottle Opener	149
2,004,974	June 18, 1935	August 23, 1933	Bordener, J.	Detroit	Michigan	Combination Bottle Opener	
2,010,326	August 6, 1935	August 24, 1934	Schuchardt, J. R.	New York	New York	Novelty Bottle Opener	149
2,018,083	October 22, 1935	November 9, 1934	Murdock, J. A.	Chicago	Illinois	Bottle Cap Remover	150
D-98,968	March 17, 1936	November 5, 1935	Smythe, R. G.	Valley Stream	New York	Container Opener	
2,039,850	May 5, 1936	July 12, 1935	Silaj, T. S.	Detroit	Michigan	Combination Shrimp Cleaner And Culinary Implement	
2,054,761	September 15, 1936	March 9, 1934	Okun, E.	New York	New York	Corkscrew	
2,079,049	May 4, 1937	August 28, 1933	St. Clair, S. C.	Los Angeles	California	Bottle Tap	
2,084,194	June 15, 1937	January 8, 1936	Frank, L.	Los Angeles	California	Fruit And Vegetable Core Extractor	
2,093,541	September 21, 1937	January 9, 1936	Bohler, W.	Frankfort-on-the-Main	Germany	Cork Removing Device	
2,115,289	April 26, 1938	February 17, 1936	Smythe, R. G.	New York	New York	Container Opener	150
D-109,879	May 31, 1938	August 3, 1937	Ruby, W.	Long Beach	New York	Combination Pencil, Corkscrew And Bottle Opener	151
2,145,129	January 24, 1939	April 7, 1938	Puccetti, M.	Kelseyville	California	Cork Remover	
2,164,191	June 27, 1939	July 15, 1936	Knudsen, K.	Danbury	Connecticut	Remover For Bottle Closures	151
D-117,210	October 17, 1939	January 24, 1938	Zimmer, M. J.	Chicago	Illinois	Can Opener	151
2,186,430	January 9, 1940	February 16, 1937	Richter, K.	Elkins Park	Pennsylvania	Household Implement	
2,190,940	February 20, 1940	May 5, 1936	Frins, M. C.	Plainfield	New Jersey	Can Opener	
D-120,613	May 21, 1940	December 29, 1939	Deerf, A.	Brooklyn	New York	Combination Kitchen Tool	
2,204,734	June 18, 1940	September 7, 1939	Sarnecky, M. J.	Edwardsville	Pennsylvania	Picking Tool	
2,222,177	November 19, 1940	August 16, 1938	Johnston, H. A.	Anaheim	California	Can Opening And Spout Forming Device	
D-124,223	December 24, 1940	March 18, 1940	Neal, M. S.	South Pasadena	California	Bottle Opener	152, 154
2,237,138	April 1, 1941	July 15, 1939	Fender, F. E.	Evanston	Illinois	Can Opener	
2,256,707	September 23, 1941	February 1, 1940	Fultz, D. E.	Spokane	Washington	Pencil Sharpener	
2,292,452	August 11, 1942	October 21, 1939	Kulling, R. C.	Chicago	Illinois	Kitchen Implement	
2,304,159	December 8, 1942	April 30, 1941	Florsheim, F. F.	Chicago	Illinois	Combination Opener	
2,304,997	December 15, 1942	May 8, 1941	Generales, N. C.	Beverly Hills	California	Culinary Implement	
2,342,156	February 22, 1944	August 14, 1940	Miller, J. H.	Baltimore	Maryland	Stopper Remover	
D-139,160	October 17, 1944	June 3, 1944	Hiscock, C.	St. John's, Newfoundland	Canada	Cork Extractor	
D-140,622	March 20, 1945	December 6, 1944	Cotton, L.	Miami	Florida	Bottle Opener	
D-140,817	April 10, 1945	December 9, 1944	Joyce, W. H.	Hollis	New York	Bottle And Can Opening Tool	
D-141,817	July 10, 1945	November 17, 1944	Johnson, M. A. C.	Coral Gables	Florida	Combination Bottle Cap Remover And Cork Screw	
D-144,920	June 4, 1946	August 17, 1945	Graham, E. F.	Normandy	Missouri	Multipurpose Tool	
D-145,184	July 9, 1946	January 11, 1946	Simpson, J. C.	Portland	Oregon	Combination Bottle Stopper And Extractor	

NUMBER	ISSUE DATE	FILE DATE	NAME	RESIDENCE	STATE/COUNTRY	TITLE	ILLUSTRATIONS ON PAGE
D-145,245	July 23, 1946	September 11, 1945	De Lemos, J. G.	Palo Alto	California	Combination Jigger And Bottle Opener	
2,407,793	September 17, 1946	September 2, 1943	Mitchell, R. A.	Evansville	Indiana	Bottle Cap Or Jar Cover Remover	
D-146,833	May 27, 1947	February 12, 1946	Peterson, J. E.	Los Angeles	California	Cork Puller	
D-146,956	June 24, 1947	March 8, 1946	Howells, H. C.	Bethesda	Maryland	Corkscrew	
D-146,957	June 24, 1947	January 10, 1946	Kaderli, M.	Old Greenwich	Connecticut	Combination Bottle Opener And Corkscrew	
2,434,212	January 6, 1948	March 21, 1945	Ippolito, G.	New York	New York	Corkscrew With Point Protector	
D-148,345	January 6, 1948	June 4, 1946	Wyler, P.	Forest Hills	New York	Combination Corkscrew And Bottle Opener	154
D-148,810	February 24, 1948	April 26, 1946	McDowell, M. T.	Eatentown	New Jersey	Cork Screw	154
D-150,957	September 14, 1948	January 2, 1947	Kahlen, F. &	Jackson Heights	New York	Combined Bottle Opener And Cork Remover	155
2,458,778	January 11, 1949	November 9, 1945	Hines, W. J.	San Francisco	California	Cork Remover	
2,470,492	May 17, 1949	January 30, 1946	Jenkins, A. W.	New York	New York	Picnic Set	
2,478,063	August 2, 1949	October 8, 1947	Strauss, L.	New York	New York	Utility Tool Kit	155
D-154,880	August 16, 1949	February 25, 1948	Ross, H. L.	Greenwich	Connecticut	Combined Bottle Cap Remover And Cork Screw	155
2,481,055	September 6, 1949	May 24, 1945	Whitaker, R. J.	Newport	Rhode Island	Flexible Strip Jar Cap Wrench	
D-155,390	October 4, 1949	July 16, 1948	Comerford, J. J.	Brooklyn	New York	Combination Tool	
2,486,286	October 25, 1949	June 20, 1947	Irving, J. H.	Los Angeles	California	Cork Puller	
2,495,308	January 24, 1950	June 15, 1948	Amigone, J. N.	Buffalo	New York	Gripper-Type Cork Extractor	155
D-158,341	April 25, 1950	June 8, 1948	Turgeon, Jr., F. A.	Rockville	Maryland	Combination Container Opener And Bottle Seal Breaker	
2,510,195	June 6, 1950	December 10, 1946	Tinsley, J. D.	Bakersfield	California	Cutter Blade Can Opener	
2,512,238	June 20, 1950	January 9, 1947	Nakamura, R. I.	Waipahu	Hawaii	Frame With Slidable Tool Bit	156
D-159,151	June 27, 1950	May 16, 1949	Haverkost, L. E.	Overland	Missouri	Combination Bottle Opener	
2,522,219	September 12, 1950	June 27, 1946	Gaeta, S. C.	West Medford	Massachusetts	Sleeve Reciprocating Corkscrew	
D-160,082	September 12, 1950	October 26, 1949	Gerson, S. L.	Vineland	New Jersey	Bar Utensil	156
2,524,595	October 3, 1950	March 10, 1947	Jacobsen, H. E.	Kingsley	Michigan	Corkscrew With Pivoted Lateral Projection	
D-160,605	October 24, 1950	January 17, 1950	Iskyan, G. S.	Jackson Heights	New York	Combination Bar Utensil	157
D-163,785	July 3, 1951	October 23, 1948	Amigone, J. N.	Buffalo	New York	Combination Tool	
2,561,682	July 24, 1951	June 4, 1949	Barnett, B. G.	Dallas	Texas	Pivoted Jaw Type, Toggle Actuated Wrench	
D-164,803	October 9, 1951	August 7, 1950	Pandele, C. L.	Grand Rapids	Michigan	Bottle Opener	
D-164,909	October 23, 1951	March 17, 1951	Fowler, A. W.	Fort Worth	Texas	Combination Tool	157
2,578,983	December 18, 1951	February 14, 1947	Primak, A.	Milwaukee	Wisconsin	Can Opener	
2,585,536	February 12, 1952	April 11, 1947	Chicglo, J.	Pottstown	Pennsylvania	Seal Cutter	
2,599,968	June 10, 1952	January 21, 1949	Acard, D.	Brooklyn	New York	Bottle Cap Lifter With Pivoted Arms	
D-167,920	October 7, 1952	July 17, 1952	Zuras, C.	Silver Spring	Maryland	Combined Jar Wrench, Can Punch And Bottle Opener	
2,620,558	December 9, 1952	February 2, 1951	Bergeron, R.	St.-Simon de Drummondville, Quebec	Canada	Punch For Opening Cans	
D-170,999	December 1, 1953	January 4, 1952	La Forte, M. J.	Park Ridge	Illinois	Bar Tool	157
D-173,600	December 7, 1954	April 28, 1951	Amigone, J. N.	Buffalo	New York	Combination Tool	158
2,712,251	July 5, 1955	March 18, 1953	Hanson, A. H.	Garrison	New York	Corkscrew Device	
2,717,526	September 13, 1955	October 26, 1953	Cronin, W. J.	Point Lookout	New York	Closure Opener With Slidably Adjustable Gripper	
2,718,055	September 20, 1955	May 18, 1954	Frins, M. C.	Plainfield	New Jersey	Can Opener	158
2,729,124	January 3, 1956	December 21, 1950	Farandatos, D.	New York	New York	Cork Extractor With Gas Pressure Generating Means	
2,758,736	August 14, 1956	November 10, 1955	McCleary, H. C.	Cumberland	Maryland	Bottle Closure Device	
2,823,395	February 18, 1958	September 14, 1956	Brownson, H. A.	Baltimore	Maryland	Combined Seal Cutter And Closure Removing Device	
2,837,946	June 10, 1958	July 31, 1956	Berkman, H. A.	Chicago	Illinois	Closure Remover With Venting Means	
D-184,613	March 17, 1959	June 13, 1958	Gemelli, C.	Milan	Italy	Bottle Opener	159
2,886,994	May 19, 1959	August 30, 1956	Hanson, A. H.	Garrison	New York	Combination Bar Tool	
2,895,357	July 21, 1959	March 12, 1958	Perez, J. B.	Havana	Cuba	Cork Extractor	
3,017,700	January 23, 1962	June 20, 1960	Civitelli, G.	Hamden	Connecticut	Can Opener Or The Like	
3,085,454	April 16, 1963	November 16, 1961	Federighi, G. J.	San Francisco	California	Pressurized Device For Uncorking Bottles	
D-197,983	April 14, 1964	April 26, 1963	Mourreau, S. &	Geneva	Switzerland	Gas Pressure Operated Cork Remover	
3,132,421	May 12, 1964	August 1, 1960	Huck, Jr., E.	Livonia	Michigan	Container Opener	
3,135,144	June 2, 1964	October 19, 1962	Cameron, R. W.	Belvedere	California	Combined Film Cutter And Cork Remover	
3,135,410	June 2, 1964	January 20, 1964	Federighi, G. J.	Belvedere	California	Ejective Pressurized Cork	
3,192,803	July 6, 1965	March 30, 1964	Federighi, G. J.	Belvedere	California	Cork Ejector With Pressurized Liquid Propellant	163
3,216,290	November 9, 1965	October 22, 1962	Rizzo, S. R.	North Hollywood	California	Means For Retrieving Flexible Bottle Stoppers From Below The Bottle Necks	
3,256,756	June 21, 1966	March 17, 1964	del Piccolo, M.	Brooklyn	New York	Bottle Cork Extractor	
3,257,873	June 28, 1966	October 7, 1964	Stampler, D.	New York	New York	Cork Extractor	
D-205,407	August 2, 1966	November 22, 1965	Vogel, K. M.	Westport	Connecticut	Bottle Cork Remover	
D-205,408	August 2, 1966	November 22, 1965	Vogel, K. M.	Westport	Connecticut	Bottle Cork Remover	
D-205,409	August 2, 1966	November 22, 1965	Vogel, K. M.	Westport	Connecticut	Bottle Cork Remover	
D-209,001	October 24, 1967	December 8, 1965	Amigone, J. N.	Buffalo	New York	Combination Tool	163
3,359,838	December 26, 1967	May 31, 1966	Vogel, K. M.	Westport	Connecticut	Cork Puller And Protective Sheath Therefor	
D-214,078	May 6, 1969	April 17, 1968	Steiner, F. S.	Woodmere	New York	Combined Container Opener And Corkscrew	163
3,451,076	June 24, 1969	October 10, 1966	Deaver, A. V.	Colma	California	Submerged Cork Recovery Device	
3,552,241	January 5, 1971	December 11, 1968	Steiner, W.	Winterthur	Switzerland	Apparatus For Opening Of Bottles, Cans, Containers, Casks, And The Like	
3,570,027	March 16, 1971	November 4, 1968	Steiner, W.	Winterthur	Switzerland	Combination Device For Opening Of Bottles, Cans, Containers And Casks Of All Types	
D-228,613	October 16, 1973	August 31, 1972	Ghidini, C.	Brescia	Italy	Corkscrew	164
3,815,448	June 11, 1974	October 10, 1972	Artmer, G.	Vienna	Austria	Corkscrew	164
3,909,860	October 7, 1975	September 3, 1974	Cantales, J.	New Rochelle	New York	Combination Can-Opener Tool	
3,926,076	December 16, 1975	April 14, 1975	Szumacher, B.	Chicago	Illinois	Cork Puller	
D-239,362	March 30, 1976	September 16, 1974	Peterson, G. F.	Boonton Township	New Jersey	Cork Screw	160, 164
3,967,512	July 6, 1976	May 19, 1975	Soldano, M. J.	New York	New York	Cork Remover	
D-244,002	April 12, 1977	October 24, 1975	Bonin, B. R.	Westbrook	Connecticut	Cork Retriever	165
4,063,473	December 20, 1977	January 9, 1976	Bozzo, G. J.	New Milford	New Jersey	Method Of Assemblying Mechanical Cork Puller	
D-247,279	February 21, 1978	June 18, 1976	Marceca, R. K.	New York	New York	Combined Corkscrew And Can Opener Or Similar Article	165
4,097,980	July 4, 1978	March 1, 1977	Bozzo, G. J.	New Milford	New Jersey	Method Of Manufacture Of A Mechanical Cork Puller	
4,135,415	January 23, 1979	June 17, 1977	Liebscher, J. &	Nassau (Lahn)	Germany	Corkscrew	165
D-252,972	September 25, 1979	January 29, 1977	Essig, T.	Noblesville	Indiana	Cork Extractor	
4,253,351	March 3, 1981	July 9, 1979	Allen, H.	Houston	Texas	Cork Extractor	166
D-259,698	June 30, 1981	April 2, 1979	MacNeill, A. B.	Sudbury	Massachusetts	Handle For A Golf Spike Wrench, Screw Driver, Corkscrew And Other Devices	

NUMBER	ISSUE DATE	FILE DATE	NAME	RESIDENCE	STATE/COUNTRY	TITLE	ILLUSTRATIONS ON PAGE
4,276,789	July 7, 1981	July 17, 1978	Allen, H.	Houston	Texas	Cork Extractor	
4,291,597	September 29, 1981	March 5, 1979	Allen, H.	Houston	Texas	Cork Extractor	166
4,295,392	October 20, 1981	June 22, 1979	Peck, W. C.	Norwell	Massachusetts	Corked Bottle Opener	
4,317,390	March 2, 1982	September 16, 1980	Nakayama, M.	Tokyo	Japan	Bottle Opener	166
4,374,464	February 22, 1983	September 5, 1980	Tillander, B. S. R.	Froslunda	Sweden	Cork Mounting Apparatus	
D-268,245	March 15, 1983	October 31, 1980	Makino, K. &	Hirakata	Japan	Wine Cork Remover	
4,377,096	March 22, 1983	January 7, 1981	Allen, H.	Houston	Texas	Cork Extractor	167
4,393,733	July 19, 1983	August 1, 1980	Desnoulez, B. &	Neuilly	France	Corkscrews With Tackle Reduction	167
4,399,720	August 23, 1983	May 17, 1982	Cuppett, D. J.	New York	New York	Cork Puller	
4,429,444	February 7, 1984	March 19, 1981	Allen, H.	Houston	Texas	Cork Extractor	
4,437,359	March 20, 1984	May 27, 1981	Dejoux, A. &	Paris	France	Wine Waiter's Corkscrews	
D-274,974	August 7, 1984	March 26, 1982	Colombo, A.	Milan	Italy	Corkscrew	167
4,464,956	August 14, 1984	July 10, 1981	Hashimoto, K.	Tokyo	Japan	Cork-Extracting Device	
D-276,788	December 18, 1984	February 26, 1982	Ravreby, F. A.	Framington	Massachusetts	Cork Ejector	
D-281,855	December 24, 1985	December 12, 1983	Kuhn, J.	Rikon	Switzerland	Corkscrew	167
D-281,946	December 31, 1985	June 13, 1983	Youhanaie, G.	Tempe	Arizona	Corkscrew	168
4,570,512	February 18, 1986	December 6, 1984	Pracht, G.	Solingen	Germany	Cork Screw Having A Bell-Shaped Housing	168
4,572,034	February 25, 1986	November 21, 1984	Lee, W. H.	Kaohsiung City	Taiwan	Cork Screw	
4,574,662	March 11, 1986	January 31, 1985	Jones, M. R.	Houston	TX	Device For Removing A Cork Or Other Resilient Stopper From The Neck Of A Bottle	
4,574,663	March 11, 1986	May 2, 1984	Delisle, Jr., B.	Edgartown	Massachusetts	Cork Extractor	168
4,580,303	April 8, 1986	January 14, 1985	Henshaw, G. E.	Tujunga	California	Bottle Opener And Resealer	168
4,584,911	April 29, 1986	September 21, 1984	Cellini, F.	Maniago	Italy	Corkscrew Device	169
D-286,483	November 4, 1986	October 4, 1985	Hagedorn, L. &	Niederneisen	Germany	Rack For Corkscrew	
4,637,283	January 20, 1987	May 24, 1985	Bertram, L. &	Stolberg	Germany	Corkscrew Device	169, 170
D-288,521	March 3, 1987	August 27, 1984	Van Asten, J. F.	Leek	Netherlands	Electric Cork Remover	
4,658,678	April 21, 1987	October 7, 1985	Pracht, G.	Solingen	Germany	Cork Screw Furnished With A Bell-Shaped Housing	169
4,677,883	July 7, 1987	June 9, 1986	Lee, W. H.	Kaohsiung City	Taiwan	Cork Screw	
D-290,682	July 7, 1987	January 30, 1985	Rogers, J. J.	Vancouver, B.C.	Canada	Cork Retriever	170
4,679,467	July 14, 1987	March 20, 1986	Delnero, T. V.	West Palm Beach	Florida	Broken Cork Remover	
D-291,052	July 28, 1987	January 14, 1985	Henshaw, G. E.	Tujunga	California	Combination Bottle Opener And Resealer	
D-291,174	August 4, 1987	August 17, 1984	Koziol, S.	Odenwald	Germany	Corkscrew	170
D-291,960	September 22, 1987	March 12, 1984	Kerti, P.	Toronto, Ontario	Canada	Can Opener	
4,703,673	November 3, 1987	April 8, 1985	Allen, H.	Houston	Texas	Cork-Extracting Apparatus	171
D-293,200	December 15, 1987	January 25, 1985	Barone, C. A.	Newcastle	Delaware	Cork Puller	
D-293,414	December 29, 1987	April 23, 1985	Allen, H.	Houston	Texas	Corkscrew	
D-294,218	February 16, 1988	March 4, 1985	Johnson, D. B.	Rickmansworth, Herfordshire	England	Corkscrew	171
4,727,779	March 1, 1988	April 1, 1987	Lee, W. H.	Kaohsiung	Taiwan	Cork Screw	
D-294,449	March 1, 1988	May 7, 1985	Kuhn, J.	Rikon	Switzerland	Combination-Opener, Capsule Holder And Cork-Screw	
D-296,755	July 19, 1988	November 5, 1985	Eayds, K.	North Vancouver, B.C.	Canada	Cork Remover	
4,759,238	July 26, 1988	April 3, 1987	Farfalli, G.	Maniago	Italy	Pocket Corkscrew	172
4,765,206	August 23, 1988	June 4, 1987	Poehlmann, P. W.	Stinson Beach	California	Corkscrew	
4,766,780	August 30, 1988	September 21, 1987	Sechen, F.	San Francisco	California	Automatic Corkscrew	
4,791,834	December 20, 1988	November 3, 1986	Federighi, G. L.	San Francisco	California	Pressure Metering Cork Extractor	172
D-299,001	December 20, 1988	August 13, 1985	Barnett, D. J.	Hemel Hempstead	England	Corkscrew	
4,800,784	January 31, 1989	March 15, 1988	Allen, H.	Houston	Texas	Apparatus For Removing Corks From Bottles	
D-301,113	May 16, 1989	July 1, 1986	Lapsker, J.	Thornhill	Canada	Compact Combination Corkscrew Bottle Opener	172
4,836,060	June 6, 1989	May 2, 1988	Klefbeck, R. J.	Albany	New York	Energy Efficient Cork Extractor	
4,838,128	June 13, 1989	March 18, 1988	Tischler, W.	Bad Neustadt/Saale	Germany	Corkscrew	173
D-301,532	June 13, 1989	April 10, 1986	Hölterscheidt, S.	Huckelhoven	Germany	Combination Coaster Set, Corkscrew And Bottle Opener	
D-301,539	June 13, 1989	May 30, 1986	Cheung, P. W.	Kowloon	Hong Kong	Combined Can Opener, Corkscrew And Bottle Opener	
D-302,233	July 18, 1989	January 27, 1986	Barnett, D. J.	Hemel Hempstead	England	Corkscrew	
D-303,203	September 5, 1989	August 13, 1986	Chow, Y. C.	Kwai Chung	Hong Kong	Combination Corkscrew And Stand	
D-306,549	March 13, 1990	March 10, 1987	Williams, D. M.	New South Wales	Australia	Corkscrew	
D-307,102	April 10, 1990	March 9, 1987	Desnoulez, B.	Neuilly	France	Corkscrew	173
4,916,985	April 17, 1990	August 31, 1989	Yen, R. C. K.	Los Angeles	California	Apparatus For Removing A Soft Stopper From A Container	
4,955,261	September 11, 1990	March 19, 1990	Chiang, Y.-T.	Chung Ho	Taiwan	Automatic Corkscrew	173
D-312,032	November 13, 1990	January 15, 1988	Segato, S.	Flume Veneto	Italy	Corkscrew	
4,996,895	March 5, 1991	November 15, 1989	Puig, R. B.	Sabadell	Spain	Pocket Hand Corkscrew	174
5,005,446	April 9, 1991	July 21, 1988	Mackey, E. R.	Dracut	Massachusetts	Pressurized Cork-Removal Apparatus For Wine Bottles And Other Containers	
5,007,310	April 16, 1991	February 5, 1990	Cellini, F.	Maniago	Italy	Screw With Differentiated Sections For Corkscrews	
5,010,790	April 30, 1991	March 29, 1990	Yen, R. C. K.	Glendora	California	Apparatus For Removing A Soft Stopper From A Container	
5,012,703	May 7, 1991	February 5, 1990	Reinbacher, H.	Canoga Park	Illinois	Cork Removal Apparatus	174
5,020,395	June 4, 1991	April 13, 1990	Mackey, E. R.	Dracut	Massachusetts	Pressurized Cork-Removal Apparatus For Wine Bottles And Other Containers	
5,031,486	July 16, 1991	February 9, 1990	Rydgren, J.	Vestby	Norway	Corkscrew	
D-319,170	August 20, 1991	July 18, 1989	Franke, P.	Santa Monica	California	Corkscrew	175
5,079,975	January 14, 1992	June 27, 1991	Spencer, Jr., F. W.	Louisberg	North Carolina	Automatic Corkscrew	
5,086,675	February 11, 1992	August 16, 1990	Leung, T. L. &	North Point	Hong Kong	Corkscrew	
5,095,778	March 17, 1992	February 12, 1991	Bocsi, S. &	Worcester	Massachusetts	Electric Cork Screw	
D-327,615	July 7, 1992	December 24, 1990	Fenner, P.	Guildford, Surrey	England	Bending Corkscrew	
5,134,906	August 4, 1992	December 10, 1990	Sit, H. A.	Daly City	California	Cork Removal Device	
5,220,855	June 22, 1993	January 10, 1992	Leung, D. T. L. &	Kowloon	Hong Kong	Corkscrew	
5,253,553	October 19, 1993	March 23, 1992	Mothershead, M.	Forest Grove	Oregon	Apparatus And Method For Removing A Stopper From A Bottle	
5,257,565	November 2, 1993	February 25, 1993	Hung, J. C.	Changhua City	Taiwan	Corkscrew	
D-347,775	June 14, 1994	April 27, 1993	Seiler, R. L.	St. Louis	Missouri	Cork Screw Opener	
5,347,889	September 20, 1994	December 10, 1993	St. Denis, A. R.	Amherstburg, Ontario	Canada	Multi-Purpose Wine Bottle Stopper Device	
5,351,579	October 4, 1994	May 20, 1993	Metz, R.	Scarborough, Ontario	Canada	Rechargeable Electric Corkscrew	
5,361,652	November 8, 1994	June 25, 1993	Andina, D.	Gussago Brescia	Italy	Corkscrew	
5,363,725	November 15, 1994	May 24, 1993	Cellini, F.	Maniago	Italy	Corkscrew With Fitting To Shear The Tinfoil, Plastic Or Other Caps On The Neck Of Bottles	175
5,365,806	November 22, 1994	July 26, 1993	Paramest, S. S.	Bothell	Washington	Mechanical Bottle And Jar Opener	
5,367,923	November 29, 1994	September 10, 1991	Fabbro, A.	Cassacco	Italy	Corkscrew That Extracts Simultaneously With The Cork A Preventively Cut Portion Of The Capsule On The Neck Of The Bottle	
5,372,054	December 13, 1994	January 14, 1993	Federighi, Sr., G. J.	San Francisco	California	Automatic Cork Extractor	

U. S. Corkscrew Patents: Totals By State Or Country Of Residence

(a) Alphabetical

UNITED STATES

	UTILITY PATENTS	DESIGN PATENTS	TOTAL PATENTS
ALABAMA	3	0	3
ALASKA	1	0	1
ARIZONA	2	1	3
ARKANSAS	1	0	1
CALIFORNIA	53	6	59
COLORADO	3	0	3
CONNECTICUT	51	9	60
DELAWARE	2	2	4
DISTRICT OF COLUMBIA	14	0	14
FLORIDA	4	2	6
GEORGIA	4	0	4
HAWAII	0	1	1
IDAHO	2	0	2
ILLINOIS	84	4	88
INDIANA	12	1	13
IOWA	7	0	7
KANSAS	2	0	2
KENTUCKY	7	1	8
LOUISIANA	5	0	5
MAINE	9	0	9
MARYLAND	13	3	16
MASSACHUSETTS	36	3	39
MICHIGAN	20	3	23
MINNESOTA	8	1	9
MISSISSIPPI	0	0	0
MISSOURI	12	3	15
MONTANA	4	0	4
NEBRASKA	4	0	4
NEVADA	1	0	1
NEW HAMPSHIRE	8	1	9
NEW JERSEY	50	8	58
NEW MEXICO	2	0	2
NEW YORK	157	22	179
NORTH CAROLINA	5	0	5
NORTH DAKOTA	2	0	2
OHIO	26	2	28
OKLAHOMA	1	0	1
OREGON	5	1	6
PENNSYLVANIA	83	3	86
RHODE ISLAND	7	0	7
SOUTH CAROLINA	3	0	3
SOUTH DAKOTA	1	0	1
TENNESSEE	7	1	8
TEXAS	14	2	16
UTAH	3	0	3
VERMONT	1	0	1
VIRGINIA	11	0	11
WASHINGTON	12	2	14
WEST VIRGINIA	1	0	1
WISCONSIN	18	2	20
WYOMING	2	0	2
SUB TOTAL	**784**	**83**	**867**

(b) Ranked

UNITED STATES

1	NEW YORK	179
2	ILLINOIS	88
3	PENNSYLVANIA	86
4	CONNECTICUT	60
5	CALIFORNIA	59
6	NEW JERSEY	58
7	MASSACHUSETTS	39
8	OHIO	28
9	MICHIGAN	23
10	WISCONSIN	20
11-12	MARYLAND	16
	TEXAS	16
13	MISSOURI	15
14-15	DISTRICT OF COLUMBIA	14
	WASHINGTON	14
16	INDIANA	13
17	VIRGINIA	11
18-20	MAINE	9
	MINNESOTA	9
	NEW HAMPSHIRE	9
21-22	KENTUCKY	8
	TENNESSEE	8
23-24	IOWA	7
	RHODE ISLAND	7
25-26	FLORIDA	6
	OREGON	6
27-28	LOUISIANA	5
	NORTH CAROLINA	5
29-32	DELAWARE	4
	GEORGIA	4
	MONTANA	4
	NEBRASKA	4
33-37	ALABAMA	3
	ARIZONA	3
	COLORADO	3
	SOUTH CAROLINA	3
	UTAH	3
38-42	IDAHO	2
	KANSAS	2
	NEW MEXICO	2
	NORTH DAKOTA	2
	WYOMING	2
43-50	ALASKA	1
	ARKANSAS	1
	HAWAII	1
	NEVADA	1
	OKLAHOMA	1
	SOUTH DAKOTA	1
	VERMONT	1
	WEST VIRGINIA	1
51	MISSISSIPPI	0

OTHER COUNTRIES

1	CANADA	28
2	GERMANY	27
3	ENGLAND	23
4	ITALY	10
5	SWITZERLAND	7
6-7	FRANCE	5
	TAIWAN	5
8	HONG KONG	4
9-13	AUSTRALIA	3
	JAPAN	3
	NORWAY	3
	SPAIN	3
	SWEDEN	3
14-22	AUSTRIA	2
	BELGIUM	1
	CUBA	1
	DENMARK	1
	IRELAND	1
	NETHERLANDS	1
	NEW ZEALAND	1
	RUSSIA	1

Other countries

	UTILITY PATENTS	DESIGN PATENTS	TOTAL PATENTS
AUSTRALIA	2	1	3
AUSTRIA	2	0	2
BELGIUM	1	0	1
CANADA	23	5	28
CUBA	1	0	1
DENMARK	1	0	1
ENGLAND	19	4	23
FRANCE	4	1	5
GERMANY	24	3	27
HONG KONG	2	2	4
IRELAND	1	0	1
ITALY	6	4	10
JAPAN	2	1	3
NETHERLANDS	0	1	1
NEW ZEALAND	1	0	1
NORWAY	3	0	3
RUSSIA	1	0	1
SPAIN	2	1	3
SWEDEN	3	0	3
SWITZERLAND	4	3	7
TAIWAN	5	0	5
SUB TOTAL	**107**	**26**	**133**
TOTAL	**891**	**109**	**1,000**

U. S. Patents: Yearly Totals

YEAR	FIRST UTILITY PATENT NUMBER	NUMBER OF UTILITY PATENTS	NUMBER OF UTILITY PATENTS FOR CORKSCREWS	FIRST DESIGN PATENT NUMBER	NUMBER OF DESIGN PATENTS	NUMBER OF DESIGN PATENTS FOR CORKSCREWS	TOTAL PATENTS	TOTAL CORKSCREW PATENTS	NUMBER OF TOTAL PATENTS FOR EACH CORKSCREW PATENT
1836	1	109	0				109		
1837	110	436	0				436		
1838	546	515	0				515		
1839	1,061	404	0				404		
1840	1,465	458	0				458		
1841	1,923	490	0				490		
1842	2,413	488	0	1	1	0	489	0	
1843	2,901	494	0	2	14	0	508	0	
1844	3,395	478	0	16	11	0	489	0	
1845	3,873	475	0	27	17	0	492	0	
1846	4,348	566	0	44	59	0	625	0	
1847	4,914	495	0	103	60	0	555	0	
1848	5,409	584	0	163	46	0	630	0	
1849	5,993	988	0	209	49	0	1,037	0	
1850	6,981	884	0	258	83	0	967	0	
1851	7,865	757	1	341	90	0	847	1	847
1852	8,622	890	0	431	109	0	999	0	
1853	9,512	846	0	540	86	0	932	0	
1854	10,358	1,759	0	626	57	0	1,816	0	
1855	12,117	1,892	0	683	70	0	1,962	0	
1856	14,009	2,315	2	753	107	0	2,422	2	1,211
1857	16,324	2,686	0	860	113	0	2,799	0	
1858	19,010	3,467	0	973	102	0	3,569	0	
1859	22,477	4,165	1	1,075	108	0	4,273	1	4,273
1860	26,642	4,363	4	1,183	183	0	4,546	4	1,136
1861	31,005	3,040	2	1,366	142	0	3,182	2	1,591
1862	34,045	3,221	4	1,508	195	0	3,416	4	854
1863	37,266	3,781	3	1,703	176	0	3,957	3	1,319
1864	41,047	7,922	3	1,879	139	0	8,061	3	2,687
1865	48,969	2,815	3	2,018	221	0	3,036	3	1,012
1866	51,784	8,874	6	2,239	294	0	9,168	6	1,528
1867	60,658	12,301	7	2,533	325	0	12,626	7	1,804
1868	72,959	12,544	11	2,858	446	0	12,990	11	1,181
1869	85,503	12,957	4	3,304	506	0	13,463	4	3,366
1870	98,460	12,157	4	3,810	737	0	12,894	4	3,224
1871	110,617	11,687	7	4,547	905	0	12,592	7	1,799
1872	122,304	12,200	1	5,452	884	0	13,084	1	13,084
1873	134,504	11,616	2	6,336	747	0	12,363	2	6,182
1874	146,120	12,230	5	7,083	886	0	13,116	5	2,623
1875	158,350	13,291	7	7,969	915	0	14,206	7	2,029
1876	171,641	14,172	12	8,884	802	0	14,974	12	1,248
1877	185,813	12,920	7	9,686	699	0	13,619	7	1,946
1878	198,733	12,345	6	10,385	590	0	12,935	6	2,156
1879	211,078	12,133	3	10,975	592	0	12,725	3	4,242
1880	223,211	12,926	4	11,567	515	0	13,441	4	3,360
1881	236,137	15,548	6	12,082	565	0	16,113	6	2,686
1882	251,685	18,135	13	12,647	861	0	18,996	13	1,461
1883	269,820	21,196	15	13,508	1,020	0	22,216	15	1,481
1884	291,016	19,147	19	14,528	1,150	0	20,297	19	1,068
1885	310,163	23,331	8	15,678	773	0	24,104	8	3,013
1886	333,494	21,797	19	16,451	595	1	22,392	20	1,120
1887	355,291	20,429	9	17,046	949	0	21,378	9	2,375
1888	375,720	19,585	20	17,995	835	1	20,420	21	972
1889	395,305	23,360	13	18,830	723	0	24,083	13	1,853
1890	418,665	25,322	20	19,553	886	0	26,208	20	1,310
1891	443,987	22,328	9	20,439	836	0	23,164	9	2,574
1892	466,315	22,661	10	21,275	817	1	23,478	11	2,134
1893	488,976	22,768	7	22,092	202	0	22,970	7	3,281
1894	511,744	19,875	13	22,294	1,628	0	21,503	13	1,654
1895	531,619	20,883	15	23,922	1,115	0	21,998	15	1,467
1896	552,502	21,867	11	25,037	1,445	2	23,312	13	1,793
1897	574,369	22,098	14	26,482	1,631	0	23,729	14	1,695
1898	596,467	20,404	17	28,113	1,803	3	22,207	20	1,110
1899	616,871	23,296	13	29,916	2,139	2	25,435	15	1,696
1900	640,167	24,660	14	32,055	1,758	1	26,418	15	1,761
1901	664,827	25,558	16	33,813	1,734	1	27,292	17	1,605
1902	690,385	27,136	13	35,547	640	0	27,776	13	2,137
1903	717,521	31,046	21	36,187	536	0	31,582	21	1,504
1904	748,567	30,267	15	36,723	557	0	30,824	15	2,055
1905	778,834	29,784	17	37,280	486	1	30,270	18	1,682
1906	808,618	31,181	11	37,766	625	1	31,806	12	2,650
1907	839,799	35,880	18	38,391	589	0	36,469	18	2,026
1908	875,679	32,757	27	38,980	757	0	33,514	27	1,241
1909	908,436	36,574	17	39,737	687	0	37,261	17	2,192
1910	945,010	35,168	9	40,424	639	0	35,807	9	3,979

YEAR	FIRST UTILITY PATENT NUMBER	NUMBER OF UTILITY PATENTS	NUMBER OF UTILITY PATENTS FOR CORKSCREWS	FIRST DESIGN PATENT NUMBER	NUMBER OF DESIGN PATENTS	NUMBER OF DESIGN PATENTS FOR CORKSCREWS	TOTAL PATENTS	TOTAL CORKSCREW PATENTS	NUMBER OF TOTAL PATENTS FOR EACH CORKSCREW PATENT
1949	2,457,797	35,147	5	152,235	4,451	2	39,598	7	5,657
1950	2,492,944	43,072	5	156,686	4,718	4	47,790	9	5,310
1951	2,536,016	44,363	2	161,404	4,164	3	48,527	5	9,705
1952	2,580,379	43,667	3	165,568	2,959	1	46,626	4	11,656
1953	2,624,046	40,516	0	168,527	2,714	1	43,230	1	43,230
1954	2,664,562	33,872	0	171,241	2,536	1	36,408	1	36,408
1955	2,698,434	30,479	3	173,777	2,713	0	33,192	3	11,064
1956	2,728,913	46,849	2	176,490	2,977	0	49,826	2	24,913
1957	2,775,762	42,805	0	179,467	2,362	0	45,167	0	
1958	2,818,567	48,406	2	181,829	2,375	0	50,781	2	25,390
1959	2,866,973	52,470	2	184,204	2,769	1	55,239	3	18,413
1960	2,919,443	47,238	0	186,973	2,543	0	49,781	0	
1961	2,966,681	48,422	0	189,516	2,488	0	50,910	0	
1962	3,015,103	55,698	1	192,004	2,300	0	57,998	1	57,998
1963	3,070,801	45,686	1	194,304	2,965	0	48,651	1	48,651
1964	3,116,487	47,378	3	197,269	2,686	1	50,064	4	12,516
1965	3,163,865	62,864	2	199,955	3,424	0	66,288	2	33,144
1966	3,226,729	68,414	2	203,379	3,188	3	71,602	5	14,320
1967	3,295,143	65,657	1	206,567	3,165	1	68,822	2	34,411
1968	3,360,800	59,107	0	209,732	3,352	0	62,459	0	
1969	3,419,907	67,563	1	213,084	3,335	1	70,898	2	35,449
1970	3,487,470	64,439	0	216,419	3,218	0	67,657	0	
1971	3,551,909	79,630	2	219,637	3,156	0	82,786	2	41,393
1972	3,631,539	76,190	0	222,793	2,902	0	79,092	0	
1973	3,707,729	74,185	0	225,695	4,034	1	78,219	1	78,219
1974	3,781,914	76,327	1	229,729	4,304	0	80,631	1	80,631
1975	3,858,241	72,030	2	234,033	4,282	0	76,312	2	38,156
1976	3,930,271	70,249	1	238,315	4,566	1	74,815	2	37,408
1977	4,000,520	65,292	1	242,881	3,930	1	69,222	2	34,611
1978	4,065,812	66,140	1	246,811	3,865	1	70,005	2	35,002
1979	4,131,952	48,915	1	250,676	3,120	1	52,035	2	26,018
1980	4,180,867	61,890	0	253,796	3,950	0	65,840	0	
1981	4,242,757	65,865	4	257,746	4,749	1	70,614	5	14,123
1982	4,308,622	57,957	1	262,495	4,945	0	62,902	1	62,902
1983	4,366,579	56,944	4	267,440	4,569	1	61,513	5	12,303
1984	4,423,523	67,332	3	272,009	4,940	2	72,272	5	14,454
1985	4,490,855	71,741	0	276,949	5,071	2	76,812	2	38,406
1986	4,562,596	70,930	6	282,020	5,520	1	76,450	7	10,921
1987	4,633,526	83,068	5	287,540	5,960	7	89,028	12	7,419
1988	4,716,594	78,058	5	293,500	5,680	4	83,738	9	9,304
1989	4,794,652	95,703	3	299,180	6,095	5	101,798	8	12,725
1990	4,890,355	90,572	2	305,275	8,026	3	98,598	5	19,720
1991	4,980,927	96,909	7	313,301	9,577	1	106,486	8	13,311
1992	5,077,836	98,050	4	322,878	9,292	1	107,342	5	21,468
1993	5,175,886	98,960	3	332,170	10,648	0	109,608	3	36,536
1994	5,274,846	102,513	7	342,818	11,114	1	113,627	8	14,203
1995	5,377,359			353,932					
Totals		892			108		1000		

POST SCRIPT

I hope you have enjoyed the story of U. S. patented corkscrews and that you will find continued use for the book as you walk down the aisles and rows of life. Who knows what might turn up at the next table or in the long forgotten box in Granny's attic.

Should anyone wish to correspond with me about corkscrews in general or U. S. patents in particular, let me encourage you to write. I would welcome the opportunity to learn more, explore new sources of information and generally share with you whatever limited knowledge I may have accumulated on my own journey.

As there beats in me first the heart of a collector, I would also not want to discourage any offer of a corkscrew for sale, particularly if it is one that has not yet found its way into my collection. At the very least we could talk about it, so that we might both get to know your corkscrew a little better.

So, whether it is a question, a nugget of information, or a real live corkscrew, please jot down your name and address on a card or note and send it to the publisher. They promise to pass it on to me promptly, as do I promise to answer all mail, God willing.

Write:
Fred O'Leary
"Corkscrews"
c/o Schiffer Publishing Ltd.
77 Lower Valley Road - Rt 372
Atglen, PA 19310

VALUE GUIDE

In traversing the aisles and rows of North America and Europe in search of corkscrews, I have often overheard the question, "How much is it?"—as if "it" had a set price beyond the control of the buyer and seller to negotiate. I know what these well-intentioned folks mean, but perhaps we have been conditioned too much by department store shopping, where sales clerks have no say over the matter. Bringing that mentality to an antiques market can be costly to a collector, if not sooner, then certainly later when all things bought are eventually sold.

To a large extent, corkscrews have managed to avoid commoditization. Prices are determined by what one buyer will pay and one seller will accept at one moment in time. For the true seekers of antiques, the dialogue between seller and buyer usually ends at either "I can do ..." or "Would you take ...?" It is a ritualistic dance performed over and over again. As far as I am concerned, it is infinitely more fun than shopping at Macy's.

There are two great myths in the buying and selling of corkscrews, if not all antiques:

Myth #1:
Buyers and sellers know what they're doing.

Most likely one of the parties will know more than the other. There does not have to be knowledge equilibrium for a transaction to take place. The weaker of the two pays the difference. It may be cheaper to factor in someone's knowledge and integrity (i.e., pay a premium to a reputable dealer) than be diverted from earning money employed at what you do best. In the long run, the flow of the game will find a middle ground. For one side to make a score on one deal may be shortsighted; greater benefits inure in a continuing dealer/collector relationship.

Moreover, as a buyer, I have more often regretted *not* pulling the trigger, than paying "too much." Does a seller exist who has not at one time or another second-guessed a selling price ("If only I had asked more") or was unable to pass on a mistake from overpaying in the first place? As with anything in life, there is a learning curve. Mistakes are called "learning experiences." No collection exists without transactions occurring at both extremes.

Myth #2:
Prices are rational.

If a collector wants a corkscrew and/or a dealer needs to sell one for a car payment, chances are a deal will be made. However, a corkscrew does not always move on price alone. If I don't want it for my collection or a trade, a "good price" in the eyes of the dealer will not sway me. If a corkscrew does not sell after exposure to many buyers, one would have to question the motives of the dealer. I have seen the same old corkscrew in the same old display case literally for years. Some degree of emotion, be it greed, lust, fear, stubbornness, etc., is never far below the surface of any transaction or lack thereof.

Valuation Factors

There are a number of factors that enter into the price asked and offered for a corkscrew. Some of the more important considerations are discussed here.

The Market

There is a wide range of "markets" in which corkscrews can be found today, and their prices vary considerably. The price of a corkscrew at a garage sale will be much lower than the price for the same item at an antiques show. The same buyer/seller tension exists at each venue, but at entirely different levels. As a corkscrew rises through the various stages from a "moving sale" to a Christie's auction, who is to say which level is most representative of the market? While it is hard to argue with a bargain price found at a garage sale, a dealer in corkscrews can save you a lot of time and aggravation driving around the neighborhood every Saturday morning. That's got to be worth something!

Markings

Manufacturer's markings are a critical factor in valuing a corkscrew. Generally speaking, an item with an identifiable maker and/or patent mark is preferable to an unmarked example. First, the mark helps to identify the corkscrew's age and pedigree. Second, a marked item is likely to be rarer than its unmarked counterpart. After the patent protection period expired, anyone could manufacture it, based on market risk rather than legal risk, which meant the quantity produced was likely to be greater.

Quality

As with any antique, a corkscrew's quality is always a factor in determining its price. Corkscrews have their own criteria. A broken point, an out-of-true or stretched helix, corrosion, chipping, cracking, loose mechanics, general wear, etc., all lower value incrementally, with allowances for age (what else would you expect for a 100-year-old workhorse?). Outright breakage, missing pieces, shoddy or poor repairs, replacements, etc., are generally the kiss of death, except for rare and old examples. If it is a choice between a worn or damaged example and nothing at all, many collectors will rationalize a purchase but look to "trade up" to better quality at the first opportunity. At least

that is the story line we keep telling ourselves. It doesn't always happen.

In evaluating quality, factors determining value today are not the same as existed when the corkscrew was first introduced. If the corkscrew as it was originally manufactured was not up to the task, it would have been considered "of low quality." Production would likely have been curtailed, with those already in use eventually discarded. That makes the corkscrew in short supply to today's brand of consumer (the collector). *Singularity, uniqueness,* and *anomaly* translate into $$$ today for anything found in theoretically good "working" order.

Cross-Collectors

Put a knife on a corkscrew and it becomes an object that knife collectors will compete for. The same phenomenon exists for canes, bottle openers, can openers, match boxes, kitchen gadgets . . . name your theme. Collectors of silver things have no reservations about taking a sterling-handled corkscrew out of circulation. Western memorabilia collectors do indeed like those antler handles. Pig collectors will buy anything with a curly tail that oinks—chalk up one less corkscrew for the rest of us. Each of these specialties has its own market, with prices dictated independently of the corkscrew part.

Advertisements

Collectors of antique advertising pose a similar threat to the budgets of corkscrew collectors. The ubiquitous "NIFTY" is a case in point (No. 1,207,100). The generic version can easily be picked up at any flea market, generally for $5 or less. But with an advertisement on it, the action may be considerably different. A hotel or package store advertisement may run little more than the generic version; an obscure brewer may command a premium. I once innocently tendered $2.00 for a NIFTY with advertising on it, based on a sticker marked "125". Red faced and a little taken aback by the righteous indignation of the dealer, I learned a quick lesson in humility: it's not always the corkscrew that controls the price. A $125.00 NIFTY was simply not in my vocabulary. Whether it was appropriately priced as an advertising collectible is not mine to judge. I doubt if a serious corkscrew collector—generally defined as someone with a twisted point of view and limited resources—would buy it. There are too many other temptations out there for that kind of money.

Other Considerations

Even taking all of these factors into consideration is often not enough. The buyer's or seller's purpose often dictates the ultimate price. A dealer, who must be able to resell the item, may be willing to pay only $50 for an item that may then be offered to other collectors at $100. The collector might insure it for $200, while the "trade for" value could be something else again. Who is to say which basis is representative of the market? Values can also depend on which country you are in and even which *part* of a country, where supply and demand dynamics may differ.

Some Useful Examples

Since corkscrews do not exist in a price list world, we can characterize only by example the world in which real corkscrews change hands.

The Top of the Line

A well-conceived and well-made antique corkscrew in good condition is highly valued by collectors, and deservedly so. These are silent witnesses to an earlier era, representing a technology that, astonishingly, has changed little from the time they were created. Manufactured for a vastly smaller population of consumers, it is a privilege for our generation to have these artifacts amongst us today. At the very top, there simply is no "market." That a Russel (No. 34,216), Pitt (No. 262,613) or Blake (No. 27,665) are known to even exist is sufficient cause to celebrate. It gives legs to our faith and justifies the never-ending hunt. These are rare corkscrews, and transactions (when they do occur) are extremely personal. Practically speaking, photographs will be the closest most of us will get to knowing them. The same can be said for such fine old corkscrews as Clapp (No. 74,199), Lant (No. 219,101), White (No. 280,697), Trunk (No. D-16,799), etc. Corkscrews like these are so infrequently sold that there is no predicting their values. They are, indeed, the corkscrew equivalent of "priceless."

Common Corkscrews

On the other hand, being old does not *necessarily* make a corkscrew rare. The 1877 Havell patent (No. 196,226), a plain 1885 Haff (Nos. 315,773 and 317,123) and some of the glass-cutter tools dating from 1875, although contemporaries of the above, are relatively common and can be found for not much more than the price of admission to the antiques show (well, maybe if you include parking too). The same applies to the ubiquitous Clough wire corkscrews, as well as the Walker and Williamson bells, highlighted in Chapters 1 and 2. From this group alone, one could assemble a respectable collection, numbering in the hundreds, for an "affordable" price. Whether or not they provide inner satisfaction is the stuff that separates the collector from a normal person.

The Middle Ground

In between are the corkscrews where the majority of helixophile action takes place. These are corkscrews that are in play; they are "available," but for a price. Starting at around $100, here is a representative sampling, ranked more or less in ascending order: the Prohibition figurals discussed in Chapter 4, Davis (No. 455,826), Murphy (No. 672,796), a simple Curley (No. 297,232), Chinnock (No. 35,362), Bennit (No. 277,442), Williamson's "Power Cone" (based on Clough's patent No. 172,868), Barnes (No. 179,090), Mumford (No. 474,480), Brady's "U-NEEK" (No. 1,213,452).

Crossing the $1,000 threshold, the list extends to Curley variations (No. 297,232), Twigg (No. 73,677), Maud (No. 561,016), Strait (No. 279,203), Woodman (No. 344,556), Tucker (No. 207,631), Sperry (No. 204,389), Van Gieson (No. 61,485); even the relatively recent "Hootch Owl" by Smythe (No. D-98,968 and 2,115,289) has broken the four-figure barrier. These are all fine specimens, each with a unique story. Many of the corkscrews chosen to grace the cover of the book fall into this elite group.

Combination Tools

Combination tools have their own constituents. Being strictly utilitarian and generally without melt-down value, they are sought for their rarity, condition, and even oddity, with functionality often bringing up the rear. A Nylin (No. 914,601), Jenkins (No. 1,784,488), or Alderson (No. 1,845,038) would quickly attract bids starting in the low $100s. A simple can opener like the patented "KING" by Browne (No. 541,034) might conceivably be "acquired" with change back for $5.

A Final Note

In conclusion, the price of any corkscrew boils down to a private matter between consenting adults. Anyone with a corkscrew deficiency who meets a person with a corkscrew to sell will determine the market. If you should happen to be one of the latter, I respectfully encourage you to send a card to the publisher, who will forward it to me. If, based on the timeless process of negotiation, we make a deal, great. If not, that OK too. It is the only way we will find out the truth.

Send your inquiries to Fred O'Leary, "Corkscrews," c/o Schiffer Publishing, 77 Lower Valley Road/Rt. 372, Atglen, PA 19310 USA.

INDEX OF PATENTEES

Page numbers are for illustrated patents. Only primary patents are referenced; related patents are noted in the caption.